ARTS OF ALLUSION

ARTS OF ALLUSION

Object, Ornament, and Architecture in Medieval Islam

MARGARET S. GRAVES

OXFORD
UNIVERSITY PRESS

Oxford University Press is a department of the University of Oxford. It furthers
the University's objective of excellence in research, scholarship, and education
by publishing worldwide. Oxford is a registered trade mark of Oxford University
Press in the UK and certain other countries.

Published in the United States of America by Oxford University Press
198 Madison Avenue, New York, NY 10016, United States of America.

CIP data is on file at the Library of Congress
ISBN 978–0–19–069591–0

9 8 7 6 5 4 3 2 1

Printed by Sheridan Books, Inc., United States of America

Try to be precise, and you are bound to be metaphorical . . . for the volatile essence you are trying to fix is quality, and in that effort you will inevitably find yourself ransacking heaven and earth for a similitude.

—J. Middleton Murry, *The Problem of Style*

And know that a well-arranged artifact indicates a wise artisan, even though the artisan is veiled from sight perception.

—Ikhwān al-Ṣafāʾ, *Epistles*

CONTENTS

ACKNOWLEDGMENTS

"All small things must evolve slowly, and certainly a period of leisure, in a quiet room, was needed to miniaturize the world."

—Gaston Bachelard, *The Poetics of Space*

MUCH OF THIS BOOK WAS written during a year spent as a 2015–2016 member of the Institute for Advanced Study, Princeton, and I would like to express my deep gratitude to that institution and to the Herodotus Fund for providing me with a quiet room and much else besides, as well as to the Art History Department of Indiana University for granting me leave for the year.

It would be impossible to write a book about museum objects—never mind illustrating it—without the goodwill and cooperation of a whole host of museum professionals and other colleagues. I would like to record my thanks to the following for their generosity in providing access to objects and/or help with obtaining images and information: Mariángeles Gómez Ródenas, Museo Arqueológico de Murcia; Basma El Manialawi and Nigel Fletcher-Jones, American University in Cairo Press; Jehad Yasin, Ministry of Tourism and Antiquities, Palestinian Territory; Samia Khouri, Department of Antiquities, Jordan; Youssef Kanjou, formerly National Museum, Aleppo; Ladan Akbarnia, British Museum; Moya Carey and Mariam Rosser-Owen, Victoria and Albert Museum; Nahla Nassar, Khalili Collection; Janet Boston, Manchester Art Gallery; Carine Juvin and Brice Chobeau, Musée du Louvre; Djamila Chakour, Institut du monde arabe; Jens Kröger and Stefan Weber, Museum für Islamische Kunst; Anki Börjeson, Länsmuseet Gävleborg; Kjeld von Folsach and Mette Korsholm, David Collection; Anton Pritula, State Hermitage Museum; Mustafakulov Samariddin, Afrasiab Museum of Samarkand; Sabiha el-Khemir, Dallas Museum of Art; Judy Stubbs and Kevin Montague, Eskenazi Museum of Art, Indiana University; Sheila Canby, Martina Rugiadi, and Deniz Beyazıt, Metropolitan Museum of Art; Amy Landau, Walters Art Museum; Massumeh Farhad, Freer Gallery of Art; John Hanson and Joni Joseph, Dumbarton Oaks Collection; Filiz Cakir Phillip and Bita Pourvash, Aga Khan Museum; Matt Saba, Aga Khan Documentation Center; Joanne Toplyn, Fine Arts Library, Harvard University; Robert Hillenbrand, Jaś Elsner, Hans-Caspar Graf von Bothmer, Valentina Laviola, Lev Arie Kapitaikin, Bekhruz Kurbanov, Daniel Burt, and Jeremy Johns.

Image costs for this book were generously funded by an Outstanding Junior Faculty Award from Indiana University, a publication award from the Barakat Trust, and grants from the Art History department and Islamic Studies Program, Indiana University. Parts of Chapter 5 previously appeared in an article published in the journal *Art History*, and I am grateful to the Association of Art Historians for granting me permission to reproduce that material here.

Several colleagues read and commented on or discussed parts of this book with me during drafting, and I owe a deep debt of gratitude to them all. First among them is Robert Hillenbrand, who also waded through more than one version of the PhD thesis that distantly prefigured parts of this work—to say nothing of his heroic earlier labors in shaping and sharpening my undergraduate mind. I am endlessly grateful to Anton Pritula for illuminating discussions, on topics ranging from metalwork to poetry, which have greatly enriched the text in many places. Many of my colleagues at the Institute for Advanced Study provided helpful comments and answered queries during the writing process: Yve-Alain Bois, Sabine Schmidtke, Marisa Bass, Sarah Bassett, Matt Canepa, Wen-Shing Chou, Christine Guth, Michael Kunichika, Eric Ramírez-Weaver, Rebekah Rutkoff, Maurice Pomerantz, Nahyan Fancy, Hassan Ansari, and Dan Smail are all thanked for their suggestions. Melanie Gibson, Anna McSweeney, and Bret Rothstein each pointed me in important directions at critical stages. For commenting on drafts of various sections of this text, I thank Gardner Bovingdon, Moya Carey, Barry Flood, Paul Losensky, and Ittai Weinryb, as well as my writing-group colleagues at Indiana University: Marina Antić, Guadalupe González Diéguez, Seema Golestaneh, Ayana Smith, and Izabela Potapowicz. Finally, at Oxford University Press the anonymous peer reviewers and my indefatigable editor Sarah Pirovitz provided invaluable suggestions for refining and framing the final work. The book has benefited throughout from the input of all these individuals, and the errors that remain are mine alone.

The list of friends and loved ones who supported me in myriad ways throughout the genesis of this text is much too long to enumerate, and I will record only that I am grateful to every last one. I would, however, like to remember here two who are very much missed: Oliver Grant, who encouraged the very first flickers of the idea that would eventually become this book, and Nora Bartlett, whose conversation and correspondence always, and to the very last, revealed new ways of seeing the world.

Most of all I thank A. D. B. and A. G. B., who have brought happiness to the years of research and writing.

My mother Ellen Graves, who contributed to this book in more ways than I could ever recount or she may ever have realized, died shortly before I finished writing it. It is dedicated, with love, to her memory.

A NOTE ON TRANSLITERATION

WHERE A TERM HAS BEEN transliterated from Arabic or Persian, diacritical marks have been used following the system of the *International Journal of Middle East Studies*. Foreign words that have entered English usage are neither italicized nor provided with diacriticals. For convenience, the plurals of some Arabic words in frequent use within the text have been formed by adding a Romanized letter *s*, for example *kilga*s. Dates are given in the Common Era (CE) calendar unless otherwise specified.

INTRODUCTION

Trainer of man, the hand multiplies him in time and space.
　　　　　　　　　　　　—Henri Focillon, "In Praise of Hands"

The lot of the specialist in medieval Islamic portable arts is, from some perspectives, an alarming one. Before her is a vast corpus of dislocated objects, many (if not most) of them without a shred of any archaeological record or reliable provenance data prior to their arrival on the international art market in the nineteenth or twentieth century. She can never be too vigilant about the authenticity of her subjects, which have a tendency to pick up interesting "enhancements" or become optimistically "completed" on their way to market. At night she has horrible dreams about clever forgeries. But before you weep too much for this hypothetical scholar, consider the extraordinary richness of the materials among which she picks her way. The art of the object reached unparalleled heights in the medieval Islamic world. Objects of beauty and technical virtuosity, objects that traveled and passed between hands—these works were at the heart of the cosmopolitan city cultures that blossomed across the *dār al-Islām* in the centuries prior to the Mongol conquests of the thirteenth century, and beyond.[1]

Moreover, the medieval Islamic art of the object offers far more than just beautiful surfaces, in spite of the pervasive characterization of Islam as a zone of paradigmatically "minor" arts that are to be admired only for their "decorative" and sensual qualities.[2] Many of the plastic artworks of the medieval Middle East are

deeply intelligent artifacts born of a culture of craftsmanship that recognized what I have termed in this book the "intellect of the hand." This was also a context in which craftsmen engaged the plastic arts in fertile dialogue with literature, poetry, painting, and architecture. It is the relationship between the last of these, architecture, and the three-dimensional art of the object that forms the primary focus of this book, but all of the others will come into play along the way. By exploring the potential for medieval theories of perception, cognition, and rhetoric to illuminate the art of the object, this text follows in the footsteps of others who have also sought to locate artistic practices within the broader intellectual history of the medieval Islamic world, and to show how artworks were imbricated with currents in philosophy, theology, science, and literature.[3] In particular, the book explores the ways in which the medieval Islamic art of the object synthesized a mutable, visuospatial poetics of allusion. By these means, it propounds a system of "likeness" that is quite distinct from the paradigms that have traditionally dominated art history, such as representation, symbolism, or abstraction. The allusive objects of this book are therefore potent subjects not only for Islamic art history but for art history as a whole.

The following chapters frame discrete groups of metalworks, ceramics, and stonecarvings that allude to buildings, placing the objects into historical context and tracing the nature of their relationships with architecture. Groups of objects have been drawn from the Eastern Mediterranean to the Iranian plateau and date from the ninth to the thirteenth centuries; many of them are from the twelfth and thirteenth centuries, a period of particular acceleration and inventiveness in the plastic arts across several regions, and from which a great number of artworks survive. Hence, the "medieval Islam" of this book's title is primarily a network of urban locales spread through the Middle East and into Central Asia, from the ninth- and tenth-century florescence of Baghdad up to the Mongol conquests of the thirteenth century. This is by no means the only possible definition of the term, but a reasonable one for a book dealing with urban artistic production and particularly with a vibrant, sometimes experimental plasticity that seems to ebb away from many of the luxury arts in later centuries, to be replaced by more polished forms. Exploring diverse groups of objects from distinct historical contexts side by side and bringing together multiple milieux are somewhat unorthodox practices in the field of Islamic art history, outside of the special conventions of the exhibition catalogue. But by setting each piece and group into its own historical context, while at the same time taking an approach that is both comparative and closely focused on individual objects, this book allows a category of creativity to emerge across dynastic, regional, and material boundaries: the plastic art of allusion.

Arts of the Third Dimension

Allusions to architecture abound across the medieval Islamic portable arts, and they have the capacity to illuminate perceptions of both the built environment

and the arts of making. Lanterns fashioned after miniature shrines, stands that reconfigure the forms of garden pavilions or water features, incense burners that assume the contours of domed monuments, inkwells that play at removes with the egress and ingress of monumental architecture: the subjects of this book are functional objects that allude to the forms of buildings without precisely recreating them. To coin a neologism, they are archimorphic rather than archimimetic, for the most part working through systems of indirect reference that allow a plastic poetics to emerge. In each case, the conceit of resemblance drawn between object and building has been constructed around some perceived kinship between the miniature and the monumental, whether of form (for example, domed lids and domed roofs), function (frequently containment, whether of precious substances or sacred spaces), or both. The web of evocation between objects and buildings is subsequently elaborated through a plastic system of allusions, analogies, correspondences, and correlations, from the meaningful placement of individual motifs to the architectonic articulation, in miniature, of volumetric spaces.

The relationship between the two artforms of architecture and objects is by no means arbitrary: despite differences in scale, both are arts of the third dimension. Indeed, if one thinks of things like furnishings or tilework, it is not always possible to say where architecture ends and objects of use begin. Art history, with its disciplinary predisposition toward images, tends to frame its subjects in imagistic terms. The paradigm is undoubtedly a productive one: as the doyen of Islamic art history, Oleg Grabar, has observed, "there are many mansions for the feast offered to the mind by the eyes."[4] But why stop at the eyes? For the arts of the third dimension, the contiguous faculties of touch, sound, smell, and even taste must be invited to the table as well. Without attempting exhaustively to recreate a medieval "sensorium," throughout this book I bring the reader's attention to the material and haptic aspects of the subjects of study, their weight, their physical and spatial presence, and the temporal experience of manipulating them.[5] The allusive relationship between objects and buildings explored in the following chapters acts within a regime of resemblance rather than representation—meaning that parallels should be sought not only in morphology but also in structure, function, and phenomenology, where connections reside that are manifested, in Foucault's terms, "by virtue of imagination."[6]

Given the cognitive duality of the materials under study, it will be best to frame an example here as a point of departure. Mehmet Aga-Oglu, one of the great pioneers of Islamic art history, was among the first to give serious consideration to the observable reciprocities between monumental architecture and the plastic arts of the medieval Middle East. In an article that appeared in *The Art Quarterly* in 1943, titled "The Use of Architectural Forms in Seljuq Metalwork," he proposed that the striking fluted bodies of some ewers from Khurasan, the northeast region of the Iranian plateau, were signs of "an artistic approach influenced by

architectonic thought." Specifically, he likened them to tomb towers.[7] The article is brief, and structured around an explicated sequence of "compare and contrast" image pairings that seem to have been drawn in large part from the then recently published *Survey of Persian Art* (1938–1939). In fact, it probably stands as a testament to that publication's unprecedented assimilation of a superabundance of diverse materials into six navigable volumes. The image pairings as originally presented in the article substantially aided Aga-Oglu's argument, for they reproduced ewers and buildings at roughly equal dimensions and in grayscale—a reprographic convention that enhances both the monumentality of the objects and the sculptural iconicity of the architecture. Although short, Aga-Oglu's study neatly illustrates both the possibilities and the pitfalls of direct morphological comparison as a methodology for linking objects with buildings.

The relationship between objects and buildings is intriguing when Aga-Oglu brings the thirteenth-century Kishmar tomb tower (Fig. I.1) into conjunction with a Khurasanian inlaid ewer of the late twelfth or early thirteenth century, now in Berlin (Fig. I.2).[8] The principal point of formal kinship between the two is the use of alternating convex flutes and triangular ribs to articulate the full length of the cylindrical body or shaft, something that appears on a few surviving ewers of this type.[9] As Aga-Oglu notes, the combination of alternating flutes and ribs was not common on surviving Iranian tomb towers, although its celebrated appearance on the Quṭb mīnār (begun by *c.* 1200) at Delhi suggests it might once have been in more widespread architectural use.[10] He stages a similar comparison between the tomb tower at Radkan in northeastern Iran (dated to 1205–1206 by Sheila Blair, and to 1280–1281 by Ernst Herzfeld; Fig. I.3) and a ewer now in the Metropolitan Museum (probably also late twelfth- or early thirteenth-century; Fig. I.4): both are articulated with vertical convex flutes.[11] In both of these pairings the

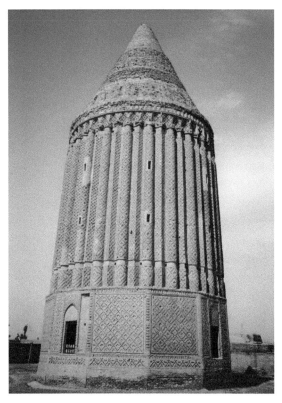

FIGURE I.1 Tomb tower, Kishmar, Iran, thirteenth century.

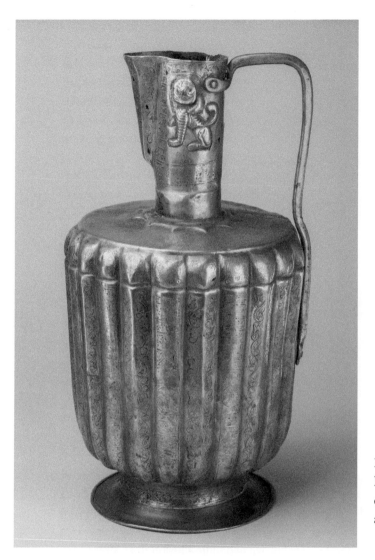

FIGURE I.2 Ewer, Khurasan,
late twelfth or early thirteenth
century. Copper alloy with silver
and copper inlay. Height 32 cm.

analogy between vessel and tomb tower is encouraged by the rough geographical
and temporal proximity of the subjects, and propelled by the striking formal like-
ness between the monumental and miniature articulations of the vertical bodies of
buildings and objects.

Not discussed by Aga-Oglu, but giving further weight to his argument, is
another point of formal comparison between the vessels and their monumental
analogues: the crowning of the shaft in each of his examples with a "cornice" of
deeply recessed and highly plastic ornamentation. While the individual ornaments
within these cornice sections differ—addorsed repoussé harpies and faceted and
beveled compartments on the ewers, recessed trefoil arches on the towers—it is the
manner of their use and placement that draws connections between metalwork and

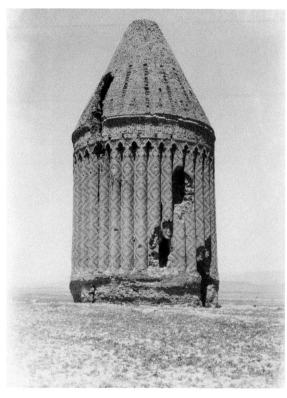

FIGURE I.3 Tomb tower at Radkan East, Iran, thirteenth century.

architecture. In each case, the cornice section breaks the vertical emphasis of the fluting and demarcates the start of the zone of transition, from body to shoulder on the vessels and from shaft to conical dome on the towers, with a strong play of light and shadow.

Moreover, the famous 1181/ 1182 fluted ewer of this type now in Tbilisi, which praises itself at length and in the most extravagant terms in its inlaid inscriptions, is decorated on the cornice band with a frieze of discrete compartments. These present, in alternation, the inlaid image of an arch occupied by a figure and that of a vase-lamp from which symmetrical vegetal tendrils grow into an enclosing quasi-arched frame (Fig. I.5).[12] The image of the arch, a unit that can operate simultaneously as a means of compartmentalizing a surface and as a point of entry into a fictive spatial register, is thus set into play and double-play on the Tbilisi ewer through its placement at a point upon the body of the object where it correlates with and gestures toward the (equally nonsupporting) brickwork arch designs of tomb tower decoration. The alternation of occupied arch with vegetal quasi-arch in this sequence only adds another level of wit and ludic allusion to an already supremely self-conscious object.

The connection that Aga-Oglu proposes between ewers and towers is a way of articulating form and space transcribed from one modality to another. Aga-Oglu regarded this phenomenon as the outcome of a one-way transfer of form from architecture to the "minor arts," a top-down dissemination from the most expensive medium of patronage—architecture—to the smaller-form arts of the elite and those of the bazaar. Modern taxonomies may have conditioned us to regard architecture as having an inviolable right of primogeniture among the arts, but we should remain open to the possibility that in the febrile artistic and intellectual environment of pre-Mongol Iran, the arts of the third dimension were mutually constitutive. The overall corpus of the visual and material arts from this historical context is notable not only for its dynamism and inventiveness, but also

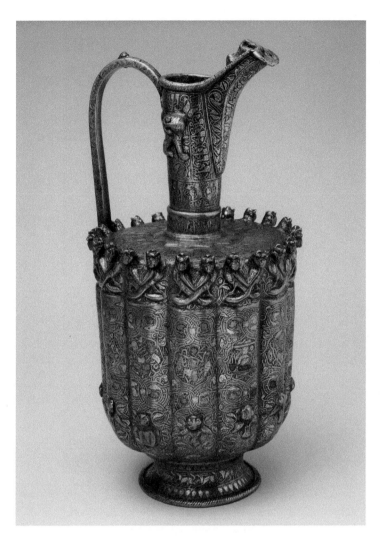

FIGURE I.4 Ewer, Khurasan, late twelfth or early thirteenth century. Copper alloy with silver inlay. Height 40 cm. New York, Metropolitan Museum of Art, 44.15.

for a high degree of engagement between media—as will be explored thoroughly at several points in this book. In the case of Aga-Oglu's ewer-tower comparison, the architectonic articulation of the ewers certainly endows these small objects with a surprising monumentality. In the tomb towers, however, it is the plasticity of the brickwork that is remarkable, bringing the articulation of these buildings close to that of a malleable medium like brass. The rhythmic undulations of the fluted shaft and the encrustations of projection and recession in the zone of transition turn this most self-contained and autonomous form of monumental architecture, often intended to be seen in isolation and from afar, into an invitation to the hand, sacrificing spatial complexity for a delight in the play of surface articulation. There is no reason to assume, prima facie, that correspondences and similitudes can travel in one direction only between architecture and the portable arts.

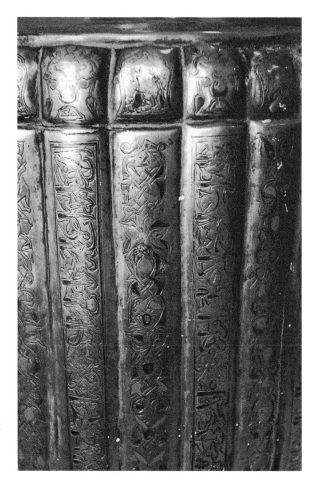

FIGURE I.5 Ewer,
signed Mahmud
ibn Muhammad al-
Haravi. Probably
Herat, Afghanistan,
dated Shaban 577
AH (December 10,
1181–January 7, 1182).
Copper alloy with silver
and copper inlay. Height
38.5 cm.

To return to Aga-Oglu's analogy, the rhetorical power of his argument diminishes significantly when he applies it to a pairing of faceted vessel and faceted building. It collapses more or less entirely when he likens the eleventh-century cylindrical tomb tower at Lajim, near the Caspian Sea in northern Iran, to a cylindrical ewer in the Berlin collections.[13] In both of these last pairings the point of analogy between object and building has become too generalized, too far from formal specificity, to bear the weight of art historical argumentation. The first two of Aga-Oglu's ewer-tower pairings stand up because there are a sufficient number of points of particular correspondence between object and building, in particular the various highly differentiated forms of fluting and ribbing. The last comparison does not, because as a general rule, the simpler the forms involved, the less likely connections between disparate media become. Self-evidently, not every cylindrical vessel manufactured by a medieval craftsman refers to a tomb tower, and to suggest that there must be a causal relationship between the two raises the specter of what Erwin Panofksy termed "pseudomorphism"—a coincidental convergence of form that, at its most problematic, is mistakenly treated as evidence for a meaningful historical connection between two artifacts.[14]

The problem in this case stems from Aga-Oglu's treatment of what archaeologists call "affordances"—that is, properties of things that relate to their potential use—as if they were informed only by immaterial aesthetic concerns and were somehow unaffected by either functionality and potential use, or by the qualities of materials. The ewer is made by and for human hands: at the moment of use it merges artifice and nature, conjoining a manufactured object with the human body and with water. Rather than pointing to something external, a cylindrical form for a ewer is in the first instance a logical and materially intuitive solution to the challenge of creating a pouring vessel from sheet metal. It does not in and of itself construct a relationship of similitude with an external thing. However, artists may yet choose to build upon the potential for allusion to an external referent that is contained in even the simplest of forms, through the conscious development and articulation of more specific points of likeness—as demonstrated by the first two of Aga-Oglu's ewer-tower pairings.

As the basis for an architectural structure, meanwhile, the cylindricality of the Lajim tomb tower is less obviously an outcome of baked brick and its material demands. Indeed, the initial motivations for the development of the tomb tower in Iran and Afghanistan, with its spectacle of centered verticality, are the subject of much speculation.[15] Nonetheless, the coincidence of a cylindrical form for two types of container—one for liquid and the other for a body, or rather the idea of a body—does not constitute enough specificity of form to indicate that any deliberate correlation is being drawn between the two. Aga-Oglu's proposal that the fluted ewers of Khurasan evidence a strain of "architectonic thought" in the plastic arts of twelfth- and thirteenth-century Iran represents a profound insight. However, in carrying his argument beyond the point of sustainability, he has also provided an important cautionary tale for the art historian on the quarry of likeness and allusion between objects and buildings. Spend long enough looking at things in a certain way, and you will start to see everything that way—an axiom that bears directly on major issues of object perception and likeness running throughout this book.

These issues notwithstanding, Aga-Oglu's model of "architectonic thought" reflects a primary tenet of this text that will be explored fully in Chapter 1: making is thinking. Furthermore, embedding *thought* into the core of this model of likeness permits the intellectual and experiential dimension of architecture to come to the fore. Buildings are experienced through the senses and the mind; as such they can be refracted onto the plastic arts in myriad ways and are not necessarily tied to a rigid mimetic paradigm of direct representation. The elastic processes of shrinkage and compression that effect the architectural allusions encountered in this book do not result from scaling down complete architectural schema precisely until they fit onto the bodies of objects. Rather, they engage cognitive practices and manual processes of abstraction, reduction, exaggeration, and omission that enable forms—and ideas about forms—to flow freely across the boundaries created by scale, medium, material, color, and so forth.[16] The play of correlations—of

function and meaning as well as form—is formed and discerned through the hand and the mind, as well as the eye.

Portable Objects and Art Historical Horizons

The specific case of the Khurasan ewers and tomb towers provided an opportunity to explore the possibilities and limits of plastic allusion in the portable arts. This venture immediately raises a question: Whose cognitive processes are we exploring, besides our own, when we scrutinize an object like an inlaid brass ewer in this way? Who, in the most general terms, might have been the makers and users of these objects? What were the contexts of creation and reception? The subjects of this book are drawn from diverse locales and periods; accordingly, the specificities of historical and geographical context will be addressed in detail within the individual chapters. This introductory discussion will simply sketch a brief overview of some of the historical and historiographic issues that these questions bring to the study of the medieval Islamic art of the object.

Looking for landscapes of production in the pre-Mongol Middle East immediately raises one of the great challenges presented to art historians by the portable arts of the medieval Islamic world: the inherent mobility of the materials and their tendency to wander, sometimes far from the sites where they were created. I have already mentioned the undocumented condition of most of the extant medieval portable arts prior to their appearance on the international art market; add to this their native propensity to move within their original landscapes of production and the taxonomist is faced with a colossal puzzle of moving parts. Medieval Islamic craftsmen produced their works in an interconnected landscape of primarily urban locales, in which manufactured goods moved within networks of trade connections. The mere existence of lists of the agricultural and manufactured products of successive regions that appear in texts like the tenth chapter of the *Laṭāʾif al-maʿārif* of Thaʿālibī (d. 1038) or scattered throughout Yaʿqūbī's "administrative geography," the *Kitāb al-buldān* (completed in 891), is a testament to the early existence of these well-established trade networks.[17]

It is also significant that regional specialization seems to have generated a form of pedigree for products in the medieval marketplace. A narrative work attributed to Hamadhānī (d. 1008), although possibly the work of a slightly later author, includes a list of almost forty medicinal ingredients purportedly used in a mountebank's compounds. More than half of these are distinguished by a *nisba* indicating the town or region of origin: "Khurāsānī wormwood, Kirmānī cumin, pellitory from Zāryān" and so forth. The pairing of individual materials with their geographical point of origin is in this context a means of highlighting both their rarity and the collector's expertise and ingenuity in obtaining them, but it also articulates a broad and connected economy of recognized localities, each with specialized products of renown that circulated far and wide.[18] Within the realm

of manufactures, textiles were evidently the most portable, versatile, and widely traded liquid asset of the pre-modern Islamic world.[19] The trope of geographical regions represented by their textile products reaches a sort of apotheosis in the final passages of the *Laṭāʾif al-maʿārif*, in which the tenth-century author Abū Dulaf invokes blessings for himself in the form of regional textile products: "May He bring down on *me* the mantles of the Yemen, the fine linens of Egypt, the brocades of Rūm, the satins of Sūs" and so forth, down to "the trouser-cords of Armenia and the stockings of Qazwīn."[20]

While textiles may have been the most widely traded medium of manufacture, the available evidence of archaeological findspots shows that other forms of manufactured object, including metalwork and ceramics, could also travel considerable distances.[21] Medieval textual sources occasionally mention cities particularly renowned for their manufactures, most famously Kashan for ceramics and Mosul for inlaid metalwares, suggesting or sometimes even expressly stating that these goods were exported far from their sites of production.[22] Craftsmen, too, sometimes moved around, as conditions deteriorated in previously flourishing cities as a result of conflict, natural phenomena, or the relocation of courts, and new opportunities arose on farther horizons.[23] Within this panorama of motion it is striking how little information we have about craftsmen, the economic conditions within which they worked, and indeed the very structure of society below the level of the elite. Art historians have searched particularly for social and economic factors that would explain the notable florescence of figural art across media in the twelfth- and thirteenth-century Persianate realm. Faced with this phenomenon, both Richard Ettinghausen and Oleg Grabar arrived, via slightly different routes, at an "open-market" hypothesis. This supposed that a prosperous and burgeoning urban mercantile "bourgeoisie," the upper levels of which almost touched the aristocracy, constituted the main market for the surviving superabundance of fine ceramics and metalwares manufactured in the twelfth- and thirteenth- century Iranian plateau. In this economic model, it was assumed by both scholars that those materials were mostly made speculatively for an open market, rather than being crafted on commission. The argument rests in large part upon the increasing incidence of makers' names on objects in this context, as well as the prevalence of objects inscribed with benedictions directed toward an anonymous possessor of the object (*li-ṣaḥibīhī*, "to the owner") rather than a named patron—a phenomenon that will be encountered in Chapter 3.[24]

While Grabar and Ettinghausen's arguments are attractive, Yasser Tabbaa has already observed that the picture they paint is somewhat at odds with that of their peers in economic history.[25] David Durand-Guédy's recent study of Seljuq Isfahan rounds out that picture a little: as he frames it, Seljuq society was ordered around a descending hierarchy: rulers, "notables" (families who acted as political and social leaders within the city, and intermediaries between the urban population and the extramural Seljuq court), their followers within a client-patron system, self-supporting craftsmen and small bazaar traders, and—at the bottom—peasants

and the urban poor.[26] This vision of society in the medieval Iranian capital might lend support to Grabar and Ettinghausen's projected "open market" for luxury artworks by giving some substance to the elevated classes who had sufficient wealth for a market in luxury goods like inlaid metalwares. It also has the potential to nuance the "haute bourgeoisie" argument, by illuminating the middle-to-upper levels of the market that presumably constituted the consumer base for a large-scale industry in glazed ceramic production and fine wares. At the same time, Durand-Guédy's research into the dynamics of two major "notable" families in Isfahan suggests that urban social structures within the medieval Middle East may have varied significantly from one locale to the next, and one must remain cautious about extrapolating too much from the case of any individual city. In a different vein, Ruba Kana'an's recent research on the legal concepts embodied in inlaid metalwares has many interesting implications for the status and roles of different classes of craftsmen within the medieval metalworking industry.[27] However, in spite of these new channels of investigation into the social and economic life of medieval Middle Eastern cities, the precise mechanics of the luxury goods markets within those cities remain, for the moment, largely obscure.

The mobility of the objects, the frequent uncertainty as to their place of origin, the opacity of the very systems that brought them into being: all of these conditions of the medieval Islamic portable arts bring them into confrontation with art history's "fictitious creed of immaculate classification."[28] Like Michel de Certeau's vision of history as a discipline that fractures the past, leaving "shards created by the selection of materials, remainders left aside by an explication," art history's predilection for taxonomical classification by material, period, dynasty, artist, and so forth inflicts similar breakages.[29] In this case, it has also generated a lingering uncertainty about the plastic arts of medieval Islamic societies, in which the art of the object of use was elevated to a higher status than it attained in coeval European contexts, outside of liturgy. What to call these objects that are both functional and supremely aestheticized, when they have no real correlate in the European traditions upon which the discipline is based? And where to put them in the great narrative of art history? The quotidian functions and the sheer volume of the "industrial arts" of ceramics, metalwork, glass, and woodwork, as Grabar has termed them, constitute difficulties in and of themselves for the location of the "art of the object" as a meaningful category within a discipline founded to no small degree upon Romantic ideals of individualism and canonized masterpieces.[30]

Historiographically, then, the medieval Islamic art of the object has been a problem for art history. Attempts to assimilate these portable arts into existing art historical categories have been quite revealing. In the early twentieth century, the imposition of the problematic category "sculpture" onto pre-modern objects of use from the Islamic world represented one attempt to fit the material into a hierarchy of artistic production devised for post-medieval European representational art.[31] The emphasis placed on figural representation by early collectors and

scholars alike was another outcome of the same value system.[32] The allusive objects of this book present yet another facet of the same problem: the very notion of resemblance that they embody defies the paradigm of mimetic visual representation that still occupies the disciplinary core of art history. They are not "models" of architecture; instead they pose other ways in which the idea of a building can be made to resonate within and upon the body of an object. For these reasons, the subjects of this book embody some of the core provocations that Islamic art can present to the larger discipline of art history: they represent a world in which the object of use is a superlative art form, the intellectual dimension of the crafts is tangible and reverberates throughout the cultural landscape, and an artistic system resides that can construct resemblance through other means than mimesis.

Miniature, Model, Microcosm

Miniaturization is, naturally, a major part of the refraction of architecture onto haptic objects, although it is possible that sometimes small forms, like Aga-Oglu's ewers, might be monumentalized too. Chapters 2–5 will delineate the precise terms of these micro/macro relationships in the medieval Islamic world through close studies of individual objects. This introduction, meanwhile, will use a comparative cultural perspective to establish some of the mechanics and meanings of miniaturization when applied to architectural forms.

 The first examples of miniaturized architecture that come to mind for a twenty-first-century reader are likely to be architectural maquettes or construction models designed to aid the architectural process.[33] Working models of this type were most likely in use in the Islamic world by the early modern period, and it is entirely possible that models of wood or other materials were also used for this purpose in earlier centuries, although there remains very little surviving evidence to substantiate the practice.[34] The objects of use examined in this book, though, were never intended to serve as representational, didactic models in that way: being things that can be simultaneously "seen as" functional objects and allusions to architectural form, they occupy quite a different territory in both material and conceptual terms. Nonetheless, they partake in some of the affective powers of miniaturization, a particularly resonant phenomenon in the case of architecture and one that should be considered in some detail.

 A distinction must first be drawn between the working model of the architect and the commemorative architectural model intended to celebrate a building or an event. Spectacular models of individual buildings, created in celebration of major architectural projects, were made for display and parading in the early modern world in particular.[35] Gülru Necipoğlu has pointed out that surviving miniature buildings from the Ottoman period, executed in various media, have sometimes been conflated with architects' models but would usually be better understood as commemorations of building donation or celebrations of individual monuments

for other reasons, such as the completion of restoration works. In this sense, they are related to the miniature buildings presented in paintings or carvings of donors in medieval church decoration.[36] A potent latter-day example of the three-dimensional commemorative simulacrum can be found in the case of the Dome of the Rock. As the supremely visible touchstone of Islamic presence in Jerusalem, the Middle East, and the world, the image of this foundational monument circulates not only in countless prints, posters, postcards, and on currency but also in three-dimensional form. Mother-of-pearl inlaid wooden boxes in the shape of the Dome of the Rock constitute a staple of the modern-day tourist trade as well as prime donative gifts, and they can be seen in various collections around the world. For example, Saddam Hussein possessed one that was later looted from the museum dedicated to him in Baghdad.[37] The keyword is in this case "possession": model-making, a form of miniaturization, is a potent means of holding and harnessing the otherwise ungraspable power of monumental architecture—an act with unmistakable symbolic significance in the case of the Dome of the Rock. I will return to this aspect of miniaturization below.

Some architectural "models," particularly those made from ephemeral materials, seem to have held other kinds of celebratory role in the pre-modern Islamic world that were not connected with the iconicity and civic weight of individual monuments. Medieval sources record miniature palaces and pavilions made from sugar or halva that were included within the spectacular table displays of the medieval Islamic world, in conjunction with sugar figures of humans and animals, boats and gardens. Like the pavilion of halva that towered toward the ceiling at a feast held at the eleventh-century court of a Ghaznavid sultan, such confections seem to have been conceived as centerpieces, although they were also sometimes paraded through the streets during times of festivity.[38] Mention is not usually made of specific monuments commemorated in this way; rather, as Oleg Grabar suggests, these sweet constructions seem to have "served as symbol-souvenirs of the complex life of the palace," as well as a form of short-lived celebratory artwork that could marshal humor as well as spectacle to good effect.[39] A different kind of use for the confectioner's art is described by the polymath al-Ghazālī (d. 1111): "Abū ʿAlī al-Rūdhbārī [a well-known Baghdadi Sufi, d. 933/4] bought some loads of sugar and ordered the sweet-makers [al-ḥalāwayīn] to build a wall of sugar on which were battlements [shuraf] and miḥrābs on decorated pillars [aʿmida manqūsha], all made of sugar. He then invited the Sufis and they destroyed and plundered them."[40] This passage, while somewhat enigmatic, seems to describe the staging of a kind of fantasy of architectural destruction through sugar sculpture, perhaps presenting a lesson in the transitory nature of earthly power. At any rate, it illuminates one unexpected mode of consumption that awaited these ephemeral buildings.

Medieval and early modern records of model buildings given on feast days expand the tantalizing history of miniature architecture as a form of beneficent

or commemorative gift.[41] A thirteenth-century Arabic legal text from al-Andalus condemns Muslim participation in non-Muslim festivals including the New Year (*nayrūz*); singled out for particular opprobrium is the practice of gifting model buildings populated with figures.[42] Into this category of festive gift-giving I would also place the ceramic house models attributed to twelfth- or thirteenth-century Iran (Fig. I.6). These schematized representations of courtyard houses, populated by tiny musicians and drinkers, contain festive celebrations tightly bound within the walls of domestic architecture. The viewer is granted visual and tactile access, via his vantage point above the Lilliputian structure's interior, to a form of celebration normally concealed behind closed doors for reasons of cultural propriety and legal imperative. I have argued elsewhere that these objects were most likely made for gift-giving, quite possibly on the occasion of the New Year or other domestic celebrations such as weddings, and it is entirely possible that the ceramic house models are the chance survivals of a larger tradition that once included cognates in ephemeral materials such as sugar and wax.[43]

As well as commemorating celebrations, the house models may also have held an apotropaic role by acting as synecdoche for that most fundamental architectural unit: the home. The scene of domestic festivity presented by the house models could be intended as an invocation for happiness to reign in the home of the owner, or equally for inauspicious events to stay away. Such efficacious practices are now

FIGURE I.6 "House model," Iran, twelfth or thirteenth century. Glazed stonepaste. Length 14.2 cm. Brooklyn Museum, 75.3.

or have been in the past widespread throughout many societies. Within these practices miniaturization becomes a means of capturing the essence of something larger and less directly tangible in order to control, protect or possess it as well as take delight in it—a perspective that permeates some of the best-known theoretical writings on miniaturization, from Gaston Bachelard to Susan Stewart.[44]

For these reasons, the symbolic and synecdochic charge of miniature buildings is perhaps most directly availed in grave goods like ancient Egyptian "soul houses" or the famous miniature buildings from Han-dynasty China created in the tradition of *mingqi* ("spirit articles"; Fig. I.7). Our understanding of these superbly executed pavilions, grain stores, courtyard houses, pigpens, and so forth rests on recognizing that they were created as symbolic substitutes for real-life personal property—or the ideals of property to which the sub-elite classes aspired—intended to accompany the dead into the afterlife.[45] Miniaturized, held forever in the permanence of glazed earthenware, they stand outside the time and space of this world while laboring to simulate earthly details of construction and use.[46] And yet, in spite of their close interest in both realia and the modeling of an ideal, the *mingqi* buildings are not exactly models, or at least not in the modern, didactic sense that depends upon a precisely correlative relationship with a tangible, full-scale referent.[47] It can instead be argued they act as a form of microcosm, in the sense of

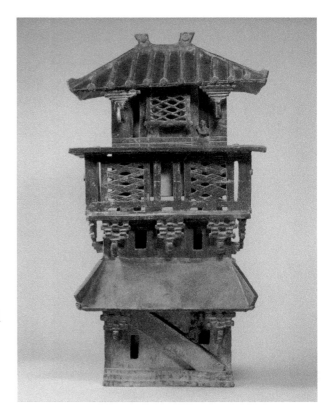

FIGURE I.7 Model of a watchtower, China, Eastern Han Dynasty period (25–220). Glazed earthenware. Height 104.1 cm. New York, Metropolitan Museum of Art, 1984.397a, b.

the word developed by John Mack in his global study of miniaturization. Like the house models, they are the outcomes of a conceptualization process that distills the entire social semiotic of an architectural form, producing results that are "neither scrupulous and small reproductions of larger totalities, nor fragments of larger entities," but intensified essences.[48]

The miniature buildings discussed up to this point are linked by a common thread: regardless of contexts of use and cultural inflection, their primary function is representational and their role is to depict. At the cusp of this mode lie objects of use that combine, paratactically, the forms of containers with unambiguous representations of architecture. Into this category can be placed certain vessels closely related to grave goods. Chinese soul jars (*hunping*) of glazed ceramic, created south of the Yangzi river from the second half of the third to the early fourth centuries, are characterized by a complex and often minutely realized and populated architectural superstructure mounted atop a large jar, aiming to create "an ideal world in miniature for the posthumous soul" who was hoped eventually to inhabit the vessel (Fig. I.8).[49] Comparable phenomena in other cultures, such as the architectonic Soghdian ossuaries discussed in Chapter 2 of this book, manifest similar concerns about appropriately articulating containers for the earthly remains of the dead; whether the dead were to inhabit the container corporeally or spiritually,

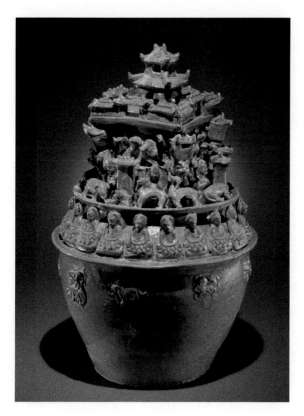

FIGURE I.8 Funerary urn, China, Western Jin Dynasty period (265–316). Glazed stoneware. Height 45.4 cm. New York, Metropolitan Museum of Art, 1992.165.21.

architecture was regarded as an appropriate means of elevating the form of the underlying container. In the pre-Columbian context, meanwhile, a type of "architectural vessel" recovered from high-status tombs of the Moche (200–800) on the Peruvian coast similarly combines the form of a container—usually a spouted, handled vessel—with an architectural superstructure. While some of these integrate architectonics into the body of the container (Fig. I.9), there remains, as there does also in the Chinese soul jars, an ontological disjunction between container and represented architectural form: the form adorns the container by sitting on top of it, but does not entirely modify the essential container-ness of its support.[50]

The honorific function of the architectural superstructure as container is perhaps most elaborately developed in the microarchitecture of medieval Christian liturgical instruments. It is in Western Christendom that the phenomenon was carried furthest, leading to François Bucher's proposal that microarchitecture embodies and produces "the 'Idea' of Gothic Theory and Style."[51] Reliquaries, monstrances, censers, chrismatories, sacrament houses, and candelabra all presented opportunities for free-standing microarchitecture, while microarchitectural ornament accreted on capitals, canopies, baldachins, tombs, baptismal fonts, and elsewhere as the Gothic period advanced. Achim Timmermann has recently argued that many of these mnemonic micro-structures, "all of them of course afterimages

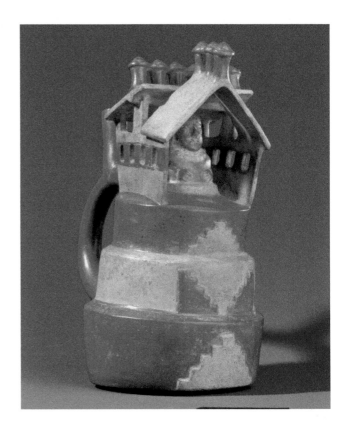

FIGURE I.9 Spouted vessel, Moche culture, Peru, c. 450–550. Earthenware. Height 24 cm. Division of Anthropology, American Museum of Natural History, 41.2/8022.

in one way or another of St John's visionary Heavenly Jerusalem," can be arranged around three conceptual nexuses, each of which induces a vertiginous experience of rescaling in the viewer. In his terms, these are the floating city, the kinetic cathedral, and the scopic labyrinth.[52] The dazzling complexity of much Gothic microarchitecture is magnified by the continuous exchange between micro- and macro-construction that took place in the architectural environment of the medieval cathedral, with individual elements reproduced across a scalar range.[53] In relation to this last quality, Elizabeth Lambourn has called for the parallel adoption of the term "microarchitecture" in studies of medieval South Asian architecture, where a comparable shuttling of potent architectural forms across the scalar spectrum sees temples decorated with tiny shrines or mosque portals framed by miniature niches.[54] A distinct but related phenomenon, recently explored by Jeehee Hong, is encountered within middle-period China's sacred and funerary architecture, whereby the interiors of sacred structures were decorated and constructed to resemble the exteriors of contemporary buildings, scaled down.[55] While divergent in their forms and aims, all these phenomena seem to share a certain ritualizing function of "layering and concealment," for which the visual language of sacred architecture is uniquely suited.[56]

In its most characteristic forms, Gothic liturgical microarchitecture stages the total recasting of a container into a largely autonomous visualization of a fantastic building. And for all the anti-rationality of materials and forms that this practice upholds, the fundamental "containerhood" of these reliquaries, monstrances, and so forth is often largely outstripped by their fantasies of architectural representation and glittering materiality (Fig. I.10). By contrast, the subjects of this book are each self-evidently designed to perform some quotidian action—whether that is supporting something else, containing or collecting a material substance, or emitting an immaterial one—in addition to any allusions to architecture they exhibit. One must therefore look outside of the Western European liturgical tradition for comparable objects that present a more immediately discernible dual identity, where objecthood coexists with allusions *to* architecture rather than disappearing behind the representation *of* architecture.

A good example hails from Byzantium, where some surviving processional cross-holders (Fig. I.11) present the carapace of a Middle Byzantine cross-in-square church.[57] While they make recognizable reference to an identifiable type of building, these cross-holders are not only some distance away from mimetic precision in representational terms but are also manifestly made for doing something: the affordances of sockets clearly indicate the object's function as a connecting component. Accordingly, the allusion to a recognizable architectural form that the cross-holder presents to the viewer would have been, in its original context of use, somewhat less arresting than it is now in the piece's role as an isolated and aestheticized museum object. Once, it provided a point of linkage in a larger composite object to be carried in procession, and remained visually

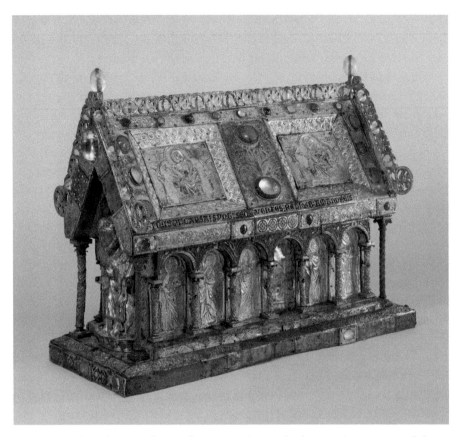

FIGURE I.10 Reliquary shrine of St. Amandus, early thirteenth century with later additions, Belgium. Wood, gilded copper, silver, brass, enamel, rock crystal, and semiprecious stones. Height 48.9 cm. Walters Art Museum, 53.9.

and spiritually ancillary to the large metal cross that would have been lodged in the upper socket—an inversion of the normal scalar relationship between a full-scale Byzantine church and its crowning cross. It is probable that the very idea of creating a cross-holder in the form of a church type arose from recognition of the kinship between the socket that holds the cross on the dome of a church, and the socket that holds the cross on a processional shaft. The centralized, cruciform structure of Middle Byzantine church architecture also lends itself extremely well to this particular role: the cross-in-square form, with a drum rising from the intersection of four vaults, is both stable and identifiable even when dramatically simplified and miniaturized. The result is an intelligent spiritual metaphor: the miniaturized and highly schematized church is both support and subordinate to the realm of the Holy symbolized by the cross.

This last artifact, then, brings us fully into the realm of allusion and the subjects of this book. The allusive object, like the cross-holder but unlike architectural

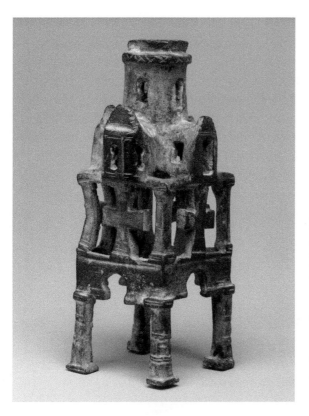

FIGURE I.11 Fragment of a processional cross holder, eleventh or twelfth century, possibly Constantinople. Cast copper alloy. Height 12.7 cm. New York, Metropolitan Museum of Art, 62.10.8.

maquettes or grave models, constructs a web of correlations that permit the imaginative reconstitution of architectural form while the utilitarian function of the object remains visible and tangible. There are, however, issues of positionality engendered by the miniaturization of architectural forms that are pertinent to the architecturally allusive object just as they are to the most slavishly accurate architects' models.

The first of these is the change that miniaturization effects in the relationship between human observer and architectural form: as Kee and Lugli have observed, rescaling always displaces the viewer.[58] To shrink a building, or to allude systematically to one on the body of an object, puts the beholder into the position of looking down upon and apprehending at a glance, even turning over by hand, something that would in its full-scale form contain and control the human body.[59] Secondly, this transfer of positional superiority also invites the beholder to imagine himself within the miniature structure at the same time that he stands outside it—a process that compresses perceptions of time as well as bodily space, and into which the imagination expands.[60]

Closely related to such "scalar travels" is another factor: miniaturization, particularly when not rigorously bound to the paradigm of mimetic verisimilitude, can permit and indeed sometimes encourages the simultaneous presentation

or evocation of interior and exterior architectural space. The striking interest
in flexible and deliberately ambiguous spatial constructions found within the
subjects of this book prefigures, I think, the unique mode of architectural repre-
sentation developed in Middle Eastern miniature painting from the thirteenth cen-
tury onward, and some specific points of connection between these media will be
elaborated in Chapter 3. In particular, Persianate book painting from the four-
teenth century and later sees architectural spaces opened out, multiple perspectives
presented simultaneously, and an extraordinary architecture of the mind and the
senses conveyed through a two-dimensional planar system (Fig. I.12).[61] No single
factor can account for what seems to be a predilection within certain contexts of

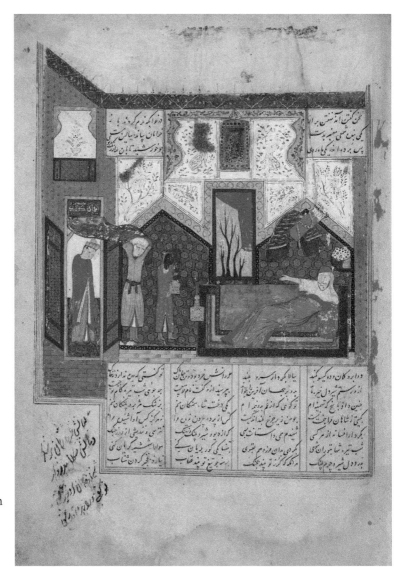

FIGURE I.12
*Tahmīna entering
Rustam's chamber,*
illustrated page
from a manuscript
of the *Shāhnāma,*
copied by
Maḥmūd ibn
Muḥammad
ibn Maḥmūd
al-Jamālī. Iran,
dated 861 (1457
CE). Page: 33.8 x
24.6 cm. Aga Khan
Museum, AKM
268, fol. 86v.

the medieval and early modern Islamic world for visuospatial play on the dialectics
of architectural space. However, architecture's unfolding in objects and pictures
suggests that there might be a metaphysics of space particular to the medieval
Islamic cultural sphere, potentially accessible through textual sources as well as the
plastic and painterly arts.[62] To give just one example, an isolated but intriguing tra-
dition of the Prophet hints at a theological facet to the phenomenon: "In paradise
there are rooms from inside which the exterior can be viewed, and from outside
which the interior can be viewed; they are for the soft-spoken who have provided
food for people and prayed at night when people were asleep."[63] Whether such a
tradition can be meaningfully related to the visual and material arts remains, how-
ever, a topic for another book.

The Art of Allusion

The five chapters of this book lay out the case for a medieval Islamic art of al-
lusion, exploring the web of connections drawn by medieval craftsmen between
objects and buildings—those arts of the third dimension—and the modes of indi-
rect reference that they harnessed to generate formal and conceptual correlations
between the two practices. At the same time, the book returns the intelligent art
of the object in medieval Islam to an expanded cognitive field that encompasses
awareness not only of architecture but also other forms of art—literary, poetic, and
painterly—and recognizes the mutual reinforcement of those different modes of
creativity within cultural environments that inculcated high achievements in all of
them. By employing a framework of "allusion," this book not only acknowledges
the textual paradigm that unavoidably orders the verbal discussion of visual and
material phenomena, but also uses it to explore the entanglement of operations
that are typically considered to be solely lexical—metaphor, allusion, and descrip-
tion—with the world of material things and human bodies.

Chapter 1, "The Intellect of the Hand," situates the act of making within
the intellectual history of the pre-modern Islamic world, arguing that in this con-
text making was often tacitly—and sometimes explicitly—recognized as a form
of thought. Using textual sources drawn from philosophical, theological, and
social traditions, it traces a craft-oriented worldview that maps manual and cere-
bral processes of making into the intellectual realm. Looking particularly at archi-
tectural design and creation, metaphors of matter and materiality, and the role of
makers, I argue that the value of craft and the "thinking hand" were more widely
recognized in the medieval Islamic world than has been acknowledged in much
existing scholarship. The chapter ends with a reassessment of the perceived role of
the craftsman within medieval Islamic society.

In Chapter 2, "Building Ornament," the allusive potential of ornament and
the two-dimensional paradigm that dominates ornament studies are both placed

under scrutiny. Surveying the historiography of architecture-as-ornament, I explore ornament's relationship with the third dimension, and in particular the potential for architectural motifs, especially arches and arcades, to confound two-dimensionality through the generation of fictive spaces that articulate and order form as well as surface. The chapter focuses first on the image of the arcade in various media and particularly inlaid metalwares. Next, it moves to the environs of thirteenth-century Mosul to explore the reciprocal relationship between plastic systems of three-dimensional ornament on buildings, metalwares, and a remarkable group of large architectonic earthenware water jars known as *ḥabb*s.

The human form can impart both scale and spatial logic to the objects it adorns, a phenomenon that was exploited by medieval artisans, particularly in the pre-Mongol Persianate world, to unexpected and sometimes humorous ends. Focusing on perception, the book's third chapter, "Occupied Objects," considers the role of the human figure in architectural allusions on objects from the twelfth- and thirteenth-century Iranian plateau. The power of the represented human form is explored through ceramic stands that make explicit reference to architectural pavilions; after these, a group of inlaid metalwork inkwells, and the delicately allusive nature of their relationships with full-scale architecture, forms the chapter's main focus. This study models a means of approach that considers the complex ornamental programs of the inkwells in their entirety: architectural, figural, epigraphic, geometric, and vegetal ornament are recognized as inseparable from each other and also from the three-dimensional materiality of pieces that respond to vision, touch, movement, and use.

Tracing parallels between material and verbal poetics, the fourth chapter, "Material Metaphors," begins and ends with close consideration of literary techniques. It makes particular reference to changing conceptions of metaphor and imagery during the florescence of medieval Arabic literary theory, and uses textual sources as well as artifacts to demonstrate the intertwining of verbal, visual, and material realms in medieval Islamic conceptualizations of metaphor and indirect reference. The first section expands a widespread but under-analyzed allegorical framework in medieval Arabic and Persian literary criticism that aligns poetry with manual crafts. Following this, two discrete groups of objects in the form of domed buildings are contextualized and considered as materialized metaphors. I place the first of these, cast metal incense burners of the eighth or ninth centuries, into an expanded context of eastern Mediterranean portable arts and architectural components that were active within late and post-Antique "pathways of portability."[64] The second group, lanterns from the eastern Mediterranean world of the twelfth and thirteenth centuries, reflects a later period when the central-plan domed monument had been fully assimilated into Islamic architectural culture as a standard form of commemorative architecture.

Chapter 5, "The Poetics of Ornament," continues with the paradigm of rhetoric established in the previous chapter, but moves discussion from metaphor to

ekphrasis—that is, description that seeks to make an absent artwork or building present in the mind of the reader or listener. I use a group of carved marble jar stands from medieval Cairo to pose a question that crosses modalities: Can decoration be description? Individual stands have been inscribed with a dramatically reconfigured and miniaturized set of components from a full-scale form of architectural water feature. Tracing the re-description of architecture onto object, this chapter applies to its subjects the rhetorical model of ekphrasis, arguing that the atomized architecture of effect and spectacle encountered in medieval Arabic and Persian poetry is paralleled in the refraction of architectural form upon three-dimensional objects.

Rather than straining to trace architectural referents precisely and unambiguously into objects, the plastic art of allusion permits polyvalence, ambiguity, and wit. Perhaps most of all, it creates a space in which it is possible to recognize the value of play in the plastic arts, in the sense of the word provided by Paul Barolsky: "All art, no matter how serious, is a form of play . . . what might well be restored to the study of art is the sheer joy of observing such play for its own sake, the joy of seeing the very play of the imagination, of finding suggestive but informed ways of describing the play of the artist's fantasy."[65] Play engages the hands and the body as well as the eyes and the mind; play is a means of taking pleasure in one's own capacities and engaging them in the imaginative as well as the material world; play permits experimentation and generates feedback. In these senses, the allusive artworks of the medieval Islamic world are, perhaps above all, seriously playful objects.

I

THE INTELLECT
OF THE HAND

Making something well is not solely a bodily act but a process in which intellectual, sensory, and manual faculties become profoundly intertwined. The manipulation of substance and the creation of new forms not only requires learned sensitivity and responsiveness to the possibilities and limitations of materials, but also obliges the maker to undertake a sequence of decisions that only ends when the object is deemed complete. The work of getting something to turn out how one wants it to may appear mechanical much of the time, but even the most mechanical act is the outcome of a decision: choice of tools, number of strikes, space between components, knowing when to stop. The process is possible only when the information concerning judgment and responses is flowing back and forth continuously between the senses, the brain, the body, and most particularly the hands; complete mastery is only attained when those faculties become fully integrated into each other through hundreds of hours of practice. Anyone who has ever trained in a practical craft can attest to this, and yet the act of making has only recently been admitted to the realm of the intellect through research in the nascent fields of embodied and extended cognition.[1] This chapter traces the "intellect of the hand" discernible in both the material culture and the textual sources of the

medieval Middle East. In so doing, it argues for the reinstatement of craftsmanship into medieval Islamic intellectual history.

"Making Is Thinking"

The interconnectivity of the mental, manual, and sensory faculties is something that unites all realms of making.[2] This is true not only for the so-called "industrial arts" of metalworking, ceramic manufacture, or stonecarving that are explored in this book, but also for painting, sculpture, and even installation art.[3] Postindustrial perspectives and the concomitant subordination of the "applied" to the "fine" arts have tended to discount both the sensory and intellectual engagement necessary to craft production, and the laborious and often very repetitive processes necessary to the most vaunted contemporary forms of artistic expression. Some of the reasons for this are internal to the discipline of art history and the institution of the art museum, both of which are founded on the identification and categorization of things that have been deemed complete. As such they have an inbuilt bias toward static objects rather than processes and ongoing transformations.[4] More insidiously, the still-pervasive Romantic myth of the (usually male) artist-genius has served to elevate the moments of inspiration and completion in the story of any given artwork, while eliding the long, labor-intensive, and repetitive processes of making that lie between, around, and over those two poles.[5]

Correctives to the hegemony of the static object in art history can be found in discourses on the materiality of process and the ethics of making that have emerged in recent years from various fields, including anthropology and sociology.[6] Tim Ingold, one of the most vocal scholars working in this vein, argues for the primacy of processes over final products: he places this in opposition to "reading creativity 'backwards', from a finished object to an initial intention in the mind of an agent."[7] The ultimate conclusion of his argument, that all objects should be apprehended as materials in flux, has more to offer for some types of artifact than others.[8] Nevertheless, an arrested version of this line of thought presents valuable opportunities for understanding the complexities of the allusive object. If materiality represents "the meeting of matter and imagination," as one art historian has put it, it is also the field in which the human body and matter respond to each other through manipulation.[9] In this book, I argue that the objects under study were formed through responsive processes of making and thinking that reacted to and were stimulated by the materials and techniques in hand, as well as preexisting and medium-specific forms and motifs and the external stimuli of full-scale architecture, rather than representing the imposition of fully formed anterior designs onto passive matter.

Histories of making are only rarely transcribed into texts; as a result, the greatest mass of evidence for processes of thinking and making comes from the

objects themselves, not from written documentation.[10] Material evidence of various kinds forms the primary subject matter of this book.[11] However, the tacit knowledge generated by the intellect of the hand can be glimpsed laterally in a great range of texts, and should be properly considered to belong within, or at least directly alongside, the documented intellectual environment of the medieval Islamic world.[12] Here, I argue the case for a "thinking hand" through discussions of, or allusions to, making and craftsmanship that appear in a number of medieval sources. Most of these date from the tenth to the twelfth century, an era of intense and expansive intellectual activity in the Islamic world and also the period in which many of the objects in this book were created.

This chapter enters the world of medieval making through architecture, the craft that lies at the heart of this book and with which its subjects are in dialogue. Architecture is explored here as an art of process, aligning it with the responsive models of craftsmanship for which this book argues. Next, the text moves to the realms of philosophy and theology to trace the impact of craftsmanship, processes of making, and manufactured artifacts upon the medieval Islamic intellectual landscape. The encyclopedic tenth-century *Rasāʾil* (Epistles) of the Ikhwān al-Ṣafāʾ (Brethren of Purity) is used as a point of departure for exploration of medieval Islamic philosophical and religious perspectives on matter, making, and materials. After introducing the Epistles of the Ikhwān al-Ṣafāʾ, I explore the intertwining of the Ikhwān's epistemology with the act of making, before considering the craft-oriented worldview expounded in the Epistles and related traditions. Next, metaphors of materiality and makers in medieval Arabic philosophical and theological traditions are examined. The chapter ends with discussion of the perceived role of the manual crafts within medieval Islamic society, arguing that the value of craftsmanship and the intellect of the hand were more widely recognized in this milieu than some earlier scholarship has acknowledged.

Architecture, Art of Process

The cultural product that most obviously announces itself as an art of process is architecture. Not only was premodern building a necessarily responsive form of craftsmanship, with ongoing modifications and rethinks leaving traces on the fabric of the building, but it is also the artform that is most readily recognized as being experienced processually by its users, over time and through movement. The subjects of this book are all argued to engage in intentional relationships of one sort or another with the forms of architecture, and sometimes also with its functions; accordingly, this section will consider the art of building, its processes, and its place in the intellectual landscape of the medieval Middle East.

In spite of the amazing achievements of medieval architects and builders, there is little surviving textual or notational evidence from earlier than the fourteenth century that documents the processes of architectural practice or the transmission

of architectural knowledge in the Islamic world. However, suggestive textual evidence for a tradition of applied geometry in architectural construction survives from the tenth century. The extant texts, including the *Aʿmāl al-handasa* (geometric constructions) of Abū l-Wafāʾ al-Būzjānī (d. 998), and the second epistle of the Ikhwān al-Ṣafāʾ, are thought to follow on from a now-lost treatise on geometry by al-Fārābī (d. 950). These works clearly demonstrate the circulation and application of solutions to problems of building among literate craftsmen.[13] Būzjānī's stated mission in his handbook was to wean artisans off the practice of eye measurement and instead give them the tools to apply geometry properly to construction. He contrasted the artisan who judges "through his senses and by inspection" with the geometer's mathematical proofs, which cannot always be transformed easily into construction.[14] As Renata Holod notes, Būzjānī's text "offers a constructive hands-on version of geometry explained in fairly simple language," making possible the inscription of geometric figures into each other using only simple instruments and no complex mathematics.[15]

Būzjānī also reports that he was present at gatherings of artisans and geometers in which problems of applied geometry were discussed and solutions were tried out. From his comments, it is clear that a continuous dialogue between these disciplines was taking place in tenth-century Baghdad, as was quite probably the case throughout the medieval and early modern periods. Būzjānī's friendship with the polymath Abū Ḥayyān al-Tawḥīdī (d. after 1009/1010), author of, among other things, a treatise on calligraphy, further hints at the sophisticated level of interchange taking place between the scholarly and artistic realms.[16] This raises a fundamental point, which is the potential intellectual sophistication of craftsmen. Not every hod-carrier was a poet, but it is equally untenable to suppose that all skilled craftsmen were illiterate, unsophisticated, and entirely disconnected from the wider cultural and intellectual environment reflected in the textual sources.[17] Būzjānī's text affords modern observers a rare glimpse into the largely undocumented connections between makers and thinkers in the tenth-century center of the Islamic world.

It is not surprising to learn that architecture was a collaborative practice between artisans and mathematicians, but it nonetheless begs a question: How was information transmitted between parties? Cut-and-paste techniques may have been the medium of teaching and problem-solving at the meetings Būzjānī attended in tenth-century Baghdad.[18] Occasional references to architectural plans executed on skins, parchment, cloth, or paper prior to the thirteenth century are tantalizing, but it is not clear if these were common practices or not.[19] The discovery of a thirteenth-century plaster plate at Takht-i Sulayman in Iran, inscribed with a geometric design that is generally accepted as a schematic projection of a muqarnas quarter vault, represents the earliest surviving example of a working architectural drawing from the Islamic world (Fig. 1.1).[20] Later architectural drawings are preserved in "design scrolls" (*ṭūmār*) from the fifteenth century and later.[21] These include in

FIGURE 1.1 Plaster plate excavated at Takht-i Sulayman, Iran. Thirteenth century. Length 47 cm.

some cases ground plans of buildings on grids as well as patterns and geometric projections, and employ a modular unit as their system of notation.

The use of a modular system for communicating architectural knowledge in the early modern design scrolls has significant implications. Rather than metrology, the design scrolls rely for their effectiveness on proportion and consistency of the modular units from which their designs are constructed. Sometimes they also compress complex schema into a kind of shorthand. Both of these aspects imply a modular imagination at work that permits a flexible application of designs during the actual processes of making, and hint at practices of projection, experimentation, and adaptation that were routinely practiced on site but not necessarily transcribed.[22] Nasser Rabbat raises the possibility, suggested by a passage from the observations on Cairo made by the Iraqi physician 'Abd al-Laṭīf al-Baghdādī (d. 1231/32), of a practice of architectural design without any graphic representation. This apparently entirely mental process of visualizing and planning architectural units and the sequence of their construction raises astonishment and admiration in the Baghdad-born author, implying that it may have been a practice peculiar to Egypt. It is notable that this process, as described by 'Abd al-Laṭīf al-Baghdādī, depends heavily on modularity.[23]

Early modern design scrolls also combine, in a continuous field, schematic drawings for projecting three-dimensional forms and two-dimensional patterns for designs in tilework and other media. In doing so, they demonstrate their creators' conceptualizations of architectural decoration as an integrated component of both the building process and the completed monument, rather than an applied skin that can be mentally separated from the underlying structure. This point has been made before in discussions of Islamic architectural history, but it cannot be stressed enough and has particular relevance to the discussion of ornament and three-dimensionality that will come in Chapter 2 of this book.[24]

It is likely that the early modern design scrolls represent continuations of an older tradition of knowledge transmission and practice, but the fact remains that records for the medieval period are much more limited. Discussions of building practice encountered in *ḥisba* manuals for the regulation of the marketplace—notably the manual from eleventh-century Seville by Ibn ʿAbdūn—are concerned primarily with the soundness and safety of buildings. Emphasis is laid on the depth and perpendicularity of walls; maintenance of proper standards for materials; and the correct use of angles, plumb lines, and so forth.[25] In terms of nomenclature, it is striking that the *ḥisba* manuals use only *bannāʾ* ("builder") to designate the agents of the construction process; the alternative term *muhandis*, which properly meant a designer of waterways but came to have the broader meaning of land surveyor, engineer, or architect, is not encountered.[26] Maya Shatzmiller's survey of labor in the medieval Islamic world lists some sixty-three occupations that fall under the rubric of construction, and other scholars have supplied further terms.[27] Collectively they attest to the extremely organized nature of construction, not just at the level of the elite, within medieval Islamic urban cultures.

While this data is illuminating, it does not shed much light on the thought processes that go into the creation of buildings. The *muhandis* who appears occasionally in certain texts is generally understood to operate as an architect in the sense of a designer and possibly also an overseer, but the textual references prior to the fourteenth century are not sufficiently numerous or consistent to give a clear sense of what this role entailed. Some lateral insight can be gleaned from the philosophical tradition. In the *Al-maqṣad al-asnā fī sharḥ maʿānī asmāʾ Allāh al-ḥusnā* (Highest goal in explaining the beautiful names of God) written by the great Persian scholar and mystic al-Ghazālī, three of the names for God that enshrine the generative principle are grouped together and treated collectively as the stages of a generative process. God is creator (*al-khāliq*), producer (*al-bāriʾ*), and fashioner (*al-muṣawwir*). This process is likened to the creation of a building, beginning with an architect (*muhandis*) who sketches and portrays it (*fayarsumuhu wa yuṣawwirhu*), then a builder (*bannāʾ*) who begins the foundations, then a decorator (*muzayyin*) who chisels the surface and adorns it.[28] Elsewhere Ghazālī famously compares the Creator with an architect (*muhandis*) who "draws [*yuṣawwir*] a dwelling-place [ʾ*abnyat al-dār*] on a blank page [*bayāḍ*, literally "whiteness"], and then brings it into existence according to the transcription [*nuskha*]."[29] Although *nuskha* is sometimes translated as "plan" in this context, the word properly implies copying or transcribing from an original, or superseding it.[30] The two quotes suggest that, in Ghazālī's mind at least, the *muhandis* was a designer who used some form of notation on paper or another blank surface prior to the execution of the actual building.[31] The same distinction between the architects who portray the building (*ṣūwaraha al-muhandisūn*) and the workers who build it from the foundations up appears in tenth-century reports on the topography of Iran by Abū Dulaf.[32]

Ghazālī's description of the building process is succinct and remains largely abstract; the processes of construction are sublimated to his main point, which is glossing the divine Names and the generative principle.[33] But the same analogy did, on occasion, burst out of its spiritual framework with an overflow of technical detail. One of the most striking examples of this is the creation of the universe analogized as the building of a house in the *Kitāb al-bad' wa'l-ta'rīkh* (Book of creation and history) of al-Maqdisī, a tenth-century author from Bust in Afghanistan. Maqdisī's argument that there can be no creation without a Creator is, as Oleg Grabar and Renata Holod have pointed out, hardly an original one, but it is in the detailed description of construction that the passage becomes remarkable. The author invites us to imagine the unimaginable: self-generation of a building through every stage, from the gathering of earth and its mixing and molding to make mudbricks; through the felling, sawing, planing, and raising of joists for ceilings; and finally paving, plastering, and decoration with ornaments (*tazāwīq*) and designs (*nuqūsh*)—all without the hands of any creators or designers.[34]

The text goes into great detail, and its value as a data mine for architectural historians goes without saying. It is also a striking example of the rhetorical power of the material imagination. Al-Maqdisī argues the case for a Creator by inviting the reader to undertake the extended and detailed visualization of a highly complex, multistage process of material manipulation. The efficacy of his analogic argument depends upon the visualization of building materials and their passage through the sequential processes of preparation and use, requiring the reader to recognize the impossibility of those processes without creators. The more concretely the author conveys the material processes of building, the more successful the analogy is, because concretization forces the reader to confront the impossibility of such processes without the hands and tools of a great range of craftsmen. The collective nature of architectural construction, and its interdependent processes of thinking, doing, planning, and modifying, are brought to the fore in al-Maqdisī's description. By requesting the reader to remove the person of the craftsman from an imagined sequence of building activities, the author has in fact placed greater emphasis on the roles of individuals and their cooperation in the process of building than is to be found in almost any other source currently known from the pre-Mongol era.

Al-Maqdisī's text, with its wealth of information for the pre-Mongol history of architectural construction in the Central Asian lands, demonstrates very clearly the utility of philosophical and theological texts as windows into the historical world of material artifacts. By looking beyond "documentary" sources, it becomes possible to see the impact that craftsmanship had upon medieval writers of all kinds. Accordingly, the next sections of this chapter will examine craftsmanship, matter, and making in the philosophical and theological traditions, using the tenth-century Epistles of the Ikhwān al-Ṣafā' as the first point of entry.

Thinking and Making in Tenth-Century Iraq

The Epistles of the Ikhwān al-Ṣafāʾ present one of the most extended and explicit engagements with craftsmanship to survive from the medieval Arabic-speaking world, and they explore the act of making across several registers. Making is considered in the Epistles as process, as metaphor, and as social desideratum.

The authors of the Epistles have not been identified with absolute certainty and even their sectarian identity is a matter of ongoing debate, although the dominant theory favors an Ismaili Shia affiliation.[35] They are generally agreed to have been members of an esoteric organization primarily operative during the tenth century in Basra, a major cosmopolitan center, and possibly also Baghdad. Questions of identity notwithstanding, the monumental compendium produced by the Ikhwān holds a very important place in the history of science and learning.[36] Comprising fifty-two individual *rasāʾil* (epistles), the heterogeneous contents of the Ikhwān's encyclopedic text are divided into four sections: the propaedeutic (*al-riyāḍiyya*) sciences or sciences of training, followed by the physical, intellective, and theological sciences.[37] Together they constitute a syncretic amalgam of the diverse philosophical and theological traditions available to a tenth-century coterie in Mesopotamia, as well as a window into the society they inhabited.

The esotericism of the Ikhwān's text and ensuing accusations of heresy from the orthodox Sunni establishment have made explicit acknowledgments of the Epistles' influence by subsequent medieval authors rarer than they might otherwise have been.[38] However, the text must have circulated far and wide soon after it was first completed, for passages from it and references to it appear as far afield as Spain by the early eleventh century, and possibly even earlier.[39] That the Epistles had a significant impact on medieval Islamic intellectual circles is quite evident from the work of later writers. The fiercely orthodox Mamluk theologian Ibn Taymiyya (d. 1328), who classed the Ikhwān as *falāsifa* (philosophers) and as such abominated them, regarded the Epistles as a work that had exerted a significant influence on many major thinkers of the Islamic world by his own time, most particularly the polymaths Ibn Sīnā (known in the Latin West as Avicenna; d. 1037) and Ghazālī.[40] Ghazālī, indeed, is reported by his younger contemporary al-Māzarī (d. 1141) to have been "addicted to [ʿukūf ʿalā] reading the *Rasāʾil ikhwān al-ṣafāʾ*."[41]

At the same time, the text of the Epistles is marked by frequent appeal to the artisan or craftsman, and the idiom of the Ikhwān is generally more accessible than that of the high philosophers and can be judged to address a more general educated audience.[42] It is quite clear that the Ikhwān included craftsmen among its members. The centrality of the manual and intellective processes of making within the *Rasāʾil*, coupled with the discussion of individual crafts found throughout the text but most particularly in epistle eight, make it plain that at least some of the authors were familiar with craft practice and in frequent contact with craftsmen, if

not craftsmen themselves. Within the Ikhwān's own descriptions of their hierarchy, the lowest of their four categories of membership are termed craftsmen (*arbābu dhawī al-ṣanā'i'*), members of which group must be at least fifteen years old. Above this are the categories of political leaders, kings, and prophets and philosophers.[43] The titles of these groups are obviously not to be taken literally, but they indicate a keen sense of the craftsman's value both autonomously and within society.[44] Most conclusively, the forty-eighth epistle describes the Ikhwān's presence among various classes of society, including the sons of (i.e., groups of) craftsmen (*awlādu al-ṣunnā'*) and the leaders of crafts and professions (*umana'u al-nās*).[45]

In art historical scholarship, the Epistles of the Ikhwān al-Ṣafā' have thus far provided substance for theories of aesthetics that are predicated on harmonious proportions and precise geometry as a source of pleasurable wonder and a means of spiritual elevation.[46] Most recently, the Epistles have been exhaustively mined to construct a model of Fatimid aesthetics centered on proportionality as an expression of piety, although the material evidence presented is quite selective.[47] Some elements of the text were also mobilized by Samer Akkach in his mystical interpretation of Islamic architectural space, in which he links the processes of making described in medieval literature with cosmological modes of spatial organization and the revelatory power of symbolism.[48] While the Ikhwān's theories of proportionality undoubtedly constitute a key source for the study of aesthetics in the medieval Islamic world, in this chapter I will foreground the aspects of the text that address the practices and processes of craftsmanship, rather than the effects generated by completed artworks. This chapter will leave largely to one side both aesthetics and mystic symbolism in order to concentrate instead on the insistent materiality of the act of making within the writings of the Ikhwān.

The act of manual creation is central to both the epistemology and the ontology expounded in the Epistles. It is most singularly highlighted in the Ikhwān's striking conceptualization of the internal senses, the post-sensationary faculties of the mind that process the information received from the senses and ultimately produce thought. Like other medieval Arabic-speaking intellectuals, the Ikhwān operated within a philosophical tradition that recognized complex and variable cognitive procedures of sensing, imagining, estimating, and remembering. Of the five post-sensationary faculties that they tabulate, the first three replicate a threefold classification found in earlier sources, hence imagination (here *al-mutakhayyila*, used to mean the sense-receiving faculty), cogitation (*al-mufakkira*), and memory (*al-hāfiẓa*).[49] But the fourth and fifth faculties of the Ikhwān are much more unusual within the greater tradition of the internal senses, for they are in fact productive faculties. These two are termed the "speaking" (*al-nāṭiqa*) faculty and the "making" (*al-ṣāni'a*) faculty.[50]

While the Ikhwān's explicit inclusion of speaking and making within the internal senses is highly unusual, it is not without precedent in medieval Arabic philosophy. It echoes the two modes of "imitation" proposed by the philosopher

al-Fārābī (d. 950), which denoted references to external subjects effected through action (as in the creation of a sculpture) or through speech.[51] An earlier prefiguration of this model can also be found in the writing of the Basran litterateur al-Jāḥiẓ (d. 868 or 869) who observed that "man is called the microcosm ['ālam ṣaghīr, literally 'small world'], because he is capable of producing anything with his hands and imitating all the sounds with his mouth."[52] The microcosmic nature of man, a trope that reached its medieval Arabic zenith in the Epistles of the Ikhwān al-Ṣafā', is in Jāḥiẓ's argument fulfilled through production of objects and sounds, the outward manifestations of the Ikhwān's "speaking" and "making" faculties.[53] Thus the Ikhwān's model of the internal senses, while departing somewhat from the Aristotelian model that would be further elaborated by Ibn Sīnā and others (see Chapter 5), formalized another tradition that recognized the uniqueness of man's productive faculties of making and speaking. In effect, the Ikhwān recognized making as thinking.

In the conception of the mind presented by the Ikhwān, the intertwining of the receptive and productive internal senses conveys a strikingly fluid exchange between the medieval subject and the world of matter that he or she occupies. Sensory information is received and processed by the intellect and then returned back to the world through products of the hand, the tongue, and—by extension of those faculties—the pen.[54] The recognition of reciprocity between the material, sensory, and intellectual spheres leads the Ikhwān to the belief that the development of the intellect is initially dependent upon close attention to the sensorially perceptible, physical world.[55] The rationale for this sensory engagement is predicated on the microcosm/macrocosm worldview that underpins all of the Epistles. According to the cosmological principles of the Ikhwān, the workings of God are apparent in everything in the physical universe.[56] Thus, only through scrutiny of the objects of sensation can the objects of intellection become first principles within the soul, assuring the eventual autonomy of the intellect through a complete understanding of the Created universe.[57] The necessity of practical training in physical crafts for the eventual elevation of the individual soul is first made explicit in the Ikhwān's second epistle, on geometry.[58]

As in the text of Būzjānī discussed above, geometry is explicitly presented by the Ikhwān in the first instance as an applied science of material use to the craftsman; only after the applied skills have been fully expounded does the epistle move to the realm of the abstract. The writings of the Ikhwān are steeped in Neoplatonic principles. Through careful observation, they argue, the mind can be trained to abstract geometric principles from matter, visualize them internally, and use them to create geometric constructs that have no preexistence in the material world but that can be externalized through the acts of design and making. It is only when this stage has been mastered that geometry can become an instrument of elevation. The ultimate outcome of this inductive progression is a soul that can elevate itself and escape "the sea of matter" (baḥr al-hayūla), a term with distinctly Neoplatonic

resonance that is used throughout the Epistles to denote the quotidian physical world.[59] A similar elevation of the soul through "geometry made manifest" can be found in the Persian context, as in the work of the Ghazanvid poet Sanāʾī (d. between 1131 and 1141) who likened "the ability to behold the divine manifestation . . . to the intellectual way of perception of a geometrician."[60]

Because the spiritual ascent counseled by the Ikhwān begins with such a complete, and unapologetic, engagement of the senses with the tangible world, the frequent recourse in the Epistles to models and metaphors of craftsmanship is no mere literary conceit. Nor is the heightened awareness of materials and their transformations that is displayed throughout the text. Rather, materials and the act of making are the essential substrates of the Ikhwān's enterprise. This is most clearly evident in the treatment of the manual crafts that is intimated in the general classification of the sciences presented in epistle seven, before being fully explored in epistle eight, "On the practical arts [al-ṣanāʾiʿ al-ʿamaliyya] and their aims."[61]

The Eighth Epistle

In epistle seven, the Ikhwān undertake a classification of the known human sciences into three major groups. First of these are the propaedeutic sciences (ʿilmu al-riyāḍiyat), meaning in this instance those established for subsistence and the enhancement of daily life. Following this are the religious sciences for the elevation of the soul, and finally the philosophical sciences.[62] Unlike earlier Arabic classifications of the sciences, the Ikhwān's conception of the propaedeutic sciences places considerable emphasis on their practical applications in everyday life.[63] Their treatment of this category of activity has been described by Godefroid de Callataÿ as a "kind of lumber room of mundane practices."[64] Most notable is the inclusion of "the science of crafts and [manual] arts" (ʿilmu al-ḥiraf wa al-ṣanāʾiʿ) in the list of propaedeutic sciences, a feature that sets the Epistles apart from other tenth- and eleventh-century classifications of knowledge.[65] The complementary treatise is contained in epistle eight, and is probably the fullest exploration of the manual crafts and their roles in an ordered society to survive from the Islamic world prior to the fourteenth century.

In light of the pervasive substratum of making that runs throughout the Epistles, the eighth epistle is worthy of much deeper consideration than it has thus far received. It should be viewed not only as a very significant extension of the Ikhwān's highly materialized ontology but also as an extremely important source on makers, materials, and artifacts in Mesopotamia at a time when the region was the intellectual center of the Arabic-speaking world. To date, scholarship on the eighth epistle of the Ikhwān has been concerned for the most part with establishing the text's utility as evidence for the existence of guild systems in the early Islamic world,[66] or of a uniquely Ismaili worldview within the Epistles.[67] The contention that the practical arts "play no more than a minor part" in the Epistles is fairly

typical, and this attitude helps explain why the eighth epistle has not been translated into a European language since Friedrich Dieterici's somewhat abridged nine-teenth-century translation of much of the Epistles into German.[68]

In brief, epistle eight begins with an outline of the Ikhwān's ontological and epistemological views of matter and form as related to the processes of making and the created artifact, before proceeding to categorization of the individual crafts by several different systems. Initially, the epistle organizes crafts by the materials that they employ, grouped first by the four elements of water, earth, air, and fire, indi-vidually and in combination, then by the mineral, vegetable, and animal kingdoms. Then come those that use as their material the measurement of bodies (maqādīru al-ajsām), for example the weigher (wazzān) and the measurer (kayyāl). This is followed by those who work with the worth of things, for example the money-changer (siyyarfa); those who work with human bodies, such as the practitioners of medicine (al-ṭibb) and the barber (muzayyin); and finally those who work with human souls as their material: scholars (al-muʿalimīn ajmaʿ).

The second system of categorization presented in the eighth epistle is organ-ized by the tools and bodily members that each craft utilizes, and is followed by a discussion of the use of fire as an agent in various different craft practices. Third is categorization by rank (marātib), which is predicated on a craft's necessity to so-ciety. This system gives precedence to the primary crafts of agriculture (ḥirātha), weaving (ḥiyāka), and building (binā'); then to the many ancillary crafts that sup-port these activities; and lastly to the luxury trades that beautify and adorn, such as silk and perfume. The fourth categorization is by nobility (sharf), a construct determined by several factors: the craft's necessity, the value of its materials, the benefits it confers on society at large (as in the case of bath-attendants, ḥammāmīn; excrement collectors [?], sammādīn; and street sweepers, kannāsīn), or the skill that it requires.[69] The last of these groups includes conjurers (mushaʿbadhīn), painters (muṣawwirīn), and musicians (mūsīkiyyīn).

Following these categorizations, the remainder of the chapter examines the parallels between skilled artisans and the Creator; the suitability of certain natures and horoscopes for apprenticeship in crafts and the soundness of the principle of he-reditary craftsmanship; the cosmological framework of making which links every craftsman to the world-soul (nafsu al-ʿālam); and the great chain of knowledge transmission that links every human craftsman, through his teacher (ustādh), to an originary craftsman whose knowledge does not derive from any human source.

The eighth epistle of the Ikhwān al-Ṣafā' comprises a careful consideration of individual craft processes and an extended experiment with their conceptual organization; as such, it clearly shows a concern with craftsmanship that extends far beyond its utility as an abstract analogy for Neoplatonic principles. For those among the Ikhwān who did not have formal connections to craftsmanship, the ar-tisanal activities of the bazaar would still have been visible within the cosmopolitan environment of medieval Basra, as in all major urban centers of the Islamic world

at that time, engendering a level of common familiarity with craft practices that is generally quite absent from modern life.[70] The *ḥisba* literature tells us that certain industries, including ceramics manufacture, were supposed to be located outside of the city walls because they produced fumes or bad smells, or required ready access to a source of water. This accords with the archaeological evidence from sites like Raqqa.[71] Other crafts, including goldsmithing and jewelry-making, were traditionally located in the heart of the city, while noisier practices such as carpentry and metalwork were closer to the city gates. The centrality of the marketplace, including craft production and sale, to the urban structure of premodern settlements in the Middle East is such that many medieval writers defined towns principally through the presence of a congregational mosque and markets.[72] The possibility of a distinctly medieval material imagination, generated in part by the proximity to making and materials that must have a normal part of life in premodern urban societies, will be the subject of the next section.

The Material Imagination

Analogies between the concrete and the spiritual are frequently encountered in medieval Islamic mystic writings and are commonly ascribed to the duality of the seen (*al-shahāda*) and the unseen (*al-ghayb*) worlds in the Qur'anic and Prophetic traditions.[73] Attempts to make the spiritual realities of the superior, unseen world accessible to the human imagination are enacted through analogy and metaphor with the inferior, sensible world, as for example in the Light Verse of the Qur'an (24:35) and Ghazālī's famous exegesis of this Qur'anic similitude, the *Mishkāt al-anwār* (Niche of lights).[74] In his short book, Ghazālī details symbolic meanings for the physical entities of lamp, glass, oil, niche, and light that are presented in the Light Verse as a simile for divine illumination, and from these he draws out a cosmology of radiating lights, veiled and unveiled.

At the same time, in the philosophical traditions, the duality of the seen and the unseen worlds is paralleled in the distinction—descended by degrees from Plato but developed in new directions in the Arabic literature—that is drawn between the sensible and the intelligible, the physical and the metaphysical. Developments of this thesis are a major theme in medieval Arabic metaphysics, which is in no way surprising given the ongoing reinterpretation of Greek scholarship and its interaction with Qur'anic hermeneutics.

But while the articulation of the spiritual or metaphysical realm was generally the primary aim of medieval mystics and philosophers, it does not follow that all material analogies encountered in the literature should be collapsed without trace into their immaterial referents. Modern scholars of intellectual history and esoteric mysticism alike have tended to interpret the medieval sources in such a way that the material realm is constantly subsumed by the immaterial, as if the physical world was voided of specificity and immanence and left nothing in the text once

it had pointed the way to a higher truth.[75] To treat the textual deployment of imagery drawn from the material world in this way fails to acknowledge the material imagination at work across the medieval Arabic philosophical tradition. At a more fundamental level, it also ignores the underlying cognitive processes that make metaphor, analogy, and similitude such powerful rhetorical tools in the first place.

Modern theorists of language working in phenomenological traditions, notably Paul Ricoeur, have drawn our attention to metaphor's merging of the cognitive and the affective, "the pairing of sense and the senses," that requires the reader or listener to look *at* the metaphor rather than *through* it. "In other words, instead of being a medium or route crossed on the way to reality, language itself becomes 'stuff,' like the sculptor's marble."[76] In the example of the Light Verse, the highly materialized image of the lamp does not simply disappear from the mind when it is overwritten by the concept of divine illumination. Instead, the two coexist and their network of associations multiplies.[77] The central claim of "cognitive poetics" and embodied cognition—that structures of language and thought are derived from our somatic experience as corporeal beings in a material world—enables the blending of distinct conceptual domains, even material artifacts with abstract tenets of faith.[78] While the operations of metaphor are explored much more fully in Chapter 4, these initial observations are fundamental to understanding the material imagination that forms such an important substratum within many of the medieval Islamic philosophical traditions.

The epistemology of the Ikhwān exemplifies this material-mindedness. In quite explicitly Neoplatonic terminology, the Ikhwān conceive of knowledge as being generated through forms impressed upon the substance or essence (*jawhar*) of the soul. The reception and retention of information by the internal senses is likened to the impression that remains in wax after it is stamped with a seal (*yabqa naqshu al-faṣṣi fī al-shamʿi al-mukhutūmi muṣawwaran*).[79] In this the Ikhwān follow a well-known Aristotelian conception of sensory perception and the intellect that dominated medieval Islamic philosophy, whereby the mind was conceptualized as matter analogous to a wax tablet into which information was materially impressed.[80]

This fundamentally somatic model for cognition developed its own specificities in Islamic intellectual terrain, and related ideas would be further developed in the writings of Ibn Sīnā (d. 1037) in particular.[81] When Ibn Sīnā and others return to the Platonic metaphor of wax (Arabic: *shamʿ*) to demonstrate existents that are receptive to multiple forms, the material qualities of wax as experienced by the senses—its mutable and additive nature, and its ability to take an impression—are precisely the things that produce the metaphor.[82] The analogy was carried over from Greek philosophy but it is nonetheless immanent in its new context. The use of seals and seal rings was widespread in the medieval Islamic world, following the pre-Islamic institution of sealing documents encountered particularly in the Sasanian territories but also in the Mediterranean

littoral.[83] Surviving examples tend to exhibit certain characteristics, such as the use of reversed inscriptions in angular scripts that would become raised in the wax impression (Fig. 1.2).[84] Much less common but not unknown are seals with figural imagery, such as a jasper example bearing the image of St. George slaying the dragon inscribed *sulṭān malik* or *mulk* ("sultan king" or "sultan kingship"), possibly from twelfth- or thirteenth-century Anatolia (Fig. 1.3).[85] Seal inscriptions acted as a kind of personal motto, binding a widespread and mobile type of artifact ever more closely with personhood.[86]

As a form of material signification, the analogy of the seal-impression had wide circulation not only in the Islamic world but also in medieval Europe, where the relationship between seal matrices and their impressions also "resonated deeply within contemporary ontological concerns."[87] In the philosophical employment of seals and wax impressions as tools for visualization, it is only through the reader's sensory recall of physical substance that the metaphysical allusion can be sustained: hence, the evocation of the material "wax" and all its physical qualities remains present in the text, and in the reader's mind, even when the allegory has been fully expounded. This engagement with substances and matter would evolve in some esoteric texts into full symbolism, but it never entirely departs from the material sphere, remaining dependent on the material imagination for its very efficacy.[88]

In this vein, many medieval Islamic philosophers followed a hylomorphic ontology that evolved from Aristotelian and Neoplatonic traditions. In such a conception of the tangible, spatial world, physical things are comprised of two principles that are cognitively separable, although never actually separable in reality: matter and form. As Akkach has observed, most medieval Muslim philosophers worked with this hylomorphic paradigm and it continued to dominate conceptions of the sensible world throughout the medieval period, but the Ikhwān were among the earliest to explore systematically its relevance for the arts of making.[89]

Within this metaphysical framework, it is the created artifact, the product of the craftsman, which provides the Ikhwān with their first and most intuitive point of reference for the concept of "things." The opening passages of the fifteenth epistle, "On Matter and Form," launch almost immediately into a fashioning of the world through tools and

FIGURE 1.2 Seal, excavated at Sabz Pushan in Nishapur, Iran, in 1936. Tenth or eleventh century. Carved jet. Height 2 cm. New York, Metropolitan Museum of Art, 39.40.141.

instruments that manipulate and impress the substances of being. The first example that the Ikhwān harness to illustrate the capability of one type of matter to take many forms is that of tools made from iron (*ḥadīd*). The point is also elaborated in epistle eight, with the observation that the same body, iron, could be matter (*hayūlā*), material (*mawḍūʿ*, in the sense of substrate), form (*ṣūra*), artifact (*maṣnūʿ*, including created objects which will become tools at the point of use), tool (*āla*), or equipment (*adāt*).[90]

FIGURE 1.3 Seal, probably Anatolia, eleventh or twelfth century. Red jasper. Width 1.7 cm. London, British Museum, 1880.36 35.

While they certainly underscore the multivalent nature of matter, with these illustrative examples the Ikhwān also build a veritable blacksmith's workshop in the mind's eye. The implied distinction between material that has been made ready for use (*mawḍūʿ*) and raw material (*hayūlā*) not only suggests familiarity with craft processes and material differentiation but also embodies the emanationist theory of matter that underpins the ontology of the Ikhwān. This is clarified in the fifteenth epistle, where the Ikhwān's meditation on matter and form continues by describing a hierarchy of four types of matter. These ascend from the matter of art (*hayūlā al-ṣināʿu*), through the matters of nature, and of the whole, to the topmost level: Prime Matter (*al-hayūla al-ʾūlā*).[91]

The lowliest and most differentiated of these levels, the matter of art, is of the greatest interest for the student of material culture:

> The matter of art is every body from which and in which a manufacturer makes his piece of art, as with wood for carpenters, iron for blacksmiths, earth and water for builders, yarn for weavers, and flour for bakers; and according to this example each manufacturer certainly has a body from which and in which he makes his piece of art, and that body is the matter of art.[92]

Elsewhere in epistle fifteen, garments of cotton and astrolabes of copper are employed as illustrations of the ascending "nobility" (*sharaf*) of substance from raw materials to manufactured objects. When a piece of copper (*nuḥās*) receives the

form of an astrolabe, it becomes more noble.[93] The astrolabe is perhaps the most important manufactured object to appear in the Epistles, where it is clearly intended to represent the ultimate embodiment of man's ingenuity in mastering measurement and forming ever more complex creations from raw materials.[94] Planispheric astrolabes from the Islamic world have survived from the ninth and tenth centuries onward, the earliest ones coming from Baghdad, and it is clear that such instruments were widely known at the time the Ikhwān were writing. The earliest dated astrolabe currently known from the Islamic world (inscribed with the date 315 H/927–928 CE) was signed by its maker Nasṭūlus (Fig. 1.4), who was justifiably proud of his skill as a maker of scientific instruments and signed two other surviving examples.[95] "A two-dimensional model of the three-dimensional celestial sphere, reduced to a plane" through stereographic projection, the moving plates of the astrolabe could be used to perform over one thousand operations, according to a tenth-century astronomer. However, it has also been suggested that many, if not most, of them were made as collector's items or display pieces rather than for scientific use—a circumstance perhaps reflected in the astrolabe's status within the Epistles as the acme of artifacts.[96]

In epistle eight the creation of astrolabes and other scientific instruments, such as celestial globes, is recognized as an art that takes its eminence from the level of skill that it requires rather than the value of the materials involved. Indeed, the skill of the astrolabe maker is reckoned by the Ikhwān in explicitly economic terms that once again underscore the text's overarching concern with distinguishing form from matter in the concrete as well as theoretical realms. At the same time, the Ikhwān's example of the skilled astrolabe maker prefigures the economic theory of labor as a source of value that would later be expanded in the *Muqaddima* of Ibn Khaldūn (d. 1406). "A piece of bronze [*ṣufr*], worth five dirhams, when made into an astrolabe is worth one hundred dirhams. This price is not for the material but for the form into which it has been made." The goldsmith and the minter, it is noted, do not add the same degree of value to their materials.[97]

The treatment of the astrolabe in the Epistles brings together the two sides of the medieval Islamic material imagination. On the one hand, the astrolabe is figured as a supremely differentiated artifact that embodies the divine metaphysical order of craftsmanship and matter emanating from the Wise Artisan. On the other hand, it is also a resolutely material object, formed from copper by an ingenious craftsman and produced within a labor economy. Neither of these aspects cancels the other out, and their coexistence in the text is symptomatic of more widespread habits of thought, not unique to the Ikhwān, that permit the material and the metaphysical to coexist comfortably and indeed to reinforce each other.

Makers, Movements, and Mutable Materials

The repeated appearance of manufactured artifacts and craft processes in the Ikhwān's ontological scheme naturally gives rise to the question of makers. Who is doing what, to which materials, to create these forms in matter?

FIGURE 1.4
Astrolabe, dated
315 H (927/8
CE) and signed
Nasṭūlus. Probably
made in Iraq. Cast
and engraved
copper alloy. Width
17.5 cm. Kuwait
City, Al-Sabah
collection,
LNS 36 M.

The eighth epistle of the Ikhwān gives a great quantity of data on the various craft occupations necessary to an optimally functioning society. This aspect of the text finds its strongest echo in the fourteenth-century *Muqaddima* (Introduction) of Ibn Khaldūn, to which this chapter will return. Since Bernard Lewis has already undertaken a tabulation of all the individual crafts contained in the Ikhwān's eighth epistle, they will not be listed here.[98] At the level of individuals, the identification of named craftsmen is a longstanding preoccupation for connoisseurs of medieval Islamic art, and is almost entirely dependent on names culled from signed objects since there is so little textual documentation of any sort relating to premodern artistic production.[99] Some signatures provide certain kinds of taxonomic information, such as the geographical origins of craftsmen's families as indicated in their *nisba*s. Moreover, Kana'an's innovative recent research has suggested new avenues of approach to the information that can be gleaned from artists' and

patrons' titles on certain types of objects.[100] However, artists' signatures for the most part offer very little information about the cognitive processes of making or the conceptualization of those processes in their cultural environment, and this section will instead consider in more general terms what makes a maker.

Under normal circumstances, tools, body, mind, and materials are all necessary for the act of making; however, these are not always easily separable. That individual tools are emblematic of particular crafts is certainly recognized by the Ikhwān, as in the sequence of examples given to illustrate the necessity of specific tools to individual crafts: "the hammer [miṭraqa] of the blacksmith [ḥaddād], the needle [ibra] of the tailor [khiyāṭ], the pen [qalam] of the scribe [kātib], and the knife [shafrit] of the cobbler [iskāf]."[101] The Ikhwān's preoccupation with the instruments of craft, most evident in the classification of crafts in epistle eight by the number and nature of tools that they require, is extended to the bodies of craftsmen: the trades that use first one and then two tools are mingled with classifications according to movement and posture.[102]

The Ikhwān's treatment of equipment (adāt, pl. adawāt) also points to a fluid extension of the maker's body into his instruments. Body parts are likened to, and at times discussed as, tools (āla, pl. ālāt).[103] The topos of the tool that becomes an extension of the craftsman's person appears in craft traditions across cultures and has found confirmation in recent studies that show how quickly tool use can alter subjects' perceptions of their own body schema—the proprioceptive map of one's own body, and its posture and position, that is constantly shaped through the impressions received from the senses.[104]

Finally, the human artisan, it is stated by the Ikhwān, needs six things to complete his work: matter (hayūlā), place (makān), time (zamān), equipment, tools, and movement (ḥaraka).[105] The Creator, of course, needs none of these things, because all have been created by Him, the Wise Artisan (al-ṣāniʿu al-ʿalīm).[106] God, accordingly, is repeatedly characterized within the Epistles as the originary and ultimate craftsman, who is at one point said to need no tools.[107]

In placing an emphasis on the generative role of the creator God as the artisan of the universe, the Ikhwān followed a path already firmly established within Arabic Neoplatonic philosophy—even if their concentration on the craftsman analogy goes beyond that of earlier authors. The Arabic versions of the Plotinus corpus, the so-called Uthūlūjiyā or "Theology" ascribed by medieval Arab commentators to Aristotle, were the major source for Neoplatonic thought in the medieval Islamic world.[108] Unlike the original Greek texts, the Arabic versions repeatedly refer to the First Principle as a creator God. This represents a rethinking of Neoplatonic emanationism that is reflected in the unknown translator's recurring use of honorific titles for God that emphasize His generative powers, and has the very significant result of aligning the philosophical traditions with those of the Qur'an and its commentaries. The terms for the supreme being that appear most frequently within the Arabic Plotinus corpus are three of the canonical Muslim names for God

that denote the generative principle: *al-khāliq* (the creator or maker), *al-bāriʾ* (the producer or animator), and *al-mubdiʿ* (the originator).[109]

The tenet of God the Craftsman is echoed in the traditions that present prophets or other figures from Islamic history as the first figures to practice certain crafts.[110] These include the first writer Idrīs, mentioned twice in the Qurʾan and frequently identified with the biblical Enoch, who was also in some reports the first person to sew garments from cloth.[111] In some traditions Idrīs is credited with the invention of crafts more generally, and for these reasons he was later held in particular regard by craftsmen's guilds.[112] Chief among the prophetic craftsmen of the Qurʾan are Dāwūd (David) and his son Sulaymān (Solomon). The latter received the divine endowment of a spring of molten brass or copper placed at his disposal, as described in Qurʾan 34:12–13:

We made a spring of brass [or copper; *qiṭr*] to flow for him; and many jinns labored for him by the Will of his Lord. [...] They made for him whatever he wished, places of worship [*maḥārīb*] and statues, dishes large as reservoirs, and cauldrons firmly fixed.

The same passage describes how David was given the power of using iron that was transformed in state, from fixed to mutable: "And we made iron pliable for him. 'Make long coats of mail,' (We said), 'and fix their links, and do the right. I surely see whatsoever you do' " (34:10–11). Qurʾan 21:80 confirms that God taught David the armorer's craft (*ṣanʿata labūs*).[113] Divine transmutation of matter meant that solid iron became for David, in the description of the literary scholar al-Thaʿālibī (d. 1038), "just like wax or dough or dampened clay, completely malleable in his hands to whatever form he wished without the need of fire or hammering."[114] Elsewhere, in a closely observed material analogy, Thaʿālibī parallels the malleability of iron for David with the pliability of a type of stone native to Tus in Iran.[115] This presumably refers to chlorite, a type of silicate softstone found in northeastern Iran that has been fashioned into various artifacts, including cooking pots, and exported from pre-Islamic times to the present.[116] The pliant nature of chlorite, which takes an impression easily while retaining fine lines and detailed carving, is a characteristic rare enough in stone to seem remarkable, even counter-intuitive, and the analogy with the miraculously mutable iron of David is a very apposite one.

The Qurʾanic description of David and Solomon's miraculous metalworking, and the commentaries on it, speak of a preoccupation with the protean nature of metals during the processes of founding (melting, refining, and casting) and forging (heating and beating, or cold-forging without heating).[117] The changing states of metal from solid ore to molten liquid, cast solid, hammered sheet, and stretched

wire lend themselves to allegorical, theological, and even mystical interpretations. This allegorizing of material transformation is also evident in the closely related tradition of alchemical writings from the medieval Arabic- and Persian-speaking spheres.[118] But the prevalence of mystical interpretations does not preclude more precise technical interest on the part of even the most cosmologically inflected authors. For example, from the description of gold found in the nineteenth epistle of the Ikhwān, on minerals:

> When it is hammered, it is stretched by hammers, be it hot or cold; it can then be extended in all directions, can be made thin and stretched, and twisted in threads; it takes every form of vessels and pieces of jewellery, can be mixed in fusion with silver and copper, and gets separated from them when golden marcasite is thrown on them, because [marcasite] is of the genus of sulphur that burns other things and is not burnt.[119]

More detailed descriptions of the processes of smelting, purifying, and mixing molten gold with other metals (primarily silver and copper), as well as the process of gilding, can of course be found in various metalworking treatises; observations on the qualities of different types of gold and the uses to which they can be put are also found in the tenth-century geographical epistle of Abū Dulaf.[120] However, while the treatment of the precious metal in the Epistles is cursory, it suggests some real knowledge of gold's qualities in the goldsmith's workshop, particularly its ductility and malleability, and stresses the processes of transformative working rather than the end products. It is notable too that this passage emphasizes sheet metal and twisted wire, two of the dominant techniques for gold jewelry production in the medieval Islamic world prior to the twelfth century.[121] Since goldsmithing was traditionally one of the crafts located in the very heart of the bazaar, its processes were likely to be visible to medieval urbanites—as the Ikhwān are presumed to be.

In this light, an artifact like the armlet worked in filigree, granulation, and beaten and twisted gold now in the Metropolitan Museum (Fig. 1.5) becomes an intricate embodiment of the fluctuating processes of transformation encountered in the goldsmith's workshop, signaling the varying technologies and techniques required to hammer the metal into sheets, twist it into wire, and solder miniscule granules of gold to paired wires. This piece and its partner in the Freer Gallery reveal, on the reverse of the hemispheres that flank the clasp of each, a surprising further exploitation of the plasticity of gold. The base of each bears a pseudo-coin, a flat disk of gold pounced over a coin bearing the name of the caliph al-Qādir Bi'llāh (r. 991–1031) and retaining the impressed memory of a vanished object (Fig. 1.6).[122]

FIGURE 1.5
Armlet, probably
Iran, first half
of the eleventh
century. Beaten
gold with filigree
and granulation.
Height of clasp
6.4 cm. New York,
Metropolitan
Museum of Art,
57.88a–c.

It is well known that clay holds a special place in the Qur'anic tradition. At several points in the Qur'an it is written that the first man was created when God shaped the human form from clay and breathed life into it, a tradition of divine creative prerogative that would become central to ongoing debates about the permissibility of image-making in Islam.[123] While the belief in an artisan Creator is shared with the other Abrahamic faiths, as well as many other belief systems, it is notable that the Qur'anic paradigm favors the plastic immediacy of clay over the "dust of the earth" described in Genesis 2:7.[124] The Qur'anic words used for clay are *ṭīn* and *ṣalṣāl*: the latter is sometimes translated as "fermented clay" or "sounding clay" and was distinguished by the historian al-Ṭabarī (d. 923) as "potter's clay." Ṭabarī interpreted it to mean clay that had been made ready for use through drying, and which made a sound when struck, hence the translation "sounding."[125] Extract of clay (*sulāla min ṭīn*), sticky clay (*ṭīn lāzib*), mud (*ḥamā'*), and *ṣalṣāl kal-fakhkhār*, attractively translated by Ali as "clay dried tinkling hard like earthenware," are also described as generative substances in the Qur'an.[126]

The differentiation of the various types of clay in the Qur'anic text and its many commentaries, while somewhat enigmatic, signals a tradition of closely observing this most elementary form of artisanal substrate, and an awareness of the necessity for its correct preparation prior to the acts of making, molding, and firing.[127] The distinguishing quality of clay in these contexts is its plasticity and retention of direct impress, by which it becomes an immediate and direct record

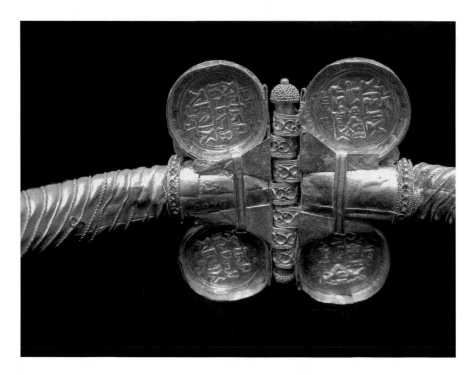

FIGURE 1.6
Reverse of
clasp of armlet
in figure 1.5.
New York,
Metropolitan
Museum of Art,
57.88a–c.

of the actions of craftsmen—both divine and earthly. Turning an object over to find traces left by the fingers that once pressed damp clay into a mold brings invisible, long-dead craftsmen into startling proximity. Earthenware, unlike the stiffer stonepaste body that was increasingly used for fine molded ceramics in the Islamic world from the eleventh century, is sufficiently plastic to take even the impression of fingerprints. This feature is just about discernible on the undersides of certain moulded earthenware objects, such as a lamp from the Late Antique or early Islamic eastern Mediterranean (Fig. 1.7).[128]

Even without the indexical marker of fingerprints, other types of touch can be traced in clay. Smearing and pulling on the surface of the join between two halves of a molded cup (Fig. 1.8) have left evidence of the rather casual hand that once smoothed the slip uniting the upper and lower hemispherical sections (Fig. 1.9). When Ghazālī praises God who created man from sticky clay and "fashioned mankind's appearance in the best of molds and proportioned it in the most complete way," the analogy with potters' practice and the very widespread creation of molded wares from fired earthenware matrices is drawn even closer.[129] Some matrices were made by carving directly into earthenware, or by casting a mold from a model to create the negative of the desired design (Fig. 1.10); others were clearly created through the use of metal, wooden, or fired clay stamps or punches (Fig. 1.11). Unglazed molded ware makes up a large proportion of the

FIGURE 1.7 Underside of lamp, eastern Mediterranean, seventh or eighth century. Molded earthenware. Height 4 cm. New York, Metropolitan Museum of Art, 61.150.6.

medieval Islamic ceramic corpus and must have been in very wide use, but because early scholars and collectors focused their attentions on glazed wares it is only recently that unglazed molded wares have come to be the focus of serious art historical study.[130] As a widespread medium of artistic dissemination, the ubiquity of unglazed molded ware can be traced not only from its archaeological presence but also through the many philosophical analogies drawn with molding from clay.

Both humble and noble, clay is the substance of the earth and lies as close to prime matter as the human mind can visualize. The so-called father of Islamic philosophy, al-Kindī (d. *c.* 870), defined "element" (*'unṣur*), a term used in philosophical texts to denote earth, fire, air, and water but also used in the sense of "matter," as "clay of all clay" (*ṭīntu kuli ṭīna*).[131] Clay's primal nature, as undifferentiated matter, can reassert itself even in defiance of the craftsman: the Ikhwān distinguish it as a material that, when made into an artifact, requires fire to bind and strengthen its new contours. Without the heat of the fire the material will repel any imposed form and seek to revert to its original state.[132] Ghazālī and others also incorporate clay into the metaphysical imagination, where it becomes on occasion the substance of the imagination

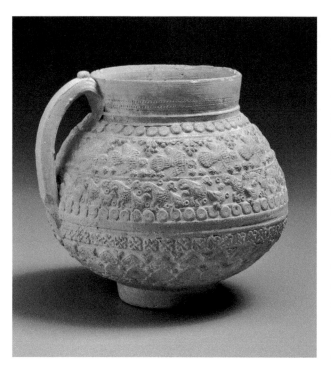

FIGURE 1.8 Jug, Iran, twelfth or thirteenth century. Molded and fired unglazed earthenware. Height 15 cm. Bloomington, IN, Eskenazi Art Museum, 73.46.2.

itself: "Imagination, which provides the clay [ṭīn] from which the similitude is taken, is solid and dense."[133] Intriguingly, the dual roles of ṭīn as physical material and metaphysical substrate are paralleled by those of *jawhar*, a Persian loanword meaning "jewel" or "essence" that came to denote both "gemstone" and "substance" in medieval Arabic writings.[134]

The Qur'anic traditions of genesis from clay and the craftsmanship of David have of course been the subjects of extensive commentary traditions, which are in turn entangled with more technical histories of the potters' and metalworkers' crafts in the Islamic world. My intention at this juncture, however, is not to trace the histories of these ideas exhaustively but simply to situate the plastic act of making within major philosophical and theological currents, recognizing it as a significant component of the intellectual sphere of the medieval Islamic world. Paradigms within various textual traditions that call for sensory imagining of manipulable materials are, I argue, generated by close attention to the behavior and capabilities of those substances in different states. As such they represent one facet of the material imagination that binds together multiple registers of meaning, from the sensory to the intellectual and from physical specificity to cosmological reverberation.

A "system of correspondences that created a web of meaning in the world" is of course not unique to the medieval Islamic milieu, and indeed such polyvalent models must be understood as the terms of encounter with materials in most, perhaps all, pre-industrial societies.[135] But there is also what Necipoğlu has termed an "analogical mentality," discussed further in Chapter 4 of this book, which is evident in a range of texts from the medieval Islamic lands and represents something particular to this context.[136] This ability to encounter the world analogically, frequently occurring in conjunction with a close attention to individual materials and the ways in which they bear and generate meaning, necessitates a multilayered approach to objects and their makers.

FIGURE 1.9
Detail of jug
in figure 1.8,
showing pull
traces at seam.

FIGURE 1.10 Mold
fragment, excavated at
Nishapur, Iran in 1947. Late
eleventh or early twelfth
century. Earthenware.
Height 16.2 cm. New York,
Metropolitan Museum of
Art, 48.101.5a.

FIGURE 1.11 Molding
stamp, excavated at Istakhr,
Iran, and impression.
Ninth or tenth century.
Fired clay.

The Craftsman in Society

Up to this point discussion has focused primarily on the place of the craftsman and
his materials in medieval Islamic philosophical and theological traditions. But the
social and economic position of the crafts, and of craftsmen, is naturally also of
critical importance in formulating an intellect of the hand in medieval Islamic craft
history. What were medieval craftsmen perceived as doing? How did they fit into
society? The early history of craft production in the Islamic world is opaque when
compared with the late medieval and early modern periods from which key im-
perial records survive, such as the celebrated *arzadasht* (petition) from a Timurid
kitābkhāna (book-production atelier), or the mass of bureaucratic data generated
by the Ottoman state in which the activities of craft guilds can be located.[137] One
outcome of this opacity is an ongoing debate about the date at which formalized
craft guilds first emerged in the Islamic world.[138] However, it is abundantly evident
from all manner of sources that the medieval Islamic city was a place of diverse
and organized craft practices. For example, Dīnawarī's *al-Qādirī fī al-taʿbīr*, a trea-
tise on oneirocriticism completed in 1006, includes in its twelfth chapter some two
hundred trades, including many crafts, which were presumably familiar enough to
the residents of early eleventh-century Baghdad to appear in their dreams.[139]

There is evidence that some of the manual crafts were held in low esteem in
pre-Islamic Arab society and that the stigma attached to certain trades, such as
weaving, may have continued to operate in early Islamic and medieval contexts.[140]
In the Prophetic literature, some well-known hadiths single out craftsmen, and
the weaver in particular, for condemnation, although others laud the profession.[141]
However, attempts to locate an "Islamic" conception of craft within the Qur'an
and hadith, which reflect pre- and early Islamic contexts, reveal little about the
reality of medieval urban life.[142] And while there are many medieval sources that

express contempt for practitioners of certain trades and handcrafts, societal disdain for crafts may have been somewhat overstated.

Hostility to crafts in medieval Islamic society is commonly attributed to a set of values inherited from pre-Islamic Bedouin Arabs.[143] This position is repeated in Umayyad poetry but, as Ignaz Goldziher has noted, was not at that point embedded into an urban context.[144] Arthur Christensen suggested that a low regard for the crafts in Sasanian society might also have contributed to a disdain for craft in the first centuries of Islam.[145] Building on these earlier arguments, Joseph Sadan further proposed that societal contempt for craftsmen led to a "generalized disagreeable pressure felt by tradesmen of all kinds" in the medieval Islamic milieu, and that in response to this tension craftsmen insulated themselves from the rest of society through the invention of guilds, *futuwwa* ideals, and, he implies, any literary and theological traditions that celebrated the manual professions.[146] However, it must be remembered that the surviving textual evidence was overwhelmingly written from the perspective of the elevated and elite classes. The scholarly valorization of certain types of literature—particularly *adab* (belles-lettres)—over other forms of textual and material evidence, and the assumption that those texts accurately and fully reflect social realities, seems to have led to the flawed supposition that any celebration of craftsmanship in medieval Islam must have been primarily defensive.

By contrast, other forms of evidence present a different picture. Material from the Sasanian period shows a well-developed infrastructure for trade that would be inherited by the Islamic conquerors in Iran: in urban contexts this included dedicated sections of the bazaar for each of a great array of crafts, as well as a regulatory system of master-craftsmen and bazaar inspectors.[147] The latter institution was in existence in Iran by the third century CE and was evidently a descendent of the ancient Mesopotamian "overseer of the markets," as well as a forerunner of the Islamic institution of the *muḥtasib* or marketplace inspector. This last office in its turn generated, though its manuals, an extremely important body of textual evidence for the history of medieval markets and material culture in the Islamic world.[148] It is certainly true that the *ḥisba* literature refers frequently to cheating and lying craftsmen, but of course a main raison d'etre of the genre was the exposure and prevention of fraud in the marketplace, and so its focus naturally lies on rules and especially their transgression.[149]

The picture is patchy, but overall the material and economic evidence from the Late Antique to medieval periods in the Middle East presents an urban craft economy that was long established, pragmatically structured, and—much of the time—actively regulated and in rude health. This would not be possible if the crafts were really held in such low esteem that only the most wretched members of society engaged in them, and indeed there is overwhelming evidence that such a situation was not the case, even in the early Islamic period. Many of the first Muslim jurists and theologians—most of them hailing from the great urban centers

of Kufa, Basra, and Baghdad—were reportedly engaged in trades and crafts.[150] In this light it becomes clear that the contemptuous remarks about smiths, weavers, and so forth preserved in some of the works of the belletrists must have co-existed with other conceptualizations of craftsmanship in the medieval period.[151]

In fact, as several authors have observed and Sadan has eloquently demonstrated, intimations of an awareness of the social value of crafts can be found even within *adab* literature, in the work of no less a figure than al-Jāḥiẓ, the great ninth-century molder of the very tradition of *adab*. The *Risāla fī ṣināʿāt al-quwwād* (Epistle on the crafts of the masters) of al-Jāḥiẓ is one of the earliest extant Arabic sources on craftsmanship, and it is a text that inaugurated its own literary genre. The epistle presents the purported responses of a series of tradesmen when asked to describe both a battle scene and the pains of love. Each tradesman cannot help but draw his metaphors from his own stock-in-trade, leading to analogies that are in turn comical, crude, or unexpectedly striking.[152] Humorous without fully descending into mean-spirited derision, Jāḥiẓ's literary showmanship exhibits an awareness of the specificities of individual trades and their illustrative potential, as well as a sympathetic consciousness of their utility, even as it mocks the tradesman's inability to frame events and emotions in descriptive terms that lie anywhere outside of the confines of his profession. The text, although short, is significant in hinting at a regard for the role of the craftsman in society that goes beyond the comedic contempt some scholars stress. It should come as no surprise to encounter a multilayered conception of the craftsman as an integral component of the living city within the literary culture that swelled in ninth- and tenth-century Baghdad: the caliphal capital was the uncontested metropolis of the Islamic Middle East at that point, and the first truly great world city founded by the Islamic state.[153]

It is when one looks beyond the Prophetic literature and *adab* sources that the complex reality of craft activity in the medieval Islamic world begins to emerge most fully. The extraordinary diversity of productive life in the medieval Islamic city is revealed in the eighth epistle of the Ikhwān al-Ṣafāʾ, and this seems to be one of the earliest surviving texts to present a systematic exploration of the role and organization of crafts in society. Critically, the Ikhwān's eighth epistle is premised upon the cooperative nature of crafts as a system of mutual exchange between specialists that enables fulfillment of society's needs. Within this framework the Ikhwān explore the interdependence of individual crafts through their various models of categorization. Some recent authors have emphasized the Ikhwān's refreshingly egalitarian judgment that the nobility of a craft can be predicated on its service to society as a whole, meaning that the refuse collector takes precedence over the perfumer.[154] However, one must recall that this idiosyncratic valuation is only one among many systems of categorization presented in the eighth epistle.

Apparently more influential was the position accorded by the Ikhwān to the primary crafts, necessary to the fulfillment of mankind's basic needs, around which

they based their system of categorization by rank. The primary crafts, according to this system, are agriculture, weaving, and building. From these three there cascade several tiers of ancillary crafts and trades dedicated to providing the necessary materials and tools for each of the primary crafts. Aspects of the Ikhwān's systems of categorization appear in discussions of craft found in the *Kitāb al-siyāsa* (Book of governance) attributed to Ibn Sīnā,[155] the *Adab al-dunyā wa'l-dīn* (The ethics of the world and religion) of al-Māwardī (d. 1058),[156] and some manuscripts of the *'Ajā'ib al-makhlūqāt wa-gharā'ib al-mawjūdāt* (The wonders of created things and the marvels of existence) of al-Qazwīnī (d. 1283), especially its Persian translations.[157] It is true that other means of approach also existed.[158] For example, Ghazālī divides the crafts into essential and non-essential along straightforwardly religious lines, with concern for delineation of the permissible and the prohibited apparently outweighing any interest in social significance.[159] Ghazālī does, however, recognize skill in the crafts, as when he makes a sharp distinction between the huckster physician who expects payment simply for providing the name of a medicinal plant, and the skilled craftsman who can fix a defected object with one movement. His example of the latter is the master sharpener who can remove "curves from swords or mirrors by a single stroke, owing to the expertise of the sharpener in determining where the curves originate," and clearly shows an appreciation for the understanding, as well as the dexterity, of the skilled craftsman.[160] Alternative frameworks notwithstanding, the Ikhwān's model for understanding the roles of the crafts within society was undoubtedly influential, and was to find its most comprehensive reflection several centuries later in the *Muqaddima* (Introduction) of Ibn Khaldūn (d. 1406).

A monumental work that resists classification, the *Muqaddima* was originally intended as an introduction to a history of the Islamic world. It applies philosophy to the study of history and society and, in doing so, "re-evaluates, in an unprecedented way, practically every single individual manifestation of a great and highly developed civilization."[161] The text has been hailed as both the first work of sociology and a forerunner of the *Annales* school of historical studies, although valorizations of this type risk decontextualizing a work that is thoroughly grounded in Sunni theological principles.[162] Most importantly for the present study, it gives one of the most thorough presentations of the social role of crafts to be found anywhere in premodern Islamic literature.

For Ibn Khaldūn, the cooperative project of civilized society, both in his own time (the fourteenth century) and as projected backward through earlier Islamic history, is predicated in large part on tool manufacture and use, because these serve man's requirements for survival. Within the great schema of nature, the arts of making and the creation and use of tools were generally considered by medieval authors to be functions that definitively separated man from animals, as indeed they are still.[163] Another distinguishing feature arising from these criteria was the ability to unite thought with manual creation—essentially, what I have

conceived in this chapter as the intellect of the hand. In the words of Ibn Khaldūn,
God gave man "the ability to think, and the hand. With the help of the ability to
think, the hand is able to prepare the ground for the crafts. The crafts, in turn, pro-
cure for man the instruments that serve him instead of limbs, which other animals
possess for their defense."[164] This differentiation between man and animals is not
unique: for example, a similar idea was expressed by Miskawayh centuries earlier,
but without the same emphasis on the thinking hand that creates the instruments
of defense.[165]

In addition to defending himself, man must grow food and prepare it for
cooking and eating, processes that require many types of tools at different stages
and for which he must therefore enlist the skills of the blacksmith, the carpenter,
the potter and so forth. To illustrate this, Ibn Khaldūn lists a sequence of interde-
pendent crafts, echoing the model used by the Ikhwān al-Ṣafāʾ.[166] Later, elaborating
the Ikhwān's primary crafts in his own discussion of the subject, he delineates the
necessary crafts as agriculture, architecture, tailoring, carpentry, and weaving.
Crafts that attain nobility through their object are midwifery, writing, book pro-
duction, singing, and medicine, each of which is discussed by the author in greater
or lesser detail.[167]

In Ibn Khaldūn's terms, the production of crafts emerges as one of the prin-
cipal diagnostics of sedentary culture, which is in turn "the goal of civilization."[168]
This is because the proper organization and mutual availability of the crafts is pos-
sible only in cities, where dynastic wealth is concentrated and many people coexist,
with the result that culture and commerce flourish.[169] As an ordering principle for
urban society, the necessity for each individual to be guided toward a suitable prac-
tical art and to cooperate in the productivity of civic life can be glimpsed in works
by earlier authors such as al-Fārābī and Miskawayh, as well as the much fuller
exposition given in the Ikhwān's eighth epistle.[170] Ibn Khaldūn's vision, however,
went beyond that of all the earlier writers. The susceptibility of urban societies
to degeneration, brought about in part by too high a regard for luxury crafts, is
unflinchingly spelled out by Ibn Khaldūn, who presents this as simply one more
manifestation of the cyclical pattern of history and a seemingly inevitable result of
an exchange economy.[171]

Craft is defined in conceptual and economic terms by Ibn Khaldūn as the ap-
plication of human labor to specific materials. This places artifacts at the center of
his economic model of labor as the source of value, a means of apprehending the act
of making that was earlier intimated in the Ikhwān's discussion of astrolabes and a
worldview that places the craftsman as "highest in importance as economic actors
in sedentary societies."[172] As activities, craft processes necessitate "thinking and
speculation" (al-afkār wa al-anẓār) as well as action, and must be learned over time
through extensive practice before perfection can be attained.[173] Craft is accordingly

characterized by Ibn Khaldūn as a "habit [*malakah*] of something concerned with action and thought," and the habits of the crafts provide intelligence, just as languages are described as "habits of the tongue" elsewhere in the *Muqaddima*.[174] Embodied knowledge of this kind requires teaching and personal observation, and while Ibn Khaldūn evinces little concern with the mechanics of training and skill transmission, he recognizes the necessity of teachers within his argument that the proper arrangement of crafts is possible only within the sedentary urban context.[175] By contrast, the importance of initiation, training, and instruction resonates throughout the Epistles of the Ikhwān al-Ṣafāʾ. This is hardly surprising given the esoteric nature of the text and its evident use as a manual for initiates.[176] The Ikhwān's approval of apprenticeships, particularly those that followed family lines, indicates the existence of organized systems of teaching and learning for the crafts even if it does not definitively prove the earlier existence of the guild systems in place by Ibn Khaldūn's time.[177]

As the preceding discussion has shown, the disdain for crafts and manual labor found in some medieval literary sources was not entirely reflective of social realities. The thoughtful analysis of the essential place of the crafts in society and the cerebral aspects of skilled craftsmanship is prefigured in Jāḥiẓ, fully initiated by the Ikhwān, and reaches its culmination in Ibn Khaldūn. One outcome of these concerns is the recognition of virtuosity in the crafts as a form of personal merit. The intelligent craftsman is lauded in Miskawayh's late tenth-century treatise on philosophical ethics, where he is cited as an example of legitimate happiness enacted through the virtuosic demonstration (and sharing) of a skill: "The accomplished writer is pleased by demonstrating his writing—as is also true of the clever mason, the fine jeweler, the proficient musician and, in general, of every clever and excellent artisan who is pleased by demonstrating excellence in his art."[178] On the whole, the greater the attention paid by medieval authors to the specificities and realia of craft practices, the more ready they were to respect those practices. Jāḥiẓ recounts in the *Ḥayawān* how watching a carpenter at work caused him to realize that carpentry is a complex skill and that the division of mankind into different trades was effected for good reason.[179]

Throughout, this chapter has drawn together the world of matter and the world of mind to bring into relief the intellect of the hand, and advance the maxim that "making is thinking." It is only by acknowledging the cerebral dimension of making that we can fully recognize and explore the achievements of medieval artisans. The intelligent craftsman hailed by Ibn Khaldūn was not a one-off, but instead had a long history in Arabic and Persian literature of various kinds. Nor did the craftsman's value lie only in his usefulness to society as a maker of clothes or cooking vessels. He was at work within a broader cultural landscape suffused with the concerns of materiality and making: these reverberated in the Prophetic tradition of the artisan God, penetrated the philosophical and metaphysical realms,

and underwrote the most intelligent considerations of social economy. Thus, the intellect of the hand was a significant component of the medieval Islamic intellectual tradition, even if it was not always directly transcribed into textual records. With this in mind, the following four chapters will explore some of the products of that thinking hand, examining interrelationships between thinking and making in the plastic art of the archimorphic object.

2

BUILDING
ORNAMENT

The intellect of the hand performs its work not only through processual time, but also through three-dimensional space. This elemental truth is particularly evident in the plastic arts of metalwork, ceramic, stonecarving, and so forth, in which construction and appreciation alike require objects to be moved through space, rotated, inverted, opened, and closed. However, much of the nineteenth- and twentieth-century scholarship on what are uncomfortably termed the "applied," "decorative," or "minor" arts has been predicated on the assumption of certain binaries that tend to elide three-dimensionality. Form is set in opposition to surface, ornament to figure, and ultimately objects of use to *objets d'art*. While the historiographic background to these constructs is complex, the implicit outcome in the scholarly history of the plastic arts has been the elevation of vision over touch and two-dimensional surface over three-dimensional space. But the products of the thinking hand can only be properly understood if they are reckoned in haptic as well as visual terms, and the portable artworks in this book repeatedly upend all such binaries.

This chapter makes, at heart, a simple case: namely, that the medieval artistic modes collectively and commonly termed "ornament" make up a fully three-dimensional system in which surface and space are mutually constitutive, rather

than a two-dimensional skin that can be unproblematically separated from its carriers.[1] This is nowhere more apparent than in the case of architectural motifs used as ornament, which, as this chapter shows, persistently and intentionally evoke fictive spaces as well as articulating real ones. In particular, I consider the capacity of architectural motifs—foremost among them the arcade—to illuminate the problems of a two-dimensional paradigm for ornament.

The chapter begins with the phenomenon at the core of this book, a material practice without a name: making something functional resemble something else. The lack of a precise term for this practice betrays its ambiguous ontological position, complicating as it does Classical conceptions of mimesis and representation. Following this, I examine some writings on ornament that expose an ongoing uncertainty regarding the place of the third dimension within the study of ornament. As I will show, this is most visible in the awkward position occupied by architectural motifs in theories of ornament from the nineteenth and twentieth centuries, from Owen Jones to Oleg Grabar. The next sections of the chapter demonstrate the capacity of the architectural motifs employed in the plastic arts of the medieval Middle East to complicate and confound the paradigm of two-dimensionality as they variously articulate surface, contours, and space, transforming signification as well as form in the process. This is explored primarily through a study of the arcade, a linear motif that was frequently employed as a means of ordering surfaces across media beyond monumental architecture, including stone, wood, and most notably inlaid metalwares. Finally, the discussion moves to the peculiarly plastic ornamentation that connected buildings, metalwork, and ceramics of the thirteenth century in the area around Mosul, in northern Iraq, and considers the architectonic allusions that harmonize this system of ornament.

Together these examples make the case that the ornamented object is both a fully three-dimensional venture and a space for the play of the intellect through the game of allusion and indirect reference. By deliberately invoking architecture—that other major art of the third dimension—the medieval craftsmen who employed architectural forms as ornament upon plastic artworks generated a particularly productive tension between ornament, space, and referentiality. In this manner, they exploited in novel ways ornament's capacity to reconstitute the forms as well as the meanings of objects.

Taking the Shapes of Images

There is a fundamental difference between an object to which motifs have been applied like a thin skin that does not significantly modify underlying form, and an object that has been made in the shape of something else. In traditional art historical scholarship, the former is a bearer or carrier of ornament, the latter harder to categorize except in individualized terms, such as "animated (or zoomorphic, anthropomorphic, etc.) vessel" or *redende Reliquiare* ("speaking reliquary").[2] Rather surprisingly, there does not seem to be a general term in English to denote "a functional thing

made in the form of something else," unless "allomorph" is to be awkwardly co-opted from its technical uses elsewhere. A late twelfth- or early thirteenth-century aquamanile from Iran provides a neat example of the phenomenon, and of its multi-layered visuo-plastic potential (Fig. 2.1). On the one hand, the surface of the object has been painted with two-dimensional ornament that in some places responds directly to the contours of the object's form, and in others makes little or no allusion to the structure on which it has been inscribed. On the other hand, the hollow pouring vessel has been created, unmistakably, in the form of a bovine creature.[3]

In medieval Persian, the word *takūk*, found in the eleventh-century lexicography of Asadī Ṭūsī, denotes zoomorphic drinking vessels in the form of bulls. Later sources extend the definition of this term to include wine-vessels in the shape of other types of animal.[4] However, a more general term for objects of use made in the form of other things is lacking in the medieval texts just as it is in modern art historical discourse. A diktat concerning representational imagery found in the *Ihyā' 'ulūm al-dīn* (Revival of the religious sciences) of Ghazālī highlights this lack by resorting to an intriguing, if somewhat cumbersome, formulation: "As for images [*al-ṣuwar*] on cushions and carpets, this is not forbidden. This also applies to dishes and bowls, but not to vessels taking the shapes of images [*al-'awānī al-muttakhadha 'alā shakl al-ṣuwar*]."[5]

FIGURE 2.1 Aquamanile, Iran, *c.* 1180–1220. Glazed stonepaste with luster decoration. Height 14.6 cm. Eskenazi Art Museum, Bloomington, IN, 60.58.

Ghazālī's formulation is part of a wider debate in medieval Islamic law about the nature and permissibility of images, and is particularly interesting in its attempts to clarify the semantically capacious term *ṣūra*, which can indicate both two- and three-dimensional forms of representation, with the modifying concept of *shakl*, typically "shape" or "form." In this it may be linked with an early Islamic tradition which held that forms of likeness "casting a shadow" (i.e., executed in three dimensions) were more objectionable than two-dimensional images.[6] The point of particular interest here is the application of this distinction to functional objects. By singling out vessels or utensils (*'awānī*) thus transformed, Ghazālī's statement recognizes the transformative capabilities of the plastic arts and the creative potential of utilitarian objects, at the same time that it demonstrates the non-existence of a specific term to denote the phenomenon he condemns: making functional objects in the form of other (living) things.

The absence of a singular term for the phenomenon of functional, three-dimensional objects made in the form of other things, in the Islamic world and elsewhere, arises from the visual, material, and cognitive polysemy inherent in this phenomenon: it is a mode of creativity that resists classification to the point of remaining nameless.[7] Doubly difficult to define is the material that falls somewhere between the two categories of the ornamented surface and the object created in the form of something else. Architectural motifs can be used both individually and in combination within works of the plastic arts to generate evocations of architectural structures and spaces, without necessarily presenting a complete or coherent architectural schema or transforming an object into a miniature building. By most modern qualifications this allusive archimorphism would be considered a form of ornamentation, but the phenomenon is sufficiently meaningful, specific, and intellectually complex that it transcends the expectations commonly placed upon "mere ornament."[8]

Trails of Ornament

There is little surviving written evidence to describe how medieval producers and consumers made and received what we would now term "ornament" in material culture. Ornament's role and function in the medieval Islamic world can be reconstructed only tangentially, using parallels drawn from medieval texts on topics other than visual art, later tabulations of ornament that arose in early modern settings, and the evidence of objects.

Of interest among the first of these are medieval literary theories in which material and poetic concepts of adornment or embellishment repeatedly converge. For example, a Qur'anic term for ornament, *zukhruf*, originates in one of the names for gold and came in the medieval literary sphere to indicate adornment or embellishment in both the literary and the visual arts.[9] The term is symptomatic of a medieval discourse on aesthetics and beauty that is entangled with adornment and particularly with certain crafts such as goldsmithing and textile production. (This is in its turn part of a broader phenomenon of craft analogies and converging

conceptions of the literary and material arts, which I will explore in detail in Chapter 4.) To give only one example here, Ibn al-Haytham cites the goldsmith's deliberate roughening and texturing of surfaces as a means of producing optical beauty.[10] The root word *zāna* (to adorn or embellish), with its focus on the production of beauty, engenders terms for ornament or adornment that refer to moral as well as physical beauty. While such linguistic traces demonstrate the centrality of ornament to aesthetics within the Arabic-speaking world, they give little information about the forms and motifs, both individually and in combination, that made up medieval systems of ornament.

The situation is quite different for the early modern period, from which there are surviving textual sources specifically concerned with applied motifs for art production. Sevenfold classifications of decorative design (*naqqāshī*) recorded in sixteenth-century Persian texts show that a conscious and systematic differentiation of ornamental systems had emerged by the Safavid period. The individual categories of ornament encountered in these texts vary from one author to the next; of these, *faṣṣālī* ("compartmentalized") forms probably lie closest to the architectonic modes that form the focus of the present study—although as Yves Porter has noted, this term could refer to a number of things including, quite possibly, the setting of margins.[11]

More illuminating is the description of *how* individual motifs are to be used, from the 1597 manual for painters by the court artist and librarian Ṣādiqī Beg: "Whatever your basic pattern be, in drawing your sketches (*raqam sākhtan*) you must be certain to attach equal weight both to the actual design, say, a floral leaf (*barg*), and to the field (*būm*) in which it lies."[12] Ṣādiqī Beg also valued connectivity of design and an awareness of the suitability of individual motifs for particular roles within a larger composition, as befits the practitioner of a paper-based tradition that was more holistic than atomistic in its conception of the flat decorated surface. However, while the highly distinctive aesthetics of Safavid book arts certainly reflect these principles, it is hard to gauge the depth of the tradition from which they sprang, and it would be unwise to project them retrospectively onto the artistic products of earlier centuries.[13] Additionally, the focus of the Safavid texts is squarely on book arts, leaving the relationship between these motifs and the third dimension largely untouched. Before turning to the evidence of medieval objects themselves, it is worth asking what we might learn from modern trajectories in scholarship about the relationship between ornament and the three-dimensional arts.

The three-dimensionality of ornament has always posed a problem for scholarship. Nineteenth-century sourcebooks of ornament, exemplified by Owen Jones's 1856 *Grammar of Ornament* (Fig. 2.2), tasked themselves with recording and ordering the world's decorative systems.[14] In the first instance, Jones and his confreres cemented a linguistic paradigm for the study of ornament that remains in wide circulation today, analogizing motifs, combinatory units, and spatial patterns of organization with syntax, grammar, and language itself—and the racial

dimensions of this analogy were never far away. Yet the material and spatial aspects of ornament confound the linguistic analogy and are almost impossible to transmit on the page, where description can only go so far and the limitations of print publishing impose tremendous restrictions on visual and spatial information.

As an architect with a deep interest in structure Owen Jones may not have precisely intended his own study to void form from surface. Collectively, however, the nineteenth-century field of ornament studies overwhelmingly presented ornament as a two-dimensional skin that could be stripped from its "carriers" and flattened against the page. Jones's designs drawn from Islamic architectural decoration, for example, were transposed from volumetric surfaces to two-dimensional schema in order to extract their flat patterns for commercial industrial development (Fig. 2.2).[15] Similarly, scholars of the plastic arts working in the nineteenth and twentieth centuries developed ingenious techniques to convey the maximum possible amount of schematic information from an object in a single image, unpeeling surface from form and spatchcocking it against the page (Fig. 2.3).[16] Within these practices, ornament is recognized at best as a cognitive system overlaying a form, at worst as an arbitrary or superficial afterthought that could be skimmed off one surface and stuck onto another without disruption to its inherent nature. This paradigm gave rise to a condition of two-dimensionality that often persists in later writings on ornament.[17] While there has in recent years been much productive critique of ornament's historiography and the tensions it has generated within the study of Islamic art in particular, the cleavage of ornament from structure lingers.[18]

Building Ornament

For the reasons outlined above, architectural motifs pose a particular problem for ornament studies. Among the twentieth-century taxonomies developed by European scholars, a fourfold division of "Islamic" ornament emerged: veg-

FIGURE 2.2 *Turkish No. 3*, plate XXXVIII from Owen Jones, *The Grammar of Ornament*, folio edition (London: Day and Sons, 1856).

etal, geometric, epigraphic, and

FIGURE 2.3 David Storm Rice, schematic drawing of an inkwell of brass inlaid with silver.

figurative.[19] While much of the material thus configured, including tilework and carpets, was drawn from architectural ornament and fittings, architecture *as* ornament was not normally recognized as a distinct category in spite of the relatively common occurrence of certain forms, particularly arches and arcades. This exclusion is symptomatic of a recurring uncertainty about how to treat architectural motifs within any categorizations or theories of ornament. The ornamental aspects of the Classical orders, for example, may be acknowledged, but when Classical columns and capitals are themselves scaled down and applied to objects they seem to pass into a zone of ambiguity: architecture-as-ornament is neither a self-contained and essentially abstract system, like epigraphy and geometry, nor one that emerges from the natural world as do the vegetal and figurative registers.[20] Predicated on an indissoluble relationship with manmade external referents, and incapable of being totally abstracted from the realms of the concrete, the architectural mode seems to enfold too many layers of artifice and differentiation to be accommodated comfortably within much of the discourse on ornament.

Some of the problems of architecture's position within theories of ornament stem from the influential thesis of Alois Riegl (d. 1905) concerning the origins of ornament itself. In his famous *Stilfragen: Grundlegungen zu einer Geschichte der Ornamentik* ("Questions of Style: Foundations for a History of Ornament") of 1893, Riegl proposed that all ornament descends ultimately from observation of natural forms.[21] This led to an increased focus on the vegetal "arabesque" as the paradigmatic expression of Islamic cultures—a tendency reflected within the developing field of Islamic art history in Ernst Kühnel's 1949 publication, *Die Arabesque: Sinn und Wandlung Eines Ornaments* ("The Arabesque: Meaning and Transformation of an Ornament").[22] Riegl formulated his position in opposition to the "technical-materialist" school of Gottfried Semper (d. 1879) and his followers, who argued that manmade artifacts and in particular weaving were the origins of ornament.[23] While Riegl's thesis was not universally accepted it has nonetheless had a long reach, and since it effectively bars architectural motifs from consideration as ornament in their own rights it is worth looking at the alternative models proposed by the technical-materialist camp.

One of the oddest and yet most instructive of these is an essay written by a British medical doctor called Henry Colley March and published in 1889 in the

journal of a regional English antiquarian society. At first glance "The Meaning of Ornament: Or Its Archaeology and Its Psychology" might not present much promise of a major contribution to ornament studies. But it in fact coined a term now in increasingly wide currency: "skeuomorphism." The word has gained circulation in the last twenty or so years to denote the digital representation of attributes belonging to now-superseded physical analogues. It also has a closely related meaning in material culture studies where it is used to refer to "the manufacture of vessels in one material intended to evoke the appearance of vessels regularly made in another."[24] An example of the latter is the incorporation on ceramic vessels of functionless hanging loops and rivet heads copied from metalwork prototypes, a noteworthy trait of some ceramic production of the thirteenth-century Persianate lands (Fig. 2.4).[25]

While the word's usage is now dominated by transmedial emulation, skeuomorphism was initially intended by March to denote more broadly an entire category of ornament—namely, that which emulates manmade artifacts:

> The forms of ornament demonstrably due to structure require a name. If those taken from animals are called zoomorphs, and those from plants phyllomorphs, it will be convenient to call those derived from structure, skeuomorphs, from σκεύη, tackle, tools, vessels, equipment, dress.[26]

March's primary examples of his new concept are the incised and modeled devices found on ancient ceramic production and bronzes which echo thong-work, plaiting, matting, and weaving. This, he argued, was the origin of ornament, marking him as one of the followers of Semper against whom Riegl would consciously position himself. March's own rather portentous line of reasoning ends up pitting modes against each other in a kind of gladiatorial deathmatch of ornament, but his essay, and to some extent the larger materialist discourse on ornament that it represents, does three important things. First, it acknowledges the existence of a second level of differentiation within extant modes of ornament, through the distinction drawn between natural and manmade referents. This opens the way for a self-replicating universe of ornament as forms are brought into being through the practices of craftsmanship, then emulated and reinvented from one modality to another. Second, it recognizes and considers in some detail the changes in form, as well as signification, which are wrought upon motifs when they are transferred from one medium to another—precisely the aspect of ornament that Riegl wished to overcome. Thirdly and perhaps most importantly, the materialism of March and his colleagues also highlights the indivisibility of form, material structure, and processes of making within the constitution of ornament, and is therefore able to transcend the paradigm of two-dimensionality. In these ways the materialist discourse creates a space in which

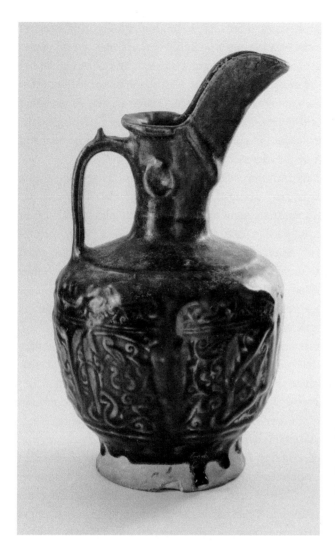

FIGURE 2.4 Jug, Iran,
thirteenth century. Glazed and
molded stonepaste. Height
23.5 cm. Museum für Islamische
Kunst, Berlin, I. 1360.

the thinking hand, and its movements through time and space, can be recognized
as a vital component of ornament.

Architectural ornament, particularly geometric designs, have been the subject
of considerable scholarly attention in the field of Islamic art history. Necipoğlu's
extraordinarily expansive study of the early modern design scroll in the Topkapı
Palace Museum Library remains the seminal work on this subject.[27] However, ar-
chitecture *as* ornament has not received the same kind of focus. The phenomenon
has been most thoroughly explored in Oleg Grabar's *Mediation of Ornament*, where
Grabar organized his thesis of ornament as a system of "intermediaries" into the
categories of writing, geometry, architecture, and nature.[28] In what is probably his
best-known book, Grabar's model of ornament as intermediary placed a spotlight
on the perceptual responses that ornament elicits as it mediates between object,
viewer, and world.[29] In the chapter on architecture-as-ornament, *The Mediation*

of Ornament argues that architectural motifs have a unique status as ornament because of their direct referential relationship with buildings. Architecture is the medium of mankind's greatest and most visible achievements, and constitutes both locus and emblem of many human experiences, at least in the urban societies that have historically produced complex artworks. Hence, Grabar argues, its recurring role in Late Antique and medieval book arts and relief carvings as a system that divides and organizes a surface at the same time that it enhances the cultural and social worth of the artifact that it adorns.[30]

Curiously, while one might have expected such a consummate historian of both architecture and the "industrial arts" to engage extensively with the relationship between architecture as an ornamental system and the fully three-dimensional art of the object, Grabar dedicates only half a paragraph at the very end of his architecture chapter to the phenomenon of "objects shaped as buildings."[31] Jonathan Hay has noted that Grabar's formulation of ornament as a "dynamics of mediation between human beings and nature or culture" has the effect of sidelining the agency of the ornamented surface itself, and this can also be related, I would argue, to Grabar's concentration in the *Mediation* upon only the two-dimensional representation of architecture.[32]

The *Mediation*'s chapter on architecture begins with the schematic architectural drawings found on the parchment frontispieces of the Sanaʿa Qurʾan that have generated so much debate since their first publication in the 1980s (Fig. 2.5).[33] After entering through this portal, Grabar's discussion is naturally framed around the interpretive mediations afforded by various systems of architectural representation, and gravitates overwhelmingly toward two-dimensional modes. Where he discusses three-dimensional artifacts, most of them are objects wrapped in a skin that is divided into cells by low-relief architectural elements but leaves the underlying form of the object basically unaltered. In contrast to the other sections of the *Mediation*, which largely conform to Grabar's overarching definition of ornament as "any decoration that has no referent outside of the object on which it is found," the architecture chapter cleaves to an essentially imagistic conception of architecture-as-ornament. It is primarily concerned with the various visual systems by which architecture can be represented two-dimensionally and the relationships between these and their referents in the built environment.[34] By remaining preoccupied with the "conceptualization and encoding of the visible and of the known" in the representation of architecture, Grabar ultimately binds his argument to the paradigm of mimetic referentiality, even as he repeatedly points out the failure of that very paradigm to account for the arcades and domes that do not refer to individual buildings and yet are inscribed all over the surfaces of books, altarpieces, and other objects.[35]

Evidently, architecture-as-ornament continues to pose a problem for theories and taxonomies of ornament.[36] Perhaps more than any other mode of ornament it has a tendency to order space along lines that cannot help but raise potential for mimetic interpretation. Put a framed window, or an occupied arch, onto a surface and very often the surrounding spaces will start to conform to some sort of architectural logic preexisting in the viewer's mind, a phenomenon that has been exploited by the

FIGURE 2.5 Half of a double-page frontispiece from a Qur'an manuscript found in San'a, Yemen. Ink and pigment on parchment. Original dimensions approx. 51 x 47 cm. Late seventh or early eighth century. Dār al-Mukhṭūṭāt al-Yaminiyya, San'a, Yemen, 20–33.1.

makers of many of the objects in this book (see Chapter 3 for further exploration).[37] If one goes further and arranges individual architectural motifs into an overall schema that mimics the form of a recognizable building, the mimesis is no longer potential but actualized, and the ornamental aspect of the architectural motifs—their "aesthetic autonomy and elusive allusiveness," to quote Necipoğlu's choice phrase—has been largely subordinated to the direct referentiality of mimesis.[38] If, however, the object's formal engagement with "real spaces" remains within the register of allusion, architecture emerges as an ornamental system with tremendous potential for the intelligent—and sometimes playful—articulation of space as well as surface. Craftsmen in the medieval Islamic world were ready to capitalize on the visuospatial possibilities offered by architecture-as-ornament, and their products showcase inventive ways of thinking about ornament and its communicative potential.

Arcades and Cordons Sanitaires

Across the medieval Islamic corpus of plastic arts, the most immediately apparent use of an architectural motif as ornament is the arcade. Taken as a

transferable unit, this device embodies all the polysemy—as well as the perceptual instability—that characterizes architecture-as-ornament. Derived from "true" architectural forms by way of a spectrum of miniaturized versions or "dwarf arcades," both structural and nonstructural, that have been put to work in monumental architecture, the arcade's application across the plastic and the portable arts engenders new semantic possibilities at each turn. But the "translation" of the arcade into ornament does not merely entail borrowing a set of forms and their accompanying connotations from monumental architecture and rehousing them without further adaptation (beyond rescaling) in a new, diminutive setting—although such inherited signification naturally has an important part to play.[39] Nor is the formal role of the arcade within ornamental schema limited solely to the compartmentalization of individual elements.[40] Particular to the image of the arcade is its capacity to evoke fictive spaces at the same time that it delineates real ones, a characteristic exploited in various ways by premodern craftsmen as well as architects.

The rapidly developing artistic and architectural culture of the nascent Umayyad state launched itself from a Late Antique foundation in which the arcade already played a number of different roles, at both full and reduced scale.[41] The form's dissemination within the vocabulary of Late Antique ornament was enacted through various channels, of which one of the most visible was the group of so-called columnar sarcophagi made in Rome and Asia Minor of the second and third centuries. It has been argued that the miniature arcades on these sarcophagi, commonly occupied by figures, allude to colonnades on civic architecture enclosing honorific statues. This would make them a means for the virtual patronage of architecture by an aspirational middle class, while also carrying in some instances strongly theatrical overtones.[42] The "rhetoric of framing" presented on these Asiatic sarcophagi had a long reach.[43] As Edmund Thomas notes, "the transfer of pagan columnar symbolism to Christian art and thought ensured the continued life of the column sarcophagus": fourth-century examples with Christian scenes in the niches of the arcades, such as the famous Junius Bassus sarcophagus discovered under old St. Peter's basilica in Rome, are justly celebrated as masterpieces of early Christian sculpture (Fig. 2.6).[44]

In some of the early Christian examples the human action breaks fully free of the architectonic cells, which are in turn left to recede into the role of background imagery; in others the sculptural dimensions of the represented human figures remain subordinated to an architectural framework. Some go further in their emulation of totalizing architectural schema: on certain examples, lids carved in imitation of pitched, tiled roofs, and consciously architecturalizing arrangements of fictive openings, are foreshadowed by containers for human remains articulated fully into miniature buildings, such as a first-century carved marble ash-chest with pitched and tiled roof and four walls each decorated with two closed doors (Fig. 2.7).[45]

FIGURE 2.6
Sarcophagus of Junius
Bassus, front and
remains of lid, dated
359. Carved marble.
Museum of St. Peter's
Basilica, Vatican.

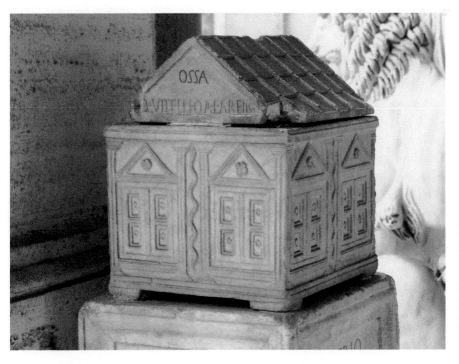

FIGURE 2.7
Ash-chest of
Q. Vitellius,
first century CE.
Marble. Vatican
Museums.

The image of the door—closed, ajar, or sometimes open and framing one or more figures—has long held an important position in eastern Mediterranean funerary markers.[46] Closely related to this is the Jewish and early Christian temple imagery that exalts the closed or slightly ajar doorway, frequently framing it within a niche or portal, and sometimes adding a suspended light, jewel, or other signifier that further emphasizes the simultaneous invitation and impenetrability of the entryway image, as well as its sacrality.[47] The play of "closure, opening and the penetrative gaze" enabled by the doorway image exerted a continuous force upon the forms and designs codified for use in Late Antique sepulchral contexts, absorbing strands from Judeo-Christian traditions as well as pagan antiquity and extending in the early Christian context to a sustained engagement with images of doors and openings on caskets and reliquaries.[48] As such, the image of the doorway shares with that of the miniature arcade an invitation to imagine miniature spaces, or an extra-dimensional beyond, re-scaled to human dimensions.

Unlike the arcade, however, the doorway image marks a single point of penetration into an interior, at once glimpsed and withheld, and often extends an explicit invitation to imagine the bodily experience of passage from exterior to interior. Thus the doorway stands alone as an independent unit even when multiplied (as on Fig. 2.7). The arcade, on the other hand, is inherently sequential and therefore primed for extension across a surface. Hence its recurring use as a means of delimiting planes, rather than points, where different types of space abut one another, whether in an architectural context or upon the surfaces of containers. The arcade's suitability for the containment of figures adds further potential for play with fictive space by incorporating the scale-marker of the human form, a factor I discuss in more detail in Chapter 3.

Such was the success of the miniaturized arcade as a motif and its penetration across media in the Classical and Late Antique context that the device can be found on objects created very far from the eastern Mediterranean: one famous early example is the gold reliquary casket excavated from the one of the stupas at Bimaran in Afghanistan (Fig. 2.8). This diminutive repoussé container is decorated with a blind arcade of eight ogee arches sprung from plain pilasters; inside each arch is a haloed figure representing Buddha, the gods Brahma and Indra, and a fourth unidentified character—each repeated twice.[49] Much of the scholarship on this object is symptomatic of the larger entanglement of so-called Gandharan artworks into colonial, nationalist, and globalizing discourses, and the occupied arcade on the casket has been presented repeatedly as evidence of Hellenizing "influences" in the region.[50] Its lineage has been speculatively traced to Syrian columnar sarcophagi through the intermediary of Iran, the region supposedly acting as a zone of transmission between southern Syria, Transoxiana, and beyond the Hindu Kush to Gandhara.[51] The occupied arcades that appear on some later Sasanian metalwork, with their round arches dissolved into parabolae of independent discs rather than continuous solid lines, are quite different in appearance from those on the Bimaran casket but are

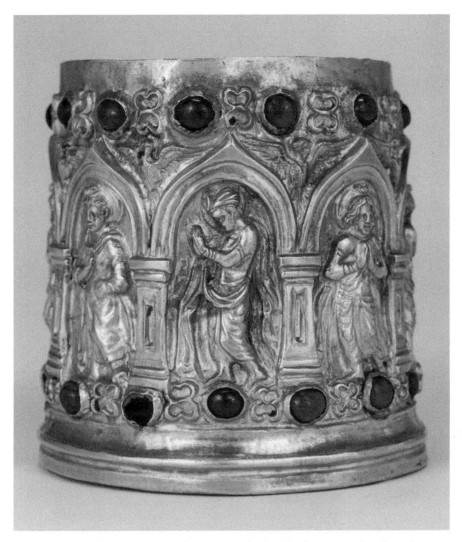

FIGURE 2.8 The "Bimaran Reliquary": cylindrical reliquary casket, found in Bimaran stupa 2, Afghanistan. First century CE. Gold inset with garnets. Height 6.5 cm. British Museum, London, 1900,0209.1.

related to arcade images on certain architectonic earthenware ossuaries from southern Sogdiana (Fig. 2.9), as well as the arcade on the famous "Marwan II" ewer, probably from eighth- or ninth-century Syria.[52] This confluence of forms suggests multidirectional passages of the arcade image over time. It also serves to remind us that regional adaptations of a widely dispersed form have their own autonomy—a factor sometimes overlooked in the great art historical quest for origins, where there is a tendency to regard all such phenomena only as nodal points on an evolutionary trajectory.

In the case of the Bimaran casket, a direct and clearly meaningful connection to architectural decoration is quite evident when the reliquary's golden gallery is

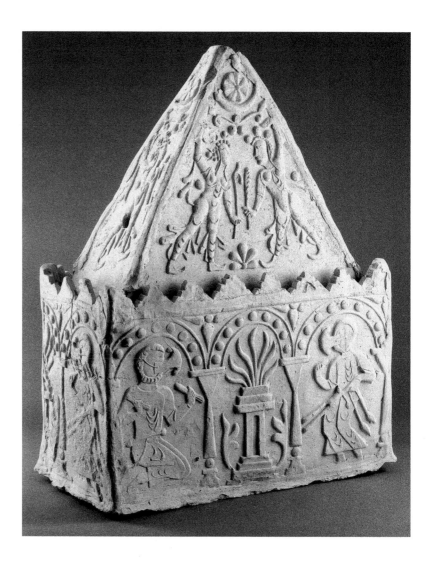

FIGURE 2.9 Ossuary
found at Mulla Kurgan,
Uzbekistan. Seventh or
eighth century. Carved
and molded earthenware.
Height 75 cm. Afrasiyab
Museum, Samarkand.

viewed alongside the blind arcade filled with relief-carved figures from one of the
stupas near Ḥadḍa, Afghanistan, now in the Musée Guimet.[53] Remarkably similar
in form, despite the differences in scale, the occupied arcades of the architectural
monument and the tiny container alike bear draped and haloed figures who oc-
cupy the full height of the ogee arches in which they stand. The dual functions of
concealing bodily remains and signposting their presence are mirrored—micro/
macro—between reliquary and stupa; the articulation of both with occupied
arcades plays upon a dialectic of concealing and revealing by generating a fictive
space in which multiple images of the Buddha and deities dwell across multiple
scales.[54]

 It is little wonder that the image of the arcade came to have so many
applications across media in the first centuries of Islamic art. It extended and
redefined certain connotations that the arcade had already accrued. The so-called

dwarf arcade, a reduced-scale version of the monumental form that could be structural or solely decorative, figured prominently in a number of Umayyad buildings
constructed in late seventh- and eighth-century southern Syria, for example the
palace complexes at Qaṣr al-ḥayr al-Gharbī and Khirbat al-Mafjar (Fig. 2.10), as
well as playing a part in the decoration of the first great monuments of Islam, the
Dome of the Rock in Jerusalem and the Great Mosque of Damascus.[55] But in spite
of its evident importance to the architects and patrons of the first great Islamic
monuments, Robert Hillenbrand has rightly pointed out that "the history of the
Islamic dwarf arcade as a bearer of meaning, not least in Umayyad architecture,
remains to be written."[56]

It is immediately notable, however, that the dwarf arcade frequently operated
as a plane of intersection between different types of space in Umayyad architecture. At Qaṣr Kharāna, for example, it repeatedly marks boundary points between
public and private.[57] Beyond a strictly architectural function, it also appears in a
representational role within an Umayyad-era sculpture found at Qaṣr al-ḥayr al-
Gharbī that depicts an enthroned ruler, his feet resting upon a step defined across its
frontal plane by the image of an arcade. The debt this sculpture owes to Byzantine
models has already been recorded.[58] Sixth-century carved Byzantine thrones such
as that associated with Maximian, with its front panel filled by a framed and occupied arcade, participate like the Qaṣr al-ḥayr sculpture in an image of dominion
that merges spiritual and temporal authority through the careful delineation and

FIGURE 2.10 "Dwarf arcade" at Khirbat al-Mafjar, Palestinian territories, first half of
the eighth century.

exaltation of discrete spaces, in this case thrones.[59] The arcade was a crucial component of this practice.

The inbuilt quality of liminality gave the arcade image a particular status within the plastic arts of the early Islamic period. Finbarr Barry Flood has shown that the original mihrab of the Great Mosque of Damascus (completed *c.* 715) was most likely inset with multiple miniature arcades, a mode of decoration prominently revived in the mihrabs created for the Mamluk rulers of Egypt in the thirteenth century.[60] The traveler Ibn Jubayr (d. 1217), writing in 1184, regarded the Damascus mihrab as one of the most wonderful in Islam, and described it thus: "Within it are small mihrabs adjoining its wall and surrounded by small columns, voluted [*maftūlāt*] like a bracelet as if done by a turner [*makhrūṭa*], than which nothing more beautiful could be seen, some of them being as red as coral."[61] Likening architectural ornament to the delicate manipulation of materials in jewelry making, Ibn Jubayr's description marries process with effect and structure with surface.

The use of a miniature arcade in the mihrab at Damascus would place the arcade image at the very heart of Islamic sacred space in its formative period, and underscores the device's vital position as a marker of threshold. Through its placement within the mihrab—itself a liminal arcuated space that acts as projective interface with both a distant geographic location (Mecca) and the extra-dimensional space of the holy—the miniature arcade at Damascus would have operated as both mise en abyme and cordon sanitaire. The imagery of arcades, columns, and architectural composites ordered around the unit of the arch that appears in some early

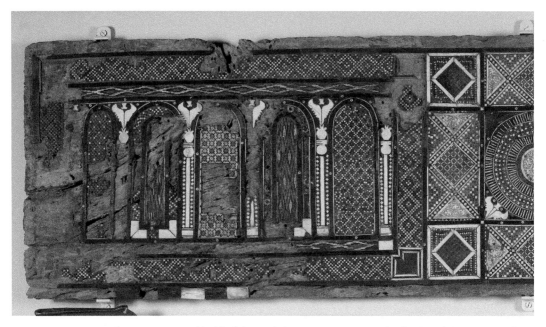

FIGURE 2.11 Panel, Egypt, second half of the eighth century. Fig wood inlaid with bone and other types of wood. Length 194.3 cm. New York, Metropolitan Museum of Art, 37.103.

Qur'an manuscripts, such as the Sana'a frontispieces described above, reproduces this system of demarcating the sacred, and the mode is shared with other liturgical manuscripts in the Late Antique and early medieval milieu.[62] Notably, semischematic depictions of arched portals and arcades also came to play a critical role in Christian manuscript illumination of the Eastern and subsequently Western Churches, as canon tables were encoded within the image of arcades possibly from as early as the fourth century.[63] Similar devices also played their part in the larger tradition of author portraits as manuscript frontispieces: whether an Evangelist or a secular writer, the author is often framed within an arch, introducing the access point to the knowledge contained within the book.

Extending the sacral and sepulchral connotations of the arcade image in early Islam are spectacular arcade images inlaid into wooden panels probably made in eighth-century Egypt (Fig. 2.11). Executed with extraordinary fineness in mosaic of wood and bone, the panels—now dispersed between several museums—were reportedly found in a cemetery near Fustat, in old Cairo. While they have been long been taken for fragments from a cenotaph, recent research has suggested that they might have come from a different form of container, possibly a chest for a precious manuscript of the Qur'an.[64] There are other examples of arcades on containers for the Qur'an, and the phenomenon sets in play another sort of mise en abyme as the sometime preference for column and arcade motifs in the illumination of early Qur'an manuscripts becomes nested within arcaded Qur'an containers, themselves housed within arcaded buildings.[65] The arcade represented upon the

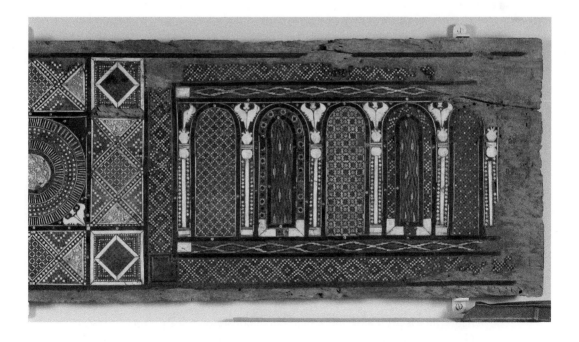

Egyptian panels is strikingly elegant: the space within each attenuated arch is filled with geometric tiling designs, while the slender columns are crowned with rounded capitals surmounted by symmetrical motifs that fill the spandrels and recall designs of paired, feathered wings. The spandrel designs on this inlaid arcade are also strongly reminiscent of those seen in the gilded marble arcade frieze in the Dome of the Rock, part of a decorative program that famously synthesizes Late Antique Mediterranean and Sasanian imagery.[66] The presence in the same monument of spoliated capitals carved with eagle designs, bearing connotations of regnal and spiritual dominion, layers further victory symbolism into the architectural motif of paired, outstretched wings on capitals.[67]

Two significant points already emerge from these isolated examples of the miniaturized arcade in Late Antique and early Islamic architecture, manuscripts, and plastic arts. The first point is the overlap of the arcade image across several closely related fields of material signification: containers for the word of God (manuscripts and Qur'an chests); containers for the remains, real or projected, of the dead (sarcophagi, cenotaphs, reliquaries); and planes of intersection (formed in architecture or furniture) between sacred or otherwise significant space and elsewhere. What all these uses have in common is their expression of liminality.

The second notable aspect of all these arcades is the absence of figures within most of the early Islamic examples when compared with the synchronous use of arcades in Christian and Byzantine contexts. This aniconism, which is in line with orthodox Islamic positions that had crystallized by the ninth century with regard to art in the sacred realm, to some extent renders the arcade image more flexibly adapted to two-dimensional application and patternation across a broad range of surfaces. While it does not follow that the human element was banished from the arcade motif by orthodoxy, never to be seen again within the Islamic world, it is undeniable that the Christian associations of the occupied arcade lingered. The device is most intimately associated in the field of Islamic art history with a group of silver-inlaid metalwork objects bearing Christological scenes as well as other motifs.

The Inlaid Surface

A famous group of inlaid "metalworks with Christian images" are often attributed to Ayyubid Syria and Egypt between the late 1230s and 1250s, although debates about the manufacture sites of certain pieces are ongoing.[68] While there has been much discussion of whether these works were created for members of the Muslim upper class, Crusader nobility, or wealthy local Christians, their stylistic and technical traits are part of a tradition of inlaid metalwork that was practiced in more than one major center of the Islamic world and confounds differentiation into confessional silos.[69]

Architecture is present in more than one mode among this group of vessels. In the first, imagistic mode represented primarily by the scenes on the celebrated

Freer canteen, the frontal depiction of monuments drawn from the *loca sancta* of the Holy Land endows the metalwork vessels with a set of architectural reference points familiar from a wide spectrum of medieval Mediterranean artworks bearing Christological imagery.[70] However, the predominant use of an architectural device within this group of inlaid metalworks is the occupied arcade. Almost all of the pieces in this group bear somewhere on their surfaces a frieze of arch-shaped fields occupied by figures, making occupied arcades a major, and indeed definitive, characteristic of the group. The figures within the arcades are generally understood to be of Christian derivation, and are sometimes described as saints or priests. In point of fact, the designation of those figures as Christian holy men has been assumed not only from their costumes, poses, and the objects they hold, but sometimes also from the very fact of their containment within an arcade. The occupied arcade was by the thirteenth century very widely visible in portable artifacts of Christian liturgical use such as manuscript bindings, reliquary caskets, pyxides, and textiles (Fig. 2.12), as well as the early Christian sarcophagi that must have been part of the thirteenth-century visual landscape of the eastern Mediterranean.[71]

The overwhelming focal point for the scholarship on these inlaid vessels has been the elucidation and contextualization of the Christological figural imagery that they bear.[72] Scholars have given scant attention to the occupied arcades as anything other than a generic signifier of Christian content on even the best-known pieces. One author has suggested that the occupied arcade was selected as a motif

FIGURE 2.12 Fragment of textile with depictions of saints, attributed to Egypt, twelfth century. Silk-embroidered cotton. Length 34.3 cm. New York, Metropolitan Museum of Art, 29.106a,b.

for these vessels because of "the ease with which it could be adapted to the circular shapes of most Islamic brasses," but there has been little discussion of even the distinctions drawn between different forms of arch within the group.[73] That these individual variations on the arcade connote different traditions of decoration, both in architecture and its refractions in the plastic arts, is quite clear. The quasi-architectonic arcades seen on an incense burner now in the Cleveland Museum of Art include slender colonettes topped by spandrels bearing linear volute designs, faintly echoing those of the Egyptian inlaid wooden panel (Fig. 2.13), while the almost-horseshoe arches beaded with discs that are seen on the heavily restored Homberg ewer in the Keir Collection are possibly connected to the same tradition of disc-arches seen on the Marwan ewer.[74] Distinct from any such recognizable echoes of the Late Antique arcade are the tangent and foiled cusped arches of an incense burner now in the British Museum (Fig. 2.14), a device also encountered on other objects in the group.[75] Eva Baer has proposed that this particular motif descends ultimately from medallion forms on Chinese artworks; however, the prevalence of a related type of nonstructural arch in Fatimid Cairene monuments also suggests a relationship with eastern Mediterranean architectural ornament.[76]

Beyond questions of origins, the placement and spatial suggestiveness of the arcades found on thirteenth-century metalworks also remain to be explored. The deployment of the occupied arcade on the outside surface of incense burners,

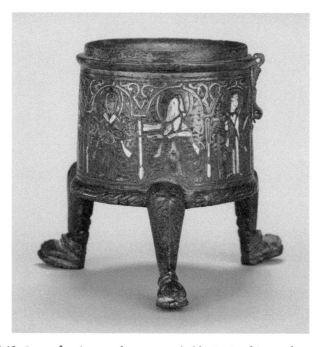

FIGURE 2.13 Base of an incense burner, probably Syria, thirteenth century. Cast copper alloy inlaid with silver. Height 10.6 cm. Cleveland Museum of Art, Cleveland, Edward L. Whittemore Fund 1937.26.

ewers, and pyxides recalls to some extent the mode that typified its Late Antique usage on sarcophagi and objects like the Bimaran casket: that is, it wraps the circumference of the object, engirdling contents and compartmentalizing surface. Unlike the earlier instances of the form, however, the thirteenth-century inlaid vessels are intended mostly for uses other than sepulchral containment. Equally distinct to these pieces is a certain curtailing of interest in the intimation of fictive space.

This is not to say that we nowhere see a consciously allusive attitude toward fictive space upon the thirteenth-century inlaid vessels. The Freer Basin, a remarkable artifact that names Sultan Najm al-Dīn Ayyūb (d. 1249) twice in its inscriptions and includes scenes from the life of Christ as well as polo players and animals in its decoration, bears upon its interior wall an inlaid arcade occupied by

FIGURE 2.14 Incense burner with domed lid, Syria or northern Iraq, thirteenth century. Cast copper alloy inlaid with silver and gold. Height 20 cm. British Museum, London, 1878,1230.679.

FIGURE 2.15 The "Freer Basin," Syria (?), 1240s. Copper alloy inlaid with silver.
Height 23.3 cm. Freer Gallery of Art and Arthur M. Sackler Gallery, Smithsonian
Institution, Washington, DC, F1955.10.

thirty-nine bare-headed figures in long robes (Fig. 2.15). The bottom edge of the
arcade frieze is located a few centimeters up the interior surface of the basin. The
basin is so large—fifty centimeters in diameter across the rim—that it is unlikely
that water poured for ceremonial handwashing would often pass the ground-line of
the arcade. In use, this would place the occupants of the arcade around the edge of
a reflective pool. The resulting conjunction of holy figures and water evokes some
of the deeply rooted histories of curative springs and their associated shrine sites
and pious visitation practices within the eastern Mediterranean and Jaziran lands.[77]
By this means, the Freer Basin must have participated during its use in a syncretic
landscape of popular piety.

On the whole, however, the makers of the thirteenth-century inlaid metalworks
with Christological imagery do not seem to have been overwhelmingly interested
in the spatial potential of the arcade image, predominantly using it not to con-
figure an object's three-dimensional impact but to supply certain formal quali-
ties at the level of surface. Thus transformed, the arcade was freed in this context
from structural sensibilities, and made fully available for synthesis with complex,
nonstructural arched forms developed in other media including coins, ceramics,
and manuscript illumination.[78] The arcaded body of the British Museum incense
burner might recall to some extent a domed structure, although the long handle

that would once have projected from its body, and its elevation on three feet, simultaneously undermine this interpretation (Fig. 2.14). Moreover, the overall focus of the piece lies primarily on the interrelationship between contrasting tones of metal and a rhythmic, linear complexity of design.[79] The figures on the body of the burner move in a counter-clockwise procession around the object, the impression of movement enhanced by the undulating and continuous line that circumscribes their individual fields. Thus rendered, the arched panels on the body of the incense burner are no longer static fields of containment but mobile, sinuous auras. In this way, the refinement of the inlay technique upon the surfaces of thirteenth-century metalworks saw the arcade gain a kind of linear compositional vitality at the same time that craftsmen seemingly abandoned much of its spatial meaning. Meanwhile, the plasticity of brass also lent itself to faceted forms within which the arch could be put to new uses—a phenomenon I explore in the next section.

Jaziran Synthesis

Within the Jazira (a region comprising northwestern Iraq, northeastern Syria and southeastern Turkey), and particularly the region around Mosul (now in northern Iraq) a remarkable artistic culture developed in the medieval period. Mosul's prosperity and stability in the thirteenth century is associated particularly with its rule from 1211 to 1259 by Badr al-Dīn Lu'lu', successor of the Zangid state and astute political tactician. The artworks and architectural decoration of thirteenth-century Mosul have often been noted for their dynamic fusion of traditions from eastern and western Islamic lands with those of Syriac Christianity. Before much of it was destroyed in the campaign of destruction waged from 2014 onward by Islamic State militants, the medieval architecture of Mosul directly attested to extremely close connections in building practices—and above all architectural decoration—between Muslim and Christian communities within the area.[80]

Accompanying this syncretizing strain in the art of the region was a pronounced interest in talismanic and apotropaic devices, and—not coincidentally—a high degree of experimentation with plasticity of form.[81] The artistic products of Mosul, and to some extent those of the twelfth- and thirteenth-century Jazira more generally, are distinguished by lively, occupied surfaces that constantly push forward into sculptural and architectonic three-dimensionality. While it is perhaps most readily apparent in architectural decoration, this tendency is also attested in inlaid brass wares, for which the city of Mosul was famed in the thirteenth century, and in some of the ceramic products of the region.[82]

The existence of an identifiable "Mosul school" of medieval metalwork, and the attribution of individual objects to that school, has long been a subject of art historical debate.[83] Typical is the case of a small group of nine-sided inlaid brass candlesticks, each with nine ogee-arch facets forming the waisted middle section of the body. These have been tentatively attributed to northern Iraq in the second half of the thirteenth century; however, as is the case with so many thirteenth-century

FIGURE 2.16 Candlestick, probably northern Iraq, thirteenth century. Copper alloy inlaid with silver. Height 13.7 cm. State Hermitage Museum, St Petersburg, ИР-1469.

inlaid metalwares, a more westerly site of production in Syria has also been proposed.[84] An example in the State Hermitage Museum strengthens the Jaziran attribution by providing intriguing parallels with the architectural decoration of Mosul, through the images of figures in long robes who decorate three of the nine arched facets (Fig. 2.16). One carries an object that appears to be a *flabellum* or liturgical fan, another a bowl-shaped suspended censer (Figs. 2.16 and 2.17), and the third a staff surmounted by a cross.[85] Through their costume, attributes, and presentation within shouldered arches, these figures can be directly compared with the robed and hooded monastic saints depicted in the interlinked arches of the carved stone portal, most likely dating from the period of Badr al-Dīn Luʾluʾ's rule of Mosul, that surrounds the entrance to the baptistery at Mar Behnam monastery near Mosul (Figs. 2.18 and 2.19).[86]

The parallels between the Hermitage candlestick and the Mar Behnam portal carvings extend beyond the individual figures to include the relationship between figural and nonfigural arch-shaped fields upon both. Within the nine arched facets that engirdle the candlestick, the three figural panels are distributed evenly around the body and each is flanked on both sides by two arches filled with geometric designs or bilaterally symmetrical vegetal interlace. This alternation recalls the schema at Mar Behnam, where arches occupied by figures alternate with those filled with the image of a Syriac cross set against, and partially subsumed into, a symmetrical ground of vegetal interlace (Fig. 2.18). Simultaneously, planar faceting transforms the Hermitage candlestick into a structure that has both crystalline elegance and architectonic mass, endowing it with a sculptural monumentality that belies its small scale and further strengthens its dialogue with architectural decoration—a dialogue that would presumably have been fully evident when the piece was in use within a religious establishment.

FIGURE 2.17
Detail of
candlestick in
figure 2.16.

The conceit of the occupied arcade, and its use as a frame around a doorway, was also to be found in other monuments in and around Mosul. Notably, it appears on a monumental stone niche excavated at the site of Gu' Kummet, near Sinjar, in the 1930s, as well as the Royal Gate portal at the Church of Mart Shmuni, Qaraqosh. Both likely date to the thirteenth century.[87] As at Mar Behnam, a continuous frieze of interwoven and looped cords creates a "knotted arcade" of shouldered arches on both. At Mar Behnam, the knotted arcade was made from the bodies of serpents whose open-mouthed heads could be seen above the doorway (Fig. 2.18), although this was not the case in the Gu' Kummet niche (the Mart Shmuni portal has been completely rearranged and therefore its original appearance is unknown). In each case the knotted arcade forms the central framing device around the doorway or niche, with each arch occupied by a figure or a bilaterally symmetrical vegetal design. However, in the Gu' Kummet niche and the Mart Shmuni portal, the figures contained within the knotted arcade are not monastic saints or priests but young men in military dress, connecting them with earlier traditions of palace decoration where images of guards mirror and amplify the retinue of the ruler.[88] A similar concept is encountered in contemporary manuscript illustration: the six surviving painted frontispieces from the twenty-volume *Kitāb al-aghānī* (Book of songs) produced for Badr al-Dīn Lu'lu' depict the ruler surrounded by his retinue of courtiers and attendants, all of them significantly smaller in scale than Lu'lu' himself.[89]

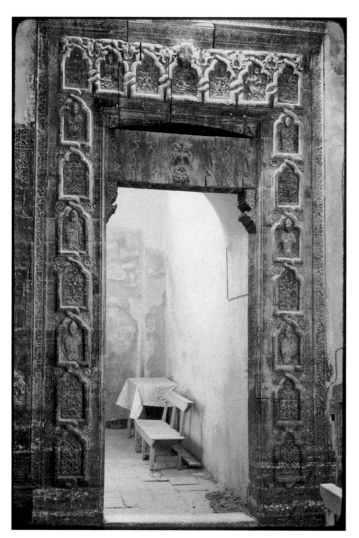

FIGURE 2.18 Carved stone portal surrounding the entrance to the baptistery in the monastery at Mar Behnam, near Mosul, Iraq, thirteenth century.

The interrelationship of knotted arcades, holy men, palace officials, frames, and processions enacted around the portals of medieval Mosul is reflected upon the surfaces of contemporary metalworks. Many of these were created by craftsmen whose *nisba*s indicate that they or their families came from Mosul. The two constituencies of palace officials and holy men coexist in banded ranks upon a number of inlaid vessels, such as a famous candlestick, signed Dāʾūd ibn Salāmah al-Mawṣilī and dated 646 H / 1248–1249 CE, currently in the Louvre.[90] On some other inlaid metalwares a knotted arcade of cusped, ogee arches came to act as a series of fields for multiple figures and more complex scenes—not all of which are well served by containment within an arch.[91]

Again, the practice of enclosing whole scenes within arches, rather than single, frontally oriented standing figures, is also reflected between metalwork and architecture, as can be seen from the arches that contain depictions of the first and second baptisms of Mar Behnam on the Gate of the Two Baptisms at the Monastery of Mar Behnam (Fig. 2.18).[92]

The "knotted arcade," emptied of figures, is also found on a number of other stone structures in the region, probably from the thirteenth century. These include the sides of the cenotaph of Imām ʿAlī al-Hādī, a doorway of the Mashhad of Imām ʿAwn al-Dīn, a mihrab in Mosul's Great Mosque of al-Nūrī, and a doorway in the mausoleum of Imām al-Bāhir (Figs. 2.20 and 2.21).[93] On the one hand, the apparent equivalence of the knotted arcade as a design component in Christian and Muslim contexts alike highlights the futility of trying to parse out precisely what is "Christian" and what is "Islamic" within the

FIGURE 2.19 Detail of portal shown in figure 2.18.

artistic culture of medieval Mosul.[94] On the other, its application to liminal surfaces and points of entry, as well as its sometime occupation by spiritual or military guardians and its construction from the bodies of serpents, strikes several notes within the theme of protection—talismanic as well as military—and bespeaks a wider societal concern with the apotropaic that was not restricted to any one denomination.

The ancient practice of knotting as a means of binding supernatural powers is explicitly enacted in thirteenth-century Mesopotamian art and architectural decoration through the image of the knotted dragon, a supernatural force whose efficaciousness is harnessed through its depiction.[95] The form is put to spectacular use in the double-frontispiece to the 1198–1199 CE manuscript of the *Kitāb al-diryaq* (Book of antidotes) now in the Bibliothèque nationale de France, in which paired dragons encircle seated figures bearing crescent moons: these have been interpreted as images of the lunar eclipse.[96] Like the architectural use of the knotted dragon as arcade at Mar Behnam, the *Kitāb al-diryaq* frontispiece images mark a threshold—in this case the opening of the book. The symmetrical knotted dragons carved above monumental portals like the Talisman Gate in Baghdad, the Gate of the Serpents in the Aleppo citadel, or the southern exterior gate at Mar Behnam seem, as Persis Berlekamp suggests, to derive their efficacy through the symmetry of countering like with like, dangerous forces with dangerous dragons. However, the knotted arcade in the architecture of Mosul also foregrounds another aspect of this ancient practice: the use of knots as "traps" for maleficence around portals and other liminal points of vulnerability.[97]

In several cases these apotropaic modes explicitly coincide in the construction of the knotted arcade from the bodies of serpents. This has already been seen in the Gate of the Two Baptisms at Mar Behnam and can be found in similar but even more spectacular form on the carved surround of the portal from the thirteenth-century mausoleum of Imām al-Bāhir in Mosul. There, the heads of paired, open-jawed serpents, serried along the top row of arches, twist around to lunge toward their own scaly flesh (Fig. 2.20). Superior artistry is notable in both the conception and execution of this portal, which Tariq al-Janabi called the finest surviving medieval Iraqi doorway.[98] Its individual arches contain precisely executed miniature muqarnas hoods, some of them atop pointed columned arches enclosing fields of vegetal interlace. The interlace designs in turn include, in the open-jawed design of the tendrils, an echo or abstraction of the open-mouthed serpents that order the whole schema (Fig. 2.21).[99]

The conflation of ferocious beasts with architectural order in the Imām al-Bāhir portal imposes multiple systems of control upon a liminal space, at the same time

FIGURE 2.20 Top section of carved stone portal removed from mausoleum of Imām al-Bāhir, Mosul, Iraq, thirteenth century.

that it acknowledges the power of the third dimension to enhance those systems. The surface is alive with writhing, scaly snakes, yet remains subordinated to the laws of geometry and spatial regularity embodied within the architectural elements, including the shouldered arches of the knotted arcade and above all the regularly receding space of the miniature muqarnas hoods. The tension thus maintained between the different elements of the portal's decoration is not merely a matter of iconographic imperative but also the product of a dynamic, three-dimensional artistic crucible in which distinctions between surface and form, ornament and structure, and even object and building were actively reshaped and reconfigured.

Against such a backdrop it is no surprise to find that Jaziran potters, working in the supremely malleable medium of earthenware, also participated in this highly plastic inter-arts dialogue. Several authors have already commented on the similarities between individual motifs employed in the thirteenth-century architectural decoration of the region, and designs found on a large group of massive unglazed earthenware water jars known as *habb*s that have been recovered, whole and in fragments, from a number of Jaziran sites and particularly at Sinjar and Mosul.[100] However, the relationship between the *habb*s and architecture is not limited to the transfer of individual iconographic units: it is also manifest in the manipulation of space.

The use of large, unglazed earthenware storage jars to store and cool water for domestic use is an ancient practice in the Middle East and North Africa, but the degree of elaborate decoration applied to such vessels in the medieval Jazira seems to have been unique. Gerald Reitlinger has charted a speculative evolution of the type in the Jazira, observing that a multiplication of handles was followed

FIGURE 2.21 Detail from lower section of carved stone portal removed from mausoleum of Imām al-Bāhir, Mosul, Iraq, thirteenth century.

by expanded false handles that created a secondary screen around the top part of the vessel, from shoulders to lip. Thus, the top third of each *ḥabb* comprised a series of closed and open spaces primed for play on architectonic recession and projection, ingress and egress. This presumably aided in cooling the jar's contents, since it created insulation around the neck and reduced heat transfer, but it also functioned as a space for three-dimensional artistry. Like the Chinese "soul jars" discussed in the introduction to this book, the *ḥabb* is essentially a large jar with an architectonic superstructure. Unlike the soul jars, however, the superstructure of the *ḥabb*s is not a mimetically rendered and ontologically distinct little building complex, but a zone of plastic experimentation on the themes of both architectural space and apotropaism that emerges somewhat organically from the form of the handled jar.

In decorating these pieces, craftsmen seem to have shifted at some point from the direct plasticity of barbotine work—that is, piping a mixture of clay and water directly onto the vessel's surface, or possibly applying it by hand as strips and beads—to the more refined clarity of molded sections and carved pierced panels of interlace designs, although the two techniques were by no means mutually exclusive.[101] It is also possible that regional workshops had their own particular practices in the production of these objects.

In the first instance, the *ḥabb*s provide striking parallels with both architectural decoration and metal inlay through the inclusion of figural types also found in those other media, such as standing guards, fantastic creatures, and seated princely figures who raise cups to their chests.[102] A good example of the latter can be seen on a fragmentary *ḥabb* now in Berlin: like many of the surviving examples, the heavily decorated upper section of the jar has become separated from the plainer, single-walled lower part (Fig. 2.22). But the relationship with architecture is also continued into the fields that surround individual figures in these objects. Many of the figures on the *ḥabb*s occupy framed fields that evoke, to greater or lesser degrees, architectonic settings of various sorts, including architectural screens and especially framing arches: shouldered or polylobed, these can be fully recessed or else intimated through outlines and pierced designs that reveal the space beyond in a modular system of design which has been appropriately described as "elastic."[103] Distinct from the regular, surface-bound arcades of the thirteenth-century inlaid metalwares described

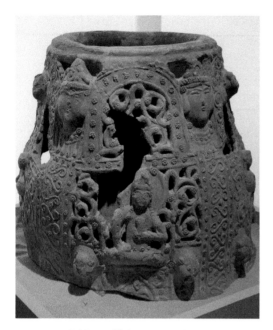

FIGURE 2.22 *Ḥabb* (storage jar), Syria or Jazira, thirteenth century. Earthenware with carved, molded, stamped, and barbotine decoration. Height 37 cm. Museum für Islamische Kunst, Berlin, I. 3714.

above, the architectonic fields of the *ḥabb*s are shunted into the viewer's own space through the use of projecting elements and piercings and openings that push the surface forward by constantly alerting us to the empty space behind it.

The *ḥabb*s decorated predominantly in the barbotine technique tend not to have pierced panels of openwork; as a consequence they play more boldly with open spaces, deep recession, and the accompanying shadows. A clear example is provided by a barbotine *ḥabb* decorated without the use of molded design components, reportedly found at Meskeneh in Syria and now in the collection of the Institut du monde arabe, Paris (Fig. 2.23). Polylobed arches formed by the handles of this piece are set over deeply recessed spaces put to dramatic artistic use: framed by the projecting polylobed arch of the screen wall, and set back onto the true wall of the vessel, is an upright barbotine figure who faces the viewer, hands on hips. This figure is found, often greatly multiplied, upon very many of the predominantly barbotine *ḥabb*s, and is sometimes identified as a goddess; certainly an apotropaic dimension seems plausible.[104] Behind the handles of the same *ḥabb* waits a surprise for those who look closely: modeled animals sit in the shadows, abruptly deepening the architectonic effect of the space that recedes behind the handles. The polylobed form of the arch itself, meanwhile, can be compared with Artuqid architectural examples in stone found in the region of Mardin from the twelfth and early thirteenth centuries, or the blind brick arcade of the Baghdad gate in Raqqa, and strengthens the connection with a specifically Jaziran architectural identity.[105]

A very similar combination of polylobed arch, standing figure, and modeled animals hidden in the shade of the handles appears on a fragment seen in the Aleppo Museum in 2009 (Fig. 2.24). Several of these elements are also found in a fragmentary example in the British Museum.[106] There may have been an eastern Syrian workshop that specialized in this particular combination of elements, although at present there are not enough published examples with documented findspots in the region to make this more than conjecture. On the Aleppo fragment, the handles themselves are formed from stylized serpents whose open mouths lunge toward the lip of the jar in a display of ferocity—a virtuoso articulation of the plastic

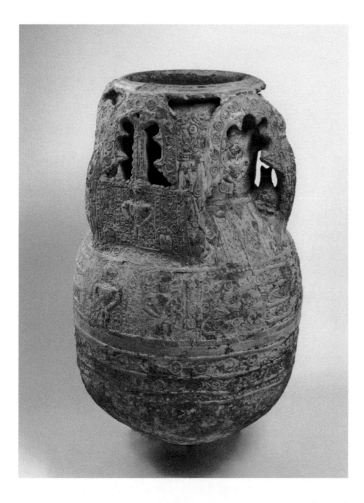

FIGURE 2.23 *Ḥabb*
(storage jar) reportedly
found at Meskeneh
in Syria; twelfth or
thirteenth century.
Earthenware with
barbotine decoration.
Height 79 cm. Musée
de l'Institut du monde
arabe, Paris, A191-04.

medium of clay that again makes explicit the relationship to talismanic architectural
decoration of the thirteenth-century Jazira.[107]

In a similar vein, the jutting lion protomes seen on many of the *ḥabb*s recall
those above doors in the monuments of Mosul and Aleppo. On some *ḥabb*s, jutting
lion protomes reach down with long front paws to grab the horizontal lintel or
frame below them (Fig. 2.22), as does the damaged protome above the Royal Gate
at Mar Behnam.[108] The writhing, grabbing, hissing, growling forces of dragons and
lions that were harnessed together to protect the monuments, citadels, and cities
of the medieval Jazira were thus also employed, on a smaller scale, to protect the
contents of water jars. This entails not merely the application of lion and serpent
images to the surface of the jars but their three-dimensional integration into the
very structure of the vessels that they protect—as is also the case in the contempo-
rary architectural decoration of the region. Individual motifs are here active agents
in the process of constructing space from ornament.

The most common feature on all of the *ḥabb*s of this type, regardless of their mode
of decoration, is the strongly projecting modeled mask of a woman's face and neck,
decorated with a necklace of pendant jewels and sometimes with a diadem or crown,

FIGURE 2.24 Fragment from a *ḥabb* (storage vessel), Syria or Jazira, twelfth or thirteenth century. Earthenware with barbotine decoration. Aleppo, National Museum.

further jewels at her temples, and twisted ropes of falling hair or decorative cord (Fig. 2.22). The emphasis placed upon the jewelry that adorns these busts parallels a larger practice of adorning earthenware vessels with forms that imitate jewelry, likened by Eva Baer to an "animation" of the lifeless clay body.[109] Typically, the female busts are on a larger scale than any other figural element on an individual *ḥabb*, and their staring domination of the decorative schema has been linked with shamanistic and apotropaic masks.[110] These striking female masks are often included at several points around the top of the *ḥabb*'s ornamented section and therefore near the vessel's lip; most often, they are fitted in between the arches formed by the handles, occupying a space that comes to act as a frame from which they stare out.

The double play of framing as both a division of surface and an allusion to architectural space has been quite consciously exploited by the creators of certain *ḥabb*s. On some examples, including a damaged piece in the Damascus museum, a woman, visible from the chest up although her face has been destroyed,

FIGURE 2.25 Detail of a *ḥabb* (storage jar), Syria or Jazira, thirteenth century. Earthenware with carved, molded and stamped decoration. Damascus, National Museum.

leans with folded arms upon the lower side of the frame that confines her while her headdress projects over the arched lintel above (Fig. 2.25). Her posture and the extension of her person over the frame turn it into a window from which she once gazed out. This is a startling device that brings the viewer into sudden confrontation with the artificiality of the spatial conceit, and endows the figure with an animating consciousness of, and witty reflection on, her own position within the larger arrangement. The abrupt shift in scale means that she is dwarfed by other elements within the schema, particularly the female mask that projects immediately below her, but this causes no real rupture within the overall design, predicated as it is upon the dynamic juxtaposition of discontiguous elements. The same device, on a larger scale, can be seen on an example in the Baghdad Museum published by Reitlinger (Fig. 2.26).[111] A similar phenomenon is also seen in the frieze of shouldered arches containing figural busts in the stucco decoration of the thirteenth-century Kara Saray near Mosul, and has antecedents in the fully modeled stucco heads that pop out of the interlinked "geometry of frames" in the eighth-century decoration of Khirbat al-Mafjar, in turn connecting them with Classical animated scrolls.[112]

The device of the female bust framed within an architectural aperture also has much more ancient resonances. The famous "woman in the window" panels from the Neo-Assyrian Nimrud ivories, originally inset into furniture of the ninth to seventh

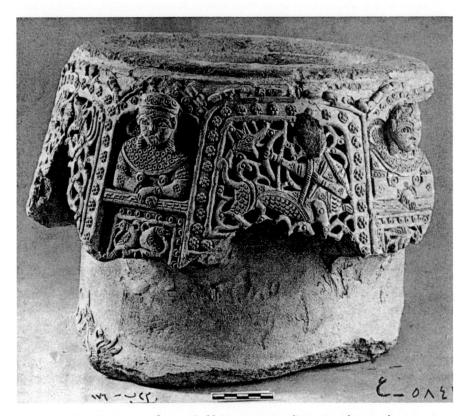

FIGURE 2.26 Fragment from a *ḥabb* (storage vessel), Jazira, thirteenth century. Earthenware with carved, stamped, and molded decoration. Baghdad Museum.

centuries BCE, have been the subject of sometimes fevered speculation about sacred prostitutes, goddess cults, and fertility symbolism. While the temporal gulf between those artifacts and the *habb*s is vast, it is possible that some echo of this enigmatic imagery could have made its way onto water vessels in the medieval Jazira.[113]

The *habb*s boast such a remarkable and disjunctive density of ornament that there is a great temptation to analyze them only in terms of individual motifs, particularly given the arresting vocabulary of apotropaic devices that they share with the architectural decoration of the twelfth- and thirteenth-century Jazira. To do so would mean losing sight of their extraordinarily dynamic three-dimensional presence, which is brought about through the visuospatial combination of individual motifs, including animate beings, with a series of architectonic fields and plates that restlessly shift between projection and recession. Here, ornament is not an applied skin that can be detached from structure: it *is* structure, and it manufactures spatial form as well as meaning.

As I have argued in the introduction to this book, architecture and the plastic arts may well have been mutually constitutive in the medieval Islamic milieu. The *habb*s are a case in point. While I have shown that many of the individual motifs found on the *habb*s have direct parallels in architectural decoration, they neither mindlessly nor mimetically replicate programs of architectural ornament. Rather, it is entirely possible that the systems of decoration found on some of the architectural portals, such as three-dimensional knotwork or projecting beasts, derived their individual motifs and their vivacity from the portable arts rather than vice versa. Many of the concerns about efficacy, liminality, and enclosure that so clearly motivated the decoration of both doorways and water jars in the thirteenth-century Jazira were arguably addressed more fully in the less refined but more dynamic and widely available material of earthenware: the scale and medium of the *habb*s permitted the creation of a denser, more direct, and perhaps more autonomous interplay between motifs, fields, and spaces than could be attained within monumental carved stone portals.

The objects discussed in this chapter demonstrate the capacity of ornament to alter the operational terms, both spatial and semantic, of the structures upon which it is employed. Within the examples discussed above, it is the arcade (and by extension its component unit, the arch) that most comprehensively embodies the varying degrees of differentiation available for an ornamental device derived from the vocabulary of architecture. The arcade can hold a "true" structural role as a component of built space; it can play a nonstructural role within full-scale architecture; in miniature it can provide a means of articulating the surface and space of an object; in all of these it serves to differentiate spaces. Transfers of signification from one of these roles to another contribute to the arcade's great potential to act as what I will call an "ordering motif": that is, an instance of two-dimensional or low-relief ornament that prompts, through its placement on a three-dimensional object, the construction of a deliberately architectural reading of space and volume, albeit on a Lilliputian scale. This conceit comes into its own when craftsmen are moved to make intentional allusions between the volumetric spaces of objects and those of architectural structures.

3

OCCUPIED
OBJECTS

The most elemental truth of vision is also the easiest to forget: we see not with our eyes but with our minds. Visual information enters through our eyes, but is only turned into sight when it encounters the huge part of the primate brain dedicated to visual processing.[1] The massively complex processes of vision create a realm in which the thinking hand can mediate between matter and mind, harnessing touch, vision, and meaning in the creation of objects that construct multiple relationships with things outside themselves. Focusing on perception and the visual codes that structure representation, likeness, and similitude, this chapter explores the vital role of the human form in creating and elucidating allusions to architecture among objects from the twelfth- and thirteenth-century Iranian plateau.

Lessons from a Storeroom

It is sometimes useful to confront the instabilities of one's own primate brain. In 2007 I visited the Museum für Islamische Kunst in Berlin to study and photograph the collection of medieval Iranian "house models" held by that venerable institution. I followed the curator into the storeroom, where I found the

models already laid out for me. Those idiosyncratic objects, briefly discussed
in this book's introduction, are, in their archetypal form, highly schematized
and miniaturized three-dimensional representations of courtyard houses com-
plete with human occupants engaged in drinking and making music. They are
made from glazed and fired ceramic, and while there are many variations on
the basic type, the group as a whole is quite homogenous.[2] On the same table
top, next to the phalanx of house models, a fragmentary object of very different
form had been placed (Fig. 3.1). While it was identifiably part of the large body
of turquoise-glazed ceramic production associated with twelfth- and thirteenth-
century Iran, I didn't know what this piece was, or why it had also been laid out
for me when it was not the same as the others in formal terms. I was too self-
conscious to do the sensible thing and simply ask what it was; not wishing to ap-
pear either ignorant or ungrateful, I dutifully started photographing it when I had
finished with the house models. At which point the curator politely observed that
I was looking at it upside down.

 After the object had been turned over I was, in truth, still baffled (Fig. 3.2). My
patient interlocutor recognized my confusion. "Look at the little people," he said,
pointing to the glazed upright protrusions ranged around the interior space.[3] The
light dawned, and finally the connection with the house models became apparent.

FIGURE 3.1 Fragmentary object, Iran, twelfth or thirteenth century. Glazed
stonepaste. Berlin, Museum für Islamische Kunst, I. 3833.

FIGURE 3.2 Fragmentary object, Iran, twelfth or thirteenth century. Glazed stonepaste. Berlin, Museum für Islamische Kunst, I. 3833.

Recognition of those little clay human figures, their tiny features just discernible through a rather thick coating of glaze, transformed the object. Awareness of their presence abruptly switched my perception of the ceramic construction from that of an unidentifiable artifact—Was it a lamp? A stand?—into a quasi-architectural space, a tiny, fragmentary belvedere filled with figures gazing outward. From the broken upper section it is evident that there was originally at least one more level with figures. It would be hard to say, however, if it was once part of an object of use with some practical function, or was primarily a representational artifact like the house models.

The mystery object in the Berlin storeroom suddenly illuminated for me the dramatic modifying power of the represented figure: the human form, that most intuitive measure of all things, is capable of imparting a sense of scale to almost any representation. By extension, the presence of figures also confers—or at times even imposes—spatial logic onto the surrounding environment, illustrating how a space might be occupied or used and allowing the viewer to scale or populate an environment or object in her imagination.

The Persianate cultural area of the twelfth and thirteenth centuries, to which the Berlin "belvedere" can be attributed, has often been noted as the site of an

artistic blossoming that was characterized by, among other things, an unprece-
dented proliferation in depictions of the human form. Seminal studies of this fig-
ural efflorescence were written in the mid-twentieth century by Oleg Grabar and
Richard Ettinghausen, who, while differing in their argumentation, both located
the phenomenon within the proto-capitalist model of an "open art market"
patronized by an increasingly prosperous urban mercantile bourgeoisie eager for
fine ceramics, decorated metalwork, and illustrated manuscripts.[4] More recently,
Oya Pancaroğlu has linked the abundance of human imagery applied to portable
arts and manuscripts in this cultural sphere with broader intellectual developments,
citing contemporary conceptualizations of man as microcosm—a topos central to
the writings of the Ikhwān al-Ṣafā' encountered in Chapter 1—and the rise of a
medieval humanist philosophy concerning the perfectibility of man.[5]

 The relatively substantial, if fragmented, publication record for the portable
arts of the pre-Mongol Iranian world reflects the preference held by twentieth-
century collectors for the figural imagery with which those arts are so amply
endowed.[6] Yet, as Pancaroğlu has noted, scholarship has for the most part focused
on the categorization of iconographic types and their sources, and still lacks de-
tailed holistic and culturally contextualized interpretations of the imagery found
on even some seminal objects, to say nothing of the other modes of ornament
such pieces display.[7] As has already been intimated in Chapter 2, the art historical
construction of taxonomic distinctions between figure and ornament, image and
object, and representation and abstraction has tended to impose false dichotomies
upon medieval visual and tactile modes that are in reality sustained by the produc-
tive tension between many different elements. Figural, epigraphic, architectural,
vegetal, and geometric registers work in concert, responding to vision, touch, and
manipulation.

 Maintaining focus on the thinking hand and its products, this chapter explores
the integral role of the human form in the architecturalization of portable artworks
from the medieval Persianate sphere through close studies of individual objects in
their entirety. The first part of the chapter considers the questions of perception
raised by the art of the allusive object. There then follows an initial exploration of
the agency of the represented human form in architectural emulation, through the
exemplar of ceramic stands that quite explicitly mimic architectural forms. Finally,
a group of inlaid metalwork inkwells, and the elusive nature of their relationships
with architectural referents, form the main focus of the chapter.

Seeing-With and the Art of the Object

In philosophy of mind, the term "seeing-as" denotes the act of seeing an object
while simultaneously seeing it as a representation of something else.[8] Seeing-as,
in its global aspect, lies at the heart of debates about the conceptual basis of per-
ception: Can there even be seeing without seeing-as?[9] However, it has a more

specialized role to play in the perception of, and cognitive response to, created artifacts, particularly those created with some degree of representational intention. A textbook example of seeing-as in philosophy of mind is a painting: a visitor to a gallery can explore the subject represented in a naturalistic depiction, all the while remaining cognizant of the fact that they are examining a painting, executed in a particular medium on a particular type of surface, that has been framed and hung on a wall.[10]

The very construct of seeing-as draws directly upon Ludwig Wittgenstein's philosophical investigations into aspect perception, the perceptual phenomena that make it possible to see one thing as another and to perceive the same image or object in more than one way. Wittgenstein was most interested in the act of switching from one aspect perception to another, which he explored in the famous "duck-rabbit" drawing, a classic example of a "bistable visual stimulus." An individual's perception can oscillate between the two "aspects" of duck and rabbit, but it is not possible to see them both simultaneously. When I was told that the protrusions on the mystery object in Berlin were human figures, I experienced the "dawning of an aspect" (*Aufleuchten eines Aspekts*) precisely as Wittgenstein outlined.[11] Through the sudden recognition of a hitherto unidentifiable aspect of the object—that is, by coming to see the upright forms *as* representations of people—my perception of the entire object underwent a radical and total transformation. I suddenly saw it as a populated, architectonic space. Most significantly, the figure-activated "aspect-dawning" that I experienced abruptly moved the object into the representational realm by endowing it with spatial coherence and scalar logic, creating a miniature architectural form where I had previously been able to see only a ceramic assemblage.

The literature surrounding the phenomena of aspect-perception and seeing-as in art history is almost entirely concerned with the pictorial image. Most famously, Ernst Gombrich in *Art and Illusion* co-opted certain aspects of Wittgenstein's argument into the wider realm of pictorial arts to maintain that a viewer could be attentive to either the image or the canvas but not both at the same time.[12] The question also preoccupied Richard Wollheim, who eventually developed a conception of "seeing-in" that overcame the problem of disjunction inherent in Gombrich's model. Wollheim argued for a projective mechanism of image perception that would permit the viewer's awareness to encompass "simultaneous attention to what is seen and to the features of the medium."[13] But while Wollheim's seeing-in ostensibly recognized the role of the material artifact that constitutes the image, in reality his discussion significantly prioritized the projective gaze of the viewer into the pictorial register of the image, as well as into nonpictorial surfaces and substances, and so left rather unfulfilled the attention to the object that it seemed to promise.[14]

A third possibility is provided by the phenomenologist Maurice Merleau-Ponty's conception of "seeing-with" or "seeing-through." This idea of visual

encounter, further developed in an article by Emmanuel Alloa, acknowledges that the manufactured image emerges in our perception in accordance with the specificities of its own rules, including its own materiality.[15] By returning material specificity to the image, rather than leaving the act of image-constitution entirely to the subjective gaze of the viewer and/or the intentionality of the artist, "seeing-with" acknowledges the ways in which the material particularities of any individual image and the circumstances of viewing, as well as the artist's representational intention and the viewer's gaze, converge to shape the viewer's perception of the image they are looking at.[16] The force of this argument lies in its recognition of the uniqueness of each instance of encounter with an artwork. As Alloa observes, it also acknowledges that "iconic evidence is not a ladder that could be thrown away after we have climbed it, but remains inherently situation-dependent, case-sensitive and thus, ultimately, precarious."[17]

Aspects of these debates have been central to certain theories of the image, but their possible relevance for the plastic arts has barely been considered outside the Western European tradition of representational sculpture, and even in that field only quite intermittently.[18] Of the three modes described above, seeing-with has by far the most to offer the investigation of allusive objects. Intimation, evocation, allusion, and metaphor accumulate in the appearance of objects that have been manipulated in order to connote a resemblance to something else, like the subjects of this book, and the eye and the mind can oscillate tantalizingly between these differing modes of apprehension. Seeing-with recognizes the specificities that construct the viewer's encounter with a created artifact, and thus enables the full emergence of the complex, multilayered, and often highly idiosyncratic visual possibilities of three-dimensional objects, and their relationships with external referents of all kinds.

Apprehension itself depends on certain conditions, and it has long been recognized that visual perception is culturally conditioned in all sorts of ways. The complex cognitive activities that enable us to see one thing as a representation of another depend enormously on the role of learning and previous experience: what we see is dependent in very large part on what we have already seen, what we have learned to see, and also what we expect and want to see, for the brain "fills in" many things automatically during the visual process of object recognition.[19] While the subjectivity of vision has been a major focus of recent research in cognitive neuroscience, it was recognized as early as the eleventh century by the great Arab physicist, mathematician, and theorist of vision, Ibn al-Haytham (d. c. 1040, known in the Latin tradition as Alhazen). In a typically acute passage, Ibn al-Haytham notes that "sight's perception of visible objects does not take place in the same way at all times and in all circumstances; rather, the manner in which sight senses the same object from the same distance and the same position varies according to the intent of the beholder, his deliberate effort to perceive the object and his determination to distinguish its properties."[20]

As Ibn al-Haytham's statement reminds us, cultural contexts of viewing, as well as individual experience and proclivities, are of particular importance in the process of seeing one thing as another. However, they are difficult to reconstruct in the case of undocumented medieval objects. No interpretive mediation can act as a reliable proxy for the encounter experienced by an artwork's original audiences, although much of the value of art history lies in the efforts it is willing to expend toward precisely this unattainable goal. Ultimately, "the contract of communicability" between maker, artwork, and viewer is one that depends on a range of perceptual responses as well as cultural stimuli, and recognition of the former can only be achieved by returning to close scrutiny of the object itself.[21] In this light, particular significance is assumed by visual and material traits and motifs that seem to act as prompts toward particular modes of interacting with and interpreting space and surface. The implications of populated architecture that were raised in Chapter 2, with reference to figures framed and contained in arcades, will now be expanded in an exploration of the human figure as one of the foremost cues for spatial organization and scaling in the perception of allusive objects.

Occupied Objects

A small group of six-sided tables or stands for trays survive from the ceramic traditions practiced in twelfth- and thirteenth-century Iran and workshops further west, including Raqqa.[22] One of these was acquired in a fragmentary state by the State Hermitage Museum in the late 1940s (Fig. 3.3).[23] Built from panels of molded stonepaste, a light-colored composite ceramic body, the walls are only a few millimeters thick. This means that the object is, like the other stands of this type, surprisingly light: these are true examples of the "portable arts." In common with some other pieces of this type, the base panel has a circular hole in the center large enough to permit a hand to be put inside. The painting on the exterior is executed in luster on a white glaze opacified with tin, and the rapid painterly execution seen on this stand accords with the "miniature style" of medieval Iranian lusterware as categorized by Oliver Watson, who has shown that the style dates to the late twelfth or possibly early thirteenth century.[24] The polygonal structure of the object is not inherently architectural, although it most likely acted as the initial springboard for a flight of architectural fancy: it is probably copied from now-lost archetypes in wood, which was most likely the dominant medium for furniture of this type in the medieval context. At some point during its life the stand's missing feet were substituted with wooden ones, reinforcing its proximity to wooden furniture.[25]

Although the polygonal Hermitage stand has been likened to Seljuq-era mausolea, garden architecture is a more likely field of reference for an object that would lend itself to use in convivial settings and pleasurable gatherings.[26] The textual sources show that garden pavilions were a vital component of

FIGURE 3.3 Stand, Iran, late twelfth century. Glazed stonepaste with luster decoration. Height 24 cm. St. Petersburg, State Hermitage Museum, IR-1425.

many medieval imperial architectural traditions, although material remains for medieval garden pavilions are lacking.[27] Later structures such as the two-story building known as the Namakdān near the shrine of Abdallāh Anṣārī at Gazargah in Afghanistan suggest a continuing tradition of polygonal, two-storied architectural pavilions that could have provided inspiration for the makers of the Hermitage stand (FIG. 3.4).[28] The colloquial name Namakdān, meaning "salt cellar," also illuminates reciprocal allusions between objects and buildings in popular perception.

The six "wall" panels of the Hermitage stand are molded to create shallowly recessed arches that extend almost to the full height of the stand on each of the six faces. Below the spring-lines of each are three freestanding columns engaged at the bottom to the projecting ledge of the stand's base, and conjoined by two perpendicular struts. In front of the bottom of each arch, running along the edge of the stand's base between the innermost columns, was once a projecting, modeled "row of rings" that is now mostly broken off. As I have shown elsewhere, this three-dimensional decorative device had a range of functions in medieval Iranian ceramic production, but here it is deliberately inducted by its immediate context

FIGURE 3.4 Namakdān
pavilion near the shrine
of Abdallāh Anṣārī at
Gazargah, Afghanistan.
Possibly fifteenth century
with later additions.

into a quasi-mimetic role as a form of balustrading, just as it is on the house models. It marks precisely the type of contextually dependent iconography that the framework of seeing-with makes recognizable.[29]

The painted decoration of the Hermitage stand serves to activate and clarify perception of the object as an architectonic space. In particular, the decoration of the spandrels of the arches with circular bosses, the solid luster glazing of the detached columns, and the thick outlining of the arches all align the piece more obviously with architectural decoration than does the more complex painted decoration of another, better-known luster-decorated stand, now in the Philadelphia Art Museum.[30] However, the decoration of the upper and lower spaces within the arches of the Hermitage stand seems to correspond to two different registers of reference (Fig. 3.5). In the lower space, between the columns of each arch, two figures in caps have been painted in a seated position on the groundline of the recessed *iwān*, where their two-dimensional presence would once have gained a third dimension through the plastic addition of the "balustrade" in front of them. The ground-floor figures of the Hermitage stand have not been depicted with enough precision to make particularities of pose readily apparent, but they are in keeping with the figural repertoire of leisure and pleasure that is so notable a characteristic of twelfth- and thirteenth-century artworks from greater Iran.[31] Pictorially populating the fictive spaces of the object, these figures turn the spaces that they adorn into three-dimensional architectural recesses, supplementing the architectural conceit that transforms each side of the object into a view of an occupied garden pavilion or belvedere.

Gestures toward architectural verisimilitude in the Hermitage stand necessitate a different interpretation of its upper sections. Within the upper part of each arch the luster painting depicts a horse mounted by what seems to be either a veiled

FIGURE 3.5 Detail of stand shown in figure 3.3.

rider or a covered litter. To read these panels as pictorially and spatially equivalent
to the seated figures below—that is, mounted horses crouched in the arcaded upper
storey of a polygonal building—would defy even the dream-logic of miniaturization.
More plausible is the interpretation of these upper panels as allusions to architec-
tural decoration rather than depictions of figural presence. Referents could be relief
carving or, more likely, wall frescoes. The imagery on the Hermitage stand is some-
what enigmatic, and it is possible that L. T. Giuzal'ian was correct in his suggestion
that the image of a woman on horseback in the upper section of the *iwān*s might illus-
trate a specific literary episode.[32] The very uneven survival of material evidence for

wall painting in the premodern Islamic world, together with the absence of surviving garden architecture dated prior to the early modern period, makes it necessary to rely on textual descriptions of wall painting in the palace architecture of medieval eastern Iran, as well as scant material evidence such as fragments of painted stucco from Nishapur, and photographic records of now-lost seated figures painted on plaster at the thirteenth-century bathhouse of Alara castle, near Alanya in Turkey.[33] Taken altogether and considered alongside later descriptions of painted scenes inside garden pavilions, the fragments of available evidence suggest that pavilions decorated with paintings may not have been uncommon in medieval Iran.[34]

The juxtaposition on the Hermitage stand of painted scenes that operate at different levels of remove from a real-world model showcases the elasticity of reference afforded by the allusive object. Below the scenes are paintings of human figures that occupy a quasi-architectural space, while above them is a painting of a painting that could decorate an architectural surface. The possibility that the lower figures are also paintings of paintings, depictions of figural frescoes like the eleventh-century wall-paintings of courtiers that swelled the ranks of the palace guard at the Ghaznavid palace in Lashkar-i bazar, Afghanistan, adds another dimension of perceptual and cognitive play to a ludic object.[35]

The viewer's ability to read the Hermitage stand as representative of an ornamented and populated pavilion, however fantastic, stems in part from the immediate visual and spatial connections that exist between architectural elements and the human figures who occupy them. Through the associative dimension that connects architectural elements with human scale, it is possible to remove the human form entirely from an object and yet still utilize it as a scale marker. A six-sided stand of a different type (now in the David Collection), attributed to early thirteenth-century Syria, illustrates this phenomenon (Fig. 3.6).[36] The arched windows that perforate each face of the stand connote an occupiable architectural space with egress and ingress, and scale an imaginary human form accordingly. The practical logic of this scalar relationship between man and his constructions is reflected in the development in the Arabic-speaking world, as in many cultures, of a system of units of measurement based on human body parts.[37] The

FIGURE 3.6 Stand, Syria, late twelfth or early thirteenth century. Glazed stonepaste. Height 32 cm. Copenhagen, David Collection, 21/1982.

iṣbaʿ ("finger"), modeled on the breadth of the middle joint of the middle finger, is one twenty-fourth of the *dhirāʿ*, or cubit, originally the distance from the elbow to the tip of the middle finger, and so on.[38] Making explicit the connection between human dimensions and architecture, the units of measurement recorded in tenth-century Iraq by the Ikhwān al-Ṣafāʾ and al-Khwārizmī include a measure called the "doorway" (*al-bāb*), "which has the length of six arms, which is forty-eight fists, or 192 fingers."[39] The scaling of architecture to the human form invoked in the "doorway" as a unit of metrology is playfully co-opted in the David Collection stand, through the act of miniaturization. The architectural motif of the "window" perforation, deliberately created in the identifiable form of an arch sprung from colonettes, thus becomes the generator of human proportions at vastly reduced scale.

Although the artist(s) who made the Hermitage stand explored the boundaries between mimesis and allusion, the object ultimately adheres to a recognizable interpretation of architectural space. Even the more elliptical invocation of a pavilion in the David Collection stand, enacted primarily through the placement and precision of its window perforations, presumably represents a quite deliberate reference on the part of the artist to a specific architectural mode, however generalized. Rather than a conceit conjured out of thin air, the gambit of turning a furnishing into a miniature pavilion was most likely set in motion by the upright polygonal form common to wooden stands and polygonal garden structures. However, this kind of deductive reasoning from the object, tracing the ways a craftsman might have chosen to develop an incidental kinship of form through intentional play with ornament, is not always straightforward—as the next subjects of this chapter will show.

Inkwells, Architecture, and Conditioned Vision

A particular type of cylindrical lidded inkwell is commonly attributed to Khurasan, a region that encompasses the northeastern part of modern Iran and Afghanistan and which held a position of considerable cultural and economic importance in the medieval Islamic world.[40] Made from cast, engraved, and inlaid copper alloy, inkwells of this type are found in collections around the world (Fig. 3.7).[41] A few bear the names of craftsman whose *nisba*s indicate that they or their forebears were from Herat or Nishapur, two of the major metalworking centers of the Iranian plateau prior to the Mongol invasions in the 1220s.[42] Dated examples are vanishingly rare, and it is normally through stylistic, epigraphic, and technical comparison with dated inlaid metalwork objects of other forms that they have been collectively attributed to the twelfth and thirteenth centuries.[43] The copper alloy bodies of the inkwells were cast, a process that has contributed to a striking standardization of the underlying form across all examples. Artistic attention was then focused on engraving designs into the surface and inlaying it with silver and copper: wires of precious metal were hammered into prepared channels, and larger pieces of silver or copper into areas scraped back to receive them.

FIGURE 3.7 Inkwell, Khurasan, twelfth or thirteenth century. Cast copper alloy with engraved decoration and silver and copper inlay. Height 13.3 cm. Philadelphia Museum of Art, 1930-1-45a,b.

Ruba Kana'an has argued from various sources, legal as well as material, that the application of individualized (and quite possibly commissioned) inlaid decoration to standardized metal forms produced elsewhere in the bazaar was probably a common practice in thirteenth-century Jaziran metalwork, indicating a division of the creative process between the makers and decorators of fine metalwares. Similarly, the manufacture of inlaid metalwork in Khurasan was certainly, in some instances at least, a cooperative process. The inscription on the famous Bobrinski bucket, dated 599 H/ 1163 CE, includes the names of the two men who made it, revealing that the casting and inlaying were done by separate artisans.[44] The verbs of craftsmanship inscribed on the bucket are *ḍarb-e*, "struck" (presumably meaning "cast"), and *'amal-e*, "made,"

FIGURE 3.8 Inkwell,
Khurasan, late twelfth or
thirteenth century. Cast copper
alloy engraved and inlaid with
silver and copper. Diameter
8.3 cm. New York, Metropolitan
Museum of Art, 35.128a.

with the latter glossed by the maker's title *al-naqqāsh*, "the decorator," most likely
indicating responsibility for the inlay.[45] The relationship between the standardized
cast form of the Khurasan inkwells and their much more individualized decoration
may well have developed through similar practices.[46] The extremely broad range of
designs found on the inkwells is a testament to the inventiveness of the Khurasan
inlayers: no two inkwells seem to be exactly alike in decoration, although banded
registers dominate, motifs are drawn from the common stock of Khurasan inlaid
metalwork, and certain defining commonalities, such as three evenly spaced, almond-
shaped bosses or fields on the base (Fig. 3.8), appear across the group.[47]

The vast majority of the inkwells of this type have appeared through the art
market rather than documented excavation and are effectively siteless, although
there are exceptions. Undoubtedly, they traveled: one recently published ex-
ample was found in the medieval site of Otrar, in southern Kazakhstan.[48] Another
was excavated in 1958 from the palace of Masʿūd III (r. 1099–1115) at Ghazni,
Afghanistan, where it was recovered from an area in the southern section of the
building that had later been used as a kitchen.[49] Formerly in the collection of the
Ghazni Museum, its present location is unknown.[50] A previously unpublished ex-
ample (now without a lid) in the Hermitage Museum appears to be a Jaziran in-
terpretation of the type, and departs from the norms of the group in a number of
ways—including the decoration of the base—that only serve to underscore the
overall formal homogeneity of the Khurasan archetype (Figs. 3.9 and 3.10).[51]

FIGURE 3.9 Container, probably Jazira, early thirteenth century. Copper alloy engraved and inlaid with silver and copper. St. Petersburg, State Hermitage Museum, IR-1541.

Inkwells of this type invariably include some means of suspension by which the object could be fastened to the hand or the belt of the scribe, at the same time serving to secure the lid to the body. There are some examples where this was achieved by cords or chains fed through a set of internal tubes that align with a set of holes in the lid.[52] The much more common type has a suspension mechanism of three small hinged loops affixed to the outer face of the inkwell body with plates, which line up with three projecting loops on the lid through which cords would be threaded (Fig. 3.7). Paintings of officials in the mid-thirteenth-century *Maqāmāt* manuscript held in the Süleymaniye library show inkwells of this type in use, both open (Fig. 3.11) and closed (Fig. 3.12). The three cords connecting body and lid, and the toggle that holds them together, can be clearly discerned in the *Maqāmāt* images—where a certain documentary interest in realia has long been recognized.[53]

Joseph Sadan argues from textual evidence that inkwells suspended from the hand were called *dawāt*, in contrast to the type known as *maḥbara* which stood flat on a surface. However, these distinctions do not seem to have been applied universally.[54] Intriguingly, the Dehkhoda dictionary includes a further definition of *dawāt*, in an undated usage specific to Khurasan, as the crucible used by goldsmiths for melting gold and silver.[55] This double meaning suggests a possible consonance in the Khurasani context between inkwell and crucible—two types of container

FIGURE 3.10 Base of figure 3.9.

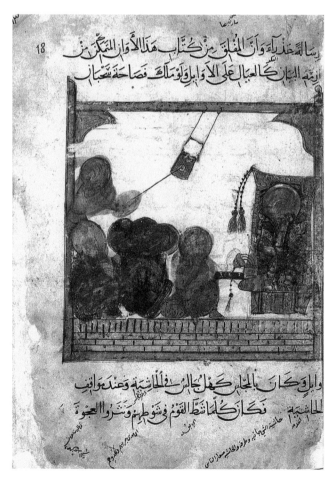

FIGURE 3.11 Illustration from a manuscript of the *Maqāmāt* of al-Hariri, mid-thirteenth century. Istanbul, Süleymaniye Library, Esad Efendi 2961, page 18 in current pagination.

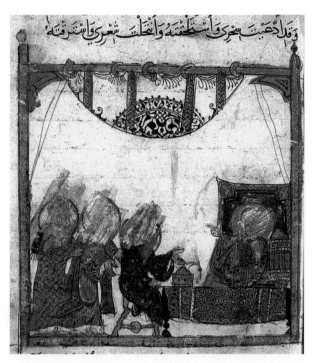

FIGURE 3.12 Illustration from a manuscript of the *Maqāmāt* of al-Hariri, mid-thirteenth century. Istanbul, Süleymaniye Library, Esad Efendi 2961, page 78 in current pagination.

for precious, transmuted liquids—evoking the rhetorical role of the art of the goldsmith (*ṣāʾigh*) as a metaphor for poetic and literary production. That analogic trope, which survives in a modern term for literary stylization (*siyāgha*), will be discussed in Chapter 4.[56] Further symbolic dimensions are propounded through the inscriptions upon, and texts that accompanied, certain inkwells, likening one ebony example to a black "mother of fates," and a Safavid inkwell to both a black-hearted enemy and a vessel for the water of life.[57]

The public roles and symbolic dimensions of inkwells in the medieval Islamic world seem to have been considerable. The special place accorded to the written word in Islam is evidenced by several references to scribal tools in the Qur'an and hadith, and some medieval authors prohibited the use of precious metals for inkwells because of this holy association—although such condemnation evidently didn't halt production of inkwells inlaid with precious metals.[58] The consumers of the inkwells were most likely an elevated class, including bureaucrat scribes and learned men, for whom inkwells were both part of the stock in trade and a symbol of office.[59] The social, as well as geographic, mobility of the ambitious scribe Iskāfī in the twelfth-century *Chahār maqāla* of Niẓāmi ʿArūḍī Samarqandī suggests that a certain degree of social fluidity as well as an itinerant lifestyle went with the position of court scribe.[60] At a less exalted level, copyists could make a significant amount of money from their labors, at least in urban centers, and they too presumably used inkwells.[61] In addition to the more frequently published examples inlaid

with silver and copper, a considerable number of simply decorated or even plain inkwells of this distinctive form also survive. Some of these are quite crude in appearance and may represent the lower end of the market, but others might have been made for consumers who eschewed precious metal inlay for pious reasons.[62] Within the transportable trade of the scribe, the portability and identifiable form of the inkwell must have been critical.

The Khurasan inkwells, then, are particularly mobile examples of the portable arts, with social, economic, and symbolic dimensions bound up in their material and functional identities. What is their relationship, if any, with architecture? No primary textual sources have yet emerged that would explicate the ornament of these objects of use, or describe the impressions they made upon a medieval viewer. The secondary literature, however, immediately reveals a rather startling and illuminating void in consensus among modern specialists. In brief, there are two modes of viewing in evidence. One group of scholars sees a building when they look at a Khurasan inkwell, apparently reflexively and without hesitation. The other group doesn't see a building at all.

Among those who do not see a building, Eva Baer and Hana Taragan, like some other authors, use terminology borrowed from architecture to describe the distinctive form of the lid—for example, it is "surmounted by a lobed, or melon-shaped dome that rests on a cylindrical 'drum' "—but make no further motion toward a comprehensive visualization of architecture.[63] This language can be understood as descriptive structural terminology rather than an interpretive agenda, although Baer has elsewhere observed that the relationship between other forms of metalwork product and monumental architecture remains to be considered.[64] Others in this category, like James Allan, describe and analyze the type without using any terms from the vocabulary of architecture.[65]

On the other side of this scholarly fault line are Assadullah Souren Melikian-Chirvani, Richard Ettinghausen, and Oleg Grabar. Melikian-Chirvani's detailed 1986 study denotes these inkwells as "tower-shaped" and explicitly refers to the type as "the inkwell designed as a miniature monument," citing the antecedent of a tenth-century ceramic object of different form, excavated at Nishapur, as evidence of the concept's longevity.[66] Ettinghausen and Grabar make much briefer observations on the type, but both present Khurasan inkwells as instances of the transfer of architectural forms across media and therefore exemplars of the transmodality characteristic of medieval Islamic art production.[67]

How can it be that one group of scholars can see a building in an inkwell, while another apparently cannot? How can the architectural aspect of the inkwells be either self-evident or entirely absent? Returning once more to Ibn al-Haytham's observations about the subjective nature of visual perception, it is certainly possible that the personally and culturally conditioned aspects of viewing, which can heighten the detection of certain patterns during visual perception, are significant in this instance. Specific examples can be cited. Four years prior to the appearance of his "State Inkwells" article, Melikian-Chirvani published a detailed catalogue

of the Iranian metalwork in the Victoria and Albert Museum that included three spectacular sixteenth-century inkwells of decidedly architectural contours, the elegance of which belies their tiny dimensions (Fig. 3.13).[68] His meticulous scrutiny of these tower-shaped containers draws the beholder into a Lilliputian world of domes and shafts. Grabar, meanwhile, returned over and over again throughout his career to the study of domed monuments in early Islam, most notably the Dome of the Rock, and was undoubtedly primed by his unparalleled experience with Islamic architectural traditions to recognize certain patterns in space and form.[69] Finally, Ettinghausen, whose remarkable scholarly range was trained primarily across the portable arts, was most equivocal about the phenomenon, remarking that it is "difficult to establish sure contingencies" between objects and architectural types. Yet he remained open to the possibility of an architectonic imagination at work in the minor arts.[70]

For the purposes of interrogating perception through historiography, some further issues are raised by the photographic reproduction of these inkwells. One of the first images in Melikian-Chirvani's article on the inkwells, a black and white photograph of the inkwell in the Walters Art Museum, reappears in Grabar's *Mediation of Ornament*, where it illustrates the brief discussion of "objects shaped as buildings" (Fig. 3.14).[71] In this image the Walters inkwell has been photographed with dramatic side-lighting on a plain ground in direct frontal elevation, capturing it from a viewpoint that beholders would seldom share when encountering a portable, handheld object of this nature. The Walters inkwell, which like all examples of the Khurasan inkwell type is small enough in reality to be easily overlooked in a museum display case, is endowed in the reproduction with a remarkable degree of sculptural monumentality. It fills the picture field as a full-scale monument would fill the eyes. Inscribed in this image is a mode of presentation that sought to emphasize and explicate the sculptural qualities of Islamic art objects and their stand-alone iconicity. The genesis of this reprographic drive toward the sculptural can be directly linked to early twentieth-century museological concerns, as well as emerging scholarly interest in the aesthetics of the object.[72] Inseparable from these practices, moreover, are concomitant developments in art market aesthetics that underwrote the commercial canonization of Islamic art as a network of iconic and transportable commodities.

FIGURE 3.13 Inkwell signed Mīrak Ḥusayn, Iran, *c.* 1510–1520. Brass, engraved and inlaid with silver. Height 9 cm. London, Victoria and Albert Museum, 2-1883.

FIGURE 3.14 Inkwell signed Muḥammad Ibn Abū Sahl al-Harawī, Khurasan, late twelfth or thirteenth century. Cast copper alloy engraved and inlaid with silver and copper. Height 8 cm. Baltimore, Walters Art Museum, 54.514.

Assuming, for the moment, that we choose to follow those scholars to whom the architectural aspect of the inkwells is apparently self-evident, it has to be asked what kind of monuments these tiny forms could implicate. It seems unlikely that they make reference to tomb towers, an architectural form that was certainly visible in the Khurasanian landscape by the twelfth century.[73] The proportions of dome to body and height to breadth found on the inkwells are impossible to relate to those of most extant tomb structures, which are generally much more elongated and crowned by truly monumental domes.[74]

A second possible source of inspiration in the Khurasanian landscape could be stupas—mound-like Buddhist commemorative monuments culminating in a solid hemispherical dome—and particularly their reflections in the portable arts.[75] The material evidence of votive stupas attests to a distinct lotus-cap that crowned the domes of both miniature and monumental stupas in the Gandharan territories in Afghanistan and Pakistan by the first to third century CE.[76] The lotus-cap is further reflected in the lotus-lidded cylindrical reliquaries of Gandharan Buddhism, where the floral ornament that doubles as a knob handle exposes the interplay between deeply interconnected forms of architecture and objects in the Buddhist devotional context, and possibly prefigures the lobed knob handles of the inkwells (Fig. 3.15).[77] In this light, it is interesting that Kashmiri metalwork practices, particularly exemplified by Buddhist temple images in metal, have been proposed as a possible source of inspiration for the development of the inlay technique in twelfth-century Khurasan.[78] But while it is certainly possible that the idea of a lotus-cap was transmitted between Buddhist reliquaries, votive stupas, and the inkwells, the very great temporal distance between Gandharan artifacts and the twelfth- and thirteenth-century inkwells leaves any such comparisons purely speculative until material comparanda can be found that is closer in date.[79]

In formal terms, ephemeral architecture offers a more plausible point of departure for an architectural conceptualization of the inkwells, and is suggested by both the scale of the prominent, lobed, and domical handle in relation to the total surface area of the lid, and the glittering, often textile-like tactility and variety

FIGURE 3.15 Cylindrical
reliquary casket, reportedly from
Kotpur Stupa 2, Afghanistan, late
first or second century. Steatite.
Height 7.4 cm. London, British
Museum, 1880.96.

of the inlay decoration seen across the group.[80] While material remains of textile
structures do not survive from the medieval period, representations on ceramics
and in manuscript painting do: the earliest surviving illustrated manuscript of
Persian poetry, a thirteenth-century copy of the romance of *Warqa wa Gulshāh*,
includes many images of domed tents.[81] A spectacular image of a tent painted on a
famous luster plaque, dated 1312 and commemorating the foundation of a shrine
to Imām ʿAlī in Kashan, provides a suggestive match for the very consistent pro-
file of the Khurasan inkwells (Fig. 3.16). The slightly ogee central dome and the
finial in the luster image—which invoke the ribbed central cupola of a cylindrical,
Turkic-type tent—as well as the placement of the topmost inscription band, echo
the distinctive domical lids so characteristic of the inkwell group and the epi-
graphic bands that typically appear on the facing edge of the lid or at the top of
the main body.[82] Critically, the luster plaque depicts not a true tent-monument,
but a structure seen in a dream, envisaged by a painter in response to a verbal de-
scription. It operates at several removes from the material reality of any true tent,
granting access to conceptualizations of textile structures that are not bound to
structural veracity.

Expanding the cognitive and cultural field in which the inkwells operate,
we encounter further possible points of confluence. The formal emphasis placed
on their domical lids is suggestively matched by a metonymical term for cylin-
drical trellis tents in use in Arabic texts of the eighth to tenth century. This term is
predicated on the central dome as the dominant attribute of such tents: *al-qubba al-
turkiyya*, "the Turkish dome."[83] The symbolic as well as social significance of trellis
tents within Seljuq society has been explored exhaustively by Durand-Guédy, who
concludes from textual evidence that they were relatively high in status.[84] Medieval
architectural transfer across media also includes the apparent monumentalization
of textile architecture in stone, as in the thirteenth- and fourteenth-century Seljuq

FIGURE 3.16
Tile from a
pair dated 1312,
Kashan, Iran.
Glazed stonepaste
with luster
decoration Sèvres,
Musée nationale de
céramique, 26903.

tomb towers in eastern Anatolia that strongly recall the forms of tents. One example of the type, the dodecagonal late-thirteenth-century tomb at Kayseri, is popularly known as the Döner Kümbet, literally "Rotating Tomb" (Fig. 3.17). Its appearance of kinetic potential, something usually so absent from monumental architecture, raises the alluring possibility of a building designed as a scaling-up in stone of something smaller, lighter, and perhaps moveable with the hands, and thus disrupts once more the referential relationship that is most often assumed to run from monumental to miniature.[85]

Potential allusions within the inkwells to mobile architecture, whether mediated or unmediated, are particularly appealing in light of the portability of the inkwells and their identity as objects that are activated through several different systems of movement. Of all of the subjects of this book, the inkwells were probably the most frequently handled during their lives as objects of use, and it is perhaps not coincidental that their relationship with architecture lies further from mimetic referentiality than does that of some of the other pieces, like the stands. Movements in the hands turn an inkwell around, lift and replace the lid, thread and loosen the suspension cords; in walking, a suspended inkwell would swing during its passage from one place to another; and in a larger scale of movement, the sale of goods and the peregrinations of scribes would move inkwells through and around a commercial landscape.

Avinoam Shalem has described the beholder's unfolding experience of a group of painted ivory boxes from Norman Sicily and in particular "the tension

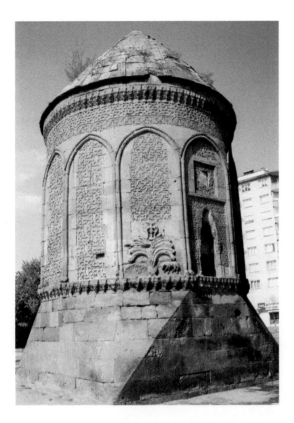

FIGURE 3.17 Döner
Kümbet ("Rotating Tomb"),
Kayseri, Turkey, 1276.

created in the beholder's mind between the container's outer and inner spaces" via
the decoration of its visible and hidden faces.[86] Unlike the Sicilian caskets, there is
no mystery about the inkwells' contents: their distinctive and highly standardized
form signals their function and it would be a surprise only to find anything other
than ink, or its traces, within. Without the anticipation of revelation, the beholder's
apprehension of the object's inner and outer spaces is freed to more speculative
forms of exploration. An intimate, kinetic enjoyment of the interplay between
form and ornament is available only to one viewer at a time because of the scale
and form of the inkwells. Pleasure is taken by the privileged handler in turning
and opening the object and encountering the hidden decorations, sometimes in-
cluding further supplicatory inscriptions, on the inside of the lid and around the
inner lip upon which the glass container for the ink would rest. The decoration
found on the insides of the lids is sometimes reminiscent of concentric designs in
architectural decoration upon dome interiors, and plays further upon the archi-
tectonic possibilities of the objects (Fig. 3.18). Upon the base, too, is more hidden
ornamentation: the almost invariable pattern of three cast almond-shaped bosses
acting as low feet or, more frequently, three "ghost feet" that simulate those bosses
in two dimensions, is commonly accompanied by fillets of geometric or animal or-
nament and sometimes more elaborate concentric designs in the center (Fig. 3.8).

 The pleasure that is offered to the beholder of the inkwells in exploring their
hidden decorations hinges on the articulation and distinction of exterior from

FIGURE 3.18
Interior an inkwell
lid, Khurasan,
late twelfth or
thirteenth century.
Cast copper alloy
inlaid with silver
and copper. Paris,
Musée du Louvre,
AA 65.

interior space. Thus, it aligns them with the most fundamental defining quality of
architecture: the separation of inside from outside. This quality may be something
they share with every container, but it is enough to set in motion the visuospatial
game of allusion. The brief sketch of possible full-scale archetypes for the inkwells
has already demonstrated that any intentional relationships the inkwells bear to
architectural forms must be, at most, delicately allusive rather than bluntly mi-
metic, and quite possibly mediated through other representations of architecture.
As Grabar so cogently noted of these inkwells, one must remain sensitive to the
difference between evocation and representation when seeking to make sense of
this material.[87] That said, a small number of examples exist in which the inscription
of human forms in combination with arches seems to exploit intentionally the ar-
chitectonic potential of the form. The remainder of this chapter will consider some
of these examples in their totality.

The Scribe in the Inkwell

Among the Khurasan inkwells that include inlaid figural imagery, a distinct sub-
group bears three evenly spaced, engraved, and inlaid images of figures seated,
kneeling, or standing within arches. Hana Taragan identified three examples of
this type that are now held in the Eretz Israel Museum, Tel Aviv; the Victoria and
Albert Museum, London; and the Royal Ontario Museum, Toronto (Fig. 3.19).[88]
To these three can be added two further examples: an unpublished inkwell in the

FIGURE 3.19 Inkwell, made for ʿAlī Ibn Muḥammad, Khurasan, late twelfth or thirteenth century. Cast copper alloy engraved and inlaid with silver and copper. Height 11.5 cm. Toronto, Royal Ontario Museum, 972.10.1-3.

Khalili Collection, and the now-lost example excavated at Ghazni in 1958 (Figs. 3.20, 3.21, 3.22).[89] The Khalili inkwell has no inlaid decoration and the design is engraved only, like that of the example in the Victoria and Albert Museum; by contrast, the Italian excavators reported that the Ghazni example was inlaid with copper and silver, like the Toronto and Tel Aviv examples.[90] On each of the five inkwells in this group, the three figures occupy arches that extend vertically over most of the height of the inkwell body, with each arch placed equidistantly between two of the three attachment plates used to hold on the lid.

The inkwells are sized to fit comfortably into the hands and they are, as has already been mentioned, kinetic objects inasmuch as they are self-evidently intended to be turned and moved through three dimensions to reveal their adornment in its entirety. Right-to-left is the intuitive direction for comprehension in a cultural sphere where reading runs in this direction, and, as will be shown with a subsequent example, directional bias impacts directly in this context upon the legibility of not only epigraphy but also figural imagery.[91] The Ghazni inkwell includes three fillets of inscription wrapped around the lower edge of the body between the arches, and

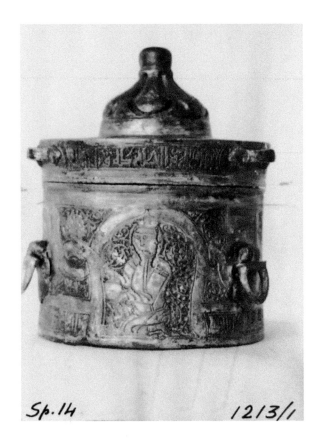

FIGURE 3.20 Inkwell, excavated at Ghazni in 1958, Khurasan, late twelfth or early thirteenth century. Cast copper alloy engraved and inlaid with silver and copper. Dimensions and current whereabouts unknown.

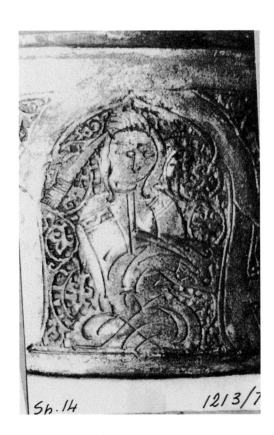

FIGURE 3.21 Inkwell, excavated at Ghazni in 1958, Khurasan, late twelfth or early thirteenth century. Cast copper alloy engraved and inlaid with silver and copper. Dimensions and current whereabouts unknown.

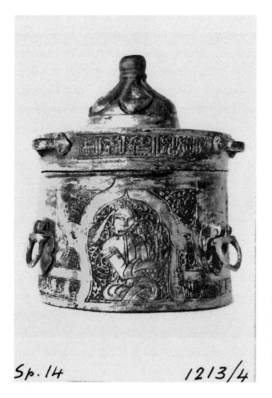

Sp. 14 *1213/4*

FIGURE 3.22 Inkwell, excavated at Ghazni in 1958, Khurasan, late twelfth or early thirteenth century. Cast copper alloy engraved and inlaid with silver and copper. Dimensions and current whereabouts unknown.

another three fillets on the outer face of the lid. The former are not visible in the available images; the latter are partially obscured but can be read as: *bi-l-yumn wa-l-baraka wa [. . .] / al-dawla wa al-karāma / [. . .] wa-l-dawla wa-l-sur[ūr]* ("with bliss and blessing and [. . .] / power and honor / [. . .] and power and joy") written in a rectilinear script. This vocabulary of single-word beneficent nouns, essentially supplicatory prayers (*duʿāʾ*, pl. *adʿiya*), threaded together on a chain of the coordinating conjunction *wa* ("and"), is typical for metalwork from twelfth- and early thirteenth-century Khurasan.[92] The well-established opening phrase seen on the Ghazni inkwell, *bi-l-yumn wa-l-baraka*, is particularly associated with inscriptions in rectilinear rather than cursive script on inlaid metalwork. Significantly, the same vocabulary was also used to articulate buildings: *al-yumn wa-l-baraka*, sometimes followed by other supplicatory terms, was inscribed repeatedly in rectilinear script within the brick and stucco decoration of the palace of Masʿūd III at Ghazni, the very site from which the inkwell was recovered.[93] This paralleling of epigraphic systems, another point of reverberation between buildings and objects in the pre-Mongol Persianate realm, also implicates certain kinds of movement on the part of the reader, who must move through the building to read the text on its walls or turn the inkwell to comprehend its entire message. The role of recognizable opening and closing formulae within the viewer's apprehension of the whole inkwell will be discussed in more detail below, using examples for which complete epigraphic information is available.

In her erudite study of some of these inkwells, Taragan follows Baer in arguing that the three figures on each can be understood as scribes engaged with the tools of

their trade, siting these particular inkwells as part of an unusual group of medieval objects that speak about themselves with images.[94] The Ghazni inkwell, like the other four in the group, shows each of the three figures engaged in a distinctive pose and activity. In one arch, a kneeling figure faces to the left and holds up an object that Baer and Taragan have interpreted on other examples as an inkwell (Fig. 3.20). Turning the object counterclockwise, the beholder encounters the next figure, who is shown seated, facing to the right and writing on a board (Fig. 3.21). Finally, the third figure is also seated, this time depicted in the act of sharpening a reed pen (Fig. 3.22).

The standardization of the figural types within this subgroup is quite striking, and is maintained down to the differentiation of headgear between the three figures in all but the Khalili Collection example. In the other four instances, the figures engaged in writing and cutting the reed pen wear turbans with long trailing ends, while the kneeling figure sports a tricorn cap or, on the Victoria and Albert inkwell, a hat with a vertical central ridge. Turbans are not unknown on figures found in Khurasan inlaid metalwork, but caps of various kinds are more common. This suggests a meaningful differentiation, which might in turn indicate that while the two turbaned figures are shown by their activities to be scribes—maybe even the same scribe at successive stages of his task—the kneeling figure is a different party. Perhaps he is one who honors the scribe by offering him the inkwell, or perhaps it is not an inkwell that he holds, but some other form of container, holding money.[95] If so, it would change the depiction from an instance of mise en abyme to an efficacious image, depicting the act of patronage that the inkwell's owner hopes to bring about, or perhaps commemorating it.

Clearly, the inkwell with three figures inside arch-shaped fields was a "type." The standardization of the figures across all five known examples raises the possibility of stencil use in Khurasanian workshops, although the varying scales and levels of accuracy in outline and execution seen across the group argue against a direct relationship, via stencils, between these specific examples.[96] The generic and simple nature of the figures, and especially their modular containment within simple arch forms, perhaps more likely reflect the copying of units freehand from source books. Nonetheless, their arrangement on the surface of the object is not haphazard or thoughtless, even if it is standardized, and implicates a conscious spatialization of the object through the now-familiar motif of the occupied arch.

The dialectic of inside and outside plays several roles within this group of inkwells. Replacing the lid and viewing the object as a closed totality brings the spatial game of the occupied arch to the fore. Almost uniquely among the larger corpus of Khurasan inkwells, the decorative focus on each of these five "scribal" examples has been placed on the relatively large, isolated, and vertically oriented fields of the occupied arches, rather than on horizontally banded registers of ornament. On the Ghazni example the arches are outlined in thick bands and extend the full height of the body, their outlining constructed through ribbons that wrap and continue around the body of the inkwell rather as the luster bands do on the Hermitage stand. On the other examples, the arches extend only slightly less than the full height of the body and stand alone, while the

surrounding ground of each inkwell has deliberately been left largely plain apart from discrete horizontal fillets of inscription and isolated roundels.

Visually, the scrolling vegetal ground that fills the arch-shaped fields behind the figures is in each instance abruptly contrasted with the plain surface that lies beyond the outlines of the arch. This combination of factors activates a perceptual response that sees both the figure and the frame of the arch as lying on top of the spiral ground, an effect that is also exploited by artists working in ceramic decoration and manuscript illumination in this milieu. By this means the populated arches are articulated as apertures into the fictive space of the occupied inkwell, at the same time that they serve as a field of presentation for the figures they contain.[97]

Arch forms appear in inlaid metalwork in a number of contexts, and they are not always intended to be understood architectonically. James Allan has even suggested that the arch form commonly encountered in twelfth- and thirteenth-century inlaid metalwork might derive from manuscript illumination rather than architecture. This would not negate the fact that the same motif can have different meanings depending on how it has been used and where it has been placed within a larger schema, as per my earlier argument for seeing-with in the art of the allusive object.[98] In the case of the scribal inkwells there is sufficient evidence in the relationships that have been constructed between the arches and human forms, background and surrounding ground, to suggest an intentionally architectonic and spatializing role for the arches on these examples. A similar composition,

FIGURE 3.23 Inkwell, Khurasan, late twelfth or thirteenth century. Cast copper alloy engraved and inlaid with silver and copper. Height 5.7 cm. New York, Metropolitan Museum of Art, 35.128a.

but without any human occupants in the arches, can be seen on an inkwell in the Metropolitan Museum of Art, where an alternative play of spatial articulation is provided by the repeated motif of baluster-shaped flower vases that stand on the inscription fillets in the lower register as if they were tables (Fig. 3.23).[99]

In the case of the five "scribal" examples, the inkwell is presented as a spatialized unit that contains and carries the inscribed form of the scribe, while it is in turn carried by the real scribe—a referential loop that collapses scalar difference upon itself. As with the ceramic stands and the Berlin "belvedere" discussed earlier in this chapter, the human form on the scribal inkwells provides both a means of scaling the quasi-architectural ornament of the object, and a point of entry into the playful construction of occupied space.

Object as Theater

Two final inkwells, ornamented with decorative programs that prioritize figures arranged in combination with arch forms, provide further evidence of an allusive, ludic relationship with architecture at work in the decoration of these small objects. In these last two cases, however, the arches are not occupied. Instead, they work in concert with figural elements and other components, especially the epigraphic

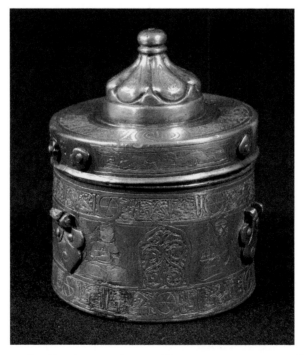

FIGURE 3.24 Inkwell, Khurasan, late twelfth century. Cast copper alloy engraved and inlaid with silver and copper. Height 9.5 cm. Copenhagen, David Collection, 32/1970.

registers, to turn the inkwells into miniature spaces of animated performance and occupation.[100]

The first and more accomplished of these two is a well-known piece in the David Collection (Fig. 3.24).[101] The main body of this inkwell has been divided into three horizontal registers with two bands of inscription, the upper written in cursive and the lower in rectilinear script, running above and below a broader central band. The outer wall of the lid, in the spaces between the three attachment points for the upper suspension loops, is decorated with three framed rectangular panels, each containing an elongated predator chasing an equally elongated prey animal. This forms a fourth register above the main body when the object is viewed in profile. The upper surface of the lid is decorated with three further epigraphic fillets of supplicatory inscription, alternating with three epigraphic roundels of rather unusual appearance that name a maker, ʿaml Shāh Malik ("made by Shāh Malik"), or possibly ʿaml Malik-shāh if the roundels are read out of sequence.[102] On the main band of the body, three inlaid arch-shaped fields are drawn from bottom to top of the central register and filled with bilaterally symmetrical scrolling tendril designs. These have been placed equidistantly between each of the three attachment plates once used for the hinged closing loops on the body. Using copper and silver inlay and engraving, figures are interspersed singly between the arch-shaped panels and the attachment plates.

The David Collection inkwell has a notable pedigree: it was among the *Meisterwerken* selected by Friedrich Sarre and Fredrik Martin for inclusion in their luxurious three-volume publication commemorating the huge exhibition of Islamic art held in Munich in 1910, to which exhibition the piece had been loaned by the Peytel Collection of Paris.[103] During its long life as a canonical collected object the David Collection inkwell has been cleaned to reveal fully the optical and pictorial distinctions afforded by the differing tones and reflectivity of the various metals exploited by the craftsman. To minimize the reflective qualities of the yellowish cast copper alloy "ground," the craftsman pitted the entire surface of the alloy body in the central register with a sea of tiny circular punch marks, a trait encountered on other Khurasan inlaid metalworks.[104] Against this the other metals are exploited for their varying levels of light reflection and absorption. Brightest is the silver inlay of faces, inscriptions, and certain linear details, acting like a highlight; at the middle level is the warm copper inlay used for clothing, the bodies of animals, and the primary delineation of registers, frames, and arches. The preponderance of copper inlay on this object, when compared with the dominance of silver inlay seen in the thirteenth-century corpus of inlaid metalwork from Khurasan, argues for a date in the second half of the twelfth century—although the possibility of art-market restorations to the inlay should also be considered.[105] Recessed elements, meanwhile, were once enhanced by the accumulated dirt and tarnish that filled in the spaces of the fine engraved foliate scrollwork behind the inscriptions and within the arches, casting them into greater relief.[106]

Instead of the splendid isolation enjoyed by the scribes that occupy the arches on the five scribal inkwells described previously, the characters on this inkwell are clearly in dialogue with each other and, in at least one case, in motion across the surface of the object. The figures are grouped into three pairs, with each figure facing toward and interacting with his partner across the arch that lies between each duo. The decidedly pictorial arrangement of the figures in the central register is segmented and, as I will argue below, sequential: the three-dimensional interruptions of the attachment plates that separate each pair from the other two serve as a visual and tactile means of demarcating formally and temporally discrete panels for each pair of figures.

A close parallel for this pictorial arrangement can be found in the arts of the book: the illustrated manuscript of the *Kitāb al-diryāq* dated 595 H (1198–1199 CE) includes the portraits of nine physicians from antiquity, arranged across three pages in a matrix of three framed cells per page (Fig. 3.25).[107] The physicians are portrayed against a blank background interacting with students and accompanied by scribal implements—including an open inkwell with its lid held on by three cords. Each cell is framed with a very simple pair of brackets that descend from arch forms in architecture. In stylistic terms the scrolling vegetal backgrounds of the inscriptions on both the inkwell and the title panels of the *Kitāb al-diryāq* are quite closely comparable, but the connection with literary arts goes beyond coinciding modes of ornament. Parallels can also be drawn in the style and placement of the epigraphy on the inkwell and in the title panels of the manuscript, and in the ensuing relationships between word, image, direction of reading, and legibility that are crucial to both manuscripts and metalwork.

Boris Marshak observed that there is very pronounced standardization in the opening and closing words of inscriptions on inlaid Khurasan metalwork from the later twelfth century, and the David Collection inkwell is no exception. The epigraphic formulae on the body of this inkwell begin in the upper register with the standard opening phrase for inscriptions of this type in cursive script: *al-ʿizz wa-l-iqbāl* ("glory and prosperity"). The cursive inscription continues with the supplicatory phrases *wa-l-dawla wa-l-saʿāda wa-l-rāḥa wa-l-salāma wa-l-raḥma wa-l-baqā li-ṣāḥibihi* ("and power and happiness and ease and health and compassion and long life to the owner").[108] The lower, rectilinear inscription begins with the familiar *bi-l-yumn wa-l-baraka* ("with bliss and blessing"): this phrase starts underneath the harpist in Fig. 3.24. Again, the inscription continues through a familiar repertoire: *wa-l-dawl[a] wa-l-saʿāda wa-l-salāma wa-l-niʿma wa-l-ʿāfiya li-ṣāḥibihi* ("and power and happiness and health and good favor and health to its owner").

While the inscriptions on the inkwell are certainly formulaic, they raise a number of interesting questions concerning their material and social roles.[109] First among these, for the present analysis at least, is the extent to which the verbal content of the decoration would have dictated the original audience's sequence of viewing a three-dimensional object decorated fully in the round. Given the very

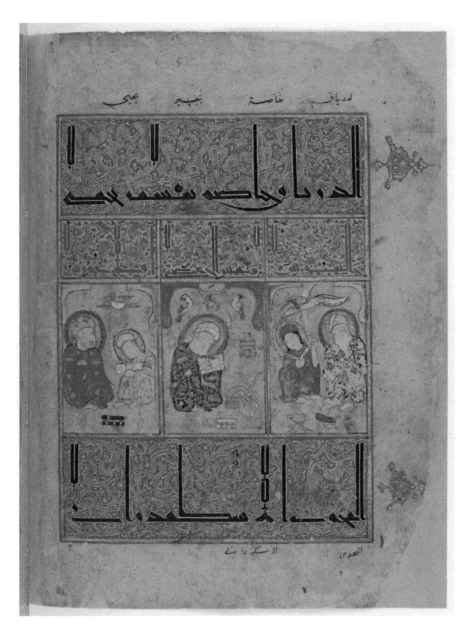

FIGURE 3.25 Portraits of the physicians in the *Kitāb al-diryāq*, manuscript dated Rabi I 595 (December 1198–January 1199). Paris, Bibliothèque nationale de France, Arabe 2964; current pagination 32.

widespread use of *al-ʿizz wa-l-iqbāl* and *[bi] al-yumn wa-l-baraka* as the opening formulae for supplicatory inscriptions, in cursive and rectilinear scripts respectively, on objects made in this milieu, are we to assume the viewers looked for those phrases first and used them to orientate themselves toward a starting point on the object? The implication of that would be a literate audience accustomed to using the verbal register of an object's ornament as a primary means of apprehension. On the other hand, the approximations, elisions, and repetitions found on many examples, like the Ghazni inkwell, would suggest that textual precision was not

considered critical to the beholder's experience. Assuming for the sake of argument that the ordering of the verbal content is in some way intentionally related to the other elements that ornament the inkwell, this could implicate a fixed start and end point for the sequence of figures and arches that decorate the main register of the body. However, there are on the David Collection inkwell, as well as other objects, two very similar sets of inscriptions running in parallel that do not start from the same point on the object. Rather than deducing from this that the relationship between epigraphy and the rest of the decorative program is entirely arbitrary, these discontiguous starting points may instead be taken to indicate the craftsman's conscious exploration and enjoyment of the multiple sequences of viewing that a three-dimensional object not only permits but actively encourages. There is also the parallel with architecture to be considered, in the ways in which discrete bands of epigraphy are used on both objects and buildings as frames, emphasizing and delineating structure, and imposing certain regimes of movement upon the human viewer who seeks to trace the message in its entirety.[110]

While each epigraphic band has a beginning and an end, both marked by familiar and therefore recognizable phrases, these are separated in both cases on the David Collection inkwell by only a roundel identical with those that intersperse the rest of the inscriptions. Their cumulative effect is to engirdle the object with a never-ending broadcast of good wishes. When you have reached one *li-ṣāḥibihi*, you can keep going and begin the sequence again, or switch to the other register and find yourself immersed in a similarly beneficent stream of words. Within this context, then, the sequencing of the figural elements on the David Collection inkwell can be understood to act in parallel with the inscriptions. The three "frames," each with its bilateral composition of figure/arch/figure, give most to the viewer when read sequentially, but they can also be followed around the object more than once and do not require the viewer to know precisely where to begin when he or she first begins to rotate the object.

For the sake of this analysis, I will assign a starting point to the three figural panels that begins with the musician seated above the opening *bi-l-yumn* of the lower, rectilinear inscription (Fig. 3.24). In this frame, the kneeling musician on the right above the *bi-l-yumn*, playing a *chang* (a stringed instrument similar to a harp), serenades the left-hand figure who sits cross-legged. Both wear belted robes decorated with *ṭirāz* bands on the upper sleeves, and on their heads are tricorn caps with trailing ribbons.[111] The seated figure holds to his chest an unidentifiable object in the form of a small isosceles triangle with the vertex angle pointing upward, and in the middle of which is a central indentation. I tentatively suggest that this might represent a vessel flute like an ocarina, or some other simple form of wind instrument. In the absence of a positive identification of this object, the pairing still stands as an image of music-making and audience, such as can be seen on a very wide range of surviving portable arts from twelfth- and thirteenth-century Iran. The longstanding interpretation is that such scenes are depictions of courtly

pleasures. The *Siyar al-Mulūk*, a so-called mirror for princes said to have been written by the famous Seljuq vizier Niẓām al-Mulk (d. 1092), stipulates that the boon companions so necessary for the relaxation of kings should be cultivated and well bred, and should know how to play the harp and other musical instruments as well as backgammon and chess.[112] The permeation of these values, in aspiration if not also in reality, into the affluent sectors of medieval society is attested within metalwork by the presence of inlaid figures playing musical instruments and backgammon as well as feasting, as on the Bobrinski bucket made for Khwaju Rukn al-Dīn, "the pride of the merchants."

On the inkwell, the arch that lies between the two figures in this abbreviated scene of revelry serves as both a compositional device and an intimation of architectural space. The perceptual complexity and scenic possibilities of this device become clearer when one turns the inkwell counterclockwise to encounter the next pair of figures (Fig. 3.26). On the right-hand side of the arch is a kneeling figure, again wearing a tricorn cap, who holds aloft a footed globular vessel with a high neck and a band of decoration, easily identified as a drinking flask.[113] He face across the arch towards his mobile partner. Alain George has shown that the objects carried by the latter figure are almost identical with the crutch and purse held by

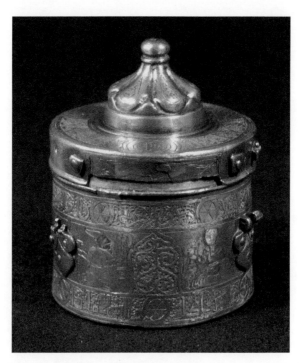

FIGURE 3.26 Inkwell, Khurasan, late twelfth century. Cast copper alloy engraved and inlaid with silver and copper. Height 9.5 cm. Copenhagen, David Collection, 32/1970.

ascetics in the illustrated thirteenth-century *Maqāmāt* manuscripts, in which the figures sometimes also wear pointed hats and beards as the inkwell figure did before the loss of the silver inlay that once formed his face. George concludes, convincingly, that the left-hand figure is an image of a dervish.[114]

The putative dervish on the inkwell is represented in rapid motion with legs bent, booted feet seen side-on and arms crooked and outstretched from the elbow, so that his lower body and face are in profile while his torso faces the viewer. This pose conventionally indicates the act of running, and the spatial logic of the object and its decoration would dictate that the figure is hurrying along the groundline provided by the horizontal division between the central and lower registers, moving in a counterclockwise direction around the inkwell and therefore running against the direction of reading but toward his partner with the wine flask. The very different types of activities displayed by the figures, one running fast while the other kneels and prepares for drinking, activate a spatial dialectic of outside and inside. In this way, the scroll-filled arch between them becomes a boundary marker or doorway between one fictive space and another.

The pay-off for the runner comes when we turn the inkwell counterclockwise again. In the final pairing, another musician sits cross-legged to the right of the third arch (Fig. 3.27). His instrument appears from the bent neck to be an '*ūd*,

FIGURE 3.27
Inkwell,
Khurasan, late
twelfth century.
Cast copper
alloy engraved
and inlaid with
silver and copper.
Height 9.5 cm.
Copenhagen,
David Collection,
32/1970.

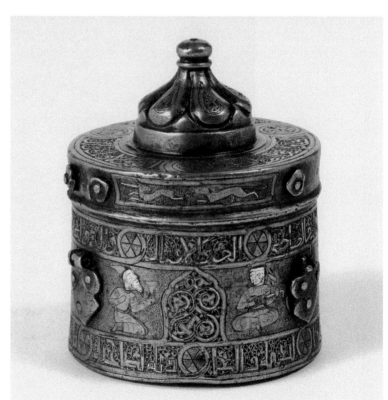

although the waisted shape also recalls a *tār*. On the other side of the arch, finally, a figure with a pointed hat and beard, identical with those of the running dervish, has come to rest on his knees. He raises a drinking cup, looking across the arch toward his musical companion, who turns his eyes to gaze back at the bearded figure and the cup that the latter holds aloft. The dervish who ran pell-mell toward a drink now reaps his reward and can enjoy it in stillness while listening to the music of his capped companion. The joke here is predicated on the conceit of time elapsing between one vignette and the next, which of course has really occurred because the viewer must turn the object through space and time to move to the new frame, creating an imaginal form of real-time animation. The actions of the dervish and his companion are now, in this final image, manifestly taking place within the same environment and they are directly engaged with each other through the exchange of gazes and the raising of the glass. The arch between them no longer suggests a divider or door but instead becomes a piece of set dressing indicating an architectural space.

In all three of the David Collection inkwell's "frames," the arch operates on several registers. As a compositional device it divides each individual frame into two compartments for the balanced containment of the figures. At another aesthetic level it interjects a formal linkage between the upper and lower registers of the body of the object through its extension, into the central register, of scrolling tendrils and silver wire inlay that echo those of the epigraphic bands, and through the continuous outlines of the epigraphic registers and the arch that are highlighted with ribbons of copper inlay outlined to appear as if lying over and under each other. By this means a carefully contrived balance is maintained between different types of surface that interpenetrate each other while remaining tightly contained and controlled. The eye, the mind, and the hand are absorbed into these surfaces as the beholder turns the object to trace the full complexities of this virtuoso piece of inlaid and engraved metalwork. Finally, at the third, critical level that lies somewhere between depiction and intimation, the arch functions as architectural fragment, spatial cue, and boundary marker. Its operation as such is largely dependent on its relationship in scale and placement with the figures that populate the central register of the object.

In the division of the surface into discrete cells, the intimation of events conducted sequentially through those cells, and the requirement that the object be turned in the hands in order to activate and follow those events, the inkwell showcases an embryonic form of three-dimensional narrativity that is related to the more complex storytelling undertaken through multiple contiguous panels on the famous glazed ceramic beaker in the Freer Collection (Fig. 3.28). The Freer beaker is dateable by technique and stylistic elements to the late twelfth or early thirteenth century and, as has been demonstrated by Marianna Shreve Simpson, testifies to a conceptualization of narrative in the round that might derive from architectural decoration as much

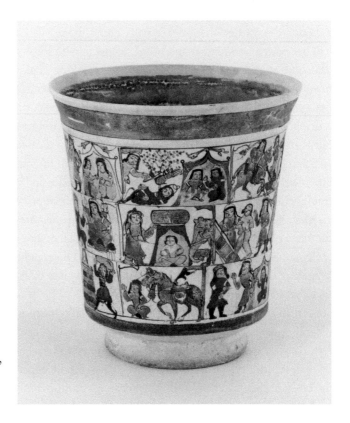

FIGURE 3.28 Beaker with
narrative images, Iran, late
twelfth century. Glazed
stonepaste decorated in
minā'ī technique. Height
12 cm. Freer Gallery of
Art and Arthur M. Sackler
Gallery, Smithsonian
Institution, Washington, DC,
F1928.2.

as or even more than it draws on the much more frequently vaunted source for *minā'ī*
decoration, manuscript illustration.[115] The architectonic framing brackets that divide
the individual scenes on the beaker also appear occasionally on other *minā'ī* wares, as
well as in manuscript illustrations like the *Kitāb al-diryāq* physician portraits.[116] These
forms ultimately derive from representations of architectural columns and spandrels
and might, as Simpson suggests, imply an architectural origin for the episodic nar-
rative format encountered on the Freer beaker. Similar forms also appear as spatial
dividers within interior scenes in the Small *Shāhnāma* manuscripts of the early four-
teenth century.[117] The interrelationships thus implied, between narrative, movement,
architecture, portable arts, manuscript illustration, and the human form, places the
inkwell into an environment of rich, multilayered cross-referencing between words,
images, structures, and objects.

A similar layout can be seen on a second Khurasan inlaid inkwell of less re-
markable craftsmanship, now in the Musée du Louvre (Fig. 3.29). Formerly in the
collection of the dealer Clotilde Duffeuty, it was acquired by the museum in 1893.
As on the David Collection piece, the interrelationship of figures and arches in
the central register serves to turn the object into an architectonic space of perfor-
mance within which figures interact and gesticulate. The division of the surface is
closely comparable to that of the David Collection inkwell, with the main body

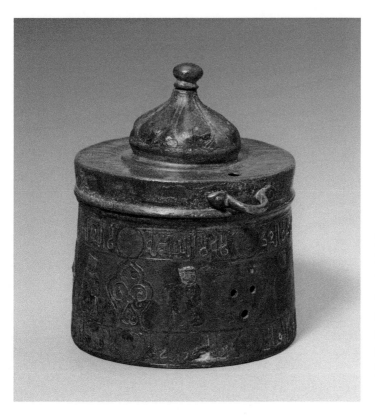

FIGURE 3.29
Inkwell, Khurasan, late
twelfth century. Cast
copper alloy engraved
and inlaid with silver
and copper. Height
8.8 cm. Paris, Musée du
Louvre, OA 3354.

divided horizontally into two narrow epigraphic bands at top and bottom and
a larger central register containing six figures and three arches. In this case the
distinctive and nonstructural form of the arches—trefoil with a tightly squeezed
waist—is familiar from eleventh- and twelfth-century architectural decoration,
including a grave stele from Ghazni in Afghanistan dated 1030.[118] It also appears
on other examples of inlaid metalwork.[119] An earlier example of the form on a
plaster panel, filled with vegetal designs not dissimilar to the much simpler
scrolling patterns within the inkwell's arches, was excavated at Nishapur (Fig.
3.30).[120] The upper surface of the Louvre inkwell's lid is very badly damaged, but
appears to have been decorated with fillets and roundels comparable to those on
the David Collection example. It is possible that the lid is not the original one.

The inscriptions on the Louvre inkwell are damaged and the inlaid silver wires
might be later replacements, which could explain certain peculiarities of script, but
they present recognizable supplicatory inscriptions of the standard type. In this case,
rather snarled rectilinear epigraphy occupies the upper band and takes its starting
point, like the rectilinear inscription on the David Collection inkwell, from the
figure of a harpist. It is not easy to decipher but seems to read, *bi-l-yumn wa-l-baraka
wa-l-dawla wa-l-ta'yīd [?] wa-l-ʿadāla wa-l-siyyada [?] wa-l-baqā liṣāḥ[ibihi]* ("with
bliss and blessing and power and support [?] and justice and lordship [?] and long

FIGURE 3.30 Panel excavated
at Sabz Pushan, Nishapur in
1938. Nishapur, Iran, tenth
century. Carved stucco.
Height 103.5 cm. New York,
Metropolitan Museum of Art,
40.170.439.

life to the owner"). Below, a more legible, though also crude and damaged, cursive inscription starts at a point halfway along the band of rectilinear inscription. The cursive inscription reads, *al-ʿizz wa-l-iqbāl wa-l-dawla wa-l-saʿāda wa-l-karāma wa-l-[. . .] wa-l-ʿāfiya wa-l-baqā liṣ[āḥibihi]* ("glory and prosperity and power and happiness and honor and [. . .] and health and long life to the owner").

Just as with the David Collection inkwell, and as with other such small, inscribed objects of use, the haptic encounter is critical to this object and the inscription works in concert with other elements of the decoration to induce rotational movement of the object by the viewer. Even someone incapable of reading the inscriptions would experience the compulsion to rotate this small object in their hands in order to follow the ornamental schema around the body and, in the figural register, see who is talking to, or looking at, whom.

I have dwelt on the inscriptions on these two inkwells in part because epigraphy has not always been treated as an integrated component of ornamental programs on Khurasan metalwares, and indeed on medieval Islamic artifacts in general. Certain kinds of inscriptions are traditionally prized above all else in the philologically descended sub-field of Islamic art history, but rather ironically this special status means they have often been reduced, in the discussion of objects at least, to the transcription of content and classification of script type,

without much regard for their relationships with other aspects of the object or consideration of their effects upon viewers and users.[121] In addition to these issues there is a sometimes tangible sense of disappointment attached to the supplicatory expressions found on many portable artworks and Khurasan metalwares in particular, for they are highly standardized and only very rarely incorporate the kind of documentary information (i.e., names, dates, and sites) most valued by collectors and scholars.[122]

As a consequence of their neglect, the sociocultural significance of the huge mass of supplicatory inscriptions on objects has yet to be considered. Clearly, however, the act of petitioning for God's favor is a socially meaningful one, whether it is performed by the tongue of a human or the script on an object. In other contexts, the application of Qur'anic verses to architecture has been recognized as an intentionally constructed "interpretive moment given permanence."[123] For the supplicatory expressions found on so many medieval objects one might argue along similar lines that they represent a performative social act given permanent expression within the bodies of artifacts. The epigraphy of the inkwells should be understood as a fully engaged component of a decorative scheme that works on several levels simultaneously, leading to a synphrastic merging of object, word, and act.

In this spirit, if we accept the textual cue of *al-ʿizz wa-l-iqbāl* and start from the beginning of the more legible cursive inscription on the Louvre inkwell, we encounter first a seated figure who is too damaged to interpret. The outline suggests that although the figure is seated frontally, it is inclined slightly toward the arch to its right, a pose that would probably once have been made more apparent by the detailing of its now-lost face. Turning the object counterclockwise, we pass the space where a hinged plate was once attached and enter a new frame, where two frontally seated figures direct their gazes toward each other across their arch (Fig. 3.29). The right-hand figure might once have held a *daf* (frame drum), the left possibly some other form of instrument. Turning the object again to pass the next attachment plate, we move to a new frame where a kneeling harpist on the right-hand side—probably once very similar in appearance to the harpist of the David Collection inkwell—plays across the arch to a seated figure on the left who faces the viewer, the outline of a three-pointed crown just visible above his head (Fig. 3.31). The left-hand figure appears to hold something to his chest, possibly a drinking vessel, making this last pairing very similar to one on the David Collection inkwell.

Continuing, we leap the last attachment plate to encounter the final figure in the sequence, the only one shown interacting not with his partner but with someone outside of his "frame" (Fig. 3.32). A kneeling man with beard and pointed hat, his arms aloft presumably in the act of speech, faces the attachment plate that separates him from the princely, seated drinker in the preceding frame. The gesticulating kneeling figure sits immediately above the *liṣ[āḥibihi]*

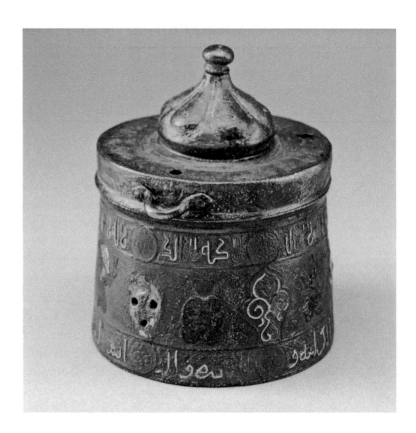

FIGURE 3.31 Inkwell,
Khurasan, late twelfth
century. Cast copper alloy
engraved and inlaid with
silver and copper. Height
8.8 cm. Paris, Musée du
Louvre, OA 3354.

that terminates the cursive inscription. His hat and beard are similar to those of
the putative dervish on the David Collection inkwell, suggesting that this is a
recognized type. His long trailing sleeves, too, are quite unusual among the fig-
ures found on the inlaid metalwork of Khurasan, and add weight to the dervish
interpretation.[124] By turning away from his partner, the dervish on the inkwell
acts as a repoussoir, working in tandem with the lower inscription to mark an
end to both the sequence of figures and the cursive text by abruptly reversing
the direction of attention. At the same time, he adopts the most animated pose
found anywhere on the object in order to petition a princely figure who lies be-
yond the three-dimensional impediment of an attachment plate. In so doing he
disrupts the fictional space of the ornamented object by drawing attention to the
artificiality of the spatial conceits that have ordered its surface, and transfers the
beholder's attention, finally, from the fictive space of figural occupation back to
the material objecthood of the inkwell, through the somewhat comic interrup-
tion of the attachment plate.

Arch forms play a major role in the decoration of both the David Collection
and Louvre inkwells, and contribute to an architectonic understanding of the pic-
torial space occupied by the figures. They do this without functioning as windows

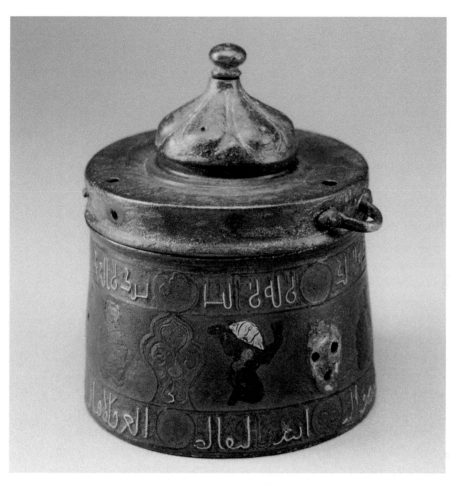

FIGURE 3.32
Inkwell,
Khurasan, late
twelfth century.
Cast copper
alloy engraved
and inlaid
with silver
and copper.
Height 8.8 cm.
Paris, Musée
du Louvre, OA
3354.

or apertures. Instead, they generate an architectural division of space predicated on their relationships with other features of the individual objects that carry them: with the cylindrical form and lobed lid, and with all the words, figures, and forms that are inset into its surface. In both examples the figures are seated on a raised floor (the lower inscription panel) and hemmed in from above by a low ceiling or frame edge (the upper inscription panel), all the while interacting over or between the architectonic interruptions of arches and attachment plates. As such, their arrangement is profoundly theatrical, being displayed around and through the inkwell for the beholder's pleasure as they rotate the object in their hands.

In these compositions there is a strong suggestion of the shadow theater that has been so frequently invoked as a source for the imagery of the illustrated *Maqāmāt* manuscripts, as well as an obvious point of comparison with the thirteenth-century manuscript paintings themselves (Fig. 3.33).[125] The highly self-conscious and visually articulate exploration of relationships between text, figure, ground, and field that is encountered upon the inkwells closely parallels developments taking place

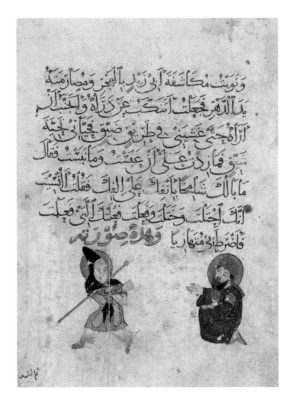

FIGURE 3.33 Illustration
from a manuscript of
the *Maqāmāt* of al-
Hariri. Probably Iraq,
thirteenth century. 32 x
21.5 cm. Paris, Bibliotèque
nationale de France, Arabe
3292, fol. 57v.

in manuscript painting during the twelfth and thirteenth centuries: the astonishing
self-awareness of this mode of image production would find its fullest realization in
the margin invasions and metatextual spaces constructed within Persianate minia-
ture painting of the fourteenth and fifteenth centuries.[126] At the heart of the artistic
idiom that links the inkwells with miniature painting lies an extraordinary fertility
of imagination concerning the articulation of interior and exterior space.

Likeness and Allusion

The Khurasan inkwells I examined in the second half of this chapter are exceptional
within the larger corpus from which they hail. Their ornament engages, through the
use of arch-shaped fields and figures, in a more overt relationship with architectonic
space than can be seen on others of the same general type. Within those inkwells that
combine human forms with arches, both populated and unpopulated, the human
figure functions as scale marker and prompt for a projected logic of occupiable
space. Ornament combining figural and architectural aspects becomes the medium
of transformation, turning a functional object into a site of ludic, visuospatial play.

 While it could be argued that the stands discussed earlier in this chapter make
consistent reference to the forms of garden architecture, albeit fancifully, it would

be a mistake to identify the inkwells as "referential" objects. As has been shown, there is no single, univocal referent for their complex games of spatiality. The Khurasan inkwell group and its relationships with architecture raises two productive problems, both of which have broader art historical resonance beyond this particular little corpus. The first of these is the subjective nature of object perception, even among those trained in its analysis—as shown by the divergences of scholarly opinion over the relationship between Khurasan inkwells and architectural forms. The second is recognizing the point at which the lens of direct mimetic referentiality ceases to be useful and starts to be restrictive in the analysis of artworks that were not created within the parameters of representation as defined by a primarily Western European tradition.

At this juncture, it is worth considering the implications of a statement made by the great philosopher, al-Fārābī (d. 950), on imitation in poetry: "Many believe that the imitation of something in the most indirect form is preferable to direct imitation, and they hold the creator of those expressions to be the author of a more genuine form of imitation, as well as more skilled and experienced in the art."[127] Al-Fārābī's conceptualization of the poetic imagination is both singular and significant, for it shows that indirect reference was—in his view at least—not only accepted but prized in the blossoming medieval Arabic poetic tradition. The Greek concept of mimesis came, during its passage into the Arabic term *muḥākāt*, to hold a rather different position within the literary and visual arts during the great blossoming of eastern Islamic philosophy and poetics. In al-Fārābī's writings on poetry and those that followed, ideas of imitation and likeness become bound up with the concept of *takhyīl*, the poetic imaginary, and the evocation of images.[128] While diverse theories of poetics arose within the medieval Arabic tradition, a common thread between these was the recognition of poetry as "imaginary speech," or a means of creating images in the mind of the listener. This could, in al-Fārābī's words, result in one of two forms of mimesis: "that which suggests the object directly, and that which suggests its presence through a different object."[129] For the purposes of this chapter, it is the latter of these two that is of most interest: al-Fārābī, and others after him, valorized the power of poetry to create images in the imagination that could allude to, without corresponding to, referents in the real world. As José Miguel Puerta Vílchez has put it, "the contribution of al-Fārābī, and after him of Arab thought, was to join mimesis to imagination or fantasy and so provide a depth to one aspect of aesthetics that had scarcely existed before."[130]

When viewed against such a backdrop, the evocative potential of the allusive object is revealed to coincide closely with strains in poetic and literary theory. This chapter has concerned itself primarily with what might be termed the visual mechanics of likeness, meaning the perceptual responses that facilitate the apprehension of one thing as alluding to another, and the ways in which certain forms,

arrangements, or experiences might prime those responses and react to them. But deeply intertwined with these are literary frameworks of likeness, allusion, and puns. One possible framework for the visual games of doubling played by both the stands and the inkwells is the medieval and early modern Persian poetic conceit of *nukta*, a terse, witty "point," often punning and sometimes hinged upon graphical resemblance between one word and another, that showcases a poet's skills.[131] The literary and poetic resurgence of the Persian language was well established by the time the subjects of this chapter were being made, and there is merit in looking for connections between these material artworks and the practices of poetry. The very act of seeing one thing as another that has been explored throughout this chapter is a practice critical to the concept of metaphor, a paradigm to be explored in the next chapter.

4

MATERIAL
METAPHORS

The intertwining of object and language in the medieval Islamic world was a variegated process. At the end of Chapter 3, I proposed some interconnections between the material and the literary arts of the twelfth and thirteenth centuries in the Persianate cultural area, but the phenomenon was certainly not limited to that particular milieu. In particular, the intellectual expansion radiating from Baghdad in the ninth and tenth centuries also generated a fertile environment for mutually constitutive relationships between the literary, visual, and material arts. Against that backdrop of an emerging, innovative, and uniquely Islamic intellectual culture, the present chapter explores textual frameworks as lenses for the apprehension of artworks in the ninth to tenth centuries as well as the later medieval period, with particular attention to changing conceptions of metaphor and imagery during the florescence of Arabic literary theory. Proposing that the artworks under discussion embody complex rhetorical devices, and thereby further implicate a system of thought in which material craftsmanship was deeply embedded within the broader intellectual landscape, the chapter builds directly on the philosophical tradition of the "thinking hand" to outline a cognitive regime in which objects can operate as material metaphors.

The Languages of Objects

Objects of use have functions, implications, and connotations; ergo, they communicate meanings. The rhetoric of objects, specifically likened by some medieval authors to a form of nonverbal metaphor, can be glimpsed through traces preserved in the premodern Arabic and Persian textual sources. Like related practices of gift exchange, rhetorical objects are most frequently recorded in diplomatic contexts.[1] Sometimes the rhetorical deployment of weapons, tools, utilitarian items, and foods is documented in such a way that context makes meaning plain, or the meaning is even glossed in the text.[2] At other times, however, the system of signification is much more opaque.

Take, for example, the case of the Seljuq princes and the awl. In the year 426 AH (1034–1035 CE) the Ghaznavid Sultan Mas'ūd ibn Maḥmūd (r. 1030–1040) released the Seljuq chieftain Arslan ibn Saljūq from captivity and instructed him to write to three of his nephews, Seljuq nobles who had recently been causing havoc in Mas'ūd's territories. Arslan was to tell them to mend their ways and cease their violent actions.[3] He obediently dispatched a messenger to convey these orders to them. However, with the messenger he also sent an awl ('ishfā), which was to be given to the nephews at the same time.[4] Upon receiving this composite communiqué, the nephews immediately reverted to "raiding and causing disorder" in Mas'ūd's territory.[5] The role of the awl in this diplomatic incident remains obscure, but there are two possible interpretations of its meaning to the Seljuq nobles. Either it augmented the verbal rebuke in some way, or, as seems more likely given the response of the nephews, it was a coded instruction that subverted and overrode the verbal directive.[6] There is no mention of an inscription: the object itself was clearly the message.

In either interpretation, the message that provoked such a violent reaction from the Seljuq nobles was delivered in part through an encoded system of objects, the meanings of which we can only guess at. Records of such a coded rhetoric of objects have on occasion been included by medieval authors under the Arabic term *ramz*, a word originally meaning winking or signaling with the eyes, and coming in later literary contexts to denote forms of indirect expression, including secret writing and codes as well as some types of esoteric symbolism. In the sense of "symbolic action," *ramz* may itself be linked with another significant literary term, *ishāra*, which in early use also referred to certain bodily acts of nonverbal expression, such as gesturing with the head or signaling with the eyes. Like *ramz*, *ishāra* later came to acquire a literary meaning, in this case roughly translatable as "allusion," that was particularly important in medieval Sufi discourse.[7]

The line of descent in the case of the terms *ramz* and *ishāra*, from gestural, nonverbal means of expression to literary techniques of coding and allusion, is a telling one. As with the medieval philosophical texts discussed in Chapter 1, which were shown to be symbiotically bound up with the physical world of matter and

making, so too are major aspects of the medieval poetic and literary traditions inseparable from, formed through, and reflected in the corporeal, visual, and material realms. The power of objects as direct agents of rhetoric, dramatically illustrated in the story of the Seljuq princes, is only one manifestation of the interrelationship between language and manufactured objects in the medieval Islamic world. When the objects in question have been made with conscious artistry to allude to things other than themselves, as with the material in this book, the entanglement of objects and language becomes ever more complex and sophisticated.

Even without embarking upon the supremely textual artform of the illustrated manuscript, the heightened textuality of medieval Islamic artifacts is striking. Three-dimensional artworks from this milieu are often inscribed with words, as has been explored in some detail in Chapter 3; sometimes they are described verbally in contemporary texts; on occasion they even engage in the metatextual act of prosopopeia and describe themselves within their own inscriptions.[8] In other instances, wordless images on objects make direct reference to verbal narratives that were transmitted through oral recitation or written records external to the object.[9]

Beyond the direct presence of texts on objects or of objects in texts, however, lie the realms of tacit corollary between the verbal and the plastic arts, which are the primary focus of this chapter and the following one. Together these two chapters argue for the existence of habits of making and beholding within the literate or semiliterate consumer bases of medieval Arabic and Persian-speaking societies that were enmeshed with contemporary literary and poetic practices, and manifest in a host of intelligent artworks. The argument has been made before, most comprehensively in relation to the palatial architecture of Islamic Spain,[10] but has less often been applied to the non-narrative portable arts.[11] Accordingly, these two chapters will expand from the narrowest definition of rhetoric, the language of persuasive expressions that would include the diplomatic awl, to a broader spectrum of literary and poetic techniques of descriptive and imaginative eloquence that seek to make the absent present and construct images in the mind of the listener or reader. Many of the phenomena under discussion in the present chapter can be grouped under the general heading of "metaphor," although this belies the complexity and diversity of the literary techniques from medieval Arabic and Persian traditions that are subsumed under this translated term. The common principle, nonetheless, is that of making something become something else in the mind of the beholder or listener, or, more simply, of seeing one thing as another.[12]

In this chapter I first explore a pervasive allegorical framework in medieval Arabic and Persian literary criticism that aligns poetic production with material craftsmanship. Following this a small group of objects of architectural form—incense burners of the eighth or ninth centuries—are placed into an expanded context of primarily eastern Mediterranean portable arts and architectural components. While these incense burners have been noted in earlier scholarship for their

potentiality as visual metaphors, and this point will be expanded, debates about attribution—often seeking to establish the nature and extent of their references to architecture on mimetic terms—have sometimes overshadowed their interpretation as complex and mobile artworks operating within late or post-Antique "pathways of portability."[13] In the last part of the chapter a further group of objects, lanterns in the form of domed monuments, are also examined. These lanterns originate from the eastern Mediterranean world of the twelfth and thirteenth centuries, a period when the central-plan domed monument had been fully assimilated into Islamic architectural culture as a standard form of commemorative architecture. Hence, although these two groups of objects are both fashioned in reference to domed structures, and perform symbolically significant roles as emanators of smoke and light, respectively, the terms and meanings of their allusions to architecture differ. The final section of this chapter will return to the literary model of metaphor as a means of apprehending material artworks.

The Poet's Craft

A deeply entrenched tradition within medieval Arabic and Persian poetics analogizes verbal arts with manual crafts, most commonly the arts of the weaver and the goldsmith or jeweler. The broad penetration of this analogical model has often been noted in art historical scholarship but has rarely been explored in depth, with the exception of a handful of studies. At the core of the analogy is a conceptualization of poetry as a craft or art (*ṣinā'a, ṣan'a*), and the poet as a craftsman or artist, a paradigm that was in broad currency by the ninth century. To quote the towering figure of ninth-century letters, al-Jāḥiẓ: "After all, poetry is a craft [*ṣinā'a*], a kind of weaving [*ḍarb min al-nasj*], a sort of image-making [*jins min al-taṣwīr*]."[14] As a poetic mode, *ṣinā'a* is frequently identified with the "moderns" of the ninth-century 'Abbasid literary movement, and in such contexts it is used to denote "conscious artistry" as opposed to the "unforced" or "natural" (*ṭab'*) qualities of earlier poetry.[15] The remarkable developments that took place in Arabic literary theory in the ninth and tenth centuries were to have an immense and continuing impact on educated Arab culture throughout the medieval period, and the trope of the poet as craftsman is a very long-lived one in Arabic literary history.

Weaving (*nasj, ḥiyāka*) appears to be the single most common craft metaphor adopted for the art of Arabic poetry, and the connection predates the coming of Islam.[16] Poetry is frequently described as having been woven and the poet as a weaver; poetry of weak structure is occasionally designated *muhalhal*, a term originally used for poor weaving.[17] Other terms from the craft can be cited: for example, the word *ghazal*, an elegiac poetic form, is derived from the root *ghazala*, "to spin [thread]"; *dībāja* can mean silk brocade, elegance of writing style, and the introductory lines of a poem.[18] Textile analogies are paralleled in Persian poetics: the word *ṭarāz* ("adornment," "embellishment," also used to mean "embroidery") forms a

verb set in Persian meaning to weave, to adorn, or to compose poetry.[19] But while weaving is undoubtedly the most frequently encountered craft analogy within medieval Arabic conceptions of poetry, this book's focus on the plastic arts leads most naturally to other metaphors of production. Thus, the arts of the goldsmith and the jeweler, and to a lesser extent the art of building, will all be considered here in their analogical roles as metaphors for poetry.

A sympathetic relationship between the arts of writing and those of the goldsmith and jeweler was already noted in Chapter 3, where it was shown that the Persian term *dawāt* normally denotes an inkwell but in Khurasanian contexts may also appear as the name for a crucible for precious metal. The strongly spiritual, even alchemical, dimension of this connection is reflected in various aphorisms recorded in the medieval period that link beautiful writing and calligraphy with noble qualities, likening the pen to a conduit or tool for precious materials that spill from the person of the writer. For example, "the heart is a mine, intelligence is the gem and the pen is the jeweler," "the pen is the goldsmith of speech," and "handwriting is jewelry fashioned by the hand from the pure gold of the intellect."[20] Such formulations derive their impact from a fairly generalized use of gold or jewels as symbols of rarefied qualities. It is, however, in the technical and descriptive language of poetic and literary discourse that the processual metaphors of working in precious metals and stones are most particular, rendering visible once more the thinking hand that articulates matter through movement and process.

At the etymological level, interchange between the arts of the poet and the jeweler has given rise to a widespread Arabic term for versification, and subsequently poetry in the more general sense: *naẓm*, which literally denotes "stringing [pearls, beads etc.]" or "arranging." This is set in opposition to *nathr* ("scattering"), normally used to mean "prose."[21] The philologist Abū Hilāl al-ʿAskarī (d. early eleventh century) was one of several medieval authors to gloss the term, explaining that "*naẓm* applies to collars and necklaces and because jewels vary in color, each is placed next to the one which brings out its color most predominantly."[22] Al-ʿAskarī's explanation thus emphasizes the importance of arranging and setting passages or phrases within the totality of the poem, while highlighting the significance of contrast and counterpoint to that arrangement. The same author elsewhere uses the term *raṣf* ("stonework" or "inlay") to mean the arrangement of words and phrases within the poem. Similarly, *tarṣīʿ* is sometimes used in medieval texts to denote both a type of internal rhyme in poetry, and the setting or insetting of precious stones. *Faṣṣ* can mean both eloquence and the stone or setting of a ring.[23] Strung necklaces from the medieval period do not tend to survive in their original arrangements, but other extant forms of jewelry with inset stones, like a sheet-gold bracelet attributed to twelfth-century Iran, demonstrate the widespread taste for both symmetry and a multiplicity of techniques and chromatic contrasts within a single object, which accord with some of these poetic analogies (fig. 4.1).[24]

FIGURE 4.1 Bracelet, Iran, probably twelfth century. Sheet gold with incising, granulation, and repoussé, inset with stones. Diameter 7.6 cm. New York, Metropolitan Museum of Art, 59.84.

Likening crafting and arranging fine verses to the stringing of a necklace is one of the most important and frequently recurring craft analogies in the Arabic poetic tradition, perhaps second only to weaving, and it was certainly in wide use by the tenth century. This much is attested by a well-known poetic anthology, *Al-ʿiqd al-farīd* (The unique necklace), by the Andalusian poet Ibn ʿAbd Rabbih (d. 940).[25] Given the very widespread use of the necklace as a metaphor for a poem, it is unsurprising that the same image plays a central role in one of the earliest surviving theoretical explorations of Persian poetics, the *Muʿjam fī maʿāyīr ashʿār al-ʿajam* (Pointed [writing] on the defects of Persian poetry) of Shams-i Qays (active first half of the thirteenth century).[26] In addition to comparing the poet to a painter with chromatic and compositional sensitivity, Shams-i Qays also likens him to "a master jeweler who increases the elegance of his necklace by beauty of combination and proportion of composition, and does not diminish the luster of his own pearls by variations in joining and disorder in arrangement."[27] Indeed, the "customary image" of the poet as the stringer of pearls is encountered so frequently in the best-known and most widely translated medieval Persian poetry that it has become something of a cliché within Orientalist scholarship.[28]

A similar analogical framework between the verbal and lapidary arts was argued by Michael Roberts to be a defining characteristic of late antiquity that

found its fullest expression in what he terms "the jeweled style" of Latin poetry. He traces the practice to the stylistic norms of ekphrasis, further discussed in Chapter 5.[29] The recurring analogy drawn in Arabic (and subsequently Persian) and Late Antique Latin sources alike, between lapidary and metallurgical arts on the one hand and literary and poetic techniques on the other, suggests a common source for those poetic traditions. However, the capacity to view and describe the world analogically is arguably enhanced through the structure of the Arabic language itself. The discontinuous morphology of Arabic is predicated on the generation of word families from individual tri-consonantal roots, wherein the root carries a central meaning that is refracted through its various forms. This can give rise at times to related terms, or even disparate meanings housed in a single term, that might initially appear ontologically dissonant but in fact share a particular essence made visible in their etymology.[30] The result can be a kind of lexical poetics. To pursue an example first encountered in Chapter 1 of this book: among the terms sprung from the root *sh-f-r*, which centers on the concept of "edge," is *shufra(t)*. This word can mean both "the edge of the eyelids" and "the knife of the shoemaker."[31] The formal similarity that exists between the curved edge of a leather-cutting blade and that of an eyelid, as well as the functional parallel of dividing a surface, are presumably responsible for the dual meaning. At the same time, linkage of the two meanings is redoubled poetically through the topos of the piercing glance or gaze, an eye that behaves like a knife.[32]

Returning from tools to jewels, the analogizing of the sumptuary arts with poetry on occasion goes beyond the setting of stones and the stringing of pearls—each of which are primarily tasks of arrangement rather than creation—to include the related crafts of metalworking and in particular casting. The words *sabk*, *mufaragh*, and *ṣawgh*, all meaning "cast" or "molded" from molten metal, are encountered in descriptions of poetry; *ṣawgh* is particularly associated with casting in gold and silver.[33] This conceptualization of poetry as a form of metalcasting was highlighted by al-Jāḥiẓ in the ninth century when he wrote that the best poetry should be "cast in one piece and molded in one piece [*qad ufrigha ifrāghan wāḥidan wa-subika sabkan wāḥidan*]."[34] The idea is fairly widely encountered in Arabic literary and poetic criticism and theory written during the florescence of those genres in the tenth and eleventh centuries. For example, the same analogy appears in the *ʿIyār al-shiʿr* (Touchstone of poetry) of Ibn Ṭabāṭabā (d. 322 AH/ 933–934 CE), who wrote that the poem should emerge "as though cast [from metal] in a mold [*mufragha ifrāghan*]."[35] The direct equivalence of the three dominant analogical models for poetry—metalworking, jewelry-making, and weaving—is made clear by Abū Hilāl al-ʿAskarī, when he describes the role of *tawshīḥ* (decoration) in creating the best poetry. This should appear "as if a cast ingot [*sabīka mufragha*], or as a decorative garment [*washy munamnam*], or as a necklace strung from jewels similar in appearance [*ʿiqd munaẓam min jawhar mutashākil*]."[36]

Casting of molten metals for jewelry, which is presumably what is being evoked
in such analogies, was probably done most frequently with molds of clay or plaster
using the lost wax technique.[37] Some casts made from stone have survived and give
a sense of the intricacy of the technique and the seamlessness of the resulting objects,
the inlet channel marking the only interruption of the end result (Fig. 4.2).[38] These
are significant qualities for the poetic analogy: while the alignment of poems with
necklaces is predicated on the arrangement of discrete units within a greater whole,
the imagery employed in the conceit of casting places stress on the aesthetic unity of
larger elements and the poem, or the individual passage within the poem, as a unitary
creation.[39] When Persian poetry started to be the subject of precise theoretical in-
terest in the thirteenth century, Shams-i Qays employed the same model of a "mold"
(*qālib*, pl. *qawālib*) into which words and meanings are poured.[40] The hylomorphic

FIGURE 4.2 Mold
for jewelry, signed
"Muḥammad al-
Maghribī." North
Africa (?), date
unknown. Carved
soapstone. Width 6.5 cm.
Metropolitan Museum
of Art, New York,
1975.32.4.

conceptions of matter and form, those cognitively separable but actually indissoluble aspects of things that were so critical to the philosophers of Chapter 1, thus return once more to shape the mental image of poetic construction.

There is even at least one case of a documented family of goldsmiths who were also poets, concretizing and embodying the linkage between the two arts. Jamāl al-Dīn Iṣfahānī (d. late twelfth century), who worked as a painter (Persian: *naqshband*) and goldsmith (*zargar*) in the Isfahan bazaar, was a poet of renown who wrote in both Arabic and Persian. Although somewhat overshadowed by the fame of his son, the poet Kamāl al-Dīn Ismāʿil Iṣfahānī (d. *c.* 1237), Jamāl al-Dīn, whose own father may also have been a goldsmith, gave thanks to God in his own poems for his knowledge of the crafts that earned him subsistence. He also thanked the fingers that enabled him to practice those crafts, denoting himself their grateful hanger-on.[41]

The craft of building appears less frequently than metalworking or jewelry as an analogue for poetic practice, but architectural structure is repeatedly used as a schema for formal poetic structure. *Bayt* can mean both "house" and "verse"; *misrāʿ*, a single panel of a double door and a hemistich; and *watad*, a tent-peg and a metrical foot.[42] Moreover, the analogy of architectural practice is sometimes sustained in much greater depth: a famous instance from Persian poetry is a well-known *qaṣīda* (ode) of Nāṣir-i Khusraw (d. 1070s) that likens the poem itself to a palace with foundations, gardens, gates, and variegated spaces.[43] The conceit was carried even further by the Karaite-Jewish poet Moses Darʿī, writing in Egypt in the twelfth century, who employed the paradigm of defensive architecture as a "metaphorical construct state" from which to defend his chosen genre, *badīʿ* (literally "novel")-style poetry:

> A tower of poetry with closed gates through
> which most creatures are unable to pass
> in which there are poetical treasures worth more
> than *Ophir* gold and *Shamir* pieces
> and the most precious of all rhetorical figures, as well as
> troves with the most desired and preferred rhymes;
> in its rooms there are hoards with the most powerful themes,
> as [much as] the shining stars.[44]

Julie Scott Meisami suggests that the architectural metaphor, and indeed all metaphors of craft encountered in the medieval Arabo-Persian literary tradition, stem from "a perception of a poem as an ordered entity based upon principles of design."[45] While the imposition of order is undoubtedly a significant concern, Meisami's emphasis on the concept of "design," which in modern usage normally denotes a discrete stage of planning preceding manufacture, possibly understates the role of process within the acts of both verbal and material creation.[46]

That process is a major component of the craft metaphors for poetic pro-
duction, including the metaphor of building, can be seen in a passage from the
great literary theorist al-Jurjānī (d. 1078 or later), part of which is also quoted
by Meisami. "One must shape the whole sentence in one's mind; one should be
like a builder who puts something here with his right hand and at the same instant
something there with his left. Indeed, as soon as he spots the place for a third part
and a fourth [part], he puts them down after the first two."[47] While confirming
the cerebral nature of the activity, Jurjānī's analogy is a processual one in which
literary creation is likened to the thinking hand of the builder, as he shapes ar-
chitectural space in response to both his evolving intentions and the immediate
requirements of his materials. Design is thus "fully embedded in the generative
processes of making."[48] Jurjānī's work will be discussed further in this chapter; at
this stage, it suffices to mention that in addition to the analogy with building, his
theories of poetic construction also repeatedly employ the metaphor of casting
gold and silver.[49]

As a coda to this overview of the sumptuary and constructed arts as literary
analogies, I add only that material metaphors of poetry do not pertain solely to the
author's act of crafting the poem or work of literature, but also to its reception. The
Arabic word naqd can be translated to mean criticism but also denotes the activity
of the assayer who distinguishes good currency from counterfeit.[50]

The penetration of all of these manual craft metaphors into Arabic and
Persian literary and poetic theory, and the recurring etymological linkage of
terms between the two spheres, speaks of more than just cross-pollination or
conceptual drift between disparate modes of creativity. It articulates a mutu-
ally constitutive field of the visual, verbal, and plastic arts, wherein material
analogues for literary theories, poetic forms, and figures of speech are not mere
scholarly conceits but reflections of a thinking hand inseparable from other
aspects of the intellect. The phenomenon flows from objects to language and
vice versa, and argues for the utility of literary lenses in the apprehension of
material artifacts, particularly the subjects of this book with their self-conscious
merging of the form of one thing—a building—with that of another—an ob-
ject of use. Specifically, it can be linked to new intellectual currents in ninth- and
tenth-century Arabic literature that emanated from the center of the Islamic
world, Baghdad, and most notably the emerging badīʿ style of poetry.[51] Before
going further with literary models, however, the next parts of this chapter will
illuminate the material side of the equation by laying out a group of "meta-
phorical objects" created in the early Islamic eastern Mediterranean. Careful
consideration will be given to their material specificities and attendant issues
such as provenance, recognizing their autonomy as manufactured products op-
erating within a particular milieu, before considering their impact as material
metaphors.

Metal, Stone, and Smoke

In a remarkable simile that unites architecture with metalworking and poetry, the ninth-century litterateur al-Jāḥiẓ described the palace-city of Baghdad as seeming to have been poured into a mold and cast.[52] The metaphor of metalcasting, employed elsewhere by the same author in praise of seamless poetic creation, in this instance was deployed to express admiration for one of the greatest architectural constructions of the early Islamic world. In Jāḥiẓ's image, the unity of the palatial complex is implicitly contrasted with the bricolage of other forms of urban fabric, the round city's physical presence and visual impact seeming so flawless as to align it with the materials and techniques of metallurgy rather than architectural construction. Symbolic aspects of metal's protean transformation from unrefined ore to liquid and then to solid artifact were discussed in Chapter 1; here, these gain further supernatural dimensions when the imagined end product is not a small thing but a city. Scale is a major component of the wonder evoked by the image. Significantly, the tale of the City of Brass in the *Thousand and One Nights* and its various antecedents, with their many references to the scriptural Solomon, employ the same analogy of the cast-metal city to emphasize the impenetrable appearance of the magical stronghold.[53]

This early Arabic textual topos of the cast-metal city or palace finds an intriguing material counterpart in a small group of cast copper-alloy incense burners, attributable to Egypt or more generally the eastern Mediterranean lands, of the eighth, ninth, or possibly tenth century. The most famous of these is, indisputably, the spectacular example now in the Freer Collection (Fig. 4.3).[54] While the Freer incense burner and its small group of cognates are clearly not intended to evoke the image of Baghdad or the mythical City of Brass, their miniaturization of monumental form via the medium of cast metal and simultaneous merging of architectural schema with portable, handheld container, access some of the same cultural currents of wonder, transformation, and metaphor that were employed in the rhetorical image of the city formed from molten metal. The potential for literary metaphor to serve as a kind of key to the Freer incense burner has been suggested in a recent article by Metzada Gelber and this idea will be further explored, after some considerations of attribution, specificity, and meaning.[55]

Perfuming spaces, things, and bodies with incense and solid and liquid scents was an integral part of life in the premodern Islamic world.[56] Liturgical and ritual uses of incense were absorbed from various pre-Islamic Arabian, Jewish, and Christian practices and quickly became established in the early Islamic milieu.[57] Scented smoke was also perceived as an essential component of funerary practices. In one example, a report from Thaʿālibī (d. 1039) tells of the search for an incense burner "in which a few pieces of fragrant ambergris could be burnt" during preparation of a corpse for burial: when nothing more elaborate could be found, a simple

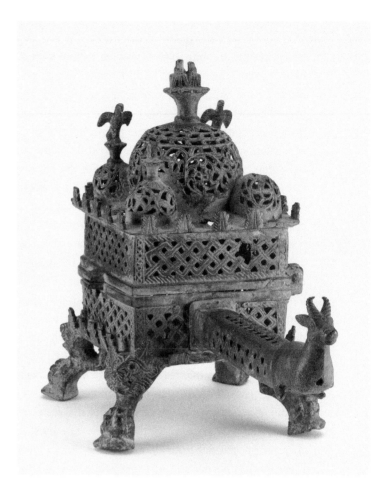

FIGURE 4.3 Incense
burner, Egypt or Eastern
Mediterranean, eighth
or ninth century. Cast
copper alloy. Height
31.5 cm. Freer Gallery
of Art and Arthur
M. Sackler Gallery,
Smithsonian Institution,
Washington, DC,
F1952.1.

earthenware bowl was brought for the purpose. And yet, when the time came to ex-
ecute the dead man's inheritance, it included "thousands of gold incense burners"
(*'alūf min majāmar al-dhahab*).[58] Even allowing for obvious hyperbole, Thaʿālibī's
tale suggests that luxurious metalwork incense burners were a customary item in
elite inventories, just as incense burners in the cheaper media of unglazed ceramic
and softstone were also in extremely wide domestic use.[59] Many descriptions of
formal banquets and parties mention the domestic use of scent, including incense,
and woe betide those who failed to comprehend the tacit codes that dictated what
was for shared use and what was intended as an individual gift, and tried to make
off with the incense burner that their host had presented for the use of his guests.[60]

 For all of these reasons, portable incense burners (Arabic *majmar, mabkhara,*
or *mibkhara*; Persian *ʿūd-sūz*) were in very wide use across the Islamic world, from
Spain to Central Asia.[61]

 Conceptualizing an incense burner as a monument was a practice with long
roots in the eastern Mediterranean world. Two objects, both excavated from eighth-
century levels on the Amman citadel in Jordan, represent two distinct pathways for

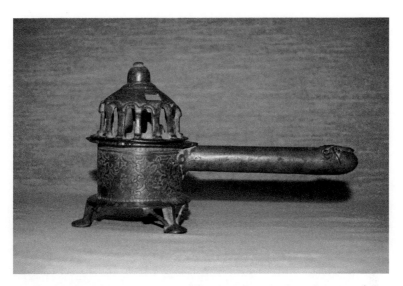

FIGURE 4.4 Incense burner, excavated from an Umayyad-era house in the citadel at Amman, Jordan, in 1949. Cast copper alloy with engraved and punched decoration. Height 11.5 cm. Amman, Jordan Archaeological Museum, Department of Antiquities, J.1660.

this practice in the early Islamic period.[62] The first of these, a cast bronze example, is cylindrical in form, with a long ram-headed handle and three bracketed feet, as well as loops for suspension projecting from the upper surface of the body section (Fig. 4.4). The last feature strongly supports the hypothesis that the handle, which is different in color from the rest of the burner, is a later addition. The hinged lid of the burner is formed from an open arcade of semi-circular arches sprung from footed columns, topped by a conical lid, and the effect is of a diminutive ciborium.

Without the later addition of the handle, the body of the Amman burner can be directly related to a type of architectonic suspended censer, created with or without supporting feet, known from examples found around the Mediterranean.[63] A similar structure surmounts a cast copper-alloy hanging lamp in the form of a fully modeled, sandaled human foot, attributed to fifth-century Syria (Fig. 4.5).[64] The paratactical combination of elements seen on the latter, which is only one example of a more widespread type, is quite typical of Late Antique plastic arts and indicates a comfort with the combination of ontologically distinct components that is also reflected in the Freer incense burner.[65] In northern Europe, the type would eventually generate a highly complex form of medieval hanging censer that reproduces in miniature the mansions of the heavenly Jerusalem as described in the biblical book of Revelation.[66] The ex-post-facto addition of the handle to the Amman piece, however, abruptly shifts it into what is normally treated as a separate category of incense burner: the domed, handled type with three feet. This form would come to be the model par excellence for luxurious incense burners in the late medieval peak of Islamic inlaid metalwork.[67]

FIGURE 4.5
Hanging
lamp, Eastern
Mediterranean,
probably fifth
century. Cast
copper alloy.
Height 12.9 cm.
New York,
Metropolitan
Museum of
Art, 62.101.1.

The particular form of the domed, handled incense burner mounted on three or four feet, which is the type under consideration here, has been traced in the western Islamic world to Late Antique sources common to Coptic and Byzantine production. The appearance of the same type as far east in the early Islamic world as Khurasan was pointed out by Ernst Kühnel and subsequently explored by Mehmet Aga-Oglu, Assadullah Souren Melikian-Chirvani, Eva Baer, and James Allan.[68] A convincing route map for the transmission of the form across the Islamic world has thus far evaded scholars, suggesting that art historical preoccupations with origins could be profitably augmented with other approaches when it comes to this highly portable and largely quotidian material. For example, Eva Hoffman has shown that identity and meaning among the portable court arts of the medieval Mediterranean were often enacted through "circulation and networks of connection rather than through singular sources of origin or singular identification."[69] However, unlike Hoffman's subjects, the identification of one incense burner with another as a "type" is predicated on rather more basic characteristics than the complex iconographies that link court arts together. The defining features of the handled, domed incense burner are essentially affordances that relate to use, rather than representing solely aesthetic choices.[70] Metal incense burners are mounted on feet and have handles because they get very hot when in use. Meanwhile, in the ancient world, cylindrical or dish-shaped incense burners, often with domed lids that protected burning substances (and users) while allowing enough air circulation for

combustion, were used all around the ancient Mediterranean and across Eurasia.[71] It is possible that the particular combination of affordances found on the domed, handled type of incense burner could have arisen independently in multiple locations.

There is, on the other hand, one nonfunctional element that suggests a common thread might run through the medieval Islamic corpus of tabletop incense burners. This is the adornment of the domed tops of incense burners with modeled figures of birds. Bird finials appear on a number of eastern Mediterranean examples from the Late Antique period and first centuries of Islam, including both the handled type and the suspended censer.[72] These avian guardians seem to have become a fixed element within the concept of the incense burner, and can also be seen in the Islamic east in the medieval period. A handled, domed incense burner of uncertain but probably early date with three legs and a bird finial was excavated at Bishapur in Iran,[73] and the "hooded" incense burners uniquely associated with tenth- to early thirteenth-century Khurasan are very frequently surmounted by bird finials (Fig. 4.6).[74] That the practice of surmounting incense burners with bird finials was widespread in the Iranian lands by the medieval period is evident not only from the surviving artifacts but also from a marketplace regulation of Ghazālī: "The tops of incense burners [ruʾus al-majāmir] are sometimes in the shape of a bird [ʿalā shakl ṭayr], but this is unlawful."[75] Thus the bird finial provides an iconographic clue that might eventually help clarify the Late Antique and early Islamic-era vectors of transmission responsible for moving portable objects, and ideas about portable objects, across the Middle East—but a comprehensive study of all the relevant material evidence is definitely outside the scope of this book.

To return from zoomorphic to architectural forms: the other line of precedence for architectural incense burners in the early Islamic context comes from stonecarved forms. A second Umayyad-era artifact, also excavated from the Amman citadel and assumed to be an incense burner, presents a strikingly coherent instance of the stone receptacle as monument (Fig. 4.7).[76] It has been carved from a single block of basalt—a stone not local to Amman and probably brought south from Hawran or Bosra—in the form of an open four-sided structure with four double-arched entrances, engaged corner columns with capitals and stylobates, stepped corner merlons, and a domed roof with four further arched openings.

Recent scholarship has linked the Amman piece with an earlier tradition of architectonic stone incense burners from the Arabian peninsula, although the latter are not normally quite so overt in their invocation of architectural forms. They construct an oblique kind of architectural allusion through rectangular recessions and low-relief crenellations on a cuboidal form, as seen on an example from Yemen (Fig. 4.8).[77] A different sort of parallel for the Amman find can be found in a remarkable carved limestone container now in the Princeton University Art Museum and thought to originate from sixth- or seventh-century Syria (Fig. 4.9). The dimensions of this object are virtually identical with those of the Amman basalt

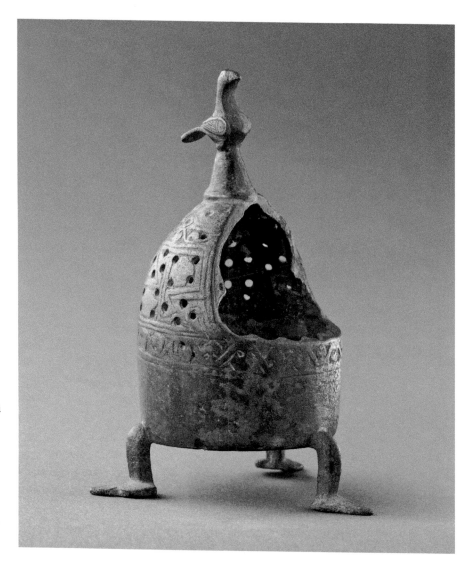

FIGURE 4.6
Incense burner,
Khurasan, eleventh
or twelfth century.
Cast copper alloy
with engraved and
inlaid decoration.
Paris, Musée du
Louvre, MAO 762.

piece, and the Princeton container follows a similar architectural conceit with four corner columns and a large arched opening on each of its four faces. However, where the Amman find is open through from one side to the other, the Princeton container has a central walled section accessible only from the top, and is decorated on one face with the relief-carved image of a closed doorway. It is quite possible that a domed lid would have completed the object originally, furthering the comparison with funerary or shrine architecture and also with the domed form of the Amman object.[78] The inscribed crosses that decorate the spandrels of one face of the Princeton object—conjectured to have functioned as a reliquary—may be original or may be a later addition endowing or confirming a Christian identity.

While there is much that remains speculative in the interpretation of these objects, the interplay of forms and ideas between the Princeton container and

the Amman basalt arti-
fact speaks of a larger cul-
tural current of eastern
Mediterranean objects that
mimicked central-plan ar-
chitectural forms and un-
doubtedly operated across
the religio-ethnic categories
into which such objects are
now divided. Regardless
of how they were origi-
nally used, these objects
attest to the colossal cul-
tural significance that was
accorded to certain forms
of architecture, particularly
the central-planned domed
building, in the Late Anti-
que Mediterranean world.
They were created within
a landscape scattered with
martyria, ciboria, and
aediculae, against the back-
drop of a monumental tradi-

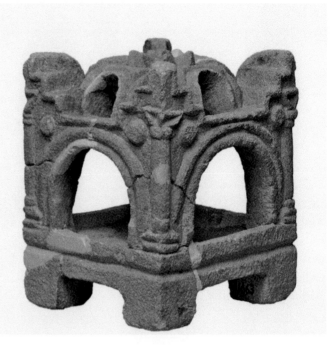

FIGURE 4.7 Incense burner (?), excavated from an
Umayyad-era house (eighth century) in the citadel at Amman,
Jordan in 1949. Carved basalt. Height 21 cm. Amman, Jordan
Archaeological Museum, Department of Antiquities, J.1663.

tion that gave rise to the first great building of the new faith, the Dome of the Rock.[79]

Mobile Monuments

Within a mobile network of manufactured goods that confound precise taxonomic
genealogies and attest to a "shared culture of objects," it is no simple matter to lo-
cate an object like the Freer incense burner in cultural context.[80] The piece has long
been attributed, with good reason, to eighth- or ninth-century Egypt—although an
argument for Iranian production has also been made. The basis for the Egyptian at-
tribution is the undeniable similarity between certain stylistic and technical elements
of the Freer burner and those of other cast openwork domed burners of copper
alloy, attributed to Coptic Egypt. Recent research and new archaeological data have
suggested that a more general attribution to the early Islamic eastern Mediterranean
area may be more appropriate for some of the latter.[81] On the Freer burner, the
standing eagles with outspread wings that once adorned all of the domes, the scrolling
vegetal forms of the openwork, the lion masks, and the handle that terminates in the
bust of a ram are all very closely aligned with those of a number of incense burners
that can be attributed with confidence to the eastern Mediterranean context.[82]

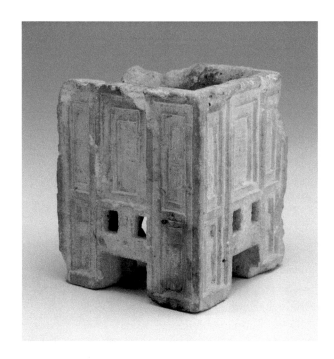

FIGURE 4.8 Incense burner,
excavated at Timna in southern
Arabia. Early first century.
Carved limestone. Freer Gallery
of Art and Arthur M. Sackler
Gallery, Smithsonian Institution,
Washington, DC, S2013.2.240.

Adding to the case for Egyptian manufacture, the closest known analogue for
the Freer piece is a smaller cast copper alloy incense burner in the Coptic Museum
in Cairo. It was reportedly found at Ahnas, a site in Middle Egypt, and has been
attributed to the eighth, ninth, or tenth century (Fig. 4.10).[83] Both the Coptic Museum
and the Freer burners were made in three parts, with handle, footed lower body, and
upper body each apparently cast as a single piece. There are minor differences: the
Coptic Museum piece has four semi-domes rather than near-complete corner domes
like those seen on the Freer burner, probably an outcome of crowding the quincunx
model into a smaller surface area. The eagles of the Coptic Museum burner have
folded rather than outspread wings, the openwork decoration on the body section is
vegetal rather than geometric, and there are hares rather than lions on the supporting
feet. However, these do not detract from the striking overall formal and conceptual
similarities between this piece and the Freer burner. The upper sections of each are
quite breathtaking in their complexity and push the technique of casting to its limits,
creating forms that are spatially complex both outside and inside. A simpler version
of the form, a cuboid surmounted by one dome with a radial floral finial supporting
a bird, can also be seen on another example in the Coptic Museum, but the poor con-
dition of the piece obscures most of its decorative detail.[84]

An equally emphatic relationship with architecture, constituted in a com-
pletely different way, can occasionally be seen on other cast incense burners from
the eastern Mediterranean context that also bear the impress of Late Antique ar-
tistic production. This is particularly evident in Fig. 4.11, with its openwork de-
sign of arcades filled with scrolling vegetation, and its paratactical employment of
three-dimensional aediculae as feet and finial.[85]

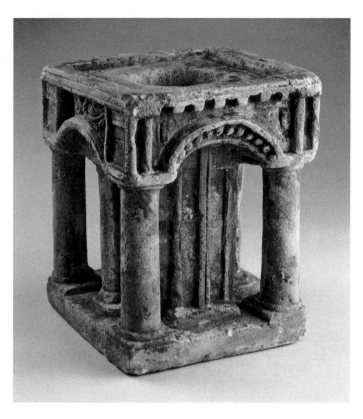

FIGURE 4.9 Container
(reliquary?), Eastern
Mediterranean, sixth or
seventh century. Carved
limestone. Height 20.7 cm.
Princeton University Art
Museum, 2003–88.

A further incense burner can be formally linked with the Freer and Coptic
Museum burners. This is an even larger example (34.5 cm. high to the Freer piece's
31.5 cm.), uncovered in a Swedish forest close to the Baltic coast in 1943 (Fig. 4.12).
In the same cache were three sets of undecorated tongs, presumably for use with
the burner, and a fragment of another copper-alloy vessel. The find thus provides
the unusual and satisfying spectacle of a medieval object of high craftsmanship
discovered complete with its attendant accessories. The footed, handled incense
burner has a large central dome, topped by a radial floral finial and mounted upon
a cuboidal body. It is without corner domes but has a parapet of stepped merlons
similar to, albeit larger than, those seen on the Freer and Coptic Museum examples,
and the parapet retains two of its four small corner projections of "pomegranate"
form. The body of the Swedish burner appears to be piece cast, with openwork
decoration and surface engraving. From photographs it looks as if the parapet was
made separately, possibly cut from sheet metal, and fixed to the lid section. The
piece is now held in Gävle County Museum, along with the other objects in the find.

Where the Freer and Coptic Museum incense burners can be securely attributed
to Egypt, the Gävle incense burner has been attributed tentatively but persistently
to eighth- or ninth-century Iran.[86] Karin Adahl published the most detailed study of
this object in 1990 and concluded from stylistic analysis and the well-documented
Viking connections between Sweden and the eastern Islamic world up to the early

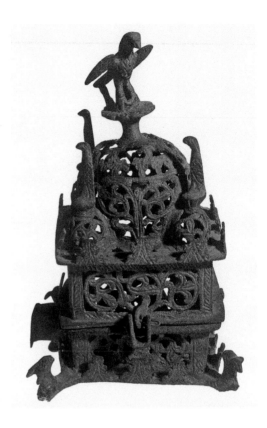

FIGURE 4.10 Cast copper
alloy incense burner,
reportedly found at Ahnas,
Egypt. Egypt or Eastern
Mediterranean, eighth or ninth
century. Height 27 cm. Cairo,
Coptic Museum, 5205.

eleventh century that the incense burner should be attributed to Iran, possibly
Khurasan, no later than the end of the ninth century.[87] She did however suggest in
an earlier publication that an eastern Mediterranean origin was also possible.[88] The
attribution of the Gävle incense burner to Iran presents us with a puzzle. The Gävle
burner and the Freer and Coptic Museum examples are suggested to have been made
in artistically distinct contexts perhaps two thousand miles apart. Yet, while they
differ on details of ornament, openwork, and architectural design, they are closely
related in form, dimensions, proportions, execution, and overall conception.

Debates over Iranian or eastern Mediterranean origins for the Gävle burner
and even the Freer piece expose the precariously speculative foundations upon
which much of the medieval metalwork corpus rests. In addition to their inherent
portability, which has taken them to findspots as far from their original places
of manufacture as Sweden, only a relatively small proportion of the handled in-
cense burners currently in museums and private collections appeared through
documented excavation from confirmed sites. This makes attribution an exceed-
ingly tricky business, and the collosal distance between the two proposed sites of
manufacture for the Gävle burner—the eastern Mediterranean and greater Iran—
shows how much is up for debate within this world of ambulatory artifacts.

As indicated above, debates about attribution have not been limited to the
Gävle incense burner. Eva Baer seems to have been the first to suggest a possible

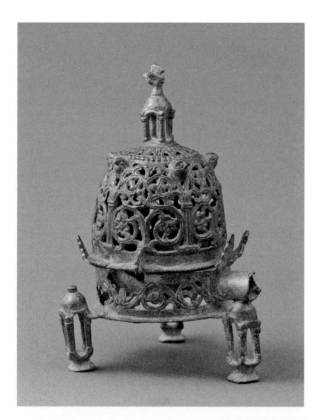

FIGURE 4.11 Incense
burner, Egypt or
Eastern Mediterranean,
eighth or ninth century.
Cast copper alloy. Paris,
Musée du Louvre, E
11707.

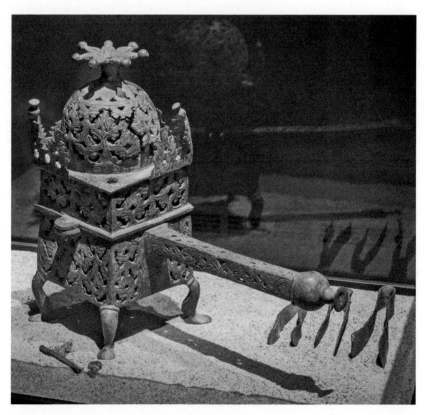

FIGURE 4.12 Incense burner, found at Gästrikland, Sweden, in 1943. Cast copper
alloy with engraved decoration. Height 34.5 cm. Gävle County Museum, 9699.

Iranian attribution for the Freer burner.[89] When Adahl subsequently proposed an Iranian attribution for the Gävle burner, she also noted that this raised questions about the origins of the Freer example. The relocation of the Freer burner to Iran was argued more forcefully by Géza Fehérvári as part of the case for a later example of related form that he believed to originate from eleventh- or early twelfth-century Ghazni, and he linked the forms of both objects to stupa architecture. However, the peculiar appearance of the later incense burner raises a number of questions that cannot be answered here.[90] Overall, the evidence for attributing the Freer burner to Iran is slim, and the overwhelming similarity between many of the decorative elements on the Freer and Coptic Museum burners and those found on other verifiably eastern Mediterranean examples leaves little doubt that the Freer burner hails from an eastern Mediterranean context.

Where does this leave the Gävle burner? It is not impossible that the idea of an incense burner as domed monument arose independently in two different locations, or that a now-lost corpus of similar objects was once in motion across the Islamic world of the eighth or ninth century. However, I will argue that the Gävle burner should probably be relocated to an eastern Mediterranean context, or, at least, not further east than the Jazira—while also considering why, beyond the basic questions of taxonomy, this matters.

Some ninth-century coins from Damascus and many more from Baghdad made their way to Sweden, and while the former probably represent the common monetary stock rather than direct trade contacts, there is certainly evidence of Viking trade connections with Baghdad.[91] It is not impossible that an incense burner could have traveled by similar routes. There are also a number of stylistic factors that suggest the Gävle burner was manufactured in a region closer to the metalworking centers of the eastern Mediterranean. First, while the drop-ended radial calyx finial of the Gävle burner has been cited as evidence of eastern origins, there is no obvious reason that it has to be so. I have not found a precise match for the form of the Gävle burner's finial in eastern or western Islamic metalwork, but similar drop-ended projections on radial vegetal elements can be seen on a number of cast bronzes attributed to the eastern Mediterranean and Islamic Spain.[92] At the same time, open, disc-like floral or radial finials, along with radial petaled forms on the crowns of the domes, are found on so many eastern Mediterranean domed burners that they can be considered part of the standard form. Similar radial floral forms appear on the spouts of some Coptic Egyptian oil lamps in bronze.[93] Architectural domes topped with open, disc-shaped collared finials can also be found in the "cityscape" of an eastern Mediterranean carved ivory plaque dated to the seventh or eighth century, suggesting that the disc-like or radial finial was a standard form in architectural representations of this milieu.[94]

Most distinctive on the Gävle burner is the palmette openwork that covers the body and the dome. The flat, regular, and rather textile-like qualities of the Gävle burner's openwork are quite different from the deeper, more fluid

openwork designs seen on the Coptic burner or the domes of the Freer burner, but this is not necessarily evidence that the Gävle burner hails from a tradition thousands of miles further east. The acanthus design of the openwork body of the Gävle burner has been compared with late Sasanian architectural decoration in stucco, which it does indeed resemble,[95] but it is different from openwork designs found in Khurasan metalwork. The latter typically follow a modified version of the Sasanian palmette rather than exactly copying the forms found in architectural decoration.[96] Exchanges between the Sasanian and Roman empires in the sixth and seventh centuries led to circulation of "Sasanianizing" ornament, including symmetrical palmette designs, in the architectural decoration of the Roman territories, where the symmetrical palmette went on to appear in early Islamic contexts like the stucco decoration of some of the Umayyad "desert palaces," as well as in the applied arts.[97] Further examples of architectural decoration from early Islamic Syria, such as an alabaster capital reportedly from ninth-century Raqqa, present useful forms for comparison with the openwork of the Gävle burner, and raise the possibility of a Jaziran connection for this highly regularized palmette patterning (Fig. 4.13).[98]

Architectural decoration has the important benefit of (sometimes) remaining in situ and thereby providing a secure point of comparison for motifs that moved

FIGURE 4.13 Capital, reportedly from Raqqa, Syria, probably ninth century. Carved alabaster. Height 27 cm. Berlin, Museum für Islamische Kunst, I.2195.

around via the portable arts, but individual motifs change when they are transferred from one medium to another. It is always preferable to compare like with like, metalwork with metalwork, wherever possible. I have so far found one instance of the same or very similar acanthus-type openwork in cast metalwork objects. It appears on an incense burner now in the Khalili Collection and attributed specu- latively by Michael Rogers to eighth- or ninth-century Syria (Fig. 4.14). In addi- tion to similarities between the drop-ended, petaled finials of both, the register of openwork acanthus-type palmette designs on the "drum" of the Khalili Collection piece is almost identical with that on the Gävle burner. Below, the lower body of the Khalili Collection burner is made up of two bands of openwork ornament that evoke architectural constructs: a highly stylized arcade runs below, and above it a band of stepped merlons projects upward and alternates with inverted triangular inserts that point down from the band above.[99] The stepped merlon is a particularly potent motif, with connotations of Sasanian architectural traditions: the stepped merlons on the Gävle and Freer burners have been presented as part of the argu- ment for Iranian origins.[100] However, they reflect a form that, while drawn from Sasanian architectural traditions, was in fact in wide circulation in the eastern Mediterranean by the Umayyad period.[101] The eighth-century palace known as Khirbat al-Mafjar or Hisham's Palace, near Jericho in Palestine, furnishes direct

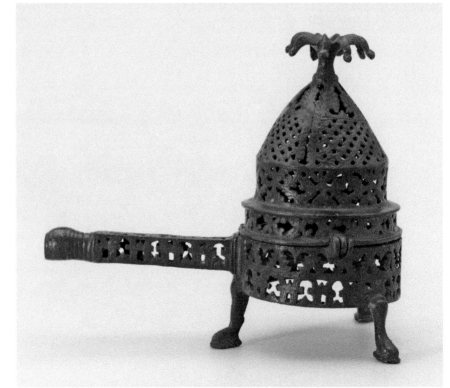

FIGURE 4.14 Incense burner, eastern Mediterranean, eighth or ninth century. Cast copper alloy. Height 26.6 cm. London, Nasser D. Khalili Collection of Islamic Art, acc. no. MTW 1044.

parallels in carved stone and plaster for the stepped merlons of all three of the incense burners, and other examples of the form could be cited.[102] Furthermore, stepped merlons can be found not only in the early and medieval architecture of the Islamic Mediterranean but also on a group of early medieval bronze candlesticks of architectonic form solidly attributed to al-Andalus and dated probably to the ninth, tenth, or eleventh century.[103] They also appear on the four corners of the basalt incense burner excavated from the Amman citadel (Fig. 4.7). Evidently the form, while perhaps still carrying exotic connotations, was in significant use in the Islamic West by the medieval period.

There is a further piece of architectural comparanda furnished by Khirbat al-Mafjar that has significant bearing on the questions of provenance and similitude surrounding the Gävle, Freer, and Coptic Museum incense burners. However, before discussing that artifact, I wish to consider the problems raised by attempts to use extant buildings as a means of locating archimorphic objects in time and space.

Fueled by questions of geographical provenance, the comparison of the Freer and Gävle incense burners with extant buildings has to date been largely unproductive. In an eastern Mediterranean context, the obvious architectural point of comparison that would provide the arrangement of domes seen on the Freer and Coptic Museum burners is the Middle Byzantine five-domed church type, which seemingly came into existence with the completion of the now-lost church of Nea Ekklesia at Constantinople in 880.[104] The canon of Islamic art history furnishes an obvious monument of domed cube form for comparison from the eastern Islamic world, the so-called Tomb of the Samanids, Bukhara (tenth century), which the proponents of an eastern origin for some of the domed burners have foregrounded in their arguments. This building is demonstrably descended from the Iranian model of the Zoroastrian *chahār ṭāq* ("four arches") fire temple, a type that is in turn proposed to have developed out of Roman architectural forms.[105] The idea of an incense burner that recalls a fire temple has obvious appeal, but without a definitive case for the Khurasanian origin of the Gävle burner there is no need to infer that the domed burners and the Tomb of the Samanids have any connection with each other.

Ultimately, the problem with all such comparisons is that they presuppose a direct referential relationship between object and building. To counter this emphasis on mimetic referentiality, Gelber has argued that the forms of the Freer burner and other domed incense burners should be understood as universalizing in their approach to architecture because "they do not display specific stylistic features" and are without direct reference to real-world monuments.[106] It is certainly true that trying to project individual extant buildings onto the incense burners, or vice versa, is a dead end: the lens of mimetic referentiality is not a productive one for these objects any more than it was for the inkwells of Chapter 3. However, the architectural specificity and spatial complexity of the Freer, Coptic Museum, and Gävle incense burners marks them out within the much larger corpus of domed burners, and this much can be recognized without either reducing them to failures

of mimesis or retreating into universalisms. The mounting of a large central dome atop a cuboid edged around with stepped merlons (in combination with four smaller corner domes in the case of both the Coptic Museum and Freer burners), is both complex and coherent enough in all three instances to constitute quite a pronounced emulation of a particular architectural schema, even when combined with the non-architectural features of handle and zoomorphic feet. There is no possibility of failing to understand these objects as allusions to built structures. In particular, the proportions of monumentality are thoroughly articulated, in spite of the tremendous reduction in scale.

If extant architecture is not a productive lens for the burners, what is? Esin Atıl has suggested that a now-lost Christian architectural type was probably the model for the Freer incense burner, either directly or—tellingly—through the intermediary of other works of the plastic arts.[107] The Late Antique redescription of domed architectural forms across a scalar spectrum, from monuments to ciboria and baldachins to portable arts, seems to provide the most productive avenue of enquiry, and the Umayyads inherited a rich tradition of such structures. Of particular relevance to this argument, and especially for the attribution of the Gävle burner, is an aedicule executed in carved stone that was excavated from the ruins of the audience hall at Khirbat al-Mafjar (Fig. 4.15). The archaeologist Robert Hamilton

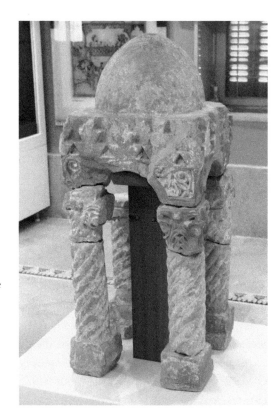

FIGURE 4.15 Carved marble "cupola" found at Khirbat al-Mafjar, Palestinian territories. Eighth century. Dimensions unknown, Hisham's Palace Museum.

believed it to have functioned as a cupola on top of the brick dome of the *diwan* space, although there is little evidence for such a configuration and it is much more likely that the object originally stood on the ground.[108]

The structure, which appears to be little more than three feet high, has been reconstructed but was carved from sandstone and decorated with paint and plaster. A dome of slightly pointed and elongated hemispherical form is mounted on a cuboidal plinth. The latter sits on four corner brackets formed from the spandrels of semi-circular arches on each of its four faces, and is decorated with a horizontal frieze of relief-carved stepped merlons above foliate decoration in the spandrels. Supporting the plinth are four capitals with vegetal designs, beneath which four short barley-sugar columns have been mounted on simple cuboidal bases. The proportions of the dome and plinth, and in particular the frieze of stepped merlons that delineates a virtual parapet around the dome, provide an important point of comparison for the Gävle incense burner in particular. The Sasanian line of descent evident in its decoration was cause for Melikian-Chirvani to link the structure speculatively with the form of Iranian fire temples.[109] While the "Iranian" elements are indeed striking, the object participates directly in the broader tradition of Late Antique Mediterranean ciboria.[110]

The Khirbat aedicule is only one happenstance survival of a larger tradition of intermediary structures of domed form in the early Islamic eastern Mediterranean—as the Amman burner and possibly also the Princeton container also attest. I have been unable to find any early ediculae, ciboria, or containers with five domes, but it is certainly possible that the Freer and Coptic Museum burners reflect other now-lost intermediary structures that once afforded space for experimentation with the quincunx arrangement that would come to crown Middle Byzantine church architecture.[111] This may be a case where formal arrangements in the plastic arts have prefigured those of architecture. The three cast-metal incense burners and other objects discussed in this section are part of a multi-scale architectural spectrum of domed units in the Late Antique eastern Mediterranean and beyond, and attest to the penetration of that model into the portable arts—where it was not bound by the structural constraints of monumental architecture. While the idea of combining incense burners with architecture must have arisen in part from the paralleling of domed forms across different modes of making, the specifics of the individual designs were undoubtedly consciously chosen for their gravitas in a milieu where there was a long tradition of significant and sacred spaces demarcated by central-plan domed structures, both miniature and monumental. Against such a backdrop, questions of attribution—on which this section has lingered—are unlikely to be resolved with absolute precision, but viewing the incense burners through the lens of Late Antique spatial practices acknowledges their participation within a fluid and evolving vocabulary of forms demarcating sacred and significant spaces in the eastern Mediterranean and beyond. Whether liturgical or domestic,

Christian or Islamic, their assimilation of a significant architectural form endows the incense burners with greater cultural weight.

The most striking aspects of the Freer, Coptic Museum, and Gävle incense burners are their unitary nature as objects and the resulting vividness of their immediate visual and spatial impact. Object and monument are fully merged into a self-contained unit that stresses its chosen architectural concept by foregrounding the formal unit of the dome and its relationship to the cuboidal structure that it crowns. At the same time, mimetic precision is not a driver, and elements of architectural fantasy, such as the exaggerated calyx finials, coexist with monumental forms of greatly reduced scale, zoomorphic feet, handles, and surface decoration containing little that is specific to architecture. In this respect, the incense burners under discussion embody two vital qualities of a particular kind of literary metaphor: immediacy and autonomy. They are not sustained descriptions of architecture to be traced through stages and experienced through time, but totalizing units that impress themselves upon the beholder as vividly and instantaneously as a mental image.

In use, the incense burners would have been wreathed in smoke, partially dematerializing their forms. Therefore, the beholder's apprehension of these objects would be directly affected by their role as generators of an emission—smoke—that is without substance but nonetheless affects vision. A later group of eastern Mediterranean lanterns share with the incense burners not only the form of the domed monument but also the function of housing another even more profoundly visually affective emission—light. I will now turn to these lanterns and the question of meaning that is raised by the recurring use of the domed form among all of these objects, before finally returning to the subject of metaphor.

Radiant Monuments

Architecture and metalwork were certainly not the only crafts in dialogue with each other in the medieval Islamic world. Many scholars have noted the reciprocal relationships that existed between the media of ceramics and metalwork, in pre-Mongol Iran and Central Asia in particular. The more expensive medium of metalwork is normally ascribed precedence, although, as Alison Gascoigne has recently noted, we should always look closely at such hierarchies to establish if they are really reflected across all forms.[112] In turn, it has also been argued that some of the forms now surviving in bronze or brass were originally made in imitation of precious metal vessels that have not survived.[113]

A glazed ceramic container of domed form, attributed by Oliver Watson to thirteenth-century Syria and now in the al-Sabah Collection in Kuwait, exhibits several signs of borrowing from metalwork (Fig. 4.16). The socket for a projecting handle, the four molded figures that act as elevating feet as well as providing scale, and the small piercings in the dome, would all make more structural sense

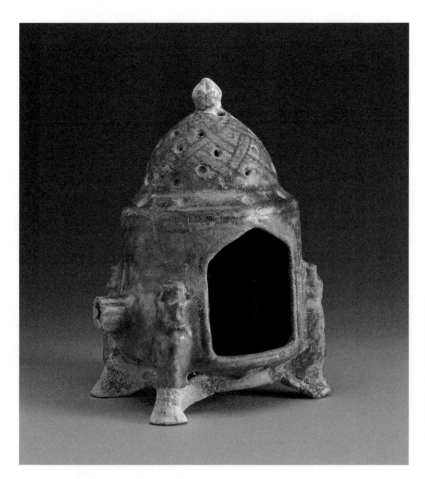

FIGURE 4.16 Incense
burner, Syria, probably
thirteenth century.
Molded and glazed
stonepaste. Height
18 cm. Al-Sabah
Collection, Kuwait,
LNS 121 C.

in metal than they do in the medium of glazed ceramic.[114] Compare, for example,
the perforations, many of them rendered redundant in ceramic by clogging with
glaze, and the incised strapwork design on the dome of Fig. 4.16, with the "hood"
of Fig. 4.6. The unmistakable form of a domed monument with a pointed finial that
defines the ceramic burner was presumably also carried over from the tradition of
cast-metal incense burners. The large arched opening cut into the wheel-thrown
form of the al-Sabah piece seems to be a response to the problem of making a
domed incense burner in a medium that does not allow for the creation of hinged
and movable parts, and it connects the object with both the domed incense burners
of metalwork traditions and a pair of domed ceramic lanterns (Figs. 4.17 and 4.18).
These last are also believed to have come from Syria, and have been linked with
production at Raqqa in the late twelfth or early thirteenth century.[115]

The lantern in the Metropolitan Museum is better preserved and better
known, and must have entered the international art market at some point prior
to 1888, when it was sold as part of the collection of Albert Goupil (Fig. 4.17).[116]
The much-repaired lantern in the Dumbarton Oaks collection was acquired from

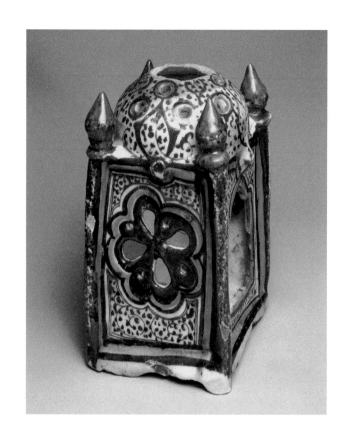

FIGURE 4.17 Lantern, Syria, probably Raqqa, late twelfth or early thirteenth century. Glazed stonepaste with cobalt underglaze and luster decoration. Height 23.2 cm. New York, Metropolitan Museum of Art, 91.1.138.

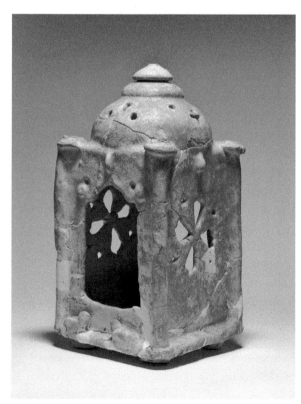

FIGURE 4.18 Lantern, reportedly found at Raqqa in 1950. Glazed stonepaste with traces of luster decoration. Washington, DC, Dumbarton Oaks Collection, BZ 1950.39.

the Beirut dealer Elie Bustros in 1950, who offered it to the collection as a "petit autel en céramique byzantine" or "tabernacle byzantin" reportedly found at Raqqa in 1950 and reconstructed from fragments (Fig. 4.18).[117] The identification with Christian practices appears to have been based on the pierced square crosses on the dome, but these are probably incidental decorative forms rather than markers of Christian identity.[118] A third example of the type, looking heavily restored, was sold at auction in 1986.[119]

The Metropolitan and the Dumbarton Oaks lanterns follow the same form very closely, and the two are clearly products of the same environment—probably even the same workshop. The profile is that of an elongated cuboid, with a large central dome and engaged corner columns surmounted by disks that once supported four corner projections around the dome: those on the Dumbarton Oaks example are missing, and at least some of the ones the Metropolitan Museum lantern seem to be replacements. Both of the lanterns have large, arch-shaped entrances cut into two facing walls, and four-petaled "rose windows" with smaller, interstitial circular perforations cut into the other two. The Metropolitan Museum lantern once had colored glass pieces on the inner face of the petaled "windows," but these were subsequently removed as later additions. The projecting crowns of both domes have been broken off and lost, the Dumbarton Oaks example having received a modern replacement and the Metropolitan Museum piece formerly sporting a pierced replacement top complete with hanging chains. On the Dumbarton Oaks lantern, two rather crude birds of pinched and shaped clay face each other below the arched openings on two sides. Walls and floor of both have been constructed from slabs, while the domes appear to have been molded.

Traces of designs in brown can still be seen on the heavily degraded surface of the Dumbarton Oaks lantern: enough is present on one of the open faces to show that it was originally decorated along very similar lines to the Metropolitan Museum example, with outlined spandrel panels and a scattered ground of curlicues. One fragment of the Dumbarton Oaks lantern also retains traces of what appears to be an inscription, but too little survives to guess the content; furthermore, given the state of the object, this could quite possibly be a sherd from another artifact used to fill a gap during reconstruction. The characteristic glassy, greenish glaze associated with Raqqa production has pooled thickly in the interior, covering the "floor" with a now irridesced and cracked surface of glaze several millimeters thick.

The monument type invoked by the ceramic lanterns is a domed cuboidal structure with corner projections. The form conveys a type rather than a specific monument and is directly identifiable with Islamic commemorative architecture as it had developed by the medieval period.[120] Where the incense burners were too early to be placed unequivocally into the same tradition and have been shown to relate more closely to multilayered honorific currents in Late Antique art and architecture, the lanterns are products of a medieval Islamic landscape in which the central-plan domed monument was highly visible and had been fully assimilated

into Muslim pious visitation and funerary practices.[121] Its proliferation across Central Asia and the Middle East by the medieval period and its incorporation into popular religious practice meant that the type, from its grandest to its humblest incarnations, would have been familiar to audiences across the social spectrum, as would its meaning. The centrality of the dome to this architectural form, literally and figuratively, is reflected in the metonymical term by which it is frequently known: *qubba* or *gunbadh*, Arabic and Persian words for "dome."[122] Evidence to suggest that the phenomenon was not limited to the eastern Mediterranean world comes from two surviving monument-shaped lamps in the Herat Museum, speculatively dated to the tenth to thirteenth centuries. Both are considerably squatter in form than the pieces associated with Raqqa, and they are made from slip-painted earthenware rather then glazed stonepaste, but the basic idea of a lantern made to look like a cuboidal building topped with a dome is unmistakable. The more elaborate of the two pieces in the Herat Museum is even decorated in its dome with cross-shaped incisions like those seen on the Dumbarton Oaks lantern.[123]

The visual trope of the domed or pyramid-roofed lantern as a building is also encountered in extant eastern Mediterranean metalwork. A striking instance of this is the gilt bronze lantern formerly in the Mevlevi Sufi lodge in Konya, central Turkey (Fig. 4.19). Its maker, Ḥasan ibn ʿAlī, included his own name within its intricate pierced decoration. The wealth of fantastic decoration on the piece that draws from the pool of Anatolian Seljuq imagery—double-headed eagles, dragon-tailed lions, open-jawed serpents—suggests a date in the second half of the thirteenth century.[124] Where the Syrian ceramic lanterns are formed of solid slab walls perforated by discrete arched apertures and rose-window-like piercings, the metalwork lantern is—by necessity—partially dissolved through openwork and hence much further removed from any sense of architectonic solidity. At the same time, however, the dissolution of surface with complex patterning carries its own connotations of textiles and tent architecture, often cited as inspirations for the development of central-plan funerary architecture in Central Asia and the Iranian plateau.[125]

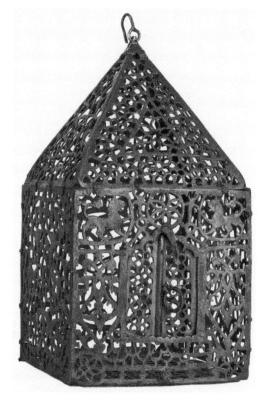

FIGURE 4.19 Lantern, probably Konya, Turkey, 1250–1300. Cast copper alloy with gilding. Height 25 cm. Konya Müze Müdürlüğü, 400.

The Konya lantern's planar construction from sheets of metal, riveted, soldered, and wired together, also precludes the possibility of a dome. The "roof" is instead pyramidal, while the body is an equilateral cuboid. In spatial terms the Konya lantern assumes one of the simplest enclosed forms possible, and indeed without the inclusion of an elaborate double door of cusped arch form on the front face there would not be much to prompt an architectural interpretation of the object.[126] The floor is hinged and presumably when the lantern was being made ready for use it would have been the primary means of setting a lamp in the interior, although the door could also be used to access the inner space. The form of the door, therefore, is not solely an outgrowth of function but also a conscious artistic choice to exploit the proto-architectural aspect of the lantern's form by mapping an architectural schema onto it.

The emphasis on the doorway of the metalwork lantern is continued in a number of later examples, including a unique six-sided brass lantern in the Keir Collection that has been variously attributed to twelfth- or thirteenth-century Anatolia, fourteenth-century North Africa, and Egypt (Fig. 4.20).[127] The Keir lantern is considerably more elaborate than the Konya piece, with ledges, finials, and lions for feet, and has been likened to a Seljuq-era *kümbet*, a polygonal or cylindrical tomb monument with a conical or pyramidal roof (Fig. 3.17).[128] Later, a number of openwork six-sided pyramidal brass mosque lamps that survive from Mamluk Egypt are adorned with domes and doors (Fig. 4.21).[129] The form of the Mamluk lamps, with walls set at a pronounced batter and varying degrees of rotundity seen on the individual domes, is architectonic without making reference to an identifiable type of building. The emphasis placed on the doorways in these examples becomes their most purposefully articulated connection with monumental architecture. Some are even fitted with tiny multifoil doorknockers in imitation of a well-known type of fitting found in Mamluk and post-Mamluk buildings (Fig. 4.22).[130]

As with the incense burners, attempts to establish a prehistory of the lantern formed as a radiant monument in the eastern Mediterranean lead in several directions. A second-century BCE earthenware lantern in the form of the Lighthouse of Alexandria attests to one impulse in this practice,[131] while some so-called house shrines, earthenware structures in the form of little buildings from eastern Mediterranean sites, might also have functioned as lanterns.[132] Most striking is a remarkable polycandelon in the form of a basilica found near Chlef, Algeria (Fig. 4.23), and attributed to the fifth century CE.[133] A spectacular work of cast bronze, the polycandelon demonstrates the remarkable dematerialization of structure that the portable arts can bring to bear on architectural form: the dissolution of the outer aisles and narthex allows the viewer visual access to the miniature structure's interior and the *cathedra* that occupies the apse.[134] This unusual object attests to a correlation of light, spiritual symbolism, and architectural structure in Late Antique Christianity, but it is entirely distinct from the

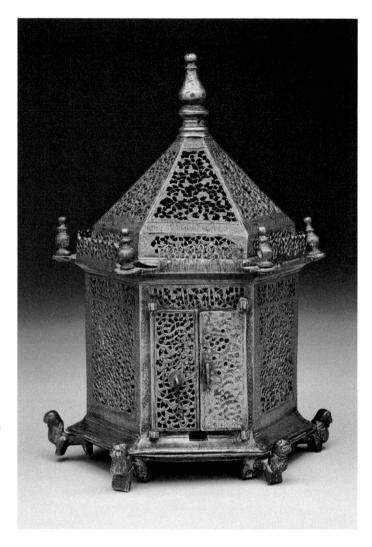

FIGURE 4.20
Lantern. Cast
copper alloy.
Height 29 cm. The
Keir Collection on
loan to the Dallas
Museum of Art,
K.1.2014.75.A-B.

medieval Islamic lanterns in both its concern with typological precision, and its location of radiance in extensions from the building rather than the building itself.

None of this earlier material, then, fully accounts for the particular versions of the radiant miniature monument created in the medieval Islamic sphere. By creating lanterns in forms that allude to Islamic commemorative architecture, the artists of these objects must have been strongly motivated by symbolic connotations. Light (*nūr*) is "the most inclusive attribute by which God is described," and became, in the Muslim tradition, one of the ninety-nine beautiful names of God.[135] Correspondingly, light is frequently understood in medieval Islamic exegesis to be a visible, temporal counterpart of the preexistent divine light. The medieval period saw the subsequent development of an Islamic metaphysics of light, much of it initiated by exegeses of the famous "Light Verse" of the Qur'an (24:35), already discussed briefly in Chapter 1, which begins, "God is the light [*nūr*] of the heavens

and the earth; the likeness of His light is as a niche [*mishkāt*] wherein is a lamp [*miṣbāḥ*]."[136] In a cultural setting steeped in the religious value of both light and similitude, crafting a lantern in an architectural form associated with Islamic funerary buildings and shrines creates the possibility of a fully radiant miniature monument, a light of the faith. The domed lanterns represent, in use, both a materialization of immaterial effulgence and a layering of visual metaphor. The lantern becomes a commemorative building, which becomes a beacon, which becomes Islam.

Metaphor and Modality

The shifting ground of forms, meanings, and allusive objects brings this chapter back, finally, to the question of metaphor. To entertain the possibility of visual metaphor, one must consider the ways in which language designates meaning. Medieval Arabic writings on grammar and poetics are structured around the dualism of *lafẓ* ("word" or "sound") and *maʿnā* ("concept" or "meaning"), that is to say, "vocal form and mental content." [137] This indigenous literary philosophy of

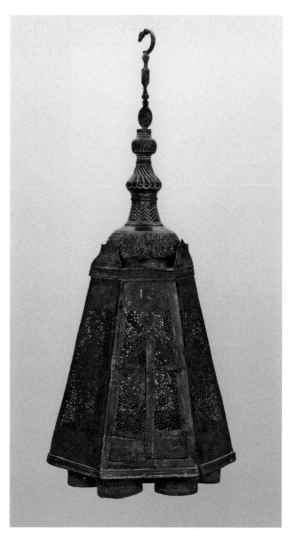

FIGURE 4.21 Lantern, Egypt, possibly fourteenth or fifteenth century. Cast brass with openwork and engraving. London, Nasser D. Khalili Collection of Islamic Art, acc. no. MTW 0847.

language was rooted in pre-Islamic poetic and oratorical traditions that were distinct from, and sometimes set in contrast to, the tripartite theory of linguistic meaning (sounds, thoughts, and things) imported from Aristotelian sources. However, the two systems would eventually prove mutually productive, and the blossoming of Arabic literary theorization and criticism in the late ninth to eleventh centuries saw the emergence of fully fledged Arabic theories of language and poetics.[138]

The medieval expansion in the focus of Arabic literary studies, from the philological study of the Qur'an to broader criticism and theorization of poetry and

FIGURE 4.22 Detail
of figure 4.21.

literature, developed alongside new trends in poetry that emanated from the so-
called modern poets of the ʿAbbasid capital in ninth-century Baghdad. The de-
fining characteristic of the poetry of the ʿAbbasid moderns was a group of stylistic
features bracketed under the name *badīʿ*, literally "novel" or "original," which
came to have the technical meaning "rhetorical ornamentation" or "figures of
speech."[139] The terms gathered under this new poetic category cover a range of
consciously and frequently used forms of rhetorical artifice, many of which are
directly concerned with the construction of images in the mind of the reader or lis-
tener. These techniques are difficult to systematize because their precise uses tend
to vary from one context to another and even from one author to the next. *Ishāra*,
discussed at the very beginning of this chapter, came to have a general meaning of
"allusion" but was in the eleventh century divided into thirteen subcategories by
Ibn Rashīq (d. 1064 or later).[140] *Taʿrīḍ*, also sometimes translated as "allusion" or
"intimation"; *kināya* ("metonymy"); *ramz*; and so forth—all these represent fur-
ther forms of indirect expression equally prone to shifts of categorization.[141] The
diversity of figures of speech available within medieval Arabic and Persian literary
discourse, and the variability of their usage, makes a total survey neither viable nor
desirable in this context. It also attests very clearly to an extremely energetic in-
terest in indirect expression and the rhetorical imagination within medieval Arabic
literary circles.

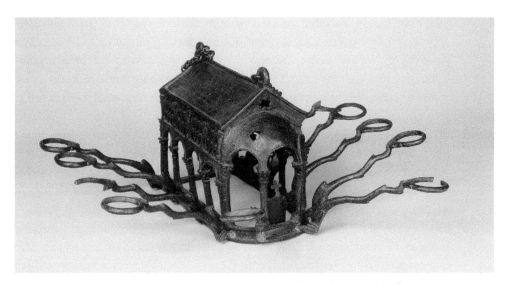

FIGURE 4.23 Polycandelon, reportedly found near Chlef, Algeria, fifth century. Cast copper alloy. Height 26 cm. St. Petersburg, State Hermitage Museum, ω 71.

Among all such terms, it is *istiʿāra* (literally "borrowing," usually translated as "metaphor") that has garnered the most attention, in ninth-century Baghdad and modern scholarship alike.[142] The contrast drawn by Wolfhart Heinrichs between "old" and "new" uses of *istiʿāra* is of particular interest in this context. Heinrichs argues that early uses of the term to denote an attributive relationship—"making something belong to something else"—were gradually supplanted in the ninth, tenth, and eleventh centuries with a new meaning predicated on direct substitution of one thing for another, "making something become something else."[143] The earlier uses of *istiʿāra* are notable for their capacity to endow the abstract with concrete qualities, in the process turning "real [immaterial] things into imaginary [concrete] ones," as when a hand is given to the wind or claws to death. Strikingly, most of the examples cited by Heinrichs constitute anthropomorphism or zoomorphism.[144]

In this earlier sense, the technique of *istiʿāra* involved more than just the transfer of a name, borrowed from one thing and applied to another. Rather, it consisted in the " 'borrowing' of an object from an owner who possesses it in our world and giving it on loan to one who does not."[145] Later definitions of *istiʿāra* are predicated on direct verbal substitution, and normally originate in a perceived point of likeness between the original subject and the substituted one. By this means, beautiful faces become moons, eyes are narcissi, and so forth.[146]

The fusion of building with incense burner invoked in the first group of objects in this chapter emerges somewhere in between Heinrich's two modes of *istiʿāra*. On the one hand, the incense burners are endowed with forms borrowed from things external to themselves, with the result that they are recast in ways that

merge one type of created artifact with another, and transcend utilitarian function-
ality with a new visuospatial identity. But they are not miniature buildings. The
parataxis of their decorative elements is not intended to add up to a mimetic rend-
ering of anything in the real world, but to merge disparate modalities into a new
synthetic creation in which multiple associations coexist and reinforce each other.

On the other hand, the centrality of likeness to the substitutions enacted
through the "later" formulation of *istiʿāra* is directly analogous to a recurring
theme in this book—that is, the point of perceived formal or functional affinity that
acts as catalyst for the construction of an allusive relationship from object to archi-
tecture. To tease out the role of points of likeness within medieval conceptions of
istiʿāra, one can turn once more to the work of the literary theorist Jurjānī. Jurjānī's
classification of *istiʿāra* was not the only one available in the eleventh century, but it
is one of the most comprehensive and influential to have survived. It is of particular
interest here for its preoccupation with the processes of visualization upon which
the success of poetic imagery depends.[147] In his studies of style, rhetoric and poetic
imagery, the *Asrār al-balāgha* (Secrets of eloquence) and the *Dalāʾil al-iʿjāz* (Proofs
of the inimitability [of the Qurʾan]), Jurjānī argued that the effective use of met-
aphor is predicated on an affinity between the resembling attribute or dominant
trait (*al-khāṣṣa al-raʾīsiyya* or *akhaṣṣ al-ṣifāt*) that links two entities. The point of
similarity upon which an effective metaphor hinges, according to Jurjānī, can be
recognized in a number of ways. These range from direct association to the acti-
vation of more complex processes of remembrance, evocation and visualization.[148]
He goes on to rank different types of metaphor by the extent of the interpretation
(*taʾawwul*) that they require.[149]

Jurjānī's theory of metaphor, in its emphasis upon a perceived point of affinity
between the subject and its substitute, can be related very directly to the points of
kinship that have been shown to act as catalysts for the self-conscious development
of allusive relationships between objects and buildings. In the first group of objects
in this chapter, the formal point of kinship lies between the domed spaces of
buildings and the domed form of a common type of incense burner. In Chapter 3 it
subsisted in the shape of polygonal pavilions and polygonal stands. In Chapter 5 an
affinity of function rather than form will constitute the initial point of departure for
a correlation drawn between architectural water features and carved stone stands
for water jars. In all of these there is an identifiable point of kinship between two
otherwise distinct modalities, and this connection has prompted further elaboration
of the object in ways that accentuate its relationship with the architectural form in
question. This can be either self-evident and almost automatically extrapolated by
the beholder because it is based on outward appearances (e.g., domes, polygonal
plans), or else can require elucidation because the point of linkage lies between
effects or outcomes rather than initial appearances (e.g., the provision of water by
fountains and by water jars on stands). In this light, the combination of incense
burner with domed building represents not a disjunctive combination providing a

puzzle to be decoded by the viewer, but an intuitive, ludic development built upon a particular point of similitude.[150]

As a linguistic framework for apprehending, describing, and making the world, metaphor directly affects cognition and behavior. Words can neither be separated from concepts, nor from the material, spatial world. Studies in cognitive poetics provide useful vocabulary that can be applied to these material metaphors: when a single point of affinity has been established between object and architecture, the schema of the building can be mapped onto the burner, including both formal features and sociocultural meanings. For example, the initial point of commonality between lanterns and domed shrines or funerary monuments is that both are enclosed, domed spaces with a controlled point of human access to the interior. Finials, crenellations, corner colonettes and so forth represent a further mapping of the metaphor onto the lantern through secondary features, drawing the object into the social semiotic of the building—in this case the sacred and funerary associations of the domed, central-plan monument.[151] The flexibility of this framework permits a divergence from mimesis, resulting in permutations of the type that lie further and further from an identifiable architectural reference point.

The great thirteenth-century Sufi metaphysician Ibn al-ʿArabī (d. 1240) recognized the cognitive power of material embodiment when he composed a passage with striking implications for the conceptualization of metaphor—verbal, visual, and material. The human imagination, he writes, is

> incapable of receiving meanings disengaged from substrata as they are in themselves. That is why it sees knowledge in the form of milk, honey, wine and pearls. It sees Islam in the form of a dome [*qubba*] or pillar [ʿ*amud*]. It sees the Qurʾan in the form of butter and honey. It sees religion in the form of a cord. It sees the Real [*al-ḥaqq*] in the form of a human being or a light.[152]

Thus, by Ibn al-ʿArabī's time, the metonymy of "dome" as a term to denote a domed commemorative building is matched by the visual synecdoche of the dome that is understood as shorthand for Islam. This is coexistent with a well-developed iconography of height and the heavens in material and poetic conceptions of the dome.[153] The mediation of the faith through its most distinctive architectural forms, from the columned prayer halls and arcaded courtyards of mosques to the ubiquitous dome, provides one of the great material embodiments of metaphor in medieval Islam. It is little wonder, then, that the anonymous craftsmen who elevated the medieval Islamic art of the object would seek to participate in the gravitas of this architectural form.

Throughout this chapter, the shortfalls of taxonomic art history have been evident in the traditional segregation of objects into religio-cultural silos—Coptic, Byzantine, Islamic—that are neither sustainable nor always very useful, in any deep sense, at the level of mobile material culture. While it has been necessary to

tackle the question of attribution head-on in the case of the domed incense burners, that was the secondary outcome of a study that has sought to construct alternative frameworks for the meanings and modes of architectural allusion across a spectrum of objects designed to be handled and used as well as looked at. The model of metaphor proves to be productive for objects endowed with the immediately comprehensible and self-contained form of the central-plan, domed building, an architectural type that evolved to have colossal significance in the medieval Islamic world. The next chapter will extend the verbal framework beyond metaphor to consider the poetics of the portable object in a different light. Returning to the evocative qualities of ornament and its potential to act as a system of spatial transformation raised in Chapter 2, the last chapter of this book poses a final question: Can decoration be description?

5

THE POETICS
OF ORNAMENT

L ike ornament, the poetics of architecture lie "at the juncture of diverse expe-
riential realms."[1] Medieval texts that liken the poet's craft to that of the archi-
tect, and individual poems and even poetry itself to buildings—examples of
which were discussed in Chapter 4—are only one aspect of a larger entanglement
that produces buildings from poetry and poetry from buildings. Images and objects
extend this web of signification, offering visual and material means by which the
somatic, social, and semiotic experiences of architecture can be represented and
embodied. To take an example mentioned briefly in the introduction, the hyper-re-
fined idiom of Persianate miniature painting brings into one field the painted image
and the graphical and semantic charge of poetry. In this unique genre, painters
developed startlingly inventive models for relaying the sensory and imaginative
experience of architectural space at the same time that they exploited the architec-
tonic potential of the text grid (Fig. I.12).[2]

Beyond painting, the spatial dimension afforded by the art of the object offers
some of the most lyrical, but also elliptical, possibilities for the transubstantiation of
architecture. The primary subjects of this chapter are complex objects; only through
close analysis of the individual architectural forms carved upon them is it pos-
sible to grasp the full weight of their signification and the mechanisms of rescaling

and rearrangement that have ordered their appearance. The first, and longest, part of the chapter is therefore taken up with decoding and contextualizing the group of jar stands from medieval Cairo known as *kilga*s (Figs. 5.1 and 5.2). Through detailed comparison with contemporary structures, it is possible to unlock the referential dimensions of the objects and the complex ways in which they recast not only the form but also the social, cultural, and civic significance of a particular type of structure. This will be done by identifying component motifs and combinatory passages of ornament and locating these within the medieval Cairene urban environment and broader context of the Mediterranean littoral.

The second part of the chapter changes gear to consider certain questions of perception and artistic license raised by these objects and the ways in which they play with architectural form. In this part I focus particularly on the potential of poetic description or ekphrasis as a productive model for accessing ornament's evocative potential and its ability to conjure an external referent allusively. Like metaphor, ekphrasis is a literary device that seeks to generate an image or sensory experience in the mind of the reader or listener. Its success as a technique relies upon the judicious selection of particular components for close description, and their vivid evocation through sometimes startling imagery.

In the last part of the chapter, the parallels drawn between the poetic act of description and the allusive ornamentation of objects lead to consideration of the relationships between description, allusion, and the workings of memory and time within the somatic experience of architecture. In Chapter 1 of this book I directed attention toward the bodily interface between the internal world of the intellectual faculties and the external world of matter that the medieval subject sensed, inhabited, and manipulated. In this final chapter, the internal senses return to the fore via the connections that they articulate between sensation, imagination, and memory, and the outward expression of these cognitive processes through visual, verbal, and material creation. I argue for the ornament of the *kilga*s as a form of redescription, an inscribed refashioning of form that articulates relationships with architectural structures by describing them in new terms upon the stone body of the object. Simultaneously, the same processes of redescription compress the temporal and spatial experience of architecture into the miniature field of the artwork, just as verbal description compresses those experiences into sequences of words.

From Nile to *Kilga*

The *kilga*s of Cairo, a group of carved stone stands used to support water jars, were brought into being by the need for a small-scale unit of water storage and distribution within a medieval metropolis precariously reliant upon the vagaries of the Nile.[3] While the unique four-footed form of these objects is striking, it is the intricately architectural nature of much of their carved decoration that forms the

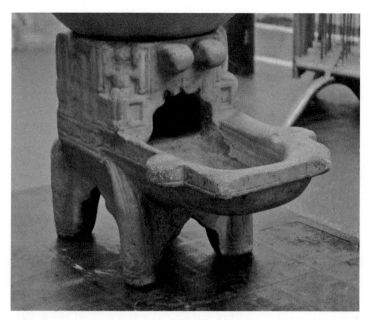

FIGURE 5.1 *Kilga*, Egypt. Carved marble. Height 47 cm. City Art Gallery, Manchester, 1934.235.

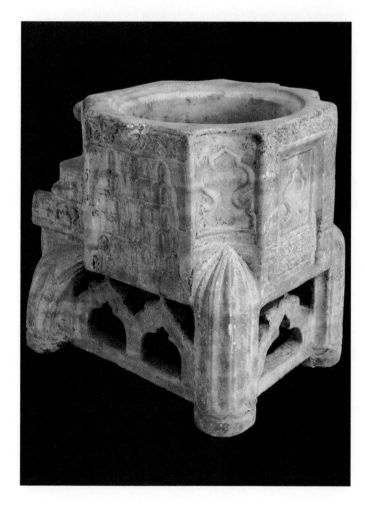

FIGURE 5.2 *Kilga*, Egypt. Carved marble. Museum of Islamic Arts, Cairo. Length 40 cm.

most intriguing aspect of the group and speaks most directly of their role as urban objects par excellence. The ornament of the *kilga*s is somewhat incoherent at first glance, but closer analysis resolves the jumble of tiny arches and muqarnas panels into a miniaturized architectural framework that plays a complex, allusive game with full-scale water structures upon the bodies of objects that rarely stand above knee height. The relationship between the scaled-down architectural forms that have been carved upon the *kilga*s, and the monumental configurations of water-spout, channel, pool, and fountain that once dominated whole courtyards in medieval Cairo, sites these small but carefully articulated stone objects within the very architectural fabric of the city.

The locational anxiety of medieval Cairo, so dependent on the seasonal flooding of the river, is publicly manifested in the structure of the Nilometer (*miqyās*), a gauge for measuring the annual rise of the Nile.[4] The famous Nilometer on Rawda Island in Fustat (part of old Cairo) was rebuilt in 861 at the order of the caliph al-Mutawakkil and comprises an octagonal marble column marked with cubit and finger measurements, set in the center of a stone-lined pit connected with the river by means of three tunnels (Fig. 5.3).[5] Staircases on the internal walls lead down to the base of the pit, and Arabic inscriptions in Kufic script on the same walls include several Qur'anic verses calling for rain, making explicit the votive aspects of this structure.[6]

In the late tenth century CE, the geographer al-Muqaddasī (d. c. 990 or later) reported that when the water had risen twelve cubits the sultan would receive notice of the rising of the river, with the herald praising Allah for increasing the blessed Nile; when the level reached sixteen cubits there would be rejoicing.[7] Conversely, if the river's rise did not meet expectations a gloom fell upon the people of Cairo in anticipation of the troubled times ahead.[8] In an attempt to manage public panic, and to prevent the hoarding of produce and subsequent inflation in food prices, the first Fatimid caliph to rule Egypt (al-Muʿizz; r. 953–975) reportedly went as far as banning the practice of measuring and announcing the rising of the Nile until the inundation had reached the critical level of sixteen cubits.[9] Not for nothing did al-Muqaddasī say of the Cairenes that "they are in constant fear of famine and the failure of the river, and are on the verge of compulsory exile—in fact they are constantly expecting calamity."[10]

But in spite of periodic disasters, the city flourished. Fustat replaced the Mediterranean port city of Alexandria as the foremost metropolis of Egypt in the Islamic period, and was augmented in the tenth century with the construction of the nearby Fatimid capital at Cairo. The conurbation went on to become the largest city in the medieval Islamic world, with a population estimated at a possible 450,000 in the thirteenth century.[11] Laila Ibrahim's research in *waqf* (religious endowment) documentation has shown how cramped some living quarters in medieval Cairo must have been, the lack of space driving building upward so that incredible numbers of people were literally living on top of each other.[12] The squalor

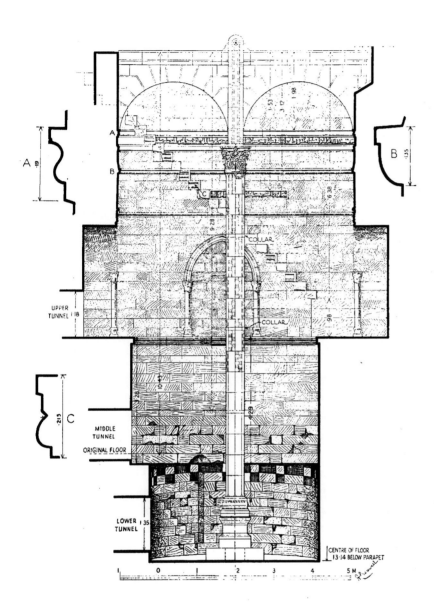

FIGURE 5.3
Section view
of the Rawda
Nilometer, Cairo,
861 with later
additions.

and overcrowding are described in detail by medieval writers, but simultane-
ously we hear that this is the greatest city on earth, "the glory of Islam," and
the entrepôt of the Orient. "Indeed," writes al-Muqaddasī, "were it not that
it has faults aplenty, this city would be without compare in the world."[13] The
Geniza documents attest to the horror experienced by medieval residents of
the Egyptian capital when forced, through business or marriage, to live in the
countryside or even the provincial cities; more generally, Thaʿālibī, writing in
the early eleventh century, observes that one of the characteristics of Egyptian
people is that they very rarely settle in any country other than their own.[14]

Within medieval Cairo fresh water was not a resource that could be taken for granted. Nile water for drinking was brought from the river in jars and skins, leading to the development of a seemingly enormous industry of water-carrying: eleventh-century Cairo was reputedly home to fifty thousand camels belonging to water-carriers, and al-Muqaddasī reports that a unit charge was added per story as the containers of river water were transported upward through the city's living quarters.[15] The changing nature of the Nile through its annual cycle brought different qualities of water as the seasons turned, and while water for other purposes could be stored in cisterns and reservoirs, drinking water was taken daily from the river.[16] The fifteenth-century historian al-Maqrīzī records a number of quotes from earlier writers praising the water of the Nile for its sweetness and clarity, but he also notes that other authors warned against drinking unpurified Nile water.[17] And with good reason: Ibn Riḍwān, a Cairene physician writing in the eleventh century, reports that the natives of Fustat routinely dumped human and animal excrement as well as carrion into the Nile, only to end up with it in their drinking water when the river was too low to carry it off rapidly. Little wonder, then, that he dedicated a lengthy section of his treatise *Risāla fī dafʿ maḍārr al-abdān bi-arḍ Miṣr* (On the prevention of bodily ills in Egypt) to the importance of purifying water, through the processes of boiling and filtering, before drinking it.[18]

The Cairene jar stands known as *kilga*s, of which more than eighty examples are known in museums and collections in Cairo and elsewhere,[19] are believed to have been used in conjunction with large permeable water jars.[20] Carved from a single block of marble, each *kilga* comprises a hollow, upright, chamfered cylindrical trunk section with a solid base that continues, via a short sloping passage through an arch-shaped opening, into a projecting frontal basin. The whole is elevated off the ground on four thick legs (Fig. 5.4). In a short article from 1947, Nikita Elisséeff provided what appears to be the first published explanation for this idiosyncratic form: when a large unglazed water jar with a pointed base was placed upright on the cylindrical trunk of the *kilga*, the water that seeped out through the porous body of the jar during the process of evaporation would drip down into the base of the trunk and collect in the basin at the front.[21]

Elisséeff believed that this mechanism was intended to provide purified water for the purposes of ritual ablution rather than drinking, but the basis for his assertion seems to have been an interpolation by the scholar Jean Sauvaget into the text of a medieval *waqf* document, rather than the document itself.[22] It is more likely that the *kilga*s were intended to provide drinking water. There is an apparent dearth of documentary evidence for this treatment of water for ablutions, while at the same time medieval textual sources mention the use of large earthenware jars for the provision of drinking water in public and private contexts.[23] In *al-Bukhalāʾ* (The misers), written in ninth-century Iraq, al-Jāḥiẓ even recounts a tale that depicts a hierarchy of waters: a miser chastises his guest for apparently performing ablutions before prayer with a pottery jug of fresh (ʿadhb) water when

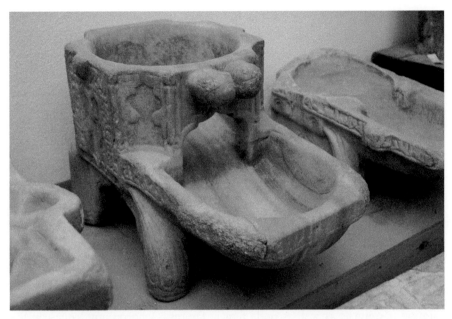

FIGURE 5.4 *Kilga*, Egypt. Carved marble. Height 37.5 cm. Berlin, Museum für Islamiche Kunst, I.7261.

the well (presumably representing non-potable water) was right in front of him.[24] Certainly Laila Ibrahim, a notable historian of medieval Cairene architecture, had no doubt that the raison d'être of the *kilga*s was the provision of drinking water and stated as much in her short 1978 study of selected examples held in Cairene museums.[25] Elfriede Knauer, the author of a longer article on the *kilga*s published in 1979, came to a similar conclusion.[26]

As water percolated through an unglazed jar and collected in the trough of the *kilga* it would undergo some degree of filtration. Medieval practices of filtering water through animal skins and porous clay jars prior to drinking are attested by a passage in Ibn Riḍwān's treatise.[27] The troughs of some *kilga*s are worn through from years of scraping and there is no reason to doubt that they were used to collect the water that seeped out of the porous water jars stood on their trunks. However, it is unlikely that this process would have provided sufficient quantities of filtrate to make it the sole function of the *kilga*s in the provision of potable water, as some authors have suggested: the troughs are not that large, and even in hot climates water does not necessarily percolate very rapidly through unglazed earthenware.[28] Since the process of evaporation would also cool the water contained inside the jar, it is more likely that the water jar was also provided with a scoop or cup so that water could also be drunk directly from it, making the filtered seepwater a useful byproduct of this mode of water dispensation rather than the sole purpose of its existence. A simpler version of the system, whereby a porous jar supported on a stand

is accompanied by a receptacle below for catching seepage and a ladle or tin mug above for dipping directly into the jar, could be seen in use in Egypt until recently.[29] The whole arrangement can be understood as one geared toward minimizing the wastage of drinking water. Later instances of *kilga*s used in combination with non-porous stone, metal or plastic water containers therefore represent only a partial loss of their original purpose.[30]

The City Reinscribed

Marble not being native to Cairo, the *kilga*s were presumably created from spolia.[31] Ibrahim has suggested broken sections of Classical columns as the material, since these would tally with the fairly uniform dimensions seen across the group.[32] Their material, then, anchors the *kilga*s further in the urban matrix of the city, as well as evoking an important range of preexisting associations between marble and water.[33] As for original sites of use, the presence of certain examples in mosques up to the recent past confirms a place in public religious life. However, the incorporation of animals as well as nude female figures—who occupy ledges on the chamfered corners of the trunks—into the decoration of several of the more elaborate examples would militate against those pieces having been originally intended for such a role (Fig. 5.1).[34] The figural examples, at least, were probably originally intended for domestic or palatial use.[35]

Indeed, later hands have gone to some lengths to excise the nudes, and even some of the animal figures, from several *kilga*s.[36] Transformations of this nature were most likely undertaken to address concerns about reusing figured objects in religious contexts: at least one of the modified *kilga*s was taken directly from use in a mosque to the Museum of Islamic Art in Cairo.[37] But it is also possible that they may have undergone iconophobic alterations in other contexts. Changing attitudes to the depiction of living beings in nonreligious contexts have left certain periods in the history of Islamic Egypt more closely associated with figural art than others; the art of the period of Fatimid rule (969–1171) is often noted for an unprecedented level of interest in depictions of human and animal figures, and for this reason some of the most elaborately ornamented *kilga*s have been attributed to the Fatimid period, a point that leads naturally to the issue of dates.[38]

Only one of the surviving *kilga*s, a well-published piece in the Museum of Islamic Art in Cairo, has thus far been found to include a date, and it is sadly mutilated.[39] The remaining section of the relevant inscription band can be read as a date ending *wa-khamsami'a* ("and five hundred"), placing the piece in the sixth century of the Hijri calendar (1106–1203 CE).[40] On the basis of this partial date and certain stylistic aspects of some examples, including the figural elements, many of the *kilga*s have been attributed to the eleventh to the thirteenth century. However, with so many plain or largely undistinguished examples in existence there is no reason to assume that all of them are so old.

The Arabic inscriptions that wrap some of the *kilga*s in scrolling bands of rectilinear script are for the most part similar in content and social function to those discussed in Chapter 3. Standardized supplicatory formulae wind around the objects, many of them variations on such well-worn themes as *baraka kāmila wa niʿma shāmila* ("perfect blessing and complete favor"), *salāma dāʾima wa-l-ʿizz (li-ṣāhibihi)* ("enduring health and glory [to the owner]"), and *al-ʿizz al-dāʾim* ("enduring glory").[41] Such expressions may have some use as dating diagnostics: *al-ʿizz al-dāʾim* appears to have come into more common use on Egyptian objects in the Ayyubid period, while the rhyming *sajʿ*-style formula of *baraka kāmila wa niʿma shāmila* also suggests a late- or post-Fatimid context since it seems to become more common in the Islamic West after the twelfth century. Perhaps surprisingly, the inscriptions of the *kilga*s are often crudely executed, with poorly hatched letters and frequent mistakes, although some examples are much more refined than others (Fig. 5.5).[42] In spite of their sometimes crude appearance, however, one can draw a relationship in both script type and architectonic quality between these ribbons of inscription that wrap around and define the *kilga*s, emphasizing their heft and three-dimensionality, and some of the scrolling architectural inscriptions of late Fatimid monuments in Cairo (Fig. 5.6).[43] For this reason the inscriptions

FIGURE 5.5 *Kilga*, Egypt. Carved marble. Height 39 cm. Berlin, Museum für Islamiche Kunst, I.7924.

FIGURE 5.6
Bands of carved
ornament and
inscription, mosque
of al-Ṣāliḥ Ṭalāʾiʿ,
Cairo, 1160.

have also been cited as reason to date many of the *kilga*s to the Fatimid and/or
Ayyubid periods.

The banded inscriptions of the *kilga*s are an important point of entry to the
relationship between object and architecture, for when one looks beyond the ques-
tion of content and style the inscriptions also implicate movement through time
and space. Unlike most of the other objects discussed in this book, the *kilga*s can
only just be termed "portable arts": they are heavy pieces of marble intended for
stasis rather than movement, and during use would be further anchored to the
floor by bearing huge jars of water. To read their inscriptions, a linear process
that nonetheless leads the reader through the full spatial complexity of the object,
one cannot turn them in the hands like the inkwells of Chapter 3 but must instead
perform a complete circumambulation by walking around them if possible, or at
least shuffling along all visible sides. The viewer's somatic experience of the ob-
ject is thus enacted through movement in time and space in a manner that in some
degree resembles the somatic experience of architecture—a point to which I will
return. Moreover, architectural inscriptions are perhaps the most obvious means
by which relationships between architecture and the literary arts are concretized,
in the material as well as the imaginative realms. The apprehension of epigraphic
content is deeply linked, through the act of reading along walls, around portals,
and across spaces, to the somatic experience of architecture—it makes literal the
idea of "reading" the building.[44]

Inscriptions are only one of the means by which architecture is connoted
in miniature among the *kilga*s. Through their medium, through their architec-
tonic articulation and heft, and most obviously through their ornament, the

*kilga*s make direct and indirect reference to a number of architectural motifs and structures. Many of these are interesting in and of themselves, and two of the most striking architectural forms that recur upon the *kilga*s are the tricusped blind arch and the muqarnas.

The first of these is a nonstructural arch form particularly characteristic of Cairene architecture from the late Fatimid to Mamluk periods, and it is the most frequently recurring device across the whole corpus of *kilga*s.[45] The form is rather ornate and bears little relation to true load-bearing arches, with an upper section of tricusped or polylobed arch swelling out from a tightly squeezed neck formed between two square or slightly pointed shoulders, the whole being mounted on an upright oblong or square lower section. This tricusped arch appears most frequently on the corner chamfers of the trunk (visible in Fig. 5.4); alternatively, it is sometimes employed on the sides or the back panel of the trunk.

While the origins of the arch may be Mesopotamian,[46] its proliferation in the Fatimid monuments of Cairo led Ahmad Fikri to consider it a characteristic device of the architecture constructed during that dynasty's reign.[47] At the same time, there are a small number of *kilga*s that include unequivocally Christian imagery and can be assumed to have come from Coptic establishments in Cairo. Those examples—reminders of the multi-confessional nature of the medieval city—are unsurprisingly devoid of Arabic inscription panels and also lack the tricusped arch motif, suggesting that the latter can possibly be identified with the city's Islamic self-image.[48]

In true architecture the tricusped arch appears as both a blind form and as a pierced but nonsupporting element in a number of buildings, notably punctuating the circumference of architectural drums on domed structures from the Fatimid period and later.[49] The frequent placement of the miniature tricusped arch on the chamfered corners of the *kilga*'s octagonal trunk section, sometimes framed between pairs of engaged colonettes (Fig. 5.4), sets in play a reference, undoubtedly intentional, to architectural drums. It is the placement of this arch that sets it up as an ordering motif, deliberately engaging the form of the *kilga* in a game that mimics real-world architectural spaces and extending the tricusped arch of the *kilga*s from surface ornament into a means of evoking architectural space.

The spatializing action of the tricusped arch when used as an ordering motif is supplemented, in some examples, by the inclusion of the nude female figures seated on ledges that project from the chamfers of the trunk section. These figures, their hands either raised or cupping their breasts, generally have rounded bellies with prominent navels that indicate their nudity, and are sometimes adorned with crowns and armbands. Given their presence on objects intended for the provision of fresh water, as well as the details of their iconography, these nudes most likely represent the late echo of a far older association between nude goddess imagery and fertility cults, a phenomenon well attested within material culture from the ancient Mediterranean littoral.[50] Spatially, they extend the allusion to architecture

FIGURE 5.7 Detail of carved marble *kilga* in figure 5.1.

within the *kilga*s in strikingly three-dimensional terms. Modeled almost in the round, the nudes sit on their ledges with their legs hanging down; one appears almost to brace herself against the engaged colonettes at either side of her (Fig. 5.7). As in previous chapters, the human image once again provides a very strong cue for the eye of the beholder to sort and animate the object into a series of architectural spaces.

The tricusped arch may be the most frequently employed motif on the group, but the most elaborate architectural device, found on at least fifteen of the extant *kilga*s, is the representation of muqarnas (Figs. 5.2 and 5.5). This element has garnered the most attention in the scholarship surrounding the group, not least for its utility in dating.[51] A system of tiered "honeycomb" vaulting, muqarnas has been used on squinches, capitals, niche hoods, cornices, and other architectural surfaces across the Islamic world since at least the early twelfth century, and has come to act as an Islamic identifier in the built environment.[52] Its scaled-down appearance on the side panels of several of the more elaborately ornamented *kilga*s has naturally prompted comparisons with the well-known early muqarnas panel on the exterior wall of the Aqmar Mosque in Cairo (1125 CE; Fig. 5.8), which some examples closely resemble.[53] The downward transition of the Aqmar Mosque muqarnas panel, with

FIGURE 5.8
Restored muqarnas panel from the façade of the Aqmar Mosque, 1125. Cairo.

its increasing dissolution of the modular unit from two deeply recessed keel-arch-shaped niches in the top level down to low-relief "stalks" in the bottom, is almost exactly matched in the miniature muqarnas of a *kilga* now in the Victoria and Albert Museum (Fig. 5.9). This is not to say that the *kilga*s bearing such panels— a group that includes several examples ornamented with nude women—carry "portraits" of the Aqmar Mosque muqarnas. It is more likely that panels of this type were once a more widely visible form of architectural ornament in Cairo, and may have been employed in vernacular architecture in addition to—and possibly prior to—the extant examples that survive on religious monuments.[54] While the muqarnas has presumably been used on the *kilga*s because it is an attractive means of articulating a stone surface, it also works to prompt a further quasi-architectural reading of the object: in this case the marble sides of the *kilga* trunk become stone walls through the application of a miniaturized form of architectural ornament.

Thus far, it could be argued that the ornament of the *kilga*s should be regarded as a visual exercise in scaling down without any particular rationale; a jumble of architectural motifs that have not resolved themselves into a coherent relationship with any real-world structure. Certainly, it is a notable feature of the *kilga*s as a group that no two are exactly alike, and there are a great number of decorative devices displayed across the entire corpus: as well as figures, inscriptions, blind tricusped arches, and muqarnas, one could also point to the true arches that appear between the legs of almost all examples and at the point of transition between trunk and trough, or the less frequent but by no means insignificant appearance of other types of blind arch, interlace panels, geometric designs, engaged columns, and

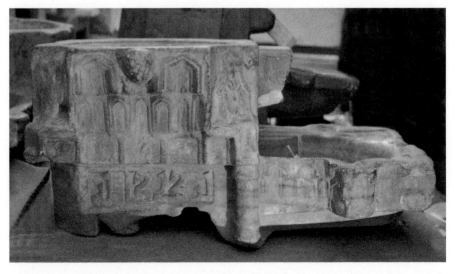

FIGURE 5.9 *Kilga*, Egypt. Carved marble. Height 30.5 cm. London, Victoria and Albert Museum, A.24-1982.

FIGURE 5.10

Kilga, Egypt.
Carved marble.
Gayer Anderson
Museum, Cairo, 32.

pilasters.[55] One example in the Gayer Anderson Museum even bears a round arch
filled with a scalloped niche and symmetrical vegetal scroll designs of distinctly
Late Antique appearance (Fig. 5.10). And this is to say nothing of the four thick,
often fluted legs that support each *kilga*, giving it the rather startling appearance of
something that might hobble across the room at any moment.[56]

However, there is a small but highly significant component within the or-
nament of the *kilgas* that provides the key to a more coherent reading. This can
be found in the inclined area of transition between the trunk and the trough, the
short panel down which the filtered water would originally have trickled. On this
spot, some examples bear two narrow flanking segments carved with tiny steps,
often accompanied by the ornamentation of the central panel with chevrons (Fig.
5.11). While Ibrahim noted this decorative device as an indicator of the path
taken by the seeped water, Knauer went on to identify the element as a direct im-
itation, in miniature, of a *shādirwān*, one of the parts of a multicomponent water
feature popular in the medieval Mediterranean world and known in Arabic as a
salsabīl.[57]

Typically, the components of the *salsabīl* are a tap or spout mounted partway
up a wall and often set into a blind arch, from which water runs down the *shādirwān*,
an inclined stone slab ornamented in some instances with zig-zags or chevrons
carved in such a way that would cause the water running down it to be fanned out
into a rippling, sheet-like surface. Following this, the flow of water would continue
along narrow channels until it reached a pool, normally in the middle of a courtyard,
where a fountain might play. This arrangement was apparently in use throughout
much of the medieval Islamic world and the Mediterranean littoral, and one of the

FIGURE 5.11 Detail of carved marble *kilga* in figure 5.9, showing area carved to resemble a *shādirwān*.

earliest and best-preserved surviving examples is that of the Ziza Palace in Palermo (1165–1175; Fig. 5.12). A painted representation of a *salsabīl* can also be seen in the ceiling panels of the Capella Palatina in Palermo (building completed 1143; ceiling paintings possibly slightly later; Fig. 5.13).[58] It is clear from the Ziza and the Capella Palatina image, as well as other material remains, that a *shādirwān* in the form of a zigzagged panel flanked panel, sometimes flanked by two narrow stepped inclines, was a standard form within this construction. There can be no doubt that the *shādirwān* was the architectural model for those *kilga*s that carry this patterning.[59] Even those that are not inscribed with the patterning of a *shādirwān* at this critical point may still allude to its usage: in Fig. 5.4 the marble's natural grain, whether serendipitously or by design, emulates the languid flow of water from trunk to trough. Cascades of water are perhaps deliberately intimated, too, on the fluted legs—particularly the curved front pair—of many examples.

Once the scaled-down *shādirwān* has been identified, it is a short step, following the fantastical logic of the miniature, to compare the frontal troughs of the *kilga*s (Fig. 5.14) with the pools included in *salsabīl*s. According to the drawings made by Aly Baghat and Albert Gabriel from their excavations of medieval domestic architecture in the Cairene district of Fustat, some of those domestic pools that they termed *fisqīya* (fountain) took the form of a deep octagonal recess set into a shallower square surround. This created a basin with chamfered corners much like those seen on the front ends of the typical *kilga* trough.[60] A similar arrangement can be seen in the pools at the eleventh-century site of Lashkari Bazar in Afghanistan,[61] and at the twelfth-century Ziza Palace. Furthermore, some of the Fustat house pools also had semicircular lobe-shaped recesses projecting from each side, creating a full-size parallel for the nodular projections found upon the trough's lateral edges on a great many of the *kilga*s.

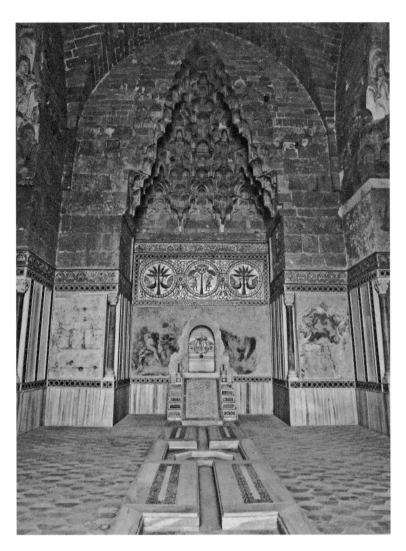

FIGURE 5.12
Fountain hall showing
detail of *salsabīl*,
including *shādirwān*, on
western wall of the Ziza
Palace, Palermo, twelfth
century.

Knauer observed that a direct comparison for the *kilga* troughs can also be
made with a quatrefoil carved marble basin, complete with carved images of lions
who brace themselves rather awkwardly inside the projecting recesses, found at
the Qalʿat Banī Ḥammād in Algeria (Fig. 5.15). [62] The scalloped edges and pendant
decoration in the corners of another basin from the same site, now in the National
Museum of Antiquities and Islamic Arts in Algiers, are also closely comparable
with the ornament of the troughs of some of the *kilga*s, such as the example in the
Victoria and Albert Museum (Fig. 5.14). [63] The gradations of recessed decoration
carefully worked into the chamfered corners and projecting lobes of the Victoria
and Albert *kilga* ape full-size architectural models where such carving would ex-
ploit the changeable optical properties of water, combining with the pooling liquid
to reflect ambient light and magnify or obscure the material and its ornament at
different depths. [64]

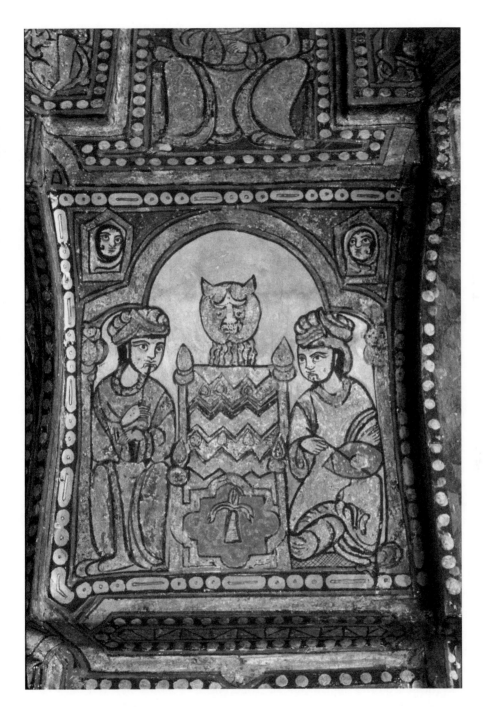

FIGURE 5.13
Painting of a
salsabīl from the
ceiling of the
Capella Palatina
in Palermo
(building
completed 1143;
ceiling paintings
possibly slightly
later).

In effect, then, the form of the standard *kilga* trough is a scaled-down version
of full-size architectural pools, with one end lopped off and the water source
feeding directly into it instead of running along a channel. In this way, the artists
responsible for the most sophisticated *kilga*s are offering consumers an abbre-
viated version of the *salsabīl*: the key elements of water source, *shādirwān* and

FIGURE 5.14
Detail of carved
marble *kilga* in
figure 5.9, showing
carving of trough
section.

architectural pool, are compressed and miniaturized into a single, water-providing
unit. A similar form of artistic compression has taken place in the Capella Palatina
ceiling painting of the *shādirwān* which flows directly into a quatrefoil basin, com-
plete with fountain (Fig. 5.13).

As Richard Krautheimer famously showed with medieval "copies" of the
Church of the Holy Sepulcher in Jerusalem, medieval artisans often sought not
to copy architectural constructions in toto but rather to create forms that "show
the disintegration of the prototype into its single elements, the selective transfer
of these parts, and their re-shuffling in the copy."[65] Critically, the relationship of
resemblance between the *kilga* and full-size water structures is not only one of
form(s) but also of function. The very simple hydraulic action of the *kilga*s—that
of seeped water trickling down a slight incline and collecting in a hollow—has been
aligned by craftsmen with far more complex, multicomponent configurations of
water architecture, and this has been enacted consciously and specifically through
the application of ornamental motifs in a deliberately allusive way across a com-
plex, three-dimensional schema.

Using the notion of the *salsabīl* as an ordering principle it is possible to go fur-
ther and argue a relationship between the panels of muqarnas found on the outer

FIGURE 5.15 Plan of carved stone pool with lions, Qal'at Banī Ḥammād, Algeria, eleventh or twelfth century. Depth 55 cm.

walls of some of the objects and the muqarnas niches in *salsabīl*s as seen at the Ziza Palace and elsewhere.[66] The *kilga*s' refusal to mimic the placement of the muqarnas element directly over the water source, as seen in true *salsabīl*s, does not exclude the possibility of a relationship between large and small. Instead, the recasting of architectural elements to fit a small object assumes a shared sense of artistic license between maker and user. The act of miniaturizing something large and complex, like a *salsabīl*, necessitates leaving things out. Moreover, the decision to recast the simple, functional form of the *kilga* as an abbreviated and reconfigured miniature of the *salsabīl* was not motivated by a desire to recreate a larger structure in minute detail for didactic purposes. Rather, the *kilga*s express a more elliptical relationship with a real-world architectural type that was probably initiated by a kinship of function and, to a lesser extent, form, concentrating the *salsabīl*'s appearance and action into one small unit. For, while the form of the *kilga*s appears to be unique, the concept of the architectonic jar stand is not, and the next section of this chapter explores some parallel forms encountered in other Mediterranean contexts.

Mediterranean Miniatures

A strikingly consistent feature of the *kilga*s is the lion protome, single or more often paired, that juts forward above the archway between trunk and trough on almost all extant examples. While these were occasionally modeled as masks (Fig. 5.16), far more often they project an inch or more and strongly recall lion-headed waterspouts.[67] A handful of examples have protomes that are pierced through, giving the element a possible mimetic role as waterspout. But even with a drilled channel running from the inner wall of the *kilga*'s cylindrical trunk straight through to the front center of the protome, very little water could have made its way down

FIGURE 5.16
Front view of
carved marble
kilga shown
in figure 5.10.
Gayer
Anderson
Museum,
Cairo, 32.

this narrow channel from the sodden surface of a water jar. And the great majority
of the lion protomes that appear on the *kilga*s are not pierced at all.

Returning to the model of the *salsabīl* provides a straightforward point of refer-
ence for these lion-headed projections. The *salsabīl* depicted in the Capella Palatina
is shown complete with a lion-headed waterspout spewing water down a *shādirwān*
(Fig. 5.13), and the twelfth-century Sicilian poet Ibn Ḥamdīs described palatial ar-
chitecture enlivened by water pouring from the mouths of lions, birds, and giraffes
to "melt on the steps of the *shādirwān*."[68] An association between lions and water
was fully established by Classical Antiquity and can be encountered throughout the
arts of the medieval Mediterranean world, particularly in courtly contexts: witness
the eponymous fountain in the Court of the Lions in the Alhambra with its twelve
spouting beasts, or the carved stone lions in the pool at the Qalʿat Banī Ḥammād.[69]
The nonfunctional nature of most of the lion protomes on the *kilga*s could per-
haps be explained as a further layer of the mimetic game being played with water
architecture, the lion-heads being skeuomorphs carried over from the full-scale
salsabīl.[70] There are other medieval materials dedicated to the provision of clean
water that should also be considered at this juncture.

Alexander Badawy identified a further type of stone stand for water jars,
widely evident in Cairo and often adorned with Coptic inscriptions and motifs, that
draws rather opaquely on architectural models of a different sort.[71] The standard
form of the "Coptic" jar stand is a low stone table carved on the upper surface with
two depressions connected by drains to a third hollow between them (Fig. 5.17).
A stand of this type received two water jars and collected the seepage from them
in the middle depression, while an exit drain at the front allowed the seepwater to

spill out into a bowl below. Badawy proposed that this Late Antique model can be linked to certain libation basins from the Ptolemaic and Roman periods in Egypt which faintly echo the form of a miniaturized architectural pylon surmounted by a parapet. In addition to a general resemblance of outline, the key elements that connect the Ptolemaic and Roman-era basins with the Coptic jar stands are the lion protomes placed at front center of both types, projecting from the parapet on the libation basins and referencing an established feature of cult temples in Egypt from the Old Kingdom onward.[72]

In many, although by no means all, examples of the Coptic-type jar stand, the lion-headed projection is pierced, either through the mouth or below the face between its paws, and located at the site of the exit drain so that the seepwater would run out through this hole (Fig. 5.17). Thus the lion waterspout of the Coptic jar stand completes the scaling down of an architectural prototype in function as well as form by replicating the action of a true waterspout. On some other Coptic jar stands, however, the protome is not pierced: without either the earlier signifier of the cornice-parapet to establish an architectural reading of such lion-headed projections, or the hydraulic function of the waterspout to explain its presence, the original meaning of the formal references has been eroded. Or perhaps it would be better to say it has simply evolved in other directions: Dominique Bénazeth has suggested that the specifically Coptic resonances of lion imagery, particularly the creature's role as the symbol of the Evangelist Mark, the bringer of Christianity to Egypt, should be brought to the fore in consideration of the Coptic jar stands.[73]

Zoomorphic projections that ape waterspouts are also to be found on yet another form of architectonic jar stand created in the Mediterranean littoral, this time

FIGURE 5.17
Jar stand
with Coptic
inscriptions.
Carved marble.
Cairo, Coptic
Museum, acc.
no. unknown.

made from unglazed earthenware rather than stone and associated with medieval al-Andalus, particularly Murcia. The best surviving example of the Murcian architectonic jar stand is a piece thought to date from the thirteenth century (Fig. 5.18). Debates about the function of this object—Vase or basin? Drinking trough for birds or stand for flowerpots? Part of a fountain?[74]—were resolved in 1987 when Julio Navarro Palazón identified it as a stand for water jars combined with a basin, an interpretation now widely accepted.[75] Navarro Palazón went on to propose a reconstruction whereby this piece might once have been part of a larger assemblage with a second architectonic structure placed behind it to support a large water jar, a waste-minimizing arrangement that essentially follows the same model of jar/stand/seepage catcher outlined above.[76]

 Related earthenware artifacts excavated from the Coptic settlement at Medinet Habu (Luxor) provide intriguing parallels with the Murcian stand.[77] A niche for water-jugs intended for domestic uses of all sorts formed an integral part of domestic structures in Egypt continuously from Pharaonic times, and some of the Coptic stands excavated at Medinet Habu were found in these niches.[78] This practice continued in the Islamic period with the *bayt azyār* ("jars house"), a recess for storing water jars near the entrance to the house, found in even quite modest

FIGURE 5.18 Jar stand with basin and incised decoration, thirteenth century. Unglazed earthenware. Height 20.1 cm. Museo Santa Clara de Murcia, MSCL/CE070089.

structures of the Mamluk period.[79] While Navarro Palazón argues that this system may have been intended to provide water for ritual ablutions in domestic contexts, there seems little evidence to suggest that such an arrangement should not, like the *kilga*s, have been for the provision of drinking water.[80]

Being made of unglazed earthenware, the Murcian jar stand would eventually become sodden when used in conjunction with an unglazed water jar. Navarro Palazón proposes that the small nodular projections placed centrally on the upper front walls of the two cuboidal "buildings" of the Murcia stand, which would drip when they became sodden, were intended to recall the action of architectural waterspouts.[81] Fragments of related objects, some of them complete with zoomorphic masks as well as ornate polylobed arches, indicate the existence of a larger and more complex body of earthenware material engaged in a direct relationship with the architecture of Islamic Spain and with the provision of water.[82] There also survive a number of glazed or partially glazed ceramic basins, jar stands, wellheads (Fig. 5.19), and water jars from twelfth- or thirteenth-century al-Andalus that carry a similar vocabulary of architectonic motifs.[83] Various tentative arguments have been made regarding the origins of the water-unit conceived as miniature building, none of which fully account for the wide application of the concept in the Mediterranean littoral.[84] Instead of attempting a chronology to trace the idea

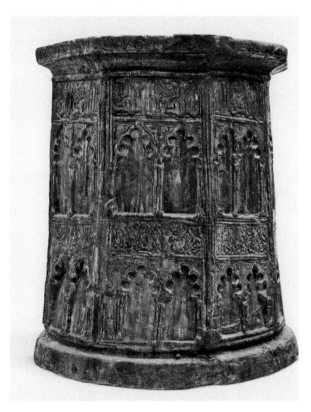

FIGURE 5.19
Wellhead, Spain,
possibly Seville, twelfth
or thirteenth century.
Glazed, modeled,
carved, and stamped
or molded ceramic.
Height 76 cm. Museo
Arqueológico de Sevilla,
Seville, ROD9902.

to its origin within this quotidian material it is perhaps most helpful at this stage to conclude only that the *kilga*s, the "Coptic" stands, and the Murcian earthenware material constitute evidence of a medieval Mediterranean continuum of miniature architectural forms employed in the provision of fresh water.

Returning, finally, to the lion protomes of the *kilga*s, it is possible to trace in these a miniature reflection of the Nilometer, the architectural structure that stands as both a symbol of Cairo's lifeblood and a synecdoche for the city itself. In the *Hieroglyphica* of Horapollo the (purportedly) fifth-century author reports that the rising of the Nile was commonly symbolized in Ancient Egyptian hieroglyphs by one of three possible images: a lion, three water jars, or a depiction of water gushing forth. Horapollo accounts for the lion image with the suggestion that the sun entering Leo is the cause of the river's annual rise, informing the reader that this is why lion-shaped waterspouts appear on temples in Pharaonic Egypt.[85] From the early account of the inscriptions on the Rawda Nilometer, written by a certain Aḥmad al-Ḥāsib, it is clear that this symbolic association had not been lost by Islamic times. Al-Ḥāsib's text tells us that a carved marble figure of a lion's head, not mentioned in later descriptions, once decorated the Nilometer.[86] The lion was mounted on the wall of the intake conduit at such a height that when the rising river reached sixteen cubits (i.e., plenitude) it would enter the creature's mouth.[87] The calculated conjunction of the lion's jaws with the life-giving natural force of the Nile at the peak of its hoped-for inundation speaks of votive, even totemic attitudes to the river and its attributes.

The phenomenon of the Nilometer may provide the final key to the *kilga*s. The containment and provision of river water enabled by the *kilga*s, in cylindrical architectonic wells decorated with overt and oblique references to water structures, suggests that in spite of their small scale they too participate in the Cairene preoccupation with the Nile that was monumentalized in the structure at Rawda. The lion protomes surmounting the archways on the great majority of the *kilga*s echo that open-mouthed creature, carved centuries earlier on the wall of the Nilometer, which once took the rising river in its maw. The *kilga*s may be small things, but each once carried the weight not only of a water jar, but also of a city.

Ornament as Ekphrasis

By exploring the individual architectural elements selected for use on the *kilga*s in the preceding sections of this chapter, I demonstrated the ability of the (unknown) intelligent craftsman to capture a specific form of architecture and reconfigure its critical elements, along with its entire social semiotic, upon the body of an object. This is not merely architecture transcribed, but architecture refracted through the senses and the mind, before its reinscription upon the surface of the *kilga*. As such it has many echoes of the atomized architecture of effect created by ekphrastic

descriptions of architectural structures in Arabic and Persian poetic traditions. Here I want to pause to consider the analogy between these two artistic modes, the plastic and the poetic, in detail.

In likening the ornament of the *kilga*s to a kind of material ekphrasis, this chapter lingers over the discursive status of architecture within other artforms, both literary and material. This does not necessarily entail identifying the subjects of architectural ekphrasis with real-world buildings: indeed, attempts to use pre-modern Arabic and Persian poetry as a source for empirical architectural history have usually been frustrated by precisely the qualities which make the same poetry such a remarkable source for apprehending the experience of architecture—its fracturing of somatic experience and perceptual effect.[88] Rather, it is the *action* that poetic ekphrasis performs upon architectural subjects that is here argued as a correlate to the actions of the thinking hand, as it fragments and reconstructs architectural form through the art of the object.

The architectural environment as subject matter for poets has a long history in the Islamic world, composed of several strands. First among these was a well-established theme, inherited from pre-Islamic Arabic poetry, which cast ruined or abandoned sites as catalysts for elegiac reflection. While the "trigger" in pre-Islamic odes was, classically, the sight of an abandoned campsite, the genre gave rise in the medieval period to such well-known examples of architecturally inspired eulogy as the odes on the remains of the Sasanian arch at Ctesiphon written in Arabic and Persian by al-Buḥturī (d. 897) and Khāqānī (d. 1202), respectively.[89] Meanwhile, a related form of descriptive and materially focused architectural ekphrasis emerged in the florescence of literary Arabic that radiated from ʿAbbasid Baghdad. This genre of "palace panegyric" identified great buildings with the might of their patrons and became, as Meisami has shown, a particularly significant topos following the construction of the ʿAbbasid caliphal palace city of Samarra in Iraq in the ninth century. The palace panegyric also underwent a notable further development in Persian within the Ghaznavid territories of the eleventh century.[90]

Additionally, a slightly later type of urban encomium developed along somewhat different lines from the traditions of elegiac ekphrasis and architectural panegyric. This later poetic form celebrated not just individual buildings but cities. The literary genre of *shahrāshūb* or *shahrangīz* ("upsetting the town") would eventually come to its fullest development in the poetry of Safavid Iran and Ottoman Turkey, but its roots must predate its definitive establishment in the eleventh- and twelfth-century Persianate sphere. Predicated at first on odes to craftsmen, sometimes with a particular emphasis on the *sūq* of an identifiable locale, the genre expanded to become more and more concerned with the celebration of individual towns.[91] This is hardly surprising, for the increasingly urbanized context of the medieval Islamic world frequently expressed itself in the staging of civic pride to the point of city chauvinism—a phenomenon already described above with regard to Cairo.

While these three trajectories of poetry on architectural themes may stem from varied origins, in practice they were synthetic and quite receptive to development in new directions. All three modes shared a fascination with the act of description, and with the varied means by which an effective description can be enacted. Description (*wasf*) was a critical component of early and medieval Arabic and subsequently Persian poetry: the term is applicable to descriptions of all kinds of subjects and thus does not correlate precisely to the primary modern use of the word "ekphrasis" to denote the verbal description of nonverbal artworks.[92] However, like ekphrasis, and also like the models of metaphor outlined in Chapter 4, effective *wasf* is commonly understood as a means of generating images in the mind of the listener: the eleventh-century poet-critic Ibn Rashīd suggests that *wasf* is at best, in Akiko Sumi's words, "a transformation of hearing (*sam*ʿ) into seeing/ vision (*baṣar*)."[93]

Thus, a significant form of *wasf* developed around the description of buildings and their decoration, as is particularly evident in the ninth-century growth of palace panegyric. It is true that the topos of buildings as the subject of ekphrasis, including both the imperial monument and the wider city, had a rich history in the Byzantine world too. This is most notable in the mid-sixth-century *De Aedificiis* of Procopius, with its blend of "panegyric, biography, protreptic and geography."[94] Sarah Bassett suggests that Late Antique rhetorical modes produced "a habit of composition and seeing on the part of artists and their viewers analogous to the habits of writing and listening deployed by rhetors and their audiences," and Thomas Leisten has proposed something similar for the ʿAbbasid sphere.[95] Nonetheless, the practice of masters such as the ʿAbbasid poet al-Buḥturī was quite distinct from Byzantine models: the influential ʿAbbasid odes reflect the finely crafted ideals of *badīʿ* poetry, with its protean imagery and allusive gestures. For example, in the case of al-Buḥturī writing on the palace of al-Muʿtazz (r. 866–869), the compounding of description from multiple and complex metaphors of materiality and sense impression, layering nature and artifice, produces an ever-changing, animated dynamic of building and landscape that constantly dissolves into other materials. Walls are raised to the winds, becoming glass, then waves, then marble, which in turn becomes textile into which clouds are woven and braided.[96] The mutability of metaphor, so prized by the poets of the *badīʿ* school, becomes a means both of encountering built structure as a "flow" of changing states, and of accommodating the somatic experience of architecture.

The "*badīʿ* aesthetics" informing poetic descriptions of architecture and, quite possibly, the appearance of the architecture itself, are a cultural lens particular to ninth-century Iraq.[97] However, the analogical mode of description and the emphasis on surface effects and materiality that were so pronounced in the *badīʿ* poetic style echo throughout many medieval descriptions of architecture, not only in poetry but also prose.[98] Within the Arabic tradition of architectural ekphrasis,

water plays a particularly striking role. The emphasis placed on luxury and sensory pleasure within the panegyric mode privileges description of the play of water in fountains, channels, and pools; at the same time, the genre favors the comparison of elements with precious materials, and the changing states of water in movement and stillness lend themselves particularly well to this treatment.[99] Al-Buḥturī, in a famous *qaṣīda* on the artificial lake created by caliph Mutawakkil (d. 861), likens its water channels to molten silver and polished armor:

> It is as though shining silver liquefied
> from ingots were flowing in its courses.
> When the East wind stirs it up it displays ripples
> Like coats of mail with finely polished fringes.[100]

This fascination with the movement of water, and the search for metaphors that would cause the listener to envision the apparent solidity of water flowing in channels and gathering in pools versus the diffuse or refracted movements of its broken surfaces, would continue to hold sway over later poets writing in both Arabic and Persian. Yasser Tabbaa has noted that Andalusian poets and writers of the twelfth century show a particularly sustained interest in hydrodynamics, but they were not the only ones captivated by this subject.[101] The palace panegyrics of the eleventh-century Ghaznavid court poetry studied by Meisami also evince a fascination with the changing states of water and their visualization through shifting metaphors, as can be seen in a jaw-dropping description of water channels leading to a cistern, written by Azraqī of Herat (active late eleventh century):

> Turquoise, like drawn-out wire, it descends
> From the corner of the golden water-pipe to the reservoir.
> You'd say that skins of refined gold were being cast off
> By silver-bodied serpents with turquoise bones.[102]

Meisami observes that the poets of this "Ghaznavid school" relish the vividness of concrete detail as a means of achieving striking variety in their imagery. Certainly this would accurately describe Azraqī's layering and stretching of precious metal and colored stone with serpent flesh, skin, and bone, to raise in the listener's mind the image of water flowing down a channel.

Azraqī's description of the water channel is notable for, among other things, its departure from the standard repertoire of elements. In the case of water features and gardens, poetic attention was usually focused on the more obvious spectacles of water jets, fountainheads, or the *shādirwān*, rather than connecting devices. Azraqī's innovation was to bring a less commonly lauded component of hydraulics into the visual-verbal spectacle of the poem. And yet this component is not

included as part of an exhaustive, didactic inventory of parts that "strives to create an impression of the real," but rather represents the novel selection of one unusual element, lingered over as a near-autonomous fragment, from which an image of startling suddenness flashes forth.[103]

The process of verbal description is by necessity one of fragmentation. Buildings, or components thereof, are broken into units in order to relay these to the listener sequentially; in the poetic traditions under discussion this form of description often focuses on the phenomenological aspects of each unit and produces its effect in the mind's eye through a series of metaphors. Much of the time, the repertoire of architectural components selected to carry the weight of *wasf* was quite standardized, and it was the poet's job to present these familiar tropes in the most novel or effective terms. Parapets, walls, battlements, towers, arches, vaults, and above all domes constitute the standard units of palace description in a poetic system that frequently combines spectacle with hyperbole. As mentioned in Chapter 4, domes are very often analogized with the heavens, while pools, streams, and fountains are compared with the paradisal waters of Kawthar and salsabīl, topoi that poetically mythologize the environment through sacral associations. In many such cases, little concrete detail is supplied to aid visualization, and the description relies instead on shared external touchstones such as Qur'anic water imagery or a well-developed material and poetic trope of celestial domes.[104] But on other occasions poetic description could, as in the case of Azraqī's inlet pipe, suddenly assemble an image of startling newness through a sequence of inventive metaphors that observe closely the material qualities of both the subject and its unexpected analogues.

Yasser Tabbaa recently suggested that a reciprocal relationship between gardens and garden poetry meant that as gardens, fountains, and water features "became increasingly viewed in poetic terms, the gardens themselves may have aspired to this literary ideal."[105] The phenomenon has also been explored by Puerta Vílchez in the Iberian context.[106] This convergence of literary and material modes is, I think, evident also in the *kilga*s, which are of course dedicated, like garden fountains and pools, to the provision of water and the practice of hydraulics. When the group is viewed as a whole, the selection of architectural components for inclusion upon the *kilga*s seems to have been a largely organic process arising out of the form of the object itself. The odd, even awkward form of the *kilga* is essentially made up of a clunky cylindrical trunk and a projecting receptacle, with an opening connecting the two. Just as in Chapter 3 we saw fantasies of garden pavilions develop out of low stands seemingly from the simple kinship of a shared polygonal form, so in the *kilga*s there are points of likeness that can be easily traced between a supporting trunk and an architectural drum, a projecting trough and a pool for a fountain. In the case of the *kilga*s, however, the connection is clearly not only formal but also functional, and the play of likeness is spun in several directions at once. As in the examples of poetic ekphrasis cited above, the architectural

components selected for inclusion upon the *kilga*s do not aim for an inventory of the real in the way that a model would, but instead reflect the poetic construction of architecture—and particularly water architecture, with its dramatic effects and complex flow through interior and exterior spaces—from discrete elements that

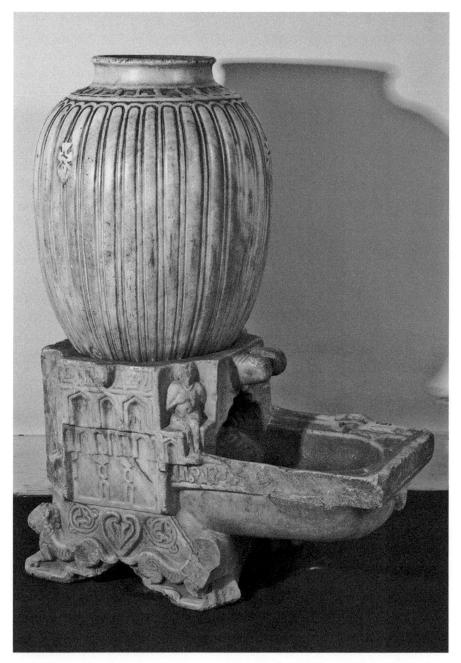

FIGURE 5.20 *Kilga*, Egypt. Carved marble. Height 48 cm. Museum of Islamic Art, Cairo, MIA 4328.

dazzle or amaze or strike anew. At the same time, the inscription of architectural motifs upon the marble surface is, as stated at the beginning of this chapter, an act of redescription: through ornamentation, the body of the object is re-presented to the viewer as a new entity that alludes, in both its entirety and its components, to the abstracted external referent of monumental water architecture.

Through their ornament, the *kilga*s have been endowed with an architectural identity that is liquid in two senses, with the conveyance of water meeting the refraction of architecture as it is experienced, imagined, recalled, and recast. It is easy to see why the *shādirwān*, the core unit of the *salsabīl*, is the single component that has been most faithfully replicated on the more elaborate *kilga*s. The *shādirwān* is the element in which the structure and function of the *kilga* converge upon the most direct resemblance to the *salsabīl*, and marks the point at which the kaleidoscopic field of architectural allusion is brought into a single point of full focus upon the body of the object. Other elements that would be equally spectacular but remain impracticable within the diminutive unit of the *kilga*, such as fountains or long water channels, are entirely absent (Fig. 5.20). Beyond the *shādirwān*, the components from the *salsabīl* and other architectural forms that have been selected for use on the *kilga*s show a mix of interest in the closely referential (the chamfered pool), the dramatic (muqarnas), and the fanciful (the ledges on which the nude female figures sit, or the articulation of the trunks as architectural drums). Reconfigured through the three-dimensional space of the object, brought into abrupt conjunction with one another and yet remaining somewhat discontiguous, it is these individual motifs that transform the *kilga*s, or at least the most elaborately decorated examples, from rather ponderously shaped marble stands into microcosmic odes to water architecture.

Memory and Imagination

Architectural structures can be experienced in many different ways inside and out, from collective circumambulation to solo exploration of concealed spaces. However, the human sensory experience of architecture always takes place through time as well as space. The poetic description of architecture therefore performs another action, beyond fragmentation, that is paralleled in the art of the archimorphic object: it sets the somatic experience of architecture into a new temporal framework. That is to say, poetry transcribes a bodily mode of spatial and material experience into a verbal, and therefore sequential, system. Paul Losensky, in his close studies of the relationship between architecture and Persian poetry in the sixteenth century, has recognized this as a means of bringing "visual objects into the temporal and verbal flow of poetry," and shows how the representation of architecture through poetry effects a form of translation across modalities, transforming the experience of time as well as space in the process and subjecting both to the internal logic of the poem itself.[107]

In distinct but related ways, the redescription of architecture upon the body of a much smaller object also changes certain temporal relationships between the viewing subject and the object of perception. In the first instance, the form of even a comparatively large object like a *kilga* can be apprehended in its entirety in a single, static glance. Even if one has to move around the object, or move the object itself, to experience every aspect of its ornament, the somatic relationship that exists between a building and a human is inverted by miniaturization of the architectural form. Where architectural space is commonly understood as controlling, at least to some extent, the behavior of the humans who move within it, the archimorphic object can be apprehended from outside by the viewer who attains mastery of it in a glance or a grasp. In the words of Claude Lévi-Strauss, the man-made miniature thus "compensates for the renunciation of sensible dimensions by the acquisition of intelligible dimensions."[108] In the oft-cited analyses of Gaston Bachelard and Susan Stewart this possessive dimension of miniaturization is inextricably entangled with play and imaginative transportation, as the beholder explores the miniature space of the object using her eyes and her mind. Imagining herself inside the object, yet simultaneously standing outside of it, she occupies two positions simultaneously.

The effect of this dual consciousness during "scalar travel" is a compression of time concomitant with the shrinkage of space, as was shown in a famous experiment by Alton DeLong. He presented subjects with model rooms of different scales and asked them to imagine themselves doing things within those miniature rooms and to gauge when they felt a certain amount of time had elapsed. Across the group, subjects' experiences of time were compressed against the clock in line with the increasing compression of dimensions in the miniature environments they imagined themselves exploring. The "genuine shift in temporal experience" effected by changes in architectural scale has a profound effect on the experience of time offered by such artworks: they can collapse the temporal duration of architectural experience into the field of the object.[109]

At the same time, relaying the temporal experience of architecture by any means—visual, verbal, material—hinges upon a two-stage process. First is the transcription of bodily sensation and perception of architectural space and its features onto the "internal senses" of memory and imagination. This immanent internal act leaves no direct traces in the external world, but it can then be transmitted outward through those "productive faculties," as the Ikhwān al-Ṣafāʾ styled them—that is, the "faculties" of speaking and making that give rise to the verbal and material arts. The relationship between architecture and its representations thus becomes most comprehensible when viewed through the prism of the internal senses that produce both cognition and, ultimately, artworks of all kinds. This is particularly relevant to a medieval Arabic-speaking context where the internal senses were understood to be multiple and complex in their operations.

The theorization of the post-sensationary faculties represents one of the major achievements of the medieval Arabic philosophical tradition, and within the medieval landscape of objects and buildings it is worth pausing over the implications of this paradigm of cognition. In medieval Arabic and Hebrew philosophical traditions, the post-sensationary faculties were conceptualized in the plural as internal senses or powers (*al-ḥawāss al-bāṭina* or *quwā bāṭina*). This is quite distinct from the single post-sensationary faculty described in some early Latin philosophical texts. The simplest interpretations in the Arabic tradition include three major faculties drawn ultimately from Aristotle: imagination, cogitation, and memory.[110] But in the work of Ibn Sīnā and others a complex and variable tabulation of the internal senses was developed which most often included five components. In Ibn Sīnā's version, first is the common sense (*al-ḥiss al-mushtarak*), the "form-recipient of all things," which receives the perceptions of the five external senses.[111] This is followed by the retentive or representative imagination (*khayāl* or *muṣawwira*); the estimative faculty (*wahm*); memory, either preservative (*ḥāfiẓa*) or recollective (*dhākira, mutadhakkira*); and the "compositive imagination" (*al-mufakkira* or *al-mutakhayyila*).[112] This paradigm and its variants, all of which presuppose sensation to be the foundation of cognition, provide a model by which sensory information can be perceived, evaluated, recorded, and abstracted.[113] This would become, through Latin translations of the works of Ibn Sīnā, Ghazālī, and Ibn Rushd (d. 1126), the basis for the medieval European theories of cognition expounded within Scholasticism.[114]

The paradigm of the internal senses was not limited to debates between philosophers but underwrote the conception of mind across medieval scholarship in the Islamic world. Working with this paradigm, scholars outside of philosophy as well as inside it recognized the importance of repeated or sustained perception of a form in order to fix it within the subject's cognition. The great advancer of optics, Ibn al-Haytham, draws a critical distinction between the glance and the repeated, contemplative gaze, with only the latter capable of causing objects to become "firmly fixed in the soul," a model of cognition that again calls up the Aristotelian paradigm of the mind as a wax tablet into which the forms of the world are impressed.[115] A similar delineation between brief and sustained looking appears in the work of the literary theorist Jurjānī, who notes that the same distinction applies to perception through the other senses.[116] Both of these redoubtable scholars constructed theories of visual perception and mental imagery, respectively, upon the premise that repeated and contemplative viewing allows an object of visual perception and its qualities to be fully apprehended, recorded, retrieved, and eventually recombined within the workshop of the mind.

The place accorded to memory varies within the various medieval Arabic schema of the internal senses, as does memory's very nature. In some conceptions memory is conceived as a primarily retentive faculty, while in others it is viewed

as playing a perceptual role.[117] However, the functions of remembering, retaining, and recollecting are frequently implicated in the other internal senses, with which memory (however conceived) works in concert. For example, in Ibn Sīnā's scheme a combinatory faculty, the compositive imagination, "combines and divides the forms and intentions [ma'ānī] perceived and retained by the other faculties," and thus acts as a studio for the construction of new ideas and images from things previously experienced. Ibn Rushd arrives at a similarly synthetic role for memory within the creative imagination.[118] The poetic images discussed in this chapter and the preceding one, for example, would be outcomes of this process since they represent new entities formed through the novel combination of existing fragments drawn from lived sensory experience.

We cannot know whether the craftsmen responsible for objects like the *kilga*s had any direct contact with the high scholarship in which these ideas were most completely articulated, and on the face of it, it seems unlikely that they would have. However, it is apparent that the underlying ideas about how sense impression, memory, and imagination worked in concert—ideas upon which more complex models of cognition were built—were in wide circulation. I believe those ideas should be accepted as the intellectual backdrop against which habits of making and beholding were constructed in the medieval Islamic world. A symbiotic relationship between the internal senses and the visual and poetic arts is in fact suggested in the articulation of those senses in terms of artistic practice: the imaginative faculties are frequently conceived in the medieval Arabic tradition as being primarily visual, to the extent of being analogized with the painter's art, while the processes of abstraction from sensory impression that preoccupy the recording and estimating faculties are sometimes likened to verbal description.[119] Thus, the deep interconnections between sensation, cognition, memory, and manual and verbal creation that ordered medieval conceptions of mind and matter flow continuously from subject to world and back again.

By recognizing the *kilga*s as both functional objects and concentrated encapsulations of ideas and impressions related to the architecture of water, it is possible to trace the compositive functions of memory and imagination within the ornament that articulates solid marble with liquid architecture. The creators of the *kilga*s have reordered fragments of architectural impression upon the bodies of the objects, with multiple points of rupture and realignment where individual elements have been brought up against each other. Within those points of rupture, the imagination can expand. The impressionistic description of architecture upon the body of the *kilga*, bringing pool up against *shādirwān*, discarding channels, building a fantasy of ingress into the drum that supports the water source, carving muqarnas into walls, and binding the whole assemblage with ribbons of inscription, successfully inscribes an architecture of the mind into a piece of marble sixty centimeters long.

CONCLUSION
OBJECTS IN AN
EXPANDED FIELD

For in the last analysis it is human consciousness which is the subject-
matter of history. The interrelations, confusions, and infections of human
consciousness are, for history, reality itself.

—Marc Bloch, *The Historian's Craft*

The art of the object is an inherently malleable category. It's right there
in the name, for what could be more open-ended and disarmingly capa-
cious a term than "object"? The prevailing structures of art history have
long delimited this category in terms of negatives: the art of the object is not
painting; it is not sculpture; it is not architecture. It is, implicitly, the bric-a-brac
left over when the rest have been dealt with. The material culture of the Islamic
world, where so many of the finest works of art are also objects of use, is perfectly
placed to disrupt art history's entrenched hierarchies of production and prejudices
concerning the "applied" arts—and yet, even Islamic art history has sometimes
tended to follow the larger art-historical pattern and subordinate the art of the ob-
ject to those of architecture and manuscripts.[1] There is an emic case to be made for
this hierarchy, to some extent: the special position held by the written word and
particularly calligraphy within Islamic culture is beyond doubt, and the historical
sources have more to say about major monuments of premodern sacred and im-
perial architecture than they do about ceramics or metalwork—naturally enough,
when one considers that the authors of those sources were usually more con-
cerned with kings than craftsmen. But the privileging of other modes of produc-
tion in medieval Islamic written sources does not mean that the artistic attainment

embodied in the plastic arts merits any less positive attention from art historians. As this book has shown, the intelligent art of the object is defined by characteristics that demand to be recognized in the positive: both pleasure and cleverness reside and work within the object's three-dimensionality, its haptic dimensions, and its insistent materiality. Above all, there is a source of intellectual delight in the object's unique potential for plastic allusion and wordless wit.

Medieval art production was of course not uniform in time or space, and one might well ask where the story of the plastic arts goes after the Mongol conquests of the thirteenth century, since those events have acted as a loose cut-off point for the materials included in this study. The Mongol invasions devastated many locales, and seemingly brought about the migration of artisans from others, but they did not effect an artistic blackout across all of the conquered territories of the Middle East and Central Asia.[2] All this makes plain the dangers of propounding generalizations about artistic production across such a vast geographic area—but I am nonetheless going to venture some. The allusive object, a category of material creativity I have linked with the medieval florescence of Arabic and subsequently Persian poetic and literary innovations and theory, as well as other cultural currents, arguably reached a peak in the extraordinarily inventive metalwork and ceramic production of the twelfth- and thirteenth-century Iranian plateau. From the fourteenth century onward, in both the eastern Islamic and Mediterranean realms, there seems to be less prevailing interest in the plastic poetics and spatial games of allusion that generated so many of the startling objects in this book. While the phenomenon does not entirely disappear—the Mamluk lamp in Fig. 4.21 shows that the allusive, archimorphic object continued to exert a hold in certain instances—it seems to have lost ground long before the decisive arrival of the great early modern empires in the sixteenth century. I would tentatively link this transition with a palpable, if complex, late medieval and early modern shift toward the privileging of highly finished surfaces and the two-dimensional image over materiality and three-dimensional models of signification. The motivations behind these tectonic movements in material and visual emphasis might well lie as much in the histories of poetry, literature, philosophy, vision science, and economic structures as in the histories of the visual arts.[3] To seek further explanations here would turn this conclusion into a whole other book.

Accepting the allusive object as a primarily medieval phenomenon, one can return to the question of its position within art history. It is entirely possible to change the way we think about a type of artwork by restructuring the categories that we use to define it. Rosalind Krauss famously contended that by the 1960s, contemporary sculpture had "entered a categorical no-man's-land: it was what was on or in front of a building that was not the building, or it was what was in the landscape that was not the landscape."[4] In Krauss's mapping of postmodernist art production, the developments that followed this stalemate can be understood as the expansion of the attributes "not-building" and "not-landscape," from a closed

binary of exclusion to a field that encompassed their opposed, positive values of "building" and "landscape." This created a dynamic space into which conceptions of three-dimensional art expanded during the 1970s to include, for example, land art and certain types of installation.[5] Although the context and the outcomes are radically different, one can borrow the principle to expand the field in which the medieval Islamic art of the object operates as an art-historical category. This is done by moving it from suspension between a cluster of exclusions—not-painting, not-sculpture, not-architecture—into a complex that recognizes its many points of contiguity and continuity with those other arts in its own time, by admitting them, along with the poetic and literary practices that have been shown throughout this book to have strong resonances in the plastic arts, into the field of the object.

Co-opting Krauss's model of the "expanded field" enables two particularly important means of intellectual encounter with the medieval Islamic art of the object. First, it accommodates multidirectional relations between modes of creativity that have traditionally been segregated in scholarship: for example, functional objects, architecture, and rhetoric. Acknowledging that these different modalities can in fact occupy the same field makes it possible to explore the extent to which they mutually construct intermedial phenomena, such as architectural decoration, spatial poetics, and the allusive objects of this book. By recognizing that different modalities could be mutually constitutive in multiple ways, this construct also has the happy outcome of providing an alternative to that pernicious art-historical mechanism, "influence," with its "wrong-headed grammatical prejudice about who is the agent and who is the patient."[6] Rather than imagining that, through some uncharted means, a tomb tower "influences" a ewer, expanding the field of the object instead makes space for a more plausible network of reciprocities between ewers, buildings, the hands that make and use them, the minds that think them, and the words that describe them.

Secondly, setting artifacts into this expanded field also makes it easier to imagine objects of use, most of which now exist primarily as static and aestheticized museum pieces, as they once were: mobile agents within a medieval continuum of humans, objects, buildings, and landscapes.

Display objects in museums, a category that includes almost all of the pieces in this book, occupy a strange position. Functional items such as inkwells, stands, jars, and incense burners have the potential for use built into them, and they advertise those modes of use through affordances. Openings, handles, lids, feet, dimensions: these construct the human encounter with an object of use, and speak of its terms of operation whether it is in the hand or in a vitrine. The objects in this book have not yet transitioned into "things," in the philosophical sense of objects that can no longer serve their function and hence have lost their defining relationship with the human subject.[7] But while some of them may have been primarily intended for display from the moment of manufacture, their current categorization as museum objects necessarily requires the semi-suppression of their manually

"usable" aspects, which are, concomitant with their elevation as artworks, usually off-limits to the hand—although not the eye. It is a truism, and one that reeks of connoisseur's privilege, to say that such objects of use can only be fully experienced when held and moved in the hands. Of course, no one would deny that two-dimensional reproductions are not a substitute for the experience of handling an object, feeling its surface, its heft, and its balance; nevertheless, images can tell us a great deal about what that experience would be like—now more than ever, when the internet and digital photography have exponentially increased our visual access to many pieces. Art history is, after all, an imaginative discipline as well as an empirical one, and there are only a few objects in this book that I have actually lifted up and cradled in my own hands as an owner might once have done. (There are many more that I have gingerly rotated on tabletops, under the watchful eyes of curators.) With all the practical barriers that exist to physically touching museum objects, returning the haptic experience to the analysis of objects of use may require some exertion of the imagination, but it is by no means an impossible task—and it is an essential part of the challenge offered by the medieval Islamic art of the object to the existing structures of art history.

Beyond art historical exigencies, then, the quest to understand better what allusive objects do has expanded the cognitive field occupied by the plastic arts. By positing the "intellect of the hand" as a discernible faculty in medieval Islamic culture, the first chapter of this book engaged the art of the object into the cognitive realm through the traces left by making, matter, and artifacts within intellectual and social history. Recognizing that a wide range of textual sources might reflect, prismatically, the nonverbal histories of knowing, thinking, and making that are embodied within material objects, that premise enabled a reassessment of the nature and position of craftsmanship and the plastic arts within medieval Islamic society. Above all, it has made it possible to recognize objects of use as embodiments of thought processes. The four subsequent chapters explored different cognitive avenues of approach to the art of the allusive object: spatial perception, object recognition, mental imagery, description, memory. By synthesizing these multiple angles of approach, an expanded cognitive field in historical context allows us to move closer to understanding how all aspects of the object were intended to work together. Materiality, structure, movement, use, inscriptions, and ornament of all sorts act in combination to produce the beholder's experience of the object's presence, and its construction of meaning—the model of "seeing-with" developed by Alloa and utilized in Chapter 3 of this book. Trying to recover and recreate historical structures of thought and cognitive paradigms, as a means of understanding not only behaviors but also the physical manifestations of those behaviors in artifacts, is both an impossible task and the most productive project art history can undertake.[8]

Finally, this book's premise of "allusion" as a form of indirect reference that can be verbal, gestural, visual, or material, takes its subjects out of the register of direct referentiality and thereby circumvents "the assumption that only the mimetic can be meaningful." This prejudice has long inhibited the art-historical study of objects of use, and indeed of Islamic art more generally.[9] Rather than tightly conclusive, the art of allusion is as concerned with processes of construction—material and rhetorical—as it is with outcomes. While I have argued that a meaningful relationship exists between these allusive objects and the building types with which they are in dialogue, that relationship does not eclipse the objects themselves. The play of fictive space produced through the judicious placement of ordering motifs and figures, the paratactical combination of architectural and non-architectural forms, or the dramatic redescription of identifiable architectural elements: all of these produce new figurations that have their own discrete existence, independent of any relationships to external referents, or even of what they can tell us about how people perceived buildings in a particular moment and setting.[10] A successfully performed allusion, Carmela Perri argues, is not a straightforward act of identification but instead will produce in its audience the actions of "recognizing, remembering, realizing, connecting."[11] It is always an active process: clever and often complex, the allusive object demands prolonged contemplation and interpretation. It thus becomes its own mechanism for extending the beholder's engagement with itself.

NOTES

Introduction

1 For a summary of some of the literature on city growth in the medieval Islamic world, see Stefan Heidemann, "How to Measure Economic Growth in the Middle East? A Framework of Enquiry for the Middle Islamic Period," in *Material Evidence and Narrative Sources: Interdisciplinary Studies of the History of the Muslim Middle East*, ed. Daniella Talmon-Heller and Katia Cytryn-Silverman (Leiden: Brill, 2014), 30–57.

2 On the historiography of ornament studies in relation to artworks of the medieval Islamic world, see in particular, Gülru Necipoğlu, *The Topkapı Scroll: Geometry and Ornament in Islamic Architecture, Topkapı Palace Library MS H. 1956* (Santa Monica, CA: Getty, 1995), 61–71; Gülru Necipoğlu, "L'idée de décor dans les régimes de visualité islamiques," in *Purs décors? Arts de l'Islam, regards du XIXe siècle*, ed. Rémi Labrusse (Paris: Les Arts Décoratifs and Musée du Louvre, 2007), 10–23.

3 For example, Necipoğlu, *Topkapı Scroll*; Finbarr Barry Flood, *Objects of Translation: Medieval "Hindu-Muslim" Encounter* (Princeton, NJ: Princeton University Press, 2009); Persis Berlekamp, *Wonder, Image, and Cosmos in Medieval Islam* (New Haven and London: Yale University Press, 2011); Jamal Elias, *Aisha's Cushion: Religious Art, Perception, and Religious Practice in Islam* (Cambridge, MA: Harvard University Press, 2012); and most recently, and from a different perspective, Shahab Ahmed, *What Is Islam? The Importance of Being Islamic* (Princeton, NJ: Princeton University Press, 2016).

4 Oleg Grabar, *The Mediation of Ornament* (Washington, DC: A. W. Mellon Lectures, 1992), 7.

5 See Hans Ulrich Gumbrecht, "Erudite Fascinations and Cultural Energies: How Much Can We Know about the Medieval Senses?," in *Rethinking the Medieval Senses: Heritage, Fascinations, Frames*, ed. Stephen G. Nichols, Andreas Kablitz, and Alison Calhoun (Baltimore: Johns Hopkins University Press, 2008), 1–10; Richard G. Newhauser, "The Senses, the Medieval Sensorium, and Sensing (in) the Middle Ages," in *Handbook of Medieval Culture*, ed. Albrecht Classen, 3 vols., (Berlin: De Gruyter, 2015), 3:1559–1575.

6 Michel Foucault, *The Order of Things: An Archaeology of the Human Sciences* (New York: Pantheon Books, 1970), 68. Similarly, Caroline Walker Bynum, "Avoiding the Tyranny of Morphology; Or, Why Compare?," *History of Religions* 53 (2014): 368, and on the question of resemblance in Chinese art, Jonathan Hay, "Editorial: The Value of Forgery," *RES: Anthropology and Aesthetics* 53/54 (2008): 9. See also Oleg Grabar, *The Mediation of Ornament* (Princeton, NJ: Princeton University Press, 1992), 193.

7 Mehmet Aga-Oglu, "The Use of Architectural Forms in Seljuq Metalwork," *Art Quarterly* 6 (1943): 93.

8 On the tower, see Ernst Diez, *Churasanische Baudenkmäler* (Berlin: Reimer, 1918), 109–112; Donald N. Wilber, "The Development of Mosaic Faïence in Islamic Architecture in Iran," *Ars Orientalis* 6, no. 1 (1939): 41–42; and Douglas Pickett, *Early Persian Tilework: The Medieval Flowering of Kāshī* (London: Associated University Presses,

1997), 104. The ewer is Museum für Islamische Kunst no. I.3566: Friedrich Sarre and Fredrik R. Martin, eds., *Die Ausstellung von Meisterwerken muhammedanischer Kunst in München 1910*, 3 vols. (Munich: Bruckmann, 1912), vol. 2, plate 142, exhibition number 3047.

9 Other ewers with the same alternation of fluting and ribs are held in the Gallerie Estensi, Modena (acc. no. 6921), for which see Sheila R. Canby, Deniz Beyazıt, Martina Rugiadi, and A. C. S. Peacock, *Court and Cosmos: The Great Age of the Seljuqs* (New York: Metropolitan Museum of Art, 2016), 143; the British Museum (acc. no. 1848,0805.1); the Museum für Islamische Kunst (no. I. 3568); former Kabul Museum collection (acc. no. 58-2-16 and another, accession number unknown), for which see Valentina Laviola, *Metalli islamici dai territori iranici orientali (IX–XIII sec.): La documentazione della Missione Archeologica Italiana in Afghanistan* (PhD diss., Università Ca' Foscari Venezia, 2016), 398; Museo Nazionale d'Arte Orientale "G. Tucci," Rome, acc. no. 5945 (Laviola, *Metalli islamici*, 399).

10 Aga-Oglu, "Architectural Forms," 84; Diez, *Baudenkmäler*, 109–111; Ebba Koch, "The Copies of the Quṭb Mīnār," *Iran* 29 (1991): 95; Ralph Pinder-Wilson, "Ghaznavid and Ghūrid Minarets," *Iran* 39 (2001): 172–173.

11 On the tower and debates about its date, see Sheila S. Blair, "The Madrasa at Zuzan: Islamic Architecture in Eastern Iran on the Eve of the Mongol Invasions," *Muqarnas* 3 (1985): 87; on the ewer, Canby et al., *Court and Cosmos*, 200–201.

12 See the illustration in Canby et al., *Court and Cosmos*, 155–156; for further discussion of the inscription, see Sheila S. Blair, *Text and Image in Medieval Persian Art* (Edinburgh: Edinburgh University Press, 2014), 65–67.

13 On the tower, see Sheila S. Blair, *The Monumental Inscriptions from Early Islamic Iran and Transoxiana* (Leiden: Brill, 1992), 88–90; Melanie Michailidis, "In the Footsteps of the Sasanians: Funerary Architecture and Bavandid Legitimacy," in *Persian Kingship and Architecture: Strategies of Power in Iran from the Achaemenids to the Pahlavis*, ed. Sussan Babaie and Tallin Grigor (London: I. B. Tauris, 2015), 141–142. The ewer is Museum für Islamische Kunst no. I.3567; illustrated in Sarre and Martin, *Ausstellung*, vol. 2, plate 141, exhibition number 3045.

14 Pseudomorphism as art historical "booby trap" was first proposed by Erwin Panofsky in *Tomb Sculpture* (New York: Harry N. Abrams, 1964), 26–27. Yve-Alain Bois has recently published further discussion of the phenomenon with particular emphasis on the issues of temporal priority that it so often generates: "On the Uses and Abuses of Look-alikes," *October* 154 (2015): 127–149. Discussion of the phenomenon is also central to Bynum, "Avoiding the Tyranny," and Finbarr Barry Flood, "Picasso the Muslim: Or, How the Bilderverbot Became Modern (Part 1)," *RES: Anthropology and Aesthetics* 67/68 (2016/2017), especially 42–44.

15 Michailidis, "In the Footsteps of the Sasanians"; Robert Hillenbrand, *Islamic Architecture: Form, Function, Meaning* (Edinburgh: Edinburgh University Press, 2000), 273–294.

16 Joan Kee and Emanuele Lugli, "Scale to Size: An Introduction," *Art History* 38:2 (2015): 258.

17 Muhammad Qasim Zaman, "al-Yaʿḳūbī," *Encyclopaedia of Islam*, 2nd ed., http://dx.doi.org/10.1163/1573-3912_islam_SIM_7970. Yaʿqūbī, *Kitāb al-buldān*, trans. Gaston Wiet as *Les pays* (Cairo: Imprimerie de l'institut français d'archéologie orientale, 1937); Al-Thaʿālibī, *The Book of Curious and Entertaining Information: The Laṭāʾif al-maʿārif of Thaʿālibī, translated with introduction and notes by C. E. Bosworth* (Edinburgh: Edinburgh University Press, 1968).

18 Bilal Orfali and Maurice A. Pomerantz, "A Lost *Maqāma* of Badī' al-Zamān al-
 Hamaḏānī?," *Arabica* 60 (2013): 245–271. See also Ibn Khaldūn, *The Muqaddimah: An
 Introduction to History*, 3 vols., trans. Franz Rosenthal (London: Routledge and Kegan
 Paul, 1958), 2:301–302.

19 See Lisa Golombek, "The Draped Universe of Islam," in *Content and Context of Visual
 Arts in the Islamic World*, ed. Priscilla P. Soucek (University Park: Pennsylvania State
 University Press, 1988), 26, and the bibliography she lists in notes 6–10; R. B. Serjeant,
 Islamic Textiles; Materials for a History up to the Mongol Conquest (Beirut: Librarie du
 Liban, *c.* 1972).

20 Al-Tha'ālibī, *Curious and Entertaining*, 145–146.

21 To give a particularly far-flung example, fragments of thirteenth-century Syrian glassware
 were excavated from the site of the thirteenth-century moated castle at Caerlaverock in
 southwest Scotland: Martin Brann, ed., *Excavations at Caerlaverock Old Castle 1998–9*
 (Dumfries: Dumfries and Galloway Natural History and Antiquarian Society, 2004),
 68–69. The much more regular movement of metalwork manufactures, as well as
 metals, around the Mediterranean and between the Arabian Peninsula and India is well
 documented and some of the major studies are summarized in James W. Allan and Ruba
 Kana'an, "The Social and Economic Life of Metalwork, 1050–1250," in *A Companion to
 Islamic Art and Architecture (Blackwell Companions in Art History)*, ed. Finbarr Barry Flood
 and Gülru Necipoğlu, 2 vols., (Malden, MA: Wiley-Blackwell, 2017), 1:453–477.

22 Oliver Watson, *Persian Lustre Ware* (London: Faber and Faber, 1985), 41–42;
 Julian Raby, "The Principle of Parsimony and the Problem of the 'Mosul School of
 Metalwork,'" in *Metalwork and Material Culture in the Islamic World: Art, Craft and Text*,
 ed. Venetia Porter and Mariam Rosser-Owen (London: I. B. Tauris, 2012), 22.

23 For example, see the possible trajectories of metalwork families across the Levant and
 Jazira outlined in Raby, "The Principle of Parsimony," 23–44. A later example can be
 found in the architect of the mosque at Fīrūzābād in the Deccan, whose name "Aḥmad
 ibn Ḥusayn al-Ḥisnkayfī" indicates that he and/or his forebears were from Hasankeyf,
 in southeastern Turkey: George Michell and Richard Eaton, *Firuzabad: Palace City of the
 Deccan* (Oxford: Oxford University Press, 1992), 34.

24 Oleg Grabar, "The Visual Arts: 1050–1350," in *Cambridge History of Iran, vol. 5: The
 Saljuq and Mongol Periods*, ed. John Andrew Boyle (Cambridge: Cambridge University
 Press, 1968), 626–658; Richard Ettinghausen, "The Flowering of Seljuq Art,"
 Metropolitan Museum Journal 3 (1970): 113–131.

25 Yasser Tabbaa, "Bronze Shapes in Iranian Ceramics of the Twelfth and Thirteenth
 Centuries," *Muqarnas* 4 (1987), 110.

26 David Durand-Guédy, *Iranian Elites and Turkish Rulers: A History of Iṣfahān in the Saljūq
 Period* (London: Routledge, 2010), 230–255.

27 Ruba Kana'an, "The *de Jure* 'Artist' of the Bobrinski Bucket: Production and Patronage
 of Metalwork in pre-Mongol Khurasan and Transoxiana," *Islamic Law and Society* 16,
 no. 2 (2009): 175–201; Ruba Kana'an, "Patron and Craftsman of the Freer Mosul Ewer
 of 1232: A Historical and Legal Interpretation of the Roles of Tilmīdh and Ghulām in
 Islamic Metalwork," *Ars Orientalis* 42 (2012), 67–78; Ruba Kana'an, "The Biography
 of a Thirteenth-Century Brass Ewer from Mosul," in *God Is Beautiful and Loves
 Beauty: The Object in Islamic Art and Culture*, ed. Sheila S. Blair and Jonathan M. Bloom
 (New Haven, CT: Yale University Press, 2013), 176–93; Allan and Kana'an, "Social and
 Economic Life of Metalwork."

28 Christopher B. Steiner, "Can the Canon Burst?," *The Art Bulletin* 78, no. 2 (1996): 217.

29 Michel de Certeau, *The Writing of History*, trans. Tom Conley (New York: Columbia University Press, 1988), 4.

30 Oleg Grabar, "Between Connoisseurship and Technology: A Review," *Muqarnas* 5 (1988): 1–8; Oleg Grabar, "An Art of the Object," *Artforum* 14 (1976): 36–43.

31 Eva-Maria Troelenberg, "On a Pedestal? On the Problem of the Sculptural as a Category of Perception for Islamic Objects," in *Art History and Fetishism Abroad: Global Shiftings in Media and Methods*, ed. Gabriele Genge and Angela Stercken (Bielefeld: transcript, 2014), 159–174. Alex Potts's comments about the awkwardness of "sculpture" as a category even for works produced in the European and North American studio traditions are very resonant here: Alex Potts, *The Sculptural Imagination: Figurative, Modernist, Minimalist* (New Haven and London: Yale University Press, 2000), esp. 1–4.

32 Oliver Watson, "Museums, Collecting, Art-History and Archaeology," *Damaszener Mitteilungen* 11 (1999): 421–432.

33 See the essays collected in Sabine Frommel, ed., *Les maquettes d'architecture: function et évolution d'un instrument de conception et de réalisation* (Paris and Rome: Picard and Campisano Editore, 2015).

34 Gülru Necipoğlu-Kafadar, "Plans and Models in 15th- and 16th-Century Ottoman Architectural Practice," *The Journal of the Society of Architectural Historians* 45, no. 3 (1986): 236–237. Ronald Lewcock ("Materials and Techniques," in *Architecture of the Islamic World: Its History and Social Meaning*, ed. George Michell [London: Thames and Hudson, 1978], 132) reports that wooden architectural models were used in Abbasid Baghdad prior to or during the construction process, but gives no source for this.

35 A well-known illustration from a *c.* 1587 manuscript of the *Surname-i Hümayun* shows the royal architects carrying a resplendent model of the Süleymaniye Mosque in Istanbul (completed 1558) through the Hippodrome as part of the circumcision festivities held in honor of the son of the Ottoman Emperor Murad III: Serpil Bağcı, Filiz Çağman, Günsel Renda and Zeren Tanındı, *Ottoman Painting* (Ankara: Ministry of Culture and Tourism, 2010), 147. The painting appears to depict a cloth construction, while models in precious and semiprecious materials survive from the Ottoman period: Hilmi Aydın, *The Sacred Trusts: Pavilion of the Sacred Relics* (Somerset, NJ: The Light, 2004), 198–99.

36 The bibliography on donor buildings in medieval Western, Byzantine, and Caucasian art is considerable: the most recent comprehensive study of the Western material is Emanuel Klinkenberg, *Compressed Meanings: The Donor's Model in Medieval Art to Around 1300* (Turnhout, Belgium: Brepols, 2009). See also Paolo Cuneo, "Les modèles en pierre de l'architecture arménienne," *Revue des études arméniennes* 8 (1971): 201–231; Giulio Ieni, "La rappresentazione dell'oggetto architettonico nell'arte medieval con riferimento particolare ai modelli di architettura Caucasici," *Atti del primo simposia internazionale di arte armena* (Venice: 1975), 247–264; Cristina Maranci, "Architectural Models in the Caucasus: Problems of Form, Function, and Meaning," in *Architectural Models in Medieval Architecture*, ed. Yannis D. Varalis (Thessaloniki: University Studio Press, 2008), 46–52; Mabi Angar, "Stiftermodelle in Byzanz und bei christlich-orthodoxen Nachbarkulturen," in *Mikroarchitektur im Mittelalter: Ein gattungsübergreifendes Phänomen zwischen Realität und Imagination*, ed. Christine Kratzke und Uwe Albrecht (Leipzig: Kratzke Verlag für Kunst- und Kulturgeschichte, 2008), 433–453; Slobodan Ćurčić and Evangelia Hadjitryphonos, *Architecture as Icon: Perception and Representation of Architecture in Byzantine Art* (Princeton, NJ: Princeton University Art Museum, 2010), esp. 162–171; Maria Cristina Carile, "Buildings in Their Patron's Hands? The Multiform Function of Small Size Models Between Byzantium and Transcaucasia," *kunsttexte.de* 3 (2014), https://edoc.hu-berlin.de/bitstream/handle/18452/8347/carile.pdf?sequence=1&isAllowed=y.

37 P. McGough, "Looters Break for Farce amid the Dictator Kitsch," *The Age*, April 13, 2003, http://www.theage.com.au/articles/2003/04/12/1050069120987.html. On the circulation of the Dome of the Rock as maquette and model, see Christiane Gruber, "Islamic Architecture on the Move," *International Journal of Islamic Architecture* 3, no. 2 (2014): 249–252; Christiane Gruber, "Jerusalem in the Visual Propaganda of Post-Revolutionary Iran," in *Jerusalem: Idea and Reality*, ed. Suleiman Mourad and Tamar Mayer (London: Routledge, 2008), 168–197.

38 Clifford Edmund Bosworth, *The Ghaznavids: Their Empire in Afghanistan and Eastern Iran, 994: 1040* (Edinburgh: Edinburgh University Press, 1963), 136. Shmuel Moreh cites a description of seven palaces of sugar paraded through the streets of Cairo in 1024 given by Maqrīzī (d. 1442), who was in turn citing al-Musabbiḥī (d. 1029): *Live Theatre and Dramatic Literature in the Medieval Arab World* (Edinburgh: Edinburgh University Press, 1992), 53.

39 Oleg Grabar, "Imperial and Urban Art in Islam: The Subject-Matter of Fatimid Art," reprinted in *Constructing the Study of Islamic Art, Volume. I: Early Islamic Art, 650–1100* (Burlington, VT: Ashgate, 2005), 236.

40 Al-Ghazālī, *Iḥyāʾ ʿulūm al-Dīn*, 4 vols. (Cairo: Dār Iḥyāʾ al-Kutub al-ʿArabiyya, 1957), 2: 21. Al-Ghazālī, *Al-Ghazālī on the Manners Relating to Eating: Book XI of the Revival of Religious Sciences*, trans. and notes D. Johnson Davies (Cambridge: Islamic Texts Society, 2000), 51.

41 Cornelis de Bruyn, *Voyages de Corneille le Brun par la Muscovie, en Perse, et aux Indes Orientales*, 2 vols. (Amsterdam: Wetstein, 1718), 1:191.

42 Fernando de la Granja, "Fiestas Cristianas en al-Andalus (materiales para su studio), I: 'Al-Durr al-munazzam' de al-ʿAzafī," *Al-Andalus* 34, no. 1 (1969): 34–35. I thank Barry Flood for bringing this to my attention.

43 Margaret S. Graves, "Ceramic House Models from Medieval Persia: Domestic Architecture and Concealed Activities," *Iran* 46 (2008): 227–251. In addition to the examples and bibliography cited in that article, a further study of these objects by Umberto Scerrato has since been published posthumously: "Hausmodelle," *Quaderni di Vicino Oriente* 7 (2014): 14–46. A catalogue entry by Martina Rugiadi in Canby et al., *Court and Cosmos*, 115, includes an image of a fragment from a house model excavated at Rayy, Iran.

44 Bachelard, *The Poetics of Space*, 148; Susan Stewart, *On Longing: Narratives of the Miniature, the Gigantic, the Souvenir, the Collection* (Durham and London: Duke University Press, 1993), 37–69. See the comments on this text in Kee and Lugli, "Scale to Size," 254.

45 Qinghua Guo, *The* mingqi *Pottery Buildings of Han Dynasty China 206 BC–AD 220: Architectural Representations and Represented Architecture* (Brighton and Portland, OR: Sussex Academic Press, 2010), 7.

46 Jeehee Hong, "Mechanism of Life for the Netherworld: Transformations of *Mingqi* in Middle-Period China," *Journal of Chinese Religions* 43, no. 2 (2015): 161–193. Something similar occurs in the vibrant architectural "models" of the pre-Columbian Americas: Joanne Pillsbury, "Building for the Beyond: Architectural Models from the Ancient Americas," in *Design for Eternity: Architectural Models from the Ancient Americas*, ed. Patricia Joan Sarro, James Doyle, and Juliet Wiersema (New York: Metropolitan Museum of Art, 2015), 3.

47 Ludmilla Jordanova, "Material Models as Visual Culture," in *Models: The Third Dimension of Science*, ed. Soraya de Chadarevian and Nick Hopwood (Stanford, CA: Stanford University Press, 2004), 447–448; Albert C. Smith, *Architectural Model as*

Machine: A New View of Models from Antiquity to the Present Day (Oxford: Architectural Press / Elsevier, 2004), 5–32.

48 John Mack, *The Art of Small Things* (London: British Museum, 2007), 71; Carl Knappett, "Meaning in Miniature: Semiotic Networks in Material Culture," in *Excavating the Mind: Cross-Sections through Culture, Cognition and Materiality* (Aarhus, Denmark: Aarhus University Press, 2012), 103. See also Doug Bailey, *Prehistoric Figurines: Representation and Corporeality in the Neolithic* (London: Routledge, 2005), 26–44, on "model" and "miniature."

49 Wu Hung, "The Invisible Miniature: Framing the Soul in Chinese Art and Architecture," *Art History* 38, no. 2 (2015): 291–295; Suzanne G. Valenstein, *Cultural Convergence in the Northern Qi Period: A Flamboyant Chinese Ceramic Container: A Research Monograph* (New York: Metropolitan Museum of Art, 2007), 67.

50 Juliet B. Wiersema, *Architectural Vessels of the Moche: Ceramic Diagrams of Sacred Space in Ancient Peru* (Austin: University of Texas Press, 2015), 79–81. For some related issues in a later period of Peruvian art production, see Andrew J. Hamilton, *Scale and the Incas* (Princeton, NJ: Princeton University Press, 2018).

51 François Bucher, "Micro-Architecture as the 'Idea' of Gothic Theory and Style," *Gesta* 15, nos. 1/2 (1976): 71–89. See also the essay by John Summerson, "Heavenly Mansions: An Interpretation of the Gothic," in *Heavenly Mansions and Other Essays on Architecture* (London: Norton Library, 1963), 1–28.

52 Achim Timmermann, "Fleeting Glimpses of Eschaton: Scalar Travels in Medieval Microarchitecture," in *Microarchitecture et figure du bâti: l'échelle à l'épreuve de la matière*, ed. Clément Blanc, Jean-Marie Guillouët, and Ambre Vilain (Paris: Picard, forthcoming). My thanks to the author for sharing the prepublication text with me.

53 Hans Sedlmayr, *Die Entstehung der Kathedrale* (Zurich: Atlantis-Verlag, 1950), 82, cited in Timmermann, "Fleeting Glimpses." See also Alina Payne, "Materiality, Crafting and Scale in Renaissance Architecture," *The Oxford Art Journal* 32, no. 3 (2009): 372–377.

54 Elizabeth Lambourn, "A Self-Conscious Art? Seeing Micro-Architecture in Sultanate South Asia," *Muqarnas* 28 (2010): 121–156.

55 Jeehee Hong, "Crafting Boundaries of the Unseeable World: Dialectics of Space in the Bhagavat Sutra Repository," *Art History* 40, no. 1 (2017): 10–37; Jeehee Hong, *Theater of the Dead: A Social Turn in Chinese Funerary Art, 1000–1400* (Honolulu: University of Hawai'i Press, 2016), 89–100.

56 Hong, "Crafting Boundaries," 23.

57 Ćurčić and Hadjitryphonos, *Architecture as Icon*, 260–271.

58 Kee and Lugli, "Scale to Size," 252.

59 Claude Lévi-Strauss, *The Savage Mind (La Pensée sauvage)*, trans. Sybil Wolfram (London: Weidenfeld and Nicolson, 1966), 23–24; Stewart, *On Longing*, 65–69; Bachelard, *Poetics*, 151–155.

60 The seminal study is Alton J. DeLong, "Phenomenological Space-Time: Toward an Experiential Relativity," *Science*, new series 213, no. 4508 (August 7, 1981): 681–683. On the invitation to imagine oneself within the miniature, Bachelard, *Poetics*, 148–172; and how this actually works in artworks, Timmermann, "Fleeting Glimpses."

61 Margaret S. Graves, "Inside and Outside, Picture and Page: The Architectural Spaces of Miniature Painting," in *Treasures of the Aga Khan Museum: Architecture in Islamic Arts* (Geneva: Aga Khan Trust for Culture, 2011), 295–303, and the bibliography in that article.

62 David Roxburgh's comments on the idiom of Persianate painting and its relation to the themes of seeing in premodern Persian literature are particularly relevant: "Micrographia: Towards a Visual Logic of Persianate Painting," *RES: Anthropology and Aesthetics* 43 (2003): 28–30.

63 Quoted in al-Ghazālī, *Al-Ghazālī on the Manners Relating to Eating*, 20. The tradition is recorded by Tirmidhī: https://sunnah.com/tirmidhi/27/90.

64 Eva R. Hoffman, "Pathways of Portability: Islamic and Christian Interchange from the Tenth to the Twelfth Century," *Art History* 24, no. 1 (2001) 17–50.

65 Paul Barolsky, "Writing Art History," *The Art Bulletin* 78, no. 3 (1996): 400. Cf. J. Huizinga, *Homo Ludens: A Study of the Play Element in Culture* (London: Routledge and Kegan Paul, 1949), 165–169.

Chapter 1: The Intellect of the Hand

1 The literature is growing apace; some of the most relevant ideas for this study are found in Chris Gosden, "What Do Objects Want?," *Journal of Archaeological Method and Theory* 12, no. 3 (2005): 193–211; Lambros Malafouris, "At the Potter's Wheel: An Argument *for* Material Agency," in *Material Agency: Towards a Non-Anthropocentric Approach*, ed. Carl Knappett and Lambros Malafouris (New York: Springer, 2008), 19–36; Lambros Malafouris, *How Things Shape the Mind: A Theory of Material Engagement* (Cambridge, MA: MIT Press, 2013). On the separation of the making of knowledge and the making of objects in the European traditions, see Pamela H. Smith, *The Body of the Artisan: Art and Experience in the Scientific Revolution* (Chicago: University of Chicago Press, 2004).

2 "Making is thinking" is quoted from Richard Sennett, *The Craftsman* (New Haven, CT: Yale University Press, 2008), ix. On the "thinking hand," Martin Heidegger, *What Is Called Thinking?*, translation of *Was Heisst Denken?* by J. Glenn Gray (New York: Perennial, 1976), 16. My own perspective on this matter is directly informed by an undergraduate degree in studio art, but art college is not the only way to experience the processes of making: cookery, for example, is one of the most commonly practiced arts of making.

3 The separate but related issue of artistic intelligence and decision-making versus "unthinking tradition" has been explored in Molly Emma Aitken, *The Intelligence of Tradition in Rajput Court Painting* (New Haven and London: Yale University Press, 2010).

4 Historically this has been reflected not only in a lack of scholarly art-historical interest in craft processes but also in certain anxieties about post-production interventions, such as repair, restoration, or remounting. See Moya Carey and Margaret Graves, "Introduction: The Historiography of Islamic Art and Architecture, 2012," *Journal of Art Historiography* 6 (2012): 8–10.

5 The inflation of the Romantic ideal of individual genius and the parallel conversion of artistic ability from "skill to self" is discussed in Richard Sennett, *The Fall of Public Man* (New York: Knopf, 1977), particularly 199–205. On the identification of craft (and by implication, labor) with female production, and inspired, God-like creation with male expression, see Rozsika Parker and Griselda Pollock, *Old Mistresses: Women, Art and Ideology* (New York: Pantheon Books, 1981), 50–81; Christine Battersby, *Gender and Genius: Towards a Feminist Aesthetics* (Bloomington: Indiana University Press, 1989).

6 Major works are Tim Ingold, *Making* (London: Routledge, 2013), and Sennett, *The Craftsman*.

7 Tim Ingold, "The Textility of Making," *Cambridge Journal of Economics* 34 (2010): 91. See also Tim Ingold, "Materials against Materiality," *Archaeological Dialogues* 14,

no. 1 (2007): 1–16. Ingold consciously aligns himself with Gilles Deleuze and Félix Guattari, *A Thousand Plateaus*, trans. B. Massumi (London: Continuum, 2004). For critiques of Ingold's characterization of "materiality," see the responses published with "Materials against Materiality," especially Carl Knappett, "Materials *with* Materiality?," *Archaeological Dialogues* 14, no. 1 (2007): 20–23.

8 Also consciously following Deleuze and Guattari, Laura Marks has argued for a related differentiation of "becoming" from "being" within the artifacts of premodern Islamic cultures: "From Haptic to Optical, Performance to Figuration: A History of Representation at the Bottom of a Bowl," in *Islam and the Politics of Culture in Europe: Memory, Aesthetics, Art*, ed. Frank Peter, Sarah Dornhof, and Elena Arigita (Bielefeld: transcript, 2013), 237–263.

9 Michael Ann Holly, contribution to "Notes from the Field: Materiality," *The Art Bulletin* 95, no. 1 (2013): 15.

10 The most diverse selection of written sources on craft production in the Islamic world currently available in English is Marcus Milwright's *Islamic Arts and Crafts: An Anthology* (Edinburgh: Edinburgh University Press, 2017).

11 On "making and knowing," see Pamela H. Smith, "In a Sixteenth-Century Goldsmith's Workshop," in *The Mindful Hand: Inquiry and Invention from the Late Renaissance to Early Industrialisation*, ed. Lissa Roberts, Simon Schaffer, and Peter Dear (Amsterdam: Royal Netherlands Academy of Arts and Sciences, 2007), 32–57; and Pamela H. Smith, "Making as Knowing: Craft as Natural Philosophy," in *Ways of Making and Knowing: The Material Culture of Empirical Knowledge*, ed. Pamela Smith, Amy Meyers, and Harold Cook (Ann Arbor: University of Michigan Press, 2014), 17–47.

12 José Miguel Puerta Vílchez's magisterial study of aesthetics in premodern Islamic intellectual history has shed much light on conceptualizations of the arts in the medieval Islamic world, which he frames as a subject lying "on the margins of knowledge." *Aesthetics in Arabic Thought: From Pre-Islamic Arabia through al-Andalus*, trans. Consuela López-Morillas (Leiden: Brill, 2017), chapter 2, 97–479.

13 Necipoğlu, *Topkapı Scroll*, 131–140, 156–158; Renata Holod, "Text, Plan and Building: On the Transmission of Architectural Knowledge," in *Theories and Principles of Design in the Architecture of Islamic Societies*, ed. Margaret Ševčenko (Cambridge MA: Aga Khan Program for Islamic Art, 1988), 3–4; M. Souissi, "'Ilm al-Handasa," in *Encyclopaedia of Islam*, 2nd ed., http://dx.doi.org/10.1163/1573-3912_islam_COM_1408; Gülru Necipoğlu, ed., *The Arts of Ornamental Geometry: A Persian Compendium on Similar and Complementary Interlocking Figures = Fī tadākhul al-ashkāl al-mutashābiha aw al-mutawāfiqa (Bibliothèque nationale de France, Ms. Persan 169, fols. 180r–199r). A Volume Commemorating Alpay Özdural* (Leiden: Brill, 2017).

14 Alpay Özdural, "Omar Khayyam, Mathematicians and *Conversazioni* with Artisans," *Journal of the Society of Architectural Historians* 54, no. 1 (1995): 54; Alpay Özdural, "Mathematics and Arts: Connections between Theory and Practice in the Medieval Islamic World," *Historia Mathematica* 27 (2000): 173.

15 Holod, "Text, Plan and Building," 3; Gülru Necipoğlu, "Geometric Design in Timurid/Turkmen Architectural Practice: Thoughts on a Recently Discovered Scroll and Its Late Gothic Parallels," in *Timurid Art and Culture: Iran and Central Asia in the Fifteenth Century*, ed. Lisa Golombek and Maria Subtelny (Leiden: Brill, 1992), 62.

16 S. M. Stern, "Abū Ḥayyān al-Tawḥīdī," *Encyclopaedia of Islam*, 2nd ed., http://dx.doi.org/10.1163/1573-3912_islam_SIM_0202; Gülru Necipoğlu, "The Scrutinizing Gaze in the Aesthetics of Islamic Visual Cultures: Sight, Insight, and Desire," *Muqarnas* 32 (2015): 32; Franz Rosenthal, "Abū Ḥaiyān al-Tawḥīdī on Penmanship," *Ars Islamica* 13 (1948): 1–30.

17 See Necipoğlu, "Scrutinizing Gaze," 32.

18 Özdural, "Omar Khayyam," 55.

19 Armen Ghazarian and Robert Ousterhout, "A Muqarnas Drawing from Thirteenth-Century Armenia and the Use of Architectural Drawings during the Middle Ages," *Muqarnas* 18 (2001): 144; Necipoğlu, *Topkapı Scroll*, 3–4.

20 Ulrich Harb, *Ilkhanidische Stalaktitengewölbe: Beiträge zu Entwurf un Bautechnik* (Berlin: Dietrich Reimer Verlag, 1978); Necipoğlu, "Geometric Design"; Necipoğlu, *Topkapı Scroll*, 4–5; Ghazarian and Ousterhout, "Muqarnas Drawing." See also Yvonne Dold-Samplonius and Silvia L. Harmsen, "The Muqarnas Plate Found at Takht-i Sulayman: A New Interpretation," *Muqarnas* 22 (2005): 85–94.

21 Necipoğlu, *Topkapı Scroll*.

22 Necipoğlu, "Geometric Design," 62; Necipoğlu, *Topkapı Scroll*, 9–14, 29–39. See also I. I. Notkin, "Decoding Sixteenth-Century Muqarnas Drawings," *Muqarnas* 12 (1995): 148–171.

23 Nasser Rabbat, "Design without Representation in Medieval Egypt," *Muqarnas* 25 (2008): 147–154.

24 For example, Necipoğlu, "Qur'anic Inscriptions," 69–104. See also David Roxburgh, "Timurid Architectural Revetment in Central Asia, 1370–1430: The Mimeticism of Mosaic Faience," in *Histories of Ornament: From Global to Local*, ed. Gülru Necipoğlu and Alina Payne (Princeton, NJ: Princeton University Press, 2016), 116–129.

25 Ibn ʿAbdūn, *Seville musulmane au début du XII siècle: le traite d'Ibn ʿAbdūn sur la vie urbaine et les corps de métiers*, trans. Évariste Lévi-Provençal (Paris: Maisonneuve and Larose, 1947), 60–66; Évariste Lévi-Provençal, "Un document sur la vie urbaine et les corps de métiers à Séville au début du XII siècle: le traité d'Ibn Abdun," *Journal Asiatique* 224 (1934): 177–299, especially the glossary on 255–299. See also Ibn al-Ukhuwwa, *The Maʿālim al-qurba fi akhām al-ḥisba of Diyā al-Dīn Muḥammad Ibn Muḥammad al-Qurashī al-Shāfiʿī, known as Ibn al-Ukhuwwa*, ed. Reuben Levy (London: E. J. W. Gibb Memorial, 1938), 95 and 235; Ahmad Ghabin, *Ḥisba, Arts and Craft in Islam* (Wiesbaden: Harrassowitz Verlag, 2009), 199.

26 Ghabin, *Ḥisba*, 203–204; Maya Shatzmiller, *Labour in the Medieval Islamic World* (Leiden: Brill, 1994), 211–212. Lewcock cites the example of an early fourteenth-century craftsman known in one context as *al-muhandis al-bannāʾ* and in another as *jassās* (plaster-worker). Lewcock, "Materials and Techniques," 130.

27 Shatzmiller, *Labour*, 103–105; Ghabin, *Ḥisba*, 201–202.

28 Al-Ghazālī, *al-Maqṣad al-asnā fi sharḥ asmāʾ Allāh al-ḥusnā* (Beirut: Dār al-Mashriq, 1982), 80; al-Ghazālī, *The Ninety-Nine Beautiful Names of God, al-Maqṣad al-asnā fi sharḥ asmāʾ Allāh al-ḥusnā*, trans. with notes by David B. Burrell and Nazih Daher (Oxford: Islamic Texts Society, 1992), 68; Samer Akkach, *Cosmology and Architecture in Premodern Islam: An Architectural Reading of Mystical Ideas* (Albany, NY: SUNY Press, 2005), 51; Puerta Vílchez, *Aesthetics in Arabic Thought*, 57–58.

29 Al-Ghazālī, *Ihyāʾ ʿulūm al-Dīn*, 3:19.

30 Cf. Kojiro Nakamura, "Imam Ghazali's Cosmology Reconsidered with Special Reference to the Concept of 'Jabarūt,'" *Studia Islamica* 80 (1994): 36. Akkach (*Cosmology*, p. xvii) translates *nuskha* as "exemplar."

31 See also Iradj Afshar, "Architectural Information through the Persian Classical Texts," in *Akten des VII. Internationalen Kongresses fur Iranischen Kunst und Archaologie: Munchen, 7–10 September 1976* (Berlin: D. Reimer, 1979), 612–613.

32 Abu Dulaf, *Abu-Dulaf Mis'ar Ibn Muhalhil's Travels in Iran (circa A.D. 950): Arabic Text with an English Translation and Commentary by Prof. V. Minorsky* (Cairo: Cairo University Press, 1955), 45, 14.

33 Taneli Kukkonen, "On Adding to the Names: The Camel's Smile," *Studia Orientalia* 114 (2013): 342–344.

34 Oleg Grabar and Renata Holod, "A Tenth-Century Source for Architecture," *Harvard Ukrainian Studies* 3, no. 6 (1979–80), 310–319.

35 For example, Abbas Hamdani, "The *Rasa'il Ikhwan al-Safa'* and the Controversy about the Origin of Craft Guilds in Early Medieval Islam," in *Money, Land and Trade: An Economic History of the Muslim Mediterranean*, ed. Nelly Hanna (London: I. B. Tauris, 2002), 157–173.

36 For a recent summary, Nader El-Bizri, "Prologue," in *Epistles of the Brethren of Purity: The Ikhwān al-Ṣafā' and their* Rasā'il, ed. Nader El-Bizri (Oxford: Oxford University Press / Institute of Ismaili Studies, 2008), 1–32.

37 The original number of epistles contained within the *Rasā'il Ikhwān al-Ṣafā'* is also the subject of debate: see Abbas Hamdani, "The Arrangement of the *Rasā'il Ikhwān al-Ṣafā'* and the Problem of Interpolations," in *Epistles*, ed. El-Bizri, 88–90.

38 Godefroid de Callataÿ, "The Classification of Knowledge in the Rasā'il," in *Epistles*, ed. El-Bizri, 82.

39 See Callataÿ, "Classification," 82, who also cites copied passages in the work of al-Idrīsī (d. 1165) and al-Qazwīnī (d. 1283), as well as the Pseudo-Aristotelian *Secretum Secretorum*; Godefroid de Callataÿ, "Philosophy and Bāṭinism in al-Andalus: Ibn Masarra's *Risālat al-I'tibār* and the *Rasā'il Ikhwān al-Ṣafā'*," *Jerusalem Studies in Arabic and Islam* 41 (2014): 261–312; Ismail K. Poonawala, "Why We Need an Arabic Critical Edition with an Annotated English Translation of the *Rasā'il Ikhwān al-Ṣafā'*," in *Epistles*, ed. El-Bizri, 34–36; Puerta Vílchez, *Aesthetics in Arabic Thought*, 107.

40 Yahya Jean Michot, "Misled and Misleading . . . Yet Central in Their Influence: Ibn Taymiyya's Views on the Ikhwān al-Ṣafā'," in *Epistles*, ed. El-Bizri, 148–149, 166–169.

41 Michot, "Misled," 176; see also Eric Ormsby's introduction to al-Ghazālī, *Love, Longing, Intimacy and Contentment: Book XXXVI of the Revival of the Religious Sciences = Iḥyā' 'ulūm al-dīn, translated with an introduction and notes by Eric Ormsby* (Cambridge: The Islamic Texts Society, 2011), xvii–xviii.

42 Ibn al-Haytham, *The Optics of Ibn al-Haytham, Books I–III: On Direct Vision*, 2 vols., trans. A. I. Sabra (London: Warburg Institute, 1989), 2:100.

43 *Rasā'il ikhwān al-ṣafā' wa-khillān al-wafā'*, 4 vols (Beirut: Dār Ṣadir, 1957), 4:57–58, 174–175. References to the text of the *Rasā'il* are to this edition unless otherwise stated. See also Ian Netton, *Muslim Neoplatonists: An Introduction to the Thought of the Brethren of Purity (Ikhwān al-Ṣafā')* (London: Allen and Unwin, 1982), 36.

44 Seyyed Hossein Nasr, *An Introduction to Islamic Cosmological Doctrines: Conceptions of Nature and Methods Used for Its Study by the Ikhwān al-Ṣafā', al-Bīrūnī, and Ibn Sīnā* (Albany, NY: SUNY Press, 1993), 31–32.

45 Ikhwān al-Ṣafā', *Rasā'il*, 4:188. See also Hamdani, "Controversy," 60.

46 The theme recurs throughout the text but is most comprehensively developed in epistle six, "On the arithmetical and geometric proportions with respect to the refinement of the soul and reformation of character" (Ikhwān al-Ṣafā', *Rasā'il*, 1:242–257). An expansive and illuminating exploration of these ideas in the works of the Ikhwān and other medieval authors can be found in Necipoğlu, *Topkapı Scroll*, particularly 185–196;

Necipoğlu, "Scrutinizing Gaze," 30–32. See also Puerta Vílchez, *Aesthetics in Arabic Thought*, 166–186. The aesthetics of the Ikhwān al-Ṣafāʾ are also discussed in Valérie Gonzalez, *Beauty and Islam: Aesthetics in Islamic Art and Architecture* (London: I. B. Tauris, 2001), 51, 61, 75.

47 Mohammed Hamdouni Alami, *The Origins of Visual Culture in the Islamic World: Aesthetics, Art and Architecture in the Medieval Middle East* (London: I. B. Tauris, 2015).

48 Akkach, *Cosmology*, 36–40.

49 Ikhwān al-Ṣafāʾ, *Rasāʾil*, 2:414–415.

50 Ikhwān al-Ṣafāʾ, *Rasāʾil*, 2:414. Harry Wolfson argues that this construction is the result of a merging of two earlier classificatory systems simultaneous with a series of overly literal translations ("The Internal Senses in Latin, Arabic, and Hebrew Philosophic Texts," *Harvard Theological Review* 28, no. 2 [1935]: 78–81). However, the implication that the Ikhwān were laboring under a misapprehension is untenable when one considers the extraordinary emphasis on the acts of speaking and making that are to be found throughout the *Rasāʾil*.

51 Al-Fārābī, *Kitāb al-Shiʿr*, translated as "The Book of Poetry," in *Takhyīl: The Imaginary in Classical Arabic Poetics*, ed. Geert Jan van Gelder and Marlé Hammond (Oxford: Oxbow for E. J. W. Gibb Memorial Trust, 2008), 17.

52 Quoted in Inka Nokso-Koivisto, "Summarized Beauty: The Microcosm-Macrocosm Analogy and Islamic Aesthetics," *Studia Orientalia* 111 (2011): 265, citing al-Jāḥiẓ, *Kitāb al-ḥayawān*, ed. ʿAbd al-Salām M. Hārun (Cairo: Sharika Taktuba wa maṭbaʿa Muṣṭafā al-Bābī wa aulādihi, 1965–1969), 1:213.

53 Nokso-Koivisto, "Summarized Beauty," 265.

54 Ikhwān al-Ṣafāʾ, *Rasāʾil*, 2:415.

55 Ikhwān al-Ṣafāʾ, *Rasāʾil*, 1:438–441, 450; Ikhwān al-Ṣafāʾ, *Epistles of the Brethren of Purity: On Logic, An Arabic Critical Edition and English Translation of Epistles 10–14*, ed. and trans. Carmela Baffioni (New York: Oxford University Press / Institute of Ismaili Studies, 2010), 139–141, 153; Ikhwān al-Ṣafāʾ, *Epistles of the Brethren of Purity: On Geography, an Arabic Critical Edition and English Translation of Epistle 4*, ed. and trans. Ignacio Sanchez and James Montgomery (New York: Oxford University Press / Institute of Ismaili Studies, 2014), 59.

56 On the microcosm/macrocosm thesis, see Inka Nokso-Koivisto, *Microcosm-Macrocosm Analogy in* Rasāʾil Ikhwān aṣ-Ṣafāʾ *and Certain Related Texts* (PhD diss., University of Helsinki, 2014).

57 Ikhwān al-Ṣafāʾ, *Rasāʾil*, 1:450; *Epistles 10–14* (OUP/IIS), 153. Ghazālī, writing at the turn of the twelfth century, opined that whoever does not scrutinize the structure and component parts of an eyeball, exploring the physical properties of all the parts to marvel at the wisdom that they incorporate, "will neither know its form nor the One who forms them": al-Ghazālī, *Maqṣad al-asnā*, 82; al-Ghazālī, *Ninety-Nine Beautiful Names*, 70. This idea also underpins the textual genre of wonders-of-creation manuscripts, as skillfully demonstrated by Persis Berlekamp in *Wonder, Image and Cosmos in Medieval Islam* (New Haven and London: Yale University Press, 2011).

58 Here, the aim of the propaedeutic sciences is stated to be "training the apprentices' minds to receive the forms of the sensible entities through the sensory faculties [*al-qiwā al-ḥassāsa*], and to imagine their forms as they are in themselves through the faculty of ratiocination [*al-quwwa al-mufakkira*]." Ikhwān al-Ṣafāʾ, *Rasāʾil*, 1:103; Ikhwān al-Ṣafāʾ, *Epistles of the Brethren of Purity: On Arithmetic and Geometry: An Arabic*

Critical Edition and English Translation of Epistles 1 & 2, ed. and trans. Nader El-Bizri (New York: Oxford University Press / Institute of Ismaili Studies, 2012), 144.

59 Ikhwān al-Ṣafāʾ, *Rasāʾil*, 1:104; Ikhwān al-Ṣafāʾ, *Epistles 1 & 2* (OUP/IIS), 144, where it is translated as "ocean of matter." The term appears frequently in Arabic Neoplatonic writings including the works of Mulla Sadrā (d. 1636), who attributes it to the *Uthūlūjiyā* or "Theology of Aristotle" discussed in this chapter. I thank Hassan Ansari for this information.

60 Carol Bier, "Geometry Made Manifest: Reorienting the Historiography of Ornament on the Iranian Plateau and Beyond," in *The Historiography of Persian Architecture*, ed. Mohammad Gharipour (London: Routledge, 2016), 45, citing T. J. P. de Bruijn, *Of Piety and Poetry: The Interaction of Religion and Literature in the Life and Works of Ḥakīm Sanāʾī of Ghazni* (Leiden: Brill, 1983), 238.

61 Ikhwān al-Ṣafāʾ, *Rasāʾil*, 1:276–295.

62 That these do not precisely match the greater classificatory system of the fifty-two epistles of the Ikhwān is suggested to be the result of re-elaboration of the text over time: see Callataÿ, "Classification."

63 Cf. Fārābī's famous *Iḥṣāʾ al-ʿulūm* (Enumeration of the sciences): see "Alfarabi: The Enumeration of the Sciences," trans. Charles Butterworth, in *Medieval Political Philosophy: A Sourcebook*, 2nd ed., ed. Joshua Parens and Joseph C. Macfarland (Ithaca, NY and London: Cornell University Press, 2011), 18–23.

64 Godefroid de Callataÿ, *Ikhwan al-Safaʾ: A Brotherhood of Idealists on the Fringe of Orthodox Islam* (Oxford: Oneworld, 2005), 63; and Callataÿ, "Classification," 66.

65 Callataÿ, *Ikhwan al-Safaʾ*, 62–63; Callataÿ, "Ikhwân al-Safâ: des arts scientifiques et de leur objectif," *Le Muséon* 116, no. 1–2 (2003): 249–250. See also Alexander Treiger, "Al-Ghazālī's Classifications of the Sciences and Descriptions of the Highest Theoretical Science," *Dîvân Disiplinlerarası Çalışmalar Dergisi* 16, no. 30 (2011/1): 1–32.

66 Primarily Bernard Lewis, "An Epistle on Manual Crafts," *Islamic Culture* 17 (1943): 141–151. For a summary of debates about this text as evidence for guilds in early Islam see Hamdani, "Controversy."

67 Yves Marquet, "La place du travail dans le hiérarchie ismaʿîlienne d'après *L'encyclopédie des Frères de la Pureté*," *Arabica* 8 (1961): 225–237.

68 Ikhwān al-Ṣafāʾ, "The Seventh Epistle of the Propaedeutical Part on the Scientific Arts and What They Aim At," trans. Rüdiger Arnzen, in *Classical Foundations of Islamic Educational Thought*, ed. Bradley J. Cook (Provo, UT: Brigham Young University Press, 2010), 261, n. 2. For the eighth epistle, see Friedrich Dieterici, *Die Logik und Psychologie der Araber im zehnten Jahrhundert n. Chr.* (Leipzig: J. C. Hinrichs'sche Buchhandlung, 1868), 85–101. A précis (in Italian) of epistle eight is included in Allesandro Bausani, *L'enciclopedia dei fratelli della purità* (Naples: Istituto Universitario Orientale, 1978). Some portions of the text, including the various names of the craft professions, are translated in Lewis, "Epistle." A full English translation of the eighth epistle with commentary by Nader El-Bizri is forthcoming from Oxford University Press / Institute of Ismaili Studies in 2018.

69 Necipoğlu has stated that there is an epistle on the "loftiness of crafts" or "the loftiness of the artist/creator" (*sharaf al-ṣāniʾ*) within the Epistles (*Topkapı Scroll*, 199; "Scrutinizing Gaze," 31). This is the title of a *faṣl* (section) within the eighth epistle.

70 On the *sūq* and its place in premodern Islamic urban structure, see André Raymond, "The Economy of the Traditional City," in *The City in the Islamic World*, 2 vols., ed. Renata Holod, Attilio Petruccioli, and André Raymond (Leiden: Brill, 2008),

2:731–751; and Pedro Chalmeta, "Markets," in *The Islamic City*, ed. R. B. Serjeant (Paris: UNESCO, 1980), 104–113.

71 On Raqqa, see Julian Henderson et al., "Experiment and Innovation: Early Islamic Industry at al-Raqqa, Syria," *Antiquity* 79 (2005): 130–145; Stefan Heidemann, "The History of the Industrial and Commercial Area of ʿAbbāsid al-Raqqa, called al-Raqqa al-Muḥtariqa," *Bulletin of the School of Oriental and African Studies* 69, no. 1 (2006): 33–52.

72 Th. Banquis and P. Guichard, "Sūḳ, 1. In the Traditional Arab World," *Encyclopaedia of Islam*, 2nd ed., http://dx.doi.org/10.1163/1573-3912_islam_COM_1109.

73 A useful summary of these ideas, and of the historiography of mystic interpretations in Islamic art history, is found in Akkach, *Cosmology*, 10–17 and 25–31.

74 Al-Ghazālī, *The Niche of Lights: A Parallel English-Arabic Text*, trans. and ed. David Buchmann (Provo, UT: Brigham Young University Press, 1998).

75 This trait is also pronounced in works that read esoteric symbolism into the physical environment of the medieval Islamic world, for example, Nader Ardalan and Laleh Bakhtiar, *The Sense of Unity: The Sufi Tradition in Persian Architecture* (Chicago: University of Chicago Press, 1973).

76 Paul Ricoeur, *The Rule of Metaphor: Multi-disciplinary Studies of the Creation of Meaning in Language*, trans. Robert Czerny (Toronto: University of Toronto Press, 1993), 209.

77 Margaret S. Graves, "The Lamp of Paradox," *Word & Image* (forthcoming).

78 George Lakoff and Mark Johnson, *Philosophy in the Flesh: The Embodied Mind and its Challenge to Western Thought* (New York: Basic Books, 1999), 45–59.

79 Ikhwān al-Ṣafāʾ, *Rasāʾil*, 2:414.

80 See Ibn Sīnā, *Avicenna's Psychology, an English Translation of the Kitāb al-Najāt, Book II, Chapter VI, with Historico-Philosophical Notes and Textual Improvements on the Cairo Edition by F. Rahman* (Westport, CT: Hyperion, 1981), 26–29; discussion in Berlekamp, *Wonder*, 136–137, and in Priscilla Soucek, "Niẓāmī on Painters and Painting," in *Islamic Art in the Metropolitan Museum*, ed. Richard Ettinghausen (New York: Metropolitan Museum of Art, 1972), 14–15.

81 For example, "the forms of the active intellect are imprinted on the soul." Quoted in Dag Nikolaus Hasse, "Avicenna's Epistemological Optimism," in *Interpreting Avicenna: Critical Essays*, ed. Peter Adamson (Cambridge: Cambridge University Press, 2013), 113, citing *Avicenna's De Anima: Being the Psychological Part of Kitāb al-Shifāʾ*, ed. F. Rahman (Oxford: Oxford University Press, 1959), 7:249.21. On the Western medieval uses of this tradition, see Michael Camille, "Before the Gaze: The Internal Senses and Late Medieval Practices of Seeing," in *Visuality Before and Beyond the Renaissance: Seeing as Others Saw*, ed. Robert S. Nelson (Cambridge: Cambridge University Press, 2000), 209–210, and Mary Carruthers, *The Book of Memory: A Study of Memory in Medieval Culture* (Cambridge: Cambridge University Press, 1990), 55.

82 Ibn Sīnā, *The Metaphysica of Avicenna (Ibn Sīnā): A Critical Translation-Commentary and Analysis of the Fundamental Arguments in Avicenna's* Metaphysica *in the* Dānish Nāma-i ʿalāʾī *(The Book of Scientific Knowledge)*, trans. Parviz Morewedge (London: Routledge and Kegan Paul, 1973), 17, 29, 45. See also the extension of the metaphor to include the silver that takes the form of the ring, in Miskawayh, *Tahdhīb al-Akhlāq*, ed. Constantine K. Zurayk (Beirut: American University in Beirut, 1967), 4; Miskawayh, *The Refinement of Character: A Translation from the Arabic of Aḥmad ibn-Muḥammad Miskawayh's* Tahdhīb al-Akhlāq *by Constantine K. Zurayk* (Beirut: American University of Beirut, 1968), 6.

83 Nils C. Ritter, "On the Development of Sasanian Seals and Sealing Practice: A Mesopotamian Approach," *Orientalia Lovaniensia Analecta* 219 (2012): 99–114.

84 See Ralph Pinder-Wilson, "Seals and Rings in Islam," in *Islamic Rings and Gems: The Benjamin Zucker Collection*, ed. Derek J. Content (London: Philip Wilson, 1987), 373–387 and 539.

85 Venetia Porter, *Arabic and Persian Seals and Amulets in the British Museum* (London: British Museum, 2011), 6–7, 82.

86 Porter, *Arabic and Persian Seals*, 6.

87 Brigitte Bedos-Rezak, "Outcast: Seals of the Medieval West and their Epistemological Frameworks (XIIth–XXIst Centuries), in *From Minor to Major: The Minor Arts in Medieval History*, ed. Colum Hourihane (University Park: Pennsylvania State University Press, 2012), 136; Brigitte Bedos-Rezak, "Le sceau et l'art de penser au XIIe siècle," in *Pourquoi les sceaux? La sillographie, nouvel enjeu de l'histoire de l'art*, ed. Marc Gil and Jean-Luc Chassel (Villeneuve-d'Ascq: CEGES, Université Charles de Gaulle-Lille, 2011), 153–176; Brigitte Bedos-Rezak, *When Ego Was Imago: Signs of Identity in the Middle Ages* (Leiden: Brill, 2011).

88 On related ideas in Graeco-Roman contexts, see Verity Platt, "Making an Impression: Replication and the Ontology of the Graeco-Roman Seal Stone," *Art History* 29, no. 2 (2006): 233–257, especially 245–251.

89 Akkach, *Cosmology*, 36.

90 Ikhwān al-Ṣafāʾ, *Rasāʾil*, 1:278.

91 Ikhwān al-Ṣafāʾ, *Rasāʾil*, 2:6; Ikhwān al-Ṣafāʾ, *Epistles 15–21* (OUP/IIS), 110. The Ikhwān's Prime Matter is reminiscent of *silva* in the fourth-century Latin commentary of Calcidius on Plato's *Timaeus*. See Ittai Weinryb, "Living Matter: Materiality, Maker, and Ornament in the Middle Ages," *Gesta* 52, no. 2 (2013): 113–132.

92 Ikhwān al-Ṣafāʾ, *Rasāʾil*, 2:6; Ikhwān al-Ṣafāʾ, *Epistles 15–21* (OUP/IIS), 110.

93 Ikhwān al-Ṣafāʾ, *Rasāʾil*, 2:9; Ikhwān al-Ṣafāʾ, *Epistles 15–21* (OUP/IIS), 113.

94 For example, the inclusion of the astrolabe with the artifacts used as scales or means of measuring (Ikhwān al-Ṣafāʾ, *Rasāʾil*, 1:424; Ikhwān al-Ṣafāʾ, *Epistles 10–14* [OUP/IIS], 117).

95 David A. King, *In Synchrony with the Heavens: Studies in Astronomical Timekeeping and Instrumentation in Medieval Islamic Civilization*, vol. 2: *Instruments of Mass Calculation* (Leiden: Brill, 2005), 453–544; David A. King, "An Instrument of Mass Calculation Made by Nasṭūlus in Baghdad ca. 900," *Suhayl: International Journal for the History of the Exact and Natural Sciences in Islamic Civilisation* 8 (2008): 93–119; Willy Hartner, "Asṭurlāb," *Encyclopaedia of Islam*, 2nd ed., http://dx.doi.org/10.1163/1573-3912_islam_COM_0071.

96 King, *Synchrony*, 348, 355; Marcel Destombes and Edward Stuart Kennedy, "Introduction to *Kitab al-'Amal bil Asturlab*," reprinted in Edward Stuart Kennedy, *Studies in the Islamic Exact Sciences* (Beirut: American University of Beirut, 1983), 405–447.

97 Ikhwān al-Ṣafāʾ, *Rasāʾil*, 1:287–288. See also Lewis, "Epistle," 94–95. On the makers of astrolabes, see Allan and Kanaʾan, "Social and Economic Life of Metalwork."

98 Lewis, "Epistle." Note that Lewis translates *ḥākī* as "weaver" (147), but the inclusion of this figure in the category of those who use both the tongue and the hand for their craft, like the wailing woman (*al-nāʾiḥa*), makes it clear that *ḥākī* should be "storyteller." Jāḥiẓ, in the *Bayān*, mentions *ḥākīa* (translated by Pellat as "mimics")

who were able to reproduce voices and movements of different types of people: Charles Pellat, "Adab ii: Adab in Arabic Literature," *Encyclopaedia Iranica*, http://www.iranicaonline.org/articles/adab-ii-arabic-lit.The consonance of letters in *ḥikāya* (story, tale) and *ḥiyāka* (weaving) points the way toward the literary and poetic metaphors of craft discussed in Chapter 4 of the present book.

99 The major reference text for metalwork continues to be Leo A. Mayer, *Islamic Metalworkers and Their Works* (Geneva: Albert Kundig, 1959); see also Anatoly Ivanov, "Works of the Twelfth-Century Iranian Coppersmith Abu Nasr," *Reports of the State Hermitage Museum* LXVIII (St. Petersburg: State Hermitage Publishers, 2010), 16.

100 Kana'an, " 'Artist,' " 175–201; Kana'an, "Patron and Craftsman," 67–78; Kana'an, "Thirteenth-Century Brass Ewer," 176–193.

101 Ikhwān al-Ṣafā', *Rasā'il*, 1:279.

102 Ikhwān al-Ṣafā', *Rasā'il*, 1:283.

103 Ikhwān al-Ṣafā', *Rasā'il*, 1:282–283.

104 Lucilla Cardinalli et al., "Tool-Use Induces Morphological Updating of the Body Schema," *Current Biology* 19, no. 12 (2009): R478–479. See also Daniel Lord Smail and Andrew Shryock, "Body," in *Deep History: The Architecture of Past and Present*, ed. Daniel Lord Smail and Andrew Shryock (Berkeley: University of California Press, 2011), 69.

105 Ikhwān al-Ṣafā', *Rasā'il*, 1:278.

106 Ikhwān al-Ṣafā', *Rasā'il*, 1:279. Cécile Bonmariage, "De l'amitié et des frères: l'épître 45 des *Rasā'il Iḫwān al-Ṣafā'*. Présentation et traduction annotée," *Bulletin d'études orientales* 58 (2008–9): 323.

107 Ikhwān al-Ṣafā', *Rasā'il*, 2:127; Ikhwān al-Ṣafā', *Epistles 15–21* (OUP/IIS), 277–278. Elsewhere, however, every object in the universe is likened to a tool through which the universal soul performs all actions: Ikhwān al-Ṣafā', *Rasā'il*, 2:56; Nasr, *Introduction*, 57. All of the substances in the mineral and vegetable kingdoms are tools and instruments of the "agent artisan, the mover [of everything], namely, the heavenly universal soul." Ikhwān al-Ṣafā', *Rasā'il*, 2:126; Ikhwān al-Ṣafā', *Epistles 15–21* (OUP/IIS), 276.

108 See Peter Adamson, *The Arabic Plotinus: A Philosophical Study of the* Theology of Aristotle (London: Duckworth, 2002).

109 Adamson, *Arabic Plotinus*, 137.

110 See more examples listed in Ahmad Ghabin, "Ṣināʿa," *Encyclopaedia of Islam*, 2nd ed., http://dx.doi.org/10.1163/1573-3912_islam_SIM_7042. Joseph Sadan suggests this trope was brought about through a conscious attempt in the early medieval period to raise the status of craftsmen. See Joseph Sadan, "Kings and Craftsmen, A Pattern of Contrasts. On the History of a Medieval Arabic Humoristic Form, Part II," *Studia Islamica* 62 (1985): 94–97.

111 Al-Thaʿālibī, *Curious and Entertaining*, 39, 68.

112 See Ibn Khaldūn, *Muqaddimah*, 2:317; G. Vajda, "Idrīs," *Encyclopaedia of Islam*, 2nd ed., http://dx.doi.org/10.1163/1573-3912_islam_SIM_3491.

113 Ghabin, *Ḥisba*, 127–128.

114 Al-Thaʿālibī, *Curious and Entertaining*, 40, n. 13, citing al-Thaʿālibī, *ʿArā'is al-majālis fī qiṣaṣ al-anbiyā'* [Cairo 1347/1928].

115 Al-Thaʿālibī, *Curious and Entertaining*, 134.

116 See Hans E. Wulff, *The Traditional Crafts of Persia* (Cambridge, MA: MIT Press, 1966), 130–133; Philip Kohl, "Chlorite," *Encyclopaedia Iranica*, http://www.iranicaonline.org/articles/chlorite-pers.

117 For some of the technical literature, see A. Y. al-Hassan, "Iron and Steel Technology in Medieval Arabic Sources," *Journal for the History of Arabic Science* 2, no. 1 (1978): 31–43.

118 See the history of Islamic writings on alchemy, and particularly their relevance for studies of material signification, in Elias, *Aisha's Cushion*, 177–188.

119 Ikhwān al-Ṣafāʾ, *Rasāʾil*, 2:116; Ikhwān al-Ṣafāʾ, *Epistles 15–21* (OUP/IIS), 261.

120 See James Allan, *Persian Metal Technology, 700–1300 AD* (London: Ithaca Press for University of Oxford, 1979), 7–13; Abu Dulaf, *Travels in Iran*, 31.

121 Jack Ogden, "Islamic Goldsmithing Techniques in the Early Medieval Period," in *Islamic Rings and Gems: The Benjamin Zucker Collection*, ed. Derek J. Content (London: Philip Wilson, 1987), 414–418.

122 Marilyn Jenkins and Manuel Keene, *Islamic Jewelry in the Metropolitan Museum of Art* (New York: Metropolitan Museum of Art, 1983), 40; Avinoam Shalem, "A Note on a Unique Islamic Golden Figurine," *Iran: Journal of the British Institute of Persian Studies* 40 (2002): 173–180. A comparable piece from the State Museum of Turkmenistan, Ashgabat, is illustrated in Canby et al., *Court and Cosmos*, 101.

123 See Finbarr Barry Flood, "Between Cult and Culture: Bamiyan, Islamic Iconoclasm and the Museum," *The Art Bulletin* 84, no. 4 (2002): 641–659; Mika Natif, "The Painter's Breath and Concepts of Idol Anxiety in Islamic Art," in *Idol Anxiety*, ed. Josh Ellenbogen and Aaron Tugendhaft (Palo Alto, CA: Stanford University Press, 2011), 41–55; and the bibliography in both.

124 See Kathryn Kueny, "Reproducing Power: Qur'anic Anthropogonies in Comparison," in *The Lineaments of Islam: Studies in Honor of Fred McGraw Donner*, ed. Paul Cobb (Leiden: Brill, 2012), 235–260.

125 Al-Ṭabarī, *The History of al-Ṭabarī, Volume 1: General Introduction and from Creation to the Flood*, trans. Franz Rosenthal (Albany, NY: SUNY Press, 1989), 261.

126 Qur'an 23:12, 55:14, 15:26, 37:11, translation by Ahmed Ali (Princeton, NJ: Princeton University Press, 2001). In the story of Ḥayy Ibn Yaqẓān by Ibn Ṭufayl (d. 1185), the spontaneous generation of man from clay involves the formation of the organs of the body from the individual bubbles of gas that form within the fermenting clay: *Ḥayy Ibn Yaqẓān: A Philosophical Tale*, trans. and ed. Lenn Evan Goodman (Chicago: University of Chicago Press, 2009), 106–109. Ibn Ṭufayl seems to be borrowing this aspect of his treatise from the *Maḍnūn al-ṣaghīr*, a work sometimes attributed to Ghazālī: see Ibn Ṭufayl, n. 72, 189.

127 While the uses of these terms in the Qur'an do not make absolutely clear the different outcomes of creation from these varying substances, some later commentators believed that the types of clay could be connected to traits and dispositions of character: Kueny, "Reproducing Power," 238. See also Ghazālī's comments on the manufacture of man from *ṣalṣāl kal-fakhkhār* rather than *al-ṭīn al-mahḍ* (pure clay), in al-Ghazālī, *Maqṣad*, 80.

128 Martina Rugiadi, "The Emergence of Siliceous-Paste in Iran in the Last Quarter of the Eleventh Century and Related Issues. The Dated Assemblage from the Southern Domed Hall of the Great Mosque of Isfahan," *Vicino e Medio Oriente* 15 (2011): 233–248; Melanie Gibson, "The Enigmatic Figure: Ceramic Sculpture from Iran and Syria c. 1150–1250," *Transactions of the Oriental Ceramics Society* 73 (2008–9): 40–42.

129 Al-Ghazālī, *The Lawful and the Unlawful: Book XIV of the Revival of the Religious Sciences*, trans.Yusuf T. Delorenzo (Cambridge: Islamic Texts Society, 2014), 1.

130 Stephennie Mulder, *Contextualizing Islamic Archaeology: The Case of Medieval Molded Ceramics* (master's thesis, Princeton University, 2001); Stephennie Mulder, "A Survey and Typology of Islamic Molded Ware (9th–13th Centuries), Based on the Discovery of a Potter's Workshop at Medieval Bālis, Syria," *Journal of Islamic Archaeology* 1, no. 2 (2014): 143–192; Karl Nováček, "Moulded Pottery from Istakhr," in *My Things Changed Things: Social Development and Cultural Exchange in Prehistory, Antiquity and the Middle Ages*, ed. Petra Maříkova Vlčková, Jana Mynářová, and Martin Tomášek (Prague: Charles University, 2009), 118–126.

131 Al-Kindī, *Fi hudud al-ashya' wa rusumiha* ("On the definitions and descriptions of things"), in *Rasā'il al-Kindī al-falsafiyya*, 2 vols., ed. M. A. Abū Rīda (Cairo: Dār al-fikr al-ʿarabī, 1950–1953), 1:166. See also Adamson and Pormann (*Philosophical Works*, 329, n. 68), who translate the same phrase as "the matter of every matter."

132 Ikhwān al-Ṣafā', *Rasā'il*, 1:273–274.

133 Al-Ghazālī, *Niche*, 34.

134 See Leonard Lewisohn, "Hierocosmic Intellect and Universal Soul in a Qaṣīda by Nāṣir-i Khusraw," *Iran* 45 (2007): 195–196.

135 Smith, "Making as Knowing," 39.

136 Necipoğlu, *Topkapı Scroll*, 196; a similar observation is found in Barbara Brend, *Islamic Art* (Cambridge, MA: Harvard University Press, 1992), 17.

137 For example, Jaʿfar Tabrīzī's *arzadāsht* ("petition"), a status report on work taking place under his direction in the *kitābkhāna* of prince Bāysunghur (1397–1433), is translated in Wheeler Thackston, *A Century of Princes: Sources in Timurid History and Art* (Cambridge, MA: Aga Khan Program for Islamic Art, 1989), 323–327. On the Ottoman craft guilds, see Suraiya Faroqhi, *Artisans of Empire: Crafts and Craftsmen under the Ottomans* (London: I. B. Tauris, 2009), xix–xxi, 23–44.

138 See Hamdani, "Controversy."

139 T. Fahd, "Les corps de métiers au IV/Xe siècle a Baġdād: d'après le chapitre XII d'*al-Qâdirî fî-t-taʿbîr* de Dînawarî," *Journal of the Economic and Social History of the Orient* 8, no. 2 (1965): 186–212.

140 See R. Brunschvig, "Métiers vils en Islam," *Studia Islamica* 16 (1962): 41–60; Sadan, "Kings and Craftsmen, Part II," 90–91; Ghabin, *Ḥisba*, 138–139, 225–229.

141 Ghabin, *Ḥisba*, 193–194.

142 For a detailed discussion of the relevant texts, and their utility for medieval *muḥtasib*s and authors of the *ḥisba* texts, see Ghabin, *Ḥisba*, ch. 4 and 5, pp. 124–142. The problems that arise from the use of Qur'anic and hadith texts in isolation as evidence for material practices were noted long ago by Mehmet Aga-Oglu, "Remarks on the Character of Islamic Art," *The Art Bulletin* 36, no. 3 (1954): 175. The debates about Mecca's status as an urban center in the time of Muhammad are a separate issue: see Patricia Crone, *Meccan Trade and the Rise of Islam* (Princeton, NJ: Princeton University Press, 1988).

143 The first systematic exploration of this idea is Ignaz Goldziher, "Die Handwerke bei den Arabern," *Globus: Illustrierte Zeitschrift für Lander und Völkerkunde* 66 (1894): 203–205. The idea was developed in Brunschvig, "Métiers vils"; see also Puerta Vílchez, *Aesthetics in Arabic Thought*, 34.

144 Goldziher, "Die Handwerke"; Shatzmiller, *Labour*, 371–372.

145 Arthur Christensen, *L'Iran sous les Sassanides*, 2nd ed. (Copenhagen: Ejnar Munksgaard, 1944), 402.

146 Sadan, "Kings and Craftsmen, Part II," 90–91, 94–97; Joseph Sadan, "The Art of the Goldsmith Reflected in Medieval Arabic Literature," in *Islamic Rings and Gems: The Benjamin Zucker Collection*, ed. Derek J. Content (London: Philip Wilson, 1987), 467.

147 A. Tafazzoli, "A List of Trades and Crafts in the Sassanian Period," *Archäologische Mitteilungen aus Iran* 7 (1974): 191–196; Touraj Daryaee, "Bazaars, Merchants, and Trade in Late Antique Iran," *Comparative Studies of South Asia, Africa and the Middle East* 30, no. 3 (2010): 403–404.

148 A. Leo Oppenheim, "A New Look at the Structure of Mesopotamian Society," *Journal of the Economic and Social History of the Orient* 10 (1967): 5–6. On the *muḥtasib* and the surviving *ḥisba* manuals, see the sources listed in the introduction to Ibn al-Ukhuwwa, *Maʿālim al-qurba*, xv–xvii, and in Ghabin, *Ḥisba*, 155–175.

149 Shatzmiller, *Labour*, 387.

150 Hayyim J. Cohen, "The Economic Background and the Secular Occupations of Muslim Jurisprudents and Traditionists in the Classical Period of Islam," *Journal of the Economic and Social History of the Orient* 13, no. 1 (1970): 16–61; see also Shatzmiller, *Labour*, 375. See also the case of the early grammarian nicknamed al-Zajjāj: Wadad al-Qadi, "Al-Zajjāj and Glassmaking: An Expanded Range of Options in a Comparative Context," in *In the Shadow of Arabic: The Centrality of Language to Arabic Culture; Studies Presented to Ramzi Baalbaki on the Occasion of His Sixtieth Birthday*, ed. Bilal Orfali (Leiden: Brill, 2011), 221–248.

151 On the various hierarchies of occupation evinced in several different types of medieval literary source, see Louise Marlowe, *Hierarchy and Egalitarianism in Islamic Thought* (Cambridge: Cambridge University Press, 1997), 162–173.

152 Joseph Sadan, "Kings and Craftsmen, A Pattern of Contrasts. On the History of a Medieval Arabic Humoristic Form, Part I," *Studia Islamica* 62 (1985), 10–21. Some sections of Jāḥiẓ's text are translated in Charles Pellat, *Life and Works of Jāḥiẓ* (London: Routledge and Kegan Paul, 1963), 114–116.

153 Shatzmiller, *Labour*, 371–372. See also A. A. Duri, "Baghdād," *Encyclopaedia of Islam*, 2nd ed., http://dx.doi.org/10.1163/1573-3912_islam_COM_0084; Beatrice Gruendler, "Aspects of Craft in the Arabic Book Revolution," in *Globalization of Knowledge in the Post-Antique Mediterranean, 700–1500*, ed. Sonja Brentjes and Jurgen Renn (London and New York: Routledge, 2016), 31–66.

154 Hamdani, "Controversy," 160.

155 Ghabin, "Ṣināʿa."

156 Ghabin, *Ḥisba*, 150–151.

157 Julius Ruska, "Kazwīnīstudien," *Der Islam* 4 (1913): 244–245.

158 See Shatzmiller, *Labour*, 383.

159 Ghabin, *Ḥisba*, 151–152.

160 Al-Ghazālī, *Lawful and the Unlawful*, 248.

161 Franz Rosenthal, "Translator's Introduction," in Ibn Khaldūn, *Muqaddimah*, 1:lxxxvi.

162 For example, see Stephen F. Dale, *The Orange Trees of Marrakesh: Ibn Khaldun and the Science of Man* (Cambridge, MA: Harvard University Press, 2015); Stephen F. Dale, "Ibn Khaldun: The Last Greek and the First *Annaliste* Historian," *International Journal of Middle East Studies* 38 (2006): 431–451; Mahmoud Dhaoudi, "Ibn Khaldun: The

Founding Father of Eastern Sociology," *International Sociology* 3 (1990): 319–335. On the problems of "forerunner" syndrome in Ibn Khaldūn studies, see Franz Rosenthal, "Ibn Khaldun in His Time (May 27, 1332–March 17, 1406)," *Journal of Asian and African Studies* 18:3–4 (1983): 167.

163 Ibn Khaldūn, *Muqaddimah*, 2:347. Only in the twenty-first century has the first case been scientifically documented of any non-human organism—a female New Caledonian crow—spontaneously manipulating materials to create tools without previous coaching. See Alex A. S. Weir et al., "Shaping of Hooks in New Caledonian Crows," *Science* 297 (August 2002): 981.

164 For example, see Ibn Khaldūn, *Muqaddimah*, 1:90.

165 Miskawayh, *Refinement of Character*, 60.

166 Ibn Khaldūn, *Muqaddimah*, 1:89.

167 Ibn Khaldūn, *Muqaddimah*, 2:355, 356–405.

168 Ibn Khaldūn, *Muqaddimah*, 2:291.

169 Ibn Khaldūn, *Muqaddimah*, 2:286–288.

170 Al-Fārābī, *On the Perfect State (mabādiʾ ārāʾ ahl al-madīnat al-fāḍilah)*, trans. and ed. Richard Walzer (Oxford: Oxford University Press, 1998), 229, 233–235, 267; Miskawayh, *Refinement*, 64, 103–105.

171 Ibn Khaldūn, *Muqaddimah*, 2:291–297, 325. Those who deal in luxury crafts, such as the perfumer, the coppersmith, and so forth are mentioned only in passing, unlike those who practice the necessary or noble crafts. The exception to this is the book producer, who is included in lists of both the noble crafts and the luxury crafts. Ibn Khaldūn, *Muqaddimah*, 2:348.

172 Dale, *Orange Trees*, 238; Ibn Khaldūn, *Muqaddimah*, 2:315–317.

173 Ibn Khaldūn, *Muqaddima Ibn Khaldūn: Prolégomènes d'Ebn-Khaldoun, texte arabe*, 3 vols. (Reprint, Beirut: Maktabat Lubnān, 1970), 2:277; Ibn Khaldūn, *Muqaddimah*, 2:316–317, 346–347.

174 Ibn Khaldūn, *Muqaddimah*, 2:346, 406, 3:372.

175 Ibn Khaldūn, *Muqaddimah*, 2:346.

176 It is observed that every craftsman needs a teacher (*ustādh*), who learned the craft from his teacher, and so on, back to an originary, non-human teacher: Ikhwān al-Ṣafāʾ, *Rasāʾil*, 1:294.

177 Hamdani, "Controversy," 167–168.

178 Miskawayh, *Refining*, 90. Miskawayh's characterization of crafts as a means of demonstrating, and disseminating the benefits of, personal excellence is part of a discourse that links penmanship in particular with the expression of personal nobility: see David J. Roxburgh, "The Eye is Favored for Seeing the Writing's Form: On the Sensual and the Sensuous in Islamic Calligraphy," *Muqarnas* 25 (2008): 275–298.

179 Sadan, "Kings and Craftsmen, Part II," 92, citing Jāḥiẓ, *al-Ḥayawān*, ed. ʿA.-S. Hārūn (Cairo, 1938–1945), 3: 276.

Chapter 2: Building Ornament

1 I have purposefully avoided setting out a precise definition of ornament here because the issue is too slippery and too distracting to be dealt with definitively in this context.

Those who seek a definition are directed to Jonathan Hay, "The Passage of the Other," in *Histories of Ornament*, ed. Necipoğlu and Payne, 62–64.

2 Ernst Gombrich, *The Sense of Order: A Study in the Psychology of Decorative Art*, 2nd ed. (London: Phaidon, 2012), 171–173; Cynthia Hahn, "The Voices of the Saints: Speaking Reliquaries," *Gesta* 36, no. 1 (1997): 20–31. See also Robert Venturi, Denise Scott Brown, and Steven Izenour's famous distinction between the "duck" and the "decorated shed," in *Learning from Las Vegas* (Cambridge, MA: MIT Press, 1972), 87.

3 See other examples of the type in Canby et al., *Court and Cosmos*, cat. nos. 134 and 135, 217–218. The partial reconstruction of the Eskenazi Museum aquamanile from alien, but probably contemporary, sherds complicates its decoration, but enough remains of the original object to show that its art-market restorers were following the spirit of the original design. This object will be published in my forthcoming catalogue of the Islamic ceramics collection in the Eskenazi Art Museum, Indiana University. A parallel piece of inlaid metalwork is a flask in the form of a bird in the Victoria and Albert Museum, decorated on its wings and tail with designs that mimic plumage, and on its sides and breast with figural scenes: M.54:2-1971; illustrated in Assadullah Souren Melikian-Chirvani, *Islamic Metalwork from the Iranian World 8th–18th Centuries* (London: Her Majesty's Stationery Office, 1982), 122.

4 Assadullah Souren Melikian-Chirvani, "Le rhyton selon les sources Persanes," *Studia Iranica* 2 (1982): 276; Assadullah Souren Melikian-Chirvani, "Les taureaux à vin et les cornes à boire de l'Iran islamique," in *Histoire et cultes de l'Asie central préislamique*, ed. Paul Bernard and Frantz Grenet (Paris: Éditions du centre nationale de la recherche scientifique, 1991), 102–103.

5 Al-Ghazālī, *Iḥyā' 'ulūm al-Dīn*, 2:335. Alternative translation given in al-Shayzarī, *The Book of the Islamic Market Inspector: Nihāyat al-Rutba fī Ṭalab al-Ḥisba (The Utmost Authority in the Pursuit of Ḥisba) by 'Abd al-Raḥmān b. Naṣr al-Shayzarī*, trans. and ed. R. P. Buckley (Oxford: Oxford University Press, 1999), appendix "al-Ghazali on Ḥisba," 180.

6 The thirteenth-century Shāfi'ī jurist al-Nawawī (d. 1277) ascribed this view—which he himself refuted—to earlier scholars. By contrast with Ghazālī, it was al-Nawawī's view that two-dimensional images of animate beings, whether applied to textiles, coins, walls, or any other surface, were as objectionable as three-dimensional representations of those forms. The only exception he admitted was images that have been applied to textiles that will be stepped or sat upon: that is to say, the same "cushions and spread carpets" that Ghazālī invokes. A. J. Wensinck and T. Fahd, "Ṣūra," *Encyclopaedia of Islam*, 2nd ed., http://dx.doi.org/10.1163/1573-3912_islam_COM_1125.

7 This phenomenon is also complicated by the category of kitsch, a term bound up with the values of the industrial era but that could arguably be applied to some of the materials in this book. See my suggestion and further bibliography in "The Aesthetics of Simulation: Architectural Mimicry on Medieval Ceramic Tabourets," in *Islamic Art, Architecture and Material Culture: New Perspectives*, ed. Margaret S. Graves (Oxford: British Archaeological Reports, 2012), 79.

8 On the question of ornament and its potential as a bearer of meaning, see particularly Necipoğlu, *Topkapı Scroll*, and the works of Yasser Tabbaa, particularly *The Transformation of Islamic Art During the Sunni Revival* (Seattle and London: University of Washington Press, 2001). Other interpretations can be found in Sheila Blair and Jonathan Bloom, "Ornament and Islamic Art," in *Cosmophilia: Islamic Art in the David Collection, Copenhagen* (Chestnut Hill, MA: McMullen Museum of Art, Boston College, 2006), 9–30; and in Oliver Watson, "Review of 'The Iconography of Islamic Art: Studies in Honour of Robert Hillenbrand,'" *Journal of Islamic Studies* 18, no. 2 (2007): 299–302.

9 Al-Bīrūnī, *The Book Most Comprehensive in Knowledge on Precious Stones: Al-Beruni's Book on Mineralogy = Kitāb al-jamāhir fī maʿrifat al-jawāhir*, trans. Hakim Mohammad Said (Islamabad: Pakistan Hijra Council, 1989), 200. See also Doris Behrens-Abouseif, *Beauty in Arabic Culture* (Princeton, NJ: Markus Wiener, 1999), 19–21, 124–126.

10 Ibn al-Haytham, *Optics*, 1:202.

11 Yves Porter, "From 'The Theory of the Two Qalams' to 'The Seven Principles of Painting': Theory, Terminology and Practice in Persian Classical Painting," *Muqarnas* 17 (2000): 114; Necipoğlu, "L'idée de décor," 12–13; Gülru Necipoğlu, "Early Modern Floral: The Agency of Ornament in Ottoman and Safavid Visual Cultures," in *Histories of Ornament*, ed. Necipoğlu and Payne, 136–137.

12 Martin Bernard Dickson and Stuart Cary Welch, *The Houghton Shahnameh*, 2 vols. (Cambridge, MA, and London: Harvard University Press, 1981), "Appendix I: The Canons of Painting by Ṣādiqī Bek," 1:262.

13 Porter ("Two Qalams," 114) has suggested that the relatively late appearance of the "seven principles of painting" indicates that they "do not seem very important to the whole body of painting production."

14 First published in 1856, and most recently reissued by Princeton University Press, 2016. See also Rémi Labrusse, "Grammars of Ornament: Dematerialization and Embodiment from Owen Jones to Paul Klee," in *Histories of Ornament*, ed. Necipoğlu and Payne, 320–333.

15 See also Moya Carey, "'In the Absence of Originals': Replicating the Tilework of Safavid Isfahan for South Kensington," *International Journal of Islamic Architecture* 3, no. 2 (2014): 397–436.

16 On related practices, see Jonathan Hay, *Sensuous Surfaces: The Decorative Object in Early Modern China* (Honolulu: University of Hawaii Press, 2010), 68–77.

17 For example, Eva Baer cites Islamic ornament's independence from underlying structure and ease of transference across media as one of its most distinctive qualities: Eva Baer, "Zakhrafa," *Encyclopaedia of Islam*, 2nd ed., http://dx.doi.org/10.1163/1573-3912_islam_SIM_8098; Eva Baer, *Islamic Ornament* (New York: New York University Press, 1998), 2–3. On the genesis and outcomes of the structure/ornament paradigm in architectural history, see Anne-Marie Sankovitch, "Structure/Ornament and the Modern Figuration of Architecture," *The Art Bulletin* 80, no. 4 (1998): 687–717.

18 For critique, see Necipoğlu, *Topkapı Scroll*, 61–87; Necipoğlu, "L'idée de décor"; Avinoam Shalem and Eva-Maria Troelenberg, "Beyond Grammar and Taxonomy: Some Thoughts on Cognitive Experiences and Responsive Islamic Ornaments," *Beitrage zur islamischen Kunst und Archaologie* 3 (2012): 385–410. On the continuing cleavage of ornament from structure, see Hay, *Sensuous Surfaces*, 70–75; Hay, "The Passage of the Other," 62–69; Troelenberg, "Pedestal?," 159–174.

19 Necipoğlu, "Early Modern Floral," 132.

20 See Hay, "Passage of the Other," n. 1.

21 Alois Riegl, *Problems of Style: Foundations for a History of Ornament*, trans. Evelyn Kain (Princeton, NJ: Princeton University Press, 1992), 3–13.

22 Riegl, *Problems of Style*, 229–305; Riegl, *Historical Grammar of the Visual Arts*, trans. J. Jung (New York: Zone Books, 2004), 255–256. "[The arabesque] is the most original creation of the Arab spirit": Ernst Kühnel, *Die Arabesque: Sinn und Wandlung Eines Ornaments* (Wiesbaden: Dietrich'sche Verlagsbuchhandlung, 1949), English translation by Richard Ettinghausen published as *The Arabesque: Meaning and Transformation of an Ornament* (Graz: Verlag für Sammler, 1977), 4.

23 On Semper's thesis, see Alina Payne, *From Ornament to Object: Genealogies of Architectural Modernism* (New Haven and London: Yale University Press, 2012), ch. 1, esp. 38–56.

24 Michael Vickers and David Gill, *Artful Crafts: Ancient Greek Silverware and Pottery* (Oxford: Clarendon Press, 1994), 106; see also Carl Knappett, "Photographs, Skeuomorphs and Marionettes: Some Thoughts on Mind, Agency and Object," *Journal of Material Culture* 7, no. 1 (2002): 97–117. On the history of the term, Alice A. Donohue, *Greek Sculpture and the Problem of Description* (Cambridge: Cambridge University Press, 2005), 81–82.

25 An extraordinarily elaborate example of this can be seen on a fragment from the neck of a glazed ceramic ewer in the Herat Museum (HNM 88.043), which is decorated with "chains" attached to the body with "rivets"—all executed entirely in ceramic. Ute Franke and Martina Müller-Weiner, eds., *Ancient Herat Vol. 3—Herat Through Time: The Collections of the Herat Museum and Archive* (Berlin: Staatliche Museen zu Berlin – Preußischer Kulturbesitz and Ancient Herat Project, 2016), 366–367.

26 H. Colley March, "The Meaning of Ornament; Or Its Archaeology and Its Psychology," *Transactions of the Lancashire and Cheshire Antiquarian Society* 7 (1889): 166.

27 Necipoğlu, *Topkapı Scroll*.

28 Grabar, *Mediation of Ornament*.

29 Indeed, it has been suggested that the book possibly had greater impact outside the sub-discipline of Islamic art history than within it: Marianna Shreve Simpson, "Oleg Grabar, b. 1929. *Intermediary Demons: Toward a Theory of Ornament*, 1989," in *The A.W. Mellon Lectures in the Fine Arts* (Washington, DC: National Gallery of Art, 2002), 165. See also Robert Hillenbrand, "Oleg Grabar: The Scholarly Legacy," *Journal of Art Historiography* 6 (2012): 29–30.

30 In this Grabar follows a line of reasoning similar in some respects to that espoused by Ernst Gombrich in his search for a universal psychological model of ornament: the latter recognized the potential of architecture as an ornamental system to provide "explanatory articulation . . . to facilitate the grasp of the object it decorates." Gombrich, *Sense of Order*, 175–179, 209.

31 Grabar, *Mediation*, 191–193.

32 Hay, "Passage of the Other," 65.

33 For a recent summary see Alain George, *The Rise of Islamic Calligraphy* (London: I.B. Tauris, 2010), 74–89.

34 Grabar, *Mediation*, xxiv.

35 Grabar, *Mediation*, 174.

36 For example, Sheila Blair and Jonathan Bloom commented on the categories they employed for their 2006 exhibition on Islamic ornament: "We naturally omitted architecture as not part of a museum's collection" ("Cosmophilia and Its Critics: An Overview of Islamic Ornament," *Beitrage zur Islamischen Kunst und Archäologie herausgegeben von der Ernst-Herzfeld-Gesellschaft* 3 [2012]: 39, n. 6).

37 Gombrich's "perceptual habits" are relevant here: *Sense of Order*, 171–173.

38 Necipoğlu, "Early Modern Floral," 154. For an argument concerning the mimetic potential of other forms of ornament, and art-historical resistance to that potential, see Cynthia Robinson, "Power, Light, Intra-Confessional Discontent, and the Almoravids," in *Envisioning Islamic Art and Architecture: Essays in Honor of Renata Holod*, ed. David Roxburgh (Leiden: Brill, 2014), 30–33.

39 An exploration of this phenomenon is found in Hana Taragan, "An Artuqid Candlestick from the Al-Aqsa Museum: Object as Document," *Ars Orientalis* 42 (2012): 79–88.

40 Cf. Baer, *Islamic Ornament*, 73–79.

41 See some of the examples cited in Geoffrey R. D. King, "The Architectural Motif as Ornament in Islamic Art: The 'Marwan II' Ewer and Three Wooden Panels in the Museum of Islamic Art in Cairo," *Islamic Archaeological Studies* 2 (1980, publ. 1982): 23–57.

42 Esen Öğüş, "Columnar Sarcophagi from Aphrodisias: Elite Emulation in the Greek East," *American Journal of Archaeology* 118, no. 1 (2014): 113–136; Edmund Thomas, "'Houses of the Dead'? Columnar Sarcophagi as 'Micro-architecture,'" in *Life, Death and Representation: Some New Work on Roman Sarcophagi*, ed. Jaś Elsner and Janet Huskinson (Berlin: De Gruyter, 2011), 399–404.

43 Jaś Elsner, "Framing the Objects We Study: Three Boxes from Late Roman Italy," *Journal of the Warburg and Courtauld Institutes* 71 (2008): 30.

44 Thomas, " 'Houses of the Dead,'?" 420. See also the seminal studies by Marion Lawrence, "City-Gate Sarcophagi," *The Art Bulletin* 10, no. 1 (1927): 1–45; Marion Lawrence, "Columnar Sarcophagi in the Latin West: Ateliers, Chronology, Style," *The Art Bulletin* 14, no. 2 (1932): 103–185. The principle of dividing scenes with columns is not limited to stonecarving, as can be seen on the Old Testament scenes of the Salerno ivories: Kathrin Müller, "Old and New: Divine Revelation in the Salerno Ivories," *Mitteilungen des Kunsthistorischen Institutes in Florenz* 54:1 (2010–2012), 1–8.

45 Jaś Elsner, "Closure and Penetration: Reflections on the Pola Casket," *Acta ad archaeologiam et atrium historiam pertinentia* 26 (2013): 192–193.

46 Christopher H. Roosevelt, "Symbolic Door Stelae and Graveside Monuments in Western Anatolia," *American Journal of Archaeology* 110, no. 1 (2006): 65–91.

47 Finbarr Barry Flood, *The Great Mosque of Damascus: Studies on the Making of an Umayyad Visual Culture* (Leiden: Brill, 2001), 15–56; Elsner, "Closure and Penetration"; Jaś Elsner, "Relic, Icon and Architecture: The Material Articulation of the Holy in East Christian Art," in *Saints and Sacred Matter: The Cult of Relics in Byzantium and Beyond*, ed. Cynthia Hahn and Holger Klein (Washington, DC: Dumbarton Oaks, 2015), 13–40.

48 Elsner, "Closure and Penetration." In another example, a double door, under an arch, that can be opened to reveal rectilinear holes, forms the main decoration of a bronze plaque, quite possibly from a reliquary, attributed to Byzantine Asia Minor of the sixth or seventh centuries CE. Marielle Martianini-Reber, ed., *Antiquités Paléochrétiennes et byzantines, IIIe-XIVe siècles: Collections du Musée d'art et d'histoire – Genève* (Geneva: Musée d'art et d'histoire, 2011), 132–133.

49 Elizabeth Errington, "Reliquaries in the British Museum," in *Gandharan Buddhist Reliquaries*, ed. David Jongeward, Elizabeth Errington, Richard Salomon, and Stefan Baums (Seattle and London: Early Buddhist Manuscripts Project / University of Washington Press, 2012), 145–148; Martha L. Carter, "A Reappraisal of the Bīmarān Reliquary," in *Gandharan Art in Context: East-West Exchanges at the Crossroads of Asia*, ed. Raymond Allchin, Bridget Allchin, Neil Kreitman, and Elizabeth Errington (Cambridge and New Delhi: Ancient India and Iran Trust / Regency Publications, 1997), 71–93.

50 Michael Falser, "The *Graeco-Buddhist style of Gandhara*—a 'Storia ideologica', or: How a Discourse Makes a Global History of Art," *Journal of Art Historiography* 13 (2015): 1–53.

51 Benjamin Rowland, "Gandhāra and Early Christian Art: The Homme-Arcade and the Date of the Bīmarān Reliquary," *The Art Bulletin* 28, no. 1 (1946): 44–47.

52 G. A. Pugachenkova, "The Form and Style of Sogdian Ossuaries," *Bulletin of the Asia Institute, New Series* 8 (1994): 230–236. See also L. I. Rempel, "La maquette architecturale dans le culte et la construction de l'Asie centrale préislamique," in *Cultes et monuments religieux dans l'Asie centrale préislamique*, ed. Frantz Grenet (Paris: Éditions du CNRS, 1987), 84 and fig. 19; Aleksander Naymark, "Ossuary" and entries 470–476 in *Kul'tura i iskusstvo drevnego Uzbekistana / Culture and Art of Ancient Uzbekistan* (Moscow: Vneshtorgizdat, 1991), 64–70. On the Marwan ewer, see Friedrich Sarre, "Die Bronzekanne des Kalifen Marwān II im arabischen Museum in Kairo," *Ars Islamica* 1 (1934): 10–15; King, "Architectural Motif"; Helen C. Evans and Brandie Ratliff, eds., *Byzantium and Islam: Age of Transition, 7th–9th Century* (New York: Metropolitan Museum of Art, 2012), 235–236; Michele Bernardini, "Le succès de l'icône du Ṭāq à l'époque islamique," *Oriente Moderno, nuova serie* 23(84), no. 2 (2004): 363–364. On the Sasanian vessels, see Boris Marschak [Marshak], *Silberschätze des Orients. Metallkunst des 3.-13. Jahrhunderts und ihre Kontinuität* (Leipzig: E. A. Seeman, 1986), figs. 188–189; and Eva R. Hoffman, "Between East and West: The Wall Paintings of Samarra and the Construction of an Abbasid Princely Culture," *Muqarnas* 25 (2008): 116.

53 Rowland, "Gandhāra and Early Christian Art," 45.

54 See also the argument made by Spyros Papapetros about the "inherent dialetics between hiding and revealing" of adornment more generally: "World Ornament: The Legacy of Gottfried Semper's 1856 Lecture on Adornment," *RES: Anthropology and Aesthetics* 57/58 (2010): 310.

55 R. W. Hamilton, *Khirbat al Mafjar: An Arabian Mansion in the Jordan Valley* (Oxford: Clarendon Press, 1959), 115–116 and plates XII, fig. 1, XVII, fig. 1, LXV and LXVI fig. 1; K. A. C. Creswell, *Early Muslim Architecture*, 2nd ed., vol. 1, pt. 2 (Oxford: Clarendon Press, 1969), plate 87, fig. d; Finbarr Barry Flood, "The Earliest Islamic Windows as Architectural Decoration: Some Iranian Influences on Umayyad Iconography, Observations and Speculations," *Persica* 14 (1990–1992): 67–89.

56 Robert Hillenbrand, "Qasr Kharana Re-examined," in *Studies in Medieval Architecture, Vol. I* (London: Pindar Press, 2001), 486.

57 Stephen K. Urice, *Qasr Kharana in the Transjordan* (Durham, NC: American Schools of Oriental Research, 1987), 74–76.

58 Oleg Grabar, *The Formation of Islamic Art*, rev. ed. (New Haven and London: Yale University Press, 1987), 153–154.

59 On the throne of Maximian, see Christian Ewert, "Architectural Décor on the Ivories of Muslim Spain—'Dwarf' Architecture in al-Andalus," *Journal of the David Collection* 2, no. 1 (2005): 101.

60 Finbarr Barry Flood, "Umayyad Survivals and Mamluk Revivals: Qalawunid Architecture and the Great Mosque of Damascus," *Muqarnas* 14 (1997): 64.

61 Ibn Jubayr, *The Travels of Ibn Jubayr, Edited from a ms. in the University Library of Leyden*, 2nd ed., ed. William Wright and M. J. De Goeje (Leiden and London: Brill and Luzac / E. J. Gibb Memorial Series, 1907), 268; Ibn Jubayr, *The Travels of Ibn Jubayr*, trans. R. J. C. Broadhurst (London: Jonathan Cape, 1952), 279. See also Lutz Richter-Bernburg, "Between Marvel and Trial: Al-Harawī and Ibn Jubayr on Architecture," in *Egypt and Syria in the Fatimid, Ayyubid and Mamluk Eras, VI*, ed. Urbain Vermeulen and Kristof D'Hulster (Leuven: Peeters, 2010), 136.

62 Finbarr Barry Flood, "The Qur'an," in *Byzantium and Islam*, ed. Evans and Ratliff, 266–267. See also George, *The Rise of Islamic Calligraphy*, 74–89; Dalia Levit-Tawil, "The Elusive, Inherited Symbolism in the Arcade Illuminations of the Moses Ben Asher Codex (A.D. 894–95)," *Journal of Near Eastern Studies* 53, no. 3 (1994): 157–193.

63 Carl Nordenfalk, *Die spätantike Kanontafeln; Kunstgeschichtliche Studien über die eusebianische Evangelien-Konkordanz in den vier ersten Jahrhunderten ihrer Geschichte*, 2 vols. (Göteborg: O. Isacsons boktryckeri, 1938), 117–126; Carol Neuman de Vegvar, "Remembering Jerusalem: Architecture and Meaning in Insular Canon Table Arcades," in *Making and Meaning in Insular Art*, ed. Rachel Moss (Portland, OR: Four Courts Press, 2007), 242–256.

64 Maryam Ekhtiar, Priscilla Soucek, Sheila R. Canby, and Navina Najat Haidar, eds., *Masterpieces from the Department of Islamic Art in the Metropolitan Museum of Art* (New York: Metropolitan Museum of Art, 2011), 43–44; Bernard O'Kane, ed., *The Treasures of Islamic Art in the Museums of Cairo* (Cairo and New York: American University in Cairo Press, 2006), 16–17.

65 See also wooden panels carved with an arcaded design, attributed to ninth-century Egypt and now in the Musée du Louvre and the Museum of Islamic Art, Cairo: Elise Anglade, *Musée du Louvre: Catalogue des boiseries de la section islamique* (Paris: Réunion des musées nationaux, 1988), 24–26. Later examples can be seen on some Qur'an containers of the Mamluk and Ottoman eras. See Margaret S. Graves, "Treasuries, Tombs and Reliquaries: A Group of Ottoman Architectural Qur'an Boxes of Architectural Form," in *The Meeting Place of British Middle East Studies*, ed. Amanda Phillips and Refqa Abu-Remaileh (Newcastle: Cambridge Scholars Publishing, 2009), 78–98.

66 Myriam Rosen-Ayalon, *The Early Islamic Monuments of al-Ḥaram al-Sharīf* (Jerusalem: Hebrew University, 1989), 46–49.

67 Lawrence Nees, *Perspectives on Early Islamic Art in Jerusalem* (Leiden: Brill, 2016), 100–143.

68 Eva R. Hoffman, "Christian-Islamic Encounters on Thirteenth-Century Ayyubid Metalwork: Local Culture, Authenticity, and Memory," *Gesta* 43, no. 2 (2004): 129. On the production site of the famous Freer canteen, Teresa Fitzherbert, "The Freer Canteen: Jerusalem or Jazira?," in *Islamic Art, Architecture and Material Culture: New Perspectives*, ed. Margaret S. Graves (Oxford: British Archaeological Reports, 2012), 1–6; Raby, "Parsimony," 46–52.

69 Bas Snelders, "The Relationship between Christian and Islamic Art: West Syrian Christians in the Mosul Area (Twelfth-Thirteenth Century). A Preliminary Note," in *The Syriac Renaissance*, ed. Herman Teule, C. Tauwinkl Fotescu, R. B. ter Haar Romeny, and J. J. van Ginkel (Leuven: Peeters, 2010), 244–246.

70 Hoffman has also noted the possibility of a further, indirect relationship with architecture on the Freer canteen, predicated on the layout of scenes and compartments upon the surface of the object mirroring formats used for comparable decoration in the domes and drums of monuments, including the Dome of the Rock, when "restored" to the Christian faith and hung with Christian iconography by the Crusaders during their occupation of Jerusalem in the twelfth century. Hoffman, "Christian-Islamic Encounters," 133–138.

71 Among many possible examples, see the ebony chest from Wadi el-Nutrun, Egypt, illustrated in Kurt Weitzmann, "The Ivories of the So-Called Grado Chair," *Dumbarton Oaks Papers* 26 (1972): 43–91, fig. 60; the Gotofredo situla, *c.* 980, in the treasury of Milan cathedral; the portable altar of Countess Gertrude (d. 1077), illustrated in Julia M. H. Smith, "Relics: An Evolving Tradition in Latin Christianity," in *Saints and Sacred Matter: The Cult of Relics in Byzantium and Beyond*, ed. Cynthia Hahn and Holger A. Klein (Cambridge, MA: Harvard University Press / Dumbarton Oaks, 2015), 56; the liturgical textile embroidered with the image of saints in arcades, in Barbara Drake Boehm and Melanie Holcomb, eds., *Jerusalem, 1000–1400: Every People under Heaven* (New York: Metropolitan Museum of Art, 2016), 87, n. 28. The endurance of the pagan

occupied arcade, as demonstrated by the (possibly) fourth-century chest from a tomb in Qustul, Nubia (illustrated in Weitzmann, "Ivories," fig. 61) and the famous Umayyad-era brazier excavated at al-Fudayn, near Amman (ill. Piotr Bienkowski, ed., *Treasures from an Ancient Land: The Art of Jordan* [Liverpool: National Museums and Galleries on Merseyside, 1991], 99, cat. no. 118) is further testimony to the form's appeal.

72 Eva Baer, *Ayyubid Metalwork with Christian Images* (Leiden: Brill, 1989, repr. 2014), 8, 24, 32–40; see also Maurice S. Dimand, "A Silver Inlaid Bronze Canteen with Christian Subjects in the Eumorfopoulos Collection," *Ars Islamica* 1 (1934): 16–21; Laura T. Schneider, "The Freer Canteen," *Ars Orientalis* 9 (1973): 137–156; Ranee A. Katzenstein and Glenn D. Lowry, "Christian Themes in Thirteenth-Century Islamic Metalwork," *Muqarnas* 1 (1983): 53–68; Nuha N. N. Khoury, "Narrative of the Holy Land: Memory, Identity and Inverted Imagery on the Freer Basin and Canteen," *Orientations* 29, no. 5 (1998): 63–69; Hoffman, "Christian-Islamic Encounters"; Heather Ecker and Teresa Fitzherbert, "The Freer Canteen, Reconsidered," *Ars Orientalis* 42 (2012): 176–193; Fitzherbert, "Jerusalem or Jazira?"

73 Schneider, "Freer Canteen," 150.

74 See entry in Claus-Peter Haase, ed., *A Collector's Fortune: Islamic Art from the Collection of Edmund de Unger* (Berlin: Museum fur Islamische Kunst, 2008), 102–104; Géza Fehérvári, *Islamic Metalwork of the Eighth to the Fifteenth Century in the Keir Collection* (London: Faber and Faber, 1976), 105, no. 131, and plate I; David Storm Rice, "Inlaid Brasses from the Workshop of Aḥmad al-Dhakī al-Mawṣilī," *Ars Orientalis* 2 (1957): 311–316.

75 Rachel Ward, "Incense and Incense Burners in Mamluk Egypt and Syria," *Transactions of the Oriental Ceramics Society* 55 (1990–1991), 76–79, pl. 15; Rachel Ward, *Islamic Metalwork* (London: British Museum, 1993), 83–84; Baer, *Ayyubid Metalwork*, 7–10; Sophie Makariou, ed., *L'Orient de Saladin: l'art des Ayyoubides* (Paris: Gallimard / Institut du monde arabe, 2001), 113.

76 Baer, *Islamic Ornament*, 79. On the Fatimid form, see Graves, "Monumental Miniature," 311.

77 Ethel Sara Wolper, "Khidr and the Politics of Translation in Mosul: Mar Behnam, St George and Khidr Ilyas," in *Sacred Precincts: The Religious Architecture of Non-Muslim Communities across the Islamic World*, ed. Mohammad Gharipour (Leiden: Brill, 2015), 379–392; James Grehan, *Twilight of the Saints: Everyday Religion in Ottoman Syria and Palestine* (New York: Oxford University Press, 2014), 130–134; Josef W. Meri, "Re-appropriating Sacred Space: Medieval Jews and Muslims Seeking Elijah and al-Khadir," *Medieval Encounters* 5 (1999): 259–262.

78 Baer, *Islamic Ornament*, 73–79; James Allan, "Manuscript Illumination: A Source for Metalwork Motifs in Late Saljūq Times," in *The Art of the Saljuqs in Iran and Anatolia*, ed. Robert Hillenbrand (Costa Mesa, CA: Mazda, 1993), 119–126. For an Artuqid coin that presents an enthroned ruler within an ogee arch, see Almut von Gladiss, ed., *Die Dschazira: Kulturlandschaft zwischen Euphrat und Tigris* (Berlin: Staatliche Museen zu Berlin—Stiftung Preussischer Kulturbesitz, 2006), 113.

79 This process could be argued to parallel some of the "organic absorption" of arcade motifs into vegetal interlace on the carved ivories of Islamic Spain: see Ewert, "Architectural Décor."

80 Snelders, "Relationship." The period is characterized by some historians as a time of "Syriac Renaissance"; see also Anton Pritula, *The Wardā: An East Syriac Hymnological Collection, Study and Critical Edition* (Wiesbaden: Harrasowitz Verlag, 2015), 1–2.

81 The talismanic devices have been explored recently in Persis Berlekamp, "Symmetry, Sympathy, and Sensation: Talismanic Efficacy and Slippery Iconographies in Early Thirteenth-Century Iraq, Syria and Anatolia," *Representations* 133 (2016): 59–109.

82 On Mosul's fame, see Rice, "Inlaid Brasses," 284.

83 See the excellent summary of scholarship on this subject in Raby, "Principle of Parsimony," 11–21.

84 Eva Baer, *Metalwork in Medieval Islamic Art* (Albany, NY: SUNY Press, 1983), 29, fig. 24, and 311, n. 49; Anatoly Ivanov et al., *Masterpieces of Islamic Art in the Hermitage Museum* (Kuwait: Dar al-Athar al-Islamiyya, 1990), no. 49. On the attribution question more generally, see Raby, "Principle of Parsimony."

85 Anton D. Pritula and Mikhail B. Piotrovsky, *Vo dvorcach i v shatrakh: islamskij mir ot Kitaja do Evropy* [In palaces and tents: Islamic world from China to Europe] (St. Petersburg: State Hermitage Museum, 2008), 32; Mikhail B. Piotrovsky and Anton D. Pritula, eds., *Beyond the Palace Walls: Islamic Art from the State Hermitage Museum, Islamic Art in a World Context* (Edinburgh: National Museums of Scotland, 2006), 16.

86 Bas Snelders, *Identity and Christian-Muslim Interaction: Medieval Art of the Syrian Orthodox from the Mosul Area* (Leuven: Peeters, 2010), 310–312.

87 Snelders, *Identity*, 275–277; Gerald Reitlinger, "Medieval Antiquities West of Mosul," *Iraq* 5 (1938): 151–153; Estelle Whelan, "Representations of the *Khāṣṣakīyah* and the Origin of Mamluk Emblems," in *Content and Context of Visual Arts in the Islamic World*, ed. Priscilla P. Soucek (University Park: Pennsylvania State University Press, 1988), 222.

88 Melanie Gibson, "A Symbolic *Khassakiyya*: Representations of the Palace Guard in Murals and Stucco Sculpture," in *Islamic Art, Architecture and Material Culture: New Perspectives*, ed. Margaret Graves (Oxford: British Archaeological Reports, 2012), 81–91; Whelan, "Representations." See also Scott Redford's discussion of this tradition and its possible expression upon a thirteenth-century ceramic fragment, "Portable Palaces: On the Circulation of Objects and Ideas about Architecture in Medieval Anatolia and Mesopotamia," *Medieval Encounters* 18 (2012): 388–396.

89 David Storm Rice, "The Aghānī Miniatures and Religious Painting in Islam," *The Burlington Magazine* 95, no. 601 (1953): figs 16–19; S. M. Stern, "A New Volume of the Illustrated Aghānī Manuscript," *Ars Orientalis* 2 (1957): fig. 2.

90 Whelan, "Representations," 223–224. See also Raby, "Principle of Parsimony," 31–32. A somewhat later candlestick in the Benaki Museum, signed ʿAlī al-Mawṣilī and dated 717 H (1317–1318 CE), bears within its decoration five narrow banded friezes on body and neck containing a total of 116 officials. All of these march clockwise, as is shown by the direction of their feet, while their bodies remain largely frontal—a phenomenon also seen among the figures on the portals—and each is contained within his own waisted ogee arch. Anna Ballian, "Three Medieval Islamic Brasses and the Mosul Tradition of Inlaid Metalwork," *Mouseio Benaki* 9 (2009): 128–135.

91 This can be seen on the ewer signed Ibrāhīm ibn Mawāliyā, now in the Louvre, and a candlestick in the Boston Museum of Fine Arts, signed Abu Bakr ibn Hajji Jaldak and dated 622 H (1225–1226 CE): see David Storm Rice, "Studies in Islamic Metalwork: II," *Bulletin of the School of Oriental and African Studies, University of London* 15, no. 1 (1953): 69–79; David Storm Rice, "The Oldest Dated 'Mosul' Candlestick A.D. 1225," *The Burlington Magazine* 91, no. 561 (1949): 334, 336–41.

92 Snelders, *Identity*, plates 63 and 64.

93 Snelders, *Identity*, 280–281; Tariq Jawad al-Janabi, *Studies in Medieval Iraqi Architecture* (Baghdad: Ministry of Culture and Information, 1982), pl. 174, 160-A, 170-A; Friedrich Sarre and Ernst Herzfeld, *Archäologische Reise im Euphrat-und Tigris-Gebeit*, 4 vols. (Berlin: Dietrich Reimer, 1911–1920), 2:264–266; vol. 3, plates V and VIII.

94 Snelders, "Relationship."

95 Sara Kuehn, *The Dragon in Middle East Christian and Islamic Art* (Leiden: Brill, 2011), 159–168; Berlekamp, "Symmetry," 69–72, 75–82.

96 Oya Pancaroğlu, "Socializing Medicine: Illustrations of the *Kitāb al-Diryāq*," *Muqarnas* 18 (2001): 155–156, 163–165.

97 Berlekamp, "Symmetry," 76–83. For this practice in Late Antique Islamic and Christian contexts, see Keuhn, *Dragon*, 161.

98 Al-Janabi, *Studies*, 180.

99 See Berlekamp, "Symmetry," 101–102, on the abstraction of the open-mouthed dragon in interlace designs.

100 On sites, see Gerald Reitlinger, "Unglazed Relief Pottery from Northern Mesopotamia," *Ars Islamica* 15–16 (1951): 18. On connections with architectural decoration, Friedrich Sarre and Eugen Mittwoch, "Islamische Tongefäße aus Mesopotamien," *Jahrbuch der Königlich Preussischen Kunstsammlungen* 26 (1905): 69–88; Reitlinger, "Unglazed Relief Pottery," 19–20; al-Janabi, *Studies*, 251; and Snelders, *Identity*, 283.

101 Reitlinger, "Unglazed Relief Pottery."

102 For example, the frontal seated figure between two lions in the portal surrounding the Royal Gate at the church of Mart Shmuni (Snelders, *Identity*, pl. 68). Less directly comparable, but also worthy of consideration together, are scenes of combat between man and fantastic creature: Snelders, *Identity*, pl. 60; Friedrich Sarre, "Ein neuerworbenes Beispiel der mesopotamischen Reliefkeramik des XII.-XIII. Jahrhunderts," *Berliner Museen: Berichte aus den Preussischen Kunstsammlungen* LI:1 (1930), 7–11; Richard Ettinghausen, *Studies in Muslim Iconography, I: The Unicorn*, Freer Gallery of Art Occasional Papers, vol. 1, no. 3 (Washington, DC: Smithsonian, 1950), 43–45.

103 Linda Komaroff, "Sip, Dip, and Pour: Toward a Typology of Water Vessels in Islamic Art," in *Rivers of Paradise: Water in Islamic Art and Culture*, ed. Sheila Blair and Jonathan Bloom (New Haven, CT, and London: Yale University Press, 2009), 114.

104 Jeanne Mouliérac, *Céramiques du monde musulman: collections de l'institut du monde arabe et de J.P. et F. Croisier* (Paris: Institut du monde arabe, 1999), 139; Makariou, *L'Orient de Saladin*, 154; Canby et al., *Court and Cosmos*, 131, no. 60; it also appears on a jar fragment reportedly from Diyarbakır and now in the Turkish and Islamic Art Museum, Istanbul, acc. no. 1742, illustrated in Nazan Ölçer, ed., *Museum of Turkish and Islamic Art* ([Istanbul]: Akbank Department of Culture and Art, 2002), 130. Sarre and Herzfeld identified this figure as a "Barbotin-Männchen": *Archäoligische Reise*, 4:16.

105 Deniz Beyazıt, *Le décor architectural artuqide en pierre de Mardin placé dans son context régional: contribution à l'histoire du décor géométrique et végétal du Proche-Orient des XIIe-XVe siècles* (Oxford: Archaeopress, 2016), 147–148, plates 20.B, 29.A; Taragan, "Artuqid Candlestick," 82–84; Robert Hillenbrand, "Eastern Islamic influences in Syria: Raqqa and Qal'at Ja'bar in the Later 12th Century," in *The Art of Syria and the Jazira, 1100–1250*, ed. Julian Raby (Oxford: Oxford University Press, 1985), 27–36. See also the interpretation of the form in Tabbaa, *Transformation*, 138–146.

106 R. L. Hobson, *Guide to the Islamic Pottery of the Near East* (London: British Museum, 1932), 32–33.

107 Berlekamp, "Symmetry," 92.

108 For example, Mouliérac, *Céramiques du monde musulman*, 75; Berlin, Museum für Islamische Kunst, no. I.3714; a piece reportedly from Diyarbakır and now in the Museum of Turkish And Islamic Art, Istanbul, acc. no. 1743, published in Ölçer, ed., *Museum of Turkish and Islamic Art*, 126; an example in the National Museum,

Damascus, published in Richard Ettinghausen, Oleg Grabar and Marilyn Jenkins-Madina, *Islamic Art and Architecture: 650–1250* (London: Yale University Press, 2001), 249; and a fragment excavated at Samarra, published in Iraq Government Department of Antiquities, *Excavations at Samarra 1936–1939, Part II: Objects* (Baghdad: Government Press, 1940), plate XLVII.

109 Eva Baer, "Jeweled Ceramics from Medieval Islam: A Note on the Ambiguity of Islamic Ornament," *Muqarnas* 6 (1989): 83–97.

110 Lale Bulut, "Painted and Moulded Masks on Barbotine Ware Jars from South-Eastern Anatolia and Their Iconographic Significance," in *Art Turc: 10e Congrès international d'art turc*, ed. François Déroche (Geneva: Fondation Max van Berchem, 1999), 191–195.

111 "Unglazed Relief Pottery," fig. 22. Reitlinger describes the woman in the window as "a supreme effort of realism" (p. 20).

112 See Gönül Öney, "Human Figures on Anatolian Seljuk Sgraffiato and Champlevé Ceramics," in *Essays in Islamic Art and Architecture in Honor of Katharina Otto-Dorn*, ed. Abbas Daneshvari (Malibu, CA: Undena, 1981), 121–122; Redford, "Portable Palaces," 386–388; Grabar, *Mediation*, 137; Martina Müller-Wiener, "Lost in Translation: Animated Scrolls Reconsidered," *Beiträge zur Islamischen Kunst und Archäologie* 3 (2012): 163–176.

113 R. D. Barnett, *A Catalogue of the Nimrud Ivories with Other Examples of Ancient Near Eastern Ivories in the British Museum*, 2nd ed. (London: British Museum Publications, 1975), 145–151.

Chapter 3: Occupied Objects

1 For recent investigations into the neural mechanisms of visual consciousness, and the wider nature of phenomenal consciousness, see the pair of volumes edited by Steven M. Miller: *The Constitution of Visual Consciousness: Lessons from Binocular Rivalry, Advances in Consciousness Research, Vol. 90* (Amsterdam: John Benjamins, 2013), and *The Constitution of Phenomenal Consciousness: Toward a Science and a Theory, Advances in Consciousness Research, Vol. 92* (Amsterdam: John Benjamins, 2015), especially the introduction by Steven Miller to the first volume, 1–13, and the introduction by Zoe Drayson to the second section of the second volume, on "The Philosophy of Visual Consciousness," 273–292.

2 Graves, "Ceramic House Models," 227–252.

3 I offer my very sincere thanks to Jens Kröger for his generosity, and his patience, during my visit.

4 Grabar, "Visual Arts," 626–658; Oleg Grabar, "Les arts mineurs de l'Orient musulman à partir du milieu du XIIe siècle," *Cahiers de civilisation médiévale* 42 (1968): 181–190; Oleg Grabar, "The Illustrated *Maqamat* of the Thirteenth Century: The Bourgeoisie and the Arts," in *The Islamic City*, ed. Albert Hourani and Samuel Miklos Stern (Oxford: Bruno Cassirer, 1970), 207–222; Ettinghausen, "Flowering," 113–131.

5 Oya Pancaroğlu, " 'A World Unto Himself': The Rise of a New Human Image in the Late Seljuk Period (1150–1250)" (PhD diss., Harvard University, 2000). See also Oya Pancaroğlu, "Ornament, Form and Vision in Ceramics from Medieval Iran: Reflections of the Human Image," in *Histories of Ornament*, ed. Necipoğlu and Payne, 192–203.

6 Other currents in late nineteenth- and twentieth-century collecting and publication also served to privilege certain Iranian materials within the collected canon. See Stephen Vernoit, "Islamic Art and Architecture: An Overview of Scholarship and Collecting, c. 1850–1950," in *Discovering Islamic Art: Scholars, Collectors and Collections, 1850–1950*, ed. Stephen Vernoit (London: I. B. Tauris, 2000), 6–7.

7 Pancaroğlu, *New Human Image*, 36, cites the very apposite example of the Bobrinski bucket. One important study to go beyond the iconographic model is Marianna Shreve Simpson, "Narrative Allusion and Metaphor in the Decoration of Medieval Islamic Objects," in *Studies in the History of Art, vol. 16: Pictorial Narrative in Antiquity and the Middle Ages*, ed. Herbert L. Kessler and Marianna Shreve Simpson (Washington, DC: National Gallery of Art, 1985), 131–149.

8 See Severin Schroeder, "A Tale of Two Problems: Wittgenstein's Discussion of Aspect Perception," in *Mind, Method and Morality: Essays in Honour of Anthony Kenny*, ed. John Cottingham and Peter M. S. Hacker (Oxford: Oxford University Press, 2010), 352–372; Jennifer Church, "'Seeing As' and the Double Bind of Consciousness," *Journal of Consciousness Studies* 7, nos. 8–9 (2000): 99–111.

9 Ned Block, "Seeing-As in the Light of Vision Science," *Philosophy and Phenomenological Research* 89, no. 1 (2014): 560–572. Block's article is largely a response to the theories of visual perception put forth in Tyler Burge, *Origins of Objectivity* (Oxford: Oxford University Press, 2010).

10 Church, "Seeing As," 109.

11 Ludwig Wittgenstein, *Philosophical Investigations*, trans. and ed. Peter M. S. Hacker and Joachim Schulte (Oxford: Wiley-Blackwell, 2009), 204. See also Schroeder, "Tale of Two Problems." The phenomenon is a critical component of Whitney Davis's theory of "radical pictoriality." See Whitney Davis, *A General Theory of Visual Culture* (Princeton, NJ: Princeton University Press, 2011); Whitney Davis, "The Archaeology of Radical Pictoriality," in *Images and Imaging in Philosophy, Science and the Arts*, ed. Richard Heinrich et al. (Frankfurt: Ontos, 2011), 191–218.

12 Ernst Gombrich, *Art and Illusion: A Study in the Psychology of Pictorial Representation* (New York: Pantheon, 1960). For a critique of Gombrich's deployment of Wittgenstein's "seeing-as," see William G. Lycan, "Gombrich, Wittgenstein and the Duck-Rabbit," *The Journal of Aesthetics and Art Criticism* 30, no. 2 (1971): 229–237.

13 Wollheim originally used the term "seeing-as" but revised this in the second edition of *Art and Its Objects*: Richard Wollheim, "Essay V: Seeing-As, Seeing-In, and Pictorial Representation," in *Art and Its Objects: With Six Supplementary Essays*, 2nd ed. (Cambridge: Cambridge University Press, 1980), 212. See also Emmanuel Alloa, "Seeing-As, Seeing-In, Seeing-With. Looking through Images," in *Imaging in Philosophy, Science and the Arts*, ed. Richard Heinrich et al. (Frankfurt: Ontos, 2011), 179–190, where this passage is cited.

14 Wollheim, "Seeing-As."

15 Maurice Merleau-Ponty, *L'oeil et l'esprit* (Paris: Gallimard, 1964), 22–23.

16 Alloa, "Seeing-As," 185–188.

17 Alloa, "Seeing-As," 188.

18 On sculpture, Robert Hopkins, "Sculpture and Space," in *Imagination, Philosophy and the Arts*, ed. Matthew Keiran and Dominic Lopes (New York: Routledge, 2003), 272–290; Sherri Irvin, "Sculpture," in *The Routledge Companion to Aesthetics*, ed. Berys Gaut and Dominic Lopes (New York: Routledge, 2013), 608.

19 See Stephen Kosslyn, "Remembering Images," in *Memory and Mind: A Festschrift for Gordon H. Bower*, ed. Mark A. Gluck, John R. Anderson, and Steven M. Kosslyn (Mahwah, NJ: Lawrence Erlbaum, 2007), 101–104. In a related vein, see Russell Epstein, "Consciousness, Art and the Brain: Lessons from Marcel Proust," *Consciousness and Cognition* 13 (2004): 213–240.

20 Ibn al-Haytham, *Optics*, 1:113.

21 David Roxburgh, "Kamal al-Din Bihzad and Authorship in Persianate Painting,"
 Muqarnas 17 (2000): 136.

22 For more discussion of this group of objects, see Margaret S. Graves, "The Aesthetics
 of Simulation: Architectural Mimicry on Medieval Ceramic Tabourets," in *Islamic
 Art, Architecture and Material Culture: New Perspectives*, ed. Margaret S. Graves
 (Oxford: British Archaeological Reports, 2012), 63–80; Margaret S. Graves, *Worlds Writ
 Small: Four Studies on Miniature Architectural Forms in the Medieval Middle East* (PhD
 diss., University of Edinburgh, 2010), ch. 2; Redford, "Portable Palaces," 396–398; and
 Oliver Watson, "The Case of the Ottoman Table," *Journal of the David Collection* 3
 (2010), 19–22.

23 The piece was reportedly obtained from the village of Kubachi in Daghestan. L.T.
 Giuzal'ian, "Tri iranskich srednevekovych glinianych stolinka," *Issledovaniya po istorii
 kul'tury naradov vostoka: sbornik v vest' akademika I.A. Orbeli* (1960), 318; see also Adel
 Adamova et al., *Persia: Thirty Centuries of Art and Culture* (Aldershot: Lund Humphries,
 2007), ill. 51, 102. The State Hermitage Museum acquired some two thousand objects
 from two residents of Kubachi, Said and Rasul Magomedov, before the start of the
 Second World War; many of these acquisitions were Iranian ceramics. See Adamova
 et al., *Persia*, 49–52. For the most recent study of the Iranian ceramics found in
 Kubachi, see Lisa Golombek, "The 'Kubachi Problem' and the Isfahan Workshop," in
 Persian Pottery in the First Global Age: The Sixteenth and Seventeenth Centuries, ed. Lisa
 Golombek et al. (Leiden: Brill, 2014), 169–181.

24 Watson, *Persian Lustre Ware*, 68–85; Oliver Watson, "Persian Lustre-Painted
 Pottery: The Rayy and Kashan Styles," *Transactions of the Oriental Ceramics Society* 40
 (1973–1975): 1–19.

25 Giuzal'ian, "Tri iranskich," 317–318. A six-sided wooden stand with round, turned
 feet, attributed to eleventh- or twelfth-century Afghanistan and now held in the David
 Collection, illustrates this line of descent. Kjeld Von Folsach, "A Number of Pigmented
 Wooden Objects from the Eastern Islamic World," *Journal of the David Collection* 1
 (2003): 73, 91.

26 Giuzal'ian, "Tri iranskich," 319. The pavilion reading was first suggested by
 Ettinghausen: see bibliography in Graves, "Aesthetics," 76–78.

27 On the Ghaznavid context, for example, see Viola Allegranzi, "Royal Architecture
 Portrayed in Bayhaqī's *Tārīḫ-i Masʿūdī* and Archaeological Evidence from Ghazni
 (Afghanistan, 10th–12th Century)," *Annali—Università degli studi di Napoli
 "L'Orientale"* 74 (2014): 95–120.

28 Bernard O'Kane proposes that this building was originally a fifteenth-century Timurid
 construction, while Lisa Golombek and others propose a seventeenth-century date.
 Bernard O'Kane, *Timurid Architecture in Khurasan* (Costa Mesa, CA: Mazda, 1987), 299–
 300; Lisa Golombek, *The Timurid Shrine at Gazur Gah: An Iconographical Interpretation
 of Architecture* (Toronto: Royal Ontario Museum, 1969), 70; Sussan Babaie, "Building for
 the Shah: The Role of Mīrzā Muḥammad Taqī (Sarū Taqī) in Safavid royal patronage
 of architecture," in *Safavid Art and Architecture*, ed. Sheila Canby (London: British
 Museum, 2002), 25, n. 40.

29 Graves, "House Models," 237–241. A similar combination of molded and modeled
 elements appears on three stands decorated with monochrome turquoise glaze, and
 on a further example, of slightly different form, reportedly found at Bujnurd in
 northeastern Iran. Tehran, Glass and Ceramics Museum, no. 134, reportedly from
 Gurgan; Cairo, Museum of Islamic Ceramics, no. 256; David Collection, no. Isl. 108
 (Annika Richert, ed., *Islam: Konst och kultur / Islam: Art and Culture* [Stockholm: Statens
 Historiska Museum, 1985], 133, Graves, "Aesthetics," 68); Metropolitan Museum of

Art, NY, no. 69.225 (Richard Ettinghausen, "Islamic Art," *Metropolitan Museum of Art Bulletin*, 33, no. 1 [1975]: 18–19; Richard Ettinghausen, "Introduction," in *The Islamic Garden: Dumbarton Oaks Colloquium on the History of Landscape Architecture IV*, ed. Elizabeth B. Macdougall and Richard Ettinghausen [Washington, DC: Dumbarton Oaks, 1976], 9, fig. A; Joseph Sadan, *Le mobilier au Proche-Orient médiéval* [Leiden: Brill, 1976], 94, n. 357; Oliver Watson, *Persian Lustre Ware*, 106, n. 9; Graves, "Aesthetics," 77).

30 Philadelphia Museum of Art, McIlhenny Collection, no. 1943-41-1. See Arthur Upham Pope, *Masterpieces of Persian Art* (New York: Dryden, 1945), 120; Arthur Upham Pope and Phyliss Ackerman, eds., *A Survey of Persian Art*, 2nd impression, 18 vols (Ashiya: SOPA, 1981–2005), vol. 9, pl. 702A; Arthur Lane, *Early Islamic Pottery* (London: Faber and Faber, 1947), pl. 63B; Giuzal'ian, "Tri iranskich," 316; Ernst Grube, "Raqqa-Keramik in der Sammlung des Metropolitan Museum in New York," *Kunst des Orients* 4 (1963), 51, n. 45; Sadan, *mobilier*, 94, n. 357; Watson, *Persian Lustre Ware*, 107; Felice Fischer, *Philadelphia Museum of Art: Handbook of the Collections* (Philadelphia: Museum of Art, 1995), ill. p. 64; Géza Fehérvári, *Ceramics of the Islamic World in the Tareq Rajab Museum* (London and New York: I. B. Tauris, 2000), 177, n. 23.

31 On the luster stand in Philadelphia the painted or molded figures of seated drinkers within each arch intimate practices of conviviality and an architecture of pleasure. See Graves, "Aesthetics," 68.

32 Giuzal'ian, "Tri iranskich," 319.

33 Clifford Edmund Bosworth, "Farrukhī's Elegy on Maḥmūd of Ghazna," *Iran* 29 (1991): 45; Finbarr Barry Flood, "Painting, Monumental and Frescoes," in *Medieval Islamic Civilization: An Encyclopedia*, ed. Josef Meri (New York: Routledge, 2006), 2:586–590. A fragment of stucco painted with the image of a dog and attributed to the twelfth century was excavated at Nishapur, Qanat Tepe, by the Metropolitan Museum team (MMA no. 48.101.302). On Alara, see Scott Redford, *Landscape and the State in Medieval Anatolia: Seljuk Gardens and Pavilions of Alanya, Turkey* (Oxford: British Archaeological Reports, International Series 893, 2000), 50–51.

34 An early sixteenth-century description of a two-storeyed garden pavilion near Herat, interpreted by Bernard O'Kane as octagonal in structure, is given in the memoirs of the progenitor of the Mughal dynasty, Babur (1483–1530): Babur Padshah, *Bābur-nāma (Memoirs of Bābur)*, trans. Annette Susannah Beveridge (New Delhi: Mushiram Manoharlal, 1990), 302; O'Kane, *Timurid Architecture*, 299–300.

35 Daniel Schlumberger, "Le palais ghaznévide de Lashkari Bazar," *Syria* 29 (1952): 251–270.

36 Oliver Watson, "Small Table, Moulded Fritware with a Turquoise Glaze," *Louisiana Revy* 27, no. 3 (1987): 117; Kjeld Von Folsach, *Art from the World of Islam in the David Collection* (Copenhagen: David Collection, 2001), 163; Graves, "Aesthetics," 75. On the association between this production and Raqqa, see Graves, "Aesthetics," 66–67. A very similar piece is held in the Khalili Collection, London, acc. no. POT1700: see Ernst Grube, *Cobalt and Lustre: The First Centuries of Islamic Pottery* (London: Nour Foundation, 1994), 284–285.

37 For example, see the relationship between human members and architectural proportions in fifteenth-century Italy, following Vitruvius, that is discussed in Emanuele Lugli, "Measuring the Bones: On Francesco di Giorgio Martini's Salazzianus Skeleton," *Art History* 38, no. 2 (2015): 346–363.

38 These also include the *qabḍa* or *qubḍa* (a fist's width), the *shibr* ("span" of the outstretched hand), and the *bāʿ* or *qāma* (the width of two outstretched arms). See Clifford Edmund Bosworth, "Misāḥa (A.)," *Encyclopaedia of Islam*, 2nd ed., http://dx.doi.org/10.1163/1573-3912_islam_COM_0754.

39 Ikhwān al-Ṣafāʾ, Epistles 1 & 2 (OUP/IIS), 132–133. El-Bizri notes (132–133, n. 42) that these measurements also appear in the *Mafātīḥ al-ʿulūm* (Keys to the sciences) of Muḥammad ibn Aḥmad ibn Yūsuf al-Kātib al-Khwārizmī, composed around 977 CE, in Iraq. On the anthropocentric practice of encountering and estimating the world through units abstracted from the corporeal human body, see also Ibn al-Haytham, *Optics*, 1:179–180.

40 Deborah G. Tor, "The Importance of Khurasan and Transoxiana in the Persianate Dynastic Period (850–1220)," in *Medieval Central Asia and the Persianate World: Iranian Tradition and Islamic Civilisation*, ed. Andrew C. S. Peacock and Deborah G. Tor (London: I. B. Tauris, 2015), 1–12.

41 Graves, *Worlds Writ Small*, 1:223–260, 299–301.

42 See Richard Ettinghausen, "The Bobrinsky 'Kettle': Patron and Style of an Islamic Bronze," *Gazette des beaux-arts* 24 (1943): 196; Mehmet Aga-Oglu, "A Preliminary Note on Two Artists from Nishapur," *Bulletin of the Asia Institute* 6, nos. 1–4 and 7, no. 1 (1946): 121–124; Maurice Dimand, "Recent Additions to the Near Eastern Collections," *The Metropolitan Museum of Art Bulletin* 7, no. 5 (1949): 139; Assadullah Souren Melikian-Chirvani, "State Inkwells in Islamic Iran," *The Journal of the Walters Art Gallery* 44 (1986): 75; Kana'an, " 'Artist,' " 182, citing al-Qazwīnī, *Zakarija ben Muhammed ben Mahmud el-Cazwini's Kosmographie*, ed. F. Wüstenfeld (Göttingen: Verlag der Dieterichschen Buchhandlung, 1849), 323.

43 An example in the Khalili Collection bears the date 607 H (1210–1211 CE); this piece awaits further investigation.

44 See Kana'an, " 'Artist,' " and the further bibliography in this article.

45 L. T. Giuzal'ian, "The Bronze Qalamdan (Pen-Case) 542/1148 from the Hermitage Collection," *Ars Orientalis* 7 (1968): 105; Kana'an, " 'Artist,' " 176. Another interpretation is given in Melikian-Chirvani, *Islamic Metalwork*, 82–83.

46 Kana'an, "Patron and Craftsman," 69; Kana'an, "Thirteenth-Century Brass Ewer," 190–192. For distinct but related questions about the relationship between casting technologies and systems of ornament, see Lothar Ledderose, *Ten Thousand Things: Module and Mass Production in Chinese Art* (Princeton, NJ: Princeton University Press, 2001), ch. 2: "Casting Bronze the Complicated Way," 24–49.

47 Allan, *Persian Metal Technology*, 59–65.

48 Claudia Chang, ed., *Of Gold and Grass: Nomads of Kazakhstan* (Bethesda: Foundation for International Arts and Education, 2006), 72–73, 148.

49 UNESCO, "Museum of Ghazni: Inkwell," *Museums for Intercultural Dialogue*, *UNESCO*, http://www.unesco.org/culture/museum-for-dialogue/item/en/217/inkwell; Umberto Scerrato, "Summary Report on the Italian Archaeological Mission in Afghanistan. The First Two Excavation Campaigns at Ghazni, 1957–1958," *East and West* 10, nos. 1/2 (1959): 39 and fig. 38; Laviola, "Three Islamic Inkwells," *Vicino Oriente* 21 (2017): 111–126.

50 The inkwell is published in Laviola, *Metalli islamici*, 618, and Laviola, "Three Islamic Inkwells." I am very grateful to Dr. Laviola for making the images of the inkwell available to me prior to her publication of them.

51 Accession number IR-1530. I thank Anton Pritula for bringing this object to my attention, and for pointing out the likelihood of a Jaziran provenance for the piece. His study, "The Development of Metalware in the Jazira: A Brass Inkwell in the Hermitage

Museum," is forthcoming in the *Reports of the State Hermitage Museum*, 2019. A parallel can be found in Canby et al., *Court and Cosmos*, 151 (Musée du Louvre, Paris, OA 3446).

52 Baer, *Metalwork*, 68.

53 I am grateful to Moya Carey for informing me of these images.

54 Joseph Sadan, "Nouveaux documents sur scribes et copistes," *Revue des études islamiques* 45, no. 1 (1977), 44, 47, 54, n. 29, 68; Joseph Sadan, "Written Sources Concerning Goldsmithing and Jewellery," in *Jewellery and Goldsmithing in the Islamic World*, ed. Na'ama Brosh (Jerusalem: Israel Museum, 1991), 99, n. 34. Certainly the terminology seems to have shifted by the time of the Mamluk era: see Rebecca Sauer, "The Penbox (*dawāt*): An Object between Everyday Practices and Mamlūk Courtly Gift Culture," forthcoming in *Proceedings of the School of Mamluk Studies*.

55 Online version: http://vajje.com/search/index?query=دواة. I thank Nasrin Askari for bringing this to my attention.

56 Sadan, "Art of the Goldsmith," 464.

57 Sadan, "Written Sources," 96–97; Melikian-Chirvani, *Islamic*, 283–285.

58 Qur'an 96: 3–5. Hana Taragan also cites an unreferenced hadith that records that the inkwell or *nūn* was the second thing created by Allah, after the pen. See Hana Taragan, "The 'Speaking' Inkwell from Khurasan: Object as 'World' in Iranian Medieval Metalwork," *Muqarnas* 22 (2005): 31–32; Eva Baer, "An Islamic Inkwell in the Metropolitan Museum of Art," in *Islamic Art in the Metropolitan Museum of Art*, ed. Richard Ettinghausen (New York: Metropolitan Museum of Art, 1972), 199 and n. 2, citing Qalqashandī, *Ṣubḥ al-a'shā* (Cairo, 1913–1919), II, 432, lines 5–7, and Kashājim, *Dīwān*, 12, lines 10–11.

59 Melikian-Chirvani, "State Inkwells"; Taragan, "Speaking Inkwell," 39–40.

60 Niẓāmī 'Arūḍī Samarqandī, *Chahār maqāla*, rev. trans. Edward G. Browne (London: E. J. Gibb Memorial / Luzac, 1921), 13, 15–16.

61 See the case of Abū 'Alī ibn Shihāb al-'Ukbarī (d. 1036/7 CE), reported in George Makdisi, "An Autograph Diary of an Eleventh-Century Historian of Baghdād – 1," *Bulletin of the School of Oriental and African Studies* 18, no. 1 (1956): 10–11.

62 See for example an inkwell held in the LACMA collections, accession number AC1997.253.34a-b: http://collections.lacma.org/node/186259.

63 Baer, *Metalwork*, 68.

64 Baer, *Metalwork*, 48.

65 Allan, *Islamic Metalwork*, 36.

66 Melikian-Chirvani, "State Inkwells"; Melikian-Chirvani, *Islamic Metalwork*, 123. The Nishapur ceramic piece is Metropolitan Museum of Art, Rogers Fund 38.40.296: see also Charles K. Wilkinson, "Christian Remains from Nishapur," in *Forschungen zur Kunst Asiens: In Memoriam Kurt Erdmann*, ed. Oktay Aslanapa and Rudolf Naumann (Istanbul: Universitesi Edebiyat Fakultësi, 1969), 79–87. Melikian-Chirvani was later to change his interpretation of this object. See "The Light of Heaven and Earth: From the *Chahār-ṭaq* to the *Miḥrāb*," *Bulletin of the Asia Institute*, n.s., 4 (1990): 105.

67 Richard Ettinghausen, "Some Comments on Medieval Iranian Art," *Artibus Asiae* 31, no. 4 (1969): 295, 298; Grabar, *Mediation*, 191–193; Oleg Grabar, "From Dome of Heaven to Pleasure Dome," *Journal of the Society of Architectural Historians* 49 (1990): 19.

68 Melikian-Chirvani, *Islamic Metalwork*, 282–284. See also Melikian-Chirvani, "State Inkwells," 81–83, for further discussion of these examples.

69 See the seminal works from either end of his career: Oleg Grabar, "The Umayyad Dome of the Rock in Jerusalem," *Ars Orientalis* 3 (1959): 33–62; Oleg Grabar, *The Dome of the Rock* (Cambridge, MA: Harvard University Press, 2006).

70 Ettinghausen, "Some Comments," 298.

71 Grabar, *Mediation*, 192.

72 Troelenberg, "Pedestal?," 159–174. On markets and canons, see Margaret S. Graves, "Feeling Uncomfortable in the Nineteenth Century," *Journal of Art Historiography* 6 (2012), and in the same volume, Carey and Graves, "Introduction."

73 For examples see Oleg Grabar, "The Islamic Dome: Some Considerations," *Journal of the Society of Architectural Historians* 22, no. 4 (1963): 193–194; Oleg Grabar, "The Earliest Islamic Commemorative Structures, Notes and Documents," *Ars Orientalis* 6 (1966): 12–13, 38; Hillenbrand, *Islamic Architecture*, 280; see also Melanie Michailidis, "The Lofty Castle of Qābus b. Voshmgir," in *Early Islamic Iran: The Idea of Iran, Volume V*, ed. Edmund Herzig and Sarah Stewart (London: I. B. Tauris, 2012), 121–138; Michailidis, "Footsteps of the Sasanians," 135–173. Circular-plan tomb towers do exist, such as the eleventh-century examples at Damghan, but the polygonal plan is more common: Abbas Daneshvari, *Medieval Tomb Towers of Iran: An Iconographical Study* (Lexington, KY: Mazda, 1986), 18–31. On medieval architectural transformations from a round to a polygonal plan through copying, see Richard Krautheimer, "Introduction to an 'Iconography of Medieval Architecture,'" *Journal of the Warburg and Courtauld Institutes* 5 (1942): 1–33; Christopher S. Wood, *Forgery, Replica, Fiction: Temporalities of German Renaissance Art* (Chicago: University of Chicago Press, 2008), 47–53; Hana Taragan, "The Image of the Dome of the Rock in Cairene Mamluk Architecture," in *The Real and Ideal Jerusalem in Jewish, Christian and Islamic Art*, ed. Bianca Kuhnel, *Jewish Art* 23/24 (1997–1998): 453–459.

74 The octagonal tomb at Bust, Afghanistan, thought to date from the twelfth or early thirteenth century, is lower and wider than many extant tomb towers: see Howard Crane, "Helmand-Sistan Project: An Anonymous Tomb in Bust," *East and West* 29 (1979): 241–246.

75 For records of the medieval Muslim encounter with stupa architecture in the former Gandharan area, Ibn al-Faqīh al-Hamaḍānī, *Abrégé du livre des pays* (*Mukhtaṣar kitāb al-buldān*), trans. Henri Massé (Damascus: Institut Français de Damas, 1973), 383; Assadullah Souren Melikian-Chirvani, "Buddhism II: In Islamic Times," in *Encyclopaedia Iranica*, vol. 4 (London and New York: Routledge / Kegan Paul, 1990), 496–499.

76 Kurt Behrendt, *The Buddhist Architecture of Gandhara* (Leiden: Brill, 2004), 121–123.

77 See David Jongeward et al., *Gandharan Buddhist Reliquaries* (Seattle: Early Buddhist Manuscripts Project, 2012), 138, and other examples in this volume; Elizabeth Errington and Joe Crib, eds., *The Crossroads of Asia: Transformation in Image and Symbol in the Art of Ancient Afghanistan and Pakistan* (Cambridge: Ancient India and Iran Trust, 1992), 29, 185; Robert L. Brown, "The Nature and Use of the Bodily Relics of the Buddha in Gandhāra," in *Gandharan Buddhism: Archaeology, Art, Texts*, ed. Pia Brancaccio and Kurt Behrendt (Vancouver: University of British Columbia Press, 2006), 200.

78 Finbarr Barry Flood, "Gilding, Inlay and the Mobility of Metallurgy: A Case of Fraud in Medieval Kashmir," in *Metalwork and Material Culture*, ed. Porter and Rosser-Owen, 131–142.

79 A partial parallel for the form can be seen in a bronze lid excavated at Nishapur, thought to date from the eleventh century, which has a domical center decorated with raised lobes but is without the ogee elegance of the later inkwell lids. James Allan,

Nishapur: Metalwork of the Early Islamic Period (New York: Metropolitan Museum of Art, 1982), 53, 99.

80 Golombek, "Draped Universe," 31, 34.

81 See, for example, the forty-ninth miniature, showing Warqa mourning at a grave (which is marked by a tent), fol. 46a, illustrated in Abbas Daneshvari, *Animal Symbolism in Warqa wa Gulshāh* (Oxford: Oxford University Press, 1986), 80.

82 An alternative interpretation of the structure of this tent is given in Chahryar Adle, "Un diptyque de foundation en céramique lustrée, Kâšân 711/1312," in *Art et société dans le monde iranien*, ed. Chahryar Adle (Paris: Éditions Recherche sur les civilisations, 1982), 214–217.

83 David Durand-Guédy, "*Khargāh*: An Inquiry into the Spread of the 'Turkish' Trellis Tent within the ʿAbbāsid World up to the Saljuq Conquest (mid. 2nd/8th–early 5th/11th Centuries)," *Bulletin of the School of Oriental and African Studies* 79, no. 1 (2016): 61–64, 74–77.

84 David Durand-Guédy, "The Tents of the Saljuqs," in *Turko-Mongol Rulers, Cities and City Life*, ed. David Durand-Guédy (Leiden: Brill, 2013), 155–159.

85 For parallel arguments in the study of Gothic art and architecture, see Summerson, "Heavenly Mansions," 1–28; Bucher, "Micro-Architecture," 71–89.

86 Avinoam Shalem, "Hidden Aesthetics and the Art of Deception: The Object, the Beholder and the Artisan," in *Siculo-Arabic Ivories and Islamic Painting 1100–1300*, ed. David Knipp (Chicago: University of Chicago, 2011), 40–52.

87 Grabar, *Mediation*, 193.

88 Taragan, "Speaking Inkwell." The examples she analyses are from the Eretz Israel Museum, Tel Aviv, MHM 1.93; the Victoria and Albert Museum, London, M.86-1969; and the Royal Ontario Museum, Toronto, 972.10.

89 Khalili Collection, London, MTW1488. There is a further example in a Scottish private collection that also bears three arches occupied by single figures, but from the published description and illustration it is not clear if the figures are scribes: Mikhail Baskhanov, Maria Baskhanova, Pavel Petrov, and Nikolaj Serikoff, *Arts from the Land of Timur: An Exhibition from a Scottish Private Collection* (Paisley: Sogdiana Books / Bonhams, 2012), 141.

90 Scerrato, "Summary Report," 39 and fig. 38.

91 A substantial body of recent literature has confirmed that directional bias from reading and writing affects many other areas of cognition, including the exploration of artworks: Anne Maass, Caterina Suitner, and Jean-Pierre Deconchy, *Living in an Asymmetrical World: How Writing Direction Affects Thought and Action* (London and New York: Taylor and Francis, 2014).

92 See for example the lamp discussed in Ivanov, "Works," 16. Each of the four inscription cartouches on that object contains a phrase that begins "*bi-l-yumn wa-l-baraka.*"

93 Roberta Giunta, "New Epigraphic Data from the Excavations of the Ghaznavid Palace of Masʿūd III at Ghazni (Afhganistan)," in *South Asian Archaeology 2007: Proceedings of the 19th Meeting of the European Association of South Asian Archaeology in Ravenna, Italy, July 2007*, ed. Pierfrancesco Callieri and Luca Colliva (Oxford: British Archaeological Reports, 2010), 126.

94 Taragan, "Speaking Inkwell," 39–42; Baer, "Islamic Inkwell," 199–201.

95 Alain George suggests that the object of similar appearance carried by the figure on the David Collection inkwell is a dervish's purse: "The Illustrations of the *Maqāmāt* and the Shadow Play," *Muqarnas* 28 (2011): 22.

96 Giuzal'ian, "Qalamdan," 110.

97 As Jaś Elsner notes with regard to a fifth-century casket adorned with Christological and architectural imagery, "It is as if closure brings into being the desire for an opening, and this desire (on the beholder's part) builds itself into the box's iconography." Elsner, "Closure and Penetration," 190.

98 Allan, "Manuscript Illumination," 119–126.

99 Metropolitan Museum of Art, 35.128a,b. The combination of baluster-shaped flower vases and arches filled with symmetrical vegetal scroll designs can also be seen on two ewers in the Herat Museum, one inlaid, engraved and incised and signed by the maker *Ḥasan-i bā Sahl*, and one with engraved and incised decoration only (HNM 02.26.86 and 02.29.86). See Franke and Müller-Weiner, *Ancient Herat Vol. 3*, 112–116, and Assadullah Souren Melikian-Chirvani, "Les bronzes du Khorâssân—VI: L'oeuvre de Ḥasan-e Ba Sahl: de l'emploi de l'unité modulaire et des nombres privilégiés dans l'art du bronze," *Studia Iranica* 8, no. 1 (1979): 7–32.

100 Grabar also linked the prevalence of human figures on twelfth- and thirteenth-century artworks from the Persianate world with an "animation of the object": "Visual Arts," 648.

101 For the bibliography for this object, see Mayer, *Islamic Metalworkers*, 82–83; also Ralph Harari, "Metalwork after the Early Islamic Period," in *Survey of Persian Art*, 5:2527, n. 7; Dalu Jones and George Michell, eds, *The Arts of Islam: Hayward Gallery, 8 Apri –4 July 1976* (London: Arts Council of Great Britain, 1976), 172; Baer, *Metalwork*, 140; Kjeld Von Folsach, *Islamic Art: The David Collection* (Copenhagen: David Collection, 1990), 194; Kjeld Von Folsach et al., eds., *Sultan, Shah and Great Mughal: The History and Culture of the Islamic World* (Copenhagen: National Museum, 1996), 149; Von Folsach, *Art from the World of Islam*, 306–307.

102 Mayer, *Metalworkers*, 82–83.

103 Sarre and Martin, eds., *Die Ausstellung*, vol. 2, plate 151, cat. no. 3035. On the scholarly significance of the Munich exhibition and its publications, see Eva-Maria Troelenberg, "Regarding the Exhibition: the Munich Exhibition *Masterpieces of Muhammedan Art* (1910) and Its Scholarly Position," *Journal of Art Historiography* 6 (2012): n.p.

104 On the terminological and taxonomical confusions surrounding bronzes, brasses, and other copper alloys in the medieval Iranian world, see Allan, *Persian Metal Technology*, 39–55; Mehmet Aga-Oglu, "A Brief Note on Islamic Terminology for Bronze and Brass," *Journal of the American Oriental Society* 64, no. 4 (1944): 218–223.

105 Kjeld Von Folsach, "Inkwell, Cast Bronze with Engraved and Punched Decoration and Copper and Silver Inlays," in *Sultan, Shah and Great Mughal: The History and Culture of the Islamic World*, ed. Kjeld Von Folsach, Torben Lundbaek, and Peder Mortensen (Copenhagen: National Museum, 1996), 149.

106 The dirt that fills engraved indentations on many surviving medieval metalwork objects is distinct from but often confused with niello, a black mixture of metal sulphides that was used in the manufacture of metalwares and jewelry as a form of inlay.

107 Pancaroğlu, "Socializing Medicine," 157.

108 See Jones and Michell, *Arts of Islam*, 172. Boris Marshak, "An Early Seljuq Silver Bottle from Siberia," *Muqarnas* 21 (2004): 255–256.

109 I expand some of these aspects in a forthcoming article: Margaret S. Graves, "Say Something Nice: Supplications on Medieval Objects, and Why They Matter," in *Studying the Near and Middle East at the Institute for Advanced Study, Princeton, 1936–2018*, ed. Sabine Schmidtke (Piscataway, NJ: Gorgias Press, forthcoming 2018). On the supplicatory formulae see also Jeremy Johns, "The Arabic Inscriptions of the Norman

Kings of Sicily. A Reinterpretation," in *The Royal Workshops in Palermo during the Reigns of the Norman and Hohenstaufen Kings of Sicily in the 12th and 13th century*, ed. Maria Andaloro (Catania: Giuseppe Maimone, 2006), 324–337.

110 Robert Hillenbrand, "Islamic Monumental Inscriptions Contextualized: Location, Content, Legibility and Aesthetics," in *Beiträge zur Islamischen Kunst und Archäologie: herausgegeben von der Ernst-Herzfeld-Gesellschaft, Band 3*, ed. Lorenz Korn and Anja Heidenreich (Weisbaden: Reichert Verlag, 2012), 18.

111 These are similar to the three-pointed crowns found on thirteenth-century numismatic images of rulers, with the addition of trailing ribbons like those seen on the caps of figures that adorn *mīnā'ī* bowls from late twelfth- and early thirteenth-century Iran. See the copper dirham of Naṣr al-Dīn Maḥmūd (r. 1219–1234), minted at Mosul in 627 H (1229–1230 CE), and illustrated in Canby et al., *Court and Cosmos*, 70.

112 Niẓām al-Mulk, *The Book of Government or Rules for Kings: The Siyar al-Muluk or Siyasat-nama of Nizam al-Mulk, translated from the Persian by Hubert Darke*, 2nd ed. (London: Routledge and Kegan Paul, 1978), 89–90. On the authorship of this text, see Alexey A. Khismatulin, "Two Mirrors for Princes Fabricated at the Seljuq Court: Niẓām al-Mulk's *Siyar al-mulūk* and al-Ghazālī's *Naṣīhat al-mulūk*," in *The Age of the Seljuqs: The Idea of Iran, vol. VI*, ed. Edmund Herzig and Sarah Stewart (London: I. B. Tauris, 2015), 94–130.

113 Taragan ("Speaking Inkwell," 37) suggests that this is a scribe carrying a reed pen and inkwell.

114 George, "The Illustrations of the *Maqāmāt*," 22. On similar figures in ceramic painting and shadow puppetry see Richard Ettinghausen, "Early Shadow Figures," *Bulletin of the American Institute for Persian Art and Archaeology* 3, no. 6 (1934): 12.

115 Marianna Shreve Simpson, "Narrative Structure of a Medieval Iranian Beaker," *Ars Orientalis* 12 (1981): 22; Robert Hillenbrand, "The Relationship between Book Painting and Luxury Ceramics in Thirteenth-Century Iran," in *The Art of the Saljuqs in Iran and Anatolia: Proceedings of a Symposium Held in Edinburgh in 1982*, ed. Robert Hillenbrand (Costa Mesa, CA: Mazda, 1994), 134–141.

116 A *mīnā'ī* bowl fragment painted with *Shāhnāma* scenes and now held in the Khalili Collection, POT875, uses a similar device to compartmentalise space: illustrated in Eleanor Sims with Boris Marshak and Ernst J. Grube, *Peerless Images: Persian Painting and Its Sources* (New Haven and London: Yale University Press, 2002), 35, fig. 45.

117 See discussion of these devices on the Freer beaker in Simpson, "Narrative Structure," 21, 22; Marianna Shreve Simpson, *The Illustration of an Epic: The Earliest Shahnama Manuscripts* (New York: Garland, 1979), 243–245. For their use in interior scenes on the Small *Shāhnāmas*, see, for example, Simpson, *Illustration of an Epic*, plate 43.

118 See the arch form carved with an inscription on the marble tomb of Mahmud I at Ghazni: Roberta Giunta, *Les inscriptions funéraires de Gaznī* (Naples: Istituto Italiano per l'Africa e l'Oriente Fondation Max Van Berchem, 2003), 27–44, and plate V. A similar form is carved on an Afghan grave stele dated 591 H (1194–1195 CE): Janine Sourdel-Thomine, "Stèles arabes de Bust (Afghanistan)," *Arabica* 3/3 (1956), plate IV. See also the carved panels illustrated in Finbarr Barry Flood, "A Ghaznavid Narrative Relief and the Problem of Pre-Mongol Persian Book Painting," in *Siculo-Arabic Ivories and Islamic Painting 1100–1300*, ed. David Knipp (Chicago: University of Chicago Press, 2011), 259–272, figs. 3 and 7.

119 For example, an inlaid brass cup illustrated in Eva Baer, "A Brass Vessel from the Tomb of Sayyid Baṭṭāl Ghāzī: Notes on the Interpretation of Thirteenth-Century Islamic Imagery," *Artibus Asiae* 39, nos. 3/4 (1977): 299–335.

120 MMA 40.170.439. Charles K. Wilkinson, *Nishapur: Some Early Islamic Buildings and Their Decoration* (New York: Metropolitan Museum of Art, 1986), 241.

121 A notable exception is Oya Pancaroğlu, "Serving Wisdom: The Contents of Samanid Epigraphic Pottery," in *Studies in Islamic and Later Indian Art from the Arthur M. Sackler Museum, Harvard University Art Museums*, ed. Rochelle Kessler (Cambridge, MA: Harvard University Art Museum, 2002), 59–75.

122 See Janine Sourdel-Thomine, "Kitabat, (a), inscriptions, 1. Islamic epigraphy in general," *Encyclopaedia of Islam*, 2nd ed., http://dx.doi.org/10.1163/1573-3912_islam_COM_0525; Melikian-Chirvani, *Islamic Metalwork*, 73–75; Sheila Blair, *Islamic Inscriptions* (New York: New York University Press, 1998), 104–105. All have noted that a survey of these formulae on medieval objects is clearly needed, but as yet no real answer to the challenge has arisen. Marshak's "Early Seljuq Silver Bottle" is an important study in this respect because it lays out an evolution of benedictory expressions from silver to inlaid bronze in eleventh- and twelfth-century Iran and central Asia, and demonstrates the utility such a survey would hold for the attribution of objects.

123 Holly Edwards, "Text, Context, Architext: The Qur'an as Architectural Inscription," in *Brocade of the Pen: The Art of Islamic Writing*, ed. Carol Garrett Fisher (East Lansing, MI: Kresge Art Museum, 1991), 69; see also Finbarr Barry Flood, "Islamic Identities and Islamic Art: Inscribing the Qur'an in Twelfth-Century Afghanistan," in *Dialogues in Art History, from Mesopotamian to Modern: Readings for a New Century*, ed. Elizabeth Cropper (Washington, DC: National Gallery of Art, 2009), 91–117.

124 The sleeves are matched in much later images of dervishes in ecstasy: for example, a painting from the 1582 *Tazkira* of Shaykh Ṣafī al-Dīn now in the collection of the Aga Khan Museum (AKM 00264, fol. 280r). For recent discussions of this image, see Kishwar Rizvi, *The Safavid Dynastic Shrine: Architecture, Religion and Power* (London: I. B. Tauris, 2011), 40; Margaret S. Graves and Benoît Junod, eds., *Treasures of the Aga Khan Museum: Architecture in Islamic Arts* (Geneva: Aga Khan Trust for Culture, 2011), cat. no. 31, 120–121.

125 Ettinghausen, "Early Shadow Figures," 12–15; George, "The Illustrations of the *Maqāmāt*"; David Roxburgh, "In Pursuit of Shadows: al-Hariri's *Maqāmāt*," *Muqarnas* 30 (2013): 205–207. See also the populated trellis of the multi-author frontispiece to the early thirteenth-century *Mukhtār al-ḥikam wa-maḥāsin al-kalim* (Choice judgements and finest sayings) illustrated in Robert Hillenbrand, "Erudition Exalted: The Double Frontispiece to the Epistles of the Sincere Brethren," in *Beyond the Legacy of Genghis Khan*, ed. Linda Komaroff (Leiden: Brill, 2006), 24–26.

126 For a general overview of these themes see Graves, "Inside and Outside," 295–303.

127 Translation given in Puerta Vílchez, *Aesthetics in Arabic Thought*, 282.

128 Wolfhart Hienrichs, "*Takhyīl*: Make-Believe and Image Creation in Medieval Arabic Literary Theory," in *Takhyīl: The Imaginary in Classical Arabic Poetics*, ed. Geert Jan van Gelder and Marlé Hammond (Oxford: Oxbow, 2008), 1–14; Puerta Vílchez, *Aesthetics in Arabic Thought*, 270–286.

129 Puerta Vílchez, *Aesthetics in Arabic Thought*, 282.

130 Puerta Vílchez, *Aesthetics in Arabic Thought*, 280.

131 Ali Asghar Seyed-Gohrab, "Epigram, Persian," *Encyclopaedia of Islam*, 3rd ed., http://dx.doi.org/10.1163/1573-3912_ei3_COM_2643; Charles Pellat, "Nādira," *Encyclopaedia of Islam*, 2nd ed., http://dx.doi.org/10.1163/1573-3912_islam_SIM_5715.

Chapter 4: Material Metaphors

1 On gift exchange, see Elias Muhanna, "The Sultan's New Clothes: Ottoman-Mamluk
 Gift Exchange," *Muqarnas* 27 (2010): 189–207; Sinem Arcak, *Gifts in Motion: Ottoman-*
 Safavid Cultural Exchange, 1501–1618 (PhD diss., University of Minnesota, 2012);
 Linda Komaroff, ed., *Gifts of the Sultan: The Arts of Giving at the Islamic Courts* (Los
 Angeles: Los Angeles County Museum of Art, 2011).

2 Clifford Edmund Bosworth, "Some Historical Gleanings from the Section on Symbolic
 Actions in Qalqašandī's *Ṣubḥ al-Aʿšā*," *Arabica* 10, no. 2 (1963): 148–153. See also the
 story of the pre-Islamic Iranian king Parvīz ordering the rebellious general Bahrām
 Chūbīn to put two swords in one scabbard: Niẓām-al-Mulk, *Book of Government*, 73, and
 al-Ghazālī, *Ghazālī's Book of Counsel for Kings (Naṣīḥat al-mulūk)*, trans. F. R. C. Bagley
 (London: Oxford University Press, 1964), 94–95. On the authorship of these two texts,
 see Khismatulin, "Two Mirrors," 95–130.

3 Ibn al-Athīr, *The Annals of the Saljuq Turks: Selections from al-Kāmil fīʾl-Taʾrīkh of ʿIzz*
 al-Dīn Ibn al-Athīr, trans. and annotated D. S. Richards (London: RoutledgeCurzon,
 2002), 36.

4 Ibn al-Athīr, *Al-Kāmil fī al-tārīkh*, 13 vols (Beirut: Dar Ṣadir, 1385–1387 [1965–1968]),
 9:479. Assuming that there has been no corruption of the word on its way to the
 published edition, the meaning seems unequivocal: *ishfā* appears in a thirteenth-century
 list of bookbinding tools written in Rasulid Yemen, where it denotes the thin awl
 used to punch holes in the endbands before sewing in the threads. See Adam Gacek,
 "Instructions on the art of bookbinding attributed to the Rasulid ruler of Yemen Al-
 Malik al-Muẓaffar," in *Scribes et manuscrits du Moyen-Orient*, ed. François Déroche and
 Francis Richard (Paris: BnF, 1997), 59 and 63.

5 Ibn al-Athīr, *Annals*, 36.

6 Ibn al-Athīr, *Annals*, 36, n. 28.

7 Wolfhart P. Heinrichs, "Ramz," *Encyclopaedia of Islam*, 2nd ed., http://dx.doi.org/
 10.1163/1573-3912_islam_COM_0909; Paul Nwyia, "Ishāra," *Encyclopaedia of Islam*,
 2nd ed., http://dx.doi.org/10.1163/1573-3912_islam_SIM_3622..

8 On prosopopeia, see Olga Bush, *Architecture, Poetic Texts and Textiles in the Alhambra*
 (PhD diss., Institute of Fine Arts, New York University, 2006), 42–122.

9 Simpson, "Narrative Allusion," 131–149.

10 Cynthia Robinson, "Seeing Paradise: Metaphor and Vision in Taifa Palace
 Architecture," *Gesta* 36, no. 2 (1998): 145–155; Cynthia Robinson, "Marginal
 Ornament: Poetics, Mimesis and Devotion in the Palace of the Lions," *Muqarnas* 25
 (2008): 185–214; Olga Bush, "A Poem Is a Robe and a Castle: Inscribing Verses on
 Textiles and Architecture in the Alhambra," *Textile Society of America Proceedings*, 84
 (2008): n.p.; see also Olga Bush, "'When My Beholder Ponders': Poetic Epigraphy in
 the Alhambra," *Artibus Asiae* 66, no. 2 (2006): 55–67; Olga Bush, "The Writing on the
 Wall: Reading the Decoration of the Alhambra," *Muqarnas* 26 (2009): 119–147. In a
 different vein, Dede Fairchild Ruggles, "The Eye of Sovereignty: Poetry and Vision in
 the Alhambra's Lindaraja Mirador," *Gesta* 36, no. 2 (1997): 180–189; Mariam Rosser-
 Owen, "Poems in Stone: The Iconography of ʿĀmirid Poetry, and Its 'Petrification'
 on ʿĀmirid Marbles," in *Revisiting al-Andalus: Perspectives on the Material Culture of*
 Islamic Iberia and Beyond, ed. Glaire Anderson and Mariam Rosser-Owen (Leiden: Brill,
 2007), 81–98.

11 The most explicit argument for the entangling of object, architecture, and poetry is to
 be found in Metzada Gelber, "A Poetic Vessel from Everyday Life: The Freer Incense
 Burner," *Ars Orientalis* 42 (2012): 23–30 (to be further discussed below), and her earlier

article, "Objects and Buildings—Links and Messages," *Assaph* 12 (2007): 37–48. Some interesting parallels in the European context can be drawn from Cynthia Hahn's discussion of certain reliquary forms as potent and complex metaphors: "Metaphor and Meaning in Early Medieval Reliquaries," in *Seeing the Invisible in Late Antiquity and the Early Middle Ages*, ed. Giselle de Nie, Karl F. Morrison, and Marco Mostert (Turnhout, Germany: Brepols, 2005), 239–263; Cynthia Hahn, *Strange Beauty: Issues in the Making and Meaning of Reliquaries, 400–circa 1204* (University Park: Pennsylvania State University Press, 2012), 109–110.

12 See the definitions of *istiʿāra* cited in Wolfhart Heinrichs, *The Hand of the Northwind: Opinions on Metaphor and the Early Meaning of Istiʿāra in Arabic Poetics* (Wiesbaden: Steiner, 1977), 2.

13 Hoffman, "Pathways of Portability," 17–50. On the concept of metaphor as applied to some of the subjects of this chapter, see Gelber, "Poetic Vessel."

14 Al-Jāḥiẓ, *Kitāb al-ḥayawān*, 7 vols. (Cairo: Muṣṭafa al-Bābī al-Ḥalabī, 1938–1945), 3:132.

15 George J. Kanazi, *Studies in the Kitāb aṣ-Ṣināʿatayn of Abū Hilāl al-ʿAskarī* (Leiden: Brill, 1989), 25–28; Kamal Abu Deeb, "Literary Criticism," in *Abbasid Belles-Lettres*, ed. Julia Ashtiany, T. M. Johnstone, J. D. Latham, R. B. Serjeant, and G. Rex Smith (Cambridge: Cambridge University Press, 1990), 343–344.

16 On the possible longevity of the connection, see Anthony Tuck, "Singing the Rug: Patterned Textiles and the Origins of Indo-European Metrical Poetry," *American Journal of Archaeology* 110, no. 4 (2006): 539–550.

17 Ignaz Goldziher, *Abhandlungen zur arabischen Philologie*, 2 vols (Leiden: Brill, 1896), 1:132–134. The relationship of the weaver's craft to that of the poet in the Arabic-speaking world has been intensively explored in Bush, "A Poem Is a Robe."

18 Kanazi, *Studies*, 82; in the same text see also discussion of *taṭrīz* and *tawshīʿ*, 171–175; Hans Wehr, *Arabic-English Dictionary* (Urbana, IL: Spoken Language Services / Harrassowitz, 1994), 312.

19 Jerome Clinton, "Image and Metaphor: Textiles in Persian Poetry," in *Woven from the Soul, Spun from the Heart: Textile Arts of Safavid and Qajar Iran, 16th–19th Centuries*, ed. Carol Bier (Washington, DC: Textile Museum, 1987), 8.

20 Al-Ghazālī, *Book of Counsel*, 113; Franz Rosenthal, "Abū Ḥaiyān al-Tawḥīdī on Penmanship," *Ars Islamica* 13 (1948): 13; on pre-Islamic manifestations of this idea, see Puerta Vílchez, *Aesthetics in Arabic Thought*, 44–45.

21 Lidia Bettini, "Nathr," *Encyclopaedia of Islam*, 2nd ed., http://dx.doi.org/10.1163/1573-3912_islam_COM_1439; Geert Jan H. van Gelder and Wolfhart P. Heinrichs, "Naẓm," *Encyclopaedia of Islam*, 2nd ed., http://dx.doi.org/10.1163/1573-3912_islam_SIM_8857.

22 Kanazi, *Studies*, 96.

23 On *raṣf*, Kanazi, *Studies*, 96. On *tarṣīʿ*, Bush, "Writing on the Wall," 133; G. Schoeler, "Tarṣīʿ," *Encyclopaedia of Islam*, 2nd ed., http://dx.doi.org/10.1163/1573-3912_islam_COM_1186; Abu Deeb, "Literary Criticism," 371. For this definition of *faṣṣ*, see Francis Joseph Steingass, *The Student's Arabic-English Dictionary* (London: Allen, 1884), 792.

24 Jenkins and Keene, *Islamic Jewelry*, 54–55.

25 This author of the collection quite single-mindedly follows a jeweler's model by naming each of its twenty-five books after a jewel: the titles of the first twelve are matched, in inverse order, by those of the last twelve, so that two corresponding strings of gems flank the thirteenth book, or central jewel (*wāsiṭa*). Ibn ʿAbd Rabbih, *Al-ʿIqd al-farīd: The*

Unique Necklace, 2 vols., trans. Issa J. Boullata (Reading: Garnet, 2007), 1:xx–xxi. See also the discussion of this topic from the perspective of gemology in al-Bīrūnī, *The Book Most Comprehensive in Knowledge on Precious Stones*, 34–35.

26 Jerome Clinton, "Esthetics by Implication: What Metaphors of Craft Tell Us about the 'Unity' of the Persian Qasida," *Edebiyat* 4, no. 1 (1979): 75–82; Clinton, "Image and Metaphor"; Jerome Clinton, "Šams-i Qays on the Nature of Poetry," in *Studia Arabica et Islamica: Festschrift for Ihsan Abbas on his Sixtieth Birthday*, ed. Wadad Qadi and Ihsan Abbas (Beirut: American University in Beirut Press, 1981), 80.

27 Clinton, "Šams-i Qays," 80.

28 A. J. Arberry, "Orient Pearls at Random Strung," *Bulletin of the School of Oriental and African Studies* 11, no. 4 (1946): 699–712; Julie Scott Meisami, *Structure and Meaning in Medieval Arabic and Persian Poetry: Orient Pearls* (New York: Routledge, 2003), 1–2.

29 Michael Roberts, *The Jeweled Style: Poetry and Poetics in Late Antiquity* (Ithaca and London: Cornell University Press, 1989), 55.

30 Some aspects of this phenomenon are discussed with particular reference to visuality in Kamal Boullata, "Visual Thinking and the Arab Semantic Memory," in *Tradition, Modernity and Postmodernity in Arabic Literature: Essays in Honor of Professor Issa J. Boullata*, ed. Kamal Abdel-Malek and Wael Hallaq (Leiden: Brill, 2000), 284–303.

31 Steingass, *Dictionary*, 547.

32 For example, a line by an anonymous poet quoted by Abū Hilāl: "and the glance in his eye is keener than the edge of his sword" (Kanazi, *Studies*, 181).

33 Sadan, "Art of the Goldsmith," 463–464; Joseph Sadan, "Maiden's Hair and Starry Skies: Imagery Systems and *Maʿānī* Guides; The Practical Side of Arabic Poetics as Demonstrated in Two Manuscripts," *Israel Oriental Studies* XI (1991): 64–65, n. 27; see also Kanazi, *Studies*, 95, 96, 41.

34 Quoted in Geert Jan H. Van Gelder, *Beyond the Line: Classical Arabic Literary Critics on the Coherence and Unity of the Poem* (Leiden: Brill, 1982), 41. See also "excellence of molding" (*jūdat al-sabk*) as a measure of poetic quality (Jāḥiz, *Kitāb al-ḥayawān*, 3:132).

35 Ibn Ṭabāṭabā, *ʿIyār al-shiʿr* (Cairo: Al-Maktaba al-Tijārīya al-Kubrā, 1956), 126.

36 Abū Hilāl al-ʿAskarī, *Kitāb al-ṣināʿatayn* (Cairo: ʿĪsa al-Bābī al-Ḥalabī, 1952), 382.

37 Jenkins and Keene, *Islamic Jewelry*, 147.

38 See also an example in the Zucker collection, in Ogden, "Islamic Goldsmithing," 426, and further examples in the Museo Arqueológico Municipal, Lorca, in Yannick Lintz, Claire Déléry and Bulle Tuil Leonetti, eds., *Le Maroc médiéval: Un empire de l'Afrique à l'Espagne* (Paris: Hazan / Musée du Louvre, 2014), 304.

39 Van Gelder, *Beyond the Line*, 41. See also Rypka's proposal that a Persian poem should be read "less as a whole, more as a filigree work": Jan Rypka, *History of Iranian Literature* (Dordrecht: D. Reidel, 1968), 102.

40 Shams-i Qays, *Al-muʿjam fī maʿāyīr ashʿār al-aʿjam* (Tehran: Firdaws, 1994), 384; Clinton, "Šams-i Qays," 77. See also Necipoğlu, *Topkapı Scroll*, 206–208; Jerome W. Clinton, *The Divan of Manūchihrī Dāmghānī: A Critical Study* (Minneapolis: Bibliotheca Islamica, 1972), 92–93.

41 David Durand-Guédy, "Jamāl-al-Din Moḥammad Eṣfahāni," *Encyclopaedia Iranica*, http://www.iranicaonline.org/articles/jamal-al-din-mohammad-esfahani; David Durand-Guédy, "Kamāl al-Din Eṣfahāni," *Encyclopaedia Iranica*, http://www.iranicaonline.org/articles/kamal-al-din-esfahani; Z. V. Vorozheykina, *Isfahanskaya shkola poetov i literaturnaya zhizn Irana v predmongolskoe vremya* [*The Isfahani School of*

Poets and Literary Life of Iran in the Premongol Time: 12th–Early 13th Centuries] (Moscow, 1984), 21–24. I thank Anton Pritula for bringing the latter reference to my attention and providing me with an English précis of the relevant passages.

42 Paul Losensky, "Square Like a Bubble: Architecture, Power, and Poetics in Two Inscriptions by Kalim Kāshāni," *Journal of Persianate Studies* 8 (2015): 43.

43 See Clinton, "Esthetics by Implication," 85; Meisami, *Structure and Meaning*, 16–17; Julie Scott Meisami, "Symbolic Structure in a Poem by Nāṣir-i Khusrau," *Iran* 31 (1993): 103–117.

44 Joachim Yeshaya, "Medieval Hebrew Poetry and Arabic *Badīʿ* Style: A Poem by Moses Darʿī (Twelfth-Century Egypt)," in *Egypt and Syria in the Fatimid, Ayyubid and Mamluk Eras, VIII*, ed. Urbain Vermeulen, Kristof D'Hulster, and Jo Van Steenbergen (Leuven: Peeters, 2016), 320, 325.

45 Meisami, *Structure and Meaning*, 16.

46 Cf. the definition offered by Michael Baxandall, *Patterns of Intention: On the Historical Explanation of Pictures* (New Haven and London: Yale University Press, 1989), 7. Marta Ajmar has recently argued that the rhetoric surrounding *disegno* in Italian Renaissance art has also tended to overstate the separation between design and execution: "Mechanical *Disegno*," *RIHA Journal* 84 (2014): n.p.

47 Al-Jurjānī, *Dalāʾil al-iʿjāz* (Cairo: Maktabat al-Qāhira, 1969), 127; Meisami, *Structure and Meaning*, 16; van Gelder, *Beyond the Line*, 132.

48 Ajmar, "Mechanical *Disegno*," paragraph 26.

49 Kamal Abu Deeb, *Al-Jurjānī's Theory of Poetic Imagery* (Warminster: Aris and Phillips, 1979), 24–64.

50 Abd El-Fattah Kilito, "Sur le métalangue métaphorique des poéticiens arabes," *Poétique* 38 (1979): 162.

51 Thomas Leisten, "Abbasid Art," *Hadeeth ad-Dar* 24 (2007): 53–57.

52 Jacob Lassner, "The Caliph's Personal Domain: The City Plan of Baghdad Reexamined," *Kunst des Orients* 5, no. 1 (1968): 24.

53 Bruce Fudge, "Signs of Scripture in 'The City of Brass,'" *Journal of Qurʾanic Studies* 8, no. 1 (2006): 90, 92–93, 94–96, 99.

54 The piece has been published many times. The most detailed discussions are in Esin Atıl, W. T. Chase, and Paul Jett, *Islamic Metalwork in the Freer Gallery of Art* (Washington, DC: Smithsonian, 1985), 58–61; and Esin Atıl, *Art of the Arab World* (Washington, DC: Smithsonian, 1975), 28–29.

55 Gelber, "Poetic Vessel."

56 For overviews, see Nina Ergin, "The Fragrance of the Divine: Ottoman Incense Burners and Their Context," *The Art Bulletin* 96, no. 1 (2014): 71–74; Sterenn Le Maguer, "The Incense Trade during the Islamic Period," *Proceedings of the Seminar for Arabian Studies* 45 (2015): 177–179.

57 One story tells of a silver censer adorned with figures which was brought for use in the mosque in Medina by the caliph ʿUmar (r. 634–644), and the Dome of Rock was perfumed daily with incense according to an eighth-century observer. See Flood, "Between Cult and Culture," 644; George, "Calligraphy, Colour and Light in the Blue Qurʾan," *Journal of Qurʾanic Studies* 11, no. 1 (2009): 106. See also Béatrice Caseau, "Incense and Fragrances: From House to Church. A Study of the Introduction of Incense in the Early Byzantine Christian Churches," in *Material Culture and Well-Being in Byzantium (400–1453)*, ed. Michael Grünbart, Ewald Kislinger, Anna

Muthesius, and Dionysios Ch. Stathakopoulos (Vienna: Verlages der Österreichischen Akademie der Wissenschaften, 2007), 75–92; Sterenn Le Maguer, "De l'autel à encens au brûle-parfum: heritage des formes, évolution des usages," *Archéo. Doct* 5: Actes de la 5e Journée doctorale d'archéologie, Paris, 26 mai 2010 (Paris: Sorbonne, 2013), 183–199.

58 Al-Tha'ālibī, *Laṭā'if al-ma'ārif* (Cairo: Dār Ihya al-Kutub al-'Arabiyya, 1960), 146; Al-Tha'ālibī, *Curious and Entertaining*, 112.

59 See Sterenn Le Maguer, "Typology of Incense Burners of the Islamic World," *Proceedings for the Seminar for Arabian Studies*, 41, (2011): 173–185.

60 Al-Ghazālī, *Book of Counsel*, 35–36.

61 On the terms, see Melikian-Chirvani, *Islamic Metalwork*, 42.

62 G. Lankester Harding, "Excavations on the Citadel, Amman," *Annual of the Department of Antiquities, Jordan* 1 (1951): 9–10.

63 James Allan, *Metalwork of the Islamic World: The Aron Collection* (London: Sotheby's, 1986), 27; Pedro de Palol Salellas, "Los incensarios de Aubenya (Mallorca) y Lladó (Gerona)," *Ampurias* 12 (1950): 1–19.

64 Kurt Weitzmann, *The Age of Spirituality: Late Antique and Early Christian Art* (New York: Metropolitan Museum of Art, 1979), 337–338. A similar example is held in the National Museum of Damascus: see Helena Dìez-Fuentes, ed., *Highlights of the National Museum of Damascus* (Lebanon: Media Minds, 2006), 120–121. The simple form of the arches on both can also be likened to those seen on a carved rock-crystal object found at Carthage and attributed to the third to fifth centuries: Weitzmann, *Age of Spirituality*, 336.

65 Finbarr Barry Flood, "The Flaw in the Carpet: Disjunctive Contiguituies and Riegl's Arabesque," in *Histories of Ornament*, ed. Necipoğlu and Payne, 92.

66 Marie-Thérèse Gousset, "Un aspect du symbolism des encensoirs romans: la Jérusalem Céleste," *Cahiers Archéologiques* 30 (1982): 81–106. See also the descriptions of making such objects, in casting and repoussé, given in the (probably) twelfth-century text of *De diversis artibus*: Theophilus, *The Various Arts: De Diversis Artibus*, trans. and ed. Charles R. Dodwell (Oxford: Clarendon Press, 1986), 111–119.

67 Kühnel, "Islamisches Räuchergerät"; Aga-Oglu, "About a Type"; Allan, *Aron Collection*, 25–34.

68 Ernst Kühnel, "Islamisches Räuchergerät," *Berliner Museen* 41 (1920): 241–250; Mehmet Aga-Oglu, "About a Type of Islamic Incense Burner," *The Art Bulletin* 27, no. 1 (1945), 29–32; Assadullah Souren Melikian-Chirvani, "Recherches sur l'architecture de l'Iran bouddhique, 1: essai sur les origines et le symbolisme du stûpa iranien," *Le monde iranien et l'Islam: Sociétés et cultures* 3 (1975): 55–58; Melikian-Chirvani, *Islamic Metalwork*, 32; Baer, *Metalwork*, 45–51; Allan, *Metalwork of the Islamic World*, 25–34. See also Dominique Bénazeth, "Les encensoirs de la collection copte du Louvre," *Revue du Louvre et des musées de France* 4 (1988): 298; Rachel Ward, "Incense and Incense Burners in Mamluk Egypt and Syria," *Transactions of the Oriental Ceramics Society* 55 (1990–1991): 69–70.

69 Hoffman, "Pathways of Portability," 21.

70 Affordances meaning "functional and relational aspects which frame, while not determining, the possibilities for agentic action in relation to an object": Ian Hutchby, "Technologies, Texts and Affordances," *Sociology* 35 (2001): 444. See also Anna Estany

and Sergio Martinez, "'Scaffolding' and 'Affordance' as Integrative Concepts in the Cognitive Sciences," *Philosophical Psychology* 27, no. 1 (2014): 98–111.

71 Bernard Goldman, "Persian Domed Turibula," *Studia Iranica* 20, no. 2 (1991): 183; Elizabeth Rosen Stone, "A Buddhist Incense Burner from Gandhara," *Metropolitan Museum Journal* 39 (2004): 79; Allan, *Nishapur*, 43; Prudence O. Harper, "From Earth to Heaven: Speculation on the Form of the Achaemenid Censer," *Bulletin of the Asia Institute* 19 (2005): 47–56. See examples of the Gandharan type in John Marshall, *Taxila: An Illustrated Account of Archaeological Excavations Carried Out at Taxila Under the Orders of the Government of India between the Years 1913 and 1934*, 3 vols. (Delhi: Motilal Banarsidass, 1975), 2:577, 595–596, vol. 3, plates 163, 184; Stephen Markel, "Metalware from Pakistan in the Los Angeles County Museum of Art," *Pakistan Heritage* 2 (2010): 99.

72 Nees, *Perspectives on Early Islamic Art*, 137–141. For a suspended censer with bird finial, attributed to the fifth- to seventh-century eastern Mediterranean, see Ćurčić and Hadjitryphonos, eds., *Architecture as Icon*, 280–281. Depending on their appearance the birds on these incense burners have been interpreted as doves, eagles, or birds of prey, and ascribed Christian or specifically Coptic significance.

73 R. Ghirshman, "Les fouilles de Châpour (Iran), deuxième campaign 1936/7," *Revue des arts asiatiques* 12 (1938): 12–19. The dating of this piece is uncertain: it was attributed to the first half of the eleventh century by Aga-Oglu, but comparison with the decoration on some of the high-tin bronzes of early Islamic Iran might suggest an earlier date. Aga-Oglu, "About a Type," 30–31; Assadullah Souren Melikian-Chirvani, "The White Bronzes of Islamic Iran," *Metropolitan Museum Journal* 9 (1974): 124–126, 136–147; James Allan, "Bronze ii. In Islamic Iran," *Encyclopaedia Iranica*, vol. 4, fasc. 5, 471–472, http://www.iranicaonline.org/articles/bronze-ii.

74 The species on the Persian examples are not normally unidentifiable, but an unusually elaborate inlaid and signed example in the Boston Museum of Fine Arts (46.1135) is decorated with a rooster and signed Abū'l-Munīf ibn Masʿūd: Mehmet Aga-Oglu, "An Iranian Incense Burner," *Bulletin of the Museum of Fine Arts* 48, no. 271 (1950): 8–10; Baer, *Metalwork*, 52–53, 55.

75 Al-Ghazālī, *Iḥyāʾ ʿulūm al-Dīn*, 2:335.

76 Curiously, the excavators did not report any traces of burning on the base of the object, and its function might still be open to question. Harding, "Excavations on the Citadel," 10–11.

77 Anna Ballian, "150 A, B. Incense Burners from the Citadel of Amman," in *Byzantium and Islam*, ed. Evans and Ratliff, 218; Ali Ibrahim Al-Ghabban, Béatrice André-Salvini, Carine Juvin, Sophie Makariou, and Françoise Demange, eds., *Routes d'Arabie: Archéologie et histoire du Royaume d'Arabie Saoudite* (Paris: Somogy / Louvre, 2010), 326–327. See also Gus W. van Beek, "A New Interpretation of the So-Called South Arabian House Model," *American Journal of Archaeology* 63, no. 3 (1959): 269–273. On the example illustrated here, see Claire Hardy-Gilbert and Sterenn Le Maguer, "Chihr de l'encens (Yémen)," *Arabian Archaeology and Epigraphy* 21 (2010): 67. The Arabian cuboid type of incense burner is also sometimes inscribed not with architectonic motifs but with the names of different types of aromatics, as can be seen on an example in the British Museum (113231).

78 "Acquisitions of the Princeton University Art Museum, 2003," *Record of the Art Museum, Princeton University* 6 (2004): 134, 138; Ćurčić and Hadjitryphonos, *Architecture as Icon*, 248–249.

79 The bibliography on the Dome of the Rock, and its relationship to Late Antique architecture, is enormous. See Oleg Grabar, *The Shape of the Holy: Early Islamic Jerusalem* (Princeton, NJ: Princeton University Press, 1996).

80 Oleg Grabar, "The Shared Culture of Objects," in *Byzantine Court Culture from 829 to 1204*, ed. Henry Maguire (Washington, DC: Dumbarton Oaks, 1997), 115–129.

81 Evans and Ratliff, eds., *Byzantium and Islam*, 180–181, 215–216; Elias Khamis, "The Fatimid Bronze Hoard of Tiberias," in *Metalwork and Material Culture*, ed. Porter and Rosser-Owen, 227–228.

82 The modeling of the lion masks relates them directly to a further group of censers in the form of lions associated with Coptic Egypt: Marvin Chauncey Ross, "A Group of Coptic Incense Burners," *American Journal of Archaeology* 46, no. 1 (1942): 10–12.

83 Dominique Bénazeth, *Catalogue général du Musée copte du Caire: 1. Objets en metal* (Cairo: Institut français d'archéologie orientale, 2001), 358–359.

84 Bénazeth, *Musée copte du Caire*, 300.

85 Bénazeth, "Les encensoirs," 299; Dominique Bénazeth, *L'art du métal au début de l'ère chrétienne* (Paris: Musée du Louvre, 1992), 105.

86 Allan, *Aron Collection*, 25–26; Almut von Gladiss, "Räuchergefäß mit Zange," in *Europa und der Orient, 800–1900*, ed. Gereon Sievernich und Hendrik Budde (Berlin: Bertelsmann Lexikon Verlag, 1989), 523–524; Karin Adahl, "An Early Islamic Incense Burner of Bronze in a Swedish Collection," *Proceedings of the First European Conference of Iranian Studies* 2 (1990): 333–345.

87 Based on the mint dates of 'Abbasid and Samanid silver coins found in Scandinavian sites, Viking interactions with the eastern Islamic world slowed down in the tenth century and came to a stop in the early eleventh: Egil Mikkelsen, "The Vikings and Islam," in *The Viking World*, ed. Stefan Brink and Neil Price (London: Routledge, 2008), 546–547; Roman K. Kovalev, "Dirham Mint Output of Samanid Samarqand and Its Connection to the Beginnings of Trade with Northern Europe (10th Century)," *Histoire et mesure* 17, nos. 3/4 (2002): 4.

88 Adahl, "Incense Burner," 333–345; Karin Adahl, "Islamisk konst I svenska samlingar" [Islamic art in Swedish collections], in *Islam: Konst och Kultur/Islam: Art and Culture* (Stockholm: Statens Historiska Museum, 1985), 34.

89 Baer, *Metalwork*, 45–50.

90 Géza Fehérvári, "Islamic Incense-Burners and the Influence of Buddhist Art," in *The Iconography of Islamic Art: Studies in Honour of Robert Hillenbrand*, ed. Bernard O'Kane (Edinburgh: Edinburgh University Press, 2005), 138–140; Géza Fehérvári, "Samanid or Ghaznavid? An Early Islamic Incense-Burner from the Iranian World," *Hadeeth ad-Dar* 23 (2007): 46–50.

91 Roman K. Kovalev, "Production of Dirhams at the Mint of Damascus (Dimashq) in the First Four Centuries of Islam and the Question of Near Eastern Metallic Zones," in *The 4th Simone Assemani Symposium on Islamic Coins*, ed. Arriana D'Ottone Rambach and Bruno Callagher (Trieste: Edizioni Università di Trieste, 2015), 304; Melanie Michailidis, "Samanid Silver and Trade along the Fur Route," in *Mechanisms of Exchange: Transmission in Medieval Art and Architecture of the Mediterranean, ca. 1000–1500*, ed. Heather Grossman and Alicia Walker (Leiden: Brill, 2013), 34.

92 A bronze lamp found at Luxor, fourth or fifth century CE, has a base formed from a large open floral form with three wide petals alternating with three narrow ones, each ending in a bead-like drop very similar to those seen on the Gävle burner (State Hermitage Museum 10581, illustrated in *L'Art copte en Egypte: 2000 ans de christianisme*

[Paris: Institute du monde arabe / Gallimard, 2000], 208). Finials with drop-ended projections can also be seen on two incense burners attributed to Islamic Spain, tenth and eleventh century (Metropolitan Museum of Art 67.178.3a,b and Museo Arqueológico Provincial de Córdoba, D/92/6: John P. O'Neill et al. eds., *The Art of Medieval Spain A.D. 500–1200* [New York: Metropolitan Museum of Art, 1993], 101–102), and also on an example attributed to eighth-century Egypt (Rachel Hasson, *Masterworks from the Collections of the L.A. Mayer Museum for Islamic Art* [Jerusalem: L. A. Mayer Museum for Islamic Art, 2000], n.p.). See also the Khalili Collection incense burner discussed in this chapter.

93 Bénazeth, *L'art du metal*, 150.

94 Ivory plaque of the nativity from late seventh- or early eighth-century Palestine, now in the Dumbarton Oaks collection (BZ.1951.30): Ćurčić and Hadjitryphonos, *Architecture as Icon*, 188–189; Maria Cristina Carile and Patricia Blessing, "Architectural Illusions and Architectural Representations: Buildings and Space in the Salerno Ivories," in *The Salerno Ivories: Objects, Histories, Contexts*, ed. Francesca Dell'Aqcqua, Anthony Cutler, Herbert L. Kessler, Avinoam Shalem, and Gerhard Wolf (Berlin: Gebr. Mann Verlag, 2016), 113. The finials of the buildings in the top left have been repaired but that of the aedicule from which a lamp is suspended at left appears to be complete.

95 For example, see the half-palmette designs in stucco from Chāl Tarkhān-Eshqābād, a site near Rayy in northern Iran, illustrated in Deborah Thompson, *Stucco from Chal Tarkhan-Eshqabad near Rayy* (Warminster, Wilts: Aris and Phillips, 1976), plate XI, fig. 4 (C.319).

96 I thank Kourosh Rashidi, doctoral candidate at Universität Bamberg, for this insight. His forthcoming dissertation, "Openwork in Medieval Islamic Metalwork from Khurasan," will provide more insight into this issue.

97 Matthew Canepa, *The Two Eyes of the Earth: Art and Ritual Kingship between Rome and Sasanian Iran* (Berkeley: University of California Press, 2010), 205–223; for example, carved stucco designs of paired palmettes at Khirbat al-Mafjar, illustrated in Hamilton, *Khirbat al Mafjar*, plates XXXI and XXXIII.

98 Ballian, "Alabaster Capital," 223.

99 James Michael Rogers, *The Arts of Islam: Masterpieces from the Khalili Collection* (London: Nour Foundation, 2010), 40–41. Faintly echoing the flatness of the designs on both the Khalili and Gävle burners is yet another example in the Louvre's Coptic collection, no. E 11062: Bénazeth, *L'art du metal*, 103.

100 Adahl, "Incense Burner," 343. An argument for the eastern origins of the domed-type incense burner has also attempted to link these pieces and others with Buddhist stupa architecture: Baer, *Metalwork*, 50; Fehérvári, "Islamic Incense-Burners"; Melikian-Chirvani, "Recherches," 55–58; Fehérvári, *Islamic Metalwork*, 32.

101 Adahl, "Incense Burner," 342, 343; Allan, *Aron Collection*, 26.

102 Hamilton, *Khirbat al Mafjar*, plates XX, no. 1, and XXXI. Elsewhere, the *qubba* of the Almoravids in Marrakesh, built in the twelfth century and subsequently renovated, makes dramatic use of the stepped merlon.

103 Juan Zozaya, "Aeraria de Transición: Objectos con base de cobre de los siglos VII al IX en al-Andalus," *Arqueología Medieval* 11 (2011): 16–21; see also Jeremy Johns, "A Bronze Pillar Lampstand from Petralia Sottana, Sicily," in *Metalwork and Material Culture*, ed. Porter and Rosser-Owen, 287, 291–292.

104 Slobodan Ćurčić, "Evolution of the Middle Byzantine Five-Domed Church Type," in *First Annual Byzantine Studies Conference, Cleveland, 24–25 October 1975* (1975): 31–32.

105 Melanie Michailidis, "Dynastic Politics and the Samanid Mausoleum," *Ars Orientalis* 44 (2014), 21–39; Dietrich Huff, "Čahārṭāq," *Encyclopaedia Iranica*, http://www.iranicaonline.org/articles/cahartaq.

106 Gelber, "Poetic Vessel," 24.

107 Atıl, *Art of the Arab World*, 28–29; Atıl, Chase, and Jett, *Islamic Metalwork*, 59.

108 Hamilton, *Khirbat al-Mafjar*, plate XII, fig. 3, and 66 and 121.

109 Melikian-Chirvani, "Light of Heaven and Earth," 117.

110 For example, the fifth- or sixth-century example recently acquired by the Royal Ontario Museum, no. 2010.70.1.

111 Atıl, Chase, and Jett, *Islamic Metalwork*, 59.

112 Alison Gascoigne, "Cooking Pots and Choices in the Medieval Middle East," in *Pottery and Social Dynamics in the Mediterranean and Beyond in Medieval and Post-Medieval Times*, ed. John Bintliff and Marta Carascio (Oxford: British Archaeological Reports, 2013), 1–10.

113 Julian Raby, "Looking for Silver in Clay: A New Perspective on Samanid Ceramics," in *Pots and Pans: A Colloquium on Precious Metals and Ceramics in the Muslim, Chinese and Graeco-Roman Worlds*, ed. Michael Vickers (Oxford: University of Oxford Press, 1985), 179–203; in the same volume, Oliver Watson, "Pottery and Metal Shapes in Persia in the Twelfth and Thirteenth Centuries," 205–212; Michael Vickers, Oliver Impey and James Allan, *From Silver to Ceramic: The Potter's Debt to Metalwork in the Graeco-Roman, Chinese and Islamic Worlds* (Oxford: Ashmolean Museum, 1986); Tabbaa, "Bronze Shapes," 98–113; James Allan, "Silver: The Key to Bronze in Islamic Iran," *Kunst des Orients* 11, nos. 1/2 (1976/77): 5–21. On the problems that can be served up by these kinds of metalwork-ceramic pairings, see Oliver Watson's contribution to "Notes from the Field: Materiality," *The Art Bulletin* 95, no. 1 (2013): 31–34. In the Byzantine/Late Antique context, see Anastasia Drandaki, "From Centre to Periphery and Beyond: The Diffusion of Models in Late Antique Metalware," in *Wonderful Things: Byzantium through Its Art*, ed. Anthony Eastmond and Liz James (Farnham, Surrey: Ashgate, 2013), 163–184, where a silver vessel made in imitation of contemporary ceramic production is included.

114 Oliver Watson, *Ceramics from Islamic Lands* (London: Thames and Hudson, 2004), 297. See also a handled ceramic incense burner from tenth-century Central Asia, now in the State Museum of Oriental Art, Moscow: T. K. Mkrtychev, "A Unique Xth-Century Incense-Burner from Tashkent," *Arts and the Islamic World* 33 (1998), 18–19.

115 Marilyn Jenkins-Madina, *Raqqa Revisited: Ceramics of Ayyubid Syria* (New York: Metropolitan Museum of Art, 2006), 116. As Martina Rugiadi has recently noted, there has been a general tendency to attribute all Syrian stonepaste exclusively to Raqqa when production was in reality more widespread: Canby et al., eds, *Court and Cosmos*, 134.

116 "Belle lantern d'ancienne faïence de Perse," *Catalogue des objets d'art de l'orient et de l'occident tableaux dessins: composant la collection de feu M. Albert Goupil*, sale catalogue, April 23–28 (Paris: Hotel Drouot, 1888), 21; Jenkins-Madina, *Raqqa Revisited*, 116.

117 Dumbarton Oaks correspondence archive for Elie Bustros, letters dated May 1, 1950; June 20, 1950; and October 15, 1950.

118 The same cross-shaped piercings appear on a ceramic oil lamp formerly in the possession of Fahim Kouchakji and now in the Khalili Collection (POT475), illustrated in Grube, *Cobalt and Lustre*, 270–271.

119 Sotheby's sale 1986, lot 157. Photocopied image seen in Dumbarton Oaks object file for BZ.1950.39.

120 A different conception of the lantern as building can be found in an Umayyad-era steatite object excavated at al-Fudayn, near Amman. Previously thought to be a cooking vessel but now recategorized as a lamp base, the lowest register of incised decoration on the object's humped form depicts an arcade with a hanging lamp in each arch. See Evans and Ratliff, eds., *Byzantium and Islam*, 214–215.

121 The seminal study is Grabar, "Earliest Islamic Commemorative Structures," 7–46.

122 See Ernst Diez, "Ḳubba," *Encyclopaedia of Islam*, 2nd ed., http://dx.doi.org/10.1163/1573-3912_islam_COM_0532; Josef W. Meri, *The Cult of Saints among Muslims and Jews in Medieval Syria* (Oxford: Oxford University Press, 2002), 264–265; Durand-Guédy, "*Khargāh*," 61–64.

123 Franke and Müller-Weiner, *Ancient Herat Vol. 3*, 246, 268–269, 315–316.

124 Ülker Erginsoy, "Anadolu Selçuklu Madan Sanatı," in Gönül Öney, *Anadolu selçuklu mimarisinde süsleme ve el sanatları / Architectural decoration and minor arts in Seljuk Anatolian* [*sic*] (Ankara: 1978), 159–161; Nazan Ölçer, "No. 70. Lamp," in *Turks: Journey of a Thousand Years*, ed. David J. Roxburgh (London: Royal Academy, 2005), 394–395.

125 Ernst Diez, "Das Erbe der Steppe in der Turko-Iranischen Baukunst," in *Zeki Velidi Toğan'a Armağan* (Istanbul: Maarif Basımevi, 1950–1955), 331–338.

126 An incense burner of similar form but with a hinged lid and no door, made from cast bronze and attributed to eighth-century Egypt, is in the collection of the Hermitage State Museum, no. ДВ-10631.

127 Fehérvári, *Islamic Metalwork*, 84–85; Erginsoy, "Anadolu Selçuklu," 160–161; Almut von Gladiss, "Lantern: Morocco, 14th Century," in *A Collector's Fortune: Islamic Art from the Collection of Edmund de Unger*, ed. Claus-Peter Haase (Berlin and Munich: Staatliche Musee zu Berlin / Himler Verlag, 2007), 113–114.

128 Erginsoy, "Anadolu Selçuklu," 159–161.

129 Doris Behrens-Abouseif, *Mamluk and Post-Mamluk Metal Lamps* (Cairo: Institut français d'archéologie orientale, 1995), 67–73.

130 Luitgard E. M. Mols, *Mamluk Metalwork Fittings in Their Artistic and Architectural Context* (Delft: Eburon, 2006), plates 149, 172.

131 "Lantern of Pharos, or Lighthouse of Alexandria," *Eternal Egypt*, http://www.eternalegypt.org/EternalEgyptWebsiteWeb/HomeServlet?ee_website_action_key=action.display.element&story_id=&module_id=&language_id=1&element_id=31&ee_messages=0001.flashrequired.text.

132 Lieselotte Kötzsche, "Der Basilikaleuchter in Leningrad," in *Studien zur spätantiken und byzantinischen Kunst: Friedrich Wilhelm Deichmann gewidmet*, vol. 3 (Bonn: Otto Feld, 1986), 56–57.

133 Formerly in the Paris collection of the Russian diplomat Alexander Basilewsky and now in the State Hermitage Museum, St. Petersburg. Alexander Basilewsky and Alfred Darcel, *Collection Basilewsky: Catalogue raisonné, précédé d'un essai sur les arts industriels du Ier au XVI siècle* (Paris: Vve A. Morel, 1874), 29–30, and plate IV; Weitzmann, *Age of Spirituality*, 623; Kötzsche, "Der Basilikaleuchter"; Ćurčić and Hadjitryphonos, *Architecture as Icon*, 9–10, 158–159.

134 Ćurčić and Hadjitryphonos, *Architecture as Icon*, 9–10, 21–23.

135 Gerhard Böwering, "The Light Verse: Qur'ānic Text and Ṣūfī Interpretation," *Oriens* 36 (2001), 113–144. On other symbolic aspects of illumination, see A. A.

Seyed-Ghorab, "Waxing Eloquent: The Masterful Variations on Candle Metaphors in the Poetry of Ḥāfiẓ and His Predecessors," in *Metaphor and Imagery in Persian Poetry*, ed. A. A. Seyed-Ghorab (Leiden: Brill, 2011), 81–123.

136 On relationships between this verse and material practices, see Finbarr Barry Flood, "Light in Stone: The Commemoration of the Prophet in Umayyad Architecture," in *Bayt al-Maqdis, Part 2: Jerusalem and Early Islam (Oxford Studies in Islamic Art)*, ed. Jeremy Johns (Oxford: Oxford University Press, 2000), 311–359; Margaret S. Graves, "The Lamp of Paradox," *Word & Image* (forthcoming).

137 Peter Adamson and Alexander Key, "Philosophy of Language in the Medieval Arabic Tradition," in *Linguistic Content: New Essays on the History of Philosophy of Language*, ed. Margaret Cameron and Robert J. Stainton (Oxford: Oxford University Press, 2015), 74.

138 Adamson and Key, "Philosophy," 92–93.

139 Geert Jan Van Gelder, "*Badīʿ*," *Encyclopaedia of Islam*, 3rd ed., http://dx.doi.org/10.1163/1573-3912_ei3_COM_22907; Van Gelder, *Beyond the Line*, 2–3.

140 Geert Jan Van Gelder, "*Ishāra*," in *Encyclopaedia of Arabic Literature*, ed. Julie Scott Meisami and Paul Starkey (London and New York: Routledge, 1998), 1:398.

141 Meisami, *Structure and Meaning*, 280; Charles Pellat, "*Kināya*," *Encyclopaedia of Islam*, 2nd ed., http://dx.doi.org/10.1163/1573-3912_islam_SIM_4377.

142 See Beatrice Gruendler, "Fantastic Aesthetics and Practical Criticism in Ninth-Century Baghdad," in *Takhyīl: The Imaginary in Classical Arabic Poetics*, ed. Geert Jan Van Gelder and Marlé Hammond (Oxford: Oxbow, 2008), 198; Wolfhart P. Heinrichs, "*Istiʿārah* and *Badīʿ* and Their Terminological Relationship in Early Arabic Literary Criticism," *Zeitschrift für Geschichte der Arabisch-Islamischen Wissenschaften* 1 (1984): 180–211.

143 Heinrichs, *Hand of the Northwind*. See also Benedikt Reinert, "Probleme der vormongolischen arabisch-persischen Poesiegemeinschaft und ihr Reflex in der Poetik," in *Arabic Poetry: Theory and Development*, ed. G. E. von Grunenbaum (Wiesbaden, 1973), 94–95.

144 Heinrichs, *Hand of the Northwind*, 10, 16. See also the review of Mansour Ajami, *The Neckveins of Winter: The Controversy over Natural and Artificial Poetry in Medieval Arabic Literary Criticism* (Leiden: Brill, 1984), by Geert Jan Van Gelder, *Die Welt des Islams* 26, nos. 1/4 (1986): 172–175.

145 Heinrichs, *Hand of the Northwind*, 9.

146 Heinrichs, *Hand of the Northwind*; S. A. Bonebakker, "Istiʿāra," *Encyclopaedia of Islam*. 2nd ed., http://dx.doi.org/10.1163/1573-3912_islam_SIM_3675.

147 Abu Deeb, *Al-Jurjānī's Theory*, 65–103.

148 Kamal Abu Deeb, "Al-Jurjānī's Classification of Istiʿara with Special Reference to Aristotle's Classification of Metaphor," *Journal of Arabic Literature* 2 (1971): 63; Al-Jurjānī, *Asrār al-balāgha*, ed. Helmut Ritter (Istanbul: Government Press, 1954), 144.

149 Abu Deeb, *Al-Jurjānī's Theory*, 104–112; Kamal Abu Deeb, "Classification," 60–63.

150 Cf. Gelber, "Poetic Vessel," 26–27.

151 See the seminal study in George Lakoff and Mark Johnson, *Metaphors We Live By* (Chicago: University of Chicago Press, 2003), especially the 2003 afterword, 243–274.

152 Ibn al-ʿArabi, *Al-Futūḥāt al-makkiyya*, 4 vols. (Reprint, Beirut: Dār Ṣādir, 1968), vol. 1, 306:18–21; William C. Chittick, *The Sufi Path of Knowledge: Ibn al-ʿArabi's Metaphysics of Imagination* (Albany, NY: SUNY Press, 1989), 122.

153 Jonathan Bloom, "The *Qubbat al-Khaḍrāʾ* and the Iconography of Height in Early Islamic Architecture," *Ars Orientalis* 23 (1993): 135–141; Grabar, "Dome of Heaven," 15–21; Sadan, "Maiden's Hair," 86.

Chapter 5: The Poetics of Ornament

1 Paul Losensky, "'The Equal of Heaven's Vault': The Design, Ceremony, and Poetry of the Ḥasanābād Bridge," in *Writers and Rulers: Perspectives on Their Relationship from Abbasid to Safavid Times*, ed. Beatrice Gruendler and Louise Marlow (Wiesbaden: Reichert Verlag, 2004), 214.

2 Graves, "Inside and Outside," 295–303; for further bibliography see same.

3 See Graves, "Monumental Miniature," 305 and notes.

4 On the history of the Nilometer in Egypt, see William Popper, *The Cairo Nilometer, Studies in Ibn Taghrī Birdī's Chronicles of Egypt: I* (Berkeley and Los Angeles: University of California Press, 1951), 1–15; Omar Toussoun, *Mémoire sur l'histoire du Nil*, 3 vols. (Cairo: Impr. de l'Institut français d'archéologie orientale, 1925), 2:305–351.

5 The shaft of the column is divided into sixteen cubits averaging 54.05 cm each, with the top ten each subdivided into twenty-four fingers (Donald R. Hill, "*Miḳyās*," *Encyclopaedia of Islam*, 2nd ed., http://dx.doi.org/10.1163/1573-3912_islam_SIM_5196). Medieval Arab authors record different numbers of cubits, presumably the result of different values ascribed to the cubit at different times: see Keppel Archibald Cameron Creswell, *Early Muslim Architecture, Part Two: Early ʿAbbāsids, Umayyads of Cordova, Aghlabids, Ṭūlūnids, and Samānids* (Oxford: Clarendon Press, 1940), 292–295.

6 Creswell, *Early Muslim Architecture, Part Two*, 297–298.

7 Al-Muqaddasī, *The Best Divisions for Knowledge of the Regions: A Translation of Aḥsan al-taqāsīm fī maʿrifat al-aqālīm*, trans. Basil Anthony Collins (Reading: Garnet, 1994), 189.

8 Al-Maqrīzī, *Towards a Shīʿi Mediterranean Empire: Fatimid Egypt and the Founding of Cairo, The Reign of the Imam-caliph al-Muʿizz from Taqī al-Dīn Aḥmad b. ʿAlī al-Maqrīzī's* Ittiʿāẓ al-ḥunafāʾ bi-akhbār al-aʾimma al-Fāṭimiyyīn al-khulafāʾ, trans. Shainool Jiwa (London: I. B. Tauris and Institute of Ismaili Studies, 2009), 109 and n. 308, also citing al-Maqrīzī's *Khiṭaṭ* (Bulaq ed.), 1:97.

9 Al-Maqrīzī, *Shīʿi Mediterranean Empire*, 109.

10 Al-Muqaddasī, *Best Divisions*, 183.

11 Michael Brett, "Population and Conversion to Islam in Egypt in the Medieval Period," in *Egypt and Syria in the Fatimid, Ayyubid and Mamluk Eras*, ed. Urbain Vermeulen and Jo Van Steenbergen (Leiden: Brill, 2005), 4.

12 Laila ʿAli Ibrahim, "Middle-Class Living Units in Mamluk Cairo: Architecture and Terminology," *Art and Archaeology Research Papers* 14 (1978): 28.

13 Al-Muqaddasī, *Best Divisions*, 181.

14 Shelomo Dov Goitein, "Cairo: An Islamic City in the Light of the Geniza Documents," in *Middle Eastern Cities*, ed. Ira M. Lapidus, (Berkeley and Los Angeles: University of California Press, 1969), 83; al-Thaʿālibī, *Curious and Entertaining*, 22.

15 Nāṣir-i Khusraw, *Nāṣer-e Khosraw's Book of Travels (Safarnāma)*, trans. Wheeler J. Thackston (Albany, NY: Bibliotheca Persica, 1986), 46; al-Muqaddasī, *Best Divisions for Knowledge*, 204.

16 Amalia Levanoni, "Water Supply in Medieval Middle Eastern Cities: The Case of Cairo," *Al-Masaq* 20, no. 2 (2008): 181.

17 Al-Maqrīzī, "Description topographique et historique de l'Égypte," excerpt from *Kitāb al-mawāʿiẓ waʾl-iʿtibār fī dhikr al-khiṭaṭ waʾl-āthār*, trans. and ed. Urbain Bouriant, *Mémoires publiés par les members de la mission archéologique française au Caire*, vol. 17 (Paris, 1900), 175–183.

18 Ibn Riḍwān, *Medieval Islamic Medicine: Ibn Riḍwān's Treatise "On the Prevention of Bodily Ills in Egypt,"* trans. Michael W. Dols (Berkeley: University of California Press, 1984).

19 In her 1979 article, Elfriede Knauer estimated that "well over sixty *kilgas* have been located at this time," with more presumably extant in private collections; however, she did not provide details of all of the examples she had found (Elfriede Knauer, "Marble Jar-Stands from Egypt," *Metropolitan Museum Journal* 14 [1979]: 71). During my doctoral research on this material I located seventy-five examples, and some more have appeared at auction since then. Graves, *Worlds Writ Small*, 2:105–186.

20 On the etymology of the word *kilga*, which seems to be unique to Egypt, see Laila Ibrahim, "Clear Fresh Water in Medieval Cairene Houses," *Islamic Archaeological Studies* 1 (1978): 3, n. 1.

21 Nikita Elisséeff, "An Alabaster Water-Jar," *Bulletin of the Museum of Fine Arts* 45, no. 260 (1947): 35–38.

22 The *waqf* document relates to the Azhar mosque in Cairo and was recorded by al-Maqrīzī in the fifteenth century; the passage in question includes an order for the purchase of pottery jars (*azyār fakhār*) for water for the mosque, but does not mention ablutions: al-Maqrīzī, *Al-mawāʿiẓ waʾl-iʿtibār fī dhikr al-khiṭaṭ waʾl-āthār*, 2 vols. (Reprint, Baghdad: Maktabat al-muthanna, n.d. [1970]), 2:274. For the translation cited by Elisséeff see Jean Sauvaget, *Historiens arabes: pages choisies, tr. et présentées par J. Sauvaget* (Paris: A. Maisonneuve, 1946), 160–170, where the relevant text—and Sauvaget's footnote—is on page 164. The same suggestion was put forward by Prisse d'Avennes with regard to the *kilgas* he saw in some *"mosquées primitives,"* although his statement uses the past tense and it can be assumed that he did not witness any *kilgas* being used for ablutions: Prisse d'Avennes, *L'art arabe d'après les monuments du Kaire depuis le VIIe siècle jusqu'à la fin du XVIIIe: Texte* (Paris: V. A. Morel, 1877), 200.

23 Muhammad Manazir Ahsan, *Social Life under the Abbasids: 170–289 A.H./786–902 A.D.* (London and New York: Longman, 1979), 127, citing al-Ṣābī, *al-Wuzarāʾ*, 26, 391, and al-Jāḥiẓ, *Al-Bukhalāʾ*, 70, 101, 177.

24 Al-Jāḥiẓ, *Al-Bukhalāʾ*, ed. Ṭāhā al-Ḥājirī (Cairo: Dār al-Maʿārif, 1958), 17; al-Jāḥiẓ, *The Book of Misers: A Translation of al-Bukhalāʾ*, trans. Robert Bertram Serjeant (Reading: Garnet, 1997), 14.

25 Ibrahim, "Clear Fresh Water," 1–2.

26 Knauer, "Marble Jar Stands," 71.

27 Ibn Riḍwān, *Medieval Islamic Medicine*, 135–136.

28 In the absence of surviving material evidence it is assumed that the *kilgas* originally held earthenware vessels of local manufacture. Al-Maqrīzī reports that Cairene vessels were made using clay (*ṭīn*) from the Nile, and tells of the colossal quantities of crude earthenware thrown away each day on the rubbish heaps of Cairo after use as disposable containers for perishable foods: quoted in Marcus Milwright, "Pottery in the Written Sources of the Ayyubid–Mamluk Period (ca. 567–923/1171–1517)," *Bulletin of the School of Oriental and African Studies, University of London* 62, no. 3 (1999): 505 and 508–509. The permeability of other fabrics might also be considered. In analysis of medieval ceramic samples from central Spain, Juan Zozaya, Manuel Retuerce Velasco, and Alfredo Aparicio observed one fragment, made not from a clay body but from sand with

cementing elements, which displayed impermeability of 90 to 95 percent (Juan Zozaya, personal communication with the author).

29 Marie-Hélène Rutschowscaya, "Water Jugs and Stands," *Coptic Encyclopedia*, 8 vols., ed. Aziz S. Atiya (New York: Macmillan, 1991), 7:2320.

30 See the example photographed in use with a metal container in the late 1970s at the complex of Sultan al-Manṣūr Qalāwūn, Cairo, by Knauer ("Marble Jar Stands," 73).

31 On the "dismantle-and-rebuild" use of marble in Cairo see Michael Greenhaigh, *Marble Past, Monumental Present: Building with Antiquities in the Mediaeval Mediterranean* (Leiden: Brill, 2009), 448–464.

32 Ibrahim, "Clear Fresh Water," 1.

33 See Marcus Milwright, "Waves of the Sea: Responses to Marble in Written Sources (9th–15th Centuries), in *The Iconography of Islamic Art: Studies in Honour of Professor Robert Hillenbrand*, ed. Bernard O'Kane (Edinburgh: Edinburgh University Press, 2005), 211–221; Fabio Barry, "Walking on Water: Cosmic Floors in Antiquity and the Middle Ages," *The Art Bulletin* 89, no. 4 (2007): 627–656.

34 On the history of the so-called *Bilderverbot* in Islamic religious art, see Flood, "Between Cult and Culture," 641–659, and more recently Natif, "Painter's Breath," 41–55.

35 Ibrahim suggests that the presence of the nude figures might indicate a role in hammams ("Clear Fresh Water," 3), although this seems a rather literal interpretation.

36 Graves, "Monumental Miniature," 309–311. On the practice of symbolically "killing" the figured image by cutting its throat or obliterating its face, see Flood, "Cult and Culture," and Flood, *Objects of Translation*, 160–172.

37 Museum of Islamic Art, Cairo, no. 104, taken from the late fifteenth-century mosque of the Mamluk amir Mughulbāy Ṭāz, Cairo: Max Herz Bey, *Catalogue sommaire des monuments exposés dans le musée national de l'art arabe* (Cairo: Impr. de l'Institut français d'archéologie orientale, 1895), 29, n. 107.

38 A classic study is Grabar, "Imperial and Urban Art," 215–241. See also Jonathan Bloom, *Arts of the City Victorious: Islamic Art and Architecture in Fatimid North Africa and Egypt* (New Haven, CT: Yale University Press and Institute of Ismaili Studies, 2007).

39 MIA 4328, illustrated most recently in O'Kane, *Treasures of Islamic Art*, 117–118.

40 The terminal fragment of the preceding word is also visible in the remaining part of the inscription on this *kilga*. On the basis of that fragment, some authors have considered it possible to date the piece to 570 H (1174–1175 CE) or 590 H (1193–1194 CE): Ahmad Hamdy, ed., *Islamic Art in Egypt, 969–1517* (Cairo: Ministry of Culture of the United Arab Republic, 1969), 200; Ibrahim, "Clear Fresh Water," 2–3; and O'Kane, *Treasures*, 118. An alternative published interpretation proposes the date 550: Farouk Sadeq Askar, "Support de jarre (*kilga*) avec un bassin en saillie," in *Trésors fatimides du Caire*, ed. Marianne Barrucand (Paris: Institut du monde arabe, 1998), 180. In the published illustrations it is very hard to make out all the letters that would be necessary for either of these readings. Given the ambiguities of the script, and in the absence of first-hand examination of the object, I have retained the more general dating to the sixth century that was first published in Étienne Combe, Jean Sauvaget, and Gaston Wiet, ed., *Répertoire chronologique d'épigraphie arabe*, vol. 8 (Cairo: Institut français d'archéologie orientale, 1937), 279.

41 Ibrahim, "Clear Fresh Water," 3.

42 Elisséeff, "Alabaster Water-Jar," 35.

43 On the iconicity of Fatimid architectural inscriptions in Cairo see Irene Bierman, *Writing Signs: The Fatimid Public Text* (Berkeley: University of California Press, 1998).

44 On later architectural chronograms and architectural panegyric composed for inscription upon buildings, see Paul Losensky, "Coordinates in Space and Time: Architectural Chronograms in Safavid Iran," in *New Perspectives on Safavid Iran: Empire and Society*, ed. Colin P. Mitchell (London: Routledge, 2011), 198–219; Losensky, " 'Square Like a Bubble,' " 42–70. On walls of words created by architectural inscriptions, see Bernard O'Kane, *The Appearance of Persian on Islamic Art* (New York: Persian Heritage Foundation, 2009), 26–41, 48–56, 59–66, 121–123, 130–131, 139; Bernard O'Kane, "Persian Poetry on Ilkhanid Art and Architecture," in *Beyond the Legacy of Genghis Khan*, ed. Linda Komaroff (Leiden: Brill, 2006), 346–354.

45 Lorenz Korn, "The Façade of aṣ-Ṣāliḥ ʿAyyūb's Madrasa and the Style of Ayyubid Architecture in Cairo," in *Egypt and Syria in the Fatimid, Ayyubid and Mamluk Eras, III*, ed. Urbain Vermeulen and Jo Van Steenbergen (Leuven: Peeters, 2001), 106 and n. 13. This motif was mistakenly interpreted by Knauer as a tree or leaf ("Marble Jar Stands," 67, 77–8, 82, 84, 89), and her erroneous interpretation has been repeated in some later catalogue entries.

46 Ibrahim ("Clear Fresh Water," 1 and n. 6) proposes that the arch originated in Samarra, Iraq, at the Dār al-Khilāfa (ninth century). A related form can be seen in the Baghdad Gate in Raqqa, Syria, probably dateable to the late eleventh or twelfth century: see Hillenbrand, "Eastern Islamic Influences," 34–35.

47 Ahmad Fikri, *Masājid al-Qāhira wa-madārisuhā*, 3 vols. (Cairo: Dār al-Maʿārif, 1961), 1:204.

48 These are in the Coptic Museum in Cairo (Ibrahim, "Clear Fresh Water," plate 8 A and B), and the Ikonenmuseum, Recklinghausen, Germany (Knauer, "Marble Jar Stands," 90).

49 See, for example, the Sayyida Ruqayya Mashhad (1133; illustrated in Keppel Archibald Cameron Creswell, *The Muslim Architecture of Egypt*, 2 vols. [New York: Hacker, 1978], vol. 1, plate 86c) and the *maqṣūra* of al-Ḥafiz, in the Azhar Mosque (1138; illustrated in Bloom, *Arts of the City*, 151). Lorenz Korn sees the blind tricusped arch as a marker of the continuation between Fatimid and Ayyubid architectural decoration: Korn, "Façade," 106; see also Stéphane Pradines, "Burj al-Ẓafar: Architecture de passage des fatimides aux ayyoubides," in *Egypt and Syria in the Fatimid, Ayyubid and Mamluk Eras, VIII*, ed. Urbain Vermeulen, Kristof D'Hulster, and Jo Van Steenbergen (Leuven: Peeters, 2016), 76, 100, 106. Ibrahim has noted that it also appears as late as the Ottoman period, in the drum of the Sinan Pasha Mosque, 1571 (Ibrahim, "Clear Fresh Water," n. 6).

50 Graves, *Worlds Writ Small*, 211–214; some examples are published in Joan Aruz, Kim Benzel, and Jean M. Evans, ed., *Beyond Babylon: Art, Trade and Diplomacy in the Second Millenium B.C.* (New York: Metropolitan Museum of Art, 2008), 347; Vassos Karageorghis, Eleni Vassilika, and Penelope Wilson, *The Art of Ancient Cyprus in the Fitzwilliam Museum, Cambridge* ([Cambridge]: Fitzwilliam Museum / A. G. Leventis Foundation, 1999), 62. The closest comparable form I have seen is an earthenware mold in the form of a seated female nude holding her breasts, excavated at Tell Hariri in Syria and thought to date from the beginning of the second millennium BCE, on display in the Syrian National Museum in Damascus in 2009.

51 See Knauer's attempt to use it as a defining feature of the groupings she proposes in her study: "Marble Jar Stands," group 9, 82–86.

52 On the debates surrounding the origins of *muqarnas*, see Wilkinson, *Nishapur*, 251; Yasser Tabbaa, "Muqarnas," *The Dictionary of Art*, ed. Jane Turner (London: Grove, 1996), 22:321. For the history of its early use in Egypt, see Jonathan Bloom, "The Introduction of the Muqarnas into Egypt," *Muqarnas* 5 (1988): 21–28.

53 Ibrahim, "Clear Fresh Water," 2; Knauer, "Marble Jar Stands," 83.

54 Jonathan Bloom has proposed that a now-lost tradition of *muqarnas* squinches on vernacular architecture in Egypt may have preceded the form's appearance on religious architecture in the twelfth century; see Bloom, "Introduction of the Muqarnas," 27–28.

55 Graves, *Worlds Writ Small*, 155–222.

56 The *kilga*s have been misinterpreted by Max Herz Bey, among others, as imitative of tortoises: this was corrected by Knauer ("Marble Jar Stands," 70, n. 7).

57 Knauer, "Marble Jar Stands," 76–77. On the distinction between *shādirwān* and *salsabīl*, see Georges Marçais, "Salsabīl et Šadirwān," in *Études d'orientalisme dédiées à la mémoire de Lévi-Provençal*, 2 vols. (Paris: G.-P. Maisonneuve et Larose, 1962), 2:639–648; Laila ʿAli Ibrahim and Muhammad M. Amin, *Architectural Terms in Mamluk Documents* (Cairo: American University in Cairo Press, 1990), 66, 68–69; Yasser Tabbaa, "The 'Salsabil' and 'Shadirwan' in Medieval Islamic Courtyards," *Environmental Design: Journal of the Islamic Environmental Design Research Centre* 2 (1985), 34–37; Yasser Tabbaa "Towards an Interpretation of the Use of Water in Islamic Courtyards and Courtyard Gardens," *Journal of Garden History* 7, no. 3 (1987): 197–220; Nasser Rabbat, "Shadirwān," *Encyclopaedia of Islam*, 2nd ed., http://dx.doi.org/10.1163/1573-3912_islam_SIM_6737.

58 Ernst J. Grube and Jeremy Johns, *The Painted Ceilings of the Cappella Palatina* (Genova: Bruschettini Foundation for Islamic and Asian Art, 2005), 140 and plate XLII.

59 See also Lucien Golvin, *Recherches Archéologiques à la Qalʿa des Banú Hammád (Algérie)* (Paris: G.-P. Maisonneuve et Larose, 1965), plates XLIII and XLIV.

60 Illustrated in Creswell, *Muslim Architecture of Egypt*, 1:126. Aly Bahgat and Albert Gabriel, *Fouilles d'al Foustât, publiées les auspices du Comité de conservation des monuments de l'art arabe, par Aly Bahgat bey et Albert Gabriel* (Paris: E. de Boccard, 1921), 52–53 ("Maison III"), 55–56 ("Maison IV"), 58–59 ("Maison V"), 62–63 and 66–67 ("Maison VI"), and plate XVIII.

61 See Daniel Schlumberger, "Le palais ghaznévide de Laškari Bazar," *Syria* 29 (1952): 260–261.

62 Knauer, "Marble Jar Stands," 77; Rachid Bourouiba, "Note sur une vasque de pierre trouvée au Palais du Manar de la Qalʿa des Bani Hammad," *Bulletin d'archéologie algérienne* 5 (1971–1975): 235–245.

63 National Museum of Antiquities and Islamic Arts, Algiers, no. II.S.66: see Leila Merabet, "Fountain Basin," *Discover Islamic Art. Museum With No Frontiers*, 2014, http://www.discoverislamicart.org/database_item.php?id=object;ISL;dz;Mus01;38;en.

64 For possible symbolic meanings of flowing, pooling, and scattering water in the medieval *salsabīl*, see Tabbaa, "Towards an Interpretation," 212–218.

65 Krautheimer, " 'Iconography of Medieval Architecture,' " 14. Koch follows this line of argument in "Copies of the Quṭb Mīnār," 95–107.

66 See Tabbaa, "Towards an Interpretation," 212.

67 Golvin, *Recherches Archéologiques*, pl. LVI.

68 Quoted in Tabbaa, "Towards an Interpretation," 202.

69 Textual and material sources attest to the widespread use of lion fountainheads and waterspouts in al-Andalus and North Africa: Dede Fairchild Ruggles, *Gardens, Landscape and Vision in the Palaces of Islamic Spain* (University Park: Pennsylvania State University Press, 2000), 199–200 and 210–214. Carved stone lion heads were excavated at Fustat: Bahgat and Gabriel, *Fouilles d'al Foustât*, plate no. XXIV. The connection

seems to be very ancient: see the earthenware libation vessel from Syria, *c.* nineteenth century BCE and now in the Metropolitan Museum of Art, New York (68.155), in the form of a tower mounted by a figure who grasps two lions and a vessel. Illustrated in Pillsbury et al., *Design for Eternity*, 12.

70 However, the question of why there should so often be two lion heads at this point on the *kilga*s, rather than one, remains unanswered.

71 Alexander Badawy, "The Prototype of the Coptic Water-Jug Stand," *Archaeology* 20, no. 1 (1967): 61.

72 Badawy, "Prototype," 58–61. See an example on the temple of Hathor at Dendara, *c.* 125 BCE – 60 CE, illustrated in Finnestad, "Temples of the Pharaonic and Roman Periods," 214.

73 See the catalogue entry for a Coptic-type jar stand in the Museum of Islamic Art, Cairo (no. 27877): Dominique Bénazeth, "Support pour jarres à eau," in *L'art copte en Egypte: 2000 ans de christianisme* (Paris: Institut du monde arabe / Gallimard, 2000), 39.

74 See *Alfonso X el Sabio: Sala San Esteban, Murcia, 27 octubre 2009–31 enero 2010* (Murcia: A. C. Novograf, 2009), 699.

75 Julio Navarro Palazón, "Formas arquitectónicas en el mobiliario cerámico andalusí," *Cuadernos de la Alhambra* 23 (1987): 21–65. Some aspects of Navarro Palazón's interpretation of the Murcia piece and related fragments as stands for jars are questioned in Remedios Amores Lloret, "Maquetas arquitectónicas islámicas de Murcia," *Verdolay* 3 (1991): 104.

76 Julio Navarro Palazón and Pedro Jiménez Castillo, "Piletas de abluciones en el ajuar cerámico andalusí," *Verdolay* 5 (1993): 173.

77 Uvo Hölscher, *The Excavation of Medinet Habu, Volume V: Post-Ramessid Remains* (Chicago: University of Chicago Press, 1954), plate 36, fig. B9. Hölscher (59–60) links this artifact with the water-jug stands of carved stone which had been left amid the ruins of the Coptic houses at the site. See also the remains of an earthenware jar stand excavated at Ṭūd, near Luxor, in Geneviève Pierrat, "Essai de classification de la céramique de Tôd de la fin du VIIe siècle au début du XIIIe siècle ap. J.-C.," *Cahiers de la céramique égyptienne* 2 (1991): 153.

78 Rachel Campbell, *An Archaeological Study of Egyptian Houses, Particularly Those from the Hellenistic Period*, 2 vols. (PhD diss., University of Durham, 1984), 1:377–378. Oleg Grabar saw the depiction of water jars stored by the doors of domestic interiors in the thirteenth-century Mesopotamian *maqāmāt* manuscripts as indicators of a bourgeois setting: "Illustrated *Maqamat*," 207–222, fig. 2.

79 Ibrahim, "Middle Class Living Units," 57.

80 Navarro Palazón and Jiménez Castillo, "Piletas de abluciones," 176. The authors cite the twelfth- or thirteenth-century *ḥisba* manual of al-Saqaṭī, probably written in Malaga: this book of regulations for the marketplace inspector instructs him to ensure that potters make the mouths of jars intended for water for ablutions large enough to permit water to be scooped out by hand, but it does not follow that this means the Murcia stand would be used for ablution water: al-Saqaṭī, "El kitāb fī ādāb al-ḥisba de al-Saqaṭī," trans. Pedro Chalmeta, *Al-Andalus* 33 (1968): 409–410. The legal literature surrounding the required nature and treatment of the water used for ablutions is complex: for a brief overview see Eric Chaumont, "Wuḍū'," *Encyclopaedia of Islam*, 2nd ed., http://dx.doi.org/10.1163/1573-3912_islam_SIM_7925, and G. H. Bousquet, "G̱ẖusl," *Encyclopaedia of Islam*, 2nd ed., http://dx.doi.org/10.1163/1573-3912_islam_SIM_2524.

81 Julio Navarro Palazón and Pedro Jiménez Castillo, "La Producción Cerámica Medieval de Murcia," in *Spanish Medieval Ceramics in Spain and the British Isles*, ed. Christopher

Gerrard, Alejandra Gutiérrez, and Alan Vince (Oxford: British Archaeological Reports, 1995), 185–214.

82 Julio Navarro Palazón and Pedro Jiménez Castillo, "Maquetas arquitectónicas en cerámica y su relación con la arquitectura andalusí," in *Casas y palacios de Al-Andalus: Siglos XII–XIII* (Granada: El Legado Andalusí, 1995), 287–302.

83 Lintz, Delery, and Leonetti, eds., *Le Maroc médiéval*, 341–348, 350–352; see also the related materials in Alexandre Delpy, "Note sur quelques vestiges de céramique recueillis a Salé," *Hespéris: Archives Berbères et bulletin de l'institut des hautes études marocaines* 42 (1955): 129–152.

84 The hypothesis of the dripping projections on the Murcian material has led Navarro Palazón to the conclusion that the marble *kilga*s of Egypt are more durable imitators of a type of stand that was once most commonly made in unglazed earthenware: Navarro Palazón and Jiménez Castillo, "Piletas de abluciones."

85 Horapollo, *The Hieroglyphics of Horapollo*, trans. George Boas (New York: Pantheon, 1950), 71.

86 Popper (*Nilometer*, 54) surmises that this was probably due to the construction of a new wall around the Nilometer in 1024.

87 See Creswell, *Early Muslim Architecture, Part Two*, 299. See also Popper, *Nilometer*, 49.

88 On the parallels of subjectivity between Persian poetry and painting of the "classical" period, see Ehsan Yarshater, "Some Common Characteristics of Persian Poetry and Art," *Studia Islamica* 16 (1962): 61–71. For a different interpretation of poetry as a means of accessing the "social text" of Cairo in the *Khiṭaṭ* of al-Maqrīzī, see Martyn Smith, "Finding Meaning in the City: al-Maqrīzī's Use of Poetry in the *Khiṭaṭ*," *Mamluk Studies Review* 15 (2012): 143–161.

89 Jerome W. Clinton, "The *Madāen Qasida* of Xāqāni Sharvāni, I," *Edebiyat* 1, no. 2 (1976): 153–170; Jerome W. Clinton, "The *Madāen Qasida* of Xāqāni Sharvāni, II: Xāqāni and al-Buhturī," *Edebiyat* 2, no. 2 (1977): 191–206; Julie Scott Meisami, "Poetic Microcosms: The Persian Qasida to the End of the 12th Century," in *Qasida Poetry in Islamic Asia and Africa*, 2 vols., ed. Stefan Sperl and Christopher Shackle (Leiden: Brill, 1996), 1:173–182; Akiko Motoyoshi Sumi, *Description in Classical Arabic Poetry: Waṣf, Ekphrasis and Interarts Theory* (Leiden: Brill, 2004), 100–121; Stefan Sperl, "Crossing Enemy Boundaries: Al-Buhturī's Ode on the Ruins of Ctesiphon Re-read in the Light of Virgil and Wilfred Owen," *Bulletin of the School of Oriental and African Studies, University of London* 69, no. 3 (2006): 365–379.

90 Julie Scott Meisami, "The Palace Complex as Emblem: Some Samarran Qaṣīdas," in *A Medieval Islamic City Reconsidered: An Interdisciplinary Approach to Samarra*, ed. Chase F. Robinson (Oxford: Oxford University Press, 2001), 69–78; Julie Scott Meisami, "Palaces and Paradises: Palace Description in Medieval Persian Poetry," in *Islamic Art and Literature*, ed. Oleg Grabar and Cynthia Robinson (Princeton, NJ: Markus Weiner, 2001), 21–54.

91 Michele Bernardini, "The *masnavī-shahrāshūb*s as Town Panegyrics: An International Genre in Islamic Mashriq," in *Erzhälter Raum in Literaturen der islamischen Welt/Narrated space in the literature of the Islamic world*, ed. Roxane Haag-Higuchi and Christian Szyska (Wiesbaden: Harrasowitz Verlag, 2001), 81–94; Paul Losensky, "The Palace of Praise and the Melons of Time: Descriptive Patterns in ʿAbdī Bayk Šīrāzī's *Garden of Eden*," *Eurasian Studies* 2, no. 1 (2003): 3–6; J. T. P de Bruijn, "Shahrangīz," *Encyclopaedia of Islam*, 2nd ed., http://dx.doi.org/10.1163/1573-3912_islam_COM_1026; G. E. Von Grunebaum, "Aspects of Arabic Urban Literature Mostly in Ninth and Tenth Centuries," *Islamic Studies* 8, no. 4 (1969): 217–300.

92 See Sumi, *Description*, 6–14.

93 Sumi, *Description*, 7.

94 Jaś Elsner, "The Rhetoric of Buildings in the *De Aedificiis* of Procopius," in *Art and Text in Byzantine Culture*, ed. Liz James (Cambridge: Cambridge University Press, 2007), 39.

95 Sarah Bassett, "Style and Meaning in the Imperial Panels at San Vitale," *Artibus et Historiae* 57, no. 29 (2008): 55; Sarah Bassett, "Sculpture and the Rhetorical Imagination in Late Antique Constantinople," in *Archaeology of the Cities of Asia Minor in Late Antiquity*, ed. Ortwin Dally and Christopher Ratte (Ann Arbor, MI: Kelsey Museum, 2011), 27–41; Leisten, "Abbasid Art," 50–57.

96 See Bissera V. Pentcheva, "The Power of Glittering Materiality: Mirror Reflections Between Poetry and Architecture in Greek and Arabic Medieval Culture," in *Istanbul and Water*, ed. Paul Magdalino and Nina Ergin (Leuven: Peeters, 2015), 261–264.

97 Leisten, "Abbasid Art."

98 Examples in Lutz Richter-Bernburg, "In the Eye of the Beholder: The Aesthetic [In] Significance of Architecture in Arabic Geography, AH 250–400," *The Arabist* 26–27 (2003): 295–316.

99 Yasser Tabbaa, "Control and Abandon: Images of Water in Arabic Poetry and Gardens," in *Rivers of Paradise: Water in Islamic Art and Culture*, ed. Sheila S. Blair and Jonathan M. Bloom (New Haven and London: Yale University Press, 2009), 67, 75.

100 Translation from Stefan Sperl, *Mannerism in Arabic Poetry: A Structural Analysis of Selected Texts (3 Century AH/9th Century AD–5th Century AH/11th Century AD)* (Cambridge: Cambridge University Press, 1989), 196–199; variant translations in Pentcheva, "Glittering Materiality," 265; and Tabbaa, "Control and Abandon," 66.

101 Tabbaa, "Towards an Interpretation," 213–215, and n. 45; Tabbaa, "Control and Abandon"; see also José Miguel Puerta Vílchez, *La poética del agua en el islam / The Poetics of Water in Islam* (Sabarís: Trea, 2011).

102 Meisami, "Palaces and Paradises," 32.

103 Losensky, "Palace of Praise," 25.

104 Meisami, "Palaces and Paradises"; Clinton, *Divan of Manūchihrī Dāmghānī*, 61–62; Losensky, " 'Equal of Heaven's Vault," 205.

105 Tabbaa, "Control and Abandon," 60.

106 Puerta Vílchez, *La poetica del agua*, 94–102.

107 Losensky, "Palace of Praise," 7, 14.

108 Lévi-Strauss, *Savage Mind*, 23–24.

109 DeLong, "Phenomenological Space-Time," 682; Doug Bailey, "Touch and the Cheirotic Apprehension of Prehistoric Figurines," in *Sculpture and Touch*, ed. Peter Dent (Farnham, Surrey: Ashgate, 2014), 29–31.

110 Wolfson, "The Internal Senses," 71–72; Leonardo Capezzone, "Remembering, Knowing, Imagining: Approaches to the Topic of Memory in Medieval Islamic Culture," in *Texts in Transit in the Medieval Mediterranean*, ed. Y. Tzvi Langermann and Robert G. Morrison (University Park: Pennsylvania State University Press, 2016), 85–100.

111 Peter Heath, *Allegory and Philosophy in Avicenna (Ibn Sînâ): With a Translation of the Book of the Prophet Muhammad's Ascent to Heaven* (Philadelphia: University of Pennsylvania Press, 1992), 62.

112 Ibn Sīnā, *Avicenna's Psychology*, 30–31; Heath, *Allegory and Philosophy*, 61–63; Deborah Black, "Memory, Individuals and the Past in Averroe's Philosophy," *Medieval Philosophy and Theology* 5 (1996), 163–164; Peter E. Pormann, "Avicenna on Medical Practice, Epistemology, and the Physiology of the Inner Senses," in *Interpreting Avicenna: Critical Essays*, ed. Peter Adamson (Cambridge: Cambridge University Press, 2013), 104–106. On *wahm*, see D. B. Macdonald, "*Wahm* in Arabic and Its Cognates," *Journal of the Royal Asiatic Society* 4 (October 1922): 505–521; Deborah L. Black, "Imagination and Estimation: Arabic Paradigms and Western Transformations," *Topoi* 19, no. 1 (2000): 59–75.

113 On the implications of this model for image-making, as attested in medieval Persian poetry, see Soucek, "Niẓāmī on Painters and Painting."

114 The model would be reinserted into the Latin tradition: Camille, "Before the Gaze," 200.

115 Ibn al-Haytham, *The Optics of Ibn al-Haytham, Books I–III, On Direct Vision*, 2 vols., trans. A. I. Sabra (London: Warburg Institute / University of London, 1989), 211–212.

116 Abu Deeb, "Classification," 63, citing *Asrār al-balāgha*, 142.

117 Black, "Memory," 162; Capezzone, "Remembering, Knowing, Imagining."

118 Black, "Memory," 164, 178.

119 Puerta Vílchez, *Aesthetics in Arabic Thought*, 297–310; Black, "Memory," 169, 171.

Conclusion

1 In many of the extant survey texts of Islamic art, architecture comes first, followed by the book arts and the art of the object. In sale catalogues for this area, manuscripts normally lead the way before the field is given over to various plastic arts (which in the saleroom can also include architectural fragments as well as objects of use).

2 For example, the dramatic curtailment of ceramic production at Kashan from 1226–1261, based on the evidence of surviving dated pieces: Oliver Watson, "Pottery under the Mongols," in *Beyond the Legacy of Genghis Khan*, ed. Linda Komaroff (Leiden: Brill, 2006), 325–345.

3 On "regimes of visuality," see Necipoğlu, "L'idée de décor," and "Early Modern Floral." On the early modern "gaze," see Necipoğlu, "The Scrutinizing Gaze."

4 Rosalind Krauss, "Sculpture in the Expanded Field," *October* 8 (1979): 36–37.

5 Krauss, "Expanded Field."

6 Baxandall, *Patterns of Intention*, 58–59.

7 See Bill Brown, "Thing Theory," in *Things*, ed. Bill Brown (Chicago and London: University of Chicago Press, 2004), 1–21.

8 See Christopher Woods on "relaxing the paradox": *Forgery, Replica, Fiction* 13–15.

9 Flood, "The Flaw in the Carpet," 92.

10 Sankovitch, "Structure/Ornament," 691.

11 Carmela Perri, "On Alluding," *Poetics* 7, no. 3 (1978): 301.

BIBLIOGRAPHY

PRIMARY SOURCES

Abū Dulaf. *Abu-Dulaf Mis'ar Ibn Muhalhil's Travels in Iran (circa A.D. 950): Arabic Text with an English Translation and Commentary by Prof. V. Minorsky*. Cairo: Cairo University Press, 1955.

Al-'Askarī, Abū Hilāl. *Kitāb al-ṣinā'atayn*. Cairo: 'Īsa al-Bābī al-Ḥalabī, 1952.

Bābur. *Bābur-nāma (Memoirs of Bābur)*. Translated by Annette Susannah Beveridge. New Delhi: Mushiram Manoharlal, 1990.

Al-Bīrūnī. *The Book Most Comprehensive in Knowledge on Precious Stones: Al-Beruni's Book on Mineralogy = Kitāb al-jamāhir fī ma'rifat al-jawāhir*. Translated by Hakim Mohammad Said. Islamabad: Pakistan Hijra Council, 1989.

Al-Fārābī. *On the Perfect State (mabādi' ārā' ahl al-madīnat al-fāḍilah)*. Translated by Richard Walzer. Oxford: Oxford University Press, 1998.

Al-Fārābī. *Kitāb al-Shi'r*, translated as "The Book of Poetry." In *Takhyīl: The Imaginary in Classical Arabic Poetics*. Edited by Geert Jan van Gelder and Marlé Hammond, 15–18. Oxford: Oxbow for E. J. W. Gibb Memorial Trust, 2008.

Al-Ghazālī. *Iḥyā' 'ulūm al-Dīn*. Ṭabana ed., in 4 vols. Cairo: Dār Iḥyā' al-Kutub al-'Arabiyya, 1957.

Al-Ghazālī. *Ghazālī's Book of Counsel for Kings (Naṣīḥat al-mulūk)*. Translated by F. R. C. Bagley. London: Oxford University Press, 1964.

Al-Ghazālī. *Al-Maqṣad al-asnā fī sharḥ asmā' Allāh al-ḥusnā*. Beirut: Dār al-Mashriq, 1982.

Al-Ghazālī. *The Ninety-Nine Beautiful Names of God, al-Maqṣad al-asnā fī sharḥ asmā' Allāh al-ḥusnā*. Translated with notes by David B. Burrell and Nazih Daher. Oxford: Islamic Texts Society, 1992.

Al-Ghazālī. *The Niche of Lights: A Parallel English-Arabic Text*. Translated and edited by David Buchmann. Provo, UT: Brigham Young University Press, 1998.

Al-Ghazālī. *Deliverance from Error: An Annotated Translation of Al-munqidh min al-ḍalāl and Other Relevant Works of al-Ghazālī*. Translated by Richard Joseph McCarthy. Louisville, KY: Fons Vitae, 1999.

Al-Ghazālī. *Al-Ghazālī on the Manners Relating to Eating: Book XI of the Revival of Religious Sciences*. Translated with an introduction and notes by D. Johnson Davies. Cambridge: Islamic Texts Society, 2000.

Al-Ghazālī. *Kitāb sharḥ 'ajā'ib al-qalb, The Marvels of the Heart, Book 21 of the Iḥyā' 'ulūm al-dīn, The Revival of the Religious Sciences*. Translated by Walter James Skellie. Louisville, KY: Fons Vitae, 2010.

Al-Ghazālī. *Love, Longing, Intimacy and Contentment: Book XXXVI of the Revival of the Religious Sciences*. Translated with an introduction and notes by Eric Ormsby. Cambridge: Islamic Texts Society, 2011.

Al-Ghazālī. *The Lawful and the Unlawful: Book XIV of the Revival of the Religious Sciences*. Translated with an introduction and notes by Yusuf T. Delorenzo. Cambridge: Islamic Texts Society, 2014.

Horapollo. *The Hieroglyphics of Horapollo*. Translated by George Boas. New York: Pantheon, 1950.

Ibn 'Abd Rabbih. *Al-'Iqd al-farīd: The Unique Necklace*. Translated by Issa J. Boullata. 2 vols. Reading, UK: Garnet, 2007.

Ibn 'Abdūn. *Seville musulmane au début du XII siècle: le traite d'Ibn 'Abdūn sur la vie urbaine et les corps de métiers*. Translated by Évariste Lévi-Provençal. Paris: Maisonneuve and Larose, 1947.

Ibn al-'Arabi. *Al-Futūhāt al-makkiyya*. 4 vols. Reprint, Beirut: Dār Ṣadir, 1968.

Ibn al-Athīr. *Al-Kāmil fī al-tārīkh*. 13 vols. Beirut: Dār Ṣadir, 1385–1387 [1965–1968].

Ibn al-Athīr. *The Annals of the Saljuq Turks: Selections from al-Kāmil fī'l-Ta'rīkh of 'Izz al-Dīn Ibn al-Athīr*. Translated and annotated by D. S. Richards. London: RoutledgeCurzon, 2002.

Ibn al-Faqīh al-Hamadānī. *Abrégé du livre des pays (Mukhtaṣar kitāb al-buldān)*. Translated by Henri Massé. Damascus: Institut Français de Damas, 1973.

Ibn al-Haytham. *The Optics of Ibn al-Haytham, Books I–III, On Direct Vision*. Translated by A. I. Sabra. 2 vols. London: Warburg Institute / University of London, 1989.

Ibn Jubayr. *The Travels of Ibn Jubayr, Edited from a ms. in the University Library of Leyden*. 2nd ed. Edited by William Wright and M. J. De Goeje. Leiden and London: Brill and Luzac / E. J. W. Gibb Memorial Series, 1907.

Ibn Jubayr. *The Travels of Ibn Jubayr*. Translated by R. J. C. Broadhurst. London: Jonathan Cape, 1952.

Ibn Khaldūn. *The Muqaddimah: An Introduction to History*. Translated by Franz Rosenthal. 3 vols. London: Routledge and Kegan Paul, 1958.

Ibn Khaldūn. *Muqaddima Ibn Khaldūn: Prolégomènes d'Ebn-Khaldoun, texte arabe*. 3 vols. Reprint of Quatremère edition. Beirut: Maktabat Lubnān, 1970.

Ibn Riḍwān. *Medieval Islamic Medicine: Ibn Riḍwān's Treatise "On the Prevention of Bodily Ills in Egypt."* Translated by Michael W. Dols. Berkeley: University of California Press, 1984.

Ibn Sīnā. *The Metaphysica of Avicenna (Ibn Sīnā): A Critical Translation-Commentary and Analysis of the Fundamental Arguments in Avicenna's* Metaphysica *in the* Dānish Nāma-i 'alā'ī *(The Book of Scientific Knowledge)*. Translated by Parviz Morewedge. London: Routledge and Kegan Paul, 1973.

Ibn Sīnā. *Avicenna's Psychology, an English Translation of* Kitāb al-Najāt, *Book II, Chapter VI, with Historico-Philosophical Notes and Textual Improvements on the Cairo Edition by F. Rahman*. Westport, CT: Hyperion, 1981.

Ibn Ṭabāṭaba. *'Iyār al-shi'r*. Cairo: Al-Maktaba al-Tijārīya al-Kubrā, 1956.

Ibn Ṭufayl. *Ḥayy Ibn Yaqẓān: A Philosophical Tale*. Translated and edited by Lenn Evan Goodman. Chicago, IL: University of Chicago Press, 2009.

Ibn al-Ukhuwwa. *Ma'ālim al-qurba fī aḥkam al-ḥisba of Diyā' al-Dīn Muḥammad Ibn Muḥammad al-Qurashī al-Shāfi'ī, known as Ibn al-Ukhuwwa*. Edited by Reuben Levy. Cambridge: Cambridge University Press, 1938.

Ikhwān al-Ṣafā'. *Rasā'il Ikhwān al-Ṣafā' wa-khillān al-wafā'*. 4 vols. Beirut: Dār Ṣadir, 1957.

Ikhwān al-Ṣafā'. *Epistles of the Brethren of Purity: The Case of the Animals before Man versus the King of the Jinn, An Arabic Critical Edition and English Translation of Epistle 22*. Edited and translated by Lenn E. Goodman and Richard McGregor. New York: Oxford University Press / Institute of Ismaili Studies, 2009.

Ikhwān al-Ṣafā'. *Epistles of the Brethren of Purity: On Logic, An Arabic Critical Edition and English Translation of Epistles 10–14*. Edited and translated by Carmela Baffioni. New York: Oxford University Press / Institute of Ismaili Studies, 2010.

Ikhwān al-Ṣafā'. "The Seventh Epistle of the Propaedeutical Part on the Scientific Arts and What They Aim At," translated by Rüdiger Arnzen. In *Classical Foundations of Islamic*

Educational Thought. Edited by Bradley J. Cook, 20–37, 260–266. Provo, UT: Brigham Young University Press, 2010.

Ikhwān al-Ṣafā'. *Epistles of the Brethren of Purity: On Arithmetic and Geometry: An Arabic Critical Edition and English Translation of Epistles 1 & 2*. Edited and translated by Nader El-Bizri. New York: Oxford University Press / Institute of Ismaili Studies, 2012.

Ikhwān al-Ṣafā'. *Epistles of the Brethren of Purity: On Geography, an Arabic Critical Edition and English Translation of Epistle 4*. Edited and translated by Ignacio Sanchez and James Montgomery. New York: Oxford University Press / Institute of Ismaili Studies, 2014.

Ikhwān al-Ṣafā'. *Epistles of the Brethren of Purity: On the Natural Sciences: An Arabic Critical Edition and English Translation of Epistles 15–21*. Edited and translated by Carmela Baffioni. New York: Oxford University Press / Institute of Ismaili Studies, 2014.

Al-Jāḥiẓ. *Kitāb al-ḥayawān*. 7 vols. Cairo: Muṣṭafa al-Bābī al-Ḥalabī, 1938–1945.

Al-Jāḥiẓ. *Al-bukhalā'*. Edited by Ṭāha al-Ḥājirī. Cairo: Dār al-Maʿārif, 1958.

Al-Jāḥiẓ. *The Book of Misers: A Translation of al-Bukhalā'*. Translated by Robert Bertram Serjeant. Reading, UK: Garnet, 1997.

Al-Jurjānī. *Asrār al-balāgha*. Edited by Helmut Ritter. Istanbul: Government Press, 1954.

Al-Jurjānī. *Dalā'il al-iʿjāz*. Cairo: Maktabat al-Qāhira, 1969.

Al-Kindī. *Rasā'il al-Kindī al-falsafiyya*. Edited by M. A. Abū Rīda. 2 vols. Cairo: Dār al-fikr al-ʿarabī, 1950–1953.

Al-Maqrīzī. *Al-mawāʿiẓ wa'l-iʿtibār fī dhikr al-khiṭaṭ wa'l-āthār*. Reprint, Baghdad: Maktabat al-muthanna, n.d. [1970].

Al-Maqrīzī. "Description topographique et historique de l'Égypte," excerpt from *Kitāb al-mawāʿiẓ wa'l-iʿtibār fī dhikr al-khiṭaṭ wa'l-āthār*, translated and edited by Urbain Bouriant, 175–183. In *Mémoires publiés par les members de la mission archéologique française au Caire*, vol. 17. Paris, 1900.

Al-Maqrīzī. *Towards a Shīʿi Mediterranean Empire: Fatimid Egypt and the Founding of Cairo, The Reign of the Imam-caliph al-Muʿizz from Taqī al-Dīn Aḥmad b. ʿAlī al-Maqrīzī's Ittiʿāẓ al-ḥunafā' bi-akhbār al-a'imma al-Fāṭimiyyīn al-khulafā'*. Translated by Shainool Jiwa. London: I. B. Tauris and Institute of Ismaili Studies, 2009.

Miskawayh. *Tahdhīb al-Akhlāq*. Edited by Constantine K. Zurayk. Beirut: American University in Beirut, 1967.

Miskawayh. *The Refinement of Character: A Translation from the Arabic of Aḥmad ibn-Muḥammad Miskawayh's* Tahdhīb al-Akhlāq *by Constantine K. Zurayk*. Beirut: American University of Beirut, 1968.

Al-Muqaddasī. *The Best Divisions for Knowledge of the Regions: A Translation of Aḥsan al-taqāsīm fī maʿrifat al-aqālīm*. Translated by Basil Anthony Collins. Reading, UK: Garnet, 1994.

Nāṣir-i Khusraw. *Nāṣer-e Khosraw's Book of Travels (Safarnāma)*. Translated by Wheeler J. Thackston. Albany, NY: Bibliotheca Persica, 1986.

Niẓām al-Mulk. *The Book of Government or Rules for Kings: The Siyar al-Muluk or Siyasat-nama of Nizam al-Mulk, translated from the Persian by Hubert Darke*. 2nd ed. London: Routledge and Kegan Paul, 1978.

Niẓāmi ʿArūḍī Samarqandī. *Chahār maqāla*. Revised translation by Edward G. Browne. London: E. J. Gibb Memorial / Luzac, 1921.

Al-Saqaṭī. "El kitāb fī ādāb al-ḥisba de al-Saqaṭī," translated by Pedro Chalmeta. *Al-Andalus* 33 (1968): 367–434.

Shams-i Qays. *Al-muʿjam fī maʿāyīr ashʿār al-aʿjam*. Tehran: Firdaws, 1994.

Al-Shayzarī. *The Book of the Islamic Market Inspector: Nihāyat al-Rutba fī Ṭalab al-Ḥisba (The Utmost Authority in the Pursuit of Ḥisba) by ʿAbd al-Raḥmān b. Naṣr al-Shayzarī*. Translated and edited by R. P. Buckley. Oxford: Oxford University Press, 1999.

Al-Ṭabarī. *The History of al-Ṭabarī, Volume 1: General Introduction and from Creation to the Flood*. Translated by Franz Rosthenal. Albany, NY: SUNY Press, 1989.

Al-Thaʿālibī. *Laṭāʾif al-maʿārif*. Cairo: Dār Ihya al-Kutub al-ʿArabiyya, 1960.

Al-Thaʿālibī. *The Book of Curious and Entertaining Information: The Laṭāʾif al-maʿārif of Thaʿālibī, translated with introduction and notes by C.E. Bosworth*. Edinburgh: Edinburgh University Press, 1968.

Theophilus. *The Various Arts: De Diversis Artibus*. Translated and edited by Charles R. Dodwell. Oxford: Clarendon Press, 1986.

Yaʿqūbī. *Kitāb al-buldān*. Translated by Gaston Wiet as *Les pays*. Cairo: Imprimerie de l'institut français d'archéologie orientale, 1937.

SECONDARY SOURCES

Abu Deeb, Kamal. "Al-Jurjānī's Classification of Istiʿāra with Special Reference to Aristotle's Classification of Metaphor." *Journal of Arabic Literature* 2 (1971): 48–75.

Abu Deeb, Kamal. *Al-Jurjānī's Theory of Poetic Imagery*. Warminster: Aris and Phillips, 1979.

Abu Deeb, Kamal. "Literary Criticism." In *Abbasid Belles-Lettres*. Edited by Julia Ashtiany, T. M. Johnstone, J. D. Latham, R. B. Serjeant, and G. Rex Smith, 339–387. Cambridge: Cambridge University Press, 1990.

Adahl, Karin. "Islamisk konst i svenska samlingar / Islamic art in Swedish collections." In *Islam: Konst och Kultur / Islam: art and culture*, 31–47. Stockholm: Statens Historiska Museum, 1985.

Adahl, Karin. "An Early Islamic Incense Burner of Bronze in a Swedish Collection." *Proceedings of the First European Conference of Iranian Studies*, vol. 2 (1990): 333–345.

Adamova, Adel, et al. *Persia: Thirty Centuries of Art and Culture*. Aldershot, UK: Lund Humphries, 2007.

Adamson, Peter. *The Arabic Plotinus: A Philosophical Study of the Theology of Aristotle*. London: Duckworth, 2002.

Adamson, Peter, and Alexander Key. "Philosophy of Language in the Medieval Arabic Tradition." In *Linguistic Content: New Essays on the History of Philosophy of Language*. Edited by Margaret Cameron and Robert J. Stainton, 74–99. Oxford: Oxford University Press, 2015.

Adamson, Peter, and Peter E. Pormann. *The Philosophical Works of al-Kindī*. Karachi: Oxford University Press, 2012.

Adle, Chahryar. "Un diptyque de foundation en céramique lustrée, Kâšân, 711/1312." In *Art et société dans le monde iranien*. Edited by Chahryar Adle, 199–218. Paris: Éditions Recherche sur les civilisations, 1982.

Afshar, Iradj. "Architectural Information through the Persian Classical Texts." In *Akten des VII. Internationalen Kongresses fur Iranische Kunst und Archaologie: Munchen, 7–10 September 1976*, 612–616. Berlin: D. Reimer, 1979.

Aga-Oglu, Mehmet. "The Use of Architectural Forms in Seljuq Metalwork." *Art Quarterly* 6 (1943): 92–98.

Aga-Oglu, Mehmet. "A Brief Note on Islamic Terminology for Bronze and Brass." *Journal of the American Oriental Society* 64, no. 4 (1944): 218–223.

Aga-Oglu, Mehmet. "About a Type of Islamic Incense Burner." *Art Bulletin* 27, no. 1 (1945): 28–45.

Aga-Oglu, Mehmet. "A Preliminary Note on Two Artists from Nishapur." *Bulletin of the Asia Institute* 6/1–4 and 7/1 (1946): 121–124.

Aga-Oglu, Mehmet. "An Iranian Incense Burner." *Bulletin of the Museum of Fine Arts* 48, no. 271 (1950): 8–10.

Aga-Oglu, Mehmet. "Remarks on the Character of Islamic Art." *The Art Bulletin* 36, no. 3 (1954): 175–202.

Ahmed, Shahab. *What Is Islam? The Importance of Being Islamic.* Princeton, NJ: Princeton University Press, 2016.

Ahsan, Muhammad Manazir. *Social Life under the Abbasids: 170–289 A.H. / 786–902 A.D.* London and New York: Longman, 1979.

Aitken, Molly Emma. *The Intelligence of Tradition in Rajput Court Painting.* New Haven and London: Yale University Press, 2010.

Ajmar, Marta. "Mechanical *Disegno.*" *RIHA Journal* 84 (2014): n.p.

Akkach, Samer. *Cosmology and Architecture in Premodern Islam: An Architectural Reading of Mystical Ideas.* Albany, NY: SUNY Press, 2005.

Alami, Mohammed Hamdouni. *The Origins of Visual Culture in the Islamic World: Aesthetics, Art and Architecture in the Medieval Middle East.* London: I. B. Tauris, 2015.

Alfonso X el Sabio: Sala San Esteban, Murcia, 27 octubre 2009—31 enero 2010. Murcia, Spain: A. C. Novograf, 2009.

Allan, James. "Silver: The Key to Bronze in Islamic Iran." *Kunst des Orients* 11, no. 1/2 (1976/77): 5–21.

Allan, James. *Persian Metal Technology, 700–1300 AD.* London: Ithaca Press for University of Oxford, 1979.

Allan, James. *Islamic Metalwork: The Nuhad Es-Said Collection.* London: Sotheby Parke Bernet, 1982.

Allan, James. *Nishapur: Metalwork of the Early Islamic Period.* New York: Metropolitan Museum of Art, 1982.

Allan, James. *Metalwork of the Islamic World: The Aron Collection.* London: Sotheby's, 1986.

Allan, James. "Manuscript Illumination: A Source for Metalwork Motifs in Late Saljūq Times." In *The Art of the Saljuqs in Iran and Anatolia.* Edited by Robert Hillenbrand, 119–126. Costa Mesa, CA: Mazda, 1993.

Allan, James. "Bronze ii. In Islamic Iran." *Encyclopaedia Iranica.* Vol. 4, Fasc. 5, 471–472.

Allan, James W., and Ruba Kana'an. "The Social and Economic Life of Metalwork, 1050–1250." In *A Companion to Islamic Art and Architecture (Blackwell Companions in Art History,* volume 1. Edited by Finbarr B. Flood and Gülru Necipoğlu, 453–477. Malden, MA: Wiley-Blackwell, 2017.

Allegranzi, Viola. "Royal Architecture Portrayed in Bayhaqī's *Tārīḫ-i Masʿūdī* and Archaeological Evidence from Ghazni (Afghanistan, 10th–12th Century)." *Annali – Università degli studi di Napoli "L'Orientale"* 74 (2014): 95–120.

Alloa, Emmanuel. "Seeing-as, Seeing-in, Seeing-with. Looking through Images." In *Imaging in Philosophy, Science and the Arts.* Edited by Richard Heinrich, Elisabeth Nemen, Wolfram Pichler, and David Wagner, 179–190. Frankfurt: Ontos, 2011.

Angar, Mabi. "Stiftermodelle in Byzanz und bei christlich-orthodoxen Nachbarkulturen." In *Mikroarchitektur im Mittelalter: Ein gattungsübergreifendes Phänomen zwischen Realität und Imagination.* Edited by Christine Kratzke und Uwe Albrecht, 433–453. Leipzig: Kratzke Verlag für Kunst- und Kulturgeschichte, 2008.

Anglade, Elise. *Musée du Louvre: Catalogue des boiseries de la section islamique.* Paris: Réunion des musées nationaux, 1988.

"Acquisitions of the Princeton University Art Museum, 2003." *Record of the Art Museum, Princeton University* 6 (2004): 101–141.

Arberry, A. J. "Orient Pearls at Random Strung." *Bulletin of the School of Oriental and African Studies* 11, no. 4 (1946): 699–712.

Arcak, Sinem. *Gifts in Motion: Ottoman-Safavid cultural exchange, 1501–1618*. PhD diss., University of Minnesota, 2012.

Ardalan, Nader, and Laleh Bakhtiar. *The Sense of Unity: The Sufi Tradition in Persian Architecture*. Chicago: University of Chicago Press, 1973.

Arnold, Thomas W. *Painting in Islam: A Study of the Place of Pictorial Art in Muslim Culture*. New York: Dover, 1965.

L'Art copte en Egypte: 2000 ans de christianisme. Paris: Institut du monde arabe / Gallimard, c. 2000.

Aruz, Joan, Kim Benzel, and Jean M. Evans, eds. *Beyond Babylon: Art, Trade and Diplomacy in the Second Millenium B.C.* New York: Metropolitan Museum of Art, 2008.

Askar, Farouk Sadeq. "Support de jarre (*kilga*) avec un bassin en saillie." In *Trésors fatimides du Caire*. Edited by Marianne Barrucand, 180. Paris: Institut du monde arabe, 1998.

Atıl, Esin. *Art of the Arab World*. Washington, DC: Smithsonian, 1975.

Atıl, Esin, W. T. Chase, and Paul Jett. *Islamic Metalwork in the Freer Gallery of Art*. Washington, DC: Smithsonian, 1985.

d'Avennes, Prisse. *L'art arabe d'après les monuments du Kaire depuis le VIIe siècle jusqu'à la fin du XVIIIe: Texte*. Paris: V. A. Morel, 1877.

Aydın, Hilmi. *The Sacred Trusts: Pavilion of the Sacred Relics*. Somerset, NJ: The Light, 2004.

Babaie, Sussan. "Building for the Shah: The Role of Mīrzā Muḥammad Taqī (Sārū Taqī) in Safavid royal patronage of architecture." In *Safavid Art and Architecture*. Edited by Sheila Canby, 20–26. London: British Museum, 2002.

Bachelard, Gaston. *The Poetics of Space*. Boston: Beacon, 1994.

Badawy, Alexander. "The Prototype of the Coptic Water-Jug Stand." *Archaeology* 20, no. 1 (1967): 56–61.

Baer, Eva. "An Islamic Inkwell in the Metropolitan Museum of Art." In *Islamic Art in the Metropolitan Museum of Art*. Edited by Richard Ettinghausen, 199–211. New York: Metropolitan Museum of Art, 1972.

Baer, Eva. "A Brass Vessel from the Tomb of Sayyid Baṭṭāl Ghāzī: Notes on the Interpretation of Thirteenth-Century Islamic Imagery." *Artibus Asiae* 39, nos. 3/4 (1977): 299–335.

Baer, Eva. *Metalwork in Medieval Islamic Art*. Albany, NY: SUNY Press, 1983.

Baer, Eva. *Ayyubid Metalwork with Christian Images*. Leiden: Brill, 1989.

Baer, Eva. "Jeweled Ceramics from Medieval Islam: A Note on the Ambiguity of Islamic Ornament." *Muqarnas* 6 (1989).

Baer, Eva. *Islamic Ornament*. New York: New York University Press, 1998.

Baer, Eva. "The Human Figure in Early Islamic Art: Some Preliminary Remarks." *Muqarnas* 16 (1999): 32–41.

Baer, Eva. "Zakhrafa." *Encyclopaedia of Islam*. 2nd ed. http://dx.doi.org/10.1163/1573-3912_islam_SIM_8098

Bağcı, Serpil, Filiz Çağman, Günsel Renda, and Zeren Tanındı. *Ottoman Painting*. Ankara: Ministry of Culture and Tourism, 2010.

Bahgat, Aly, and Albert Gabriel. *Fouilles d'al Foustât, publiées les auspices du Comité de conservation des monuments de l'art arabe, par Aly Bahgat bey et Albert Gabriel*. Paris: E. de Boccard, 1921.

Bailey, Doug. *Prehistoric Figurines: Representation and Corporeality in the Neolithic*. London: Routledge, 2005.

Bailey, Doug. "Touch and the Cheirotic Apprehension of Prehistoric Figurines." In *Sculpture and Touch*. Edited by Peter Dent, 27–44. Farnham, Surrey: Ashgate, 2014.

Ballian, Anna. "Three Medieval Islamic Brasses and the Mosul Tradition of Inlaid Metalwork." *Mouseio Benaki* 9 (2009): 113–141.

Barnett, R. D. *A Catalogue of the Nimrud Ivories with Other Examples of Ancient Near Eastern Ivories in the British Museum.* 2nd ed. London: British Museum Publications, 1975.

Barolsky, Paul. "Writing Art History." *The Art Bulletin* 78, no. 3 (1996): 398–400.

Barry, Fabio. "Walking on Water: Cosmic Floors in Antiquity and the Middle Ages." *The Art Bulletin* 89, no. 4 (2007): 627–656.

Baskhanov, Mikhail, Maria Baskhanova, Pavel Petrov, and Nikolaj Serikoff. *Arts from the Land of Timur: An Exhibition from a Scottish Private Collection.* Paisley: Sogdiana Books / Bonhams, 2012.

Basilewsky, Alexander, and Alfred Darcel. *Collection Basilewsky: Catalogue raisonné, précédé d'un essai sur les arts industriels du Ier au XVI siècle.* Paris: Vve A. Morel, 1874.

Bassett, Sarah. "Style and Meaning in the Imperial Panels at San Vitale." *Artibus et Historiae* 57, no. 29 (2008): 49–57.

Bassett, Sarah. "Sculpture and the Rhetorical Imagination in Late Antique Constantinople." In *Archaeology of the Cities of Asia Minor in Late Antiquity.* Edited by Ortwin Dally and Christopher Ratte, 27–41. Ann Arbor, MI: Kelsey Museum, 2011.

Battersby, Christine. *Gender and Genius: Towards a Feminist Aesthetics.* Bloomington: Indiana University Press, 1989.

Bausani, Allesandro. *L'enciclopedia dei fratelli della purità.* Naples: Istituto Universitario Orientale, 1978.

Baxandall, Michael. *Patterns of Intention: On the Historical Explanation of Pictures.* New Haven and London: Yale University Press, 1989.

Bedos-Rezak, Brigitte. "Le sceau et l'art de penser au XIIe siècle." In *Pourquoi les sceaux? La sillographie, nouvel enjeu de l'histoire de l'art.* Edited by Marc Gil and Jean-Luc Chassel, 153–176. Villeneuve-d'Ascq: CEGES, Université Charles de Gaulle-Lille, 2011.

Bedos-Rezak, Brigitte. *When Ego Was Imago: Signs of Identity in the Middle Ages.* Leiden: Brill, 2011.

Bedos-Rezak, Brigitte. "Outcast: Seals of the Medieval West and their Epistemological Frameworks (XIIth–XXIst Centuries)." In *From Minor to Major: The Minor Arts in Medieval History.* Edited by Colum Hourihane, 122–140. University Park: Pennsylvania State University Press, 2012.

van Beek, Gus W. "A New Interpretation of the So-Called South Arabian House Model." *American Journal of Archaeology* 63, no. 3 (1959): 269–273.

Behrendt, Kurt. *The Buddhist Architecture of Gandhara.* Leiden: Brill, 2004.

Behrens-Abouseif, Doris. *Mamluk and Post-Mamluk Metal Lamps.* Cairo: Institut français d'archéologie orientale, 1995.

Behrens-Abouseif, Doris. *Beauty in Arabic Culture.* Princeton, NJ: Markus Wiener, 1999.

Bénazeth, Dominique. "Les encensoirs de la collection copte du Louvre." *Revue du Louvre et des musées de France* 4 (1988): 294–300.

Bénazeth, Dominique. *L'art du métal au début de l'ère chrétienne.* Paris: Musée du Louvre, 1992.

Bénazeth, Dominique. "Support pour jarres à eau." In *L'art copte en Egypte: 2000 ans de christianisme.* Paris: Institut du monde arabe / Gallimard, 2000.

Bénazeth, Dominique. *Catalogue général du Musée copte du Caire: 1. Objets en metal.* Cairo: Institut français d'archéologie orientale, 2001.

Berlekamp, Persis. *Wonder, Image and Cosmos in Medieval Islam.* New Haven and London: Yale University Press, 2011.

Berlekamp, Persis. "Symmetry, Sympathy, and Sensation: Talismanic Efficacy and Slippery Iconographies in Early Thirteenth-Century Iraq, Syria and Anatolia." *Representations* 133 (2016): 59–109.

Bernardini, Michele. "The *masnavī-shahrāshūb*s as Town Panegyrics: An International Genre in Islamic Mashriq." In *Erzhälter Raum in Literaturen der islamischen Welt / Narrated Space in the Literature of the Islamic World*. Edited by Roxane Haag-Higuchi and Christian Szyska, 81–94. Wiesbaden: Harrasowitz Verlag, 2001.

Bernardini, Michele. "Le succès de l'icône du Ṭaq à l'époque islamique." *Oriente Moderno, nuova serie* 23(84), no. 2 (2004): 355–373.

Bettini, Lidia. "Nathr." *Encyclopaedia of Islam*. 2nd ed. http://dx.doi.org/10.1163/1573-3912_islam_COM_1439.

Bey, Max Herz. *Catalogue sommaire des monuments exposés dans le musée national de l'art arabe*. Cairo: Impr. de l'Institut français d'archéologie orientale, 1895.

Beyazıt, Deniz. *Le décor architectural artuqide en pierre de Mardin placé dans son context régional: contribution à l'histoire du décor géométrique et végétal du Proche-Orient des XIIe-XVe siècles*. Oxford: Archaeopress, 2016.

Bienkowski, Piotr, ed. *Treasures from an Ancient Land: The Art of Jordan*. Liverpool: National Museums and Galleries on Merseyside, 1991.

Bier, Carol. "Geometry Made Manifest: Reorienting the Historiography of Ornament on the Iranian Plateau and Beyond." In *The Historiography of Persian Architecture*. Edited by Mohammad Gharipour, 41–79. London: Routledge, 2016.

Bierman, Irene. *Writing Signs: The Fatimid Public Text*. Berkeley: University of California Press, 1998.

Black, Deborah. "Memory, Individuals and the Past in Averroe's Philosophy." *Medieval Philosophy and Theology* 5 (1996): 161–187.

Black, Deborah L. "Imagination and Estimation: Arabic Paradigms and Western Transformations." *Topoi* 19, no. 1 (2000): 59–75.

Blair, Sheila S. "The Madrasa at Zuzan: Islamic Architecture in Eastern Iran on the Eve of the Mongol Invasions." *Muqarnas* 3 (1985): 75–91.

Blair, Sheila S. *The Monumental Inscriptions from Early Islamic Iran and Transoxiana*. Leiden: Brill, 1992.

Blair, Sheila S. *A Compendium of Chronicles: Rashid al-Din's Illustrated History of the World*. London: Nour Foundation, 1995.

Blair, Sheila S. *Islamic Inscriptions*. New York: New York University Press, 1998.

Blair, Sheila S. *Text and Image in Medieval Persian Art*. Edinburgh: Edinburgh University Press, 2014.

Blair, Sheila, and Jonathan Bloom. "Cosmophilia and Its Critics: An Overview of Islamic Ornament." *Beitrage zur Islamischen Kunst und Archäologie herausgegeben von der Ernst-Herzfeld-Gesellschaft* 3 (2012): 39–54.

Bloch, Marc. *The Historian's Craft*. Translated by Joseph R. Strayer. New York: Alfred Knopf, 1953.

Block, Ned. "Seeing-As in the Light of Vision Science." *Philosophy and Phenomenological Research* 89, no. 1 (2014): 560–572.

Bloom, Jonathan. "The Introduction of the Muqarnas into Egypt." *Muqarnas* 5 (1988): 21–28.

Bloom, Jonathan. "The *Qubbat al-Khaḍrāʾ* and the Iconography of Height in Early Islamic Architecture." *Ars Orientalis* 23 (1993): 135–141.

Bloom, Jonathan. *Arts of the City Victorious: Islamic Art and Architecture in Fatimid North Africa and Egypt*. New Haven, CT: Yale University Press and Institute of Ismaili Studies, 2007.

Boehm, Barbara Drake, and Melanie Holcomb, eds. *Jerusalem, 1000–1400: Every People under Heaven*. New York: Metropolitan Museum of Art, 2016.

Bois, Yve-Alain. "On the Uses and Abuses of Look-alikes." *October* 154 (2015): 127–149.

Bonebakker, S. A. "Istiʿāra." *Encyclopaedia of Islam*. 2nd ed. http://dx.doi.org/10.1163/1573-3912_islam_SIM_3675

Bonmariage, Cécile. "De l'amitié et des frères: l'épître 45 des *Rasāʾil Ikhwān al-Ṣafāʾ*. Présentation et traduction annotée." *Bulletin d'études orientales* 58 (2008–2009): 315–50.

Bosworth, Clifford Edmund. "Some Historical Gleanings from the Section on Symbolic Actions in Qalqašandī's *Ṣubḥ al-Aʿšā*." *Arabica* 10, no. 2 (1963): 148–53.

Bosworth, Clifford Edmund. *The Ghaznavids: Their Empire in Afghanistan and Eastern Iran, 994: 1040*. Edinburgh: Edinburgh University Press, 1963.

Bosworth, Clifford Edmund. "Farrukhī's Elegy on Maḥmūd of Ghazna." *Iran* 29 (1991): 43–49.

Bosworth, Clifford Edmund. "Misāḥa (A.)." *Encyclopaedia of Islam*. 2nd ed. http://dx.doi.org/10.1163/1573-3912_islam_COM_0754

Boullata, Kamal. "Visual Thinking and the Arab Semantic Memory." In *Tradition, Modernity and Postmodernity in Arabic Literature: Essays in Honor of Professor Issa J. Boullata*. Edited by Kamal Abdel-Malek and Wael Hallaq, 284–303. Leiden: Brill, 2000.

Bourouiba, Rachid. "Note sur une vasque de pierre trouvée au Palais du Manar de la Qalʿa des Bani Hammad." *Bulletin d'archéologie algérienne* 5 (1971–1975): 235–45.

Bousquet, G.H. "Ghusl." *Encyclopaedia of Islam*. 2nd ed. http://dx.doi.org/10.1163/1573-3912_islam_SIM_2524.

Böwering, Gerhard. "The Light Verse: Qurʾānic Text and Ṣūfī Interpretation." *Oriens* 36 (2001): 113–144.

Brann, Martin, ed. *Excavations at Caerlaverock Old Castle 1998–9*. Dumfries: Dumfries and Galloway Natural History and Antiquarian Society, 2004.

Brend, Barbara. *Islamic Art*. Cambridge, MA: Harvard University Press, 1992.

Brett, Michael. "Population and Conversion to Islam in Egypt in the Medieval Period." In *Egypt and Syria in the Fatimid, Ayyubid and Mamluk Eras*. Edited by Urbain Vermeulen and Jan van Steenbergen, 1–32. Leiden: Brill, 2005.

Brown, Bill. "Thing Theory." In *Things*. Edited by Bill Brown, 1–21. Chicago and London: University of Chicago Press, 2004.

Brown, Robert L. "The Nature and Use of the Bodily Relics of the Buddha in Gandhāra." In *Gandharan Buddhism: Archaeology, Art, Texts*. Edited by Pia Brancaccio and Kurt Behrendt, 182–209. Vancouver: University of British Columbia Press, 2006.

de Bruijn, J. T. P. "Shahrangīz." *Encyclopaedia of Islam*. 2nd. ed. http://dx.doi.org/10.1163/1573-3912_islam_COM_1026.

Brunschvig, R. "Métiers vils en Islam." *Studia Islamica* 16 (1962): 41–60.

de Bruyn, Cornelis. *Voyages de Corneille le Brun par la Muscovie, en Perse, et aux Indes Orientales*. 2 vols. Amsterdam: Wetstein, 1718.

Bucher, François. "Micro-Architecture as the 'Idea' of Gothic Theory and Style." *Gesta* 15, nos. 1/2 (1976): 71–89.

Bulut, Lale. "Painted and Moulded Masks on Barbotine Ware Jars from South-Eastern Anatolia and their Iconographic Significance." In *Art Turc: 10e Congrès international d'art turc*. Edited by François Déroche, 191–195. Geneva: Fondation Max van Berchem, 1999.

Burge, Tyler. *Origins of Objectivity*. Oxford: Oxford University Press, 2010.

Bush, Olga. *Architecture, Poetic Texts and Textiles in the Alhambra*. PhD diss., Institute of Fine Arts, New York University, 2006.

Bush, Olga. "'When My Beholder Ponders': Poetic Epigraphy in the Alhambra." *Artibus Asiae* 66, no. 2 (2006): 55–67.

Bush, Olga. "A Poem Is a Robe and a Castle: Inscribing Verses on Textiles and Architecture in the Alhambra." *Textile Society of America Proceedings*, paper 84. 2008.

Bush, Olga. "The Writing on the Wall: Reading the Decoration of the Alhambra." *Muqarnas* 26 (2009): 119–147.

Bynum, Caroline Walker. "Avoiding the Tyranny of Morphology; Or, Why Compare?" *History of Religions* 53 (2014): 341–368.

de Callataÿ, Godefroid. "Ikhwân al-Safâ: des arts scientifiques et de leur objectif." *Le Muséon* 116, nos. 1–2 (2003): 231–258.

de Callataÿ, Godefroid. *Ikhwan al-Safa': A Brotherhood of Idealists on the Fringe of Orthodox Islam*. Oxford: Oneworld, 2005.

de Callataÿ, Godefroid. "The Classification of Knowledge in the Rasā'il." In *Epistles of the Brethren of Purity: The Ikhwān al-Ṣafā' and their* Rasā'il. Edited by Nader El-Bizri, 58–82. Oxford: Oxford University Press / Institute of Ismaili Studies, 2008.

de Callataÿ, Godefroid. "Philosophy and Bāṭinism in al-Andalus: Ibn Masarra's *Risālat al-I'tibār* and the *Rasā'il Ikhwān al-Ṣafā'*." *Jerusalem Studies in Arabic and Islam* 41 (2014): 261–312.

Camille, Michael. "Before the Gaze: The Internal Senses and Late Medieval Practices of Seeing" In *Visuality Before and Beyond the Renaissance: Seeing as Others Saw*. Edited by Robert S. Nelson, 197–223. Cambridge: Cambridge University Press, 2000.

Campbell, Rachel. *An Archaeological Study of Egyptian Houses, Particularly Those From the Hellenistic Period*. 2 vols. PhD diss., University of Durham, 1984.

Canby, Sheila, Deniz Beyazıt, Martina Rugiadi, and Andrew Peacock. *Court and Cosmos: The Great Age of the Seljuqs*. New York: Metropolitan Museum of Art, 2016.

Canepa, Matthew. *The Two Eyes of the Earth: Art and Ritual Kingship Between Rome and Sasanian Iran*. Berkeley: University of California Press, 2010.

Capezzone, Leonardo. "Remembering, Knowing, Imagining: Approaches to the Topic of Memory in Medieval Islamic Culture." In *Texts in Transit in the Medieval Mediterranean*. Edited by Y. Tzvi Langermann and Robert G. Morrison, 85–100. University Park: Pennsylvania State University Press, 2016.

Cardinalli, Lucilla, Francesca Frassinetti, Claudio Brozzoli, Christian Urquizar, Alice C. Roy, and Alessandro Farné. "Tool-Use Induces Morphological Updating of the Body Schema" *Current Biology* 19, no. 12 (2009): R478–479.

Carey, Moya. "'In the Absence of Originals': Replicating the Tilework of Safavid Isfahan for South Kensington." *International Journal of Islamic Architecture* 3, no. 2 (2014): 397–436.

Carey, Moya, and Margaret Graves. "Introduction: The Historiography of Islamic Art and Architecture, 2012." *Journal of Art Historiography* 6 (2012): 1–15.

Carile, Maria Cristina. "Buildings in Their Patron's Hands? The Multiform Function of Small Size Models between Byzantium and Transcaucasia." *kunsttexte.de* 3 (2014): n.p. https://edoc.hu-berlin.de/bitstream/handle/18452/8347/carile.pdf?sequence=1&isAllowed=y

Carile, Maria Cristina, and Patricia Blessing. "Architectural Illusions and Architectural Representations: Buildings and Space in the Salerno Ivories." In *The Salerno Ivories: Objects, Histories, Contexts*. Edited by Francesca Dell'Aqcqua, Anthony Cutler, Herbert L. Kessler, Avinoam Shalem, and Gerhard Wolf, 111–123. Berlin: Gebr. Mann Verlag, 2016.

Carruthers, Mary. *The Book of Memory: A Study of Memory in Medieval Culture.* Cambridge: Cambridge University Press, 1990.

Carter, Martha L. "A Reappraisal of the Bīmarān Reliquary." In *Gandharan Art in Context: East-West Exchanges at the Crossroads of Asia.* Edited by Raymond Allchin, Bridget Allchin, Neil Kreitman, and Elizabeth Errington, 71–93. Cambridge and New Delhi: Ancient India and Iran Trust / Regency Publications, 1997.

Caseau, Béatrice. "Incense and Fragrances: From House to Church. A Study of the Introduction of Incense in the Early Byzantine Christian Churches." In *Material Culture and Well-Being in Byzantium (400–1453).* Edited by Michael Grünbart, Ewald Kislinger, Anna Muthesius, and Dionysios Ch. Stathakopoulos, 75–92. Vienna: Verlages der Österreichischen Akademie der Wissenschaften, 2007.

Catalogue des objets d'art de l'orient et de l'occident tableaux dessins: composant la collection de feu M. Albert Goupil. Sale catalogue, April 23–28, 1888. Paris: Hotel Drouot, 1888.

Catalogue of the International Exhibition of Persian Art at the Royal Academy of Arts, London, 7th January to 7th March 1931. 3rd ed. London: Office of the Exhibition, n.d. [1931].

de Certeau, Michel. *The Writing of History.* Translated by Tom Conley. New York: Columbia University Press, 1988.

Chalmeta, Pedro. "Markets." In *The Islamic City.* Edited by R. B. Serjeant, 104–113. Paris: UNESCO, 1980.

Chang, Claudia, ed. *Of Gold and Grass: Nomads of Kazakhstan.* Bethesda, MD: Foundation for International Arts and Education, 2006.

Chaumont, Eric. "Wuḍūʾ." *Encyclopaedia of Islam.* 2nd ed. http://dx.doi.org/10.1163/1573-3912_islam_SIM_7925.

Chittick, William C. *The Sufi Path of Knowledge: Ibn al-ʿArabi's Metaphysics of Imagination.* Albany, NY: SUNY Press, 1989.

Christensen, Arthur. *L'Iran sous les Sassanides.* 2nd ed. Copenhagen: Ejnar Munksgaard, 1944.

Church, Jennifer. "'Seeing As' and the Double Bind of Consciousness." *Journal of Consciousness Studies* 7, nos. 8–9 (2000): 99–111.

Clinton, Jerome. *The Divan of Manūchihrī Dāmghānī: A Critical Study.* Minneapolis, MN: Bibliotheca Islamica, 1972.

Clinton, Jerome. "The *Madāen Qasida* of Xāqāni Sharvāni, I." *Edebiyat* 1, no. 2 (1976): 153–170.

Clinton, Jerome. "The *Madāen Qasida* of Xāqāni Sharvāni, II: Xāqāni and al-Buhturī." *Edebiyat* 2, no. 2 (1977): 191–206.

Clinton, Jerome. "Esthetics by Implication: What Metaphors of Craft Tell Us about the 'Unity' of the Persian Qasida." *Edebiyat* 4, no. 1 (1979): 73–96.

Clinton, Jerome. "Šams-i Qays on the Nature of Poetry." In *Studia Arabica et Islamica: Festschrift for Ihsan Abbas on his Sixtieth Birthday.* Edited by Wadad Qadi and Ihsan Abbas, 75–82. Beirut: American University in Beirut Press, 1981.

Clinton, Jerome. "Image and Metaphor: Textiles in Persian Poetry." In *Woven from the Soul, Spun from the Heart: Textile Arts of Safavid and Qajar Iran, 16th–19th Centuries.* Edited by Carol Bier, 7–11. Washington, DC: Textile Museum, 1987.

Cohen, Hayyim J. "The Economic Background and the Secular Occupations of Muslim Jurisprudents and Traditionists in the Classical Period of Islam." *Journal of the Economic and Social History of the Orient* 13, no. 1 (1970): 16–61.

Combe, Étienne, Jean Sauvaget, and Gaston Wiet, eds. *Répertoire chronologique d'épigraphie arabe.* Vol. 8. Cairo: Institut français d'archéologie orientale, 1937.

Crane, Howard. "Helmand-Sistan Project: An Anonymous Tomb in Bust." *East and West* 29 (1979): 241–246.

Creswell, Keppel Archibald Cameron. *Early Muslim Architecture, Part Two: Early 'Abbāsids, Umayyads of Cordova, Aghlabids, Ṭūlūnids, and Samānids.* Oxford: Clarendon Press, 1940.

Creswell, Keppel Archibald Cameron. *Early Muslim Architecture.* 2nd ed., vol. 1, pt. 2. Oxford: Clarendon Press, 1969.

Creswell, Keppel Archibald Cameron. *The Muslim Architecture of Egypt.* 2 vols. New York: Hacker, 1978.

Crone, Patricia. *Meccan Trade and the Rise of Islam.* Princeton, NJ: Princeton University Press, 1988.

Cuneo, Paolo. "Les modèles en pierre de l'architecture arménienne." *Revue des études arméniennes* 8 (1971): 201–231.

Ćurčić, Slobodan. "Evolution of the Middle Byzantine Five-Domed Church Type." In *First Annual Byzantine Studies Conference, Cleveland, 24–25 October 1975* (1975): 31–32.

Ćurčić, Slobodan, and Evangelia Hadjitryphonos, eds. *Architecture as Icon: Perception and Representation of Architecture in Byzantium.* Princeton, NJ: Princeton University Art Museum, 2010.

Dale, Stephen F. "Ibn Khaldun: The Last Greek and the First *Annaliste* Historian." *International Journal of Middle East Studies* 38 (2006): 431–451.

Dale, Stephen F. *The Orange Trees of Marrakesh: Ibn Khaldun and the Science of Man.* Cambridge, MA: Harvard University Press, 2015.

Daneshvari, Abbas. *Medieval Tomb Towers of Iran: An Iconographical Study.* Lexington, KY: Mazda, 1986.

Daneshvari, Abbas. *Animal Symbolism in Warqa wa Gulshāh.* Oxford: Oxford University Press, 1986.

Daryaee, Touraj. "Bazaars, Merchants, and Trade in Late Antique Iran." *Comparative Studies of South Asia, Africa and the Middle East* 30, no. 3 (2010): 401–409.

Davis, Whitney. *A General Theory of Visual Culture.* Princeton, NJ: Princeton University Press, 2011.

Davis, Whitney. "The Archaeology of Radical Pictoriality." In *Images and Imaging in Philosophy, Science and the Arts.* Edited by Richard Heinrich, Elisabeth Nemen, Wolfram Pichler, and David Wagner, 191–218. Frankfurt: Ontos, 2011.

Deleuze, Gilles, and Félix Guattari. *A Thousand Plateaus.* Translated by B. Massumi. London: Continuum, 2004.

DeLong, Alton J. "Phenomenological Space-Time: Toward an Experiential Relativity." *Science* 213, no. 4508 (August 7, 1981): 681–683.

Delpy, Alexandre. "Note sur quelques vestiges de céramique recueillis a Salé." *Hespéris: Archives Berbères et bulletin de l'institut des hautes études marocaines* 42 (1955): 129–152.

Destombes, Marcel, and Edward Stuart Kennedy. "Introduction to *Kitab al-'Amal bil Asturlab.*" In *Studies in the Islamic Exact Sciences.* Edited by Edward Stuart Kennedy, 405–447. Beirut: American University of Beirut, 1983.

Dhaoudi, Mahmoud. "Ibn Khaldun: The Founding Father of Eastern Sociology." *International Sociology* 3 (1990): 319–335.

Dickson, Martin Bernard, and Stuart Cary Welch. *The Houghton Shahnameh.* 2 vols. Cambridge, MA, and London: Harvard University Press, 1981.

Dieterici, Friedrich. *Die Logik und Psychologie der Araber im zehnten Jahrhundert n. Chr.* Leipzig: J. C. Hinrichs'sche Buchhandlung, 1868.

Diez, Ernst. *Churasanische Baudenkmäler*. Berlin: Reimer, 1918.

Diez, Ernst. "Das Erbe der Steppe in der Turko-Iranischen Baukunst." In *Zeki Velidi Toğan'a Armağan: symbolae in honorem Z. V. Togan*, 331–338. Istanbul: Maarif Basımevi, 1950–55.

Diez, Ernst. "Ḳubba." *Encyclopaedia of Islam*. 2nd ed. http://dx.doi.org/10.1163/1573-3912_islam_COM_0532.

Dìez-Fuentes, Helena, ed. *Highlights of the National Museum of Damascus*. Lebanon: Media Minds, 2006.

Dimand, Maurice S. "A Silver Inlaid Bronze Canteen with Christian Subjects in the Eumorfopoulos Collection." *Ars Islamica* 1 (1934): 16–21.

Dimand, Maurice. "Recent Additions to the Near Eastern Collections." *The Metropolitan Museum of Art Bulletin* 7, no. 5 (1949): 136–145.

Dold-Samplonius, Yvonne, and Silvia L. Harmsen. "The Muqarnas Plate Found at Takht-i Sulayman: A New Interpretation." *Muqarnas* 22 (2005): 85–94.

Donohue, Alice A. *Greek Sculpture and the Problem of Description*. Cambridge: Cambridge University Press, 2005.

Drandaki, Anastasia. "From Centre to Periphery and Beyond: The Diffusion of Models in Late Antique Metalware." In *Wonderful Things: Byzantium through Its Art*. Edited by Anthony Eastmond and Liz James, 163–184. Farnham, Surrey: Ashgate, 2013.

Durand-Guédy, David. *Iranian Elites and Turkish Rulers: A History of Iṣfahān in the Saljūq Period*. London: Routledge, 2010.

Durand-Guédy, David. "*Khargāh*: An Inquiry into the Spread of the 'Turkish' Trellis Tent within the ʿAbbāsid World up to the Saljuq Conquest (mid. 2nd/8th–early 5th/11th Centuries)." *Bulletin of the School of Oriental and African Studies* 79, no. 1 (2016): 57–85.

Durand-Guédy, David. "Jamāl al-Din Moḥammad Eṣfahāni." *Encyclopaedia Iranica*. http://www.iranicaonline.org/articles/jamal-al-din-mohammad-esfahani.

Durand-Guédy, David. "Kamāl al-Din Eṣfahāni." *Encyclopaedia Iranica*. http://www.iranicaonline.org/articles/kamal-al-din-esfahani

Durand-Guédy, David. "The Tents of the Saljuqs." In *Turko-Mongol Rulers, Cities and City Life*. Edited by David Durand-Guédy, 149–189. Leiden: Brill, 2013

Duri, A. A. "Baghdād." *Encyclopaedia of Islam*. 2nd ed. http://dx.doi.org/10.1163/1573-3912_islam_COM_0084.

Ecker, Heather, and Teresa Fitzherbert. "The Freer Canteen, Reconsidered." *Ars Orientalis* 42 (2012): 176–193.

Edwards, Holly. "Text, Context, Architext: The Qur'an as Architectural Inscription." In *Brocade of the Pen: The Art of Islamic Writing*. Edited by Carol Garrett Fisher, 63–75. East Lansing, MI: Kresge Art Museum, 1991.

Ekhtiar, Maryam, Priscilla Soucek, Sheila R. Canby, and Navina Najat Haidar, eds. *Masterpieces from the Department of Islamic Art in the Metropolitan Museum of Art*. New York: Metropolitan Museum of Art, 2011.

El-Bizri, Nader. "Prologue." In *Epistles of the Brethren of Purity: The Ikhwān al-Ṣafāʾ and their* Rasāʾil. Edited by Nader El-Bizri, 1–32. Oxford: Oxford University Press / Institute of Ismaili Studies, 2008.

Elias, Jamal. *Aisha's Cushion: Religious Art, Perception and Practice in Islam*. Cambridge, MA: Harvard University Press, 2012.

Elisséeff, Nikita. "An Alabaster Water-Jar." *Bulletin of the Museum of Fine Arts* 45, no. 260 (1947): 35–38.

Elsner, Jaś. "The Rhetoric of Buildings in the *De Aedificiis* of Procopius." In *Art and Text in Byzantine Culture*. Edited by Liz James, 33–57. Cambridge: Cambridge University Press, 2007.

Elsner, Jaś. "Framing the Objects We Study: Three Boxes from Late Roman Italy." *Journal of the Warburg and Courtauld Institutes* 71 (2008): 21–38.

Elsner, Jaś. "Closure and Penetration: Reflections on the Pola Casket." *Acta ad archaeologiam et atrium historiam pertinentia* 26 (2013): 183–227.

Elsner, Jaś. "Relic, Icon and Architecture: The Material Articulation of the Holy in East Christian Art." In *Saints and Sacred Matter: The Cult of Relics in Byzantium and Beyond*. Edited by Cynthia Hahn and Holger Klein, 13–40. Washington, DC: Dumbarton Oaks, 2015.

Epstein, Russell. "Consciousness, Art and the Brain: Lessons from Marcel Proust." *Consciousness and Cognition* 13 (2004): 213–240.

Ergin, Nina. "The Fragrance of the Divine: Ottoman Incense Burners and Their Context." *The Art Bulletin* 96, no. 1 (2014): 70–97.

Erginsoy, Ülker. "Anadolu Selçuklu Madan Sanatı." In *Anadolu selçuklu mimarisinde süsleme ve el sanatları / Architectural decoration and minor arts in Seljuk Anatolian* [*sic*]. Edited by Gönül Öney, 153–178. Ankara: 1978.

Errington, Elizabeth. "Reliquaries in the British Museum." In *Gandharan Buddhist Reliquaries*. Edited by David Jongeward, Elizabeth Errington, Richard Salomon, and Stefan Baums, 111–163. Seattle and London: Early Buddhist Manuscripts Project / University of Washington Press, 2012.

Errington, Elizabeth, and Joe Crib, eds. *The Crossroads of Asia: Transformation in Image and Symbol in the Art of Ancient Afghanistan and Pakistan*. Cambridge: Ancient India and Iran Trust, 1992.

Estany, Anna, and Sergio Martinez. "'Scaffolding' and 'Affordance' as Integrative Concepts in the Cognitive Sciences." *Philosophical Psychology* 27, no. 1 (2014): 98–111.

Ettinghausen, Richard. "Early Shadow Figures." *Bulletin of the American Institute for Persian Art and Archaeology* 3, no. 6 (1934): 10–15.

Ettinghausen, Richard. "The Bobrinsky 'Kettle': Patron and Style of an Islamic Bronze." *Gazette des beaux-arts* 24 (1943): 193–208.

Ettinghausen, Richard. *Studies in Muslim Iconography, I: The Unicorn*. Freer Gallery of Art Occasional Papers 1, no. 3. Washington, DC: Smithsonian, 1950.

Ettinghausen, Richard. "Some Comments on Medieval Iranian Art." *Artibus Asiae* 31, no. 4 (1969): 276–300.

Ettinghausen, Richard. "The Flowering of Seljuq Art." *Metropolitan Museum Journal* 3 (1970): 113–131.

Ettinghausen, Richard. "Islamic Art." *Metropolitan Museum of Art Bulletin* 33, no. 1 (1975): 1–53.

Ettinghausen, Richard. "Introduction." In *The Islamic Garden: Dumbarton Oaks Colloquium on the History of Landscape Architecture IV*. Edited by Elizabeth B. Macdougall and Richard Ettinghausen. Washington, DC: Dumbarton Oaks, 1976.

Ettinghausen, Richard, Oleg Grabar, and Marilyn Jenkins-Madina. *Islamic Art and Architecture: 650–1250*. London: Yale University Press, 2001.

Evans, Helen C., and Brandie Ratliff, eds. *Byzantium and Islam: Age of Transition, 7th–9th Century*. New York: Metropolitan Museum of Art, 2012.

Ewert, Christian. "Architectural Décor on the Ivories of Muslim Spain—'Dwarf' Architecture in al-Andalus." *Journal of the David Collection* 2, no. 1 (2005): 101–115.

Fahd, T. "Les corps de métiers au IV/Xe siècle a Baġdād: d'après le chapitre XII d'*al-Qâdirî fî-t-ta'bîr* de Dînawarî." *Journal of the Economic and Social History of the Orient* 8, no. 2 (1965): 186–212.

Falser, Michael. "The *Graeco-Buddhist style of Gandhara*—a 'Storia ideologica,' or: How a Discourse Makes a Global History of Art." *Journal of Art Historiography* 13 (2015): 1–53.

Faroqhi, Suraiya. *Artisans of Empire: Crafts and Craftsmen under the Ottomans.* London: I. B. Tauris, 2009.

Fehérvári, Géza. *Islamic Metalwork of the Eighth to the Fifteenth Century in the Keir Collection.* London: Faber and Faber, 1976.

Fehérvári, Géza. *Ceramics of the Islamic World in the Tareq Rajab Museum.* London and New York: I. B. Tauris, 2000.

Fehérvári, Géza. "Islamic Incense-Burners and the Influence of Buddhist Art." In *The Iconography of Islamic Art: Studies in Honour of Robert Hillenbrand.* Edited by Bernard O'Kane, 127–141. Edinburgh: Edinburgh University Press, 2005.

Fehérvári, Géza. "Samanid or Ghaznavid? An Early Islamic Incense-Burner from the Iranian World." *Hadeeth ad-Dar* 23 (2007): 46–50.

Fikri, Ahmad. *Masājid al-Qāhirah wa-madārisuhā.* 3 vols. Cairo: Dār al-Maʿārif, 1961.

Finnestad, Ragnhild Bjerre. "Temples of the Pharaonic and Roman Periods: Ancient Traditions in New Contexts." In *Temples of Ancient Egypt.* Edited by Byron A. Shafer, 207–217. Ithaca, NY: Cornell University Press, 1997.

Fischer, Felice, ed. *Philadelphia Museum of Art: Handbook of the Collections.* Philadelphia: Museum of Art, 1995.

Fitzherbert, Teresa. "The Freer Canteen: Jerusalem or Jazira?" In *Islamic Art, Architecture and Material Culture: New Perspectives.* Edited by Margaret S. Graves, 1–6. Oxford: BAR, 2012.

Flood, Finbarr Barry. "The Earliest Islamic Windows as Architectural Decoration: Some Iranian Influences on Umayyad Iconography, Observations and Speculations." *Persica* 14 (1990–92): 67–89.

Flood, Finbarr Barry. "Umayyad Survivals and Mamluk Revivals: Qalawunid Architecture and the Great Mosque of Damascus." *Muqarnas* 14 (1997): 57–79.

Flood, Finbarr Barry. "Light in Stone: The Commemoration of the Prophet in Umayyad Architecture." In *Bayt al-Maqdis, Part 2: Jerusalem and Early Islam (Oxford Studies in Islamic Art).* Edited by Jeremy Johns, 311–359. Oxford: Oxford University Press, 2000.

Flood, Finbarr Barry. *The Great Mosque of Damascus: Studies on the Making of an Umayyad Visual Culture.* Leiden: Brill, 2001.

Flood, Finbarr Barry. "Between Cult and Culture: Bamiyan, Islamic Iconoclasm and the Museum." *The Art Bulletin* 84, no. 4 (2002): 641–659.

Flood, Finbarr Barry. "Painting, Monumental and Frescoes." In *Medieval Islamic Civilization: An Encyclopedia.* 2 vols. Edited by Josef Meri, 2:586–590. New York: Routledge, 2006.

Flood, Finbarr Barry. *Objects of Translation: Material Culture and Medieval "Hindu-Muslim" Encounter.* Princeton, NJ: Princeton University Press, 2009

Flood, Finbarr Barry. "Islamic Identities and Islamic Art: Inscribing the Qur'an in Twelfth-Century Afghanistan." In *Dialogues in Art History, from Mesopotamian to Modern: Readings for a New Century.* Edited by Elizabeth Cropper, 91–117. Washington, DC: National Gallery of Art, 2009.

Flood, Finbarr Barry. "A Ghaznavid Narrative Relief and the Problem of Pre-Mongol Persian Book Painting." In *Siculo-Arabic Ivories and Islamic Painting 1100–1300.* Edited by David Knipp, 259–272. Chicago: University of Chicago Press, 2011.

Flood, Finbarr Barry. "Gilding, Inlay and the Mobility of Metallurgy: A Case of Fraud in Medieval Kashmir." In *Metalwork and Material Culture in the Islamic World: Art, Craft and Text. Essays Presented to James Allan*. Edited by Venetia Porter and Mariam Rosser-Owen, 131–142. London and New York: I. B. Tauris, 2012.

Flood, Finbarr Barry. "The Qur'an." In *Byzantium and Islam: Age of Transition, 7th–9th Century*. Edited by Helen C. Evans and Brandie Ratliff, 265–269. New York: Metropolitan Museum of Art, 2012.

Flood, Finbarr Barry. "The Flaw in the Carpet: Disjunctive Contiguituies and Riegl's Arabesque." In *Histories of Ornament: From Global to Local*. Edited by Gülru Necipoğlu and Alina Payne, 82–93. Princeton: Princeton University Press, 2016.

Flood, Finbarr Barry. "Picasso the Muslim: Or, How the Bilderverbot Became Modern (Part 1)." *RES: Anthropology and Aesthetics* 67/68 (2016/2017): 42–60.

Focillon, Henri. *The Life of Forms in Art*. Translated by Charles Beecher Hogan and George Kubler. New York: George Wittenborn, 1948.

Foucault, Michel. *The Order of Things: An Archaeology of the Human Sciences*. New York: Pantheon Books, 1970.

Franke, Ute, and Martina Müller-Weiner, eds. *Ancient Herat Vol. 3—Herat through Time: The Collections of the Herat Museum and Archive*. Berlin: Staatliche Museen zu Berlin—Preußischer Kulturbesitz and Ancient Herat Project, 2016.

Frommel, Sabine, ed. *Les maquettes d'architecture: function et évolution d'un instrument de conception et de réalisation*. Paris and Rome: Picard / Campisano Editore, 2015.

Fudge, Bruce. "Signs of Scripture in 'The City of Brass.'" *Journal of Qur'anic Studies* 8, no. 1 (2006): 88–118.

Gacek, Adam. "Instructions on the Art of Bookbinding Attributed to the Rasulid Ruler of Yemen Al-Malik al-Muzaffar." In *Scribes et manuscrits du Moyen-Orient*. Edited by François Déroche and Francis Richard, 57–63. Paris: BnF, 1997.

Gascoigne, Alison. "Cooking Pots and Choices in the Medieval Middle East." In *Pottery and Social Dynamics in the Mediterranean and Beyond in Medieval and Post-Medieval Times*. Edited by John Bintliff and Marta Carascio, 1–10. Oxford: British Archaeological Reports, 2013.

Gelber, Metzada. "Objects and Buildings—Links and Messages." *Assaph* 12 (2007): 37–48.

Gelber, Metzada. "A Poetic Vessel from Everyday Life: The Freer Incense Burner." *Ars Orientalis* 42 (2012): 23–30.

George, Alain. "Calligraphy, Colour and Light in the Blue Qur'an." *Journal of Qur'anic Studies* 11, no. 1 (2009): 75–125.

George, Alain. *The Rise of Islamic Calligraphy*. London: I. B. Tauris, 2010.

George, Alain. "The Illustrations of the *Maqāmāt* and the Shadow Play." *Muqarnas* 28 (2011): 1–42.

Al-Ghabban, Ali Ibrahim, Béatrice André-Salvini, Carine Juvin, Sophie Makariou, and Françoise Demange, eds. *Routes d'Arabie: Archéologie et histoire du Royaume d'Arabie Saoudite*. Paris: Somogy / Louvre, 2010.

Ghabin, Ahmad. "Ṣinā'a." *Encyclopaedia of Islam*, 2nd ed. http://dx.doi.org/10.1163/1573-3912_islam_SIM_7042

Ghabin, Ahmad. *Ḥisba, Arts and Craft in Islam*. Wiesbaden: Harrassowitz Verlag, 2009.

Ghirshman, R. "Les fouilles de Châpour (Iran), deuxième campagne 1936/7." *Revue des arts asiatiques* 12 (1938): 12–19.

Ghazarian, Armen, and Robert Ousterhout. "A Muqarnas Drawing from Thirteenth-Century Armenia and the Use of Architectural Drawings During the Middle Ages." *Muqarnas* 18 (2001): 141–154.

Gibson, Melanie. "The Enigmatic Figure: Ceramic Sculpture from Iran and Syria *c.* 1150–1250." *Transactions of the Oriental Ceramics Society* 73 (2008–09): 39–50.

Gibson, Melanie. "A Symbolic *Khassakiyya*: Representations of the Palace Guard in Murals and Stucco Sculpture." In *Islamic Art, Architecture and Material Culture: New Perspectives.* Edited by Margaret Graves, 81–91. Oxford: British Archaeological Reports, 2012.

Giunta, Roberta. *Les inscriptions funéraires de Gaznī.* Naples: Istituto Italiano per l'Africa e l'Oriente Fondation Max Van Berchem, 2003.

Giunta, Roberta. "New Epigraphic Data from the Excavations of the Ghaznavid Palace of Mas'ūd III at Ghazni (Afhganistan)." In *South Asian Archaeology 2007: Proceedings of the 19th Meeting of the European Association of South Asian Archaeology in Ravenna, Italy, July 2007.* Edited by Pierfrancesco Callieri and Luca Colliva, 123–131. Oxford: British Archaeological Reports, 2010.

Giuzal'ian, L. T. "Tri iranskich srednevekovych glinianych stolinka." *Issledovaniya po istorii kul'tury naradov vostoka: sbornik v vest' akademika I.A. Orbeli* (1960): 313–319.

Giuzal'ian, L. T. "The Bronze Qalamdan (Pen-Case) 542/1148 from the Hermitage Collection." *Ars Orientalis* 7 (1968): 95–119.

Gladiss, Almut von. "Räuchergefäß mit Zange." In *Europa und der Orient, 800–1900.* Edited by Gereon Sievernich und Hendrik Budde, 523–524. Berlin: Bertelsmann Lexikon Verlag, 1989.

Gladiss, Almut von. "Lantern: Morocco, 14th Century." In *A Collector's Fortune: Islamic Art from the Collection of Edmund de Unger.* Edited by Claus-Peter Haase, 113–114. Berlin and Munich: Staatliche Musee zu Berlin / Himler Verlag, 2007.

Gladiss, Almut von, ed. *Die Dschazira: Kulturlandschaft zwischen Euphrat und Tigris.* Berlin: Staatliche Museen zu Berlin—Stiftung Preussischer Kulturbesitz, 2006.

Goitein, Shelomo Dov. "Cairo: An Islamic City in the Light of the Geniza Documents." In *Middle Eastern Cities.* Edited by Ira M. Lapidus, 80–96. Berkeley and Los Angeles: University of California Press, 1969.

Goldman, Bernard. "Persian Domed Turibula." *Studia Iranica* 20, no. 2 (1991): 179–188.

Goldziher, Ignaz. "Die Handwerke bei den Arabern." *Globus: Illustrierte Zeitschrift für Lander und Völkerkunde* 66 (1894): 203–205.

Goldziher, Ignaz. *Abhandlungen zur arabischen Philologie.* 2 vols. Leiden: Brill, 1896.

Golombek, Lisa. *The Timurid Shrine at Gazur Gah: An Iconographical Interpretation of Architecture.* Toronto: Royal Ontario Museum, 1969.

Golombek, Lisa. "The Draped Universe of Islam." In *Content and Context of the Visual Arts in Islam.* Edited by Priscilla Soucek, 25–50. University Park: Pennsylvania State University Press, 1988.

Golombek, Lisa. "The 'Kubachi Problem' and the Isfahan Workshop." In *Persian Pottery in the First Global Age: The Sixteenth and Seventeenth Centuries.* Edited by Lisa Golombek, Robert Mason, Patricia Proctor, and Eileen Reilly, 169–181. Leiden: Brill, 2014.

Golvin, Lucien. *Recherches Archéologiques à la Qal'a des Banû Hammâd (Algérie).* Paris: G.-P. Maisonneuve et Larose, 1965.

Gombrich, Ernst. *Art and Illusion: A Study in the Psychology of Pictorial Representation.* New York: Pantheon, 1960.

Gombrich, Ernst. *The Sense of Order: A Study in the Psychology of Decorative Art.* 2nd ed. London: Phaidon, 2012.

Gonzalez, Valérie. *Beauty and Islam: Aesthetics in Islamic Art and Architecture.* London: I. B. Tauris, 2001.

Gosden, Chris. "What Do Objects Want?" *Journal of Archaeological Method and Theory* 12, no. 3 (2005): 193–211.

Gousset, Marie-Thérèse. "Un aspect du symbolism des encensoirs romans: la Jérusalem Céleste." *Cahiers Archéologiques* 30 (1982): 81–106.

Grabar, Oleg. "The Umayyad Dome of the Rock in Jerusalem." *Ars Orientalis* 3 (1959): 33–62.

Grabar, Oleg. "The Islamic Dome: Some Considerations." *Journal of the Society of Architectural Historians* 22, no. 4 (1963): 191–198.

Grabar, Oleg. "The Earliest Islamic Commemorative Structures, Notes and Documents." *Ars Orientalis* 6 (1966): 7–46.

Grabar, Oleg. "The Visual Arts: 1050–1350." In *The Cambridge History of Iran, Vol. 5: The Saljuq and Mongol Periods*. Edited by J. A. Boyle, 626–658. Cambridge: Cambridge University Press, 1968.

Grabar, Oleg. "Les arts mineurs de l'Orient musulman à partir du milieu du XIIe siècle." *Cahiers de civilisation médiévale* 42 (1968): 181–190.

Grabar, Oleg. "The Illustrated *Maqamat* of the Thirteenth Century: The Bourgeoisie and the Arts." In *The Islamic City: A Colloquium [held at All Souls College, June 28–July 2, 1965]*. Edited by Albert Hourani and Samuel Miklos Stern, 207–222. Oxford: Cassirer, 1970.

Grabar, Oleg. "An Art of the Object." *Artforum* 14 (1976): 36–43.

Grabar, Oleg. *The Formation of Islamic Art*. Rev. ed. New Haven and London: Yale, 1987.

Grabar, Oleg. "Between Connoisseurship and Technology: A Review." *Muqarnas* 5 (1988): 1–8.

Grabar, Oleg. "From Dome of Heaven to Pleasure Dome." *Journal of the Society of Architectural Historians* 49 (1990): 15–21.

Grabar, Oleg. *The Mediation of Ornament*. Washington, DC: A.W. Mellon Lectures, 1992.

Grabar, Oleg. *The Shape of the Holy: Early Islamic Jerusalem*. Princeton, NJ: Princeton University Press, 1996.

Grabar, Oleg. "The Shared Culture of Objects." In *Byzantine Court Culture from 829 to 1204*. Edited by Henry Maguire, 115–129. Washington, DC: Dumbarton Oaks, 1997.

Grabar, Oleg. "Imperial and Urban Art in Islam: The Subject Matter of Fatimid Art." Reprinted in *Constructing the Study of Islamic Art, Volume. I: Early Islamic Art, 650–1100*, 215–241. Burlington, VT: Ashgate, 2005.

Grabar, Oleg. *The Dome of the Rock*. Cambridge, MA: Harvard University Press, 2006.

Grabar, Oleg, and Renata Holod. "A Tenth-Century Source for Architecture." *Harvard Ukrainian Studies* 3, no. 6 (1979–80): 310–319.

de la Granja, Fernando. "Fiestas Cristianas en al-Andalus (materiales para su studio), I: 'Al-Durr al-munazzam' de al-ʿAzafî." *Al-Andalus* 34, no. 1 (1969): 1–53.

Graves, Margaret S. "Ceramic House Models from Medieval Persia: Domestic Architecture and Concealed Activities." *Iran: Journal of the British Institute of Persian Studies* 46 (2008): 227–252.

Graves, Margaret S. "Treasuries, Tombs and Reliquaries: A Group of Ottoman Architectural Qur'an Boxes of Architectural Form." In *The Meeting Place of British Middle East Studies*. Edited by Amanda Phillips and Refqa Abu-Remaileh, 78–98 and plates. Newcastle: Cambridge Scholars Publishing, 2009.

Graves, Margaret S. *Worlds Writ Small: Four Studies on Miniature Architectural Forms in the Medieval Middle East*. PhD diss., University of Edinburgh, 2010.

Graves, Margaret S. "Inside and Outside, Picture and Page: The Architectural Spaces of Miniature Painting." In *Treasures of the Aga Khan Museum: Architecture in Islamic Arts*. Edited by Margaret S. Graves and Benoît Junod, 295–303. Geneva: Aga Khan Trust for Culture, 2011.

Graves, Margaret S. "The Aesthetics of Simulation: Architectural Mimicry on Medieval Ceramic Tabourets." In *Islamic Art, Architecture and Material Culture: New Perspectives.* Edited by Margaret S. Graves, 63–80. Oxford: British Archaeological Reports, 2012.

Graves, Margaret S. "Feeling Uncomfortable in the Nineteenth Century." *Journal of Art Historiography* 6 (2012): n.p.

Graves, Margaret S. "Kashan Ware." *Encyclopaedia Iranica.* Edited by Ehsan Yarshater. New York: Columbia University, 2014. http://www.iranicaonline.org/articles/kashan-vii-kashan-ware.

Graves, Margaret S. "The Monumental Miniature: Liquid Architecture in the *Kilga*s of Cairo." *Art History* 38, no. 2 (2015): 304–323.

Graves, Margaret S. "The Lamp of Paradox." *Word & Image* (forthcoming).

Graves, Margaret S. "Say Something Nice: Supplications on Medieval Objects, and Why They Matter." In *Studying the Near and Middle East at the Institute for Advanced Study, Princeton, 1936–2018.* Edited by Sabine Schmidtke. Piscataway, NJ: Gorgias Press, forthcoming.

Graves, Margaret S., and Benoît Junod, eds. *Treasures of the Aga Khan Museum: Architecture in Islamic Arts.* Geneva: Aga Khan Trust for Culture, 2011.

Greenhaigh, Michael. *Marble Past, Monumental Present: Building with Antiquities in the Mediaeval Mediterranean.* Leiden: Brill, 2009.

Grehan, James. *Twilight of the Saints: Everyday Religion in Ottoman Syria and Palestine.* New York: Oxford University Press, 2014.

Grube, Ernst. "Raqqa-Keramik in der Sammlung des Metropolitan Museum in New York." *Kunst des Orients* 4 (1963): 42–78.

Grube, Ernst. Cobalt and Lustre: *The First Centuries of Islamic Pottery: The Nasser D. Khalili Collection of Islamic Art, vol. 9.* London: Nour Foundation, 1994.

Grube Ernst, and Jeremy Johns. *The Painted Ceilings of the Cappella Palatina.* Genova: Bruschettini Foundation for Islamic and Asian Art, 2005.

Gruber, Christiane. "Jersualem in the Visual Propaganda of Post-Revolutionary Iran." In *Jerusalem: Idea and Reality.* Edited by Suleiman Mourad and Tamar Mayer, 168–197. London: Routledge, 2008.

Gruber, Christiane. "Islamic Architecture on the Move." *International Journal of Islamic Architecture* 3, no. 2 (2014): 241–264.

Gruendler, Beatrice. "Aspects of Craft in the Arabic Book Revolution." In *Globalization of Knowledge in the Post-Antique Mediterranean, 700–1500.* Edited by Sonja Brentjes and Jurgen Renn, 31–66. London and New York: Routledge, 2016.

Gruendler, Beatrice. "Fantastic Aesthetics and Practical Criticism in Ninth-Century Baghdad." In *Takhyīl: The Imaginary in Classical Arabic Poetics.* Edited by Geert Jan van Gelder and Marlé Hammond, 196–220. Oxford: Oxbow, 2008.

Guo, Qinghua. *The mingqi Pottery Buildings of Han Dynasty China 206 BC–AD 220: Architectural Representations and Represented Architecture.* Brighton and Portland, OR: Sussex Academic Press, 2010.

Gutas, Dimitri. *Avicenna and the Aristotelian Tradition.* Leiden: Brill, 1988.

Gutas, Dimitri. "Avicenna: The Metaphysics of the Rational Soul." *The Muslim World* 102 (2012): 417–425.

Haase, Claus-Peter, ed. *A Collector's Fortune: Islamic Art from the Collection of Edmund de Unger.* Berlin: Museum fur Islamische Kunst, 2008.

Hahn, Cynthia. "The Voices of the Saints: Speaking Reliquaries." *Gesta* 36, no. 1 (1997): 20–31.

Hahn, Cynthia. "Metaphor and Meaning in Early Medieval Reliquaries." In *Seeing the Invisible in Late Antiquity and the Early Middle Ages.* Edited by Giselle de Nie, Karl F. Morrison, and Marco Mostert, 239–263. Turnhout: Brepols, 2005.

Hahn, Cynthia. *Strange Beauty: Issues in the Making and Meaning of Reliquaries, 400–circa 1204.* University Park: Pennsylvania State University Press, 2012.

Hamdani, Abbas. "The *Rasa'il Ikhwan al-Safa'* and the Controversy about the Origin of Craft Guilds in Early Medieval Islam." In *Money, Land and Trade: An Economic History of the Muslim Mediterranean.* Edited by Nelly Hanna, 157–173. London: I. B. Tauris, 2002.

Hamdani, Abbas. "The Arrangement of the *Rasā'il Ikhwān al-Ṣafā'* and the Problem of Interpolations." In *Epistles of the Brethren of Purity: The Ikhwān al-Ṣafā' and Their Rasa'il.* Edited by Nader El-Bizri, 81–100. Oxford: Oxford University Press / Institute of Ismaili Studies, 2008.

Hamdy, Ahmad, ed. *Islamic Art in Egypt, 969–1517.* Cairo: Ministry of Culture of the United Arab Republic, 1969.

Hamilton, Andrew. *Scale and the Incas.* Princeton, NJ: Princeton University Press, 2018.

Hamilton, R. W. *Khirbat al Mafjar: An Arabian Mansion in the Jordan Valley.* Oxford: Clarendon Press, 1959.

Harari, Ralph. "Metalwork after the Early Islamic Period." In *A Survey of Persian Art.* 15 vols. 2nd. ed. Edited by Arthur Upham Pope and Phyliss Ackerman, 5:2466–529. London and New York: Oxford University Press, 1964.

Harb, Ulrich. *Ilkhanidische Stalaktitengewölbe: Beiträge zu Entwurf un Bautechnik.* Berlin: Dietrich Reimer Verlag, 1978.

Harding, G. Lankester. "Excavations on the Citadel, Amman." *Annual of the Department of Antiquities, Jordan* 1 (1951): 7–16.

Hardy-Gilbert, Claire, and Sterenn Le Maguer. "Chihr de l'encens (Yémen)." *Arabian Archaeology and Epigraphy* 21 (2010): 46–70.

Harper, Prudence O. "From Earth to Heaven: Speculation on the Form of the Achaemenid Censer." *Bulletin of the Asia Institute* 19 (2005): 47–56.

al-Hassan, A. Y. "Iron and Steel Technology in Medieval Arabic Sources." *Journal for the History of Arabic Science* 2, no. 1 (1978): 31–43.

Hasse, Dag Nikolaus. "Avicenna's Epistemological Optimism." In *Interpreting Avicenna: Critical Essays.* Edited by Peter Adamson, 109–119. Cambridge: Cambridge University Press, 2013.

Hay, Jonathan. "Editorial: The Value of Forgery." *RES: Anthropology and Aesthetics* 53/54 (2008): 5–19.

Hay, Jonathan. *Sensuous Surfaces: The Decorative Object in Early Modern China.* Honolulu: University of Hawaii Press, 2010.

Hay, Jonathan. "The Passage of the Other." In *Histories of Ornament: From Global to Local.* Edited by Gülru Necipoğlu and Alina Payne, 62–69. Princeton, NJ: Princeton University Press, 2016.

Heath, Peter. *Allegory and Philosophy in Avicenna (Ibn Sînâ): With a Translation of the Book of the Prophet Muhammad's Ascent to Heaven.* Philadelphia: University of Pennsylvania Press, 1992.

Heidegger, Martin. *What Is Called Thinking?* Translated by J. Glenn Gray. New York: Perennial, 1976.

Heidemann, Stefan. "The History of the Industrial and Commercial Area of 'Abbāsid al-Raqqa, Called al-Raqqa al-Muḥtariqa." *Bulletin of the School of Oriental and African Studies* 69, no. 1 (2006): 33–52.

Heidemann, Stefan. "How to Measure Economic Growth in the Middle East? A Framework of Enquiry for the Middle Islamic Period." In *Material Evidence and Narrative Sources: Interdisciplinary Studies of the History of the Muslim Middle East.* Edited by Daniella Talmon-Heller and Katia Cytryn-Silverman, 30–57. Leiden: Brill, 2014.

Heinrichs, Wolfhart P. *The Hand of the Northwind: Opinions on Metaphor and the Early Meaning of Istiʿāra in Arabic Poetics*. Wiesbaden: Steiner, 1977.

Heinrichs, Wolfhart P. "*Istiʿārah* and *Badīʿ* and Their Terminological Relationship in Early Arabic Literary Criticism." *Zeitschrift für Geschichte der Arabisch-Islamischen Wissenschaften* 1 (1984): 180–211.

Hienrichs, Wolfhart P. "*Takhyīl*: Make-Believe and Image Creation in Medieval Arabic Literary Theory." In *Takhyīl: The Imaginary in Classical Arabic Poetics*. Edited by Geert Jan van Gelder and Marlé Hammond, 1–14. Oxford: Oxbow, 2008.

Heinrichs, Wolfhart P. "Ramz." *Encyclopaedia of Islam*. 2nd ed. http://dx.doi.org/10.1163/1573-3912_islam_COM_0909

Henderson, Julian, Keith Challis, Sarah O'Hara, and Sean McLoughlin. "Experiment and Innovation: Early Islamic Industry at al-Raqqa, Syria." *Antiquity* 79 (2005): 130–45.

Hill, Donald R. "*Mikyās*." *Encyclopaedia of Islam*. 2nd ed. http://dx.doi.org/10.1163/1573-3912_islam_SIM_5196

Hillenbrand, Robert. "Eastern Islamic Influences in Syria: Raqqa and Qalʿat Jaʿbar in the Later 12th Century." In *The Art of Syria and the Jazira, 1100–1250*. Edited by Julian Raby, 21–48. Oxford: Oxford University Press, 1985.

Hillenbrand, Robert. "The Relationship between Book Painting and Luxury Ceramics in Thirteenth-Century Iran." In *The Art of the Saljuqs in Iran and Anatolia: Proceedings of a Symposium Held in Edinburgh in 1982*. Edited by Robert Hillenbrand, 134–141. Costa Mesa, CA: Mazda, 1994.

Hillenbrand, Robert. *Islamic Architecture: Form, Function and Meaning*. 2nd ed. Edinburgh: Edinburgh University Press, 2000.

Hillenbrand, Robert. "Qasr Kharana Re-examined." In *Studies in Medieval Architecture, Vol. I*, 480–494. London: Pindar Press, 2001.

Hillenbrand, Robert. "Erudition Exalted: The Double Frontispiece to the Epistles of the Sincere Brethren." In *Beyond the Legacy of Genghis Khan*. Edited by Linda Komaroff, 183–212. Leiden: Brill, 2006.

Hillenbrand, Robert. "Oleg Grabar: The Scholarly Legacy." *Journal of Art Historiography* 6 (2012): 1–35.

Hillenbrand, Robert. "Islamic Monumental Inscriptions Contextualized: Location, Content, Legibility and Aesthetics." In *Beiträge zur Islamischen Kunst und Archäologie: herausgegeben von der Ernst-Herzfeld-Gesellschaft, Band 3*. Edited by Lorenz Korn and Anja Heidenreich, 13–38. Weisbaden: Reichert Verlag, 2012.

Hobson, R. L. *Guide to the Islamic Pottery of the Near East*. London: British Museum, 1932.

Holod, Renata. "Text, Plan and Building: On the Transmission of Architectural Knowledge." In *Theories and Principles of Design in the Architecture of Islamic Societies*. Edited by Margaret Ševčenko, 1–12. Cambridge MA: Aga Khan Program for Islamic Architecture, 1988.

Hoffman, Eva R. "Pathways of Portability: Islamic and Christian Interchange from the Tenth to the Twelfth Century." *Art History* 24, no. 1 (2001): 17–50.

Hoffman, Eva R. "Christian-Islamic Encounters on Thirteenth-Century Ayyubid Metalwork: Local Culture, Authenticity, and Memory." *Gesta* 43, no. 2 (2004): 129–142.

Hoffman, Eva R. "Between East and West: The Wall Paintings of Samarra and the Construction of an Abbasid Princely Culture." *Muqarnas* 25 (2008): 107–132.

Holly, Michael Ann, "Notes from the Field: Materiality." *The Art Bulletin* 95, no. 1 (2013): 15–17.

Hölscher, Uvo. *The Excavation of Medinet Habu, Volume V: Post-Ramessid Remains*. Chicago: University of Chicago Press, 1954.

Hong, Jeehee. "Mechanism of Life for the Netherworld: Transformations of *Mingqi* in Middle-Period China." *Journal of Chinese Religions* 43, no. 2 (2015): 161–193.

Hong, Jeehee. *Theater of the Dead: A Social Turn in Chinese Funerary Art, 1000–1400*. Honolulu: University of Hawai'i Press, 2016.

Hong, Jeehee. "Crafting Boundaries of the Unseeable World: Dialectics of Space in the Bhagavat Sutra Repository." *Art History* 40, no. 1 (2017): 10–37.

Hopkins, Robert. "Sculpture and Space." In *Imagination, Philosophy and the Arts*. Edited by Matthew Keiran and Dominic Lopes, 272–290. New York: Routledge, 2003.

Hourani, George F. "A Revised Chronology of Ghazālī's Writings." *Journal of the American Oriental Society* 104 (1984): 289–302.

Huizinga, J. *Homo Ludens: A Study of the Play Element in Culture*. London: Routledge and Kegan Paul, 1949.

Hung, Wu. "The Invisible Miniature: Framing the Soul in Chinese Art and Architecture." *Art History* 38, no. 2 (2015): 286–302.

Hutchby, Ian. "Technologies, Texts and Affordances." *Sociology* 35 (2001): 441–56.

Ibrahim, Laila 'Ali. "Middle-Class Living Units in Mamluk Cairo: Architecture and Terminology." *AARP (Art and Archaeology Research Papers)* 14 (1978): 24–30.

Ibrahim, Laila 'Ali. "Clear Fresh Water in Medieval Cairene Houses." *Islamic Archaeological Studies* 1 (1978): 1–25.

Ibrahim, Laila 'Ali, and Muhammad M. Amin. *Architectural Terms in Mamluk Documents*. Cairo: American University in Cairo Press, 1990.

Ieni, Giulio. "La rappresentazione dell'oggetto architettonico nell'arte medieval con riferimento particolare ai modelli di architettura Caucasici." *Atti del primo simposia internazionale di arte armena*, 247–264. Venice: 1975.

Ingold, Tim. "Materials against Materiality." *Archaeological Dialogues* 14, no. 1 (2007): 1–16.

Ingold, Tim. "The Textility of Making." *Cambridge Journal of Economics* 34 (2010): 91–102.

Ingold, Tim. *Making*. London: Routledge, 2013.

Iraq Government Department of Antiquities. *Excavations at Samarra 1936–1939, Part II: Objects*. Baghdad: Government Press, 1940.

Irvin, Sherri. "Sculpture." In *The Routledge Companion to Aesthetics*. Edited by Berys Gaut and Dominic Lopes, 606–615.

Ivanov, Anatoly. "Works of the Twelfth-Century Iranian Coppersmith Abu Nasr." *Reports of the State Hermitage Museum* LXVIII, 16–19. St. Petersburg: State Hermitage Publishers, 2010.

Ivanov, Anatoly, et al. *Masterpieces of Islamic Art in the Hermitage Museum*. Kuwait: Dar al-Athar al-Islamiyya, 1990.

al-Janabi, Tariq Jawad. *Studies in Medieval Iraqi Architecture*. Baghdad: Ministry of Culture and Information, 1982.

Jenkins, Marilyn, and Manuel Keene. *Islamic Jewelry in the Metropolitan Museum of Art*. New York: Metropolitan Museum of Art, 1983.

Jenkins-Madina, Marilyn. *Raqqa Revisited: Ceramics of Ayyubid Syria*. New York: Metropolitan Museum of Art, 2006.

Johns, Jeremy. "The Arabic Inscriptions of the Norman Kings of Sicily. A Reinterpretation." In *The Royal Workshops in Palermo during the Reigns of the Norman and Hohenstaufen Kings of Sicily in the 12th and 13th Century*. Edited by Maria Andaloro, 324–337. Catania: Giuseppe Maimone, 2006.

Johns, Jeremy. "A Bronze Pillar Lampstand from Petralia Sottana, Sicily." In *Metalwork and Material Culture in the Islamic World: Art, Craft and Text*. Edited by Venetia Porter and Mariam Rosser-Owen, 283–299. London: I. B. Tauris, 2012.

Jones, Dalu, and George Michell, eds. *The Arts of Islam: Hayward Gallery, 8 April–4 July 1976*. London: Arts Council of Great Britain, 1976.

Jongeward, David, Elizabeth Errington, Richard Saloman, and Stefan Baums. *Gandharan Buddhist Reliquaries*. Seattle: Early Buddhist Manuscripts Project, 2012.

Jordanova, Ludmilla. "Material Models as Visual Culture." In *Models: The Third Dimension of Science*. Edited by Soraya de Chadarevian and Nick Hopwood, 443–451. Stanford, CA: Stanford University Press, 2004.

Kana'an, Ruba. "The *de Jure* 'Artist' of the Bobrinsky Bucket: Production and Patronage of Metalwork in pre-Mongol Khorasan and Transoxiana." *Islamic Law and Society* 16 (2009): 175–201.

Kana'an, Ruba. "Patron and Craftsman of the Freer Mosul Ewer of 1232: A Historical and Legal Interpretation of the Roles of Tilmīdh and Ghulām in Islamic Metalwork." *Ars Orientalis* 42 (2012): 67–78.

Kana'an, Ruba. "The Biography of a Thirteenth-Century Brass Ewer from Mosul." In *God is Beautiful and Loves Beauty: The Object in Islamic Art and Culture*. Edited by Sheila S. Blair and Jonathan Bloom, 176–193. New Haven and London: Yale University Press, 2013.

Kanazi, George J. *Studies in the Kitāb aṣ-Ṣināʿatayn of Abū Hilāl al-ʿAskarī*. Leiden: Brill, 1989.

Karageorgis, Vassos, Eleni Vassilika, and Penelope Wilson. *The Art of Ancient Cyprus in the Fitzwilliam Museum, Cambridge*. Cambridge: Fitzwilliam Museum / A. G. Leventis Foundation, 1999.

Katzenstein, Ranee A., and Glenn D. Lowry. "Christian Themes in Thirteenth-Century Islamic Metalwork." *Muqarnas* 1 (1983): 53–68.

Kee, Joan, and Emanuele Lugli. "Scale to Size: An Introduction." *Art History* 38, no. 2 (2015): 250–266.

King, David A. *In Synchrony with the Heavens: Studies in Astronomical Timekeeping and Instrumentation in Medieval Islamic Civilization, Vol. 2: Instruments of Mass Calculation*. Leiden: Brill, 2005.

King, David A. "An Instrument of Mass Calculation Made by Nasṭūlus in Baghdad *ca.* 900." *Suhayl: International Journal for the History of the Exact and Natural Sciences in Islamic Civilisation* 8 (2008): 93–119.

King, Geoffrey R. D. "The Architectural Motif as Ornament in Islamic Art: The 'Marwan II' Ewer and Three Wooden Panels in the Museum of Islamic Art in Cairo." *Islamic Archaeological Studies* 2 (1980, publ. 1982): 23–57.

Khamis, Elias. "The Fatimid Bronze Hoard of Tiberias." In *Metalwork and Material Culture in the Islamic World: Art, Craft and Text*. Edited by Venetia Porter and Mariam Rosser-Owen, 223–238. London: I. B. Tauris, 2012.

Khismatulin, Alexey A. "Two Mirrors for Princes Fabricated at the Seljuq Court: Nizām al-Mulk's *Siyar al-mulūk* and al-Ghazālī's *Naṣīhat al-mulūk*." In *The Age of the Seljuqs: The Idea of Iran, vol. VI*. Edited by Edmund Herzig and Sarah Stewart, 94–130. London: I. B. Tauris, 2015.

Khoury, Nuha N. N. "Narrative of the Holy Land: Memory, Identity and Inverted Imagery on the Freer Basin and Canteen." *Orientations* 29, no. 5 (1998): 63–69.

Kilito, Abd El-Fattah. "Sur le métalangue métaphorique des poéticiens arabes." *Poétique* 38 (1979): 162–174.

Klinkenberg, Emanuel. *Compressed Meanings: The Donor's Model in Medieval Art to Around 1300*. Turnhout, Belgium: Brepols, 2009.

Knauer, Elfriede. "Marble Jar-Stands from Egypt." *Metropolitan Museum Journal* 14 (1979): 67–101.

Knappett, Carl. "Photographs, Skeuomorphs and Marionettes: Some Thoughts on Mind, Agency and Object." *Journal of Material Culture* 7, no. 1 (2002): 97–117.

Knappett, Carl. "Materials *with* Materiality?" *Archaeological Dialogues* 14, no. 1 (2007): 20–23.

Knappett, Carl. "Meaning in Miniature: Semiotic Networks in Material Culture." In *Excavating the Mind: Cross-Sections Through Culture, Cognition and Materiality*, 87–109. Aarhus: Aarhus University Press, 2012.

Koch, Ebba. "The Copies of the Quṭb Mīnār." *Iran* 29 (1991): 95–107.

Komaroff, Linda. "Sip, Dip, and Pour: Toward a Typology of Water Vessels in Islamic Art." In *Rivers of Paradise: Water in Islamic Art and Culture*. Edited by Sheila Blair and Jonathan Bloom, 105–29. New Haven and London: Yale University Press, 2009.

Komaroff, Linda, ed. *Gifts of the Sultan: The Arts of Giving at the Islamic Courts*. Los Angeles: Los Angeles County Museum of Art, 2011.

Korn, Lorenz. "The Façade of aṣ-Ṣāliḥ ʿAyyūb's Madrasa and the Style of Ayyubid Architecture in Cairo." In *Egypt and Syria in the Fatimid, Ayyubid and Mamluk Eras, III.* Edited by Urbain Vermeulen and Jo Van Steenbergen, 101–121. Leuven: Peeters, 2001.

Kosslyn, Stephen. "Remembering Images." In *Memory and Mind: A Festschrift for Gordon H. Bower*. Edited by Mark A. Gluck, John R. Anderson, and Steven M. Kosslyn, 93–109. Mahwah, NJ: Lawrence Erlbaum, 2007.

Kötzsche, Lieselotte. "Der Basilikaleuchter in Leningrad." In *Studien zur spätantiken und byzantinischen Kunst: Friedrich Wilhelm Deichmann gewidmet*. Edited by Otto Feld and Urs Peschlow, 3:45–57, plates 13–14. Bonn: Otto Feld, 1986.

Kohl, Philip. "Chlorite." *Encyclopaedia Iranica*. Online, accessed December 11, 2015.

Kovalev, Roman K. "Dirham Mint Output of Samanid Samarqand and Its Connection to the Beginnings of Trade with Northern Europe (10th Century)." *Histoire et mesure* 17, nos. 3/4 (2002): 197–216.

Kovalev, Roman K. "Production of Dirhams at the Mint of Damascus (Dimashq) in the First Four Centuries of Islam and the Question of Near Eastern Metallic Zones." In *The 4th Simone Assemani Symposium on Islamic Coins*. Edited by Arriana D'Ottone Rambach and Bruno Callagher, 297–336. Trieste: Edizioni Università di Trieste, 2015.

Krauss, Rosalind. "Sculpture in the Expanded Field." *October* 8 (1979): 30–44.

Krautheimer, Richard. "Introduction to an 'Iconography of Medieval Architecture.'" *Journal of the Warburg and Courtauld Institutes* 5 (1942): 1–33.

Kuehn, Sara. *The Dragon in Middle East Christian and Islamic Art*. Leiden: Brill, 2011.

Kueny, Kathryn. "Reproducing Power: Qur'anic Anthropogonies in Comparison." In *The Lineaments of Islam: Studies in Honor of Fred McGraw Donner*. Edited by Paul Cobb, 235–260. Leiden: Brill, 2012.

Kühnel, Ernst. "Islamisches Räuchergerät." *Berliner Museen* 41 (1920): 241–250.

Kühnel, Ernst. *Die Arabesque: Sinn und Wandlung Eines Ornaments*. Wiesbaden: Dietrich'sche Verlagsbuchhandlung, 1949. English translation by Richard Ettinghausen published as *The Arabesque: Meaning and Transformation of an Ornament*. Graz: Verlag für Sammler, 1977.

Kukkonen, Taneli. "Receptive to Reality: Al-Ghazālī on the Structure of the Soul." *The Muslim World* 102 (2012): 541–561.

Kukkonen, Taneli. "On Adding to the Names: The Camel's Smile." *Studia Orientalia* 114 (2013): 341–358.

Labrusse, Rémi. "Grammars of Ornament: Dematerialization and Embodiment from Owen Jones to Paul Klee." In *Histories of Ornament: From Global to Local*. Edited by Gülru Necipoğlu and Alina Payne, 320–333. Princeton, NJ: Princeton University Press, 2016.

Lakoff, George, and Mark Johnson. *Philosophy in the Flesh: The Embodied Mind and Its Challenge to Western Thought*. New York: Basic Books, 1999.

Lakoff, George, and Mark Johnson. *Metaphors We Live By*. Chicago: University of Chicago Press, 2003.

Lambourn, Elizabeth. "A Self-Conscious Art? Seeing Micro-Architecture in Sultanate South Asia." *Muqarnas* 28 (2010): 121–156.

Lane, Arthur. *Early Islamic Pottery*. London: Faber and Faber, 1947.

Lane, Edward William. *An English-Arabic Lexicon*. 8 vols. Beirut: Librarie du Liban, 1968.

Lassner, Jacob. "The Caliph's Personal Domain: The City Plan of Baghdad Reexamined." *Kunst des Orients* 5, no. 1 (1968): 24–36.

Laviola, Valentina. *Metalli islamici dai territori iranici orientali (IX–XIII sec.): La documentazione della Missione Archeologica Italiana in Afghanistan*. PhD diss., Università Ca' Foscari Venezia, 2016.

Laviola, Valentina. "Three Islamic Inkwells from Ghazni Excavation." *Vicino Oriente* 21 (2017): 111–126.

Lawrence, Marion. "City-Gate Sarcophagi." *The Art Bulletin* 10, no. 1 (1927): 1–45.

Lawrence, Marion. "Columnar Sarcophagi in the Latin West: Ateliers, Chronology, Style." *The Art Bulletin* 14, no. 2 (1932): 103–185.

Leisten, Thomas. "Abbasid Art." *Hadeeth ad-Dar* 24 (2007): 50–57.

Le Maguer, Sterenn. "Typology of Incense Burners of the Islamic World." In *Proceedings for the Seminar for Arabian Studies* 41 (2011): 173–185.

Le Maguer, Sterenn. "De l'autel à encens au brûle-parfum: heritage des formes, évolution des usages." *Archéo. Doct* 5: *Actes de la 5e Journée doctorale d'archéologie, Paris, 26 mai 2010*, 183–199. Paris: Sorbonne, 2013.

Le Maguer, Sterenn. "The Incense Trade during the Islamic Period." *Proceedings of the Seminar for Arabian Studies* 45 (2015): 175–184.

Levanoni, Amalia. "Water Supply in Medieval Middle Eastern Cities: The Case of Cairo." *Al-Masaq* 20, no. 2 (2008): 179–205.

Lévi-Provençal, Évariste. "Un document sur la vie urbaine et les corps de métiers à Séville au début du XII siècle: le traité d'Ibn Abdun." *Journal Asiatique* 224 (1934): 177–299.

Lévi-Strauss, Claude. *The Savage Mind (La Pensée sauvage)*. Translated by Sybil Wolfram. London: Weidenfeld and Nicolson, 1966.

Levit-Tawil, Dalia. "The Elusive, Inherited Symbolism in the Arcade Illuminations of the Moses Ben Asher Codex (A.D. 894–95)," *Journal of Near Eastern Studies* 53, no. 3 (1994): 157–193.

Lewcock, Ronald. "Materials and Techniques." In *Architecture of the Islamic World*. Edited by George Michell, 112–143. London: Thames and Hudson, 1978.

Lewis, Bernard. "An Epistle on Manual Crafts." *Islamic Culture* 17 (1943): 141–151.

Lewisohn, Leonard. "Hierocosmic Intellect and Universal Soul in a Qaṣīda by Nāṣir-i Khusraw." *Iran* 45 (2007): 193–226.

Lintz, Yannick, Claire Delery, and Bulle Tuil Leonetti, eds. *Le Maroc médiéval: Un empire de l'Afrique à l'Espagne*. Paris: Musée du Louvre, 2014.

Lloret, Remedios Amores. "Maquetas arquitectónicas islámicas de Murcia." *Verdolay* 3 (1991): 101–105.

Losensky, Paul. "The Palace of Praise and the Melons of Time: Descriptive Patterns in ʿAbdī Bayk Šīrāzī's *Garden of Eden*." *Eurasian Studies* 2, no. 1 (2003): 1–29.

Losensky, Paul. "'The Equal of Heaven's Vault': The Design, Ceremony, and Poetry of the Ḥasanābād Bridge." In *Writers and Rulers: Perspectives on Their Relationship from Abbasid to Safavid Times*. Edited by Beatrice Gruendler and Louise Marlow, 195–215. Wiesbaden: Reichert Verlag, 2004.

Losensky, Paul. "Coordinates in Space and Time: Architectural Chronograms in Safavid Iran." In *New Perspectives on Safavid Iran: Empire and Society.* Edited by Colin P. Mitchell, 198–219. London: Routledge, 2011.

Losensky, Paul. "Square Like a Bubble: Architecture, Power, and Poetics in Two Inscriptions by Kalim Kāshāni." *Journal of Persianate Studies* 8 (2015): 42–70.

Lugli, Emanuele. "Measuring the Bones: On Francesco di Giorgio Martini's Salazzianus Skeleton." *Art History* 38, no. 2 (2015): 346–363.

Lycan, William G. "Gombrich, Wittgenstein and the Duck-Rabbit." *The Journal of Aesthetics and Art Criticism* 30, no. 2 (1971): 229–237.

Maass, Anne, Caterina Suitner, and Jean-Pierre Deconchy. *Living in an Asymmetrical World: How Writing Direction Affects Thought and Action.* London and New York: Taylor and Francis, 2014.

Mack, John. *The Art of Small Things.* London: British Museum, 2007.

Makariou, Sophie, ed. *L'Orient de Saladin: l'art des Ayyoubides.* Paris: Gallimard / Institut du monde arabe, 2001.

Makdisi, George. "An Autograph Diary of an Eleventh-Century Historian of Baghdad." *Bulletin of the School of Oriental and African Studies* 18, no. 1: 9–31; 18, no. 2: 239–260; 19, no. 1: 13–48; 19, no. 2: 281–303; 19, no. 3: 426–443 (1956–1957).

Malafouris, Lambros. "At the Potter's Wheel: An Argument *for* Material Agency." In *Material Agency: Towards a Non-Anthropocentric Approach.* Edited by Carl Knappett and Lambros Malafouris, 19–36. New York: Springer, 2008.

Malafouris, Lambros. *How Things Shape the Mind: A Theory of Material Engagement.* Cambridge, MA: MIT Press, 2013.

Maranci, Cristina. "Architectural Models in the Caucasus: Problems of Form, Function, and Meaning." In *Architectural Models in Medieval Architecture.* Edited by Yannis D. Varalis, 46–52. Thessaloniki: University Studio Press, 2008.

Marçais, Georges. "Salsabīl et Šadirwān." In *Études d'orientalisme dédiées à la mémoire de Lévi-Provençal,* 2:639–648. Paris: G.-P. Maisonneuve et Larose, 1962.

March, H. Colley. "The Meaning of Ornament; or Its Archaeology and Its Psychology." *Transactions of the Lancashire and Cheshire Antiquarian Society* 7 (1889): 160–192.

Markel, Stephen. "Metalware from Pakistan in the Los Angeles County Museum of Art." *Pakistan Heritage* 2 (2010): 99–105.

Marks, Laura. "From Haptic to Optical, Performance to Figuration: A History of Representation at the Bottom of a Bowl." In *Islam and the Politics of Culture in Europe: Memory, Aesthetics, Art.* Edited by Frank Peter, Sarah Dornhof, and Elena Arigita, 237–263. Bielefeld: transcript, 2013.

Marlowe, Louise. *Hierarchy and Egalitarianism in Islamic Thought.* Cambridge: Cambridge University Press, 1997.

Marquet, Yves. "La place du travail dans le hiérarchie isma'īlienne d'aprés *L'encyclopédie des Frères de la Purete.* *Arabica* 8 (1961): 225–237.

Marschak [Marshak], Boris. *Silberschätze des Orients. Metallkunst des 3.-13. Jahrhunderts und ihre Kontinuität.* Leipzig: E. A. Seeman, 1986.

Marshak, Boris. "An Early Seljuq Silver Bottle from Siberia." *Muqarnas* 21 (2004): 255–265.

Marshall, John. *Taxila: An Illustrated Account of Archaeological Excavations Carried out at Taxila under the Orders of the Government of India between the Years 1913 and 1934.* 3 vols. Delhi: Motilal Banarsidass, 1975.

Martianini-Reber, Marielle, ed. *Antiquités Paléochrétiennes et byzantines, IIIe–XIVe siècles: Collections du Musée d'art et d'histoire—Genève*. Geneva: Musée d'art et d'histoire, 2011.

Mayer, Leo A. *Islamic Metalworkers and Their Works*. Geneva: Albert Kundig, 1959.

Macdonald, D. B. "*Wahm* in Arabic and Its Cognates." *Journal of the Royal Asiatic Society* 4 (October 1922): 505–521.

McGough, P. "Looters Break for Farce amid the Dictator Kitsch." *The Age*. April 13, 2003. http://www.theage.com.au/articles/2003/04/12/1050069120987.html.

Meisami, Julie Scott. "Symbolic Structure in a Poem by Nāṣir-i Khusrau." *Iran* 31 (1993): 103–117.

Meisami, Julie Scott. "Poetic Microcosms: The Persian Qasida to the End of the 12th Century." In *Qasida Poetry in Islamic Asia and Africa*. 2 vols. Edited by Stefan Sperl and Christopher Shackle, 1:173–182. Leiden: Brill, 1996.

Meisami, Julie Scott. "The Palace Complex as Emblem: Some Samarran Qaṣīdas." In *A Medieval Islamic City Reconsidered: An Interdisciplinary Approach to Samarra*. Edited by Chase F. Robinson, 69–78. Oxford: Oxford University Press, 2001.

Meisami, Julie Scott. "Palaces and Paradises: Palace Description in Medieval Persian Poetry." In *Islamic Art and Literature*. Edited by Oleg Grabar and Cynthia Robinson, 21–54. Princeton, NJ: Markus Weiner, 2001.

Meisami, Julie Scott. *Structure and Meaning in Medieval Arabic and Persian Poetry: Orient Pearls*. New York: Routledge, 2003.

Melikian-Chirvani, Assadullah Souren. "The White Bronzes of Islamic Iran." *Metropolitan Museum Journal* 9 (1974): 123–151.

Melikian-Chirvani, Assadullah Souren. "Recherches sur l'architecture de l'Iran bouddhique, 1: essai sur les origines et le symbolisme du stûpa iranien." *Le monde iranien et l'Islam: Sociétés et cultures* 3 (1975): 1–61.

Melikian-Chirvani, Assdullah Souren. "Les bronzes du Khorâssân—VI: L'oeuvre de Ḥasan-e Bā Sahl: de l'emploi de l'unité modulaire et des nombres privilégiés dans l'art du bronze." *Studia Iranica* 8, no. 1 (1979): 7–32.

Melikian-Chirvani, Assadullah Souren. *Islamic Metalwork from the Iranian World*. London: Her Majesty's Stationery Office, 1982.

Melikian-Chirvani, Assadullah Souren. "Le rhyton selon les sources Persanes." *Studia Iranica* 2 (1982): 263–292.

Melikian-Chirvani, Assadullah Souren. "State Inkwells in Islamic Iran." *The Journal of the Walters Art Gallery* 44 (1986): 70–94.

Melikian-Chirvani, Assadullah Souren. "The Light of Heaven and Earth: From the *Chahār-ṭaq* to the *Miḥrāb*." *Bulletin of the Asia Institute*, n.s. 4 (1990): 95–131.

Melikian-Chirvani, Assadullah Souren, "Buddhism II: In Islamic Times." In *Encyclopaedia Iranica*. Vol. 4:496–499. London and New York: Routledge / Kegan Paul, 1990.

Melikian-Chirvani, Assadullah Souren. "Les taureaux à vin et les cornes à boire de l'Iran islamique." In *Histoire et cultes de l'Asie central préislamique*. Edited by Paul Bernard and Frantz Grenet, 102–125. Paris: Éditions du centre nationale de la recherche scientifique, 1991.

Merabet, Leila. "Fountain Basin." *Discover Islamic Art. Museum With No Frontiers*. 2014. http://www.discoverislamicart.org/database_item.php?id=object;ISL;dz;Mus01;38;en. Accessed December 19, 2016.

Meri, Josef W. "Re-appropriating Sacred Space: Medieval Jews and Muslims Seeking Elijah and al-Khadir." *Medieval Encounters* 5 (1999): 237–264.

Meri, Josef W. *The Cult of Saints among Muslims and Jews in Medieval Syria*. Oxford: Oxford University Press, 2002.

Merleau-Ponty, Maurice. *L'oeil et l'esprit*. Paris: Gallimard, 1964.

Metropolitan Museum of Art. *The Art of Medieval Spain A.D. 500–1200*. New York: Metropolitan Museum of Art, 1993.

Michailidis, Melanie. "Samanid Silver and Trade along the Fur Route." In *Mechanisms of Exchange: Transmission in Medieval Art and Architecture of the Mediterranean, ca. 1000–1500*. Edited by Heather Grossman and Alicia Walker, 17–40. Leiden: Brill, 2013.

Michailidis, Melanie. "Dynastic Politics and the Samanid Mausoleum." *Ars Orientalis* 44 (2014): 21–39.

Michailidis, Melanie. "In the Footsteps of the Sasanians: Funerary Architecture and Bavandid Legitimacy." In *Persian Kingship and Architecture: Strategies of Power in Iran from the Achaemenids to the Pahlavis*. Edited by Sussan Babaie and Tallin Grigor, 135–173. London: I. B. Tauris, 2015.

Michell, George, and Richard Eaton. *Firuzabad: Palace City of the Deccan*. Oxford: Oxford University Press, 1992.

Michot, Yahya Jean. "Misled and Misleading . . . Yet Central in Their Influence: Ibn Taymiyya's Views on the Ikhwān al-Ṣafāʾ." In *Epistles of the Brethren of Purity: The Ikhwān al-Ṣafāʾ and Their Rasāʾil*. Edited by Nader El-Bizri, 139–179. Oxford: Oxford University Press / Institute of Ismaili Studies, 2008.

Mikkelsen, Egil. "The Vikings and Islam." In *The Viking World*. Edited by Stefan Brink and Neil Price, 543–549. London: Routledge, 2008.

Miller, Steven M., ed. *The Constitution of Visual Consciousness: Lessons from Binocular Rivalry, Advances in Consciousness Research, vol. 90*. Amsterdam: John Benjamins, 2013.

Miller, Steven M., ed. *The Constitution of Phenomenal Consciousness: Toward a Science and a Theory, Advances in Consciousness Research, vol. 92*. Amsterdam: John Benjamins, 2015.

Milwright, Marcus. "Pottery in the Written Sources of the Ayyubid–Mamluk Period (ca. 567–923/1171–1517)." *Bulletin of the School of Oriental and African Studies, University of London* 62, no. 3 (1999): 504–518.

Milwright, Marcus. "Waves of the Sea: Responses to Marble in Written Sources (9th–15th Centuries). In *The Iconography of Islamic Art: Studies in Honour of Professor Robert Hillenbrand*. Edited by Bernard O'Kane, 211–221. Edinburgh: Edinburgh University Press, 2005.

Milwright, Marcus. *Islamic Arts and Crafts: An Anthology*. Edinburgh: Edinburgh University Press, 2017.

Mkrtychev, T. K. "A Unique 10th-Century Incense-Burner from Tashkent." *Arts and the Islamic World* 33 (1998): 18–19.

Mols, Luitgard E. M. *Mamluk Metalwork Fittings in Their Artistic and Architectural Context*. Delft: Eburon, 2006.

Moreh, Shmuel. *Live Theatre and Dramatic Literature in the Medieval Arab World*. Edinburgh: Edinburgh University Press, 1992.

Mouliérac, Jeanne. *Céramiques du monde musulman: collections de l'institut du monde arabe et de J.P. et F. Croisier*. Paris: Institut du monde arabe, 1999.

Muhanna, Elias. "The Sultan's New Clothes: Ottoman-Mamluk Gift Exchange." *Muqarnas* 27 (2010): 189–207.

Mulder, Stephennie. *Contextualizing Islamic Archaeology: The Case of Medieval Molded Ceramics*. Master's thesis, Princeton University, 2001.

Mulder, Stephennie. "A Survey and Typology of Islamic Molded Ware (9th–13th Centuries), Based on the Discovery of a Potter's Workshop at Medieval Bālis, Syria." *Journal of Islamic Archaeology* 1, no. 2 (2014): 143–192.

Müller, Kathrin. "Old and New: Divine Revelation in the Salerno Ivories." *Mitteilungen des Kunsthistorischen Institutes in Florenz* 54, no. 1 (2010–12): 1–30.

Müller-Wiener, Martina. "Lost in Translation: Animated Scrolls Reconsidered." *Beiträge zur Islamischen Kunst und Archäologie* 3 (2012): 163–176.

Murry, J. Middleton. *The Problem of Style*. London: Oxford University Press, 1960.

Nakamura, Kojiro. "Imam Ghazali's Cosmology Reconsidered with Special Reference to the Concept of 'Jabarūt.'" *Studia Islamica* 80 (1994): 29–46.

Nasr, Seyyed Hossein. *An Introduction to Islamic Cosmological Doctrines: Conceptions of Nature and Methods Used for its Study by the Ikhwān al-Ṣafā', al-Bīrūnī, and Ibn Sīnā*. Albany, NY: SUNY Press, 1993.

Natif, Mika. "The Painter's Breath and Concepts of Idol Anxiety in Islamic Art." In *Idol Anxiety*. Edited by Josh Ellenbogen and Aaron Tugendhaft, 41–55. Palo Alto, CA: Stanford University Press, 2011.

Naymark, Aleksander. "Ossuary" and entries 470–476 in *Kul'tura i iskusstvo drevnego Uzbekistana / Culture and Art of Ancient Uzbekistan*. Moscow: Vneshtorgizdat, 1991.

Necipoğlu-Kafadar, Gülru. "Plans and Models in 15th- and 16th-Century Ottoman Architectural Practice." *The Journal of the Society of Architectural Historians* 45, no. 3 (1986): 224–243.

Necipoğlu, Gülru. "Geometric Design in Timurid/Turkmen Architectural Practice: Thoughts on a Recently Discovered Scroll and Its Late Gothic Parallels." In *Timurid Art and Culture: Iran and Central Asia in the Fifteenth Century*. Edited by Lisa Golombek and Maria Subtelny, 48–66. Leiden: Brill, 1992.

Necipoğlu, Gülru. *The Topkapı Scroll: Geometry and Ornament in Islamic Architecture: Topkapı Palace Library MS H. 1956*. Santa Monica, CA: Getty Center for the History of Art and the Humanities, 1995.

Necipoğlu, Gülru. "Qur'anic Inscriptions on Sinan's Mosques: A Comparison with Their Safavid and Mughal Counterparts." In *Word of God, Art of Man: The Qur'an and its Creative Expressions*. Edited by Fahmida Suleman, 69–104. London: Oxford University Press and Institute for Ismaili Studies, 2007.

Necipoğlu, Gülru. "L'idée de décor dans les régimes de visualité islamiques." In *Purs décors? Arts de l'Islam, regards du XIXe siècle*. Edited by Rémi Labrusse, 10–23. Paris: Les Arts Décoratifs and Musée du Louvre, 2007.

Necipoğlu, Gülru. "The Scrutinizing Gaze in the Aesthetics of Islamic Visual Cultures: Sight, Insight, and Desire." *Muqarnas* 32 (2015): 23–61.

Necipoğlu, Gülru. "Early Modern Floral: The Agency of Ornament in Ottoman and Safavid Visual Cultures." In *Histories of Ornament: From Global to Local*. Edited by Gülru Necipoğlu and Alina Payne, 132–155. Princeton, NJ: Princeton University Press, 2016.

Necipoğlu, Gülru, ed. *The Arts of Ornamental Geometry: A Persian Compendium on Similar and Complementary Interlocking Figures = Fī tadākhul al-ashkāl al-mutashābiha aw al-mutawāfiqa (Bibliothèque nationale de France, Ms. Persan 169, fols. 180r–199r). A Volume Commemorating Alpay Özdural*. Leiden: Brill, 2017.

Nees, Lawrence. *Perspectives on Early Islamic Art in Jerusalem*. Leiden: Brill, 2016.

Netton, Ian. *Muslim Neoplatonists: An Introduction to the Thought of the Brethren of Purity (Ikhwān al-Ṣafā')*. London: Allen and Unwin, 1982.

Newhauser, Richard G. "The Senses, the Medieval Sensorium, and Sensing (in) the Middle Ages." In *Handbook of Medieval Culture*. 3 vols. Edited by Albrecht Classen, 3:1559–1575. Berlin: De Gruyter, 2015.

Nichols, Stephen G., Andreas Kablitz, and Alison Calhoun, eds. *Rethinking the Medieval Senses: Heritage, Fascinations, Frames*. Baltimore: Johns Hopkins University Press, 2008.

Nokso-Koivisto, Inka. "Summarized Beauty: The Microcosm-Macrocosm Analogy and Islamic Aesthetics." *Studia Orientalia* 111 (2011): 251–269.

Nokso-Koivisto, Inka. *Microcosm-Macrocosm Analogy in* Rasā'il Ikhwān aṣ-Ṣafā' *and Certain Related Texts*. PhD diss., University of Helsinki, 2014.

Nordenfalk, Carl. *Die spätantike Kanontafeln; Kunstgeschichtliche Studien über die eusebianische Evangelien-Konkordanz in den vier ersten Jahrhunderten ihrer Geschichte*. 2 vols. Göteborg: O. Isacsons boktryckeri, 1938.

Notkin, I. "Decoding Sixteenth-Century Muqarnas Drawings." *Muqarnas* 12 (1995): 148–171.

Nováček, Karl. "Moulded Pottery from Istakhr." In *My Things Changed Things: Social Development and Cultural Exchange in Prehistory, Antiquity and the Middle Ages*. Edited by Petra Maříkova Vlčková, Jana Mynářová, and Martin Tomášek, 118–126. Prague: Charles University, 2009.

Nwyia, Paul, ed. "Ishāra." *Encyclopaedia of Islam*. 2nd ed. http://dx.doi.org/10.1163/1573-3912_islam_SIM_3622.

Ogden, Jack. "Islamic Goldsmithing Techniques in the Early Medieval Period." In *Islamic Rings and Gems: The Benjamin Zucker Collection*. Edited by Derek J. Content, 408–427, 541. London: Philip Wilson, 1987.

Öğüş, Esen. "Columnar Sarcophagi from Aphrodisias: Elite Emulation in the Greek East." *American Journal of Archaeology* 118, no. 1 (2014): 113–136.

Ölçer, Nazan, ed. *Museum of Turkish and Islamic Art*. Istanbul: Akbank Department of Culture and Art, 2002.

Ölçer, Nazan. "No. 70. Lamp." In *Turks: Journey of a Thousand Years*. Edited by David Roxburgh, 394–395. London: Royal Academy, 2005.

O'Kane, Bernard. *Timurid Architecture in Khurasan*. Costa Mesa, CA: Mazda, 1987.

O'Kane, Bernard. "From Tents to Pavilions: Royal Mobility and Persian Palace Design." *Ars Orientalis* 23 (1993): 249–268.

O'Kane, Bernard, ed. *The Treasures of Islamic Art in the Museums of Cairo*. Cairo / New York: American University in Cairo Press, 2006.

O'Kane, Bernard. "Persian Poetry on Ilkhanid Art and Architecture." In *Beyond the Legacy of Genghis Khan*. Edited by Linda Komaroff, 346–354. Leiden: Brill, 2006.

O'Kane, Bernard. *The Appearance of Persian on Islamic Art*. New York: Persian Heritage Foundation, 2009.

Öney, Gönül. "Human Figures on Anatolian Seljuk Sgraffiato and Champlevé Ceramics." In *Essays in Islamic Art and Architecture in Honor of Katharina Otto-Dorn*. Edited by Abbas Daneshvari, 113–125. Malibu, CA: Undena, 1981.

Oppenheim, A. Leo. "A New Look at the Structure of Mesopotamian Society." *Journal of the Economic and Social History of the Orient* 10 (1967): 1–16.

Orfali, Bilal, and Maurice A. Pomerantz. "A Lost *Maqāma* of Badī' al-Zamān al-Hamaḏānī?" *Arabica* 60 (2013): 245–271.

Özdural, Alpay. "Omar Khayyam, Mathematicians and *Conversazioni* with Artisans." *Journal of the Society of Architectural Historians* 54, no. 1 (1995): 54–71.

Özdural, Alpay. "Mathematics and Arts: Connections between Theory and Practice in the Medieval Islamic World." *Historia Mathematica* 27 (2000): 171–201.

Palazón, Julio Navarro. "Formas arquitectónicas en el mobiliario cerámico andalusí." *Cuadernos de la Alhambra* 23 (1987): 21–65.

Palazón, Julio Navarro, and Pedro Jiménez Castillo. "Piletas de abluciones en el ajuar cerámico andalusí." *Verdolay* 5 (1993): 171–177.

Palazón, Julio Navarro, and Pedro Jiménez Castillo. "La Producción Cerámica Medieval de Murcia." In *Spanish Medieval Ceramics in Spain and the British Isles*. Edited by Christopher Gerrard, Alejandra Gutiérrez, and Alan Vince, 185–214. Oxford: British Archaeological Reports, 1995.

Palazón, Julio Navarro, and Pedro Jiménez Castillo. "Maquetas arquitectónicas en cerámica y su relación con la arquitectura andalusí." In *Casas y palacios de Al-Andalus: Siglos XII–XIII*, 287–302. Granada: El Legado Andalusí, 1995.

Pancaroğlu, Oya. " 'A World Unto Himself': The Rise of a New Human Image in the Late Seljuk Period (1150 –1250)." PhD diss., Harvard University, 2000.

Pancaroğlu, Oya. "Socializing Medicine: Illustrations of the Kitāb al-diryāq." *Muqarnas* 18 (2001): 155–172.

Pancaroğlu, Oya. "Serving Wisdom: The Contents of Samanid Epigraphic Pottery." In *Studies in Islamic and Later Indian Art from the Arthur M. Sackler Museum, Harvard University Art Museums*. Edited by Rochelle L. Kessler, 59–75. Cambridge, MA: Harvard University Art Museum, 2002.

Pancaroğlu, Oya. "Ornament, Form and Vision in Ceramics from Medieval Iran: Reflections of the Human Image." In *Histories of Ornament: From Global to Local*. Edited by Gülru Necipoğlu and Alina Payne, 192–203. Princeton, NJ: Princeton University Press, 2016.

Panofsky, Erwin. *Tomb Sculpture*. New York: Harry N. Abrams, 1964.

Papapetros, Spyros. "World Ornament: The Legacy of Gottfried Semper's 1856 Lecture on Adornment." *RES: Anthropology and Aesthetics* 57/58 (2010): 309–329.

Parens, Joshua, and Joseph C. Macfarland. *Medieval Political Philosophy: A Sourcebook*. 2nd ed. Ithaca and London: Cornell University Press, 2011.

Parker, Rozsika, and Griselda Pollock. *Old Mistresses: Women, Art and Ideology*. New York: Pantheon Books, 1981.

Payne, Alina. "Materiality, Crafting and Scale in Renaissance Architecture." *The Oxford Art Journal* 32, no. 3 (2009): 365–386.

Payne, Alina. *From Ornament to Object: Genealogies of Architectural Modernism*. New Haven and London: Yale University Press, 2012.

Pellat, Charles. *Life and Works of Jāḥiẓ*. London, 1963.

Pellat, Charles. "Adab ii: Adab in Arabic Literature." *Encyclopaedia Iranica*. http://www.iranicaonline.org/articles/adab-ii-arabic-lit.

Pellat, Charles. "*Kināya*." *Encyclopaedia of Islam*. 2nd ed. http://dx.doi.org/10.1163/1573-3912_islam_SIM_4377

Pentcheva, Bissera V. "The Power of Glittering Materiality: Mirror Reflections Between Poetry and Architecture in Greek and Arabic Medieval Culture." In *Istanbul and Water*. Edited by Paul Magdalino and Nina Ergin, 241–274. Leuven: Peeters, 2015.

Perri, Carmela. "On Alluding." *Poetics* 7, no. 3 (1978): 289–307.

Pickett, Douglas. *Early Persian Tilework: The Medieval Flowering of Kāshī*. London: Associated University Presses, 1997.

Pierrat, Geneviève. "Essai de classification de la céramique de Tôd de la fin du VIIe siècle au début du XIIIe siècle ap. J.-C." *Cahiers de la céramique égyptienne* 2 (1991): 145–204.

Pillsbury, Joanne. "Building for the Beyond: Architectural Models from the Ancient Americas." In *Design for Eternity: Architectural Models from the Ancient Americas*.

Edited by Patricia Joan Sarro, James Doyle, and Juliet Wiersema, 3–30. New York: Metropolitan Museum of Art, 2015.

Pillsbury, Joanne, Patricia Joan Sarro, James Doyle, and Juliet Wiersema, eds. *Design for Eternity: Architectural Models from the Ancient Americas.* New York: Metropolitan Museum of Art, 2015.

Pinder-Wilson, Ralph. "Seals and Rings in Islam." In *Islamic Rings and Gems: The Benjamin Zucker Collection.* Edited by Derek J. Content, 373–387, 539. London: Philip Wilson, 1987.

Pinder-Wilson, Ralph. "Ghaznavid and Ghūrid Minarets." *Iran* 39 (2001): 155–186.

Piotrovsky, Mikhail B., and Anton D. Pritula, eds. *Beyond the Palace Walls: Islamic Art from the State Hermitage Museum, Islamic Art in a World Context.* Edinburgh: National Museums of Scotland, 2006.

Platt, Verity. "Making an Impression: Replication and the Ontology of the Graeco-Roman Seal Stone." *Art History* 29, no. 2 (2006): 233–257.

Poonawala, Ismail K. "Why We Need an Arabic Critical Edition with an Annotated English Translation of the *Rasāʾil Ikhwān al-Ṣafāʾ.*" In *Epistles of the Brethren of Purity: The Ikhwān al-Ṣafāʾ and their* Rasāʾil. Edited by Nader El-Bizri, 33–57. Oxford: Oxford University Press / Institute of Ismaili Studies, 2008.

Pope, Arthur Upham. *Masterpieces of Persian Art.* New York: Dryden, 1945.

Pope, Arthur Upham, and Phyliss Ackermann, eds. *A Survey of Persian Art.* 2nd impression, in 18 vols. Ashiya: SOPA, 1981–2005.

Popper, William. *The Cairo Nilometer, Studies in Ibn Taghrī Birdī's Chronicles of Egypt: I.* Berkeley and Los Angeles: University of California Press, 1951.

Pormann, Peter E. "Avicenna on Medical Practice, Epistemology, and the Physiology of the Inner Senses." In *Interpreting Avicenna: Critical Essays.* Edited by Peter Adamson, 91–108. Cambridge: Cambridge University Press, 2013.

Porter, Venetia. *Arabic and Persian Seals and Amulets in the British Museum.* London: British Museum, 2011.

Porter, Yves. "From 'The Theory of the Two Qalams' to 'The Seven Principles of Painting': Theory, Terminology and Practice in Persian Classical Painting." *Muqarnas* 17 (2000): 109–118.

Potts, Alex. *The Sculptural Imagination: Figurative, Modernist, Minimalist.* New Haven and London: Yale University Press, 2000.

Pradines, Stéphane. "Burj al-Ẓafar: Architecture de passage des fatimides aux ayyoubides." In *Egypt and Syria in the Fatimid, Ayyubid and Mamluk Eras, VIII.* Edited by Urbain Vermeulen, Kristof D'Hulster, and Jo Van Steenbergen, 51–119. Leuven: Peeters, 2016.

Pritula, Anton D. *The Wardā: An East Syriac Hymnological Collection, Study and Critical Edition.* Wiesbaden: Harrasowitz Verlag, 2015.

Pritula, Anton D. "The Development of Metalware in the Jazira: A Brass Inkwell in the Hermitage Museum." *Reports of the State Hermitage Museum,* forthcoming 2019.

Pritula, Anton D., and Mikhail B. Piotrovsky. *Vo dvorcach i v shatrakh: islamskij mir ot Kitaja do Evropy* [In palaces and tents: Islamic world from China to Europe]. St. Petersburg: State Hermitage Museum, 2008.

Puerta Vílchez, José Miguel. *La poética del agua en el islam / The Poetics of Water in Islam.* Sabarís: Trea, 2011.

Puerta Vílchez, José Miguel. *Aesthetics in Arabic Thought: From Pre-Islamic Arabia through al-Andalus.* Translated by Consuela López-Morillas. Leiden: Brill, 2017.

Pugachenkova, G. A. "The Form and Style of Sogdian Ossuaries." *Bulletin of the Asia Institute*, New Series 8 (1994): 227–243.

al-Qadi, Wadad. "Al-Zajjāj and Glassmaking: An Expanded Range of Options in a Comparative Context." In *In the Shadow of Arabic: The Centrality of Language to Arabic Culture; Studies Presented to Ramzi Baalbaki on the Occasion of His Sixtieth Birthday*. Edited by Bilal Orfali, 221–248. Leiden: Brill, 2011.

Rabbat, Nasser. "Design without Representation in Medieval Egypt." *Muqarnas* 25 (2008): 147–154.

Rabbat, Nasser. "Shadirwān." *Encyclopaedia of Islam*. 2nd ed. http://dx.doi.org/10.1163/1573-3912_islam_SIM_6737.

Raby, Julian. "Looking for Silver in Clay: A New Perspective on Samanid Ceramics." In *Pots and Pans: A Colloquium on Precious Metals and Ceramics in the Muslim, Chinese and Graeco-Roman Worlds, Oxford Studies in Islamic Art, 3*. Edited by Michael Vickers, 179–203. Oxford: University of Oxford Press, 1985.

Raby, Julian. "The Principle of Parsimony and the Problem of the 'Mosul School of Metalwork.'" In *Metalwork and Material Culture in the Islamic World: Art, Craft and Text*. Edited by Venetia Porter and Mariam Rosser-Owen, 11–85. London: I. B. Tauris, 2012.

Raymond, André. "The Economy of the Traditional City." In *The City in the Islamic World*. 2 vols. Edited by Renata Holod, Attilio Petruccioli, and André Raymond, 2:731–751. Leiden: Brill, 2008.

Redford, Scott. *Landscape and the State in Medieval Anatolia: Seljuk Gardens and Pavilions of Alanya, Turkey*. Oxford: British Archaeological Reports, International Series 893, 2000.

Redford, Scott. "Portable Palaces: On the Circulation of Objects and Ideas about Architecture in Medieval Anatolia and Mesopotamia." *Medieval Encounters* 18 (2012): 382–412.

Reinert, Benedikt. "Probleme der vormongolischen arabisch-persischen Poesiegemeinschaft und ihr Reflex in der Poetik." In *Arabic Poetry: Theory and Development*. Edited by G. E. von Grunenbaum, 71–105. Wiesbaden, 1973.

Reitlinger, Gerald. "Medieval Antiquities West of Mosul." *Iraq* 5 (1938): 143–156.

Reitlinger, Gerald. "Unglazed Relief Pottery from Northern Mesopotamia." *Ars Islamica* 15–16 (1951): 11–22.

Rempel, L. I. "La maquette architecturale dans le culte et la construction de l'Asie centrale préislamique." In *Cultes et monuments religieux dans l'Asie centrale préislamique*. Edited by Frantz Grenet, 81–88 and plates XLVI–LIV. Paris: Éditions du CNRS, 1987.

Rice, David Storm. "The Oldest Dated 'Mosul' Candlestick A.D. 1225." *The Burlington Magazine* 91, no. 561 (1949): 334, 336–341.

Rice, David Storm. "The Aghānī Miniatures and Religious Painting in Islam." *The Burlington Magazine* 95, no. 601 (1953): 128–135.

Rice, David Storm. "Studies in Islamic Metalwork: II." *Bulletin of the School of Oriental and African Studies, University of London* 15, no. 1 (1953): 61–79.

Rice, David Storm. "Inlaid Brasses from the Workshop of Aḥmad al-Dhakī al-Mawṣilī." *Ars Orientalis* 2 (1957): 283–326.

Richert, Annika, ed. *Islam: Konst och kultur / Islam: Art and Culture*. Stockholm: Statens Historiska Museum, 1985.

Richter-Bernburg, Lutz. "In the Eye of the Beholder: The Aesthetic [In]Significance of Architecture in Arabic Geography, AH 250–400." *The Arabist* 26–27 (2003): 295–316.

Richter-Bernburg, Lutz. "Between Marvel and Trial: Al-Harawī and Ibn Jubayr on Architecture." In *Egypt and Syria in the Fatimid, Ayyubid and Mamluk Eras, VI*. Edited by Urbain Vermeulen and Kristof D'Hulster, 115–145. Leuven: Peeters, 2010.

Paul Ricoeur, Paul. *The Rule of Metaphor: Multi-disciplinary Studies of the Creation of Meaning in Language*. Translated by Robert Czerny. Toronto: University of Toronto Press, 1993.

Riegl, Alois. *Problems of Style: Foundations for a History of Ornament*. Translated by Evelyn Kain. Princeton, NJ: Princeton University Press, 1992.

Riegl, Alois. *Historical Grammar of the Visual Arts*. Translated by J. Jung. New York: Zone Books, 2004.

Ritter, Nils C. "On the Development of Sasanian Seals and Sealing Practice: A Mesopotamian Approach." *Orientalia Lovaniensia Analecta* 219 (2012): 99–114.

Rizvi, Kishwar. *The Safavid Dynastic Shrine: Architecture, Religion and Power*. London: I. B. Tauris, 2011.

Roberts, Michael. *The Jeweled Style: Poetry and Poetics in Late Antiquity*. Ithaca and London: Cornell University Press, 1989.

Robinson, Cynthia. "Seeing Paradise: Metaphor and Vision in Taifa Palace Architecture." *Gesta* 36, no. 2 (1998): 145–155.

Robinson, Cynthia. "Marginal Ornament: Poetics, Mimesis and Devotion in the Palace of the Lions." *Muqarnas* 25 (2008): 185–214.

Robinson, Cynthia. "Power, Light, Intra-Confessional Discontent, and the Almoravids." In *Envisioning Islamic Art and Architecture: Essays in Honor of Renata Holod*. Edited by David Roxburgh, 22–45. Leiden: Brill, 2014.

Rogers, James Michael. *The Arts of Islam: Masterpieces from the Khalili Collection*. London: Nour Foundation, 2010.

Roosevelt, Christopher H. "Symbolic Door Stelae and Graveside Monuments in Western Anatolia." *American Journal of Archaeology* 110, no. 1 (2006): 65–91.

Rosen-Ayalon, Myriam. *The Early Islamic Monuments of al-Ḥaram al-Sharīf*. Jerusalem: Hebrew University, 1989.

Rosenthal, Franz. "Abū Ḥaiyān al-Tawḥīdī on Penmanship." *Ars Islamica* 13 (1948): 1–30.

Rosenthal, Franz. "Ibn Khaldun in His Time (May 27, 1332–March 17, 1406)." *Journal of Asian and African Studies* 18, nos. 3–4 (1983): 166–178.

Ross, Marvin Chauncey. "A Group of Coptic Incense Burners." *American Journal of Archaeology* 46, no. 1 (1942): 10–12.

Rosser-Owen, Mariam. "Poems in Stone: The Iconography of ʿĀmirid Poetry, and Its 'Petrification' on ʿĀmirid Marbles." In *Revisiting al-Andalus: Perspectives on the Material Culture of Islamic Iberia and Beyond*. Edited by Glaire Anderson and Mariam Rosser-Owen, 81–98. Leiden: Brill, 2007.

Rowland, Benjamin. "Gandhāra and Early Christian Art: The Homme-Arcade and the Date of the Bīmarān Reliquary." *The Art Bulletin* 28, no. 1 (1946): 44–47.

Roxburgh, David J. "Kamal al-Din Bihzad and Authorship in Persianate Painting." *Muqarnas* 17 (2000): 119–146.

Roxburgh, David J. "Micrographia: Towards a Visual Logic of Persianate Painting." *RES: Anthropology and Aesthetics* 43 (2003): 12–30.

Roxburgh, David J. "The Eye Is Favored for Seeing the Writing's Form: On the Sensual and the Sensuous in Islamic Calligraphy." *Muqarnas* 25 (2008): 275–298.

Roxburgh, David J. "In Pursuit of Shadows: al-Hariri's *Maqāmāt*." *Muqarnas* 30 (2013): 171–212.

Roxburgh, David J. "Timurid Architectural Revetment in Central Asia, 1370–1430: The Mimeticism of Mosaic Faience." In *Histories of Ornament: From Global to Local*. Edited by Gülru Necipoğlu and Alina Payne, 116–129. Princeton, NJ: Princeton University Press, 2016.

Ruggles, Dede Fairchild. "The Eye of Sovereignty: Poetry and Vision in the Alhambra's Lindaraja Mirador." *Gesta* 36, no. 2 (1997): 180–189.

Ruggles, Dede Fairchild. *Gardens, Landscape and Vision in the Palaces of Islamic Spain*. University Park: Pennsylvania State University Press, 2000.

Rugiadi, Martina. "The Emergence of Siliceous-Paste in Iran in the Last Quarter of the Eleventh Century and Related Issues. The Dated Assemblage from the Southern Domed Hall of the Great Mosque of Isfahan." *Vicino & Medio Oriente* 15 (2011): 233–248.

Ruska, Julius. "Kazwīnīstudien." *Der Islam* 4 (1913): 14–66, 236–262.

Rutschowscaya, Marie-Hélène. "Water Jugs and Stands." *Coptic Encyclopedia*. 8 vols. Edited by Aziz S. Atiya, 7:2320. New York: Macmillan, 1991.

Rypka, Jan. *History of Iranian Literature*. Dordrecht: D. Reidel, 1968.

Sadan, Joseph. *Le mobilier au Proche-Orient médiéval*. Leiden: Brill, 1976.

Sadan, Joseph. "Nouveaux documents sur scribes et copistes." *Revue des etudes islamiques* 45, no. 1 (1977): 41–87.

Sadan, Joseph. "Kings and Craftsmen, A Pattern of Contrasts. On the History of a Medieval Arabic Humoristic Form, Part I." *Studia Islamica* 62 (1985): 5–49.

Sadan, Joseph. "Kings and Craftsmen, A Pattern of Contrasts. On the History of a Medieval Arabic Humoristic Form, Part II." *Studia Islamica* 62 (1985): 89–120.

Sadan, Joseph. "The Art of the Goldsmith Reflected in Medieval Arabic Literature." In *Islamic Rings and Gems: The Benjamin Zucker Collection*. Edited by Derek J. Content, 462–475. London: Philip Wilson, 1987.

Sadan, Joseph. "Written Sources Concerning Goldsmithing and Jewellery." In *Jewellery and Goldsmithing in the Islamic World*. Edited by Na'ama Brosh, 93–99. Jerusalem: Israel Museum, 1991.

Sadan, Joseph. "Maiden's Hair and Starry Skies: Imagery Systems and *Ma'ānī* Guides; The Practical Side of Arabic Poetics as Demonstrated in Two Manuscripts." *Israel Oriental Studies* 10 (1991): 57–88.

Salellas, Pedro de Palol. "Los incensarios de Aubenya (Mallorca) y Lladó (Gerona)." *Ampurias* 12 (1950): 1–19.

Sankovitch, Anne-Marie. "Structure/Ornament and the Modern Figuration of Architecture." *The Art Bulletin* 80, no. 4 (1998): 687–717.

Sarre, Friedrich. "Ein neuerworbenes Beispiel der mesopotamischen Reliefkeramik des XII.–XIII. Jahrhunderts." *Berliner Museen: Berichte aus den Preussischen Kunstsammlungen* LI:1 (1930): 7–11.

Sarre, Friedrich. "Die Bronzekanne des Kalifen Marwān II im arabischen Museum in Kairo." *Ars Islamica* 1 (1934): 10–15.

Sarre, Friedrich, and Ernst Herzfeld. *Archäologische Reise im Euphrat-und Tigris-Gebeit*. 4 vols. Berlin: Dietrich Reimer, 1911–1920.

Sarre, Friedrich, and Fredrik R. Martin, eds. *Die Ausstellung von Meisterwerken muhammedanischer Kunst in München 1910*. 3 vols. Munich: Bruckmann, 1912.

Sarre, Friedrich, and Eugen Mittwoch. "Islamische Tongefäße aus Mesopotamien." *Jahrbuch der Königlich Preussischen Kunstsammlungen* 26 (1905): 69–88.

Sauer, Rebecca. "The Penbox (*dawāt*): An Object between Everyday Practices and Mamlūk Courtly Gift Culture." *Proceedings of the School of Mamluk Studies*. Forthcoming.

Sauvaget, Jean. *Historiens arabes: pages choisies, tr. et présentées par J. Sauvaget*. Paris: A. Maisonneuve, 1946.

Scerrato, Umberto. "Summary Report on the Italian Archaeological Mission in Afghanistan. The First Two Excavation Campaigns at Ghazni, 1957–1958." *East and West* 10, nos. 1/ 2 (1959): 23–55.

Scerrato, Umberto. "Hausmodelle." *Quaderni di Vicino Oriente* 7 (2014): 14–46.

Schlumberger, Daniel. "Le palais ghaznévide de Laškari Bazar." *Syria* 29 (1952): 251–270.

Schneider, Laura T. "The Freer Canteen." *Ars Orientalis* 9 (1973): 137–156.

Schoeler, G. "Tarṣīʿ." *Encyclopaedia of Islam*. 2nd ed. http://dx.doi.org/10.1163/1573-3912_islam_COM_1186.

Schroeder, Severin. "A Tale of Two Problems: Wittgenstein's Discussion of Aspect Perception." In *Mind, Method and Morality: Essays in Honour of Anthony Kenny*. Edited by John Cottingham and Peter M.S. Hacker, 352–372. Oxford: Oxford University Press, 2010.

Sennett, Richard. *The Fall of Public Man*. New York: Knopf, 1977.

Sennett, Richard. *The Craftsman*. New Haven, CT: Yale University Press, 2008.

Serjeant, R. B. *Islamic Textiles; Materials for a History up to the Mongol Conquest*. Beirut: Librarie du Liban, *c.* 1972.

Seyed-Ghorab, A. A. "Waxing Eloquent: The Masterful Variations on Candle Metaphors in the Poetry of Ḥāfiẓ and His Predecessors." In *Metaphor and Imagery in Persian Poetry*, 81–123. Leiden: Brill, 2011.

Shalem, Avinoam. "A Note on a Unique Islamic Golden Figurine." *Iran: Journal of the British Institute of Persian Studies* 40 (2002): 173–180.

Shalem, Avinoam. "Hidden Aesthetics and the Art of Deception: The Object, the Beholder and the Artisan." In *Siculo-Arabic Ivories and Islamic Painting 1100–1300*. Edited by David Knipp, 40–52. Chicago: University of Chicago, 2011.

Shalem, Avinoam, and Eva-Maria Troelenberg. "Beyond Grammar and Taxonomy: Some Thoughts on Cognitive Experiences and Responsive Islamic Ornaments." *Beiträge zur islamischen Kunst und Archäologie* 3 (2012): 385–410.

Shatzmiller, Maya. *Labour in the Medieval Islamic World*. Leiden: Brill, 1994.

Simpson, Marianna Shreve. *The Illustration of an Epic: The Earliest Shahnama Manuscripts*. New York: Garland, 1979.

Simpson, Marianna Shreve. "Narrative Structure of a Medieval Iranian Beaker." *Ars Orientalis* 12 (1981): 15–24.

Simpson, Marianna Shreve. "Narrative Allusion and Metaphor in the Decoration of Medieval Islamic Objects." In *Studies in the History of Art, vol. 16: Pictorial Narrative in Antiquity and the Middle Ages*. Edited by Herbert L. Kessler and Marianna Shreve Simpson, 131–149. Washington, DC: National Gallery of Art, 1985.

Simpson, Marianna Shreve. "Oleg Grabar, b. 1929. *Intermediary Demons: Toward a Theory of Ornament*, 1989." In *The A.W. Mellon Lectures in the Fine Arts: Fifty Years*, 163–166. Washington, DC: National Gallery of Art, 2002.

Sims, Eleanor J., Ernst Grube, and Boris Marshak. *Peerless Images: Persian Painting and Its Sources*. New Haven, CT: Yale University Press, 2002.

Smail, Daniel Lord, and Andrew Shryock. "Body." In *Deep History: The Architecture of Past and Present*. Edited by Daniel Lord Smail and Andrew Shryock, 55–77. Berkeley, CA: University of California Press, 2011.

Smith, Albert C. *Architectural Model as Machine: A New View of Models from Antiquity to the Present Day*. Oxford: Architectural Press / Elsevier, 2004.

Smith, Julia M. H. "Relics: An Evolving Tradition in Latin Christianity." In *Saints and Sacred Matter: The Cult of Relics in Byzantium and Beyond*. Edited by Cynthia Hahn and Holger A. Klein, 41–60. Cambridge, MA: Harvard University Press / Dumbarton Oaks, 2015.

Smith, Martyn. "Finding Meaning in the City: al-Maqrīzī's Use of Poetry in the *Khiṭaṭ*." *Mamluk Studies Review* 15 (2012): 143–161.

Smith, Pamela H. *The Body of the Artisan: Art and Experience in the Scientific Revolution*. Chicago: University of Chicago Press, 2004.

Smith, Pamela H. "In a Sixteenth-Century Goldsmith's Workshop." In *The Mindful Hand: Inquiry and Invention from the Late Renaissance to Early Industrialisation*. Edited by Lissa Roberts, Simon Schaffer, and Peter Dear, 32–57. Amsterdam: Royal Netherlands Academy of Arts and Sciences, 2007.

Smith, Pamela H. "Making as Knowing: Craft as Natural Philosophy." In *Ways of Making and Knowing: The Material Culture of Empirical Knowledge*. Edited by Pamela Smith, Amy Meyers, and Harold Cook, 17–47. Ann Arbor: University of Michigan Press, 2014.

Snelders, Bas. *Identity and Christian-Muslim Interaction: Medieval Art of the Syrian Orthodox from the Mosul Area*. Leuven: Peeters, 2010.

Snelders, Bas. "The Relationship between Christian and Islamic Art: West Syrian Christians in the Mosul Area (Twelfth–Thirteenth Century). A Preliminary Note." In *The Syriac Renaissance*. Edited by Herman Teule, C. Tauwinkl Fotescu, R. B. ter Haar Romeny, and J. J. van Ginkel, 239–264. Leuven: Peeters, 2010.

Soucek, Priscilla. "Niẓāmī on Painters and Painting." In *Islamic Art in the Metropolitan Museum*. Edited by Richard Ettinghausen, 9–21. New York: Metropolitan Museum of Art, 1972.

Sperl, Stefan. *Mannerism in Arabic Poetry: A Structural Analysis of Selected Texts (3 Century AH/9th Century AD–5th Century AH/11th Century AD)*. Cambridge: Cambridge University Press, 1989.

Sperl, Stefan. "Crossing Enemy Boundaries: Al-Buḥturī's Ode on the Ruins of Ctesiphon Re-read in the Light of Virgil and Wilfred Owen." *Bulletin of the School of Oriental and African Studies, University of London* 69, no. 3 (2006): 365–379.

Souissi, M. "'Ilm al-Handasa." *Encyclopaedia of Islam*. 2nd ed. http://dx.doi.org/10.1163/1573-3912_islam_COM_1408.

Sourdel-Thomine, Janine. "Stèles arabes de Bust (Afghanistan)." *Arabica* 3, no. 3 (1956): 285–306.

Sourdel-Thomine, Janine. "Kitabat, (a), inscriptions, 1. Islamic epigraphy in general." *Encyclopaedia of Islam*. 2nd ed. http://dx.doi.org/10.1163/1573-3912_islam_COM_0525

Steiner, Christopher B. "Can the Canon Burst?" *The Art Bulletin* 78, no. 2 (1996): 213–217.

Steingass, Francis Joseph. *The Student's Arabic-English Dictionary*. London: Allen, 1884.

Stern, S. M. "A New Volume of the Illustrated Aghānī Manuscript." *Ars Orientalis* 2 (1957): 501–503.

Stern, S. M. "Abū Ḥayyān al-Tawḥīdī." *Encyclopaedia of Islam*. 2nd ed. http://dx.doi.org/10.1163/1573-3912_islam_COM_0525.

Stewart, Susan. *On Longing: Narratives of the Miniature, the Gigantic, the Souvenir, the Collection*. Durham and London: Duke University Press, 1993.

Stone, Elizabeth Rosen. "A Buddhist Incense Burner from Gandhara." *Metropolitan Museum Journal* 39 (2004): 29–99.

Sumi, Akiko Motoyoshi. *Description in Classical Arabic Poetry: Waṣf, Ekphrasis and Interarts Theory*. Leiden: Brill, 2004.

Summerson, John. "Heavenly Mansions: An Interpretation of the Gothic." In *Heavenly Mansions and Other Essays on Architecture*. Edited by John Summerson, 1–28. London: Norton Library, 1963.

Tabbaa, Yasser. "The 'Salsabil' and 'Shadirwan' in Medieval Islamic Courtyards." *Environmental Design: Journal of the Islamic Environmental Design Research Centre* 2 (1985): 34–37.

Tabbaa, Yasser. "Towards an Interpretation of the Use of Water in Islamic Courtyards and Courtyard Gardens." *Journal of Garden History* 7, no. 3 (1987): 197–220.

Tabbaa, Yasser. "Bronze Shapes in Iranian Ceramics of the Twelfth and Thirteenth Centuries" *Muqarnas* 4 (1987): 98–113.

Tabbaa, Yasser. "Muqarnas." *The Dictionary of Art*. Edited by Jane Turner, 22:321. London: Grove, 1996.

Tabbaa, Yasser. *The Transformation of Islamic Art During the Sunni Revival*. Seattle and London: University of Washington Press, 2001.

Tabbaa, Yasser. "Control and Abandon: Images of Water in Arabic Poetry and Gardens." In *Rivers of Paradise: Water in Islamic Art and Culture*. Edited by Sheila S. Blair and Jonathan M. Bloom, 58–79. New Haven and London: Yale University Press, 2009.

Tafazzoli, A. "A List of Trades and Crafts in the Sassanian Period." *Archaeologische Mitteilungen aus Iran* 7 (1974): 191–96.

Talgam, Rina. *The Stylistic Origins of Umayyad Sculpture and Architectural Decoration*. 2 vols. Wiesbaden: Harrassowitz Verlag, 2004.

Taragan, Hana. "The Image of the Dome of the Rock in Cairene Mamluk Architecture." In *The Real and Ideal Jerusalem in Jewish, Christian and Islamic Art*. Edited by Bianca Kuhnel, *Jewish Art* 23/24 (1997–1998): 453–459.

Taragan, Hana. "The 'Speaking' Inkwell from Khurasan: Object as 'World' in Iranian Medieval Metalwork." *Muqarnas* 22 (2005): 29–44.

Taragan, Hana. "An Artuqid Candlestick from the Al-Aqsa Museum: Object as Document." *Ars Orientalis* 42 (2012): 79–88.

Thackston, Wheeler. *A Century of Princes: Sources in Timurid History and Art*. Cambridge, MA: Aga Khan Program for Islamic Architecture, 1989.

Thomas, Edmund. "'Houses of the Dead'? Columnar Sarcophagi as 'Micro-architecture.'" In *Life, Death and Representation: Some New Work on Roman Sarcophagi*. Edited by Jaś Elsner and Janet Huskinson, 387–435. Berlin: De Gruyter, 2011.

Timmermann, Achim. "Fleeting Glimpses of Eschaton: Scalar Travels in Medieval Mircoarchitecture." In *Microarchitecture et figure du bâti: l'échelle à l'épreuve de la matière*. Edited by Clément Blanc, Jean-Marie Guillouët, and Ambre Vilain. Paris: Picard, forthcoming.

Toussoun, Omar. *Mémoire sur l'histoire du Nil*. 3 vols. Cairo: Impr. de l'Institut français d'archéologie orientale, 1925.

Troelenberg, Eva-Maria. "Regarding the Exhibition: the Munich exhibition *Masterpieces of Muhammedan Art* (1910) and Its Scholarly Position." *Journal of Art Historiography* 6 (2012): n.p.

Troelenberg, Eva-Maria. "On a Pedestal? On the Problem of the Sculptural as a Category of Perception for Islamic Objects." In *Art History and Fetishism Abroad: Global Shiftings in Media and Methods*. Edited by Gabriele Genge and Angela Stercken, 159–174. Bielefeld: transcript, 2014.

Tuck, Anthony. "Singing the Rug: Patterned Textiles and the Origins of Indo-European Metrical Poetry." *American Journal of Archaeology* 110, no. 4 (2006): 539–550.

Ulrich Gumbrecht, Hans. "Erudite Fascinations and Cultural Energies: How Much Can We Know About the Medieval Senses?" In *Rethinking the Medieval Senses: Heritage, Fascinations, Frames*. Edited by Stephen G. Nichols, Andreas Kablitz, and Alison Calhoun, 1–10. Baltimore: Johns Hopkins University Press, 2008.

UNESCO. "Museum of Ghazni: Inkwell." *Museums for Intercultural Dialogue, UNESCO.* http://www.unesco.org/culture/museum-for-dialogue/item/en/217/inkwell. Accessed February 14, 2016.

Urice, Stephen K. *Qasr Kharana in the Transjordan.* Durham, NC: American Schools of Oriental Research, 1987.

Valenstein, Suzanne G. *Cultural Convergence in the Northern Qi Period: A Flamboyant Chinese Ceramic Container: A Research Monograph.* New York: Metropolitan Museum of Art, 2007.

Van Gelder, Geert Jan. *Beyond the Line: Classical Arabic Literary Critics on the Coherence and Unity of the Poem.* Leiden: Brill, 1982.

Van Gelder, Geert Jan. "Review of Mansour Ajami, *The Neckveins of Winter: The Controversy over Natural and Artificial Poetry in Medieval Arabic Literary Criticism.*" *Die Welt des Islams* 26, no. 1/4 (1986): 172–175.

Van Gelder, Geert Jan. "*Ishāra.*" In *Encyclopaedia of Arabic Literature.* 2 vols. Edited by Julie Scott Meisami and Paul Starkey, 1:398. London and New York: Routledge, 1998.

Van Gelder, Geert Jan. "*Badīʿ.*" *Encyclopaedia of Islam.* 3rd ed. http://dx.doi.org/10.1163/1573-3912_ei3_COM_22907

Van Gelder, Geert Jan, and Wolfhart P. Heinrichs. "*Naẓm.*" *Encyclopaedia of Islam.* 2nd ed. http://dx.doi.org/10.1163/1573-3912_islam_SIM_8857.

de Vegvar, Carol Neuman. "Remembering Jerusalem: Architecture and Meaning in Insular Canon Table Arcades." In *Making and Meaning in Insular Art.* Edited by Rachel Moss, 242–256. Portland, OR: Four Courts Press, 2007.

Venturi, Robert, Denise Scott Brown, and Steven Izenour. *Learning from Las Vegas.* Cambridge, MA: MIT Press, 1972.

Vernoit, Stephen. "Islamic Art and Architecture: An Overview of Scholarship and Collecting, *c.* 1850–1950." In *Discovering Islamic Art: Scholars, Collectors and Collections, 1850–1950.* Edited by Stephen Vernoit, 1–61. London: I. B. Tauris, 2000.

Vickers, Michael, and David Gill. *Artful Crafts: Ancient Greek Silverware and Pottery.* Oxford: Clarendon Press, 1994.

Vickers, Michael, Oliver Impey, and James Allan. *From Silver to Ceramic: The Potter's Debt to Metalwork in the Graeco-Roman, Chinese and Islamic Worlds.* Oxford: Ashmolean Museum, 1986.

Von Folsach, Kjeld. *Islamic Art: The David Collection.* Copenhagen: David Collection, 1990.

Von Folsach, Kjeld. *Art from the World of Islam in the David Collection.* Copenhagen: David Collection, 2001.

Von Folsach, Kjeld. "A Number of Pigmented Wooden Objects from the Eastern Islamic World." *Journal of the David Collection* 1 (2003): 73–98.

Von Folsach, Kjeld, Torben Lundbaek, and Peder Mortensen, eds. *Sultan, Shah and Great Mughal: The History and Culture of the Islamic World.* Copenhagen: National Museum, 1996.

Von Grunebaum, G. E. "Aspects of Arabic Urban Literature Mostly in Ninth and Tenth Centuries." *Islamic Studies* 8, no. 4 (1969): 217–300.

Vorozheykina, Z.V. *Isfahanskaya shkola poetov i literaturnaya zhizn Irana v predmongolskoe vremya* [The Isfahani school of poets and literary life of Iran in the Premongol time: 12th–early 13th centuries]. Moscow, 1984.

Ward, Rachel. "Incense and Incense Burners in Mamluk Egypt and Syria." *Transactions of the Oriental Ceramics Society* 55 (1990–91): 67–82.

Ward, Rachel. *Islamic Metalwork.* London: British Museum, 1993.

Watson, Oliver. "Persian Lustre-Painted Pottery: The Rayy and Kashan Styles." *Transactions of the Oriental Ceramics Society* 40 (1973–75): 1–19.

Watson, Oliver. *Persian Lustre Ware*. London: Faber and Faber, 1985.

Watson, Oliver. "Pottery and Metal Shapes in Persia in the Twelfth and Thirteenth Centuries." In *Pots and Pans: A Colloquium on Precious Metals and Ceramics in the Muslim, Chinese and Graeco-Roman Worlds, Oxford Studies in Islamic Art* 3. Edited by Michael Vickers, 205–212. Oxford: University of Oxford Press, 1985.

Watson, Oliver. "Small Table, Moulded Fritware with a Turquoise Glaze." *Art from the World of Islam: 8th–18th Century, Louisiana Revy* 27, no. 3 (1987): 117.

Watson, Oliver. "Museums, Collecting, Art-History and Archaeology." *Damaszener Mitteilungen* 11 (1999): 421–432.

Watson, Oliver. *Ceramics from Islamic Lands*. London: Thames and Hudson, 2004.

Watson, Oliver. "Pottery under the Mongols." In *Beyond the Legacy of Genghis Khan*. Edited by Linda Komaroff, 325–345. Leiden: Brill, 2006.

Watson, Oliver. "Review of 'The Iconography of Islamic Art: Studies in Honour of Robert Hillenbrand.'" *Journal of Islamic Studies* 18, no. 2 (2007): 299–302.

Watson, Oliver. "The Case of the Ottoman Table." *Journal of the David Collection* 3 (2010): 2–33.

Watson, Oliver. "Notes from the Field: Materiality." *The Art Bulletin* 95, no. 1 (2013): 31–34.

Vajda, G. "Idrīs." *Encyclopaedia of Islam*. 2nd ed. http://dx.doi.org/10.1163/1573-3912_islam_SIM_3491

Wehr, Hans. *Arabic-English Dictionary*. Urbana, IL: Spoken Language Services / Harrassowitz, 1994.

Weinryb, Ittai. "Living Matter: Materiality, Maker, and Ornament in the Middle Ages." *Gesta* 52, no. 2 (2013): 113–132.

Weir, Alex A. S., Jackie Chappell, and Alex Kacelnik. "Shaping of Hooks in New Caledonian Crows." *Science* 297 (August 2002): 981.

Weitzmann, Kurt. "The Ivories of the So-called Grado Chair." *Dumbarton Oaks Papers* 26 (1972): 43–91.

Weitzmann, Kurt. *The Age of Spirituality: Late Antique and Early Christian Art*. New York: Metropolitan Museum of Art, 1979.

Wensinck, A. J., and T. Fahd. "Ṣūra." *Encyclopaedia of Islam*. 2nd ed. http://dx.doi.org/10.1163/1573-3912_islam_COM_1124.

Whelan, Estelle. "Representations of the *Khāṣṣakīyah* and the Origin of Mamluk Emblems." In *Content and Context of Visual Arts in the Islamic World*. Edited by Priscilla P. Soucek, 219–254. University Park: Pennsylvania State University Press, 1988.

Wiersema, Juliet B. *Architectural Vessels of the Moche: Ceramic Diagrams of Sacred Space in Ancient Peru*. Austin: University of Texas Press, 2015.

Wilber, Donald N. "The Development of Mosaic Faïence in Islamic Architecture in Iran." *Ars Orientalis* 6, no. 1 (1939): 16–47.

Wilkinson, Charles K. "Christian Remains from Nishapur." In *Forschungen zur Kunst Asiens: In Memoriam Kurt Erdmann*. Edited by Oktay Aslanapa and Rudolf Naumann, 79–87. Istanbul: Universitesi Edebiyat Fakültësi, 1969.

Wilkinson, Charles K. *Nishapur: Some Early Islamic Buildings and Their Decoration*. New York: Metropolitan Museum of Art, 1986.

Wittgenstein, Ludwig. *Philosophical Investigations*. Translated and edited by Peter M. S. Hacker and Joachim Schulte. Oxford: Wiley-Blackwell, 2009.

Wolfson, Harry Austen. "The Internal Senses in Latin, Arabic, and Hebrew Philosophic Texts." *Harvard Theological Review* 28, no. 2 (1935): 69–133.

Wolper, Ethel Sara. "Khidr and the Politics of Translation in Mosul: Mar Behnam, St George and Khidr Ilyas." In *Sacred Precincts: The Religious Architecture of Non-Muslim Communities across the Islamic World*. Edited by Mohammad Gharipour, 379–392. Leiden: Brill, 2015.

Woods, Christopher S. *Forgery, Replica, Fiction: Temporalities of German Renaissance Art*. Chicago: University of Chicago Press, 2008.

Wulff, Hans E. *The Traditional Crafts of Persia*. Cambridge, MA: MIT Press, 1966.

Yarshater, Ehsan. "Some Common Characteristics of Persian Poetry and Art." *Studia Islamica* 16 (1962): 61–71.

Yeshaya, Joachim. "Medieval Hebrew Poetry and Arabic *Badiʿ* Style: A Poem by Moses Darʿī (Twelfth-Century Egypt)." In *Egypt and Syria in the Fatimid, Ayyubid and Mamluk Eras, VIII*. Edited by Urbain Vermeule, Kristof D'Hulster, and Jo Van Steenbergen, 317–330. Leuven: Peeters, 2016.

Zaman, Muhammad Qasim. "al-Yaʿḳūbī." *Encyclopaedia of Islam*. 2nd ed. http://dx.doi.org/10.1163/1573-3912_islam_SIM_7970

Zozaya, Juan. "Aeraria de Transición: Objetos con base de cobre de los siglos VII al IX en al-Andalus." *Arqueología Medieval* 11 (2011): 11–24.

ILLUSTRATION CREDITS

FIGURE I.1
Melanie Michailidis, 2003, courtesy of the Aga Khan Documentation Center at MIT.

FIGURE I.2
Johannes Kramer, © Museum für Islamische Kunst—Staatliche Museen zu Berlin.

FIGURE I.3
Robert Byron collection, photo 1240 (337). Reproduced courtesy of the British Library Board.

FIGURE I.4
Metropolitan Museum of Art, Rogers Fund, 1944.

FIGURE I.5
Museum of Fine Arts, Tbilisi.

FIGURE I.6
Gift of Dr. and Mrs. Lewis M. Fraad. Photo: Brooklyn Museum.

FIGURE I.7
Metropolitan Museum of Art, Purchase, Dr. and Mrs. John C. Weber Gift, 1984.

FIGURE I.8
Metropolitan Museum of Art, Charlotte C. and John C. Weber Collection, Gift of Charlotte C. and John C. Weber, 1992.

FIGURE I.9
Courtesy of the Division of Anthropology, Natural History Museum.

FIGURE I.10
The Walters Art Museum, Baltimore.

FIGURE I.11
Metropolitan Museum of Art, Fletcher Fund, 1962.

FIGURE I.12
© Aga Khan Museum.

FIGURE 1.1
After Ulrich Harb, *Ilkhanidische Stalaktitengewölbe: Beiträge zu Entwurf un Bautechnik* (Berlin: Dietrich Reimer Verlag, 1978), plate 1, figure 1.

FIGURE 1.2
Metropolitan Museum of Art, Rogers Fund, 1939.

FIGURE 1.3
© The Trustees of the British Museum.

FIGURE 1.4
© The al-Sabah Collection, Dar al-Athar al-Islamiyyah, Kuwait.

FIGURE 1.5
Metropolitan Museum of Art, Harris Dick Brisbane Fund, 1957.

FIGURE 1.6
Metropolitan Museum of Art, Harris Dick Brisbane Fund, 1957.

FIGURE 1.7
Metropolitan Museum of Art, Gift of Miriam Schaar Schloessinger, 1961. Photo: © Metropolitan Museum of Art, NY: image source: Art Resource, NY.

FIGURE 1.8
Gift of Peter Marks. Photo: Kevin Montague.

FIGURE 1.9
Photo: Kevin Montague.

FIGURE 1.10
Metropolitan Museum of Art, Rogers Fund, 1948.

FIGURE 1.11
Courtesy of the Oriental Institute of the University of Chicago.

FIGURE 2.1
Photo: Kevin Montague.

FIGURE 2.2
Image in the public domain.

FIGURE 2.3
After David Storm Rice, "Studies in Islamic Metalwork," *Bulletin of the School of Oriental and African Studies* 14:3 (1952), plate 10.

FIGURE 2.4
Johannes Kramer, © Museum für Islamische Kunst—Staatliche Museen zu Berlin.

FIGURE 2.5
Image: Hans-Caspar Graf von Bothmer.

FIGURE 2.6
Image: Conway Library, The Courtauld Institute of Art, London, negative A74/284.

FIGURE 2.7
Photo: Jaś Elsner.

FIGURE 2.8
Photo: © The Trustees of the British Museum.

FIGURE 2.9
After Sarah Stewart, ed., *The Everlasting Flame: Zoroastrianism in History and Imagination* (London: I.B. Tauris, 2013), p. 100.

FIGURE 2.10
Image: http://www.manar-al-athar.ox.ac.uk, see Khirbet al-Mafjar, balustrade.

FIGURE 2.11
Metropolitan Museum of Art, Samuel D. Lee Fund, 1937.

FIGURE 2.12
Metropolitan Museum of Art, Gift of Mrs. Edward F. Harkness, 1929.

FIGURE 2.13
© The Cleveland Museum of Art.

FIGURE 2.14
© The Trustees of the British Museum.

FIGURE 2.15
Purchase—Charles Lang Freer Endowment.

FIGURE 2.16
Vladimir Terebenin, Alexander Koksharov, © The State Hermitage Museum.

FIGURE 2.17
Vladimir Terebenin, Alexander Koksharov © The State Hermitage Museum.

FIGURE 2.18
Yasser Tabbaa, courtesy of the Aga Khan Documentation Center at MIT.

FIGURE 2.19
Yasser Tabbaa, courtesy of the Aga Khan Documentation Center at MIT.

FIGURE 2.20
After Tariq Jawad al-Janabi, *Studies in Medieval Iraqi Architecture* (PhD diss., University of Edinburgh, 1975), pl. 170b.

FIGURE 2.21
After Tariq Jawad al-Janabi, *Studies in Medieval Iraqi Architecture* (PhD diss., University of Edinburgh, 1975), pl. 171b.

FIGURE 2.22
Photo: author, by permission of the Museum für Islamische Kunst—Staatliche Museen zu Berlin.

FIGURE 2.23
Musée de l'Institut du monde arabe.

FIGURE 2.24
Photo: author.

FIGURE 2.25
Drawing: author.

FIGURE 2.26
After Gerald Reitlinger, "Unglazed Relief Pottery from Northern Mesopotamia," *Ars Islamica* 15/16 (1951), figure 22.

FIGURE 3.1
Photo: author, by permission of the Museum für Islamische Kunst—Staatliche Museen zu Berlin.

FIGURE 3.2
Photo: author, by permission of the Museum für Islamische Kunst—Staatliche Museen zu Berlin.

FIGURE 3.3
Vladimir Terebenin, Alexander Koksharov, © The State Hermitage Museum.

FIGURE 3.4
IMG12740 © Aga Khan Trust for Culture/Cameron Rashti (photographer).

FIGURE 3.5
Vladimir Terebenin, Alexander Koksharov, © The State Hermitage Museum.

FIGURE 3.6
Photo: Pernille Klemp.

FIGURE 3.7
Purchased with the Elizabeth Wandell Smith Fund from the Edmond Foulc Collection, 1930. Photo: Philadelphia Museum of Art.

FIGURE 3.8
Metropolitan Museum of Art, Rogers Fund, 1935.

FIGURE 3.9
Vladimir Terebenin, Alexander Koksharov, © The State Hermitage Museum.

FIGURE 3.10
Vladimir Terebenin, Alexander Koksharov, © The State Hermitage Museum.

FIGURE 3.11
Image: Suleymaniye Library.

FIGURE 3.12
Image: Suleymaniye Library.

FIGURE 3.13
Image: © Victoria and Albert Museum, London.

FIGURE 3.14
The Walters Art Museum, Baltimore.

FIGURE 3.15
© The Trustees of the British Museum.

FIGURE 3.16
© RMN Grand Palais/Art Resource, NY.

FIGURE 3.17
Photo: author.

FIGURE 3.18
© 2016 Musée du Louvre/Hervé Lewandowski.

FIGURE 3.19
With permission of the Royal Ontario Museum © ROM.

FIGURE 3.20
© Istituto Italiano per l'Africa e l'Oriente, negative 123_1.

FIGURE 3.21
© Istituto Italiano per l'Africa e l'Oriente, negative 123_7.

FIGURE 3.22
© Istituto Italiano per l'Africa e l'Oriente, negative 123_4.

FIGURE 3.23
Metropolitan Museum of Art, Rogers Fund, 1935.

FIGURE 3.24
Photo: Anne-Marie Keblow Bernsted.

FIGURE 3.25
Bibliothèque nationale de France.

FIGURE 3.26
Photo: Anne-Marie Keblow Bernsted.

FIGURE 3.27
Photo: Pernille Klemp.

FIGURE 3.28
Purchase—Charles Lang Freer Endowment.

FIGURE 3.29
© 2016 Musée du Louvre/Hervé Lewandowski.

FIGURE 3.30
Metropolitan Museum of Art, Rogers Fund, 1940.

FIGURE 3.31
© Musée du Louvre, dist. RMN—Grand Palais/Raphaël Chipault.

FIGURE 3.32
© Musée du Louvre, dist. RMN—Grand Palais/Raphaël Chipault.

FIGURE 3.33
Bibliothèque nationale de France.

FIGURE 4.1
Metropolitan Museum of Art, Harris Brisbane Dick Fund.

FIGURE 4.2
Metropolitan Museum of Art, Fletcher Fund, 1975. © Metropolitan Museum of Art. Image source: Art Resource, NY.

FIGURE 4.3
Purchase—Charles Lang Freer Endowment.

FIGURE 4.4
Photo: © Museum With No Frontiers (Discover Islamic Art).

FIGURE 4.5
Metropolitan Museum of Art, Fletcher Fund.

FIGURE 4.6
© RMN-Grand Palais (musée du Louvre)/Jean-Gilles Berizzi.

FIGURE 4.7
After Helen C. Evans and Brandie Ratcliff, eds, *Byzantium and Islam: Age of Transition, 7th–9th Century* (New York: Metropolitan Museum of Art, 2012), 218.

FIGURE 4.8
Gift of The American Foundation for the Study of Man (Wendell and Merilyn Phillips Collection).

FIGURE 4.9
Princeton University Art Museum.

FIGURE 4.10
After www.eternalegypt.org.

FIGURE 4.11
© RMN-Grand Palais (musée du Louvre)/Jean-Gilles Berizzi.

FIGURE 4.12
Länsmuseet Gävleborg.

FIGURE 4.13
Johannes Kramer, © Museum für Islamische Kunst—Staatliche Museen zu Berlin.

FIGURE 4.14
© The Khalili Family Trust.

FIGURE 4.15
Photo: Jehad Yasin.

FIGURE 4.16
© The al-Sabah Collection, Dar al-Athar al-Islamiyyah, Kuwait.

FIGURE 4.17
Metropolitan Museum of Art, Edward C. Moore Collection, Bequest of Edward C. Moore, 1891.

FIGURE 4.18
© Dumbarton Oaks, Byzantine Collection, Washington, DC.

FIGURE 4.19
After David Roxburgh, ed., *Turks: Journey of a Thousand Years, 600–1600* (London: Royal Academy, 2005), 121.

FIGURE 4.20
Courtesy of Dallas Museum of Art.

FIGURE 4.21
© The Khalili Family Trust.

FIGURE 4.22
© The Khalili Family Trust.

FIGURE 4.23
Vladimir Terebenin, Alexander Koksharov, © The State Hermitage Museum.

FIGURE 5.1
Photo: author, by permission of the City Art Gallery.

FIGURE 5.2
Courtesy of The American University in Cairo Press.

FIGURE 5.3
After K.A.C. Creswell, *Early Muslim Architecture*, vol. 2 (Oxford, 1940), fig. 230. Courtesy of Special Collections, Fine Arts Library, Harvard University.

FIGURE 5.4
Photo: author, by permission of the Museum für Islamische Kunst—Staatliche Museen zu Berlin.

FIGURE 5.5
© Museum für Islamische Kunst—Staatliche Museen zu Berlin.

FIGURE 5.6
Photo: author.

FIGURE 5.7
Photo: author, by permission of the City Art Gallery.

FIGURE 5.8
Photo: author.

FIGURE 5.9
Photo: author, reproduced by permission of the Victoria and Albert Museum.

FIGURE 5.10
Photo: author.

FIGURE 5.11
Photo: author, reproduced by permission of the Victoria and Albert Museum.

FIGURE 5.12
Photo: Mariam Rosser-Owen.

FIGURE 5.13
University of Edinburgh, Barakat Trust, and Khalili Research Centre, Oxford.

FIGURE 5.14
Photo: author, reproduced by permission of the Victoria and Albert Museum.

FIGURE 5.15
After Rachid Bourouiba, "Note sur une vasque de pierre trouvée au Palais du Manar de la Qal'a des Bani Hammad," *Bulletin d'archéologie algérienne* 5 (1971–75), figure 3.

FIGURE 5.16
Photo: author.

FIGURE 5.17
Photo: author.

FIGURE 5.18
Archivo fotográfico del Museo Santa Clara de Murcia, España.

FIGURE 5.19
Courtesy of the Museo Arqueológico de Seville.

FIGURE 5.20
Courtesy of the American University in Cairo Press.

INDEX